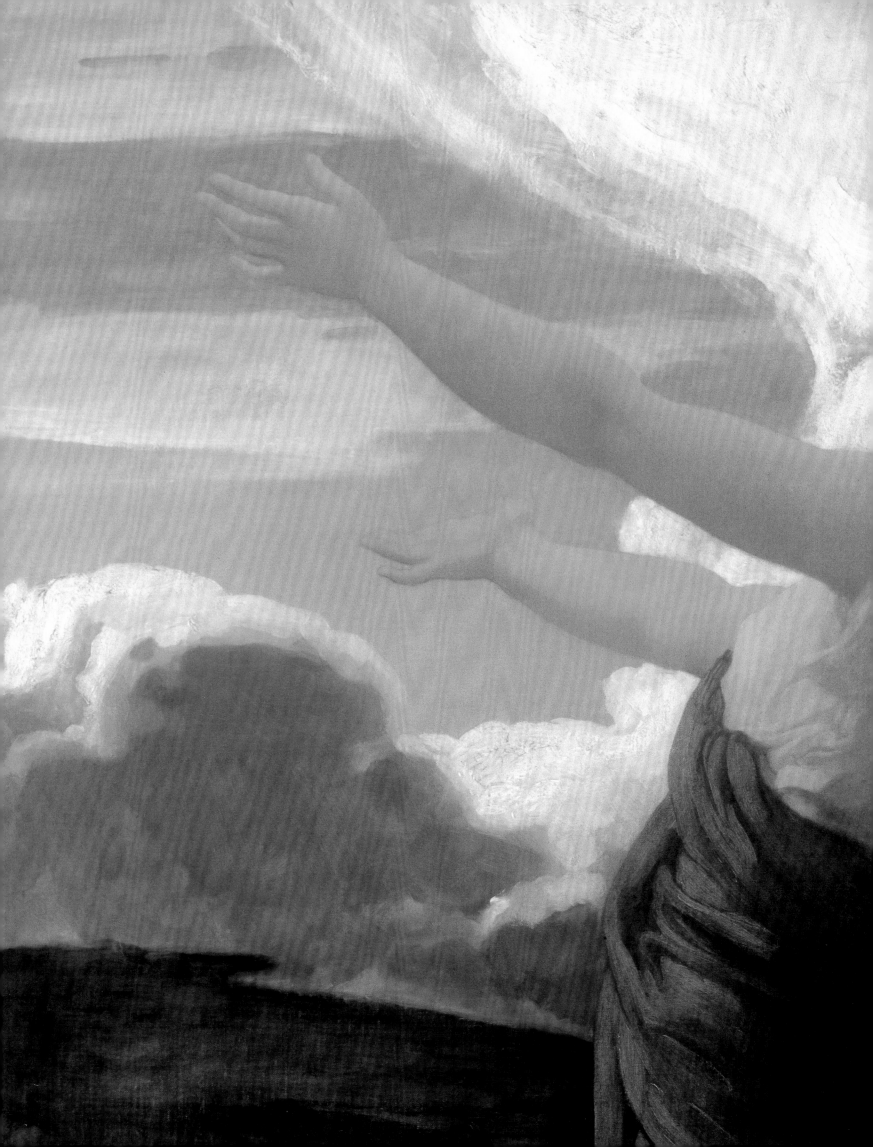

1900

ART AT THE

CROSSROADS

ROBERT ROSENBLUM

MARYANNE STEVENS

ANN DUMAS

HARRY N. ABRAMS, INC., PUBLISHERS

First published on the occasion of the exhibition
'1900: Art at the Crossroads'

Royal Academy of Arts, London
16 January – 3 April 2000

Solomon R. Guggenheim Museum, New York
18 May – 13 September 2000

EXHIBITION CURATORS
Ann Dumas with Vivien Greene
Robert Rosenblum and Cecilia Treves
Norman Rosenthal
MaryAnne Stevens

EXHIBITION ORGANISATION
Royal Academy of Arts, London
Emeline Max Sam Oakley

Solomon R. Guggenheim Museum, New York
Marion Kahan Janice Yang
Carolyn Padwa

PHOTOGRAPHIC AND COPYRIGHT COORDINATION
Miranda Bennion Roberta Stansfield

CATALOGUE
Royal Academy Publications
David Breuer Peter Sawbridge
Sophie Lawrence Nick Tite

Design: Roger Davies
Picture Research: Julia Harris-Voss, with Kathy Lockley,
 and Carla Bertini, Ikona, Rome
Production and Co-editions: Robert Marcuson, in association
 with Textile & Art Publications
Colour Origination: The Repro House, in association
 with Robert Marcuson

Printed and bound in Belgium by Snoeck-Ducaju & Zoon

Library of Congress Catalog Card Number: 99-69361
ISBN 0–8109–4303–4 (Abrams: cloth)
ISBN 0–8109–2706–3 (QPB: paperback)

Harry N. Abrams, Inc.
100 Fifth Avenue
New York, N.Y. 10011
www.abramsbooks.com

EDITORIAL NOTE
In the Catalogue, dimensions of works are given in centimetres,
height before width; (EU 1900) indicates that the work was exhibited
at the 1900 Exposition Décennale.

Biographies are signed with the following initials:
Cross-references are indicated by an asterisk (★).

AC	Alex Cooke	MO'M	Mike O'Mahony
AD	Anke Daemgen	ER	Elizabeth Raizes
VG	Vivien Greene	SR	Sarah Richardson
SH	Sharon Hecker	MAS	MaryAnne Stevens
EL	Elena Lledó	PS	Paul Stirton
JM	James Malpas	CT	Cecilia Treves
CO'M	Claire O'Mahony	HV	Helen Valentine

Illustrations (pp. 2–7 and 10–11)
pp. 2–3 Detail of cat. 27
p. 6 Detail of cat. 31
p. 7 Detail of cat. 59
pp. 10–11 Detail of cat. 172

Contents

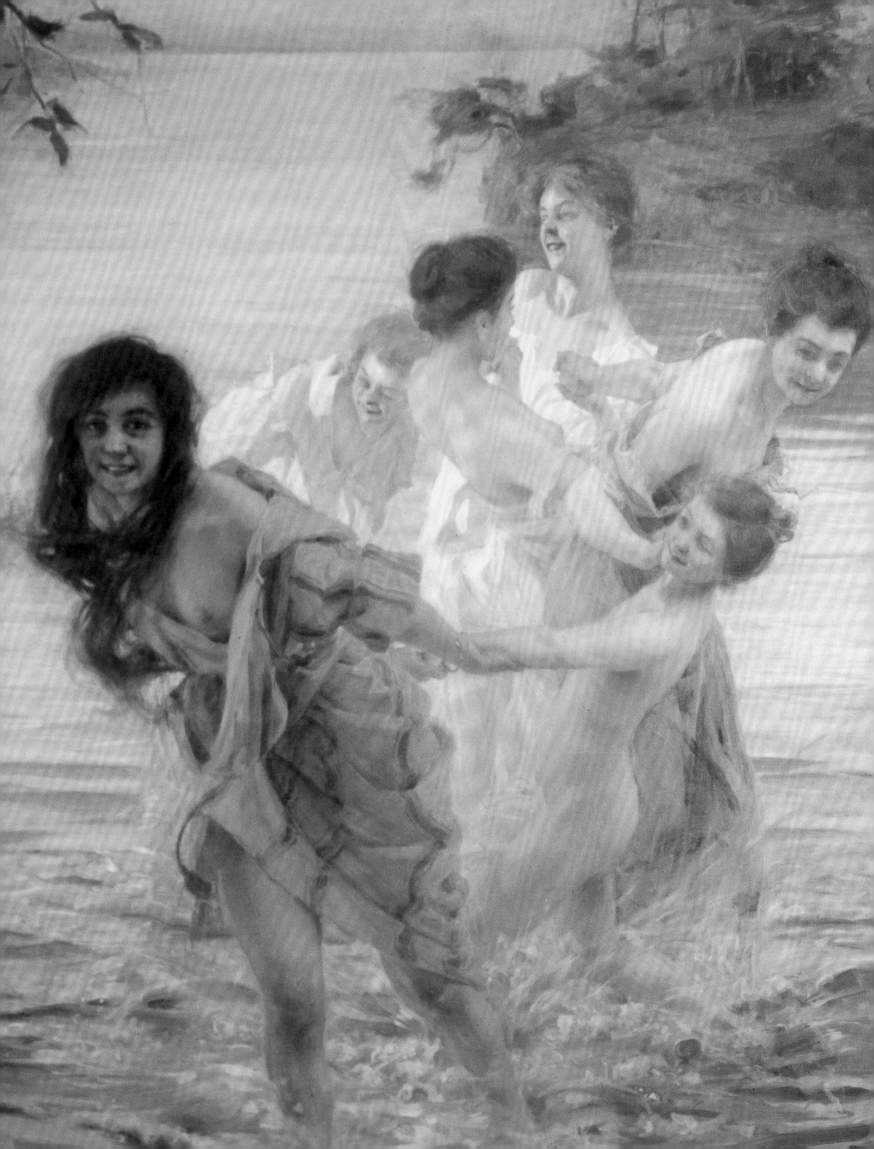

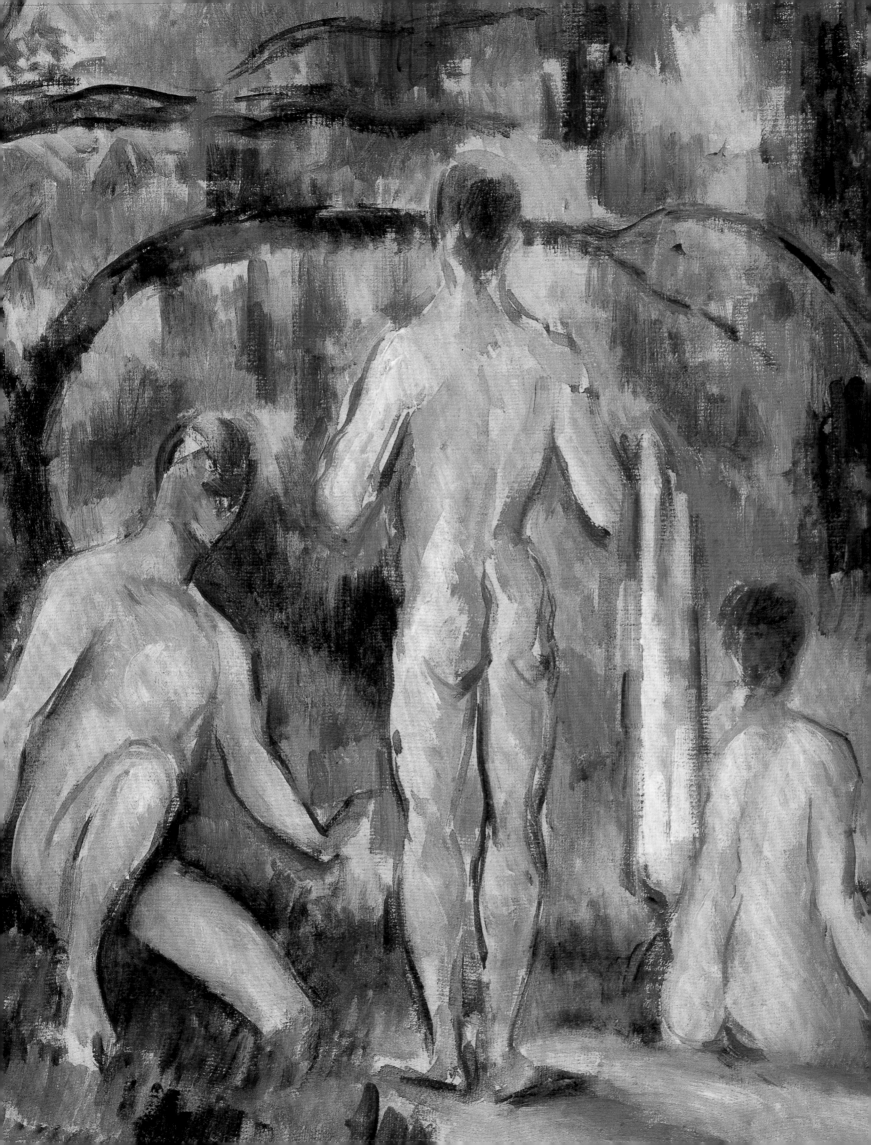

Acknowledgements

The curators of the exhibition wish to acknowledge with gratitude the support of Tom Phillips RA, Chairman of the Exhibitions Committee of the Royal Academy of Arts, and fellow committee members, and the unstinting assistance of Isabel Carlisle and Simonetta Fraquelli, Exhibition Curators at the Royal Academy of Arts. We acknowledge with thanks the assistance afforded by individual lenders, and the directors and staff of lending institutions (listed on p. 441), and by the following people who have helped in the realisation of this exhibition: Raf van den Abeele, Lynne Addison, Kathleen Adler, Timothei Alexandrov, Irina Antonova, Martha Asher, D. Scott Atkinson, Colin Bailey, Istvan Barkoczi, Tracey Bashkoff, Pierre Baudson, Martin Beisly, Gábor Bellak, the late Dr Robert Bergman, Ann Bermingham, Dorothy Berenstein, James Berry-Hill, Andreas Blühm, John Bomhoff, Violaine Bonzon-Claudel, Elodie de Bosmelet, Rod Bouc, Robert Boyce, Dominique Brachlianoff, Emily Braun, Hans Henrik Brummer, Wolfgang Büche, Cynthia Burlingham, Kim Bush, Anthony Calnek, Guadalupe Carillo, Pier Giovanni Castagnoli, Görel Cavalli-Björkman, Anne Chase-Muster, Gilles Chazal, Katherine Chevreux, Anders Clason, Michele Claudel, Linda Clous, Guy Cogeval, Françoise Cohen, Meryl Cohen, Lisa Coldiron, Isabelle Collet, Michael Conforti, Philip Conisbee, Bruno Contardi, Clementina Coradini, Judith Cox, Tim Craven, Jane DeBevoise, Sharon Dec, Lisa Dennison, C. P. Dercon, Rosa Ma Zaldivar Diaz, Barbara Divver, Claudine Dixon, Benjamin Doller, Ulla Dreyfus-Best, Rhodia Dufet-Bourdelle, Karen Duncan, Hans Dyhlen, Elizabeth Easton, Timothy Egan, Arne Eggum, John Elderfield, Scott Ellwood, Joan Enciardi, Betsy Ennis, Michael Estorick, Mark Evans, Walter and Maria Feilchenfeldt, Evelyne Ferlay, Maria Teresa Fiorio, Diane T. Fischer, Anne-Birgitte Fonsmark, Bruno Fornari, Björn Fredlund, Ben Frija, Gerbert Frödl, Leslie Furth, Barbara Gallati, Janne Gallén-Kallela Sirén, Peter Gay, Silvana Gennuso, Pierre Georgel, Eva-Maria Gertung, Claude Ghez, Pierre Giannada, Thomas Gibson, Dr Sheldon Gilgore, José Girao, Caroline Godfroy Durand-Ruel, Jacqueline Goldstein, Marilyn J. S. Goodman, Diane De Grazia, Christopher Green, Deanna M. Griffin, Tatiana Gubanova, Scott Gutterman, Ben Hartley, Caroline Harwood, Osamu Hashiguchi, Lauren B. Hauptman, Pablo Helguera, Allis Helleland, Raquel Henriques da Siwa, Uwe Hienz, Frederick Hill, Erica E. Hirshler, Alan Hobart, Joseph Holbach, John House, Jenns Howoldt, Robert Hoozee, Barry Hylton, Yasuhiro Ishida, Victoria Ivleva Yorke, José Ortiz-Izquierdo, Hans Jansen, Guy Jennings, Christos Joachimides, David and Tanya Josefowitz, Paul and Ellen Josefowitz, Kerry Junge, Jane Kallir, Laurence B. Kanter, Alexis Katz, Peter M. Kenny, Steven Kern, George Keyes, Christian Klemm, Claudia Klugmann, Geöry Költsch, Peter Kopszak, Dorothy Kosinski, Ulrich Krempel, Tom Krens, Andreas Kreul, Lela Krogh, Sandor Kuthy, David Landau, Margit Lange, Sylvie Lecoq Ramond, Thomas Lederballe, John Leighton, Jeremy Lewison, Fred Licht, Irvin M. Lippman, Knut Ljögodt, J. L. Locher, Olivier Lorquin, Henri Loyrette, Neil MacGregor, Alec MacKaye, J. Patrice Marandel, Julia Marlow, Caroline Mathieu, Stephanie Mayer, Fernando Mazzocca, Gillian McMillan, Ron Mellor, Anthony Meyer, Karen Meyerhoff, Charles S. Moffett, Julia Molinar, Kasper Monrad, Sean Mooney, Eileen K. Morales, Agnieszka Morawański, Angelo Morsello, Claus Moser, Jens Peter Munk, John Murdoch, Richard Murray, Takako Nagasawa, Susan Nalezyty, David Nash, Steven A. Nash, James Nelson, Paul Nicholls, Jovan Nicholson, Peter Nisbet, David Nisinson, Alexandra Noble, Antoinette le Norman-Romain, Edward Nygren, Maureen O'Brien, Guillermo Ovalle, Kim Pashko, Edmund Peel, Veronica Pesantes, Eugenia Petrova, Claude Pétry, Marshall Price, Simon de Pury, E. J. C. Raaseen Kruimel, J. Fiona Ragheb, Elizabeth Raizes, Benedict Read, Francis Ribemont, Sarah Richardson, Christopher Riopelle, Joseph J. Rishel, Claude Ritschard, Alex Robinson, Giandomenico Romanelli, Allen Rosenbaum, Mark Rosenthal, Phyllis Rosenzweig, Tiananne Saabye, Régis Sabre, Birgitta Sandström, Helmiriitta Sariola, Ofir Scheps, Claudia Schmuckli, Katja Schneider, Klaus Albrecht Schröder, Carla Schulz-Hoffmann, Peter-Klaus Schuster, Deiter Schwartz, Paul Schwartzbaum, George T. M. Shackelford, Tetsuji Shibayama, Natasha Sigmund, Soili Sinisalo, Tone Skedsmo, Peyton Skipwith, Dr Evelyn Silber, Mary Beth Smalley, Göran Söderland, Kathleen Soriano, Barbi Spieler, Gail Stavitsky, students from the Fall 1997 'Painting c. 1900' seminar at New York University's Institute of Fine Arts, Janos Sturcz, Edward J. Sullivan, Satushi Suzuki, Anna Szinyei-Merse-Baiza, John Tancock, Pierre Théberge, Richard Thomson, Gary Tinterow, Ferenc Toth, Jacqueline B. Tran, Zelfira Tregulova, Julian Treuherz, Helen Valentine, Kirk Varnedoe, Catherine Wallace, Ken Wane, Junko Watanabe, Bruce Weber, H. Barbara Weinberg, Leigh Bullard Weisblatt, Jeffrey Weiss, Eliane de Wilde, Dr Jorg Wille, Ully Wille, Godfrey Worsdale, Toshio Yamazaki, James Yohe, Karen Zelanka, Michael Zimmermann, Gisèle Ollinger-Zinque, and Andràs Zwickle.

Detail of cat. 55

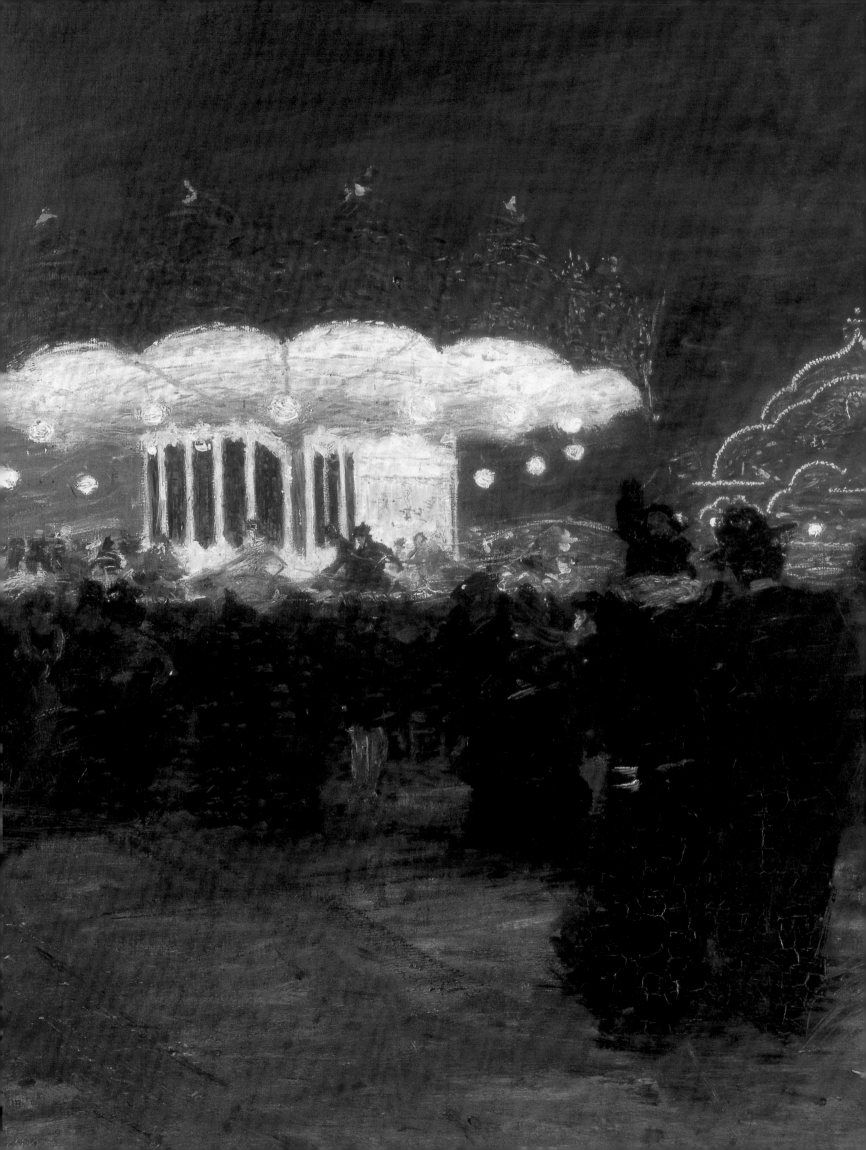

Foreword

To judge the art of our own time can be problematic and often contentious; in attempting to understand the art of a century ago we can at least afford ourselves a historical perspective. Yet there is a danger that in our desire to place things into logical sequences we may limit, distort or oversimplify this perspective.

In 1979, the Royal Academy mounted 'Post-Impressionism: Cross-Currents in European Art' in which official and avant-garde European art of 1880–1900 were brought together to provoke a reassessment of the art history of that period. '1900: Art at the Crossroads', centred on the Exposition Décennale which formed part of the 1900 Paris Exposition Universelle, further extends this innovative approach. Twenty-nine nations participated in the Exposition Décennale; each selected their most distinguished practitioners in the visual arts; tradition jostled with modern masters and those who had newly 'arrived'. From this assemblage of nations, common subject matter emerged: bathers, nudes, urban scenes, landscapes, interiors and still-lifes, religion, portraits and self-portraits. Using these themes, '1900: Art at the Crossroads' establishes a dialogue between official or traditional artists, such as Leighton, Lenbach and Bouguereau; artists, such as Monet, Degas, Cézanne and Whistler, acclaimed today as modern masters; and younger artists, such as Picasso, Matisse, Klimt, Mondrian, Balla and Kandinsky, who were to form the emerging avant-gardes. Our approach is radical and innovative: it accepts the variety of styles clamouring for attention at the turn of the century, and challenges the convention of a single, linear history of modern art.

'1900: Art at the Crossroads' is the latest fruit of our institutions' collaboration, which began in 1995–96. The curatorial team is drawn from both sides of the Atlantic: Ann Dumas, Norman Rosenthal and MaryAnne Stevens, with Cecilia Treves, for the Royal Academy of Arts, and Robert Rosenblum, with Vivien Greene, of the Solomon R. Guggenheim Museum. Scholars, museum directors and curators have generously assisted in their research for the exhibition. Their contributions are individually acknowledged elsewhere in this volume. The scope of the enterprise has made significant demands on all our lenders, both public and private; we express our deep gratitude to them all.

An exhibition on this scale requires generous sponsors. In London, the Royal Academy wishes to express its sincere thanks to Cantor Fitzgerald for their faith in this enterprise; no strangers to the Academy, nor to late nineteenth-century art, Cantor Fitzgerald sponsored the exhibition 'From Manet to Gauguin: Masterpieces from Swiss Private Collections'. In addition, we acknowledge the support of the Daily Telegraph, and, for enabling this exhibition to travel to the United States, the American Associates of the Royal Academy Trust and the Hugh and Margaret Casson Fund. Mr and Mrs John H. Schaeffer's generosity has contributed to the realisation of the catalogue.

We trust that this ambitious exhibition will challenge, delight and enthral our audiences, opening up further and more markedly for the twenty-first century the debate about those critical stages in the evolution of the art of the twentieth century.

PRESIDENT
Royal Academy of Arts, London

DIRECTOR
The Solomon R. Guggenheim Museum, New York

Detail of cat. 142

Plan of the Exposition Universelle

The numbers on the plan refer to the photographs of the 1900 Exposition Universelle on pages 16–25

Fig. 1 General view of the site around the Eiffel Tower from the top of the Palais du Trocadéro

Fig. 2 The monumental entrance to the fair with the statue of *La Parisienne* by Paul Moreau-Vauthier

Fig. 3 View along the Champ-de-Mars with the Palais de l'Electricité in the background

Fig. 4 The interior of the Grand Palais showing its spectacular ironwork and the sculpture display of the Exposition Décennale

Fig. 5 The *trottoir roulant* with the Italian pavilion in the background

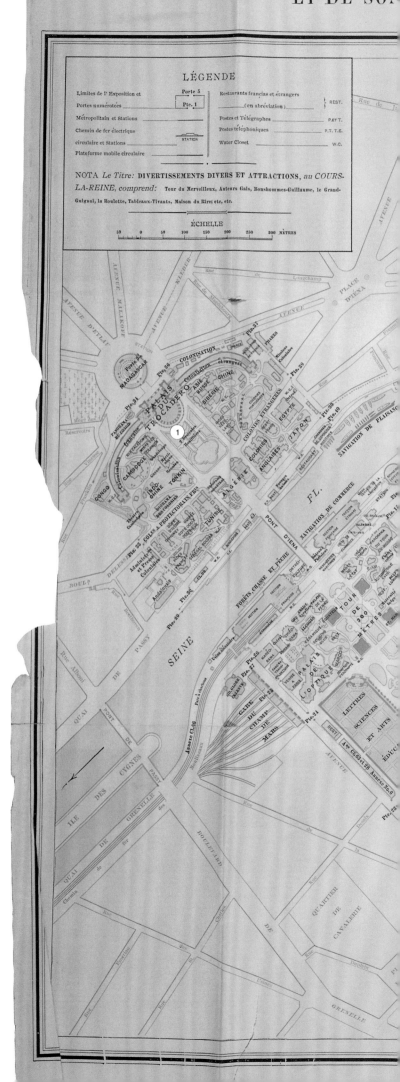

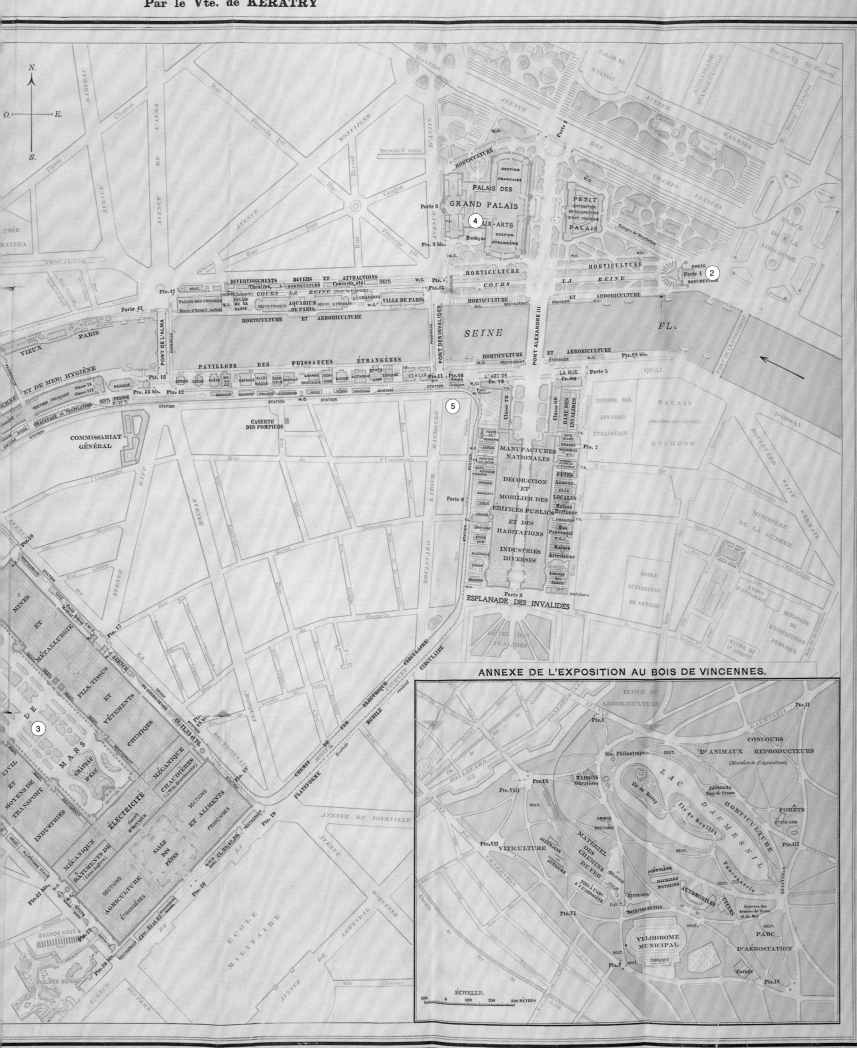

L'EXPOSITION UNIVERSELLE DE 1900

ANEXE DE VINCENNES D'APRÈS LES DOCUMENTS OFFICIELS

Par le Vte. de KÉRATRY

ANNEXE DE L'EXPOSITION AU BOIS DE VINCENNES.

ÉCHELLE.

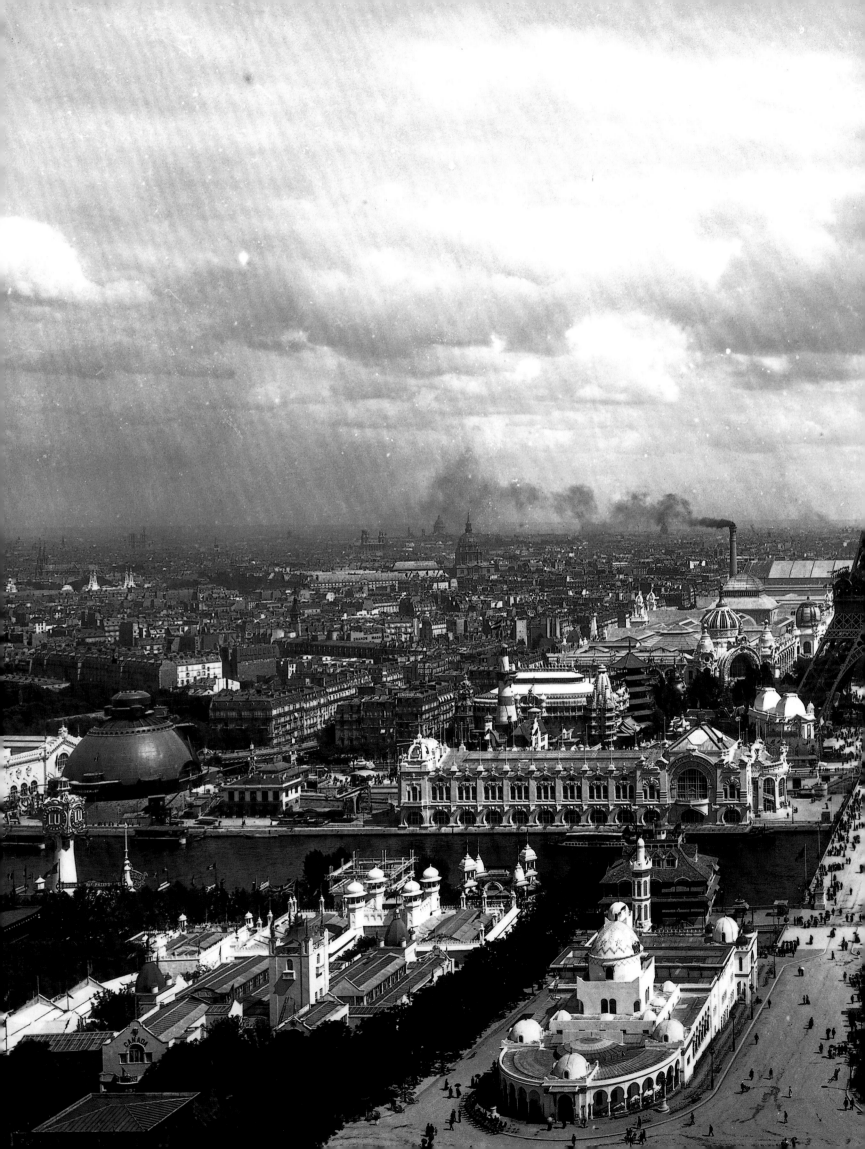

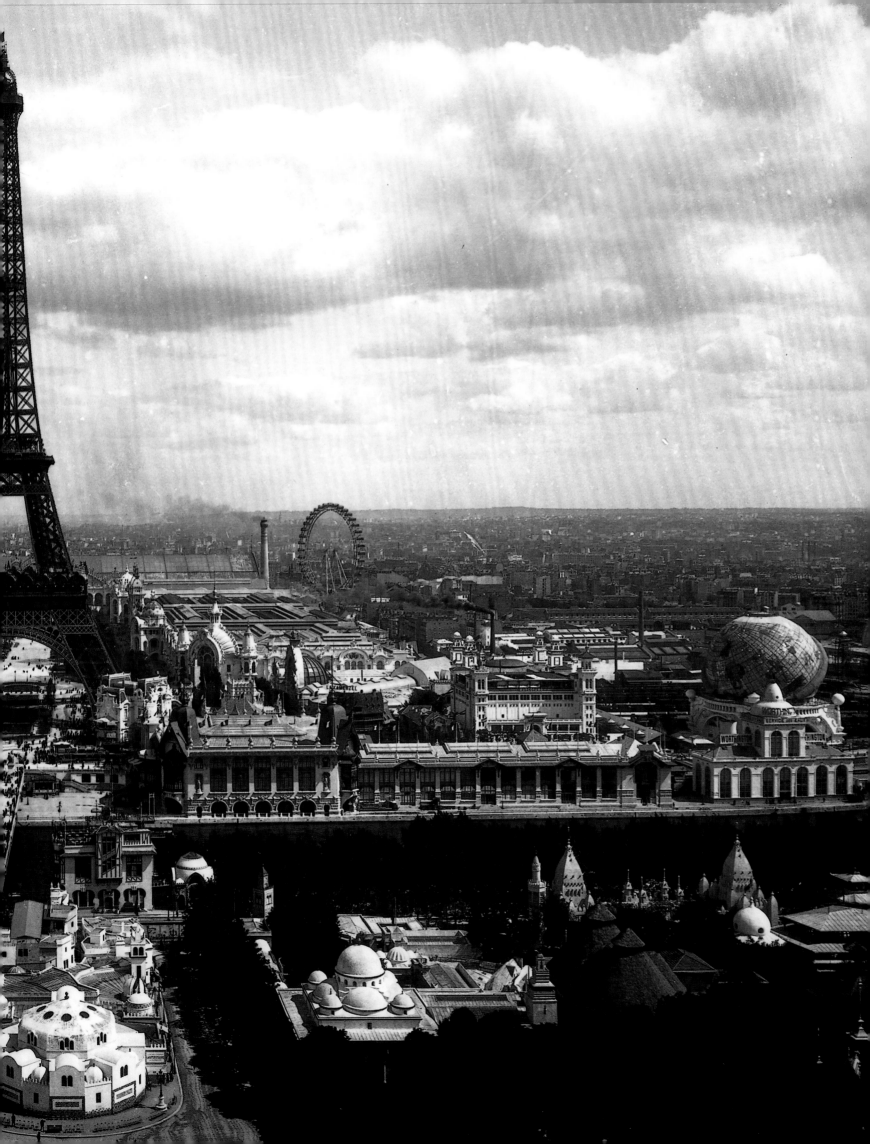

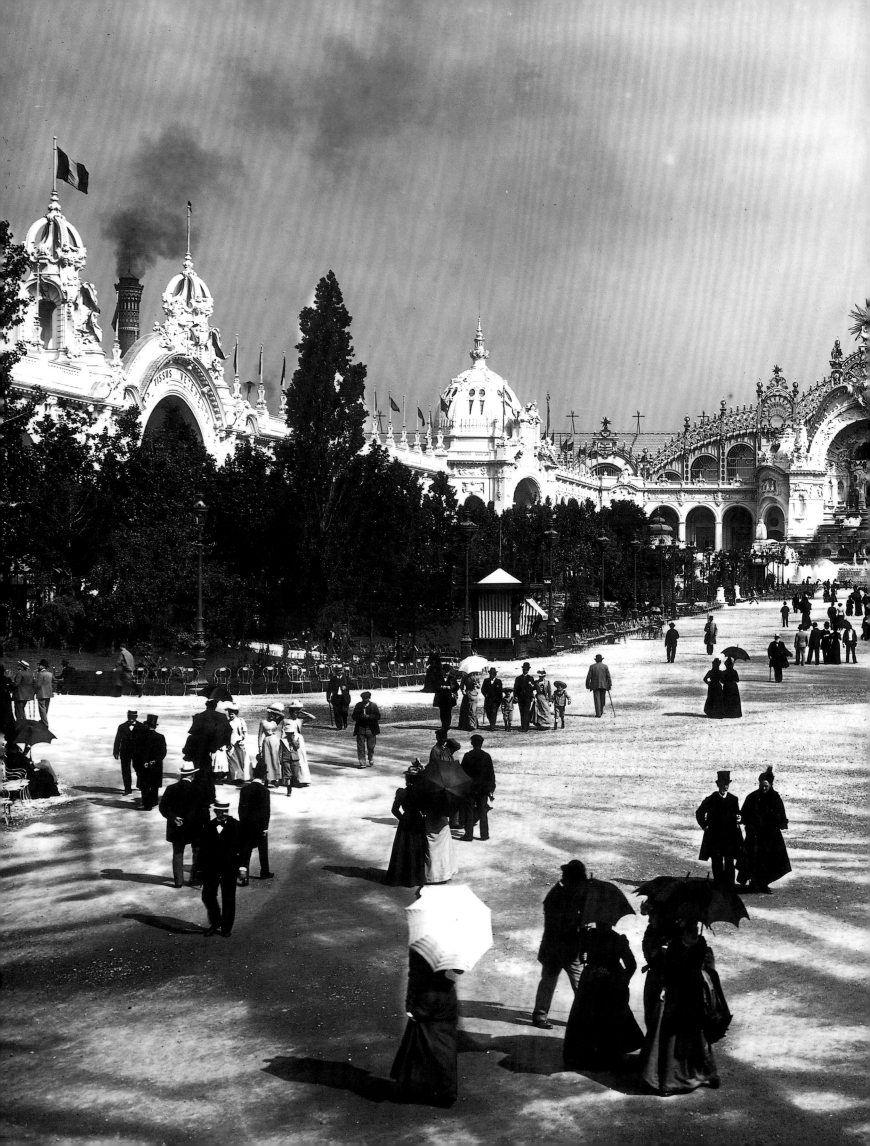

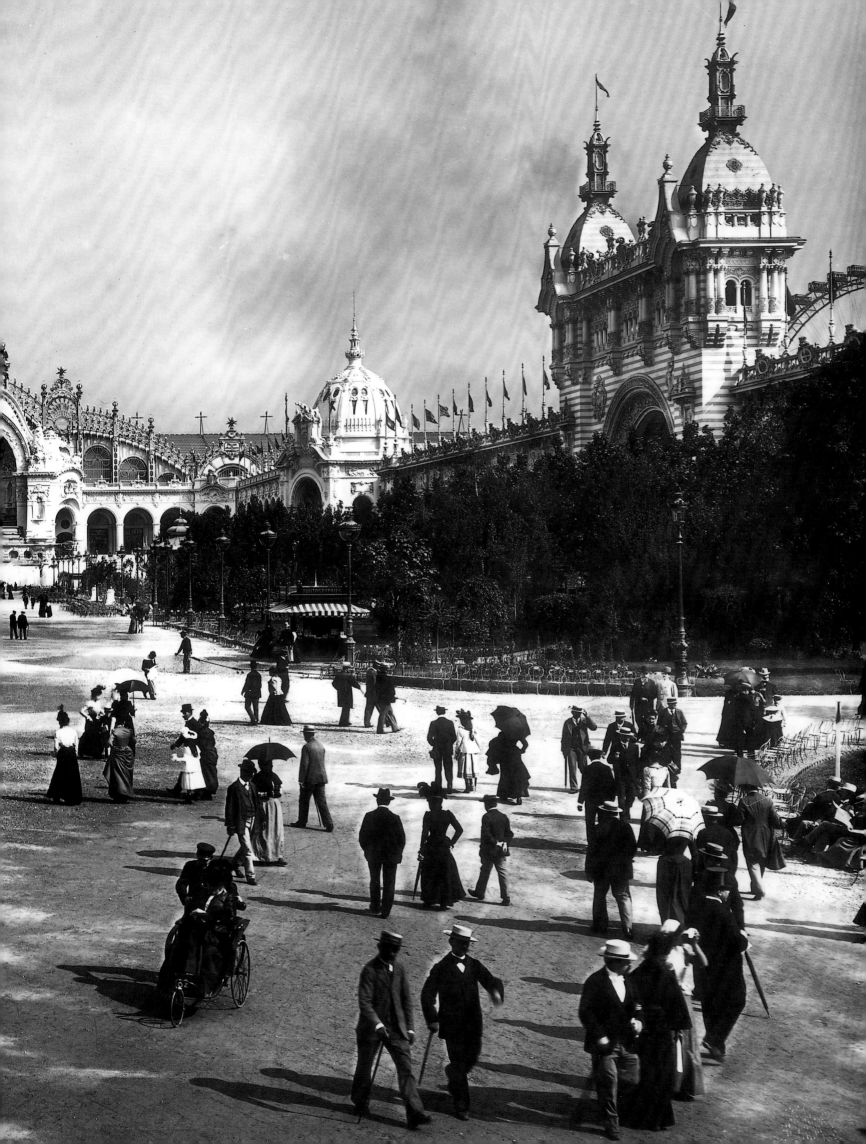

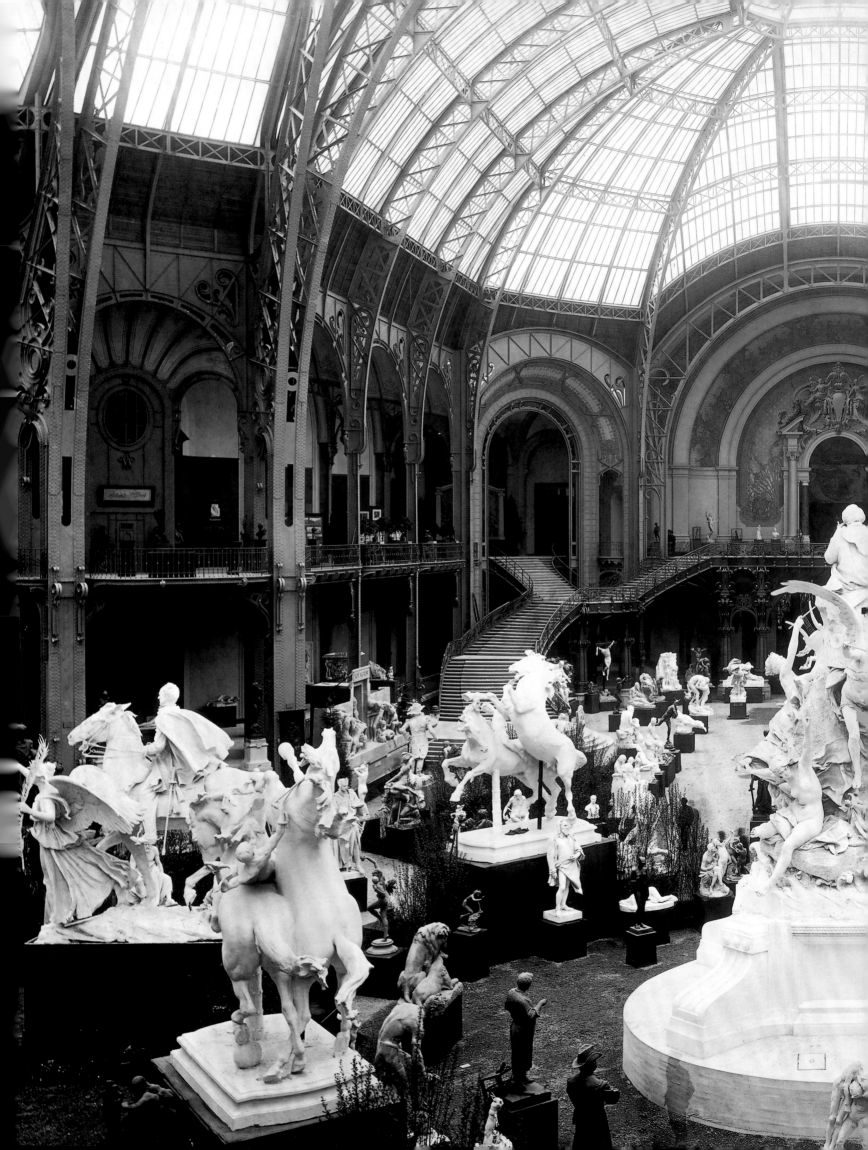

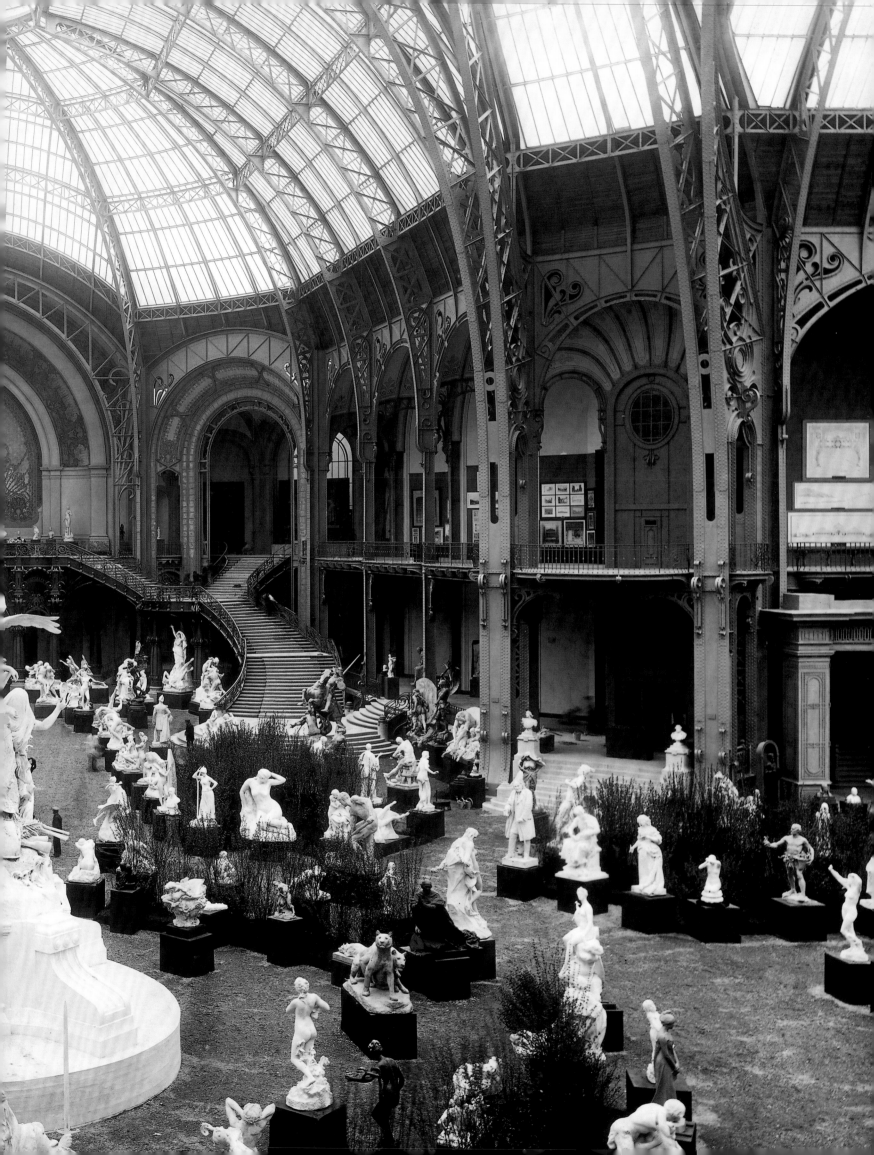

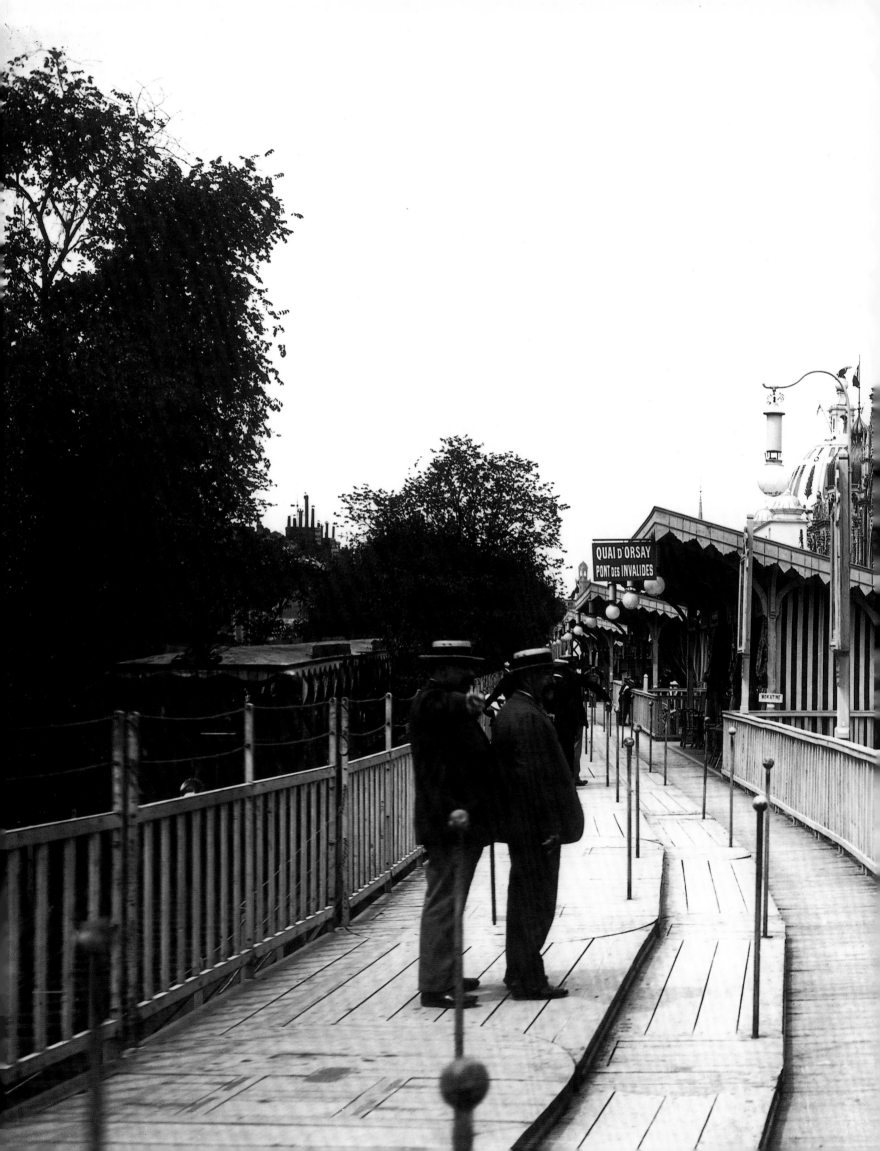

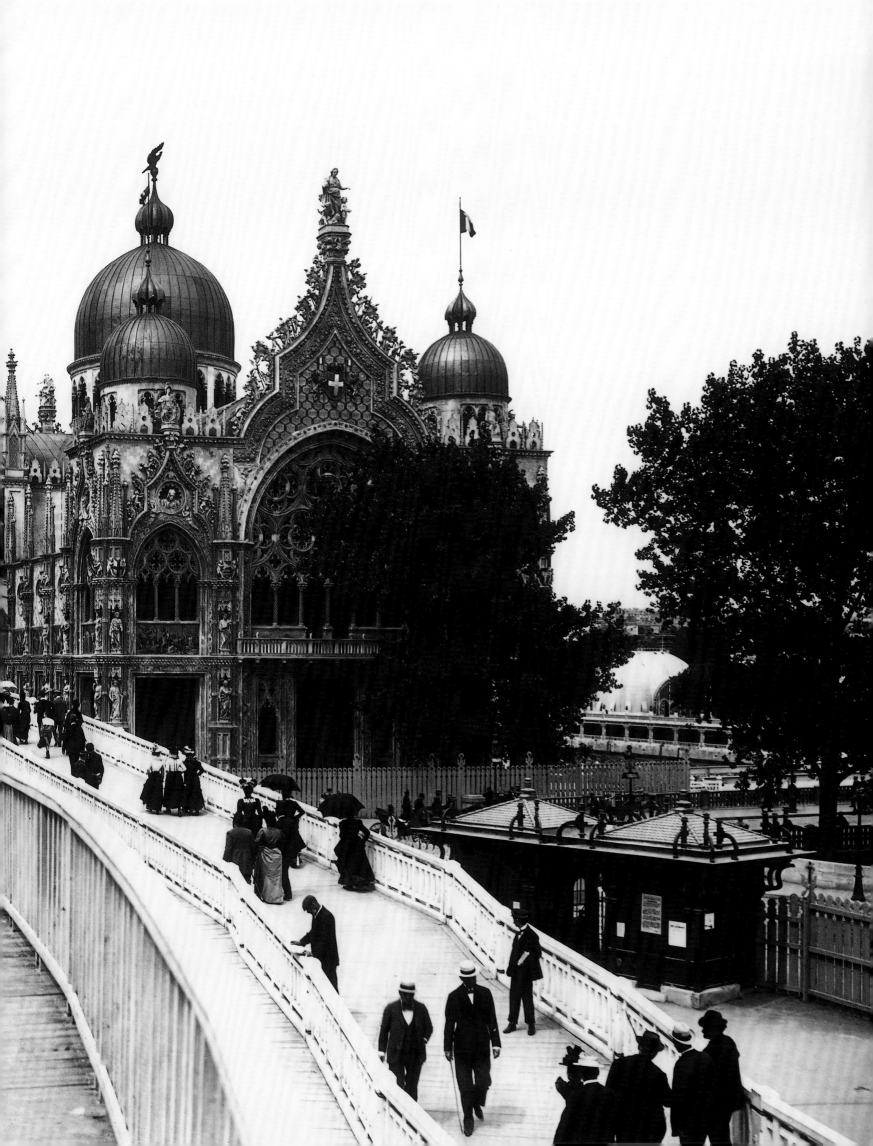

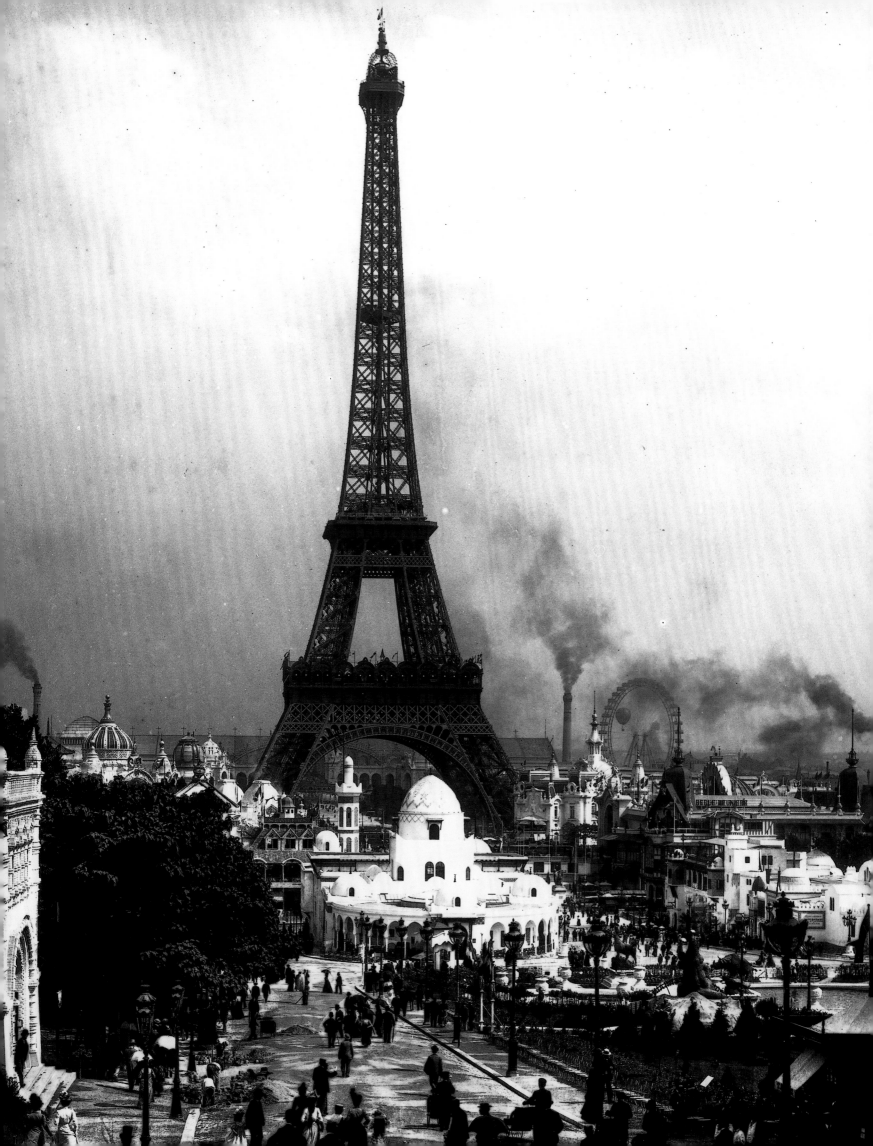

Art in 1900: Twilight or Dawn?

ROBERT ROSENBLUM

Although reason tells us that there are no connections between the momentous events of history and the turning-points of our calendar, round numbers continue to exert their magic. Inevitably, the zeros of the millennial year, 2000, invite long gazes backwards and forwards. Following one set of numbers, we might well be transported back exactly one hundred years, to the dawn of a new century and the death of an old one. Which artists working in 1900 remain in the canon? One instant answer is a list of giants who defined new signposts of modern art. But another answer demands a different kind of time-travel, an archaeological expedition to the largely buried past of art at the turn of the century, to those countless artists from all over the Western world, from Australia to Russia, who flourished at the same time and usually in the same milieus as the artists we have elevated to our pantheon. How could we give these forgotten figures another chance, a century later, to stake a fresh claim on posterity? How might they look in the shadow of those hallowed in traditional histories of modern art? Are there ways of seeing oil-and-water contemporaries like Bouguereau and Cézanne that might bridge the gulf between them? When we have fresh evidence, should we perhaps reconsider the prevailing patterns of modern art, *c.* 1900?

Of the many ways to do this, the best, prompted by calendar numbers, seemed to be to focus on the art shown at the biggest international event of the year 1900, the Exposition Universelle, that opened, still incomplete, in Paris on 14 April. From there, expanding the range to include works executed between 1897 and 1903, we would move beyond the fair, exploring a variety of pictorial themes in the hope of finding unexpected company for world-famous artists who had always seemed members of an exclusive club. What might happen, for instance, if nudes by Renoir and Degas were seen next to such official, but contemporary, artists as Carolus-Duran or Chabas? How close or distant might Munch's reinterpretation of the elemental polarity of male and female be to a far more conventional depiction of Adam and Eve by a conservative artist like Hans Thoma? How compatible would the now-beloved Parisian interiors of Bonnard and Vuillard be, if seen with other interiors from countries as far afield as Portugal and Austria? How different would a city scene painted in Tokyo or Melbourne be next to more familiar views of Paris or London?

The chronological core of this book and exhibition, then, is the year 1900, a focus that, in traditional histories of modern art, usually falls between the cracks, belonging

Fig. 6 (*opposite*) The Eiffel Tower, the legacy of the 1889 Exposition, surrounded by the 1900 Exposition Universelle

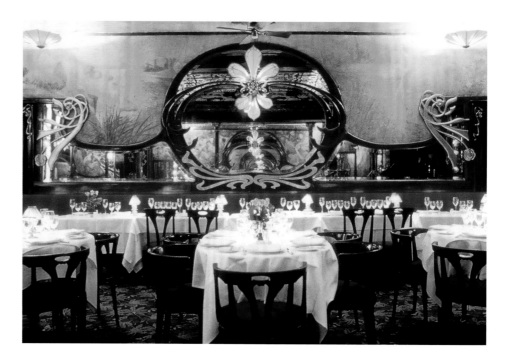

Fig. 7 The interior of Maxime's restaurant, built in 1899

neither to the mature flourishing of the Post-Impressionist giants in the 1880s nor to the early twentieth-century sequence of rebellious 'isms': Fauvism, Expressionism, and beyond. Another 'ism', Symbolism, is often called into play to define this in-between period, but it is clear that by 1900, it had lost considerable steam and that contrary viewpoints – the dashing, but belated Impressionism, say, of Sorolla, Sargent and Serov, or the unexpected emotional charge of a belated realism as practised by Morbelli, Cottet or Backer – were powerful enough to demand a reconsideration of what should be kept in or thrown out this time round. If the anthology offered contains good, bad and great art, if the masters we revere take on new dimensions by rubbing shoulders with an unruly crowd of artists who lived on only the foothills of their Olympus, if this confusing diversity makes us want to shuffle the deck of history once more, then we will have achieved our goals.

The Paris Exposition Universelle of 1900 was hardly the first of these giant, globe-encompassing spectacles. Other cities had seen world's fairs before 1900, and Paris had had a long and regular sequence of them, offering the public what must have been an exhausting panoply of international artists as well as displays of what seemed to be everything in the world, from French metallurgy to Indonesian gamelan concerts. But the 1900 fair marked the birth of a new progressive era, and had a particularly optimistic ring, felt both inside and outside the fairgrounds that stretched to both sides of the Seine. For this colossal event, many lasting changes were made in the City of Light. The city's first underground line, the Métropolitain (soon shortened to Métro), with its now famously snaky Art Nouveau entrances (fig. 35) designed by Hector Guimard (which Salvador Dalí was later to rediscover as a harbinger of Surrealism, along with the even snakier interior of Maxime's restaurant [fig. 7], built in 1899) united the East–West axis from the Porte Maillot to the Porte de Vincennes. A new railway station, the Gare d'Orsay (since 1986 the Musée d'Orsay), was built to accommodate the trains powered by electric engines that helped to bring what turned out to be a record attendance (50,607,307 visitors in seven months!) to the core of the fair. A sumptuous new bridge, the Pont Alexandre III (fig. 8), named after the late, ultra-reactionary tsar, fused the two

sides of the Seine on an axis leading to what is now the Avenue Winston Churchill, but was originally named the Avenue Nicolas II, after the young tsar who helped to cement Franco-Russian relations by laying the foundation stone for the new bridge honouring his father. Facing each other across this thoroughfare were two new palaces of art, the Grand Palais and the Petit Palais, which, unlike the other fair pavilions, were built to be permanent.

Within these two buildings most of what were thought to be the higher forms of art (painting, sculpture, designs for architecture) could be seen. Even more so than in earlier fairs, the entries spanned the planet, a United Nations of artists who represented every country from Peru and the United States to Portugal and Russia, not to mention the scattered French colonies, from the Congo and Martinique to Tunisia and Indo-China, as well as, for the first time, the *Yoga* (that is, Westernised) painters of Japan. For the host country, nationalism and retrospection were honoured with a survey of French art divided into two distinct sections, a kind of BC and AD of the nation's history. The first, in the Petit Palais, moved from the Middle Ages to the age of Watteau; the second, in the Grand Palais, embraced nine post-Revolutionary decades, from 1800 to 1889, of French painting and sculpture. In what was called the 'Centennale', there were not only such venerated upholders of the academic tradition as David and Ingres and, from later generations, Cabanel and Barrias, but also once-young Turks who, by 1900, had become old masters: Courbet, Daumier, Manet, Monet, Degas, Rodin, even Cézanne and Gauguin. Here, already, was a major collision between permanence and change, summed up in the legendary account of how the arch-conservative, Jean-Léon Gérôme, represented by an allegory of innocence in the guise of an idealised male and female nude who shyly eye each other's classically ideal bodies (fig. 9), tried to stop Emile Loubet, the newly elected president of the French Republic, from entering the Impressionist galleries, proclaiming that 'the shame of French painting is in there'. Contrariwise, the avant-garde critic André Mellerio, famous for his support of new Symbolist tendencies in French painting from Gauguin to Redon, attacked the juries for discriminating against Impressionism.

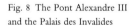
Fig. 8 The Pont Alexandre III and the Palais des Invalides

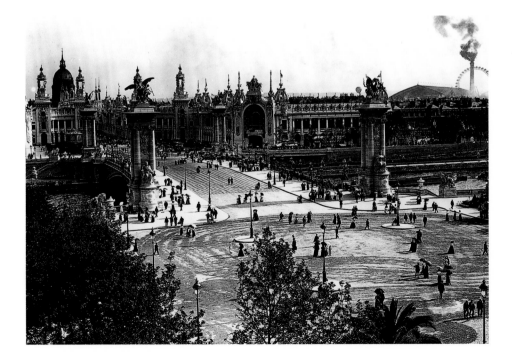

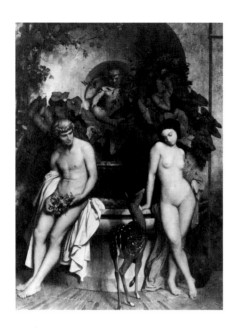

Fig. 9 Jean-Léon Gérôme, *Idyll*, 1852

Architecturally, too, the Grand Palais summed up many of the contradictions of the works exhibited inside, for its 'contemporary baroque' exterior, by Charles-Louis Girault with its profusion of bursting, sky-bound sculpture by Georges Récipon, masked huge glass-covered spaces flexible enough to be used as an automobile salon or a hippodrome as well as a showcase for art. It is no surprise that Frantz Jourdain, an architect who embraced the anti-historical language of sinuous, ductile shapes that, under the rubric Art Nouveau, was proselytised at the fair in Siegfried Bing's pavilion of new decorative arts, bewailed the hypocrisy of so many of the confectionery fair buildings that hid rather than revealed the century's innovations in engineering and design.

Such clashes of old and new were the rule in the Grand Palais. The 1890s marked the beginnings of many international art exhibitions, at times dedicated to more rebellious art, such as the Secession groups founded in Munich (1892), Vienna (1897) and Berlin (1898); and at times, to a wider sweep that could embrace older and younger generations, such as the Venice Biennale (1895) and Pittsburgh's Carnegie International (1896). But these events were temporarily eclipsed by the sheer size and global breadth of Paris's exhibition for the new century. Tens of thousands of works of art from all five continents gave rise to many towers of Babel, in which different national accents strove to be heard, young rebels jostled with moribund establishment figures, and a bewildering diversity of styles and subjects kept shifting the viewer's allegiances and attention.

Looking through the endless directory of artists who exhibited there, we may well believe, in Simon Schama's memorable phrase, that 'history is a mess'. Gérôme would surely have found some occasional comfort in the torch-bearers of the academic tradition, especially in the French and British sections, whose juries were conspicuously conservative: a Bouguereau or a Bonnat, a Leighton or a Waterhouse. But what would he have made of Rouault and Picasso, of Klimt and Whistler, of Khnopff and Hodler? And outside the fair, there were far more concerted assaults on his values. In a pavilion constructed at the Place de l'Alma, convenient to the fairgrounds, Rodin, represented by only two works in the official French sculpture section, shrewdly organised a major retrospective of 150 works, whose opening on 1 June was attended by everyone from Oscar Wilde to the Minister of Education. And Rodin's almost exact contemporary, the sixty-year-old Monet, who was represented at the fair only by early works in the Centennale, followed his friend's suit. On 22 November, ten days after the fair closed, he opened an exhibition at Durand-Ruel of twenty-six paintings that included his latest canvases in series, such as the nuanced variations on the theme of the Japanese bridge in his Giverny water-gardens, now transformed into sensuous mirages approaching the threshold of an imaginary world, like the mysterious gardens so often conjured up in the music of Debussy, Delius or Falla.

It is telling that the journalist Gustave Geffroy, who could write superbly about anything from politics to Impressionism, had already written a catalogue preface for an earlier Monet series, the *Grain Stacks*, when these were exhibited, also at Durand-Ruel, in 1891. He compared their colours to gems, fire and blood and saw evocations of mystery and fate, describing a gorgeous, phantasmic immersion that he would re-experience when confronted in 1900 with one of the fair's major themes, the miracle of electricity. At the fair, this magical, disembodied force produced awe and veneration every evening when, at the flick of a finger, 5,700 incandescent bulbs would light up the Palais de l'Electricité (fig. 10), usurper of the technological throne occupied by the

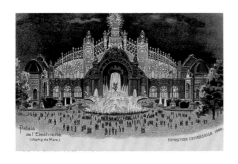

Fig. 10 A postcard from the 1900 Exposition Universelle showing the Palais de l'Electricité

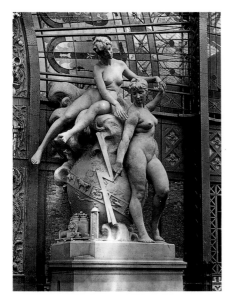

Fig. 11 Louis-Ernest Barrias, *L'Electricité, c.* 1889

Galerie des Machines and the Eiffel Tower at the 1889 fair. In the 1880s, there had been international exhibitions displaying the new world of electricity, whose luminous rays began to replace gaslight in urban centres, and at the 1889 fair, the establishment sculptor, Louis-Ernest Barrias, attempted to capture this new force in an old-fashioned allegory successful enough to be re-exhibited at the 1900 fair (fig. 11). Planet Earth, circled by signs of the zodiac and buoyed up by clouds, is surrounded by a pair of voluptuous nudes, one airborne, one standing, as lightning zigzags past these lofty muses. But the bolt might just as well have been thrown by Zeus, leaving the small electric generator on the ground as the only token of modernity. Such a shift from a clanking, gravity-bound mechanical world to what was symbolised on top of the twinkling Palais de l'Electricité in a figure named *La Fée électricité* (a scientific fairy Dufy would reinvent in his immense mural for the 1937 Paris world's fair) defined a new drift towards experiences that were invisible and impalpable. Referring to this nightly spectacle as reflected in the Seine, Geffroy saw 'an avalanche of diamonds, a sparkling of jewels', and noted how this enchanted new source of energy sent 'flashes and glimmers of light that ripple in waves to the most distant, concealed corners of darkness'. This kind of sensuous engulfment, close to the aesthetic that Monet and many Symbolist artists would explore in the 1890s, was complemented by the proliferation of practical uses that the 'fairy of electricity' could serve, from the electric chair (first used in 1890) to the telephone, telegraph, phonograph and all the new street lamps and domestic light bulbs that would alter forever public and private life in both city and country. Camille Claudel recorded this fact modestly but audaciously in her intimate sculptural vignette, shown at the fair, of an interior with a woman dreaming by, of all things, a real electric light. And already in 1892, Albert Robida, who wrote and illustrated science fiction in the shadow of Jules Verne, envisioned, in his popular book *La Vie électrique*, what the world would be like in 1955, when the news, he predicted, would be broadcast by television, when telephone conversations would be seen as well as heard, and when – hardest of all to believe! – transportation from one far place to another would be provided in the air. For the last of Robida's prophecies to be fulfilled, readers had only to wait until 1900 for the first Zeppelin flight and 1903 for the miracle at Kitty Hawk.

Comparable wonders were abundant at the fair, enticing visitors to come to Paris for the first time. One of these was the twenty-nine-year-old Futurist-to-be Giacomo Balla. Arriving in Paris from Rome on 2 September, he immediately began his love affair with the modern city. The thrill was evident in his little painting of a night-time view from the Eiffel Tower of the esplanade running down the Champ-de-Mars to the Palais de l'Electricité, a vista that obscures everything but the incandescent tracery of this distant pavilion and the two carousels that flank the view. In the foreground, black silhouettes of urban crowds surge toward these mechanised pleasures (cat. 142). The counterpart of Monet's search for a way to capture the pulsating, organic life of nature, Balla's vision embraces the dynamic forces of artificial light and modern entertainment. It is no surprise that within the next decade Balla would paint the electric bulb of a Roman street light eclipsing the moon or that he would later name his three daughters Luce (light), Elettricità (electricity) and Elica (propeller), muses born with the new century. Balla was undoubtedly thrilled, too, by the fair's display of chronophotography by Etienne-Jules Marey (fig. 12), who had developed a technique of recording the continuous, sequential movement of men and birds on a single plate, photographs, at once scientific and

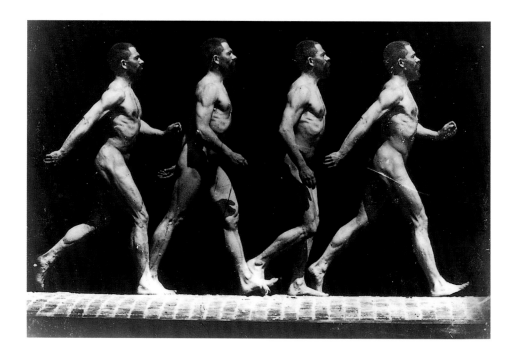

Fig. 12 Etienne-Jules Marey, *Walk*, 1891

fantastic, that would trigger new explorations of weightless, translucent matter, as if Roentgen's X-rays, also displayed at the fair, had been set in motion. Could Cubism and Futurism be far behind?

Other marvels there helped to launch many more new visions. One could see, for example, some of Georges Méliès's reel-long movies, *Cinderella*, *Red Riding Hood* or *Bluebeard*, with their fairy-tale metamorphoses mixing technology and enchantment in a brand-new medium that would soon become synonymous with the next century's popular entertainment. And one could see, too, in her own Art Nouveau pavilion, the sensational dancer from Illinois, Loïe Fuller, and her 'chromo-kinetic' choreography, a fairy-tale vision of veils billowing amidst coloured electric lights, strobes and a transparent stage that created bodiless, iridescent effects reminiscent of the airborne spectres of Symbolist art. Then there was the 'Grande Roue', the gigantic Ferris wheel that had been introduced to the world at Chicago's 1893 World's Columbian Exhibition. Together with the eleven-year-old Eiffel Tower, it altered drastically the skyline of Paris, the two soon becoming for artists like Chagall and Delaunay a paired symbol of modernity on the horizon (fig. 13). Public transportation within the fair itself opened twentieth-century vistas as well, with an electric train touring the grounds in twenty minutes and, running in the opposite direction, a *trottoir roulant* (moving pavement) over two miles long that permitted visitors to glide past a pageant of pavilions facing the Seine, a parade of nations proclaiming their unique identities with indigenous architectural styles and displays of their best natural scenery and man-made products.

Such would-be harmony between countries that were often warring enemies was a tradition launched at the first world's fair, the 1851 Great Exhibition housed in the Crystal Palace in London's Hyde Park. And, aware as we have become of the late twentieth-century revival of nationalist identity everywhere from Catalonia and French Canada to Belgium and Serbia, we may more readily discern how, against a backdrop of international unity, so much of the art at the 1900 fair intensified these awakenings of local differences. This, indeed, is one of the many subliminal themes that, in retrospect, help to put in some kind of order the daunting diversity of works displayed in the Grand

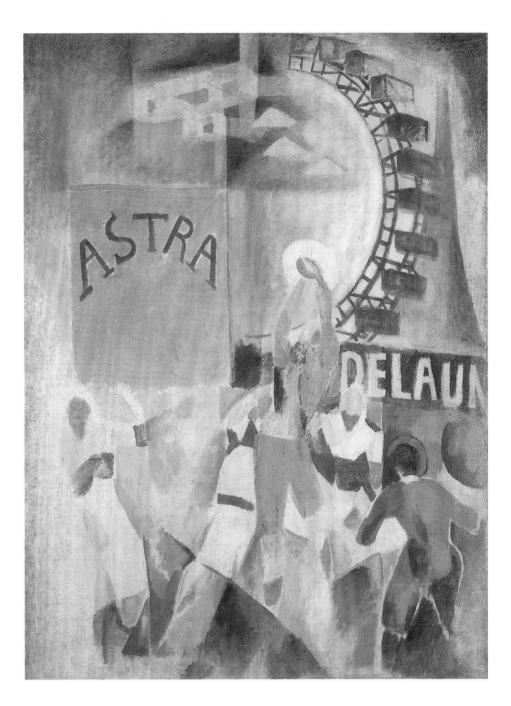

Fig. 13 Robert Delaunay,
L'Equipe de Cardiff, 1912–13

Palais. It can be found, for example, in many Eastern European entries, some of which
are virtually manifestoes of cultural identity. Among the 283 paintings from Russia,
a typical assertion of a national accent can be found in Andrei Ryabushkin's vignette
of indigenous time-travel, *A Merchant and His Family in the Seventeenth Century* (fig. 14).
In this reconstruction of a pre-Europeanised Russia, we are transported to a domestic
interior of almost Asian character, with simple rectangular patterns of wooden walls and
framed blinds. Seated and standing on a straw-strewn floor, a family group in exotically
luxurious clothing poses for us with a startlingly archaic frontality inspired by the stiff
poses and masklike faces of Russian icons and dolls (one of which the blonde daughter
holds). Amidst many Russian entries that might have been painted in any country,
Ryabushkin's canvas waved a flag of national history that, in works by other Russians,
could even go back in subject to the Scythians or in style to Byzantium. Ironically, the
so-called Russians gathered for the fair included many rebellious Finns who, only eleven

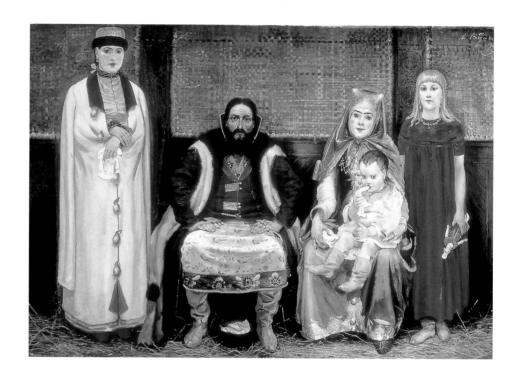

Fig. 14 Andrei Ryabushkin, *A Merchant and His Family in the Seventeenth Century*, 1896

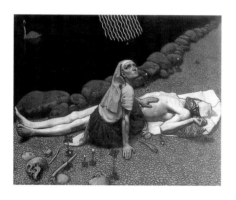

Fig. 15 Akseli Gallén-Kallela, *Lemminkäinen's Mother*, 1897

years before, at the 1889 Paris fair, had exhibited independently. But with the aggressive Russianising of Finland that reached a bitter peak on 15 February 1899, when Nicolas II, the last of the tsars, placed Finland under Russian legislative rule, Finnish nationalism surged to new heights that are still remembered in Jean Sibelius's orchestral manifesto *Finlandia*, composed at exactly this painful time. This nationalist conflict was made even more acute by the separate Finnish pavilion at the fair, designed by Eliel Saarinen (fig. 41) and decorated by such artists as Akseli Gallén-Kallela, who was obliged, however, to exhibit his easel paintings in the fair's Russian section (cat. 28). In these, he proclaimed the distinctive character of his oppressed country, submitting *Lemminkäinen's Mother* (fig. 15), a subject taken from the Finnish national epic, the *Kalevala*, whose Wagnerian hero also inspired Sibelius. Gallén-Kallela's painting reawakened the power of this lengthy archaic epic by translating, as it were, a Christian Pietà into a mythic Finnish language that would reincarnate the mysteries of the *Kalevala*'s fairy-tale legends. In much the same way, although with less political relevance, the late Sir Edward Burne-Jones was represented with a scene from a British legend, *Lancelot at the Chapel of the Holy Grail* (cat. 29), which, bathed in a magical somnolence hospitable even to an angel, transports us to the world of King Arthur. Typically for the stylistic collisions of the period, Burne-Jones's gloomy vision seems to shift back and forth from scrupulous, material details (the armour or the masonry) to a dreamlike ambience in which solid flesh might melt. Similarly, Gallén-Kallela's use of tempera (a medium that would reinforce the flat spaces and precise contours of a remote, folkloric art) produces a strange mix of reality and symbol, with figures that still smack of the anatomical knowledge gleaned in an art academy next to more arbitrary patterns of black waters, gilded sunbeams and a decorative carpet of pebbles and rocks tilted at a steep angle. Many other artists at the fair juggled these antagonistic modes of three-dimensional realist description and two-dimensional abstract fantasy, as if the nascent twentieth-century goals of an art that transcended the earthbound limitations of the visible world were still tethered to the materialist foundations of a nineteenth-century art education.

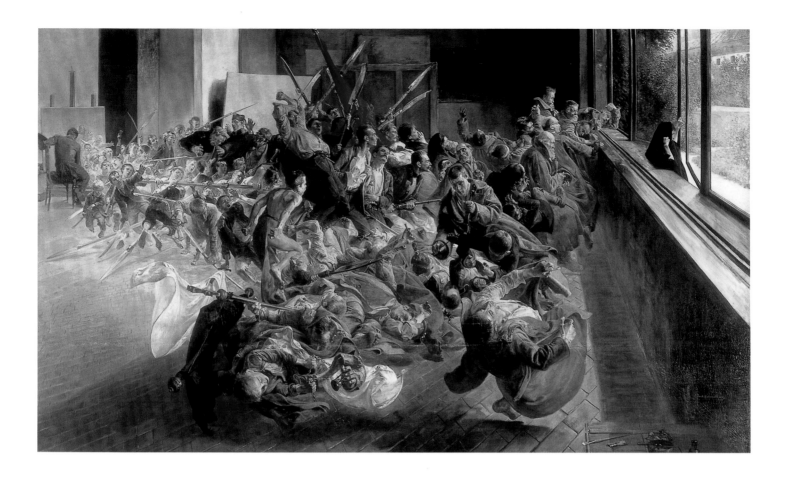

Fig. 16 Jacek Malczewski, *Melancholia*, 1894

A seething cauldron of similar contradictions married to nationalist ambitions can be found in a large canvas, *Melancholia* (fig. 16), by the Polish artist Jacek Malczewski. Malczewski had already shown this amazing painting in international exhibitions in Munich and Berlin before submitting it to the Paris fair, where it received a silver medal, a commonplace reward for so uncommon an achievement. The same ironic destiny of imperial oppression that befell Gallén-Kallela marked this work, too, for Malczewski meant his painting to be, among other things, a manifesto of rebellion against the nations (Prussia, Russia and Austria) that had ruled Poland since 1795, yet it was, in fact, exhibited in the Austrian section. (Other Polish artists at the fair were, like the Finns, exhibited under the aegis of Russia.) A maelstrom of airborne figures seems to have burst from the unfinished canvas at the upper left facing the slumping, melancholic artist who unleashes an allegory of Poland's cruel fate. Incorporating references to three failed nineteenth-century insurrections, Malczewski spews forth a more universal allegory of the cycle of life, from infancy to the threshold of death, symbolised exclusively by male figures. At the lower right, the artist is represented a second time, recording, paintbrush in hand, this torrent of humanity and history. But the volcanic outburst seems doomed: a black-robed female figure sits at the window, evoking not only death, but a grieving symbol of Polonia, the mother country. Characteristic of the changes of subject at the end of the century, this is a private invention of an artist who, like many of his more famous contemporaries, would try to come to grips with the invisible forces, whether biological, spiritual or, in the case of Malczewski's canvas, political, that shape human destiny. And here, too, Malczewski battles with the recurrent *fin-de-siècle* problem of translating what is essentially a realist vocabulary inherited from the nineteenth century

into a language that would depict the febrile images that obsessed him. How, indeed, could the turbulent world of the unconscious, which, in 1899, Freud was to make so famous in his *Interpretation of Dreams* as the irrational bedrock of human behaviour, be represented within the confines of a realist style? Looked at individually, Malczewski's figures, with their firm volumes and descriptive details of historical costume and weapons, might pass muster in a provincial art academy, and his perspective illusions are similarly based on traditional training. But these components are stretched to breaking-point, with palpable figures now defying gravity in their collective tornado of passion and gloom and with the ledge of the window rushing from near to far at a vertiginous speed and tilt that create, with still-rational tools, a space for dreams and nightmares.

In the welling search for ways to depict an invisible world of both supernatural mystery and elemental emotions, the late nineteenth century witnessed a virtual revival of religious painting, as if Nietzsche's famous proclamation in 1882 that 'God is dead' demanded fresh responses. Religion could be mixed with the patriotic fervour that marked so much art at the fair; and, in the name of Christianity, the traditional conflicts between France and Germany could be rekindled. As for France, one of its most rhetorical submissions was the huge and popular painting by Jean-Joseph Weerts, whose very title, *Pour l'Humanité! Pour la Patrie*, married church and state (fig. 17). A crucifixion, rendered in the hyper-realist style familiar to many academic painters of the period, has also become a symbol of patriotic devotion; for the martyrdom at the foot of the cross is culled not from the usual ranks of Christian iconography but from the French military who were willing to make the ultimate sacrifice. And with memories of Delacroix's *Liberty Leading the People*, a tricolor palette pervades Weerts's familiar clash between earthbound fact and airborne allegory. On the other side of the Rhine, the Munich painter Ludwig Herterich submitted to the German section his nationalist homage to Ulrich von Hutten, the short-lived sixteenth-century humanist who, for the Romantic generation of Caspar David Friedrich, had come to symbolise the German roots of · religious reform as well as knightly patriotism and learning (cat. 237). Standing in front of another life-size crucifixion, taken from the world of his great contemporary, the sculptor Veit Stoss, Ulrich von Hutten, in gleaming armour, reawakens myths of the noble German knight, a myth that flourished in German art and would even be used later to create allegorical portraits of a neo-medieval Hitler.

These strange mutations of traditional religious painting took on many forms in the late nineteenth century, a spectrum that included, outside the precincts of the fair, such haunting inventions as Munch's hellish vision of Golgotha as almost a modern lynching amidst a brutal sea of humanity that includes both demonic assailants and agonised mourners (cat. 236); Henry Ossawa Tanner's *The Annunciation*, with its mixture of the supernatural radiance of Gabriel's message and the ethnographic facts that the artist gleaned from a trip to the Holy Land (cat. 246); and Gauguin's daring fusions of Christian and Polynesian religious iconography, works that seem to belong more to the new science of anthropology, with its studies of comparative religions, than to any concepts of Western religious art in which Christianity remains unique and unchallenged.

At the fair, too, these re-creations of Christian themes appeared in amazing diversity. There were the monochrome vapours of Carrière's *Crucifixion* (cat. 235) that would take us to the threshold of an impalpable world of a kind also dreamed of by Rouault, who, in his *Christ Among the Doctors* (fig. 18), tried to fuse the luxurious Near Eastern interiors

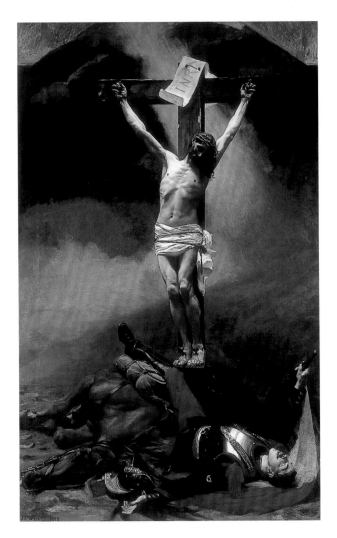

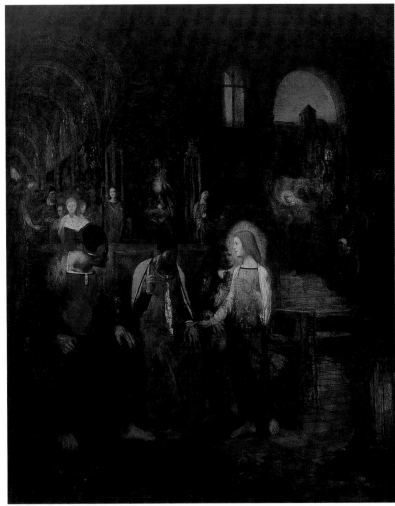

Fig. 17 Jean-Joseph Weerts,
Pour l'Humanité! Pour la Patrie!, 1895

Fig. 18 Georges Rouault,
Christ Among the Doctors, c. 1894

of his teacher Gustave Moreau with the golden-brown chiaroscuro of Rembrandt.
There was the growingly familiar theme of Christ in the present tense, suddenly
appearing to the rural or even the urban populations of Europe: Jean Béraud's staging of
the Crucifixion on the heights of Montmartre in contemporary Paris; Fritz von Uhde's
Holy Night, a Nativity as it might take place in a German peasant's barnyard (cat. 284);
and Léon Lhermitte's *Supper at Emmaus*, relocated to a French farmhouse (cat. 24). These
manifestations of a persistent faith in Christianity, resurrected even after the assaults of
Darwin and Marx, could also be found at the fair in completely secular depictions of the
Church's benevolence. Of these, the most original is surely Joaquín Sorolla y Bastida's
Sad Inheritance (cat. 122), originally titled *The Children of Pleasure*. At first, we seem
transported to a cheerful, sun-shot Mediterranean beach near Valencia, described with
the bravura mix of Impressionism and Velázquez that, around 1900, was to become
a symbol embracing both modernity and tradition. But beneath this smiling façade,
a sad story unfolds. A Spanish priest is seen supervising a group of naked, handicapped
boys bathing, the victims, presumably, of their parents' venereal sins. With its ambiguous
mixture of contemporary social problems and a more abiding faith in Christian charity,
the painting's covert theme, the scourge of syphilis, which, like AIDS, associated sex
with death, was also to be recognised more bluntly in much literature and art of the
period, from Ibsen's *Ghosts* and Munch's *Inheritance* (cat. 123) to Picasso's lethal whores.
In this context, the *femme fatale*, that mythical temptress who could be reincarnated

in many guises in the late nineteenth century – Salome, Delilah, a vampire, a mermaid – had her deadly roots in medical reality.

An awareness of modern social problems, in fact, abounded at the fair in both painting and, less frequently, sculpture. As for the latter, the vast vaulted spaces of the Grand Palais might have seemed the last bastion of traditional historical themes, where one could still find tons of marble and bronze Psyches, naiads, Dianas, Joans of Arc or Judiths, generally rendered with mechanical skills. Occasionally, however, as in Bourdelle's re-creation of Aphrodite through the use of translucent porcelain (cat. 60), the sculptor's originality in technique, if not in theme, was conspicuous enough to convince even so conservative a jury to award him a prize. The rumblings of contemporary reality could be heard even in this universe of remote mythology and history. Perhaps the most inventive of these intrusions was a marble by Eugène Robert titled *The Awakening of the Abandoned Child* (cat. 121), which had already been a success at the Paris Salon of 1894 before being re-exhibited in the sculpture galleries at the 1900 fair. There, visitors wandering through the 640 sculptures and medallions in the French section would suddenly find at their very feet this sweet, Christ-like infant, awakening in front of the fragment of a church portal to an undoubtedly miserable future. It was a heartbreaking reminder that outside the fair, Parisian pedestrians would often come upon an unwanted baby deposited for adoption in a church doorway by a desperate mother who might otherwise have violated Christian morality by abortion or infanticide. (Appropriately, Robert's infant ended up in Paris's Museum of Public Welfare.) And in two dimensions, one could find countless depictions of the miseries of both rural and urban labour, whether focused on communal workers or lonely individuals.

In France, Jules Adler, a pupil of Bouguereau (whose idea of poverty was an unshod, but immaculately clean and rounded peasant girl descended from one of Raphael's holy children), took on the plight of the urban poor in *The Weary* (cat. 126), a typical example of the work of artists who, with homage to Victor Hugo, were occasionally dubbed 'Misérabilistes'. Here, the well-heeled visitors to the fair were forced to confront a dismal slice of Parisian life, the opposite side of the familiar Impressionist coin of cheerful, leisurely pedestrians still depicted by Pissarro (cat. 129). Against the regular, urban beat of leafless tress along a boulevard wet with rain, a downtrodden population of three generations of tattered, unsmiling workers is spewed forth at the beginning of their long day. With its abrupt cropping and asymmetries, Adler's painting may recall many of Degas's innovations, but it also suggests the frightening potential of strikes and mob rule, subjects Adler also treated in the heyday of international anarchism.

Such images, which document not only the unrelieved hardship of city workers but also that of their rural counterparts in countries as far apart as Portugal and Russia, must have left their mark on the young Picasso. Just before his nineteenth birthday, he visited the fair and saw not only his own painting of a deathbed scene, *Last Moments*, which had been selected by the Spanish jury for the fair (a canvas he later painted over with his enigmatic allegory *La Vie* [1903]), but also these pictorial reminders of the lowest depths of contemporary society. He would soon transform this subject into a more universal language of the saintlike suffering of anonymous beggars, prostitutes, workers and destitute families painted in melancholic blues and greys, a monochromaticism common to much Symbolist art of the period. And in far more literal, earthbound terms, the plight of the modern worker could even be discovered in a domestic interior, as in

Fig. 19 Benjamin Constant, *Queen Victoria*, 1899

Albert Rutherston's *The Song of the Shirt* (cat. 159), its title inspired by Thomas Hood's popular poem (1843). Here the doomed life of a seamstress has been pictorially modernised in 1902 to reflect the anti-Victorian aesthetic traditions of Whistler. Exclusively feminine labour had even reached the opera house: the sweatshop scene of Gustave Charpentier's opera *Louise*, with its chorus of seamstresses, shocked Parisian audiences at the 1900 première. Such public exposures of the daily miseries of most of the population coincided, not surprisingly, with the global rise of the Socialist movement, which held an international meeting in Paris in 1900. That spirit of Utopian rebellion was thrillingly pinpointed in Pellizza's *The Fourth Estate* (cat. 216), planned for the fair, but not completed until 1901. With its orderly, forward march, this vast army of workers feels like an operatic chorus that might be singing 'Workers of the world unite!'.

Pessimism about modern humanity was summed up in Thomas Hardy's poem, 'The Darkling Thrush', written on 31 December 1900 (by literal calendar count, the last day of the nineteenth century, rather than 31 December 1899). The poem was dedicated to what Hardy called the 'century's corpse', and recounts his surprise at hearing the ecstatic warbling of a gaunt old thrush, a foolishly irrational voice of hope in an epoch when so many were struggling for their daily bread. Such retrospection can be observed in the extraordinarily melancholy portrait of Queen Victoria by Benjamin Constant (fig. 19) which, exhibited in the French section of the fair, paid homage to the eighty-one-year-old ruler of the British Empire, enthroned in lonely silence as if contemplating the era that would come to an end the year after the fair, 1901, with her death.

This aura of gloom could be balanced by a spirit of regeneration that at times reached cosmic dimensions. Such was the case in *The Stream*, a triptych by Léon Fréderic (cat. 1), a Belgian painter who had often chronicled the grim lives of contemporary workers in the fields and in the mines. Here, however, a new world is born. Partly inspired, so the artist claimed, by the primal, unpolluted nature evoked in Beethoven's 'Pastoral' Symphony, this modern altarpiece becomes a nativity appropriate to a century that had embraced Darwin's evolutionary theories as well as Henri Bergson's concept of *élan vital*, a mysterious organic energy that, like Freud's concept of the unconscious, underlies and finally dominates the artificial complexities of our repressed, civilised lives. In Fréderic's enchanted forest, the watery womb of a running stream provides the procreative force for a gargantuan abundance of infant flesh, a response perhaps to the problems of under-population in late nineteenth-century Belgium (the counter-fruits of the rise of planned parenthood), but also one that embraces an awesome vision of nature's powers of fertility and rebirth. With his cornucopia of naked, plump and ruddy infant bodies, Fréderic conjures up his national pictorial heritage, resurrecting for a new age Rubens's and Jordaens's robust ideals of physical well-being; and with his penchant for megalomaniac bombast and universal meaning, he parallels the many post-Wagnerian ambitions of turn-of-the-century composers. Typically titanic goals and achievements could be found in Mahler's Third Symphony (1893–1902), with its cosmic reaches from primal nature to Christian divinity; Scriabin's First Symphony (1899), whose six movements include a final chorus extolling art, set to the composer's own words; Schoenberg's *Gurrelieder* (1900–01), whose colossal orchestration demanded a specially printed enlargement of a musical score; and Delius's *A Mass of Life* (1904–05), constructed as a vast symphonic and choral triptych (with texts by Nietzsche) that would fuse the progression of morning, noon and night with the human life cycle of childhood, maturity and old age.

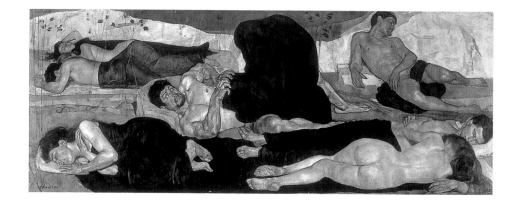

Fig. 20 Ferdinand Hodler, *Night*, 1890

For Fréderic and his contemporaries, polyptychs in general and triptychs in particular were especially suitable for such universal visions, reviving traditional structures of religious faith that could translate even the most earthbound themes into permanent truths. It may have been predictable enough, for example, that Fritz von Uhde's *Holy Night* (cat. 284) was presented as a tripartite altarpiece, but this sacred message could also be secularised. Count Leopold von Kalckreuth, Uhde's Munich contemporary, transformed the three-part cycle of an anonymous Bavarian peasant-woman's life – virgin innocence, decades of back-breaking labour, and, finally, her confrontation with imminent death – into an abiding statement (cat. 283) that encompasses not only the doomed lives of modern farmworkers, but also the more familiar, universal motif of the three stages of life which obsessed Munch in the 1890s in his post-Darwinian meditations on biological survival as enacted by women.

The search for fundamental truths about human experience recreated as modern heraldic structures helped to revive compositions of static, timeless symmetry. The Swiss painter Hodler actually developed a theory of parallelism that would strip landscape and its inhabitants to frozen emblems. It was an ambition first fully defined in *Night* (fig. 20), the earliest (1890) of the three paintings he showed at the fair and one whose evocation of the universal mysteries of sleep and death was complemented there by the even more rigorously symmetrical *Day*, completed in 1900. At a time when human sexuality was being daringly explored, whether scientifically, as in Krafft-Ebing's *Psychopathia Sexualis* (1886) and Freud's early studies of the sexual origins of hysteria, or in literary form, as in such then-shocking dramas as Frank Wedekind's *The Awakening of Spring* (1891), it was expected that artists, too, would approach the theme of sexual desire. Often, this biological necessity would be reduced to a simple male–female polarity that would offer modern translations of Adam and Eve. Hodler's *Spring* (cat. 78) re-creates this archetype in an Alpine meadow, blossoming with yellow flowers. With a throbbing, angular body language, foreshadowing the primal motions and emotions of modern dance, this pubescent couple look magnetised, drawn to one another in postures of sexual awakening in the girl and partial but useless resistance in the boy. These basic truths were also unveiled by Munch, both in terms of a nude pair, symmetrically disposed on either side of a tree, or in the contemporary translation of a rural husband and wife, in a similar setting, who embody the timeless mysteries of fertility (cat. 81). Less convincingly, other artists at the turn of the century attempted the re-creation of the Garden of Eden itself, as in Thoma's *Adam and Eve* (cat. 82), in which the mother and father of us all and the ultimate source of sexual temptation look like studio models

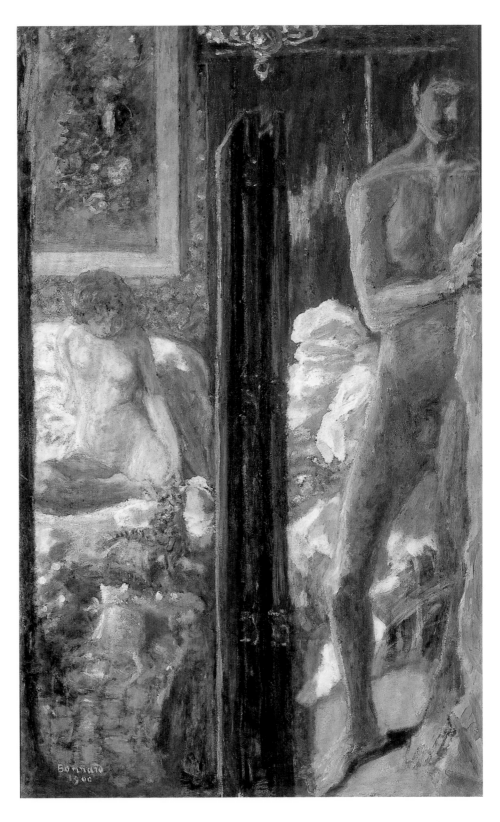

Fig. 21 Pierre Bonnard, *Man and Woman*, 1900

posed symmetrically on either side of the Tree of Knowledge. Characteristically for
a period obsessed with the cycles of life, Thoma, with iconographic originality,
included the symbol of death, a skeleton uncomfortably close to those found in art-
school anatomy classes, here ominously surrounding the wiry, muscular couple with
a shroud.

 This elemental theme, of course, was subject to countless variations. There was Henri
Rousseau's eccentrically childlike *Happy Quartet* (cat. 83), a fairy-tale excursion to an

Fig. 22 Constantin Brancusi, *The Kiss*, 1922–40

Arcadian forest, where a new version of Adam and Eve, inspired by Gérôme's academic allegory of Innocence (shown at the Centennale, fig. 9) live in a peaceable kingdom with a Cupid-like infant and a baying hound; or, at the opposite extreme Bonnard's *Man and Woman* (fig. 21), a monumental vignette that presents almost a keyhole view of a contemporary Parisian couple, naked in their bedroom and divided symmetrically by a folded screen. In the Swede Richard Bergh's *Nordic Summer Evening* (cat. 80), the Adam and Eve motif is recast in contemporary clothing, with a modern couple poised in perfect symmetry at a balcony overlooking a beckoning, mysterious landscape. They might be characters from a play by Ibsen, suggesting both private reveries and a complex psychological dialogue as yet to unfold. More frequently, though, this motif reached such elemental depths that it was conveyed in timeless, allegorical form as a passionately embracing pair of nudes, familiar to Munch's stripping of human behaviour down to its biological roots (the ids, one might say, of Bergh's superegos) and most famously incarnated in Rodin's over-life-sized *Kiss* (cat. 30), whose overt sexuality was so shocking when it arrived in Chicago for the 1893 fair that it had to be sequestered in a separate room. In Paris, it was a huge success at the Salon of 1898 and then again at the 1900 fair, when it was exhibited with only one other work by the master, a bust. It is worth recalling that one of the most innovative works of twentieth-century sculpture, Brancusi's *The Kiss* (fig. 22), stems from this milieu of primal myth and sexual truth.

The fusion of the sexes, which reaches ethereal, Wagnerian union in the Belgian Jean Delville's *The Love of the Souls*, shown at the fair (cat. 76), and their opposition (in the case of Strindberg's dramas, one can even speak of the war between the sexes) were obsessive topics at the end of the century. They were subject to such perverse variations as the Viennese Otto Weininger's pseudo-scientific and internationally influential *Sex and Character* (1903), which, in an evolutionary fantasy theorised that, unlike men, who soared to intellectual and spiritual heights, women were animal, procreative creatures.

These extremes were opposed by the counter-myth of women as reincarnations of the Virgin herself, holy, chaste, maternal, and even supernatural. A contemporary translation of such persistent pictorial venerations of the Madonna and Child was offered by Bouguereau at the fair in *Regina Angelorum* (cat. 239), the kind of painting that would bolster wavering faith, still clung to in pious rural populations, where women, more than men, followed Christian ritual. At the fair, this devotion was shown in such folkloric images of steadfast Lutheran worship as the Swede Carl Wilhelmsen's scene of fishermen's wives returning from church (cat. 242). The iconic authority of Bouguereau's work, including a celestial radiance of almost electric luminosity, made it virtually a manifesto, against the painter's youthful enemies, of an abiding faith in Christianity as well as in its noblest pictorial ancestry, the lucid symmetries and supernaturally ideal figures of Raphael. But it is worth noting that this icon of purity and motherhood was countered by another work by Bouguereau at the fair, *Admiration* (cat. 26), that told a different story. Again culled from a faith in Raphaelesque beauty, this quintet of symmetrically disposed maidens, as harmoniously graceful as in a classical ballet, surrounds a puckish Cupid in a no-less-artificial woods, their sexual curiosity aroused. In a way, Bouguereau is depicting the same universal theme of pubescent sexuality being explored by Hodler and Munch, but the quantum leap between their imaginations is so staggering that we can sense a violent rupture between a nineteenth-century past and a twentieth-century present and future.

The message of the holiness of motherhood in Bouguereau's hierarchic Madonna (cat. 239), reigning from a cloud-filled heaven and protected by an oval of cloud-borne angels, was one of the dominant themes of the turn of the century. It was a sacred Christian image frequently brought to earth in secular guise, with many subtle mutations. Often set by such Swiss artists as Segantini (cat. 8) and Amiet in the most pristine, Alpine landscapes, they tend to be centralised in a recurrent structure that would turn fact into symbol. Typical is *The Communicant*, by the American Gari Melchers (cat. 250), in which we are confronted by a contemporary girl, immersed in a virginal, lily-white ambience, at the moment of her religious initiation into the sacred precincts of womanhood. Again and again, women and mothers are set upon holy thrones. But there were, of course, more earthbound variations on this theme, including Picasso's many depictions of nomadic, poverty-stricken modern mothers and children wandering through the melancholy blues of generalised cityscapes, as if the Madonna and Child had become pariahs. Women artists were usually drawn to the more prosaic realities of maternity. Mary Cassatt, although childless herself, managed to capture the most intensely candid and intimate glimpses of the physical, almost erotic, pleasures of mothers adoring and cuddling their infants (cat. 254). Cecilia Beaux, another American, exhibited at the fair two memorable society portraits of mothers and teenage children, one with a daughter, the other with a son (cat. 101). Like the novels of Henry James and Edith Wharton, these portraits explore the subtlest psychological give-and-take between parents and children posing in a wealthy world of mannered appearances. And in keeping with the universality of the mother-and-child theme, there were countless other variations, often reaching down to primal emotions, such as Munch's shocking *Inheritance* (cat. 123), with its blasphemous inversion of the Madonna and Child as a modern mother of the 1890s who holds a syphilitic infant in her lap, or Paula Modersohn-Becker's forceful close-up of a simple peasant (cat. 253), breast-feeding a child who stares at us with a ferocious, animal energy. Here is the primitive side of Cassatt's glimpses of wealthy American and French mothers communing with their children during their many hours of elegant leisure.

The sinister complement to these both heavenly and terrestrial images of maternity was the more familiar category of the *femme fatale*. She haunted many male imaginations, embodying a Pandora's box of sexual demons who violated woman's role as wife and mother and incarnated the inevitably destructive temptation to transgress the social order of fidelity and family. Beginning with Gustave Moreau's depictions of the biblical archetype depraved by lust, embellished by Joris-Karol Huysmans in his novel *A Rebours*, Salome loomed ever larger as the century drew to a close. Her legend inspired Wilde to write (in French) his hothouse drama of sexual desire and the decapitation of a chaste holy man, St John the Baptist (1893), and Richard Strauss, in turn, to transform it into a sensational one-act opera of uninterrupted passion and horror (1905). Of the many *femmes fatales*, Salome was probably the evil temptress most frequently chosen by artists, the vile counterpart to the biblical heroine Judith, who saved the Jewish people from an enemy, Holofernes, whom she decapitated in an intrigue of seduction and drunkenness. It is telling that Gustav Klimt, the Viennese master of the *femme fatale*, painted exotically clad, head-bearing women whose identities – Salome or Judith? – could easily be, and in fact have been, confused. Treating all his mythical women as voluptuous and dangerous creatures, Klimt could unmask even the noble Judith as a menace to male virility.

The archetype of this alluring but evil female was, of course, Eve, the mother of all sin. In this guise, the first temptress fired many imaginations, of which that of the hugely successful Munich painter, Franz von Stuck, was probably the coarsest, but most popular. For him, Eve appeared in many fleshy guises, often with a phallic python coiled around her savage body, a coupling revived in Richard Avedon's photograph of Natasha Kinsky. In one of his variations on this theme (cat. 64), Stuck defines even more obviously her meaning by the inscription, 'Die Suende' (Sin), on a thick gilded frame whose mixture of conspicuous luxury and linear elegance, in both its lettering and its snakelike patterns, characterised much of what in German-speaking nations was called Jugendstil (the style of youth). This variation on Art Nouveau was treated with much greater refinement by Klimt, whose frames, gilded surfaces and altarpieces of female carnality offer a more effete version of Stuck's beer-hall prostitutes. Klimt, in fact, could offer a fantastic population of monstrous but desirable women, often moving to submarine worlds in which the female sex appeared to be slithery and subhuman, rooted in primal nature. In these aquatic surroundings, women could be imagined as fleshy goldfish or as shrouded mermaids who reveal only their demonic, lipsticked faces (cat. 65). (Even when Klimt paints a society portrait, such as Marie Henneberg's [cat. 113], the sitter appears as a dangerous, unapproachable sphinx.) Such fantasies, stemming from the sexual anxieties that Freud was exploring, were astonishingly fertile, spawning a grotesque female population that ranged from bloodthirsty animals, such as Munch's shocking nude (cat. 61), to the supernatural terrain of vampires, given literary form in Bram Stoker's *Dracula* (1897), and surviving linguistically in the 'vamps' of the 1920s. Even mythical *femmes fatales* could be so worldly that they might be encountered, like ordinary prostitutes, on the streets of a modern city. In its preparatory oil sketch (cat. 69) and even more in the completed version, Lovis Corinth's startling interpretation of the Salome story gives the viewer the impression of having abruptly encountered the scene while turning a modern street corner. Suddenly, we are pushed into an oblique, close-up view of a burly, half-naked executioner, the head and cropped corpse of St John the Baptist, and a lipsticked, bare-breasted whore, almost indistinguishable from a Berlin cabaret performer in Near Eastern costume, leaning over her gory prize.

In a curious way, Corinth undoes the exotic, remote Salome by relocating her in what feels like a modern city, almost illustrating some of the sociological theories of Georg Simmel (born, like Corinth, in 1858), whose often-quoted essay, 'The Metropolis and Mental Life' (1903), discusses the modern urban experience of city pedestrians who, with the constantly changing crush of different people and events before their eyes, can even look at the most intensely close-up situations with detachment, quickly moving on to the next unpredictable event. Our sense of almost accidental confrontation here is close to that found in, say, Jules Adler's *The Weary* (cat. 126), where, as urban strollers, we may choose to focus upon or quickly turn away from a scene of contemporary hardship. And it is found even in the astonishingly innovative sculpture of Medardo Rosso, whose work, first selected and then rejected by the Italian commissioners for the 1900 fair, was finally exhibited separately, with the work of Segantini. One of these controversial sculptures was *Impression of the Boulevard. Woman with a Veil* (cat. 131), which, like other Rossos, suggests, often with the blurring effects of wax, a ghostlike, fragmentary confrontation with a passing figure, a stranger who in a moment will disappear. This strange universe of the modern city, first defined by the Impressionists

as a new cosmos of vivid, pulsating harmony, continued to exert its ever-growing forces, producing in many artists less optimistic views, often marked with unfamiliar anxieties. City scenes could depict almost suffocating densities, whether in the patriotic mobs who celebrate the eighty-fourth anniversary of Norwegian independence in Christian Krohg's *17 May 1898* (cat. 140), or the presumably fun-loving crush of dancers, drinkers and lesbian lovers who, lit by a sulphurous gas light, populate Picasso's sinister interpretation of the Moulin de la Galette, painted in Paris during Picasso's first visit to that city (cat. 141). Inverting the message of Renoir's earlier painting of the same dance hall as a terrestrial paradise for the middle class, Picasso creates instead a contemporary hell in the city's underworld. Far more despondent pits of modern anonymity and loneliness would attract Munch, who distilled them in a relatively unknown painting, *Women in Hospital* (cat. 120), where naked and half-naked patients, totally isolated in a miserable welfare hospital, wander, stand or sit like condemned souls in a Christian inferno.

Almost as a way of detaching themselves from the darker sides of urban life, many artists aestheticised the city, staying at a sufficient distance from the welling populations to see the city as an animated spectacle, far from the realities of the individuals who lived there. This viewpoint survived in the Impressionists' later work, in Pissarro's many oblique views of Paris seen from high windows (cat. 129), or in Monet's often Whistlerian cityscapes from the turn of the century. In these, Monet could contemplate London sites such as Charing Cross Bridge, veiled in a fog that obscures the congested traffic, the waterways, the urban bustle (cat. 128), as if they were no different from the misty, totally unpopulated visions of his home and garden at Giverny (cat. 209). In both cases, Monet transforms his subject into a magical scrim of vibrant sensations, a colour-drenched atmosphere that pulverises everything – people, trees, railway bridges – into a mysterious threshold of the imagination. Enlarged, many of these paintings would provide suitable backdrops to Debussy's wraithlike opera *Pelléas et Mélisande*, which had its Paris première in 1902. These through-the-looking-glass experiences that lead to invisible realms correspond to the Symbolists' search for a gravity-defying, immaterial pictorial language appropriate to a growing retreat from commonplace life. Such moods and screen-like structures can be found in many other landscape paintings around 1900, such as Klimt's fragile fantasy of poplar trees (cat. 191), Mondrian's view of the River Gein in his native Holland, another scrim that points to the dissolution of the tangible world (cat. 186), or the Belgian Degouve de Nuncques's equally other-worldly vision of a grotto off the Catalan coast (cat. 192).

These private, dreamlike enclosures could be found most literally in the growing number of interiors painted as the century drew to an end. Some of the most famous, those by Bonnard, Vuillard and Vallotton (cats 172, 169, 170), turn ordinary domestic life into something closer to a mysterious séance in which figures appear and disappear, camouflaged by textures and patterns whose sensuous surfaces turn everyday prose into evanescent poetry. The mood of introspection, of a personal, secluded oasis that could keep at bay the urban realities just outside the door, was pervasive around 1900, as is evident in Hammershøi's monastically barren, grey interiors, more prisons than comforts to their lone inhabitants (cat. 158), or the gilded, curtained splendour of a *salone* in Venice's Palazzo Barbaro, a guarantee of luxurious insulation from the stresses of modern life for Sargent's well-heeled, expatriate sitters. The claustrophobic potential of interiors, domain of ghosts and dreams, was often explored at the turn of the century, especially in

Belgium, by such artists as Khnopff and Ensor. The latter's own studio interior of 1900 marks the furthest extremity of this private and bizarre world (cat. 165). A grotesque anthology of masks and skeletons is juxtaposed with a few domestic relics of Christian faith, a tiny crucifix on the wall and a cheap little statue of the Madonna and Child in the centre of a table, offering a blasphemous tribute to these once sacrosanct symbols.

Escape from society, from the city, was always one of the great motifs of modern landscape painting, a search for an unpolluted world that has become an even more urgent quest in our own time. The problem of air pollution was pinpointed in a would-be serious, but now only camp, allegory by the Portuguese Luciano Freire, whose *Country Perfume* (cat. 118) shows a pink and innocent nude high on a hill where the virgin air is menaced by the foul smoke rising from the factories in the city below. Yet other artists, like the Mexican José María Velasco, often represented at international fairs, occasionally welcomed the advances of the nineteenth century in their prehistoric landscapes. In Velasco's panoramic view of a volcanic landscape (cat. 201), we see this ancient valley newly traversed by a chugging railway train, a collision suggesting a vote of optimism rather than distress about technological progress. Nevertheless, around 1900, with the expansion of curiosity about the remotest parts of our planet, as mirrored in such publications as *National Geographic* (begun in 1888), new extremes of isolation began to be reached, sites often with indigenous prehistories that, when depicted, offered spectators surrogate voyages to largely inaccessible places. *Cliff Dwellers* by the American Thomas Moran transports us to the awesome immensities of the landscape near the Grand Canyon (cat. 202). Within this almost extraterrestrial world, Moran shows the prehistoric abodes carved in the cliffs where it was thought the ancestors of the Pueblo Indians had once lived, unchronicled by Western time. Similarly, the Icelandic painter Thorárinn B. Thorláksson took spectators to a remote part of his native landscape, Thingvellir, a lava plain some thirty miles from Reykjavik (cat. 203). Apart from offering us the expansive vista of this moody, lunar terrain suffused with a strange blue northern light, where two grazing horses unyoked to human needs are seen as lonely silhouettes against a dimming sky, the artist also chose an historic site, where, in AD 930, native chieftains gathered to establish local law. It was a memory of particular relevance in 1900, when Iceland was struggling to become a sovereign state, independent of Denmark. And such sites of memory may even be associated with Cézanne's beloved Mont Sainte-Victoire (fig. 23), at the foot of which the Roman general Caius Marius (a name still familiar in Provence) defeated the Teutons in 102 BC in a battle that could provide an ancient archetype for the enduring enmity between France and Germany.

Travelling in time and space to escape the new technological world so enthusiastically embraced at the 1900 fair was a typical choice for landscape painters. A familiar theme, reviving a major motif of Romanticism, was the mountain top, the point most remote from the urban world below. Both Cézanne and Hodler often turned to this image, re-creating it with a heraldic symmetry, but lesser-known artists also provided imaginary ascents to unpolluted heights. In the Norwegian Harald Sohlberg's view of a blue winter night (cat. 206), nature is again frozen into a mystical emblem. Framed by the high silhouettes of two trees, two majestic, ice-covered peaks rise like a luminous, almost supernatural vision above the minuscule, sleeping village. Above it all, in the exact centre, a white star shines, as if Christmas had been invoked by the purity of landscape. The American Augustus Vincent Tack can take us to even higher altitudes, defying

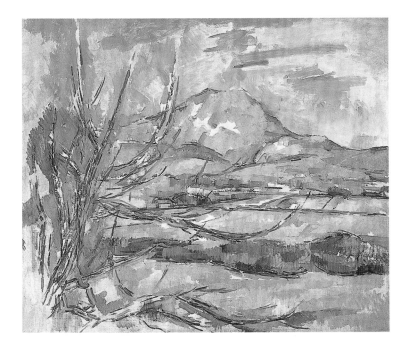
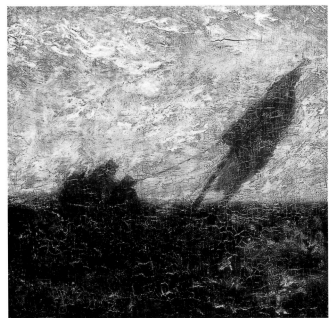

Fig. 23 Paul Cézanne,
Mont Sainte-Victoire, 1900–02

Fig. 24 Albert Pinkham Ryder,
The Waste of Waters Is Their Field, 1880s

gravity as we rise far above the earth to enter the no-man's land of uninhabitable nature (cat. 205). So immaterial is this hazy, iridescent vision of cloud, snow, rock and sky that it may be no surprise that Tack, like other turn-of-the-century landscape painters (among them Mondrian and Kandinsky), would cross the brink of nature into abstraction.

Such voyages to the thresholds of the inhabitable world had their watery counterparts, too, as in the visionary seas of the American Albert Pinkham Ryder that transcend terrestrial maps (fig. 24). And in more literal terms, his compatriot Winslow Homer depicts a barely populated region of the American Atlantic coast (cat. 194), a view from Prout's Neck, Maine, that almost overcomes us in the remote serenity of a distant sunset and the foaming turbulence of the surf. Across the Atlantic, dark and stormy Scandinavian seascapes came from the recklessly agitated brush of the writer August Strindberg, during his occasional, but unforgettable, efforts at amateur painting. His small yet awesomely expansive visions (cat. 196), often paralleling Ryder's, not only illustrate his published ideas about capturing nature's chaos in art, but prophesy the intentionally coarse and turbulent pigment of many mid-twentieth-century paintings. In the hands of a full-time painter, the German Emil Nolde, these northern seas could become equally engulfing apparitions, veils of dim light that camouflage distinctions between sea and sky and leave us floating, light-years away from the tug of gravity and the modern city (cat. 193).

Such regressions to a primordial world were expressed in countless ways, both intensely private and entertainingly public. Nudes, especially female nudes, were represented in popular Salon painting by images of mindless, animal abandon in some remote forest or waters, erotic fantasies that transcend modern calendar time. Paul Chabas's *Joyous Frolics* (cat. 31), a hit at the Salon of 1899 and shown again at the 1900 fair, typifies this genre. Like peeping Toms, we see through a screen of trees a giddy septet of half-modern, half-mythical nymphs who, linked in a childlike circle, splash about in the water. In terms of physical type, they run the gamut from blonde to brunette, and, in terms of psychological character, from the sultry temptress in the foreground who catches the voyeur's eye to her much coyer and more innocent friends who temporarily retreat. They all, however, remain elusive, more dreamlike than real,

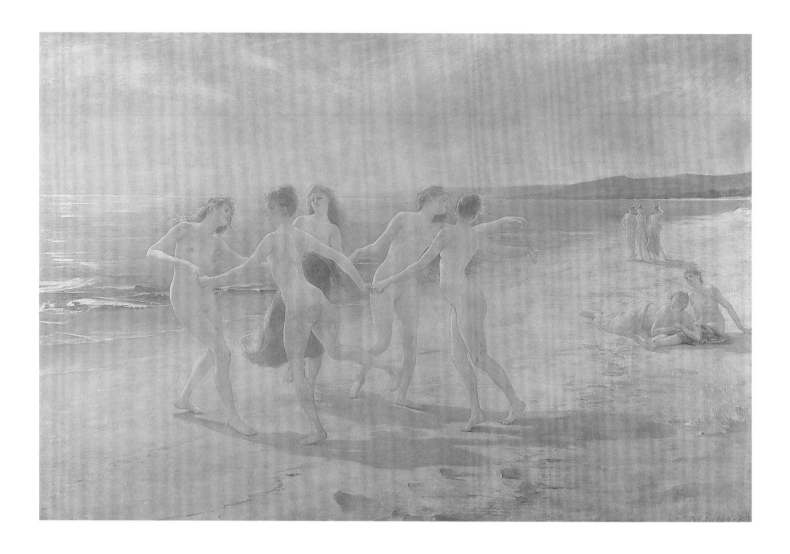

Fig. 25 Raphaël Collin, *At the Edge of the Sea*, 1892

thanks to the artist's adaptation of a relatively up-to-date Symbolist palette that produces an iridescent shimmer. And in other visions of these erotic Arcadias familiar to the late nineteenth century, the landscape and its mythical inhabitants can become as incorporeal as spirits. Such is the case in the Australian Sydney Long's *Pan* (cat. 33) or in the Catalan Joan Brull i Vinyoles's *Nymphs at Dusk* (cat. 34), which was seen at the fair. The distant creatures who can be discerned in these misty landscapes might almost be illustrations to the reveries of Mallarmé's faun.

These erotic meditations could equally take on very corporeal form in both sculpture and painting. As for the latter, one of the hugest canvases at the 1900 fair was *At the Edge of the Sea* by Raphaël Collin (fig. 25), in whose atelier many Japanese artists studied Western pictorial styles. Collin's female nudes could be seductively palpable, as in this fantasy of a quintet cavorting, again in a giddy circle, on the edge of a sea that looks so mythic that we might imagine that these nymphs, like Venus, were born from the nearby waters. Their anatomies, however, speak of a more time-bound erotic taste, looking as if they might have just been divested of the fashionable corsets and bustles that quickly identify *fin-de-siècle* ideals of female beauty. Seeing this primitive romp, drenched in a twilight blue, we may also realise that this is the theme gloriously rejuvenated a decade later by Matisse, in his famous *La Danse* (fig. 27). Against a raw expanse of blue that doubles as sky and sea, a round of five almost prehistoric women

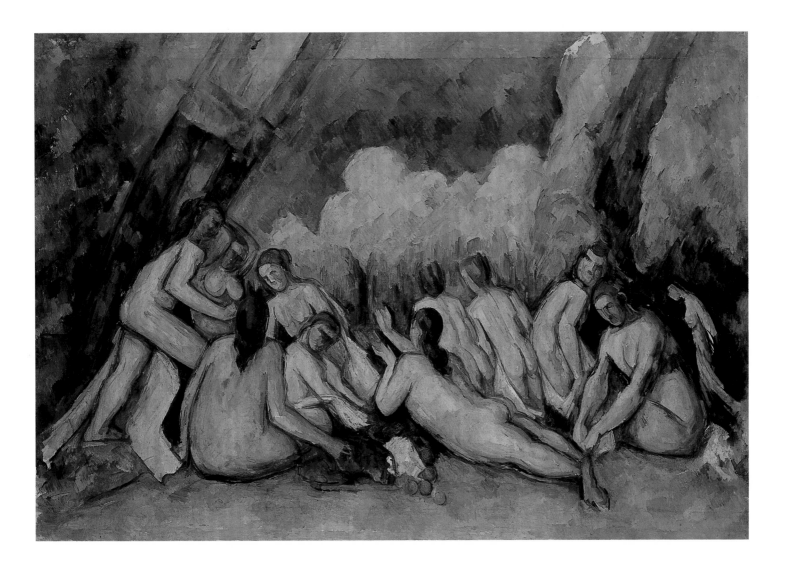

thump the green ground with rhythms soon to be heard in Stravinsky's *Rite of Spring*
(1913). In 1899, Matisse had worked on minor decorative painting for the Grand Palais,
and was obviously familiar with these Salon paintings by the likes of Chabas and Collin.
We can choose to see his own later visions of primitive Arcadias as a total rejection of
the late nineteenth-century past in which he was born and educated, but we may also
look at them as startling continuities, rather than decisive ruptures, much as we may
see Cézanne's many variations on the theme of bathers (cat. 59, fig. 26) as a strangely
personal response to the standards set at the Salons. There are, in fact, many shades
of grey here, one of them offered by the Belgian neo-Impressionist Théo Van
Rysselberghe's Salon-sized *The Burnished Hour* (cat. 32). In this work, the venerable
theme of nude bathers glimpsed on a vaguely Mediterranean shore is rendered in
a post-Seurat language of Pointillist brush strokes and heightened colours, creating
a shimmering panorama of pink flesh and ethereal blue light, the stuff of dreams. Once
more, this is a painting that fuses the official domains of popular Salon painting with
the adventurous new explorations of hue and brush stroke. In this effort to rejuvenate
moribund conventions, Van Rysselberghe's ambitious painting can also point to the early
twentieth-century Matisse, prefiguring as it does the master's re-creations of Baudelaire's
voyage to a land where all is 'luxe, calme, et volupté'.

 By the late nineteenth century, more and more male nudes began to populate remote

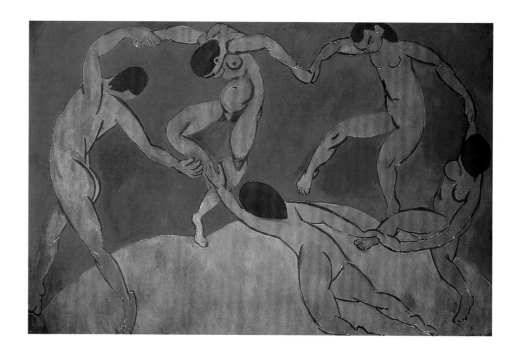

Fig. 27 Henri Matisse, *La Danse*, 1910

forests and waters, but usually these scenes took place in the present, on coasts that extended from the Mediterranean to the Baltic. In Northern Europe, especially, where vitalist ideas promoted nudity, sunbathing and swimming, youthful male nudes became abundant in paintings by such diverse artists as Munch, Liebermann and Krøyer (cats 53, 55). Some, like the British Henry Scott Tuke, even specialised in painting adolescent boys. More often naked than not, these won him continual success and his election as a Royal Academician. His own audience, unlike today's, must have been largely unaware of the pederastic fantasies he invented. A trio of fair youths would be given the Whistlerian title *Ruby, Gold and Malachite*, much as a sexual scenario might be cloaked under the equally innocuous title *Noonday Heat* (cat. 52), presumably another British veneration of the sun's welcome warmth. Here, Arcadias where female nudes would frolic are transformed into more contemporary daydreams about wholesome, unspoiled British lads relaxing in sylvan idylls. Tuke's own generation produced many such visions, from A. E. Housman's equally innocent *A Shropshire Lad* (1896) to the far less covert homoeroticism of Baron von Gloeden's internationally renowned photographs of naked Sicilian boys assuming Classical postures amidst the relics of antiquity.

Inevitably, the pressures of modern city life intruded upon these fantasies of ideal nudity masking sexual desire. In France, especially, the female nude, sometimes respectable, sometimes not, was attacked left, right and centre by one brilliant artist after another. Degas captured a sneaking glance at a woman awkwardly straining at her ablutions (cat. 41); Toulouse-Lautrec seized the pose of a prostitute momentarily crouching like a four-legged animal (cat. 44); Bonnard pinpointed the very moment that a young woman in modern clothing raises her blouse to remove it, thereby hiding her face and exposing her naked belly and black-stockinged legs (cat. 47). Reality was constantly knocking on the doors of these ivory towers.

The gulf between artifice and simple truth was no less conspicuous in portraiture, especially at a time when the heirs to vast new fortunes felt the need to commemorate themselves as people born to lifestyles once fit only for kings. Many cosmopolitan society portraitists helped them to create their self-images. At the fair, Sargent, certain to dazzle

Fig. 28 George W. Vanderbilt's Biltmore, at Asheville, North Carolina, designed by Richard Morris Hunt

Fig. 29 Franz von Lenbach's neo-Florentine house in Munich, today the Städtische Galerie im Lenbachhaus

both his sitters and their audience, showed his triple portrait of Mrs Carl Meyer with her son and daughter (cat. 99), the family of a Jewish banker associated with the Rothschilds. This gorgeous confection would resurrect the Ancien Régime, not only with the Louis XV sofa and Rococo boiseries, but through the renewed image of a drawing-room environment of cosseted casualness awash with delicate pastel tonalities. The informal but staged postures, complete with the thrust of a foreshortened fan, further endorse the sitters' claims to be members of a new aristocracy. Sargent's seemingly effortless virtuosity as a painter and draughtsman continued to evoke this lineage; for his bravura brushwork, so swift in seizing the glimmer of expensive fabrics and jewels, recalls the techniques of masters like Velázquez and Van Dyck. But aristocracy could be suggested by other forms of rarefied elegance, as in Boldini's portrait of Whistler (cat. 6), who had won his own élite status through brilliant wit and dandified manners. Whistler is captured, like the Meyer family, on the wing. Fashionably attenuated in hand and body, he is discreetly clothed in formal black attire, accented only by the tiny Légion d'honneur rosette he was awarded five years before this sitting. Perched at the edge of a chair, top hat in hand, he seems about to run off to a grand dinner party as soon as Boldini puts down his brush.

Whistler's full-length portrait of George W. Vanderbilt (cat. 89), who had recently inherited some six million dollars from the shipping fortune accumulated by his father and grandfather, wins our veneration by understatement. The impossibly thin and mannered sitter, dressed in riding costume, seems more spirit than substance, a consequence perhaps of the portrait's being unfinished, but also an aspiration of many of Whistler's late portraits, in which his patrons appear like wraiths, almost camouflaged by the shadowy nuances of a monochrome ground. Vanderbilt's own sensibilities extended to artistic patronage, including commissioning Richard Morris Hunt to build a French-style château, Biltmore, in Asheville, North Carolina (fig. 28). In many ways such lavish time-travel can be seen as the architectural counterpart of the recurrent pictorial attempts by the very rich, at the turn of the century, to resuscitate the long-lost culture of a pre-industrial Europe. And on a much lower level of achievement, we might turn to another mirror of this nouveau-riche era, the child icon of the five-year-old Peggy Guggenheim by the most fashionable and successful portraitist in Munich, Franz von Lenbach (cat. 106). An artist who had made many copies after the Old Masters, Lenbach fitted the young Peggy into the mould of a Velázquez infanta, attempting, but – unlike Sargent, Serov and Boldini – failing, to resurrect a seductive illusion of venerable nobility and a dazzling pictorial craft that could rapidly set down the child's vulgar costume of plumes and velvet. The unhappy results, which transform a mere child into the trashiest of under-age temptresses, are all the more ironic given the about-face twentieth-century future of the sitter. This same collision of crumbling late nineteenth-century pretence and early twentieth-century avant-garde can be seen, coincidentally, in Lenbach's own house (fig. 29). His family's huge, neo-Florentine villa, built in the 1890s in the centre of Munich (the counterpart to Vanderbilt's Biltmore from the same decade), is now a museum that houses not only its original owner's backward-looking work, but a fabled collection of the most adventurous early twentieth-century art, created when Munich became a major centre for artists who, like Peggy Guggenheim herself, wished to annihilate their nineteenth-century roots.

Working outside the historical fancies of society portraiture, many artists turned to plain prose, unmasking their sitters as simple human beings. In the Dane P. S. Krøyer's

depiction of the composer Edvard Grieg and his wife Nina, shown at the fair (cat. 110), we might easily imagine we were looking at a scene of ordinary domestic intimacy rather than a tribute to one of the late nineteenth-century's most renowned composers. This respect for the simple facts of the here-and-now, however, could often appear as an obstacle to the discovery of invisible emotional truths. Nowhere was this probing deeper than in the artists' self-portraits which proliferated at the end of the century. Reviving in a new context the self-scrutiny familiar to much Romantic portraiture, artists of every stripe seemed to search their mirrors for ways of reaching their inner lives. For this kind of psychological penetration, the most familiar format became a staring close-up of the artist's head alone, a passport photo of the psyche that almost illustrates the metaphor of the eyes being the windows of the soul. As often as not, the artists' heads are completely frontal, and exclude any suggestions of an outside world. These confrontations with the self have a remarkably international range. Thomas Eakins, in Philadelphia, obliges himself and us to peer into his sad and ageing eyes (cat. 279); Aurélia de Sousa, in Lisbon, makes us read her face as if it were a private diary (cat. 274); Paula Modersohn-Becker, in Worpswede, seems to strengthen her courage before our eyes (cat. 272); Matisse, in Paris, stares into a personal world that darkens the brilliant hues around him (fig. 30). The static symmetry of many of these self-portraits often has a hypnotic effect, making us feel that we must stare back at these isolated human beings and share, for the moment, their secret worlds. When we meet these eyes, whether they belong to Hodler or Mondrian, Gwen John or Picasso, we must deal with people, not with artists.

By 1900, in fact, the stubborn grasp of the external realities so familiar to nineteenth-century art – people, cities, landscapes, still-lifes – continued to loosen. With eyes open or closed, mysterious worlds – the depths of the psyche or the far reaches of the imagination – could be explored. This willingness to challenge material facts led as well to the threshold of an art that kept exploring the very tools artists used to depict visible things: daring new colours, more invented than seen; unfamiliar spaces that could float, expand and contract in total defiance of art-school perspective; surface patterns that, like tapestries or stained-glass windows, could transform familiar images into new kinds of decorative order. To pursue such daring directions, artists often found that inanimate objects, especially traditional still-life arrangements, could provide the easiest laboratory for experimentation, so that a survey of still-lifes around 1900 may herald most clearly the familiar pictorial liberations of twentieth-century art. With one foot, as usual, in the past, Cézanne can copy a Delacroix watercolour of a cornucopian bouquet of flowers, but re-create it in his personal language that fuses translucent and opaque, background and foreground, solid and void (cat. 176). Floods and sparks of intense colour keep invading, too, these static studio props. We might well have expected Gauguin, during his last years in Tahiti, to saturate a rich offering of exotic fruit on a steeply tilted table top with the tropical colours that had become his signature style (cat. 178), but artists everywhere were unsettling still-lifes with chromatic fireworks. The young Russian Alexei Jawlensky, working in Munich, could look at the most conventional set-up of oranges, dishes and a vase of hyacinths, and explode it with his original adaptation of van Gogh's colour and neo-Impressionist flecks of paint, producing a clash of complementary blues and oranges that shatter their inanimate sources on the table top and produce a confetti-like shower of colour and liberated brushwork (cat. 175). And Matisse, working in Paris, could contemplate the dullest studio arrangement of pitchers, bowl, vase, cloth

and lamp and transform it into an enchanted world of exotic hues worthy of Islam, locked into taut place by a daring mutation of traditional perspective which, following Cézanne's lead, turns the oblique thrust of the table top into a flattened pattern on the wall (cat. 177). These are just a few of the countless new languages of visual order that were being invented around 1900, and that have become familiar to the traditional narratives of the canonic triumph of early twentieth-century art over the seen world.

But in the twenty-first century, when we look back at the profusion of different and often contradictory viewpoints that mark the realities of history, we may well trace new and surprising patterns. So it is that two very odd still-lifes, by artists never associated with the thrilling revolutions of twentieth-century art, may be seen as unwitting prophecies. Who would have expected the stuffy Jean-Léon Gérôme, who railed against the Impressionists at the 1900 fair, to produce a strange painting that offered a preview of Dada and Surrealism? For a 1902 Paris exhibition of advertising signs by established artists, he submitted a fantasy, both adorable and disquieting, that would humorously serve as an optician's sign (cat. 179). The fragmented word, O PTI CIEN, becomes a pun on 'Au petit chien', that is 'Oh, little dog' or 'At the sign of the little dog', a beguiling terrier who appears in typical Gérôme style as a hyper-realist fact, sporting a monocle and miraculously supported by the thinnest of straight lines inscribed on a completely opaque blue ground. Stranger still are the symbols of the optician's profession: one Cyclopean eye that stares down at us from a frame decorated with binoculars and coloured lenses, and a pair of much smaller eyes seen through a pince-nez. Salvador Dalí himself, in 1967, wrote about this odd painting as a preview not only of Duchamp's word-plays but of his own Surrealist version of an uncannily sharp-focused realism; indeed, Gérôme's offbeat painting seems to contain a startling profusion of irrational things to come. How many young artists in Paris might have carried with them the memory of this anthology of fragmented verbal puns, grotesquely staring eyes and mirror-like renderings that shuffle fantasy and reality?

There were comparable surprises on the other side of the Atlantic. Who would ever have thought that the popular traditions of *trompe l'oeil* painting might trigger the most élite and complex of twentieth-century imaginations? Such an illusionistic *tour de force* as John F. Peto's *The Cup We All Race 4*, painted about 1900 (cat. 180), now seems to foreshadow the more sophisticated jugglings of facts and fictions so often discussed in the language of Cubism and beyond. The fake name-plate; the false protrusion of nail-heads pinning paper to the wall; the play between the cup's traditionally rounded volumes and the literal and figurative flatness of the brown wooden ground; the floating, incised inscription with its visual and verbal pun on the number 4: all these shufflings of truth and deception, of words and images, of the commonplace and the extraordinary are by now part of our vocabulary when we talk about the great achievement of Picasso's and Braque's Cubism. And looking into the next half of the century, the relevance of such popular American pictorial deceptions is not just generic, but quite specific. For Jasper Johns, Peto's painting, an extreme form of the realism that we have always thought the twentieth century hoped to bury, became a kind of talisman, inspiring him from the early 1960s onwards. Johns used Peto's title for one of his prints; he painted Peto's name on a canvas he named *4 the News*; he hung real objects on imaginary walls covered with inscriptions. Like Johns, we too may discover new ways of looking at the art that lies between the twilight of the nineteenth century and the dawn of the twentieth.

Fig. 30 Henri Matisse, *Self-portrait*, 1900

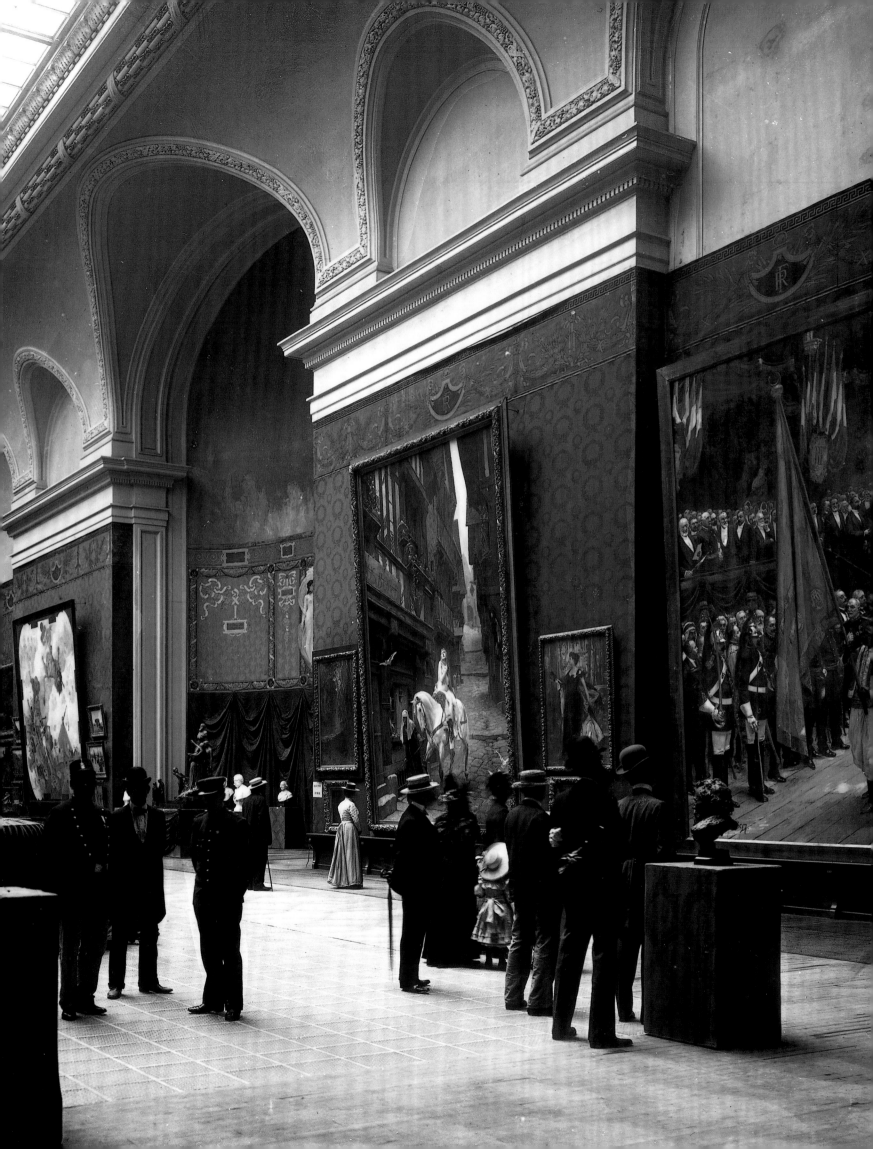

The Exposition Universelle:

'This vast competition of effort, realisation and victories'

MARYANNE STEVENS

Fig. 32 The official opening of the 1900 Exposition Universelle, next to the Pont Alexandre III

Fig. 31 (*opposite*) The French painting gallery in the Grand Palais. From the left, the three large canvases are: Jean-Paul Laurens, *Toulouse contre Monfort*; Jules Lefebvre, *Lady Godiva*; and Henri Gervex, *La Distribution des récompenses au Palais de l'Industrie. Défilé des Colonies françaises devant le Président Carnot*

The 1900 Paris Exposition Universelle was inaugurated by the President of the Republic, Emile Loubet, on 14 April. The 'Marseillaise', and music by Massenet, Saint-Saëns and Dubois punctuated a day of state processions, official inspections and the opening of the grandiloquent Pont Alexandre III (fig. 32). The aims of the Exposition Universelle – education and instruction, the fine and decorative arts, technology, labour, and state welfare and hygiene – had earlier been defined by its Commissioner-General, Alfred Picard. At the opening ceremony President Loubet was at pains to remind the assembled dignitaries of the part that France had played in the realisation of these aims: 'France has sought to offer a brilliant contribution to the coming understanding among nations. She has consciously worked to benefit the whole world at the end of this noble century whose victory over hate and error is, alas, still incomplete, but which bequeaths to us a continuing and lively faith in progress.'[1]

The first 'public exhibition of the products of French Industry'[2] had been organised by the French government in 1798 as a means to offload manufactured goods blockaded by the British during the French Revolutionary Wars. Two fairs later, in 1806, the categories were expanded to include the fine arts, as well as textiles and the chemical and mechanical arts. Subsequent fairs were held in 1819, 1823 and 1827 under the Bourbon Restoration of 1815; in 1834, 1839 and 1844 under the July Monarchy; and in 1849 under the Second Republic: all were organised and funded by the government and were strictly national in their remit. Following the French model, other fairs were held elsewhere in Europe after 1819: Ghent in 1820, Tournai in 1824, Haarlem in 1825, Brussels in 1830 and Berlin in 1834; none were organised with the support of their respective governments. London's Great Exhibition of 1851 established new precedents: international in its scope, its exhibits were selected by juries, half of whose members were appointed by the host country and half by representatives of each foreign government. Four times as large as the 1849 Paris fair, it set a pattern for applying the arts and sciences internationally to industry, education and society. Spurred on by 'the didactic intentions of their organisers, national prestige, and international politics',[3] international exhibitions were subsequently held in Paris in 1855, 1867, 1878 and 1889, London in 1862, Vienna in 1873, Philadelphia in 1876, Glasgow in 1888, Chicago in 1893, Moscow in 1896, and as far afield as Sydney and Melbourne in 1878–79 and 1880–81 respectively.

Fig. 33 The Tour du Monde in an engraving of 1900

Fig. 34 The Grand Palais (left), with the Petit Palais opposite and the Pont Alexandre III in the foreground

The 1900 Exposition Universelle attracted considerably greater international participation than its 1889 predecessor, which had celebrated the centenary of the French Revolution and was therefore shunned by countries less enamoured of such overtly republican sentiment. In 1900, over forty countries were represented, including many with extensive colonial interests around the globe. Paris was transformed. National pavilions sported indigenous styles, and corners of exotica, such as the Swiss Village, the Egyptian Souk and the 'Tour du Monde' (fig. 33), were realised. Medieval Paris was re-created. The Grand Palais and the Petit Palais were erected in an architectural style described as a manifesto of modern architecture, a perfect marriage of iron and stone, on axis with the Pont Alexandre III, to accommodate the products of 'art and genius' (fig. 34). Modern technological achievements – the Palais de l'Electricité, the *trottoir roulant* (moving pavement) which encircled the Champ-de-Mars and the Eiffel Tower (the legacy of the 1889 exhibition), and the first underground railway (the 'Métropolitain') – were celebrated. On the exhibition site, extending from the Pont de la Concorde to the Pont d'Iéna and covering some 277 acres, there rose a 'new and ephemeral city hidden in the centre of the other, a whole quartier of Paris in fancy dress, a ball, where the buildings were the masqueraders. To our childish eyes, it was a marvel, a coloured picture book, a cave filled by strangers with treasure.'[4]

The exhibition had, however, been preceded by a decade of dispute, debate, political crises, arguments concerning the primacy of Paris over rapidly expanding provincial centres, a persistent economic depression which only began to retreat in 1896, and international rivalries. In the wake of her defeat in the Franco-Prussian War of 1870–71, France's enduring animosity towards Germany was transformed into outrage when her

unquestioned supremacy in organising international exhibitions was challenged by a group of German industrialists and merchants who proposed that the successor to the 1889 Paris exhibition be held in Berlin in either 1896 or 1897. In addition, the United States had thrown down a challenge to all subsequent international exhibitions when she mounted the 1893 Columbia World's Fair in Chicago. This was admirably summarised in a comic interchange provoked by the 1900 Exposition Universelle, entitled 'At the Exposition':

> *First Chicagoan*: It don't compare with the World's Fair of Chicago.
> *Second Chicagoan*: Of course not. I knew that before I left Chicago.[5]

Despite well-laid plans, the construction of some 210 pavilions and the multifarious facilities required by an international exhibition was far from complete by 14 April, leaving the inaugural ceremonies to take place amid building sites and mud. By 1 May, the official tour of the Grand Palais, the home of the Exposition Décennale, by President Loubet, the Minister of Fine Arts, and the Commissioner-General of the Exposition Universelle found the installation of the French section barely realised, with the twenty-eight other art-exhibiting countries even further behind. None of the *c.* 1530 sculptures had even entered the building.

The Grand Palais opened to the public on 2 May 1900. It contained the Exposition Centennale, in the western wing facing the Avenue d'Antin, which celebrated the achievement of French art since 1800, and the Exposition Décennale, which occupied the majority of the ground and first floors, the latter wrapped round a huge, top-lit atrium which contained the sculpture. Twenty-nine countries chose to be represented, each with paintings, works on paper (drawings, watercolours, pastels and prints), sculpture (including medals) and architecture.[6]

The selection of the artists to represent each country was the responsibility of each participating nation, which normally established a commission to undertake the task. The selection of works was governed by the principle that all should have been created

Fig. 35 Hector Guimard, The Porte Dauphine Métro station

Fig. 36 Comparative table showing countries exhibiting at the Exposition Décennale in descending order

COUNTRY	EXHIBITORS	WORKS	PAINTING		SCULPTURE	
			ARTISTS	WORKS	ARTISTS	WORKS
France (and colonies)	1066	2612	762	1972	304	640
USA (and Cuba)	251	422	220	352	31	70
Great Britain	223	338	193	276	30	62
Germany	200	240	149	168	51	72
Japan	177	269	124	198	50	71
Russia (and Finland)	157	406	129	283	28	123
Austria	146	221	126	176	34	45
Switzerland	118	235	98	198	20	37
Italy	112	216	75	129	37	87
Hungary	101	199	81	147	20	52
The Netherlands	98	112	91	102	7	10
Belgium	96	154	79	117	17	37
Spain	83	163	60	106	23	57
Denmark	73	186	57	162	16	24
Norway	62	127	59	119	3	8
Portugal	50	161	38	123	12	38
Ecuador	48	63	36	50	12	13
Sweden	48	102	38	85	10	17
Romania	33	92	25	71	8	21
Serbia	18	55	15	46	3	9
Bulgaria	14	43	11	25	3	18
Croatia	14	43	11	32	3	11
Greece	11	31	3	5	8	26
Turkey	7	14	7	14	0	0
Peru	6	27	4	21	2	6
Bosnia-Herzogovina	4	4	2	2	2	2
Luxembourg	4	4	1	1	3	3
Mexico	2	3	2	3	0	0
Nicaragua	1	1	1	1	0	0

Fig. 37 Félix Vallotton, *The Trottoir Roulant*, woodcut from *The World's Fair* series, published in 1901, showing passengers in transit

Fig. 38 Emile Zola and his wife at the Exposition Universelle in 1900

since 1889. This rule was accepted by all participating nations except Belgium, which chose to provide a more comprehensive record of its recent artistic achievement. Some commissions, such as that of the French, both selected the artists and ordained the number of works by which they could be represented. This led to considerable criticism about inclusion and exclusion, and to a notable unevenness in relative representation.[7] The United States adopted a similar approach, seeking, however, to reflect both the federal character of the country and the existence of a significant body of influential American artists working in Paris. A Pictorial Consultative Committee was convened, with representatives from Boston, New York, Philadelphia, Washington DC, Chicago, Cincinnati and St Louis, as were two juries, one based in the United States and the other in Paris. Other countries, including Belgium, Norway and Great Britain, selected by invitation; artists were chosen from acceptances, and works proposed. The British Commission included Sir Edward Poynter, President of the Royal Academy of Arts, his fellow Academician Henry H. Armstead, and the then President of the Royal Institute of British Architects. It was served by F. A. Eaton, Secretary of the Royal Academy. Two other Academicians, Edwin Lutyens and George Aitchison, were involved in the national pavilion, the former as its architect, the latter serving on its committee. Not surprisingly, out of 193 British painters and graphic artists, 52 were either already Royal Academicians or shortly to be elected, and out of 30 sculptors, 11 likewise fell into these two categories. In the case of Belgium, an acceptance of the new tendencies in art associated with the exhibiting body Les XX, founded in 1884, and La Libre Esthétique, its successor organisation from 1893, ensured that of the 96 painters and sculptors represented, 24 were either founder members or exhibitors with Les XX and/or La Libre Esthétique. A further three had been closely involved with the independent exhibiting body, Als Ik Kan, founded in Antwerp in 1883. The resulting contrast between the British and Belgian representations was remarked upon by several critics, and is discussed below. Sweden sought to bestride several rival groups, mediated

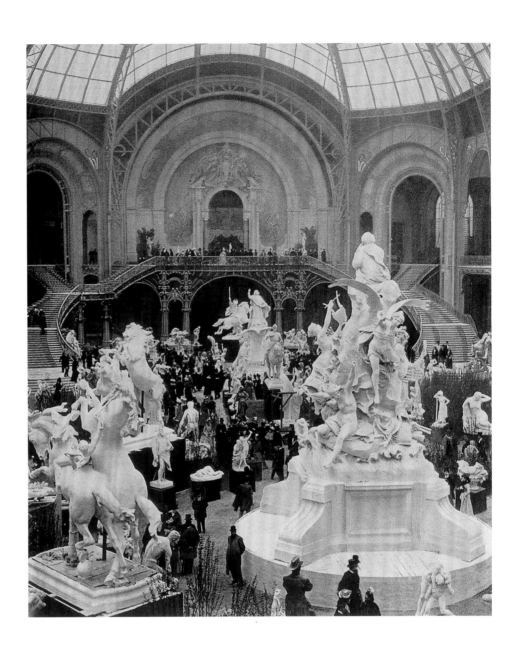

Fig. 39 The central dome of the Grand Palais, showing sculpture included in the Exposition Décennale

by the artist Anders Zorn. In an attempt to maintain a balance, Zorn, himself a member of the Swedish secessionist group, the Konstnärsförbund, tended to underplay both selection and presentation of these more radical artists, including Richard Bergh.[8]

Certain significant detractors wished to avoid visiting the Exposition Universelle if at all possible, among them Camille Pissarro and Monet, the former expostulating in a letter to his son Lucien: 'But what sort of fair is this odious bazaar! I could only go six times, and I only saw the Décennale, the Centennale and the Petit Palais! The rest is so much like a menagerie that I rushed off to go and see the apple orchards in blossom.'[9] Vuillard, Denis and the writer Paul Claudel seem studiously to have ignored the fair's very existence. Vallotton visited the exhibition and recorded it in a suite of trenchant woodcuts (fig. 37) but passed no written comment which has survived. Zola (fig. 38) frequented the fair and enthusiastically photographed its various displays. Rodin declared his independence and authority by both exhibiting within the Décennale and presenting a retrospective of 150 works in his own pavilion on the Place de l'Alma, and Monet admitted his superior position by remaining aloof from the Décennale and holding his one-man show at the Galerie Durand-Ruel ten days after the exhibition's close.

Each country's estimation of its best contemporary artists was installed within the limited space left after the overwhelming French presence had been accommodated. A fairly comprehensive photographic record survives of the jungle of sculpture from all nations which was assembled within the central atrium (fig. 39). With over 1,500 works in marble, plaster and bronze, the installation met with scant critical acclaim. Henri Frantz declared: 'Despite the immense dimensions of the atrium of the Grand Palais, the sculptures contained within it, which are so numerous, all spill out over one another, mutually crushing each other to such a point that, after the opening of the Grand Palais, a certain number had to be relegated to the gardens. The conditions, one must admit, do not favour a pleasurable examination of the exhibits.'[10] Barthelémy had little to add: '…in the Sculpture Hall…the grotesque accumulation of works is such that one must really love art in order not to be disgusted'.[11] The installation of the national painting and works on paper sections can only be partially reconstructed. In the French section, paintings and pastels were installed by Guillaume Dubufe and Albert-Pierre Dawant, figures of considerable influence within the Société Nationale des Beaux-Arts (the Salon du Champ-de-Mars) and the Société des Artistes Français (the Salon des Champs-Elysées) respectively.[12] Inspired by the more radical reforms introduced by, among others, Dubufe, into the Salon du Champ-de-Mars, the paintings and pastels were hung relatively sparsely (see fig. 55). Works were grouped by individual artist and a system of diffused lighting was achieved by stretching semi-opaque fabric beneath the glass roof. Armand Dayot considered the result an installation of 'perfect taste and praiseworthy judgement and discrimination'.[13] Diffused natural lighting was apparently adopted by several other nations, often with notable success, as in the case of the German section.[14] Unfortunately, the physical disposition of many of the galleries within the Grand Palais meant that some national sections had little access to good natural lighting, leading to comments that the American and Finnish sections were both very poorly lit, the latter having been allocated a 'poor side room' off the main Russian section.[15] Hungary made a virtue out of this disadvantage by creating a luxurious but sombrely lit interior.

The importance of sounding an individual aesthetic note in the installation of the galleries was recognised by at least Austria, Denmark, Germany and Japan. Germany displayed its works in the setting of a 'gallery of a businessman or banker suddenly enriched, an opulently decorated house of a parvenu',[16] to an evident lack of general acclaim possibly coloured by unspoken national jealousies. Austria injected a reference to the nascent Vienna Secession by using matt silver hangings and incised wood panels,[17] and Denmark chose 'blue for its decoration, with designs of lines, which reminded one of the pleasing simplicity which we are wont to admire in the porcelain work of Copenhagen'.[18] The American section adopted the French principle of a double-hang but was derided by the landscape and portrait painter Charles Melville Dewey for 'such incongruous combinations…as sage-green walls, with salmon-coloured carpets'.[19]

A myriad of guidebooks, reviews and lengthier publications by writers of all nationalities were published. These ranged from general surveys of the exhibition, such as the felicitously entitled William Heinemann guide, *A Practical Guide Containing Information as to…the Curiosities of Paris and the Exhibition – A Rapid and Easy Method of Seeing Everything in a Limited Time and at a Moderate Cost – with many Illustrations and Plans* (London, 1900), to earnest evaluations of the exhibition as a whole and extensive considerations of the two main art exhibitions.

The vast range of displays made any critical assessment problematic. The Belgian Symbolist writer Emile Verhaeren noted that reviews tended to concentrate on a small number of generally acclaimed attractions: '...[critics] were drawn to and especially surprised by the industrial innovations of Lalique, the silken embroidered wonders of the Japanese, the miracles of Parisian tailoring and dressmaking, the pâtes and enamels of modern potters, the reconstruction of a temple from Indo-China, the archaeological displays in the Petit Palais, the Ingres, the Daumiers and the Corots, the Fantins, the Manets, the Renoirs, not forgetting the Regameys and the Trutats, of the Centennale and the naïf but sophisticated, simple but complex, realist but synthetist performance... of an actress of genius: Sada Yacco [sic]'.[20] Serious evaluations of the Exposition Universelle and, more specifically, the Exposition Décennale, were the domain of a smaller, discerning group of critics, including Verhaeren, who assessed the intrinsic value of mounting an international exhibition, investigated its national and international benefits and limitations, calibrated the relative achievements of individual participants and considered the exhibits as indicators of future developments in technology and the arts. Given the overwhelming presence of the host country within the Exposition Universelle, estimated by the British Official Catalogue to be 2,691,000 square feet of space in comparison to the 1,829,880 square feet occupied by the foreign sections, the dominance of the French critical press is hardly surprising. This generated a tendency to establish a strong nationalist line. Other patterns within French and non-French criticism were apparent, however: many non-French critics supported the pro-French line; some French critics adopted a severely anti-French line; and critics of all nationalities tended to agree on the relative achievements of individual nations, especially in respect of their representation within the Exposition Décennale. With a few notable exceptions, the general level of the critical reviews of the Exposition Décennale tended towards generalisation rather than consideration of specific movements and artists. In this regard they reflected the move away from the specificity current in the critical writings of the 1880s towards considerations of a more universal nature: the current state of art, its position relative to the great art of the past, and its future manifestations.[21]

Criticism against the exhibition in general, and the Décennale in particular, abounded. In a perceptive but often acerbic discussion of the pros and cons of the exhibition as a whole, conducted between two fictional philosophers, one negative, the other positive, Gustave Geffroy had his negative philosopher deplore the extent to which Paris had been subjected to an ephemeral transformation, degrading the city physically, socially and morally 'into nothing more than a bazaar'.[22] This analogy was expressed with specific reference to the Décennale by the Belgian critic Eugène Demolder, who declared that its approach led inevitably to the relegation of 'painting to the commercial, to the insignificant place to which it has assigned itself, far from art, perhaps in the linoleum or the perfume sections'.[23] When set within the context of late nineteenth-century market economics, this inevitably engendered considerations of competition and national rivalries. Verhaeren, musing on the likely potential and longer-term significance of the exhibition, regretted that the unspoken competition between nations could initially eclipse the admiration, tolerance and understanding which should ideally exist between individual countries: 'Might it be possible', he mused, 'to draw a moral from admiration? This idea comes to us naturally on seeing this vast competition of effort, realisation and victories which constitutes a universal exhibition.'[24]

The competitive spirit in the Décennale was regularly noted. The *Art Journal* accurately caught this spirit: 'In the Grand Palais, in the gardens opposite, the competition of living artists will take place. Artists of every country have contributed the works by which they deem it most expedient to be judged.'[25] Critic after critic lamented, however, the negative impact of France in taking half of the space within the Grand Palais. Guinaudeau, in the first of six articles devoted to the Exposition Décennale, declared (with slight exaggeration) his disgust at this greediness: 'Thirty-six rooms, of which some are huge, on the ground floor and on the first floor of the Grand Palais, contain what the princes of French art have judged to be most worthy of being exhibited for the admiration of the whole world…These men have taken…three-quarters [*sic*] of the space identified for the fine arts at this Exhibition to which all nations have been invited. The foreigners have only one quarter [*sic*] left at their disposal [and]…can only proportionally hang two or three canvases to the one hundred that France can hang. Our artists have a most singular understanding, and application, of the meaning of hospitality. They no doubt believe that, by excluding all the others, they can demonstrate irrefutably that they alone exist and that they alone possess genius. Alas! They have merely demonstrated irrefutably the rottenness of their souls.'[26] Any objective comparative evaluation of the current international health of the visual arts was therefore precluded. Arsène Alexandre correctly identified the root of such a problem: 'To begin with – is it possible, at a Universal Exhibition like this, to have an absolutely accurate idea of what is called "l'art mondial"? In theory, "yes", in practice, "no".'[27]

Competition manifested itself overtly in the selection process. Alexandre continued: 'Juries are chosen from among the most celebrated men. Those who, so to speak, have "arrived". Now, those who have "arrived" do not always understand those who are about to "arrive"'.[28] The vagaries of the selection process, and particularly the exclusion of the Impressionists from the Décennale, were deplored by many critics. After long-drawn-out negotiations, Claude Roger-Marx, the commissaire, had finally given the Impressionists their own dedicated space within the Centennale but excluded them from the Décennale. Barthelémy blamed this on the lack of initiative of the French selectors of painting for the Décennale, who, unlike their architectural colleagues, had failed to seek out and include artists who had not voluntarily presented their work for selection.[29]

Favourable reactions to the Exposition Universelle fell into similar patterns of generality and specificity. There was widespread acclaim for the principle of a World's Fair. The *Art Journal*'s enthusiasm was typical: 'The Paris exhibition has brought together, in such a manner as to invite comparison and criticism, the art workers of all nations and of every school.'[30] More specifically, the benefits of the Décennale were appreciated by a reporter on the *New York Times*: 'Perhaps not at any Salon can the tendencies of modern art be judged so well as at a World's Fair. Here every nation is apt to put its best foot foremost, no matter how apathetic it may show itself in other departments, and to exhibit what its experts regard as the best of its current work. And since here, at Paris, the exhibition is not of a single year but is at once extended and limited to a decade, to the lapse of time since the last World's Fair in 1889, we ought to be able to get a better notion than can be got in any other way of what is going on in the world in this department.'[31]

The idea that positive comparison, rather than competitive criticism, should be the basis of an Exposition Universelle led several commentators to view the Exposition of

Fig. 40 Edwin Lutyens's Jacobean-style English pavilion, whose façade was based on the Hall at Bradford-on-Avon. The tower of Hungary's pavilion is visible in the background

1900 in lofty terms. It would act as a force for expanding understanding between nations, for evaluating the current progress of man and his achievements, and for considering the future path of his creativity. Octave Maus was moved to declare that, although they bring together nations who 'meet and fight', universal exhibitions also provide the framework for a 'broader critical view – a synthesis' to be made from the diverse manifestations of works displayed.[32] Such an affirmation of hope was paralleled by Geffroy's positive philosopher, who believed that the Exposition Universelle, as a product of nineteenth-century positivism, had made possible the presentation of the advances achieved across all areas of human endeavour, thereby notching up another gain for modern civilisation which could be transmitted to less-developed countries.[33] For Verhaeren, the prospect was even more positive: the universal spread of those essential elements of civilisation – philosophy, religion and beauty – as demonstrated in this Exposition Universelle, while reducing individual national identities, ensured that the goal of the future would inevitably be the unity of mankind.[34]

A closer examination of the positive evaluations of the Exposition Universelle made by the *New York Times* reporter and Gustave Geffroy reveals two approaches which were further to colour critical evaluation. Underlying that of the American reporter is the tacit acceptance of the beneficent force of national competition, while Geffroy's approach was cast within a more international, or universal, framework.

That nationalism and national identity were of common concern throughout the nineteenth century is a truism. Leaving aside the rise of the nation state, wars, and mercantile and imperial rivalries, nationalism, when applied to the arts, informed the promotion of art institutions;[35] it fostered the rise of regional and national schools of literature, from Daudet and Mérimée to Ibsen and Björnson; it dictated the assertion of national identity in the music of Sibelius and the Russian 'Mighty Handful'; and, within the visual arts, it permeated the representation of landscape[36] and the celebration of local tradition and contemporary life. The Exposition Universelle and the Exposition Décennale provided a platform for such nationalist sentiments, both in terms of symbolic representation and the choice of objects displayed.

Nationalism was most overtly expressed in the architecture of the national pavilions. Ranged along the Quai des Nations, between the new Pont Alexandre III and the Pont

Fig. 41 The Finnish pavilion, by Eliel Saarinen

de l'Alma, was a 'town of plaster and iron...fragile but wonderful',[37] an accumulation of temporary buildings constructed to proclaim distinctive national identities and to provide an environment within which the unique achievements of each country could be advantageously presented. In contrast to the emphasis on contemporary architecture found at the 1889 Exposition Universelle, in 1900 most countries chose to present themselves by referring to the past. Great Britain commissioned the re-creation of a Jacobean manor house from Edwin Lutyens RA, who met his historicist brief by using the south front of an existing house, the Hall in Bradford-on-Avon, as the source for his pavilion's northern façade, in an assertion of the British influence on house and home (fig. 40). Germany, sporting the tallest spire on the Quai, built a Gothic town hall such as would have dominated one of the Hanseatic League towns – a reference to the assumed mercantile superiority of modern Germany. The United States eschewed an indigenous architectural style which, as one critic sardonically commented, could well have been a log cabin. Rather, a vast, domed, classical building was constructed, reminiscent of both the dominant style of the Columbia World's Fair of 1893, where the United States had been recognised as a world economic power, and of the architecture of the Capitol in Washington DC, the seat of the world's seemingly most democratic nation. Amid Italy's hybrid of St Mark's Basilica in Venice and the Duomo in Siena, Spain's miniaturisation of the Escorial, Turkey's oriental mosque, Monaco's echo of its famous Opera House, and Austria's shrunken version of the Belvedere in Vienna, one pavilion alone asserted a new and independent voice: that of Finland (fig. 41). A defiant declaration of cultural independence from Russia, under whose subjugation Finland had laboured since 1809, the design, by Eliel Saarinen, used an astylar vocabulary which was 'lyrical, yet alluded to a hidden strength, like the music of Sibelius',[38] in stark contrast to the cumbersome pastiche of the Kremlin adopted for the official Imperial Russian pavilion (erected not on the Quai des Nations but at the Trocadéro).

The selection of objects presented both within national pavilions and in thematic displays also proclaimed nationalist sentiments. Germany avoided trumpeting the might of its armaments industry (contrary to its support of a pavilion devoted to Alfred Krupp at the Columbia World's Fair of 1893) by emphasising in a dedicated pavilion the achievements of its mercantile fleet. France, on the other hand, asserted its commitment to the machinery of war by according semi-official status to the pavilion of the armaments manufacturer Schneider. In the aesthetic field, Austria, Hungary and Germany proclaimed within their pavilions the triumph of their own variants of Art Nouveau, or Jugendstil, while the Scandinavian countries emphasised the simplicity and honesty of contemporary Nordic design. Great Britain featured the arts of the eighteenth and early nineteenth centuries. Apart from six paintings and a suite of tapestries by Burne-Jones and stained glass windows supplied by Morris & Company, Lutyens's Jacobean-style pavilion was hung with portraits by Reynolds, Gainsborough, Hoppner, Romney and Raeburn, landscapes by Turner and Constable and genre scenes by Morland. France, as we have seen, had more space to play with. The Petit Palais presented a historic review of French pictorial and decorative arts, while the Exposition Centennale, cohabiting with the Exposition Décennale within the Grand Palais, declared French domination of the visual arts from David to the Impressionists.

Subject matter also proclaimed national identity: national myths inspired works from France, Iceland, Finland and Britain; peasants in national costume populated the canvases

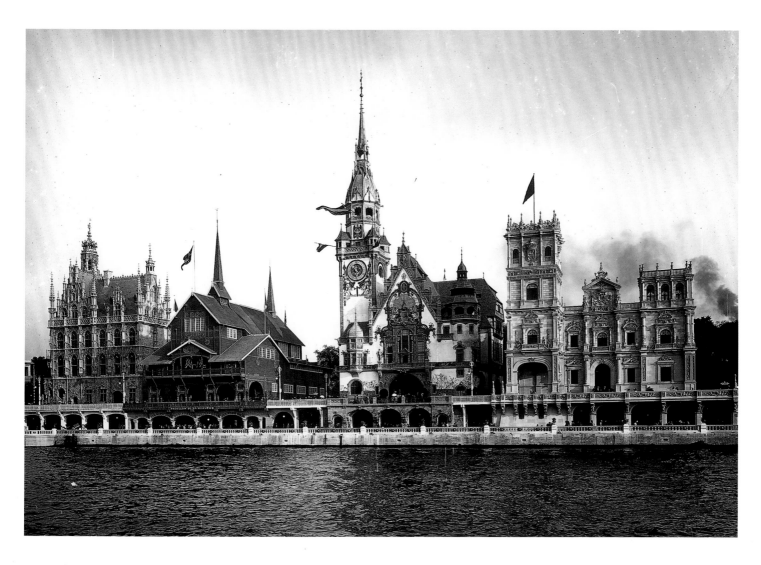

Fig. 42 The western part of the Quai de Nations from the Seine, showing the national pavilions of (from left) Belgium, Norway, Germany and Spain

Fig. 43 The eastern part of the Quai de Nations from the Seine, showing the national pavilions of (from left) Italy, Turkey and the United States of America

of Russian, Swedish, Polish, Danish, Hungarian, French and German artists; and everyday scenes could be given an immediately recognisable national identity in the works of Japanese Western-style artists. Prizes, initially rejected by Belgium, Norway and Great Britain on the grounds that their representatives had been invited and therefore classification was inappropriate, were the responsibility of international juries. Awarded in five classes, the 'grand prix', the 'prix d'or', the 'prix d'argent', the 'prix de bronze' and the 'mention d'honneur', their receipt was certainly a subject for comment, both by the press and on a more personal note, as is witnessed in the British artist Orpen's letter to a fellow Décennale exhibitor, Rothenstein, after a lightning visit to Paris in the summer of 1900: 'I have just been to Paris and seen your pearl [*A Doll's House*, cat. 148] with the English swine – and send my best congratulations.'[39]

Nationalism unavoidably informed critical responses to the Exposition Décennale. The scale of the French representation (over 1,000 artists) and the preponderance of home-grown critics inevitably produced a deluge of panegyrics in honour of the host country. Charles Ponsonailhe was no exception. There could be no doubt as to the supremacy of French art and the dominant position of Paris as capital of the art world: 'Paris…has replaced Rome. The Foreigner, wherever his place of birth…comes to Paris to seek his art training, and is content merely to visit Italy and its admirable "Past", now suffering the kiss of death. My first observation about the Décennale will thus be, as it was ten years ago, the absolute mastery, without rival, of our School, its role as educator, professor, "role chevalresque", truly French…'[40] Barthelémy seconded this opinion, although he noted that the exclusion of Renoir, Monet, Pissarro and Degas, together with the decorative arts, meant that the Décennale could not count as a comprehensive review of French artistic achievement in 1900.[41]

Critics also accepted the call for national rankings. A degree of unanimity about the relative achievement of each nation and the standing of individual artists emerges from the body of critical writing devoted to the Exposition Décennale. Belgium, winner of the greatest number of prizes after France, was universally acclaimed as the country with the most distinguished painting and sculpture sections: '…of all the foreign presentations, it is certainly the Belgian section which has the most standing and the most authority'.[42] The Belgian critic Demolder, admittedly somewhat *parti pris*, declared that only when standing in front of the Belgian paintings could one feel 'that one is in a country of painters, in the midst of a race of colourists',[43] while Arsène Alexandre echoed the consensus view of the achievements of such individual painters as Fréderic, Claus, Baertsoen, Delville, Khnopff and Laermans.[44] For sculpture, Alexandre considers Belgium to be 'the most vigorous after the French School', noting especially the particular qualities of Meunier and Lambeaux.[45] Octave Maus went further. Belgian though he was, he had since 1884 proved his supranational credentials as the organiser of the exhibitions of both the avant-garde exhibiting bodies in Brussels, Les XX and La Libre Esthétique, which from their inception had invited leading avant-garde artists from other countries to participate; he viewed Belgian sculpture at the Exposition Décennale as undoubtedly 'most glorious': 'I rejoice in the vitality of Belgian sculpture as upon inspection it is one of the greatest achievements of contemporary art.'[46] The Netherlands, Denmark, Norway and Sweden were seen, after Belgium, to be 'schools which give proof of the most intense vitality, of the most intelligent activity'.[47] As with Belgium, critics tended to agree on the qualities of specific artists from each country:

Fig. 44 Keiichiro Kume and fellow artists with their Parisian model

Breitner and Israëls for The Netherlands, Ancher, Hammershøi and Ring for Denmark, Thaulow and Backer for Norway, and Krøyer, Prince Eugen, Sohlberg and Zorn for Sweden. Russia and Finland were treated by most critics as a single section. Finland was regarded as the stronger and more original, with particular reference being regularly made to Gallén-Kallela, Halonen, Enckell and Järnefelt. However, the distinctive national character of Russian art was also recognised, with artists such as Malyavin, Repin, Levitan, Serov and Troubetzkoy being singled out as creators of 'good works' which 'express the strength and charm of the beauty of [that] country, portraits of thinkers or men of action, lively pictures of women and gentle girls, soft and melancholic images of autumn on the Steppes and in the woods'.[48]

Eastern and southern European countries did not enjoy such positive critical receptions. Both Germany and Austria suffered from presenting contrasting schools, Germany with the established artists of Düsseldorf and Munich and those who worked within a more naturalist aesthetic, and Austria with the pre- and post-Secession tendencies in her section, the latter dominated by Klimt, whose contribution to the Décennale was by no means uniformally acclaimed. Italy and Spain, both inheritors of magisterial artistic traditions, were also viewed as problematic; with the notable exceptions of Segantini and Boldini for Italy, and of Sorolla and, with certain reservations, Rusiñol for Spain, neither presented a strong hand.

Three other countries received extensive coverage: the United States, Great Britain and Japan. The apparently French character of most of the American contributions was noted. The New York Times pointed out that, of the 251 American artists included in the Décennale, only some fifty did not proclaim themselves in the catalogue to be pupils of Laurens, Carolus-Duran or Henner, and lamented the resultant reduction in the individuality of each visual statement.[49] Certain artists, however – among the portraitists, Whistler, Sargent, Alexander and Beaux, and among the landscapists, Homer, Innes and Harrison – did receive acclaim. American sculptors generally fell victim to Octave Maus's outburst against the 'pernicious influence of French production-line sculpture',[50] but two exponents – Saint-Gaudens and MacMonnies – were thought to be exceptions to this and worthy of note. Great Britain's section was generally felt to be uneven. In painting, despite the greater naturalism of Lavery, Orchardson, Shannon, Stanhope Forbes and Clausen, there was general agreement that the predominance of Leighton, Millais, Burne-Jones and Alma-Tadema (the former three already dead) had produced 'something insipid, old-fashioned, verging on the puerile at times…If England wants to remain worthy of its old glory, it must leave its museums, studios and pundits and look outside!'[51] British sculpture was deemed to be of greater significance. While the absence of Gilbert, creator of Eros, was regretted, the contributions of members of the 'New Sculpture', Frampton, Thornycroft and Onslow Ford, were highly commended, even by so stern a critic as Octave Maus.[52]

Japan presented the critics with an exceptional problem. Selected under the guidance of Tadamasa Hayashi, the Japanese dealer, collector and friend of the Impressionists, the Japanese section was dominated by traditional artists (Nihonga). Only a minority represented the recently established Western-style (Yoga) art. Of these, some had received training in Paris, primarily at Collin's studio, and hence tended to adopt their master's soft-edged compromise between Puvis de Chavannes and Cazin; others acquired French stylistic characteristics by attending the Western division of the Tokyo University of Fine

Fig. 45 The *trottoir roulant* and the electric train with the Dôme des Invalides in the background

ENDNOTES

My thanks to Claire O'Mahony for her patient, thorough and highly professional researches in periodicals and newspapers for articles on and reviews of the 1900 Exposition Universelle. This essay makes use of much of the material brought together by her.

The quotation in the title is taken from E. Verhaeren, 'Chronique de l'Exposition', *Mercure de France*, June 1900, repr. in E. Verhaeren, *Écrits sur l'Art (1893–1916)*, ed. P. Aron, Brussels, 1997, p. 770.

1 Quoted in R. D. Mandell, *Paris 1900: The Great World's Fair*, Toronto, 1967, p. 60. This remains the most useful review of the political and economic background to the history of national and international exhibitions from 1798 to 1900.

2 From the proclamation made by the French Minister of the Interior, François de Neufchâteau, on 28 August 1798. Quoted by Mandell in op. cit., p. 4.

3 Mandell, op. cit., p. 3.

4 P. Morand, *1900 AD*, transl. by Mrs R. Fedden, New York, 1931, p. 61. Approximately 211 temporary pavilions and other structures were erected at the fair which covered the Trocadéro, the Champ-de-Mars, Les Invalides, the banks of the Seine, and the Parc de Vincennes in the east of Paris.

5 *New York Times*, 9 September 1900.

6 Turkey, Mexico and Nicaragua exhibited no sculpture.

7 It was felt that France would have been better served by allotting three works per artist; see A. Darthèze, 'L'Exposition', *L'Aurore*, 2 May 1900.

8 See S. Strombom, *Nationalromantik och radikalism. Konstnärsförbundets Historia 1891–1920*, Stockholm, 1965,

Arts where the teaching was in the hands of Paris-trained artists including Kuroda and Kume (see fig. 44). The dependence of *Yoga* artists on French sources made their contributions to the Décennale difficult to assess. Furthermore, evaluations of the relative success or failure of Western-style art were complicated by the critics' awareness of the symbolic role which *Yoga* painting played within the larger story of Japan's drive towards modernisation. This broader context was fully recognised by Geffroy who commented favourably on Japan's rapid entry into the modern industrial age, but also warned prophetically of her potential to outstrip and unseat the supremacy of Western manufacturers: '…there will come a day when…[the Japanese] will offer us at a cheaper price what we want to sell to them at a high price'.[53] Moving to the more specific issue of Japanese representation within the Décennale, considerable disquiet was expressed by critics about Japanese assimilation of Western aesthetic principles. Alexandre retained a degree of optimism that Japanese artists might in the future find a distinctive style through which they could render subjects worthy of interest.[54] Réné Des Granges, on the other hand, saw the new school of Western-style art as contrary to traditional Japanese aesthetics, concluding that the results were 'nothing more than attempts that have failed'.[55]

Nationalism held within itself its antithesis, internationalism. For many critics, any consideration of this logical counterpart was overwhelmed by the pressing need to make sense of the sheer scale of an event such as the Exposition Universelle through a structure predicated on national identities and achievements. From some, however, internationalism received careful consideration. In its broadest manifestation, it was seen to encompass the expansion of human understanding and the wider dissemination of the undoubted benefits of modern civilisation as a highly desirable antidote to rampant nationalism. Applied to the visual arts, internationalism was interpreted as a reflection

and H. H. Brummer, ed., *Till ögats fröjd och nationens förgyllning – Anders Zorn*, exh. cat., Waldemarsudde, Stockholm; Göteborgs Konstmuseum, 1994

9 *Correspondance de Camille Pissarro, 1899–1903*, ed. J. Bailly-Herzberg, St-Ouen-l'Aumone, 1991, letter 1737, p. 114. See also letters 1707, p. 86; 1730, pp. 105–106; 1731, p. 107. For Claude Monet's disregard of the Exposition Universelle, see D. Wildenstein, *Monet: Vie et œuvre*, vol. 4, Geneva, 1985, p. 348, letter 1565; Monet did, however, visit Rodin's exhibition at the Place de l'Alma on 18 October 1900 (p. 349, letter 1572).

10 H. Frantz, *Le Salon de 1900, Exposition Décennale*, Paris, 1901, p. 89.

11 A. Barthelémy, 'L'Exposition décennale de l'art français (1890–1900) (Grand Palais des Beaux-Arts des Champs-Elysées, à Paris)', *Revue Encyclopédique*, vol. X, p. 645.

12 The prints were installed by Auguste Mongin (1843–1910) and Charles-Paul Renouard (1845–1924), the sculpture by Frédéric-Auguste Bartholdi (1834–1904) and Charles-René de Saint-Marceaux (1845–1915).

13 A. Dayot, 'The French Pictures (1890 to 1900) in the Grand Palais', *The Paris Exhibitions 1900*, ed. D. C. Thomson, assisted by H. E. Butler and E. G. Halton, *Art Journal*, London, 1901, p. 33.

14 Frantz, op. cit., p. 48.

15 C. Ponsonailhe, 'L'Art à l'Exposition', *L'Exposition de Paris 1900 (Encyclopédie du Siècle)*, vol. III, p. 210.

16 B. Guinaudeau, 'Le Décennale allemande', *L'Aurore*, 15 July 1900.

17 'Harlar', 'La Semaine artistique: Les Beaux-Arts à l'Exposition', *La Fronde*, 28 May 1900.

18 *Exhibition Paris 1900, A Practical Guide…*, London, 1900, p. 316.

19 C. M. Dewey, *New York Times*, 18 October 1900.

20 Verhaeren, ed. Aron, op. cit., p. 790. Called the 'Japanese Bernhardt' or 'Duse the Lesser', Sadda Yacco was a Japanese dancer who interpreted scenes in the long-admired and very popular Japanese *ukiyoe* prints. She performed in Loïe Fuller's 'Art Nouveau' pavilion. See Mandell, op. cit., p. 65.

21 For a useful exposition of the shift in critical frameworks in France between *c.* 1885 and 1900, see M. Marlais, *Conservative Echoes in Fin-de-Siècle Parisian Art Criticism*, Pennsylvania State University, 1992.

22 G. Geffroy, 'Revue des Idées: L'Exposition de 1900 et les Expositions: Plaidoyers pour et contre', *Revue Encyclopédique*, vol. X, p. 610.

23 E. Demolder, 'Au Palais des Champs-Elysées', *L'Art Moderne*, 24 June 1900.

24 Verhaeren, ed. Aron, op. cit., p. 770.

25 *Art Journal*, May 1900, p. 129.

26 B. Guinaudeau, 'La Décennale', *L'Aurore*, 20 May 1900.

27 A. Alexandre, 'Continental Pictures at the Paris Exhibition', *The Paris Exhibition 1900, Art Journal*, London, 1901, p. 322.

28 *Ibid.*

29 Barthelémy, op. cit., p. 643. Armand Dayot saw the exclusion of the Impressionists and their followers,

of French domination, which was seen both as a positive force for progress and as a negative source of aesthetic imperialism.

French aesthetic supremacy was identified in the flamboyant Impressionist style employed equally by Besnard and Helleu, and by Zorn, more Parisian than Swede, the Anglo-American Sargent, the Russian Serov, the Italian Boldini and the Spaniard Sorolla. Similarly, the treatment of peasants by the Dane Bjerre, the Norwegian Backer and the Swede Krøyer and the representations of rural and urban labourers by the British artists Clausen and Stanhope Forbes and the Russian Arkhipov owed much to the naturalism of Jules Breton, Bastien-Lepage and Lhermitte. The potency of French contemporary art was generally explained by its near-monopoly of art education. Mention has already been made of the fact that some 80% of the American artists included in the Décennale publicly acknowledged their debt to French training. Charles Ponsonailhe, in his highly laudatory article on the French section of the Décennale, noted the ease with which foreign students were admitted to the national Ecole des Beaux-Arts and to the 'twenty, thirty, fifty free studios [where] artists of all nationalities watch their work corrected, receive the tuition and advice of our most renowned painters'.[56] The international triumph of French art was the inevitable result, as Léonce Bénédite confidently asserted: 'Today, thanks to the expansion of our official education which, since the beginning of this century, has formed the majority of the great masters of the two worlds, and thanks to the expansion of the glorious, dedicated innovators who have illustrated our art by revitalising it, it is towards France that all, or almost all the great schools [of art], new or rejuvenated, in Europe, America and, let it be added, for the first time, in the Far East, have turned.'[57] Indeed, if the Far East had turned to Paris, the Japanese *Yoga* painter Tsu Iwamura confirmed this assertion: 'From morning to night he [the artist] does nothing but look at art, hear about art, as though art were all the life he knew. You might think that this could be done in London or New York, but it cannot be…for the best artistic minds, Paris alone has the right feel, the proper atmosphere.'[58]

That this French monopoly of the visual arts might have a less beneficent side occurred to a number of critics: '…internationally, we observe that the peculiarities of style are little by little dwindling and melting away in the most diverse countries. Even the tyro can nowadays at a glance distinguish an old Italian and a Flemish or a German painting; but it is by no means certain that the most practised eye will hereafter be able to make a distinction between a German, a French and a Flemish work of our own time.'[59] Verhaeren pursued this theme further, by noting the decline of individual styles both within the academic tradition established by David and within the so-called new school of Impressionism, 'la peinture moderne', which had emerged to challenge it: '…[Ever since the time of David], France has monopolised the mass production of art. Schools no longer exist. There is only one School, unique and always the same, whether it is London, Berlin, Brussels…And thus is the world geography of art fundamentally changed. Its regions are no longer specifically characterised, nor distinctively special.' Even in the case of 'la peinture moderne', with its adoption of 'blues and violets', its depiction of light and air, a similar uniformity of style had engulfed its practitioners: 'One paints, in accordance with this [new] style, in Tokyo as well as in New York. But, in time, precisely because it has been adopted by painters lacking in genius, it has become as banal as it is universal.' Verhaeren concludes in sorrow: 'Uniformity reigns

Fig. 46 Looking down from the Eiffel Tower
towards the gardens of the Champ-de-Mars and the
Palais de l'Electricité, a photograph by Emile Zola

'extravagant as are certain disciples of Pissarro, Sisley
and Claude Monet', as doubly troubling since it
deprived the Décennale of presenting pictures which
had given a considerable impulse to contemporary art;
Dayot, op. cit., p. 33. Within the Exposition
Centennale, through the determination of Claude
Roger-Marx, the Impressionists were nonetheless well
represented with their own gallery as follows: Bazille
(2 works), Cézanne (3), Degas (2), Manet (12), Monet
(14), Pissarro (8), Renoir (11) and Sisley (8).
Exceptionally, Vallotton was the only member of the
Nabis to 'qualify' for inclusion; he was represented by
one work.

30 D. C. T., 'The Paris Exhibition, 1900', Art Journal,
May 1900, p. 372.

31 M. S., 'French Art at the Fair', New York Times,
9 September 1900.

32 O. Maus, 'Sculpture à l'Exposition Universelle',
L'Art Moderne, 1 July 1900.

33 Geffroy, op. cit., pp. 611–612.

34 Verhaeren, ed. Aron, op. cit., p. 792.

everywhere. And really, covering the kilometres of carpet which determine the route through the Grand Palais…always the same from gallery to gallery, from country to country, one sees there the emblematic representation of the monotonous art of our time.'[60]

Verhaeren was not alone in seeing the Décennale, in which, despite certain exclusions, the art exhibited was 'of its time', as a provident occasion to review the current health of Western artistic endeavour. Many critics, not solely those of French nationality, vouched for the healthy state of French art and the remarkable achievement of Belgium. Others, however, expressed misgivings. Some despaired of the Exposition Décennale's ability to provide any intimation of the future directions which art might take. Roland Strang declared, in respect of France: '…it cannot be said that the characteristic works of French painting or of French sculpture in this exhibition offer any good augury for the future of those respective arts'.[61] Octave Maus, in his extensive review of the sculptural component of the Exposition Décennale, converted this pessimistic conclusion into a prophecy of imminent Armageddon which would engulf all the sculpture exhibited in the Grand Palais, with the exception of Rodin and the Belgian contingent: 'At no other time has industrial sculpture wasted so much marble and bronze. This humanity of livid flesh, petrified under skylights which let in a crude, hard light, evokes the feeling of a vengeful cataclysm, of a Sodom struck by a heavenly anger in the midst of saturnalian exaltation.'[62]

35 See, for example, R. Brettell, *Modern Art 1851–1929*, Oxford, 1999, p. 200.

36 See, for example, J. House, *Landscapes of France: Impressionism and Its Rivals*, exh. cat., Hayward Gallery, London; Museum of Fine Arts, Boston, 1995.

37 Verhaeren, ed. Aron, op. cit., p. 789.

38 Mandell, op. cit., p. 77.

39 W. Rothenstein, *Men and Memories*, London, 1931–32, p. 364.

40 Ponsonailhe, op. cit., p. 222.

41 Barthelémy, op. cit., p. 643.

42 L. Bénédite, 'Les Arts à l'Exposition Universelle de 1900 – Exposition décennale: La Peinture étrangère (1er article)', *Gazette des Beaux-Arts*, 1 September 1900, livraison 579, p. 180.

43 Demolder, op. cit.

44 A. Alexandre, quoted from an article published in *La Plume*, in Anon, 'L'Art belge à Paris', *L'Art Moderne*, 16 September 1900, pp. 268ff.

45 *Ibid.*

46 Maus, op. cit., p. 207.

47 Bénédite, op. cit., p. 179.

48 B. Guinaudeau, 'La Décennale russe', *L'Aurore*, 27 July 1900.

49 R. Strang, 'Art in Paris: Pictures by Foreign Artists at the Exhibition', *New York Times*, 16 June 1900.

50 Maus, op. cit., p. 205.

51 B. Guinaudeau, 'La Décennale anglaise', *L'Aurore*, 22 August 1900.

52 Maus, op. cit., p. 20.

53 Geffroy, op. cit., p. 611.

54 A. Alexandre, 'Continental Pictures at the Paris Exhibition', *The Paris Exhibition 1900, Art Journal*, London, 1901, p. 323.

55 R. Des Granges, 'L'Actualité: Les Promenades à l'Exposition – Japonaiseries', *Moniteur Universel*, 7 July 1900.

56 Ponsonailhe, op. cit., p. 22.

57 Bénédite, op. cit., p. 179.

58 *The Art Students of Paris*, 1902, quoted in S. Tahashina and J. T. Rimer with G. D. Bolas, *Paris in Japan: The Japanese Encounter with European Painting*, exh. cat., The Japan Foundation, Tokyo; Washington University Gallery of Art, St Louis; Wight Art Gallery, UCLA, 1987–88, p. 43.

59 Alexandre, op. cit., 1901, p. 323.

60 Verhaeren, ed. Aron, op. cit., pp. 779–781.

61 R. Strang, 'French Art at the Fair', *New York Times*, 9 September 1900.

62 Maus, op. cit., p. 205.

63 Quoted in P. Gay, *Pleasure Wars*, London, 1998, p. 193.

64 Frantz, op. cit., p. 96.

65 B. Marchand, *Paris, histoire d'une ville (XIXe–XXe siècle)*, Paris, 1993, chapter 3.

66 Alexandre, op. cit., 1901, p. 330.

Saturnalian exaltation was not restricted to the Exposition Décennale of 1900. Frederic Harrison, a British positivist writer, had already remarked some twenty years earlier that art exhibitions had tended to become nothing more than 'discordant hubbub' caused by the proliferation of subject matter and styles provoked by a 'divorce of art from the highest religious, social, intellectual movements of the age'.[63] However, given its cacophony of styles and subjects, the Exposition Décennale could, on the one hand, permit the study under one roof of both the old and the new,[64] and on the other hand, reflect the more general state of flux and transition which characterised the turn of the century.

Indeed, the closing decades of that century were shaped by a myriad of new and powerful, but often contradictory, forces: socialism rose beside right-wing reactionary extremism, nationalism and anti-semitism; the absolute authority of science was challenged by spiritualism and a return to religious faith; the understanding of man's existence was extended both by the psychological inquiries of Charcot and Freud and the sociological investigations of Durkheim; and cultural establishments experienced increasing assaults from a proliferation of potent avant-gardes.[65] Arsène Alexandre correctly interpreted this state of flux in the diversity, the contradictions and the qualitative variations contained within the Décennale: 'Whether the reservations that we thought necessary to make at the beginning have been abrogated…is a too difficult matter to determine in an epoch of transition like ours and in an exhibition imperfect despite its immensity.'[66]

That Hodler and Klimt, Pellizza and Malyavin, Stuck and Rodin, and the young Picasso and the young Rouault could be assembled within the same cross-section of ten years of contemporary art as Burne-Jones and Carolus-Duran, Lenbach and Munkáscy is indication enough of aesthetic pluralism. Beyond the Décennale, an aesthetic diversity was mirrored in the juxtapositions of medieval Paris and the Palais de l'Electricité, of the traditional artefacts of Japan and the most recent products of Western technology, of historicist national pavilions and Art Nouveau structures by Bing and Guimard, and of medieval art and the examples of Jugendstil displayed in the Austrian and German pavilions. Inevitably, such juxtapositions raised questions about what constituted the modern and the innovative, especially when applied to the arts. Within the Décennale itself, artists, critics and the general public were able to identify the art which lay outside the official canon, to measure its range and variety, and, despite the perceived subjugation of the artistic production of all the represented countries to the tyranny of the French academic or naturalist-Impressionist styles, to note specific national characteristics. Indeed, allowing for certain exclusions, it could be argued that the expansive nature of the Exposition Décennale represented the culmination of a decade of more catholic art exhibitions such as the Salon du Champ-de-Mars in Paris and the early years of the Munich and Vienna Secessions. But it also marked that moment in the history of Western art before the emergence of the monolithic, international styles such as Cubism, Surrealism and Abstraction. Given the options presented within the Décennale, a hitherto unparalleled gathering of international contemporary art, could it be that the record of artistic production after 1900, conventionally seen as linear, might admit of a broader, more tolerant and more inclusive, history?

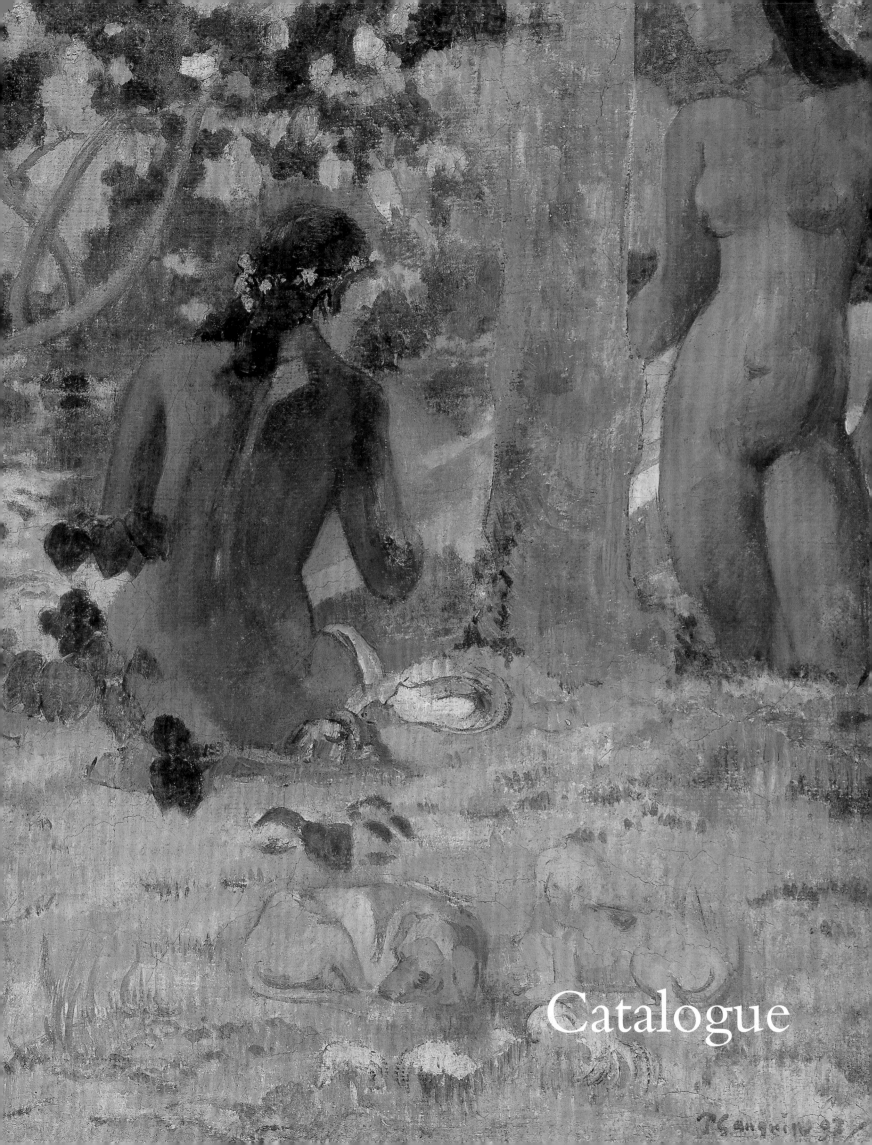

Catalogue

The Exposition
Universelle

The Exposition Universelle in Paris in 1900 included the largest international exhibition of contemporary art held to date. The Petit Palais was filled with a historic survey of French art, and the Grand Palais was given over to a retrospective exhibition of French art from 1800–89, and to thousands of paintings and sculptures from all over the world that had been made since the previous Exposition Universelle in 1889.

In this grandiose résumé of the many traditions that mingled in the artistic melting-pot at the turn of the century a few broad trends were apparent. In a period of strongly emerging national identities, landscape offered a particularly eloquent vehicle for the expression of patriotic feeling, especially in Russia and Scandinavia. Even the Bible's universal stories could be re-enacted in specifically nationalist settings (cat. 24). Paintings that dealt with national mythologies became potent representatives of nationalist sentiment (cat. 28).

Naturalism, on the other hand, was a universal style that crossed national boundaries. The Belgian Claus and the Spaniard Sorolla were particularly accomplished exponents of this painterly, *plein-air* style (cats 3, 4), as was the young Czech painter Kupka (cat. 5).

In an era of spiritual confusion, religious subjects were still revered and appeared in both traditional and modern modes. In his many scenes of motherhood Segantini lends Christian references to his secular 'madonnas' (cat. 8). Contemporary scenes of religious observance (cat. 24) also enjoyed a certain vogue.

Timeless Classical mythologies held their place in the artistic imagination and were exemplified by the flawless dream-worlds of Alma-Tadema, Bouguereau and Leighton (cats 10, 26, 27), and the sculptural heads of Bourdelle and De Vigne (cats 60, 73). Medieval myth, so popular in painting earlier in the century, lingered in the venerable British artist Burne-Jones's Symbolist interpretations of the legend of the Holy Grail (cat. 29).

Sickness, death and other miseries of the human condition remained compelling themes throughout the second half of the nineteenth century (cats 21, 122) and scenes of rural life might encompass peaceful daily routines (cat. 227) or a bucolic harmony between man and the land (cat. 9).

The heroic cycles of human existence were as much of an inspiration to the visual arts as they were to the literature and music of the time. The Belgian artist Frédéric's teeming multitude of rosy-fleshed infants (cat. 1) offers us an especially carnal affirmation of the regenerative powers of the life-force, while in the more spiritual *The Mirror of Life* (cat. 2) by the Italian Divisionist Pellizza, a glowing palette and undulating rhythm invest a line of sheep with the symbolic force of life's inevitable progression.

Other time-honoured subjects were extensively represented. Inevitably, the nude relied most heavily on academic precedent (cat. 40), although Rodin's *The Kiss* (cat. 30) extended the boundaries of traditional sculpture to incorporate a new naturalism. Grand portraiture was represented by artists of many nationalities, including the distinguished Russian Serov (cat. 7). The fast-disappearing tradition of history painting enjoyed a final kitsch flourish (cat. 19), before lying dormant for a few decades only to be revived by the new medium of cinema. AD

(*previous pages*) Detail of cat. 58
(*opposite*) Detail of cat. 5

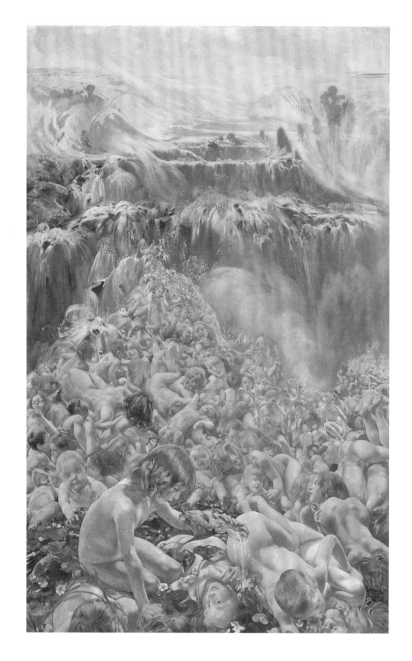
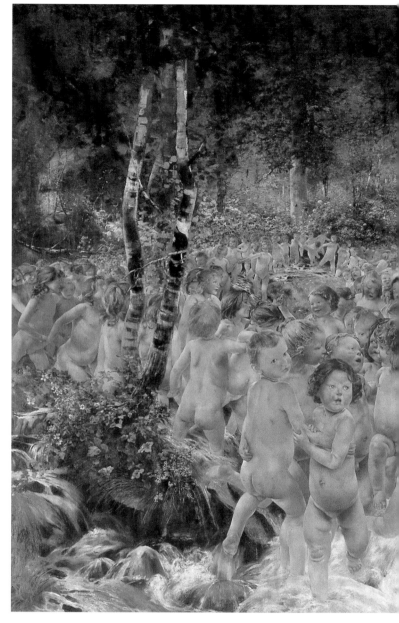

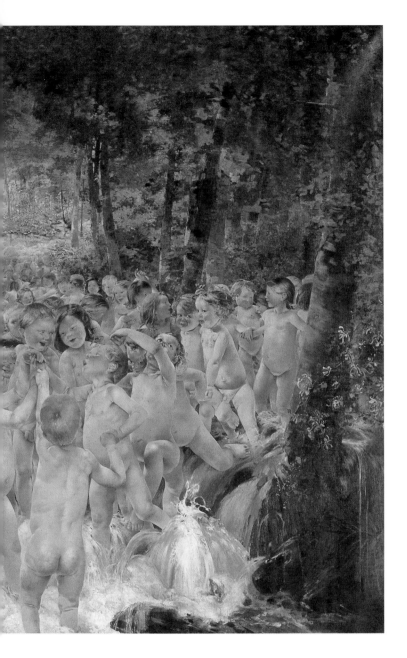

1 LÉON FRÉDERIC, *The Stream*, 1890–99. Oil on canvas, 206 × 282 cm. Musées Royaux des Beaux-Arts de Belgique, Brussels, Inv. 6222 (EU 1900)

2 GIUSEPPE PELLIZZA DA VOLPEDO, *The Mirror of Life*, 1895–98. Oil on canvas, 132 × 288 cm. Galleria Civica d'Arte Moderna e Contemporanea, Turin (EU 1900)

3 EMILE CLAUS, *Cows Crossing the Lys*, 1899. Oil on canvas, 200 × 305 cm. Musées Royaux des Beaux-Arts de Belgique, Brussels, Inv. 3584 (EU 1900)

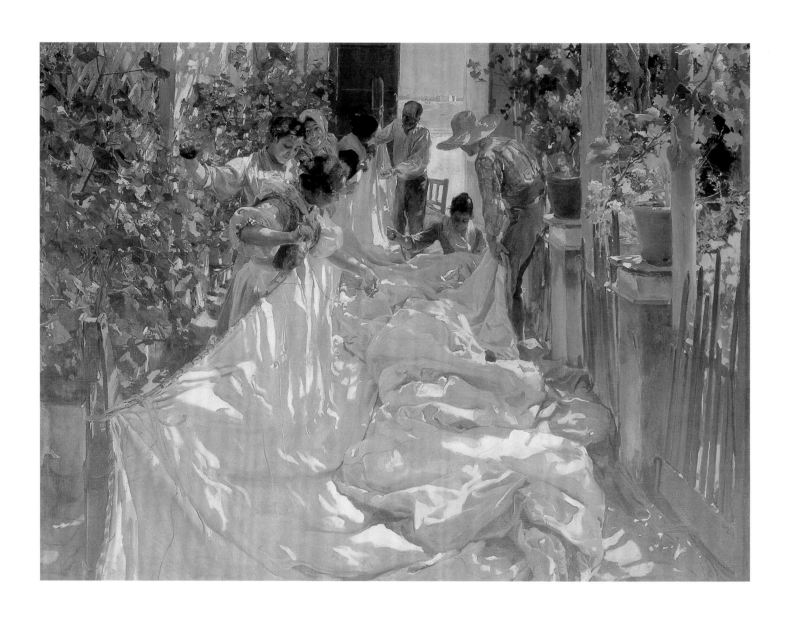

4 Joaquín Sorolla y Bastida, *Sewing the Sail*, 1896. Oil on canvas, 220.2 × 301.8 cm. Galleria Internazionale d'Arte Moderna di Ca' Pesaro, Venice (EU 1900)

5 FRANTIŠEK KUPKA, *The Book Lover I*, 1897. Oil on canvas, 95.5 × 152 cm. Art Collections of Prague Castle (EU 1900)

6 (*opposite*) GIOVANNI BOLDINI, *Portrait of James Abbott McNeill Whistler*, 1897.
Oil on canvas, 170.5 × 94.4 cm. Brooklyn Museum of Art. Gift of A. Augustus Healy 09.849 (EU 1900)

7 (*above*) VALENTIN SEROV, *Portrait of Grand Duke Paul Alexandrovitch*, 1897. Oil on canvas, 168 × 151 cm. State Tretyakov Gallery, Moscow (EU 1900)

8 *(left)*
GIOVANNI SEGANTINI,
The Fruits of Love, 1889.
Oil on canvas, 88.2 × 57.2 cm.
Museum der bildenden Künste, Leipzig
(EU 1900)

9 *(below)*
FERDINAND HART NIBBRIG,
Abundance, 1895.
Oil on canvas, 99 × 150 cm.
Private Collection, The Netherlands (EU 1900)

10 *(opposite above)*
SIR LAWRENCE ALMA-TADEMA,
The Kiss, 1891.
Oil on panel, 45.7 × 62.7 cm.
Private Collection (courtesy Christie's London)
(EU 1900)

11 *(opposite below)*
HENRI LE SIDANER, *Sunday*, 1898.
Oil on canvas, 112.5 × 192 cm.
Musée de la Chartreuse, Douai (EU 1900)

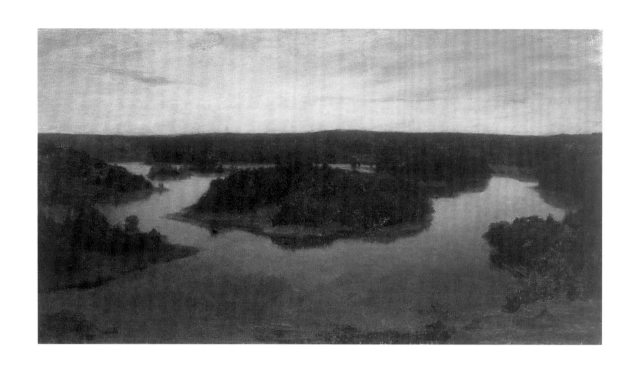

12 (*top*) PRINCE EUGEN, *A Summer Night, Tyresö*, 1895. Oil on canvas, 78 × 144 cm. Nationalmuseum, Stockholm (EU 1900)

13 (*above*) NIKOLAY DUBOVSKOY, *Calm*, 1890. Oil on canvas, 86 × 143 cm. State Tretyakov Gallery, Moscow (EU 1900)

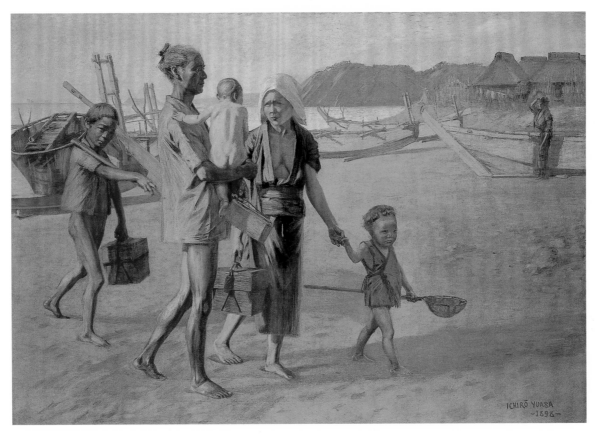

14 (*top*) AUGUSTE BAUD-BOVY, *Serenity*, *c.* 1890. Oil on canvas, 90 × 116 cm. Musée d'Orsay, Paris. Gift of the artist, 1898 (EU 1900)

15 (*above*) ICHIRO YUASA, *Fishermen Returning Late in the Evening*, 1898. Oil on canvas, 139.2 × 200.3 cm. Tokyo National University of Fine Arts and Music (EU 1900)

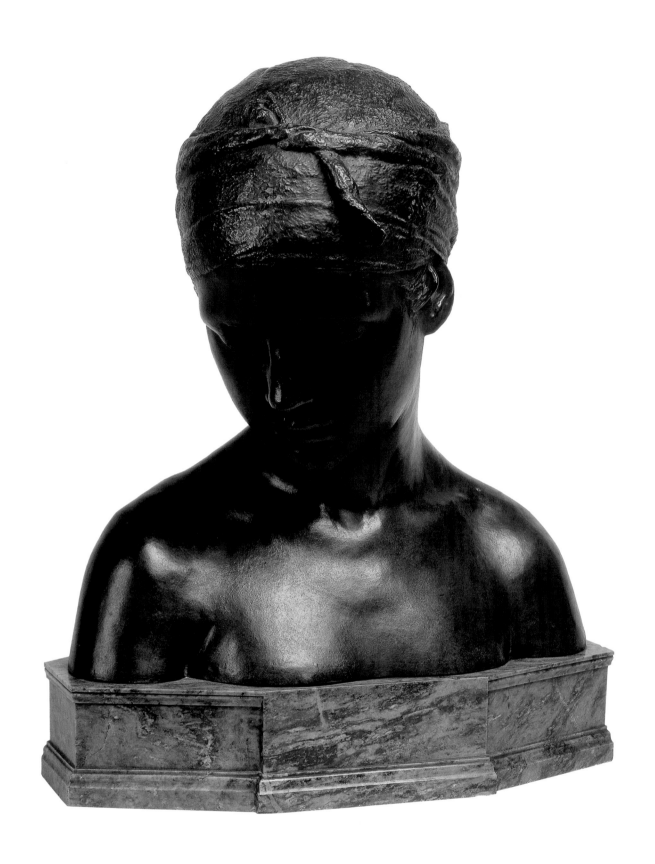

16 EDWARD ONSLOW FORD, *Meditation*, 1886. Bronze, 37 × 35 × 22 cm. City of Aberdeen Art Gallery and Museums Collection (EU 1900)

17 (*opposite*) WINSLOW HOMER, *Lookout 'All's Well'*, 1896. Oil on canvas, 101.6 × 76.8 cm. Museum of Fine Arts, Boston. Warren Collection (EU 1900)

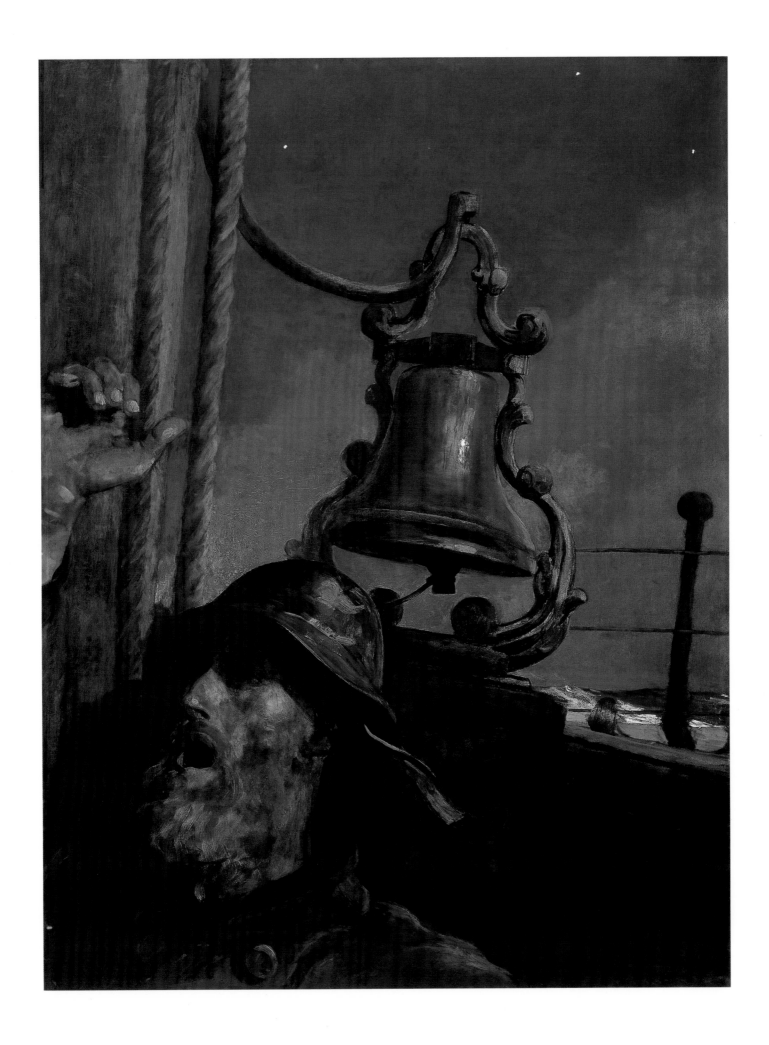

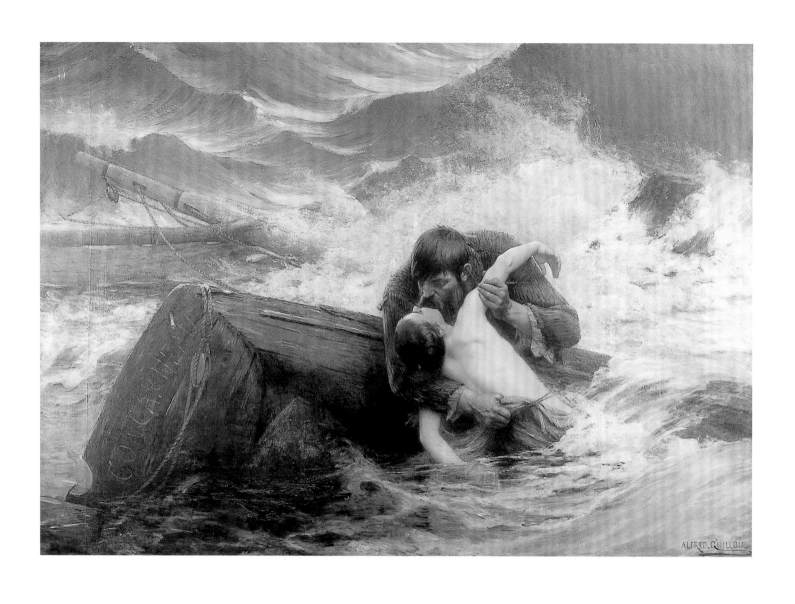

18 ALFRED GUILLOU, *Farewell*, 1892. Oil on canvas, 170 × 245 cm. Musée des Beaux-Arts, Quimper (EU 1900)

19 (*opposite*) PAUL JOSEPH JAMIN, *Brennus and His Loot*, 1893. Oil on canvas, 162 × 118 cm. Musée des Beaux-Arts, La Rochelle (EU 1900)

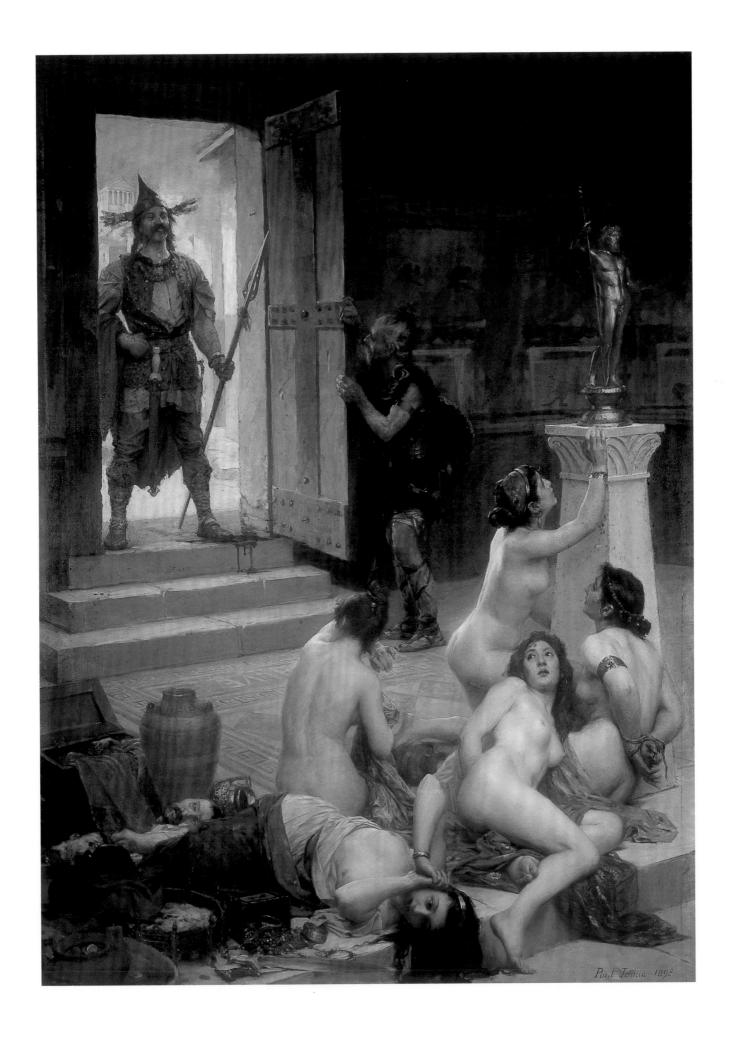

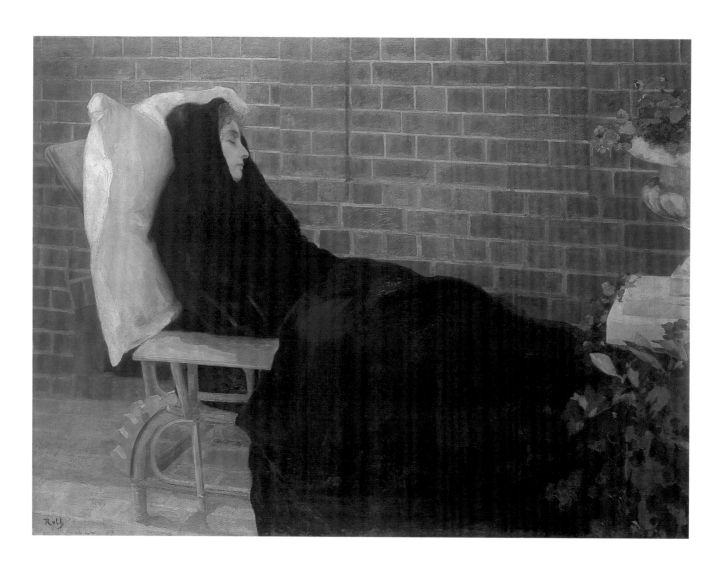

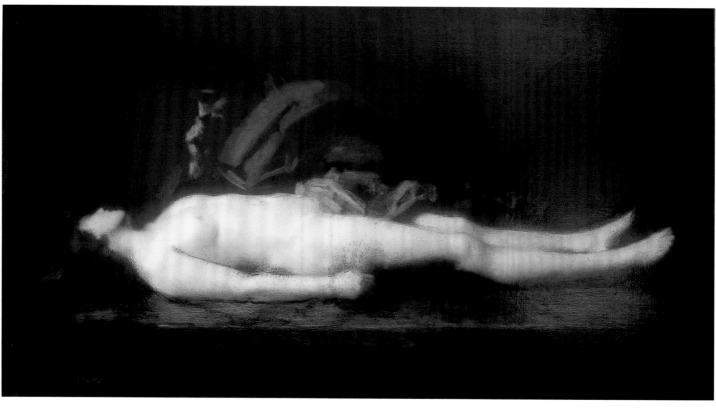

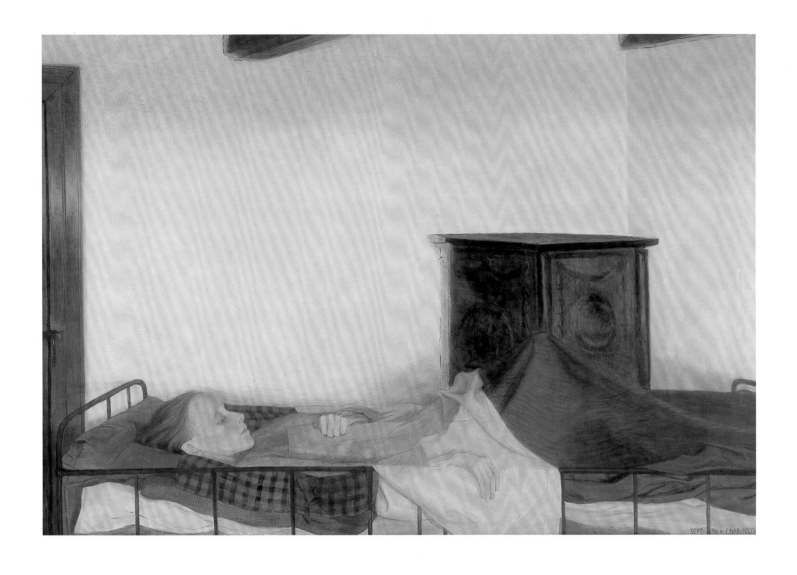

20 (*opposite above*) ALFRED ROLL, *The Sick Woman*, 1897. Oil on canvas, 110 × 147 cm. Musée des Beaux-Arts, Bordeaux (EU 1900)

21 (*opposite below*) JEAN-JACQUES HENNER, *Levite of Ephraim and His Dead Wife*, 1898. Oil on canvas, 87.6 × 163.8 cm. Joey and Toby Tanenbaum, Toronto (EU 1900)

22 (*above*) EJNAR NIELSEN, *The Sick Girl*, 1896. Oil on canvas, 112 × 164 cm. Statens Museum for Kunst, Copenhagen (EU 1900)

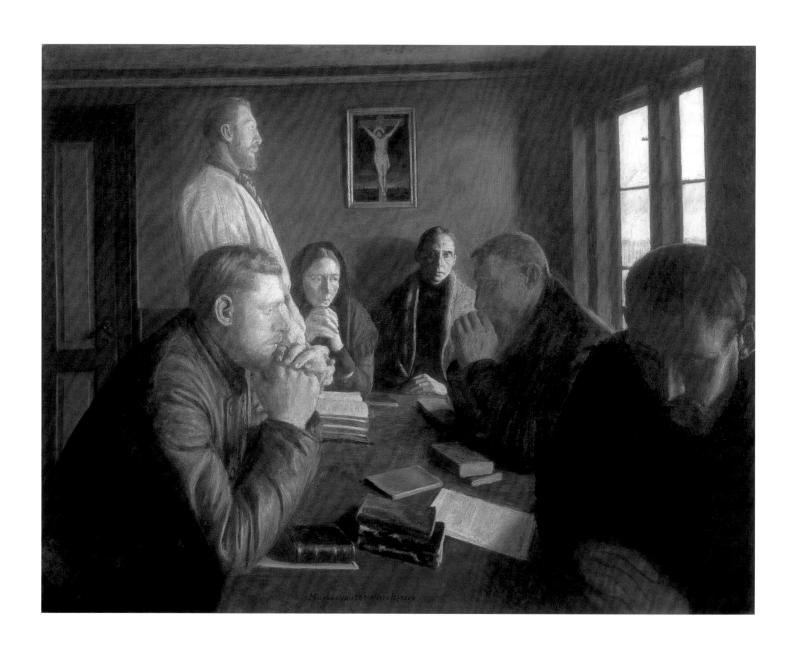

23 NIELS BJERRE, *A Prayer Meeting*, 1897. Oil on canvas, 82 × 107 cm. Aarhus Art Museum (EU 1900)

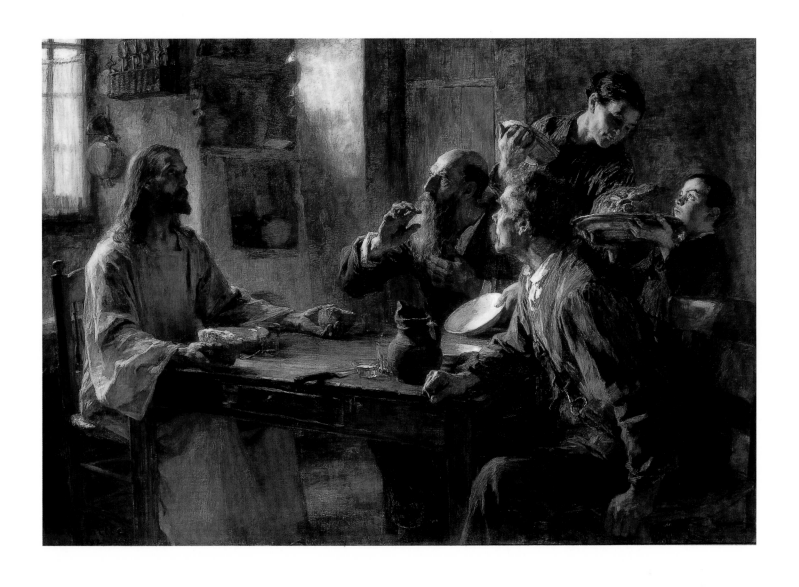

24 LÉON LHERMITTE, *Supper at Emmaus*, 1892. Oil on canvas, 155.5 × 223 cm. Museum of Fine Arts, Boston. Gift of J. Randolph Coolidge 92.2657 (EU 1900)

25 GABRIEL MAX, *The Jury of Apes (Monkey Critics)*, 1890s. Oil on canvas, 85 × 107 cm. Bayerische Staatsgemäldesammlungen, Neue Pinakothek, Munich (EU 1900)

(*opposite*) Detail of cat. 6

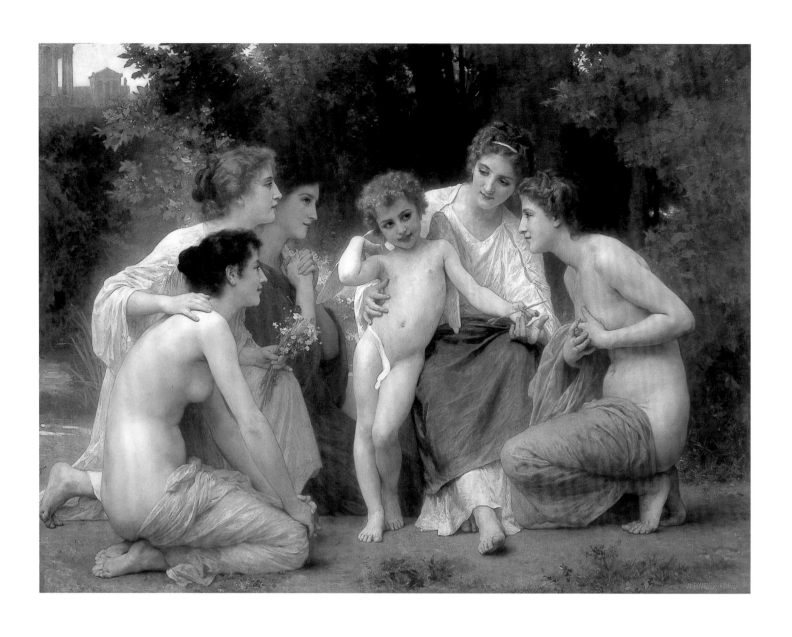

26 WILLIAM-ADOLPHE BOUGUEREAU, *Admiration*, 1897. Oil on canvas, 147.3 × 198.1 cm. San Antonio Museum of Art. Bequest of Mort D. Goldberg (EU 1900)

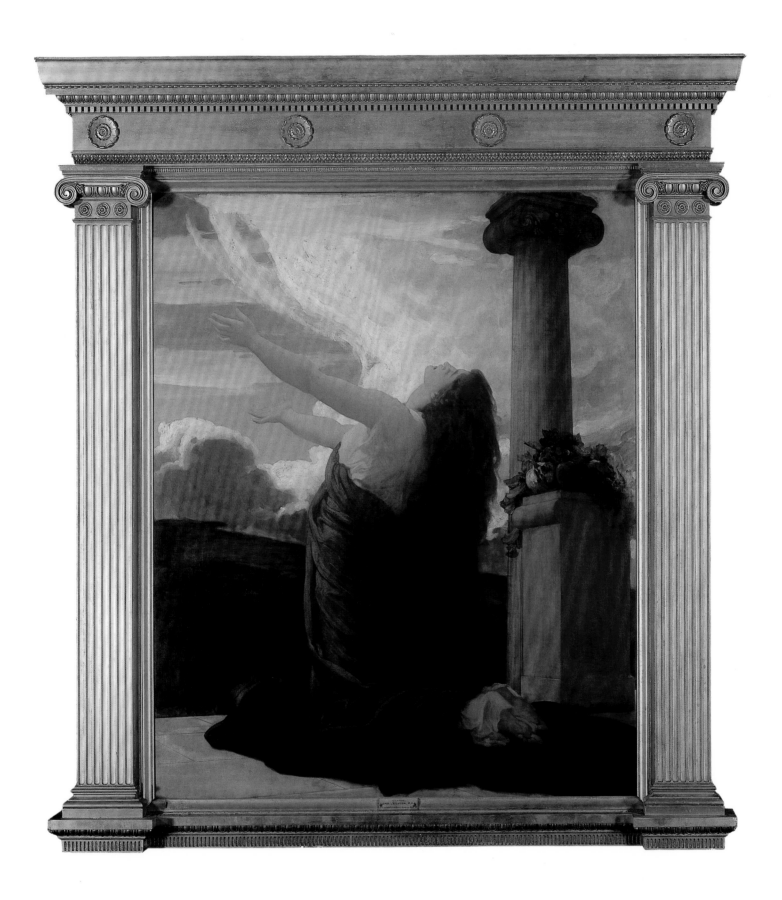

27 FREDERIC, LORD LEIGHTON, *Clytie*, c. 1895–96. Oil on canvas, 156 × 137 cm. From the collection of Mr and Mrs Schaeffer, Australia (EU 1900)

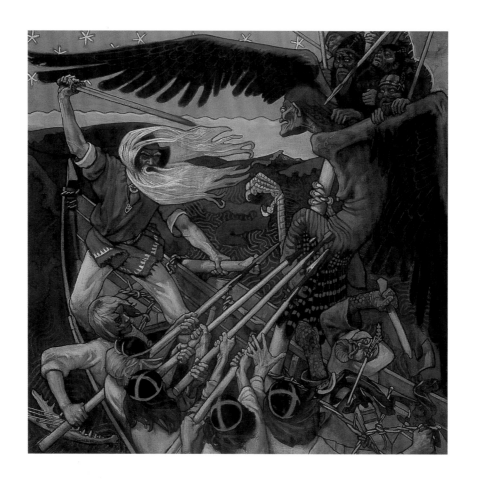

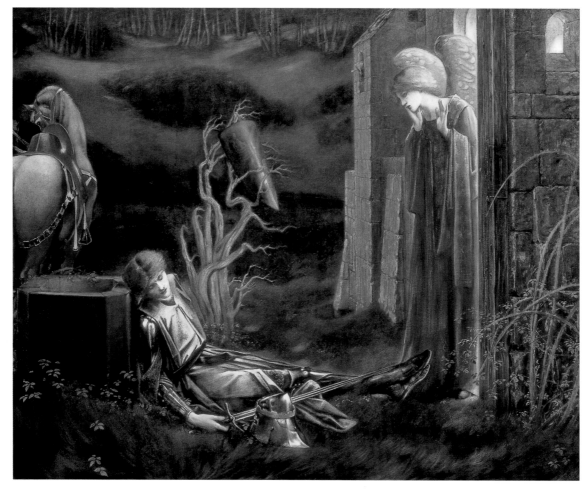

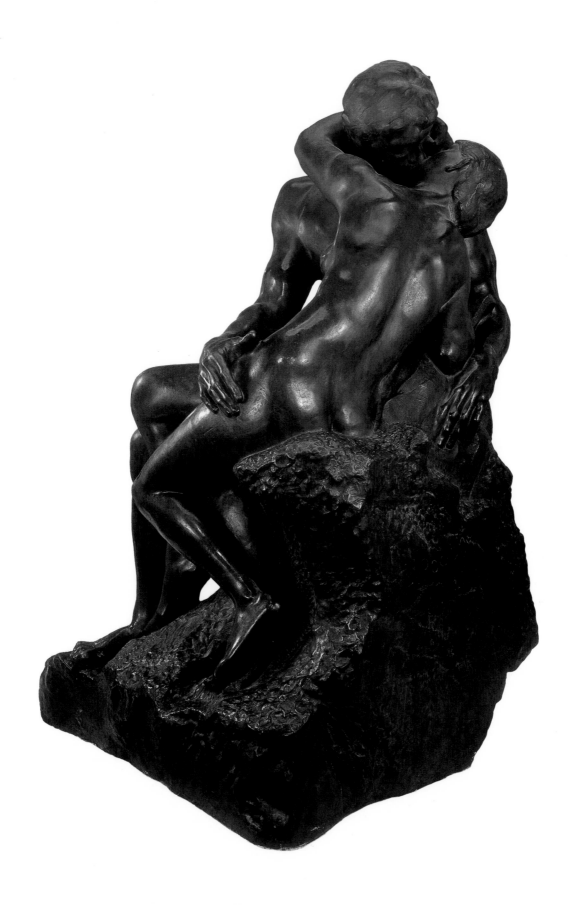

28 (*opposite above*) AKSELI GALLÉN-KALLELA, *The Defence of Sampo*, 1896. Tempera on canvas, 122 × 125 cm. The Turku Art Museum (EU 1900)

29 (*opposite below*) SIR EDWARD BURNE-JONES, *Lancelot at the Chapel of the Holy Grail*, 1896. Oil on canvas, 138.5 × 169.8 cm. Southampton City Art Gallery (EU 1900)

30 (*above*) AUGUSTE RODIN, *The Kiss*, 1898. Bronze, 182.9 × 112 × 112 cm. National Museums and Galleries of Wales (EU 1900)

Bathers and Nudes

From the statues of antiquity to the High Renaissance and beyond, the nude has remained a central theme in Western art. Many artists at the end of the nineteenth century tackled this venerable subject in ways that confirmed traditional values but also pursued different paths towards twentieth-century modernism.

In *The Spring* (cat. 37), the Swiss painter Vallotton affirms with his deliberately allegorical title and bold contours a lineage in Ingres and earlier models but, at the same time, irreverently inverts this classic theme by posing his Venus face down. Degas pursued in both paintings and sculpture a ruthless investigation of women espied unawares in the ungainly rituals of daily ablution which he surely intended as an assault on the nude as Classical ideal (cats 41, 45–46, 48). *Danaë* (cat. 40), one of the submissions to the Exposition Universelle by the esteemed academician Carolus-Duran, Degas's exact contemporary, offers a telling, though accidental, counterpart to Degas's *After the Bath* (cat. 41). With the nudes of Bonnard and Toulouse-Lautrec (cats 47, 44) we enter an unambiguously contemporary world, that of the *fin-de-siècle* Parisian boudoir.

Renoir's reinvention of himself as a modern Old Master found expression in the voluptuous female nudes that he produced in his later years (cat. 39). Maillol's sculptures successfully fuse a classicising *gravitas* with a distinctly modern idiom (cats 38, 56, 66). Rodin, on the other hand, severed parts of the bodies of his sculptural figures of around 1900. Although this undermined the ideal of Classical grace, it achieved an unexpected expressive power and anticipated modernism's fascination with fragmentation. This impressed the young Matisse who, in *Madeleine I* and *The Serf* (cats 43, 50), emulated in more experimental terms the rugged, masculine vigour and serpentine, female grace of his mentor's *Meditation I* and *Walking Man* (displayed on a Corinthian column at his one-man show in 1900 and again for this exhibition) (cats 42, 51).

One of the most enduring approaches to nude composition is the setting of bathers in a landscape, an evocation of a Virgilian longing for a vanished paradise where man could exist in timeless and innocent harmony with nature. In 1900, the myth of the Golden Age could resurface in modern settings that anticipated twentieth-century nature cults: Zorn's earthy Swedish bather (cat. 57), carefree swimming scenes by Krøyer, Liebermann and Sickert (cats 55, 53, 54), or Tuke's homoerotic sunbathers (cat. 52). Van Rysselberghe employed a modified neo-Impressionist technique to capture one vision of paradise lost (cat. 32), a Mediterranean world that heralds one of the icons of the new century, Matisse's *Luxe, Calme et Volupté* (1904–05). For Gauguin, Arcadia was to be found in the colonial exoticism of the South Seas (cat. 58), where figures transposed perhaps from a Cambodian frieze assume poses of studied elegance amidst the brilliant vegetation of a tropical landscape. Bernard's exercise in colonial inclusiveness (cat. 36), on the other hand, offers a new variation on the odalisque theme.

Other Arcadian scenes include the Catalan painter Brull's diaphanous nymphs who drift through a dreamlike, Symbolist landscape (cat. 34), Long's nymphs and satyrs dancing to pan-pipes in a *fin-de-siècle* Australian idyll (cat. 33), and the frolicking water sprites that won the French academician Chabas a gold medal at the Exposition Universelle (cat. 31). Inhabiting a different and unfathomable realm, Cézanne's inarticulate yet strangely moving bathers seem to strive for some unclear destiny beyond the confines of the nineteenth century (cat. 59). AD

(*opposite*) Detail of cat. 36

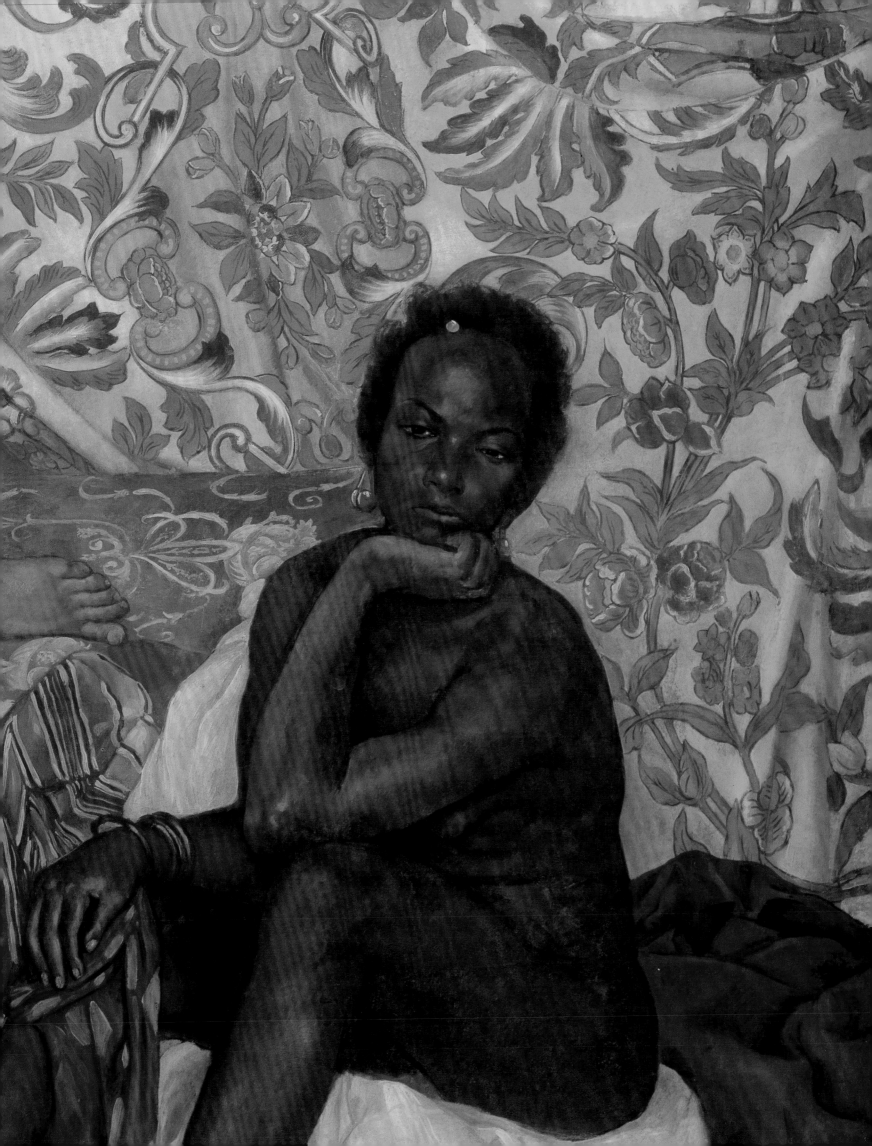

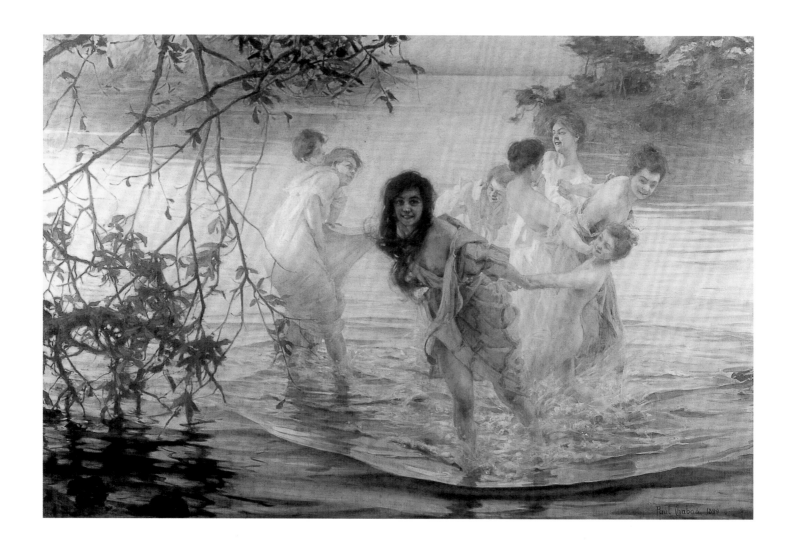

31 PAUL CHABAS, *Joyous Frolics*, 1899. Oil on canvas, 202 × 312 cm. Musée des Beaux-Arts, Nantes (EU 1900)

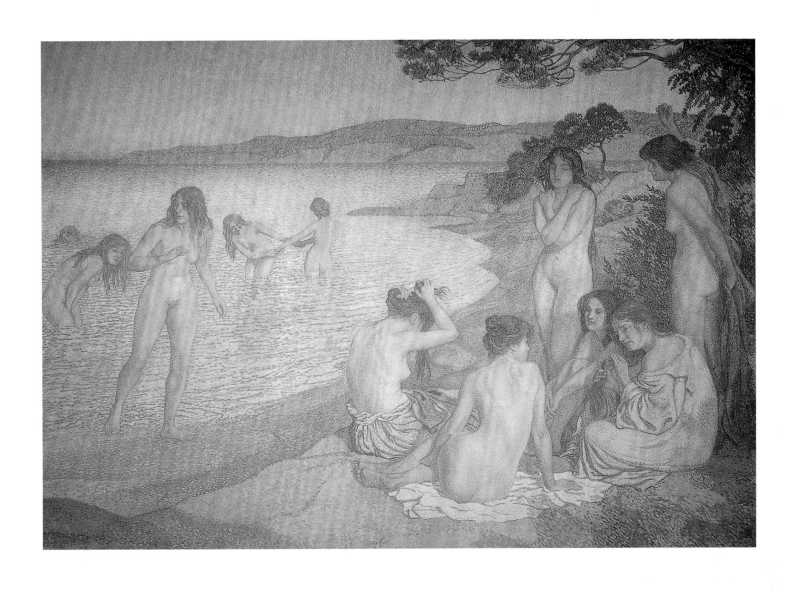

32 THÉO VAN RYSSELBERGHE, *The Burnished Hour*, 1897. Oil on canvas, 228 × 329 cm. Kunstsammlungen zu Weimar

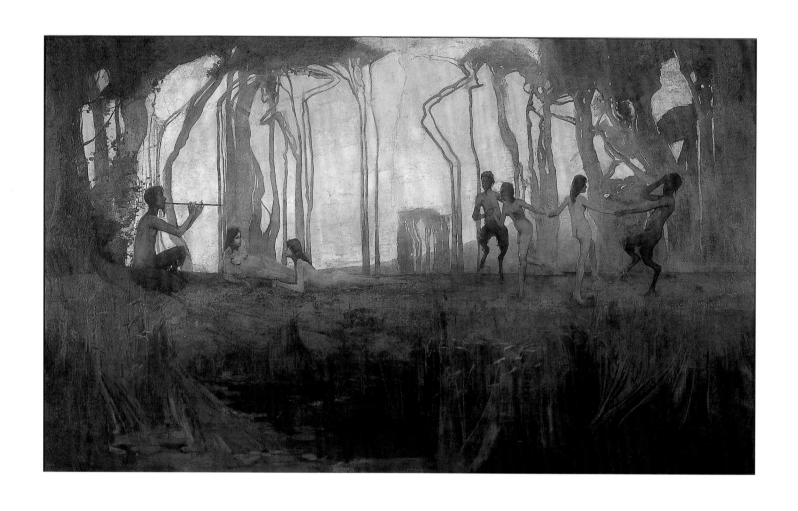

33 SYDNEY LONG, *Pan*, 1898. Oil on canvas, 108.6 × 177.8 cm. The Art Gallery of New South Wales, Sydney. Purchased 1996

34 (*opposite above*) JOAN BRULL I VINYOLES, *Nymphs at Dusk, c.* 1899. Oil on canvas, 250 × 350 cm. Museo Nacional del Prado, Madrid (EU 1900)

35 (*opposite below*) THOMAS WILMER DEWING, *The Garland*, 1899. Oil on canvas, 80 × 107.3 cm. Collection of Mr and Mrs Peter G. Terian

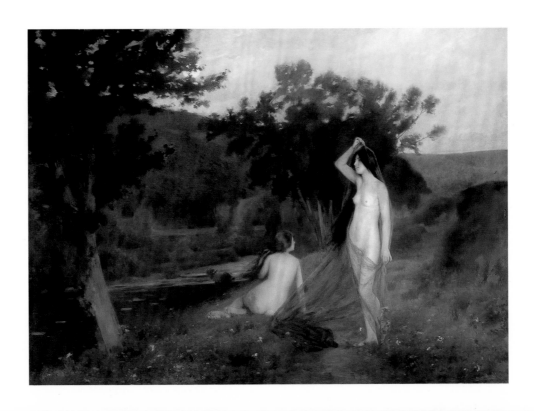

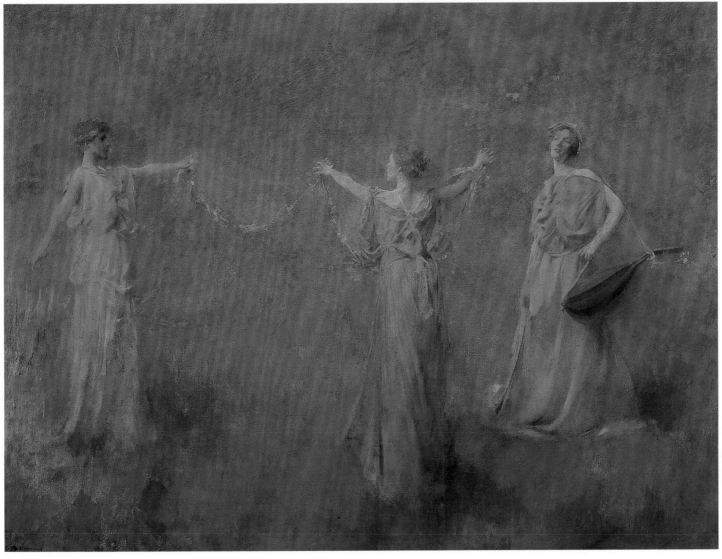

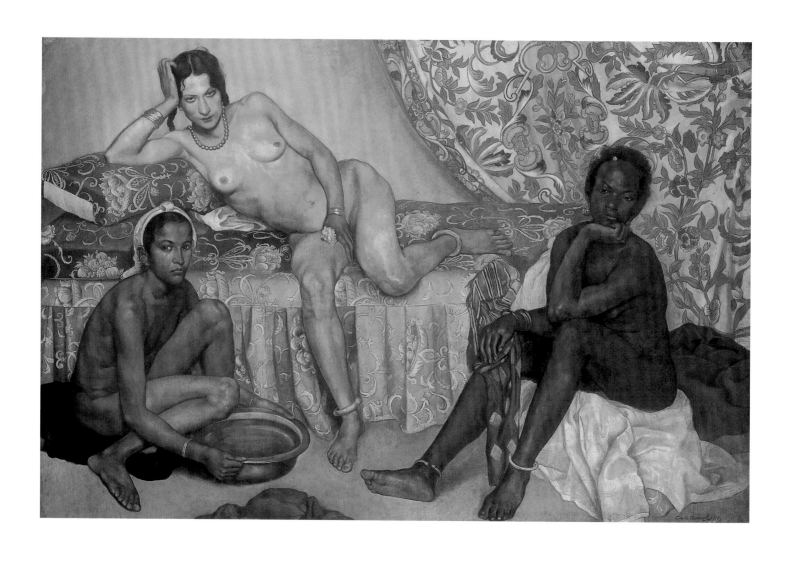

36 EMILE BERNARD, *The Three Races*, 1898.
Oil on canvas, 119.5 × 80.5 cm. The Los Angeles County Museum of Art. Purchased with funds provided by Mr and Mrs Stewart Resnick

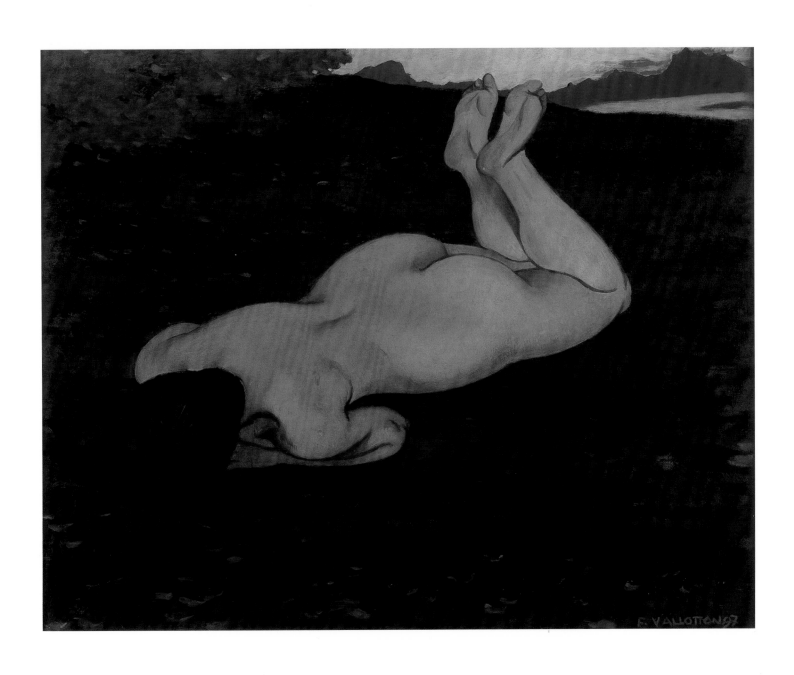

37 Félix Vallotton, *The Spring*, 1897. Oil on cardboard, 48 × 60 cm. Petit Palais, Musée d'Art Moderne, Geneva

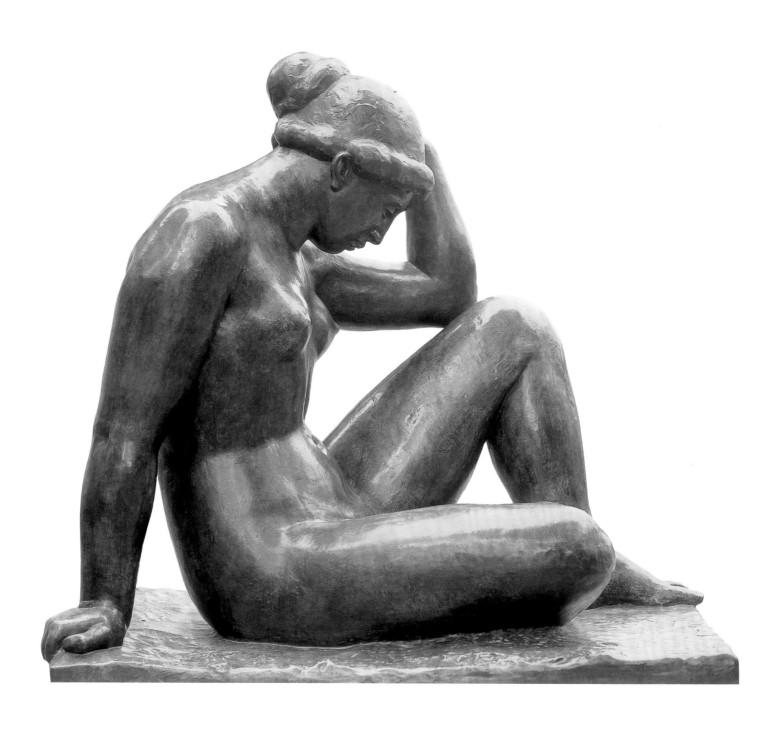

38 ARISTIDE MAILLOL, *The Mediterranean* (1st state), 1900–02. Bronze (Emile Godard: Epreuve d'artiste no. 2/4), H. 118 cm. Collection Musée Maillol, Paris

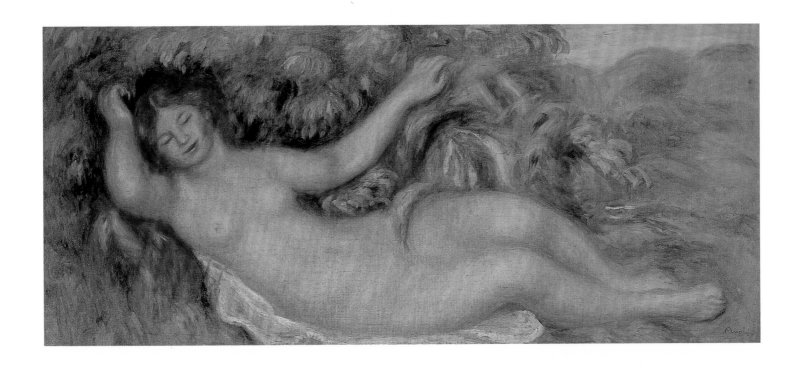

39 Auguste Renoir, *Reclining Nude*, 1902. Oil on canvas, 97.3 × 154 cm. Private Collection (courtesy Galerie Beyeler, Basel)

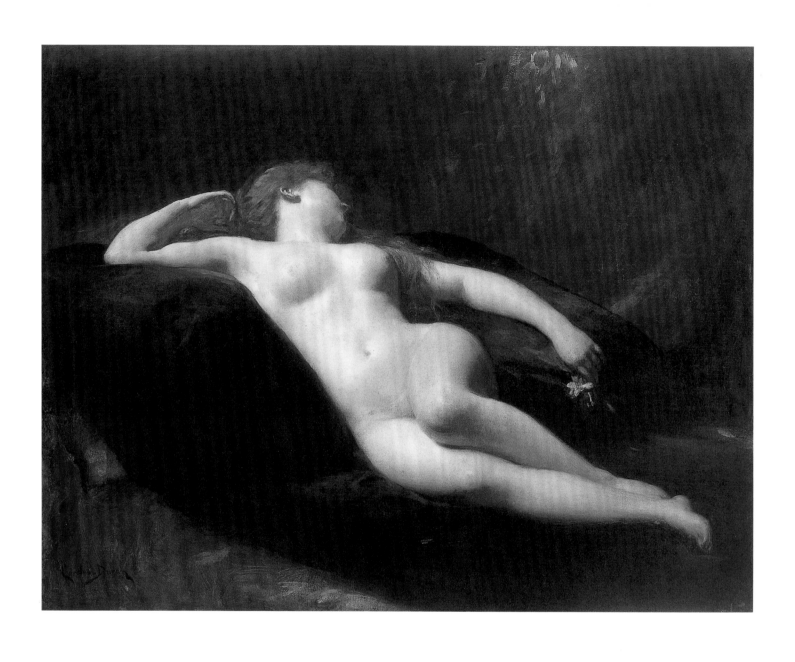

40 Carolus-Duran, *Danaë*, 1900. Oil on canvas, 100 × 127 cm. Musée des Beaux-Arts, Bordeaux (EU 1900)

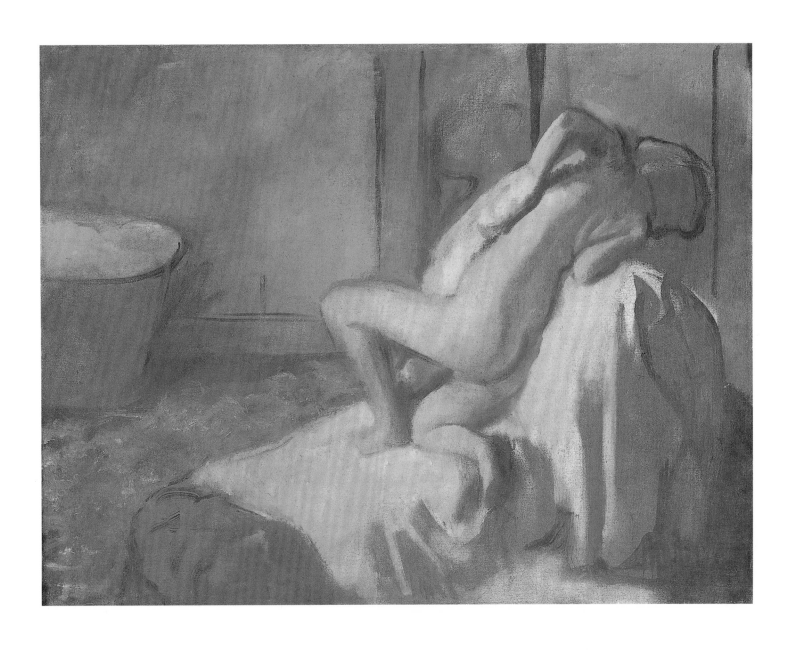

41 EDGAR DEGAS, *After the Bath*, c. 1898. Oil on canvas, 89 × 116 cm. Philadelphia Museum of Art. Purchased with funds from the estate of George D. Widener

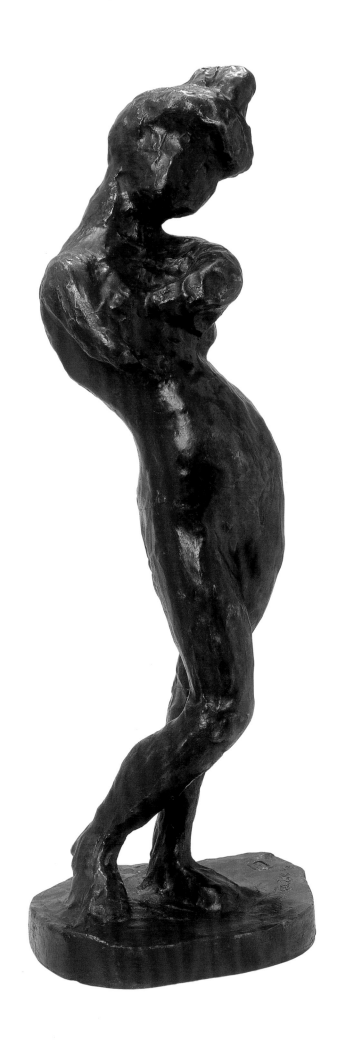

42 (*opposite*)
Auguste Rodin,
Meditation I (without arms), c. 1894.
Plaster, 54 × 18 × 15 cm.
Musée Rodin, Paris

43 (*left*)
Henri Matisse,
Madeleine I, 1901.
Bronze (ed. 2/10), 59.7 × 19.7 × 22.9 cm.
Weatherspoon Art Gallery,
The University of North Carolina at Greensboro.
Cone Collection, 1950

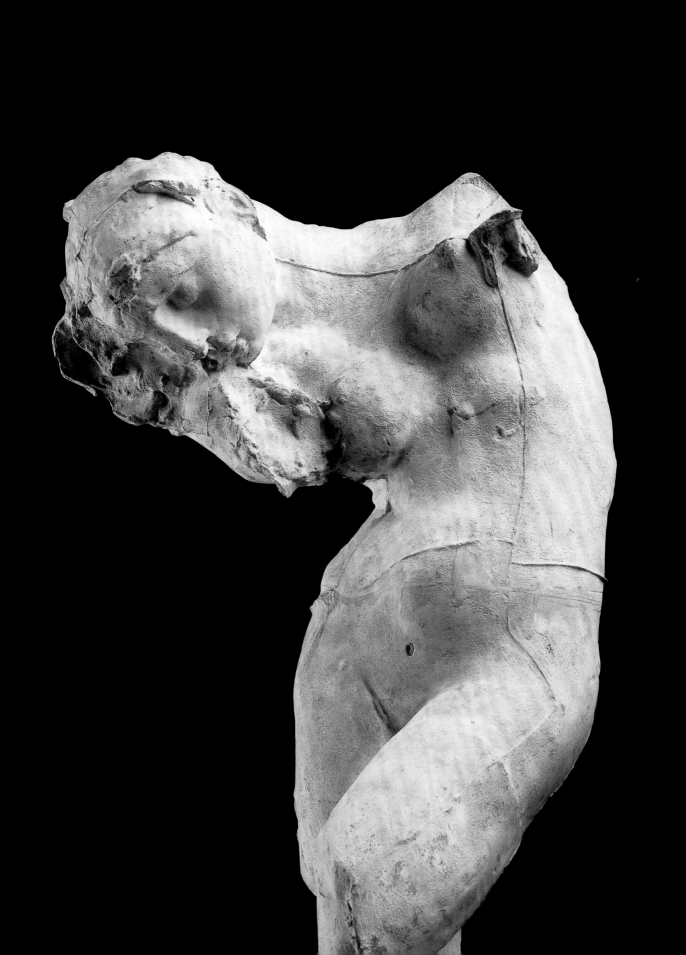

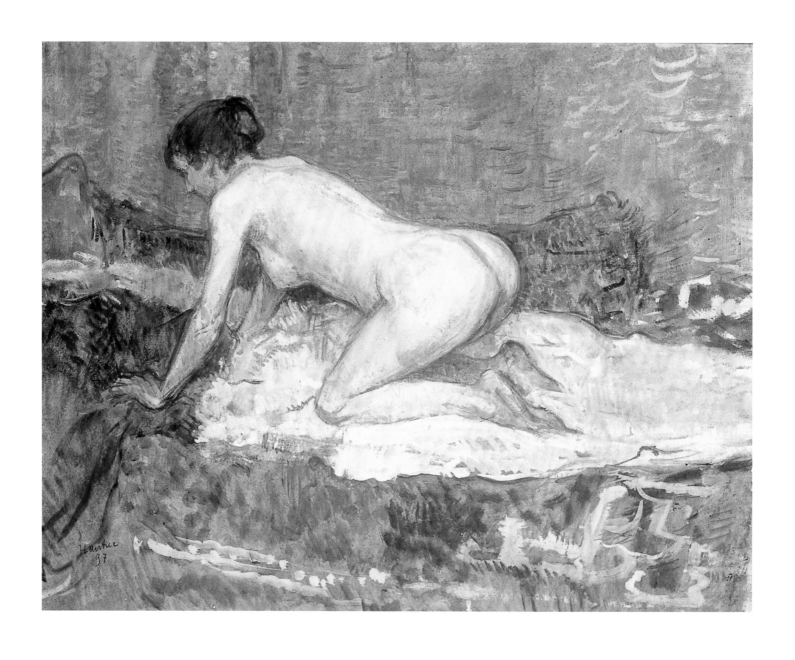

44 Henri de Toulouse-Lautrec, *Crouching Woman with Red Hair*, 1897.
Oil on cardboard, 47 × 60 cm. San Diego Museum of Art. Gift of the Baldwin M. Baldwin Foundation

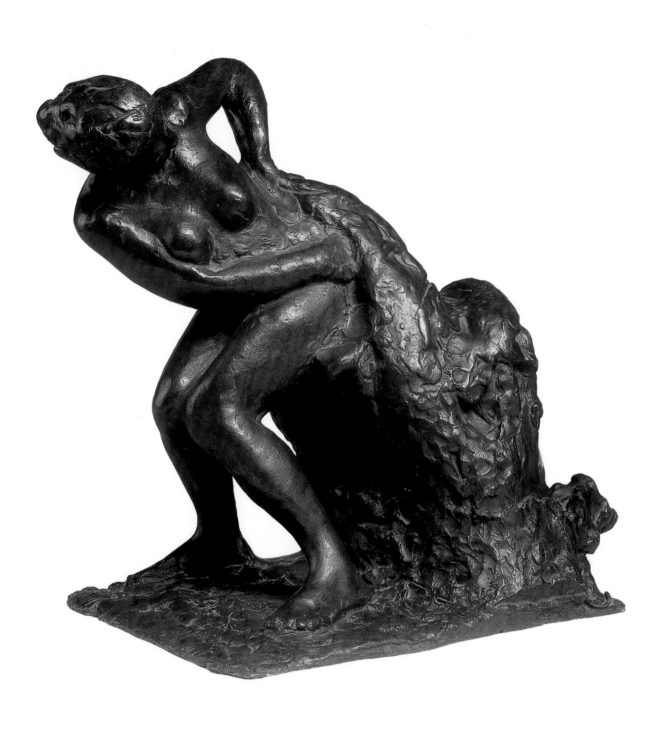

45 EDGAR DEGAS, *Seated Woman Wiping Her Left Side*, 1896–1911.
Bronze, 35.6 × 35.9 × 23.5 cm. Solomon R. Guggenheim Museum, New York, Thannhauser Collection. Gift of Justin K. Thannhauser, 1978

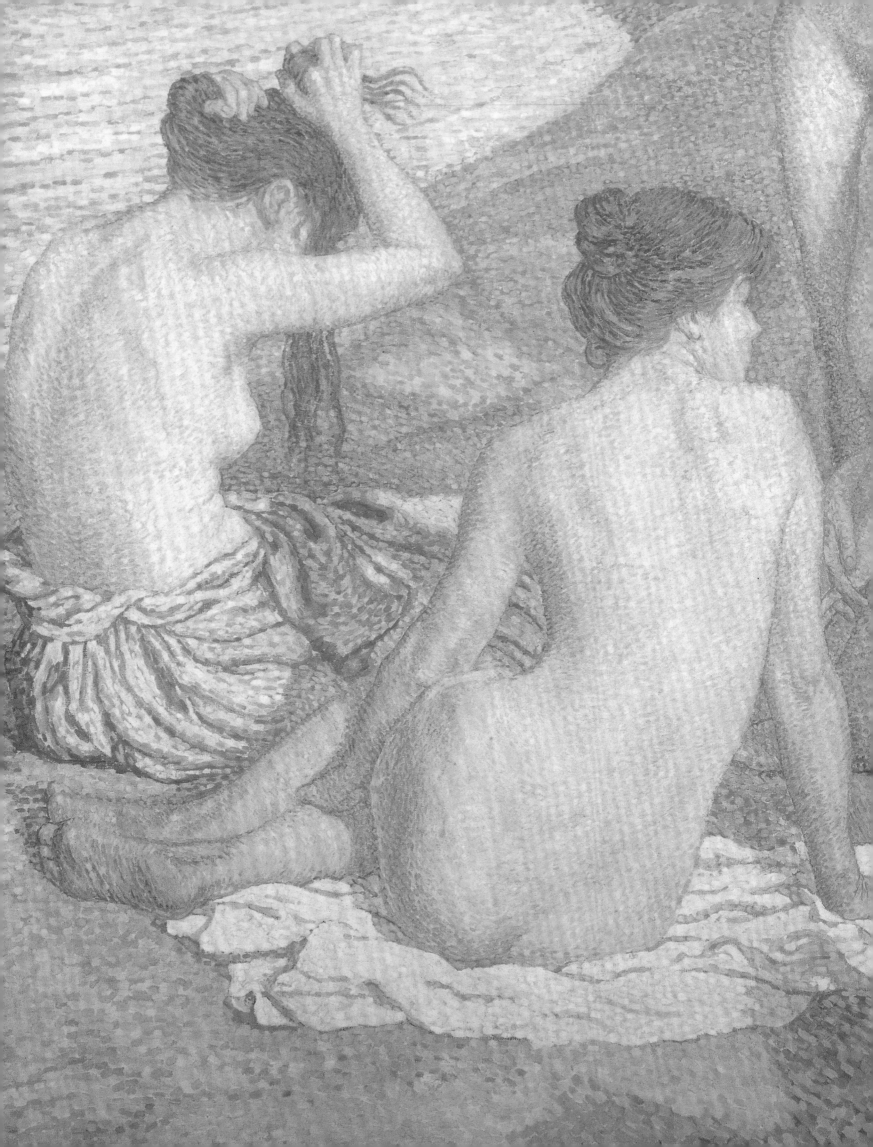

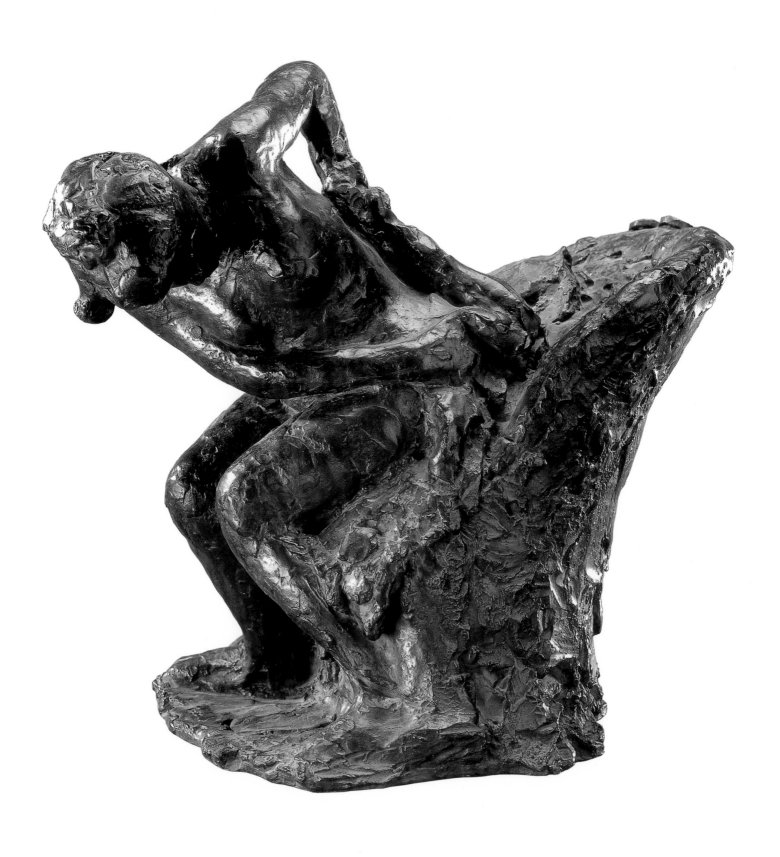

46 EDGAR DEGAS, *Seated Woman Drying Her Left Hip*, 1896–1911. Bronze, H. 47 cm. Fridart Stichting Amsterdam

(*opposite*) Detail of cat. 32

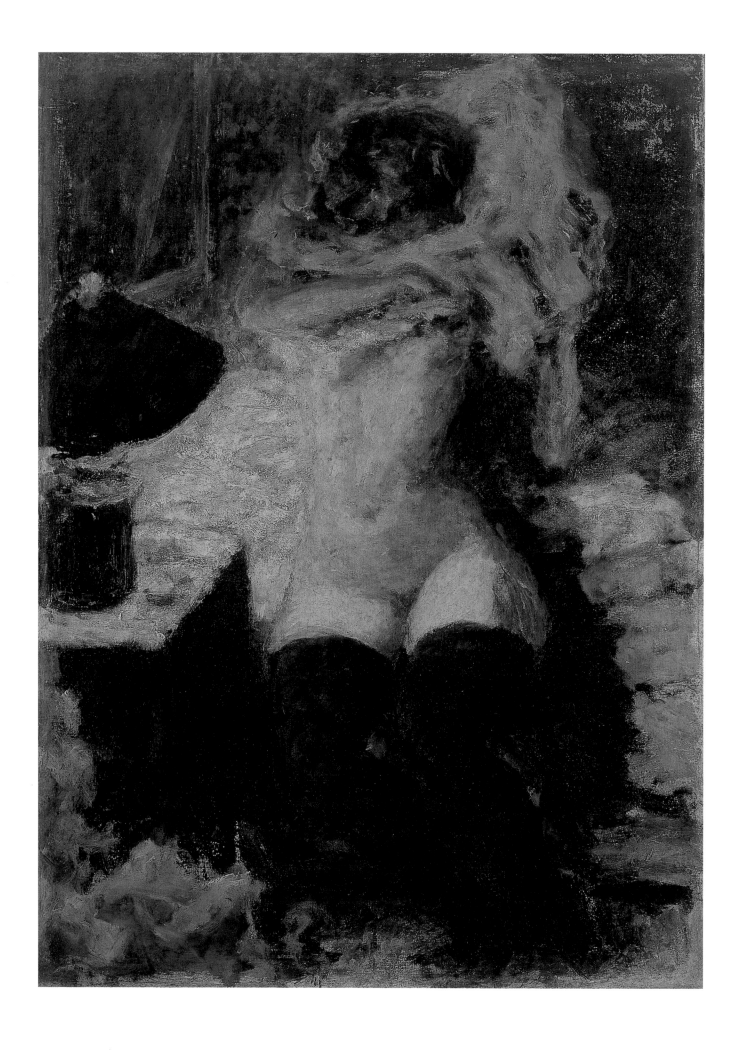

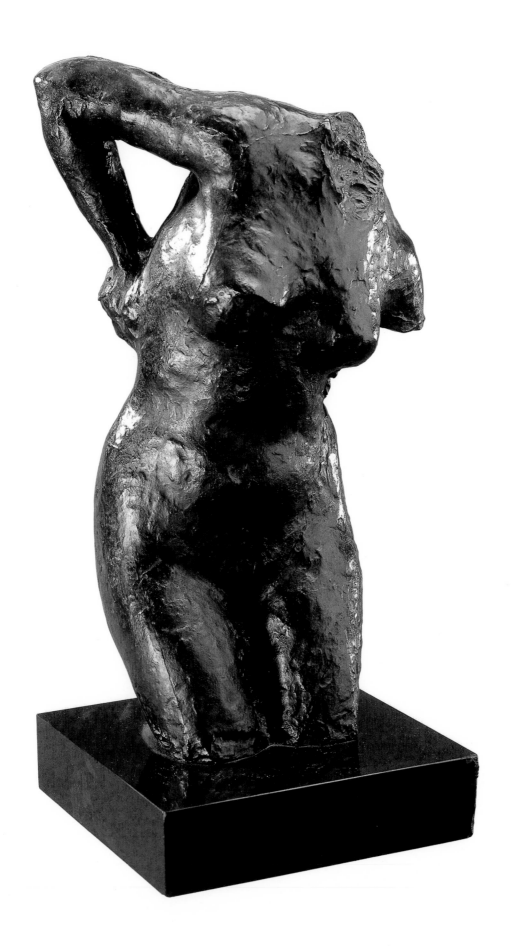

47 (*opposite*) Pierre Bonnard, *Nude with Black Stockings*, 1900. Oil on canvas, 59 × 43 cm. Private Collection, United Kingdom

48 (*above*) Edgar Degas, *Woman Rubbing Her Back with a Sponge: Torso*, 1896–1911. Bronze, H. 42.9 cm. Fridart Stichting Amsterdam

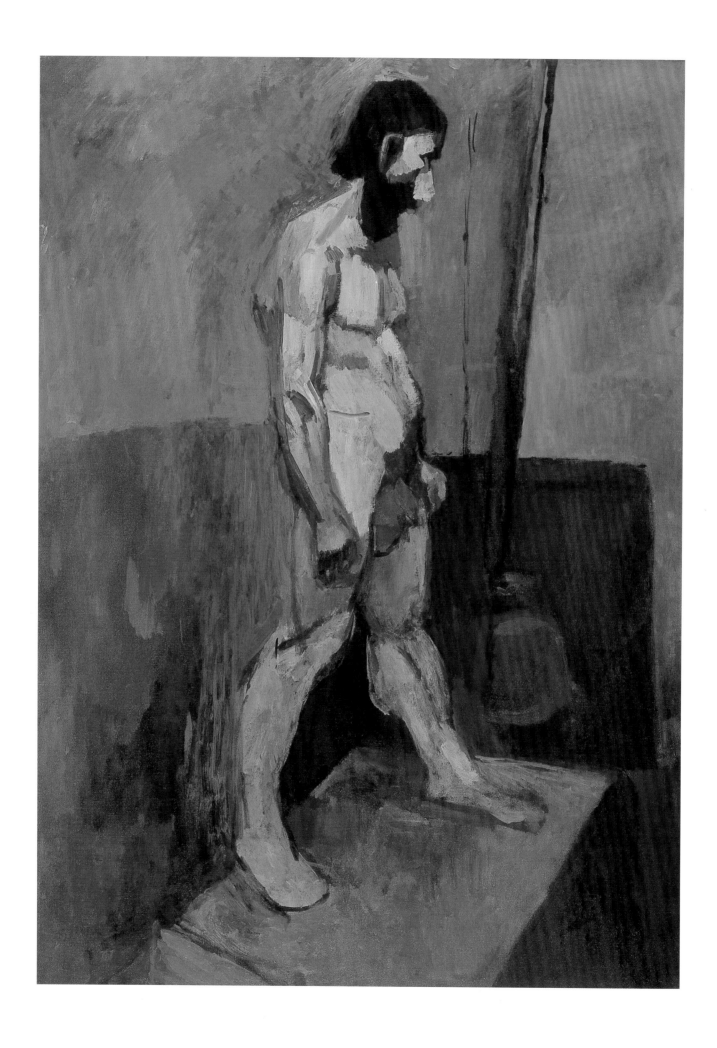

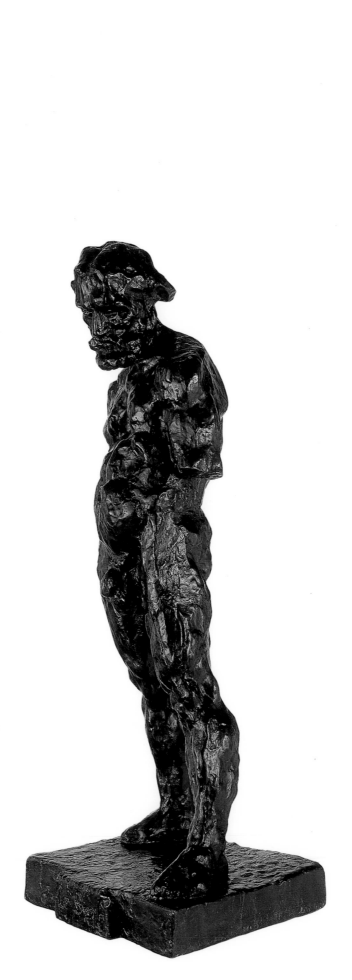

49 (opposite)
HENRI MATISSE,
Male Model, 1900.
Oil on canvas, 99.3 × 72.7 cm.
The Museum of Modern Art, New York.
Kay Sage Tanguy and Abby Aldrich
Rockefeller Funds

50 (right)
HENRI MATISSE,
The Serf, 1900–03, cast c. 1931.
Bronze, 91.5 × 37.8 × 30.7 cm.
Hirshhorn Museum and Sculpture
Garden, Smithsonian Institution.
Gift of Joseph H. Hirshhorn, 1966

51 (far right)
AUGUSTE RODIN,
Walking Man, 1900.
Bronze, 355 × 75 × 75 cm.
Musée Rodin, Paris

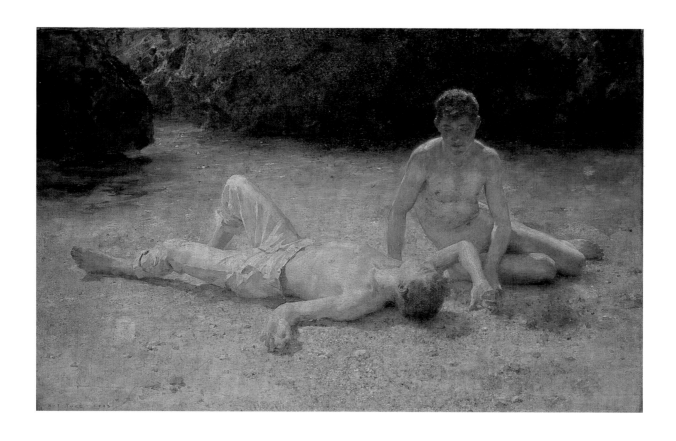

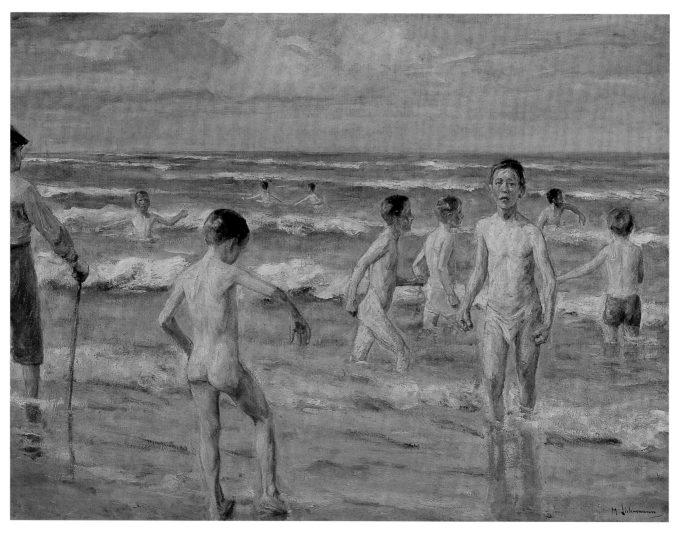

52 (*opposite above*)
HENRY SCOTT TUKE, *Noonday Heat*, 1903.
Oil on canvas, 81.9 × 133.4 cm.
The Tuke Collection, Royal Cornwall Polytechnic Society,
Falmouth

53 (*opposite below*)
MAX LIEBERMANN, *Boys Bathing*, 1898.
Oil on canvas, 122 × 151 cm.
Stadtmuseum, Berlin

54 (*right*)
WALTER RICHARD SICKERT, *The Bathers, Dieppe*, 1902.
Oil on canvas, 131.5 × 104.5 cm.
Board of Trustees of the National Museums & Galleries on
Merseyside (Walker Art Gallery, Liverpool)

55 (*below*)
P. S. KRØYER, *Boys Bathing, Summer Evening, Skagen*, 1899.
Oil on canvas, 100.5 × 153 cm.
Statens Museum for Kunst, Copenhagen (EU 1900)

56
ARISTIDE MAILLOL, *Female Bather Standing*, 1899.
Wood, 77 × 33 × 33 cm.
Stedelijk Museum, Amsterdam

57 (*opposite*)
ANDERS ZORN, *Red Sand*, 1902.
Oil on canvas, 118.5 × 94 cm.
Private Collection

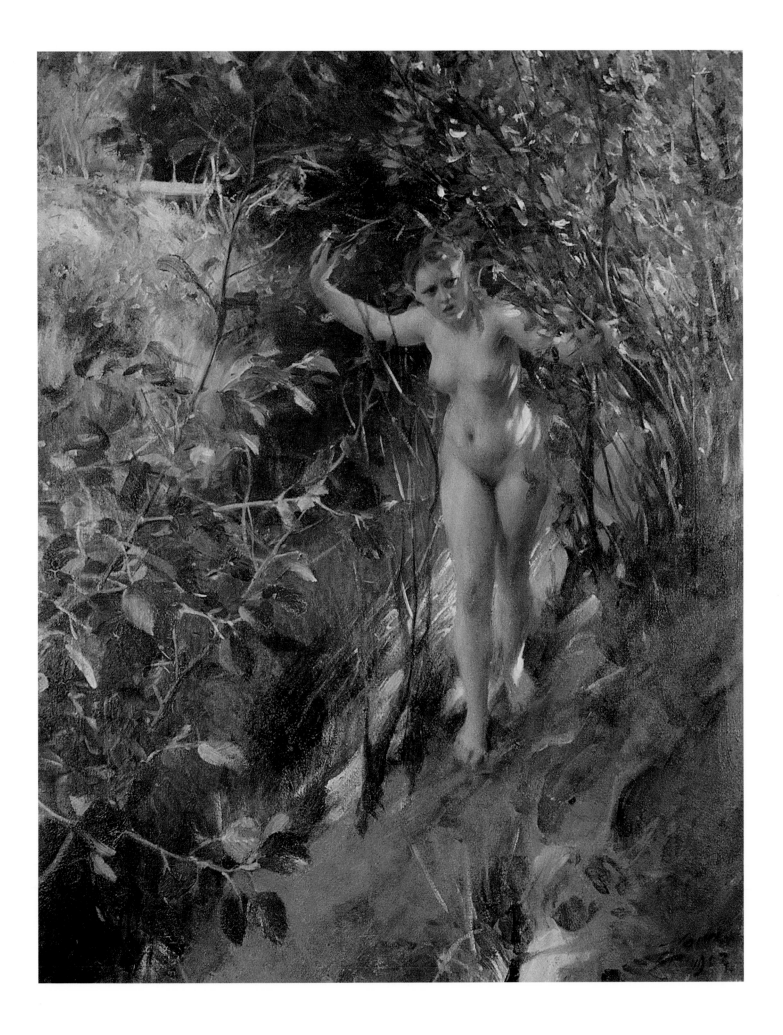

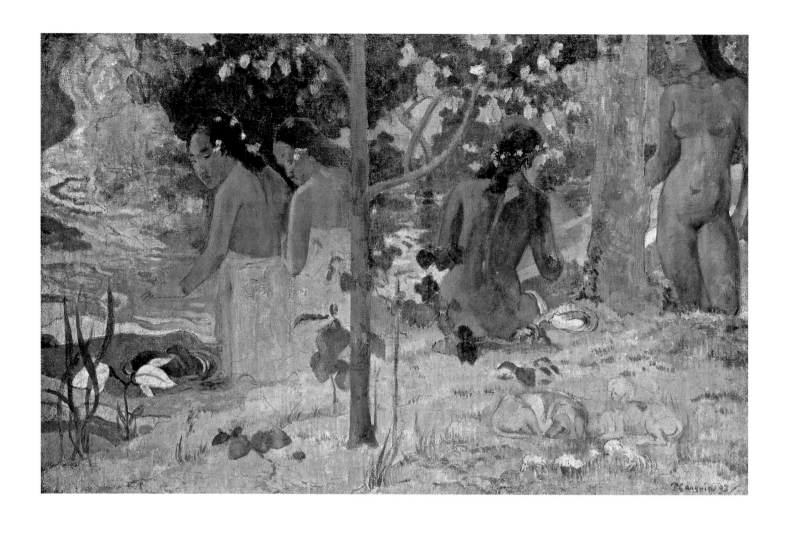

58 PAUL GAUGUIN, *The Bathers*, 1897. Oil on canvas, 60 × 92 cm. National Gallery of Art, Washington, D.C. Gift of Sam A. Lewisohn 1951.5.1

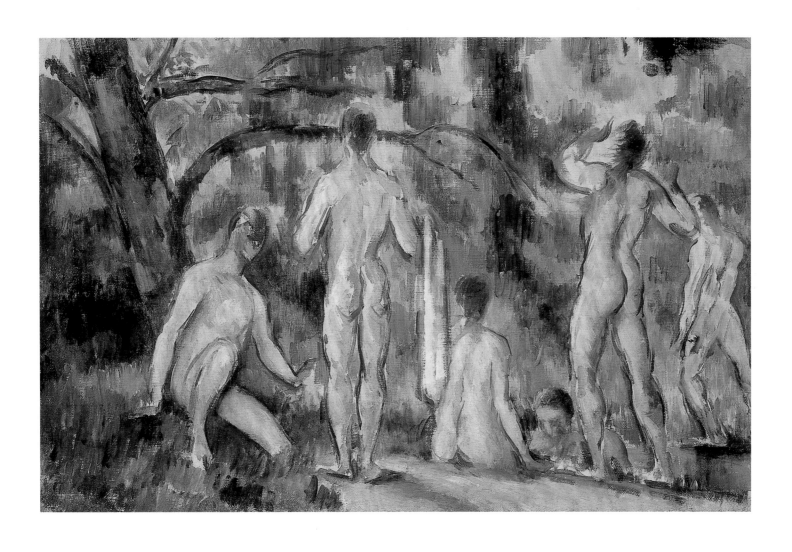

59 PAUL CÉZANNE, *Les Grandes Baigneuses*, c. 1895–98. Oil on canvas, 26 × 40 cm. Pushkin State Museum of Fine Arts, Moscow

Woman–Man

The publication in 1899 of Freud's *The Interpretation of Dreams* was symptomatic of a *fin-de-siècle* preoccupation with the unconscious drives that define human behaviour. In all of the arts this emerged as an obsessive fascination with sexual fantasies and anxieties.

In the German painter Thoma's version of the age-old story of Adam and Eve, a skeletal death's-head introduces a foreboding counterpart to the tree of life in the foreground (cat. 82). In complete contrast, Rousseau offers us a naively sophisticated vision of paradisiacal innocence in which a bouncing infant and beatific dog complete the happy quartet (cat. 83). In Bergh's more time-specific *Nordic Summer Evening*, the erotic tension is palpable in the decorous distance between the upper-class young couple on a Swedish terrace, bathed in the glowing light of an endless summer night (cat. 80). The Swiss painter Hodler's monumental idealisation of young love in a flower-strewn meadow resonates with pagan ritual (cat. 78), while in the Polish artist Weiss's *Obsession* the figures are engulfed by an inferno of lust (cat. 85). The Belgian sculptor Lambeaux brings a naturalistic vigour to his struggle of the sexes (cat. 79), and in Munch's primeval encounter (cat. 81) the naked figures confront their basic instincts in a sexually energised void in which the man bows his head in submission or despair before a heartless *femme fatale* emblazoned with a red halo of desire.

Munch's view of woman as carnal predator is explicit in his close-focus portrayal of a fleshy *femme tentaculaire* (cat. 61). Klimt's remote but no less compelling temptresses surrender to the flow of water or are metamorphosed into scaly fish-women who slither against a glittering, neutral ground (cats 65, 84). His virgin goddess, *Pallas Athene*, one of three works by Klimt that hung in the Austrian section of the Exposition Universelle, is as iconic as a Byzantine empress in her carapace of gold chain-mail (cat. 63).

In the gallery of *femmes fatales*, none equalled Salome for her hold over the morbid *fin-de-siècle* imagination. The German artist Trübner's disarmingly *plein-air* Salome could hardly be further from Benner's dramatically lit teenage siren (cats 67, 68). While both of these artists focus on the lone figure of Salome triumphantly bearing her trophy on a platter, the German realist painter Corinth expands the narrative into a theatrical *mise en scène* which brings the Biblical story to life with an almost Hollywood verismo. He freezes the action at its most chilling moment when a gloating Salome with pendulous breasts and pearls stoops to kiss the head of her victim, while an executioner worthy of Max Beckmann impassively surveys the horrific scene (cat. 69).

Images of the idyllic union of man and woman were also prevalent at the turn of the century. Rodin's lyrical *The Earth and Moon* (cat. 77) transposes love to a mythological realm. In Delville's *The Love of Souls* (cat. 76), a work that was shown in the Belgian section at the Exposition Universelle, the amorous spirits blend in a vaporous Art Nouveau apotheosis probably inspired by the famous 'Liebestod' from Wagner's *Tristan und Isolde*. AD

(*opposite*) Detail of cat. 63

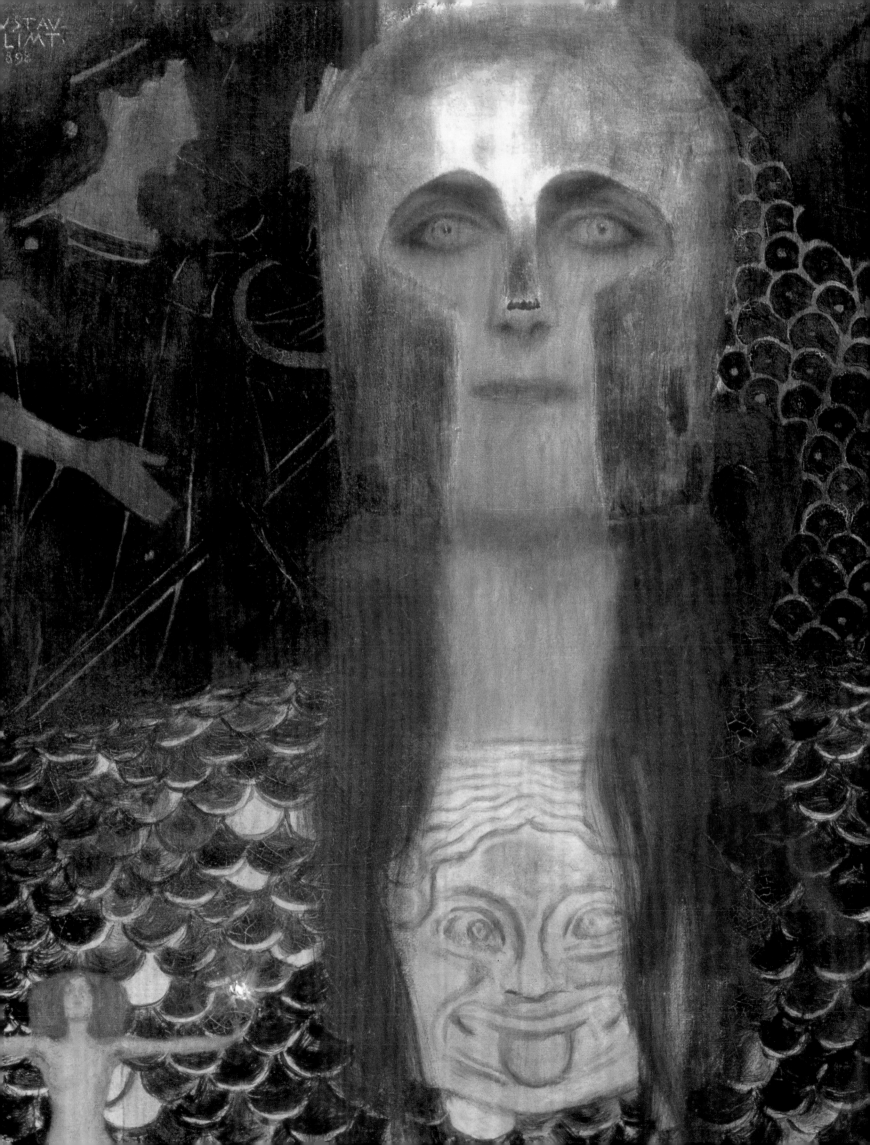

60 EMILE-ANTOINE BOURDELLE, *Aphrodite*, 1900. Porcelain, 40 × 35.6 × 23.5 cm. Musée Bourdelle, Paris (EU 1900)

61 (*opposite*) EDVARD MUNCH, *The Beast*, 1901. Oil on canvas, 94.5 × 63.5 cm. Sprengel Museum, Hanover

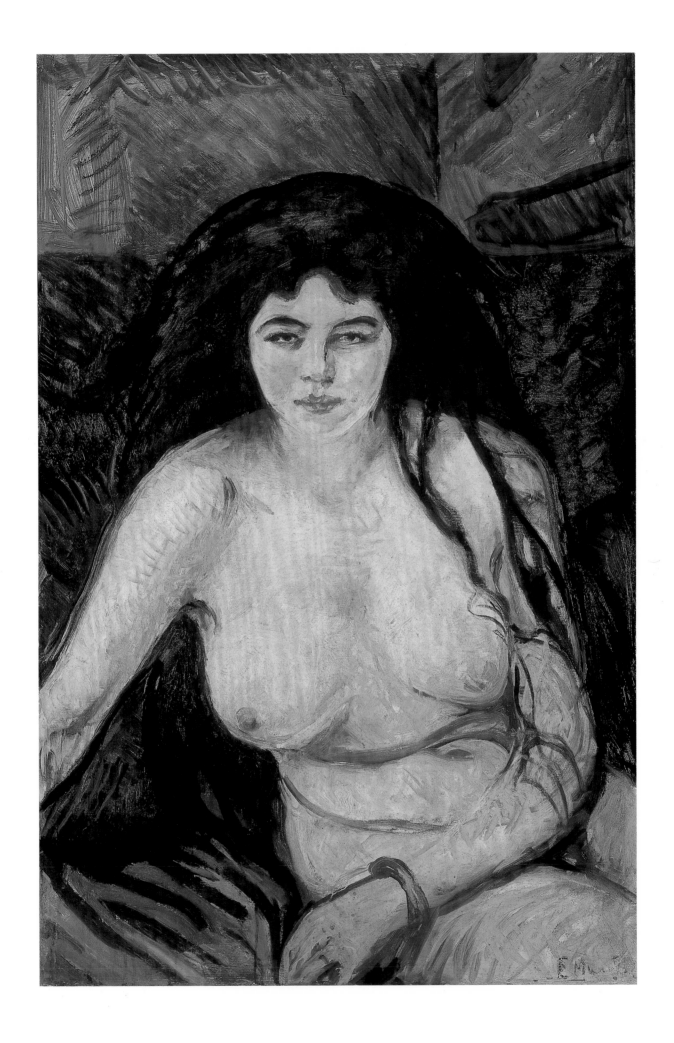

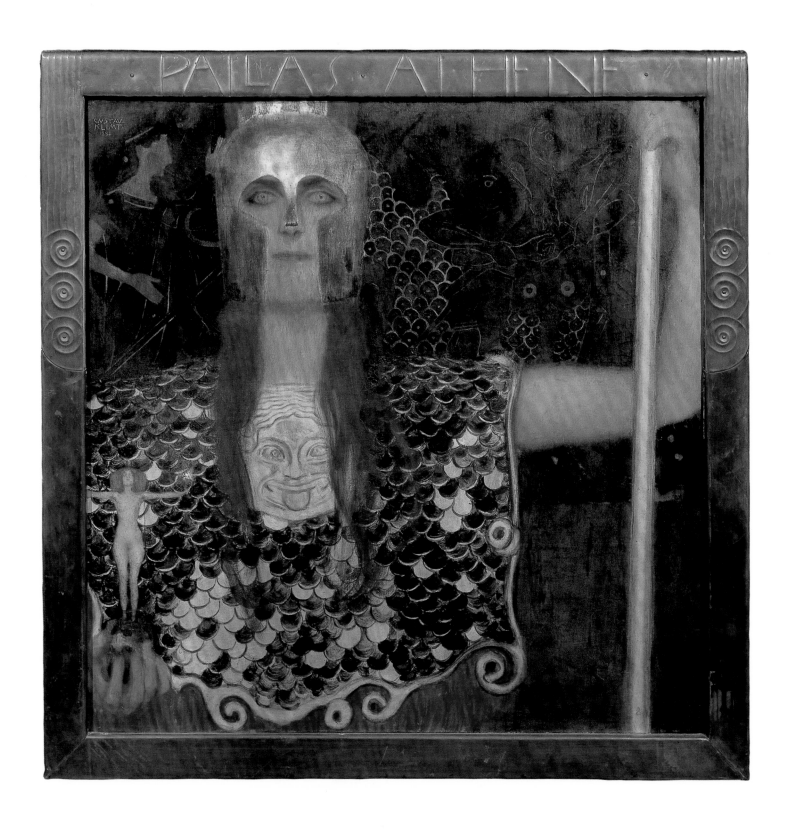

62 (*opposite*) EMILE-ANTOINE BOURDELLE, *Head of Apollo*, 1900–09. Bronze (Cast Rudier no. 1), 67 × 21 × 28 cm. Collection of Mrs Rhodia Dufet Bourdelle

63 (*above*) GUSTAV KLIMT, *Pallas Athene*, 1898. Oil on canvas, 75 × 75 cm. Historisches Museum der Stadt, Vienna (EU 1900)

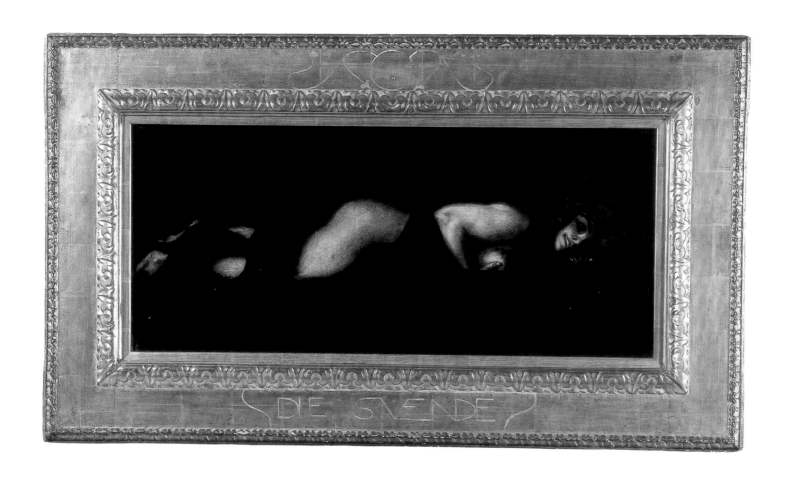

64 FRANZ VON STUCK, *Sin*, 1899. Oil on panel, 35 × 80 cm. Wallraf-Richartz Museum, Cologne

65 (*opposite*) GUSTAV KLIMT, *Silver Fishes*, 1899. Oil on canvas, 82 × 52 cm. Bank Austria Kunstsammlung, Vienna

66
ARISTIDE MAILLOL,
Eve with an Apple, 1899.
Bronze (A. Bingeu et Costenoble: Epreuve d'artiste),
58 × 21 × 12 cm.
Collection Musée Maillol, Paris

67 (*opposite*)
WILHELM TRÜBNER,
Salome, 1898.
Oil on cardboard, 101 × 53.3 cm.
Milwaukee Art Museum.
Gift of the Rene von Schleinitz Foundation

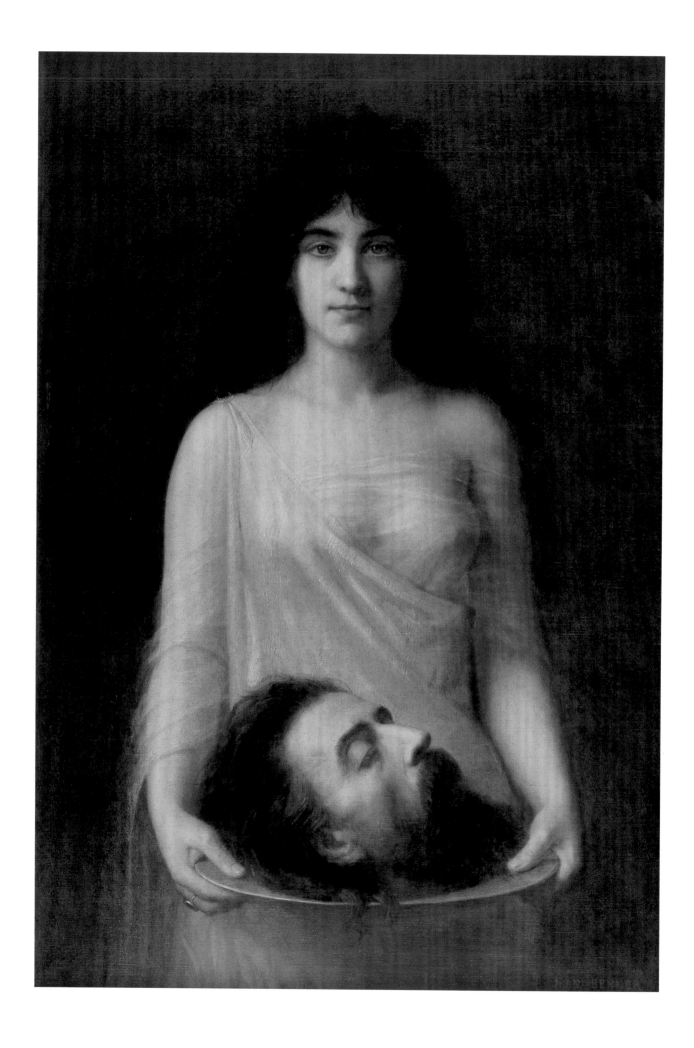

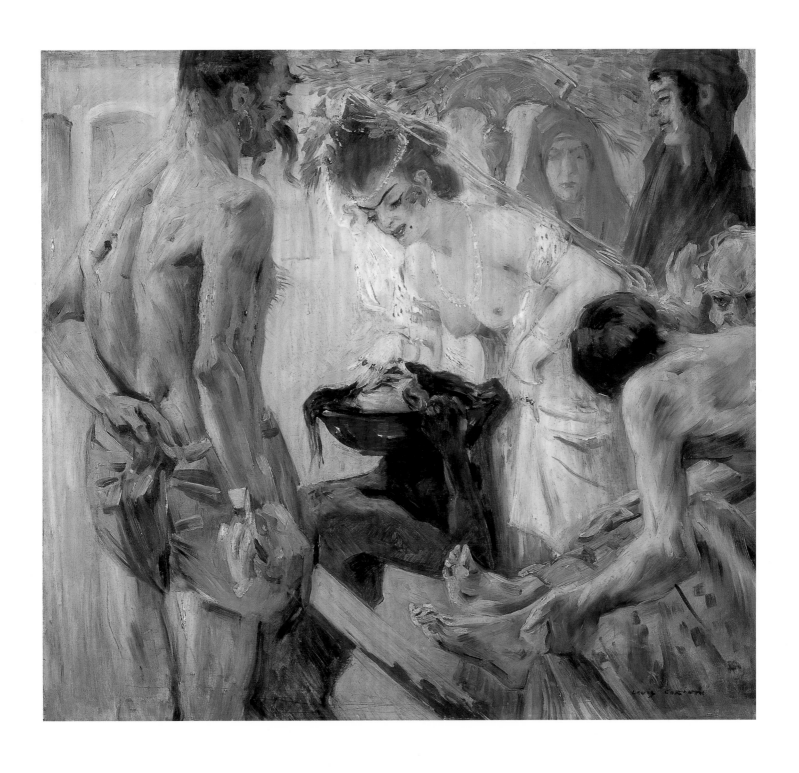

68 (*opposite*) JEAN BENNER, *Salome, c.* 1899. Oil on canvas, 117.3 × 80.9 cm. Musée des Beaux-Arts, Nantes

69 (*above*) LOVIS CORINTH, *Salome*, 1899. Oil on canvas, 76.2 × 83.5 cm. Busch-Reisinger Museum, Harvard University Art Museums

70 Franz von Stuck, *Amazon*, 1897–1903. Bronze, H. 36 cm. Museum Villa Stuck, Munich. Permanent loan from a private collection (EU 1900)

71 (*opposite*) Frederick William MacMonnies, *Bacchante with Infant Faun*, cast 1893–94. Bronze, H. 42 cm. Courtesy Berry-Hill Galleries, New York (EU 1900)

72 (*left*)
FERNAND KHNOPFF, *Study for 'The Past'*, c. 1897.
Coloured gesso, 30.5 × 10 × 5.5 cm.
Patrick Derom Gallery, Brussels

73 (*above*)
PAUL DE VIGNE, *Psyche*, 1890s.
Ivory, 30 × 13.1 × 13.1 cm.
Museum voor Schone Kunsten, Ghent (EU 1900)

74 (above)
SIR HAMO THORNYCROFT,
The Joy of Life, 1896.
Bronze, 39 × 23 × 12 cm.
Leeds Museums and Galleries (City Art Gallery) (EU 1900)

75 (right)
FRANZ VON STUCK,
Dancing Girl, 1897.
Bronze, 63 × 33.5 × 23.5 cm.
Kunsthalle, Bremen

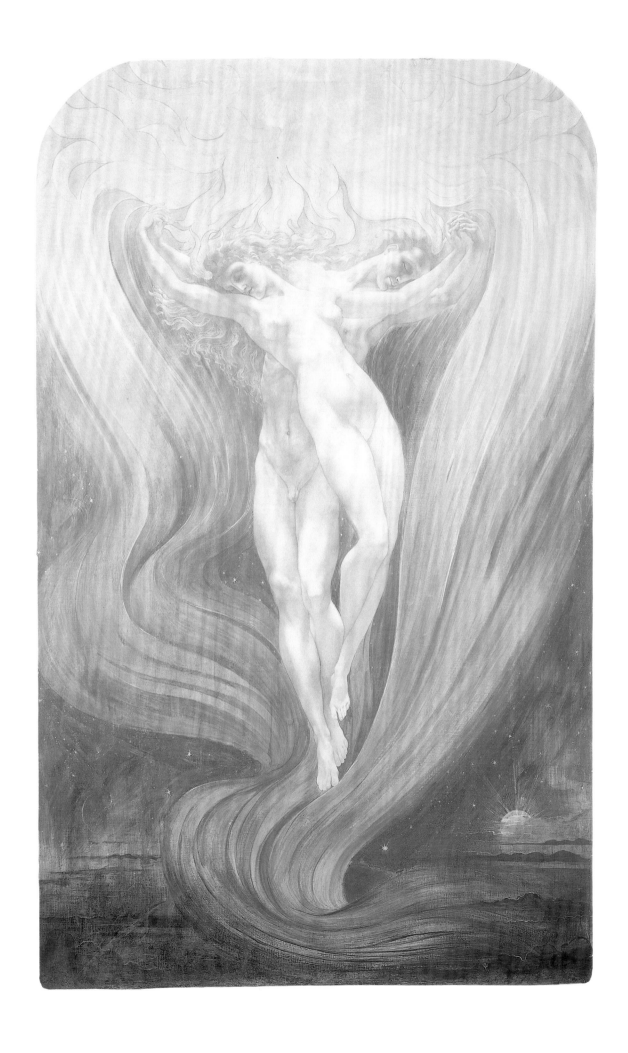

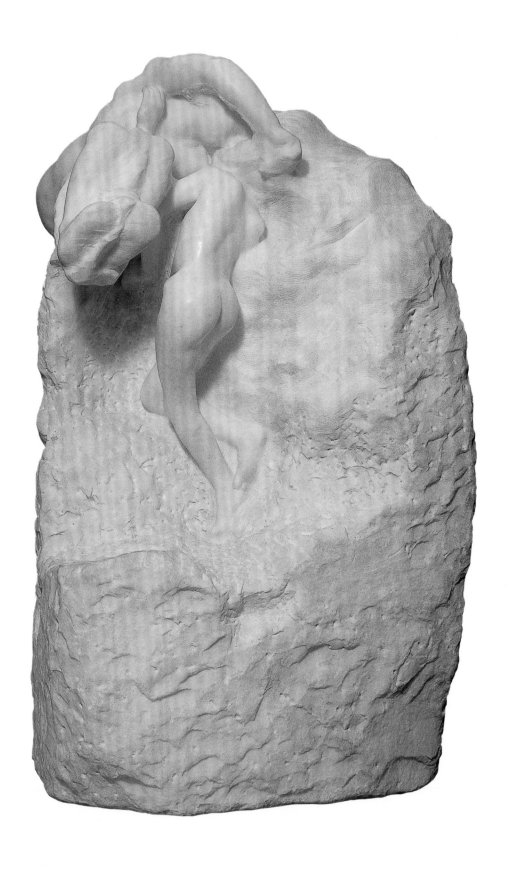

76 (*opposite*) JEAN DELVILLE, *The Love of Souls*, 1900. Egg tempera on canvas, 238 × 150 cm. Musée d'Ixelles, Brussels (EU 1900)

77 (*above*) AUGUSTE RODIN, *The Earth and Moon*, 1899. White marble, 120 × 68.5 × 63.5 cm. National Museums and Galleries of Wales

78 Ferdinand Hodler, *Spring*, 1901. Oil on canvas, 102.5 × 129.5 cm. Museum Folkwang, Essen

79 (*opposite*) Jef Lambeaux, *The Rape, c.* 1900. Bronze, H. 57 cm. Musée Royal de Mariemont, Morlanwelz (EU 1900)

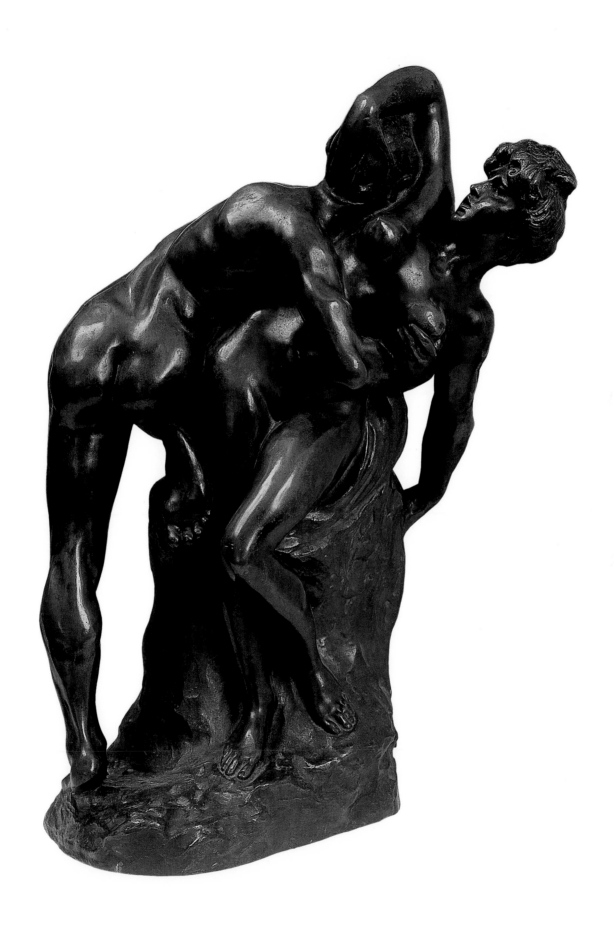

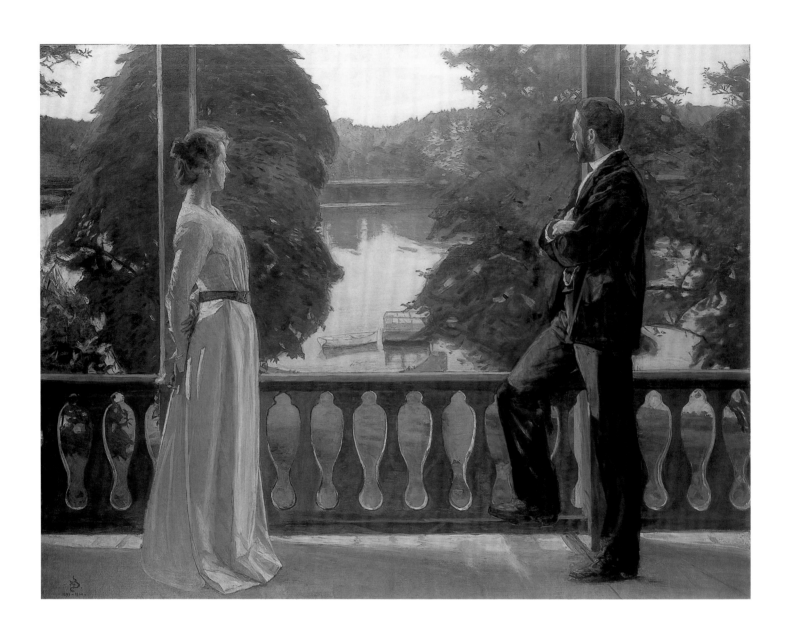

80 RICHARD BERGH, *Nordic Summer Evening*, 1899–1900. Oil on canvas, 170 × 233.5 cm. Göteborg Museum of Art

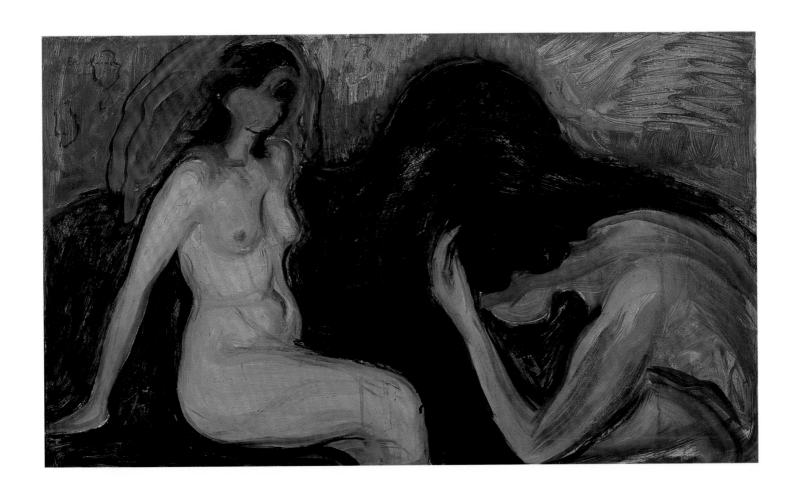

81 EDVARD MUNCH, *Man and Woman*, 1898. Oil on canvas, 60.2 × 100 cm. Bergen Art Museum, Rasmus Meyers Collection

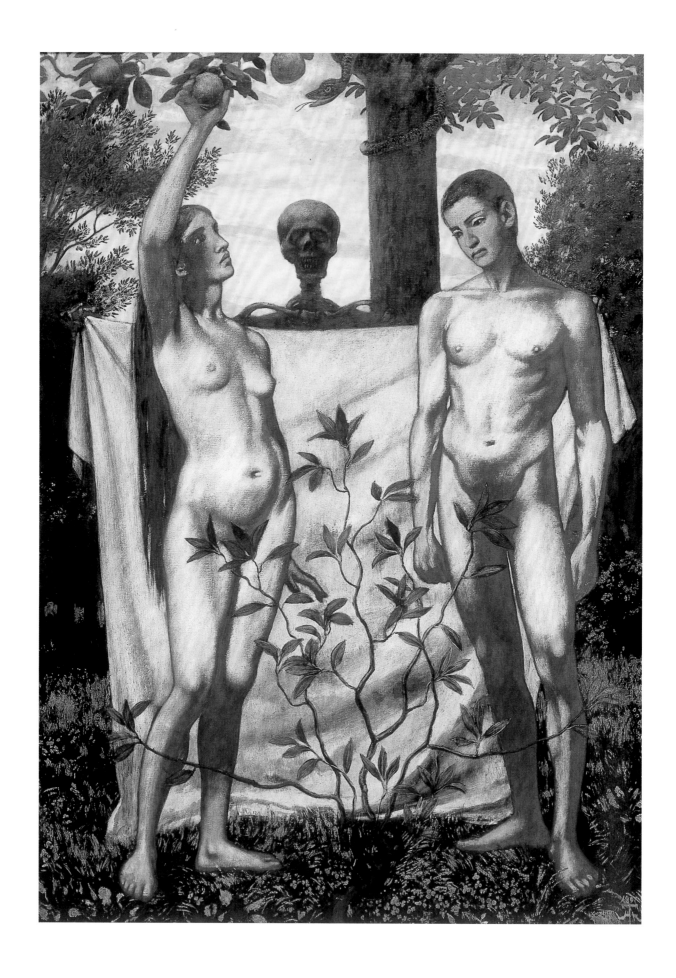

82 Hans Thoma, *Adam and Eve*, 1899. Oil on canvas, 110 × 78.5 cm. The State Hermitage Museum, St Petersburg

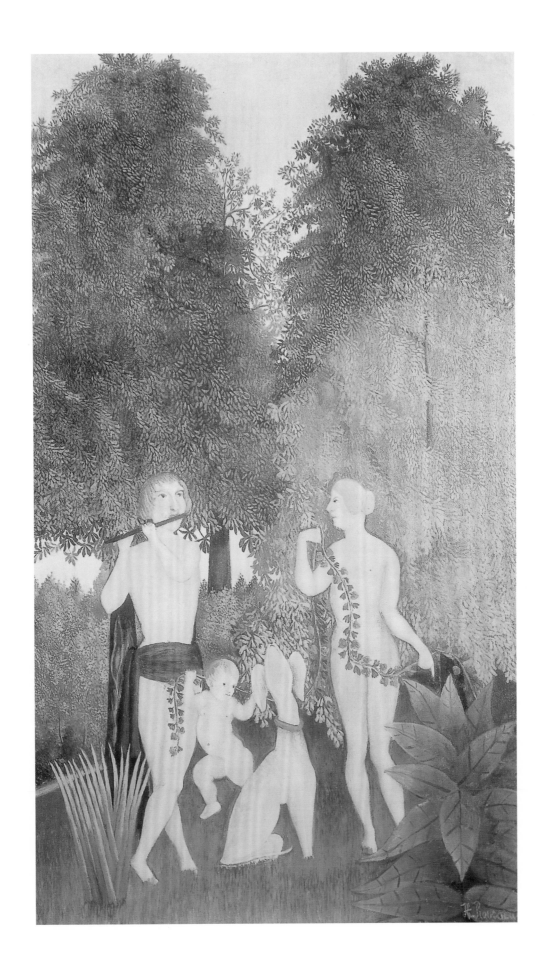

83 HENRI ROUSSEAU, *Happy Quartet*, 1901–02. Oil on canvas, 94 × 57 cm. Private Collection

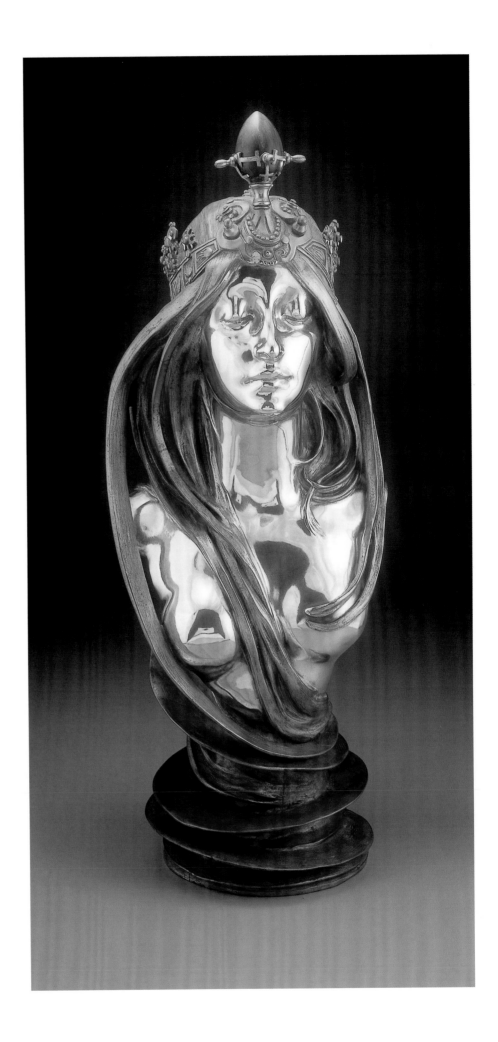

84 (*opposite above*)
GUSTAV KLIMT, *Moving Waters*, 1898.
Oil on canvas, 53 × 66 cm.
Private Collection
(courtesy Galerie St. Etienne, New York)

85 (*opposite below*)
WOJCIECH WEISS, *Obsession*, c. 1900–01.
Oil on canvas, 100 × 185 cm.
Museum of Literature, Warsaw

86 (*right*)
ALPHONSE MUCHA, *Nature*, 1900.
Bronze, 69.2 × 27.9 × 30.5 cm.
Virginia Museum of Fine Arts, Richmond.
The Sydney and Frances Lewis Art Nouveau Fund
(EU 1900)

Portraits

Rodin once called Sargent 'the Van Dyck of our times'. Certainly, Sargent's *Mrs Carl Meyer and Her Children* (cat. 99) typifies the bravura portrait that flourished internationally at the turn of the century, summing up a tradition of grand portraiture that stretches back to the Renaissance. Titian, Velázquez and Hals, as well as Van Dyck, were the models not only for Sargent but also, in varying degrees, for his contemporaries Beaux, Boldini, Eakins, Lavery, Osborne, Serov, Whistler and Zuloaga, all of whom enjoyed brilliant careers as modern 'court' painters capable of satisfying the aspirations and confirming the status of their glittering international clientele. Many of these artists' portraits represented their countries at the Exposition Universelle (cats 7, 102), while the exhibition itself, specifically the exotic Moorish café in the Tunisian Pavilion, was the setting for Blanche's more informal portrait of Gide and his bohemian friends (cat. 87).

Although many portraits around 1900 were concerned with the public persona, others explored the private self. Whistler introduced a new introspection to the grand portrait: George W. Vanderbilt (cat. 89), the suave, millionaire aesthete, becomes, in Whistler's hands, a svelte, ghostly presence. Klimt, who like Freud emerged from the cultural climate of *fin-de-siècle* Vienna, painted portraits that hint at disturbing undercurrents beneath the social veneer. His portrait of Marie Henneberg (cat. 113) shows her with over-rouged cheeks and coal-black eyes which introduce an unexpectedly vulgar, even grotesque, note to this portrayal of an otherwise impeccable Viennese *grande dame*.

An introspective strain, paralleled in the writings of Ibsen and Strindberg, runs through Scandinavian portraiture. A double portrait (cat. 109) by Munch investigates the subtle tensions between husband and wife, each isolated in their own thoughts, while Krøyer's portrait of the Griegs (cat. 110) is really about the shared, inward experience of listening to music. Find's portrait of the Norwegian painter Erichsen (cat. 97), a work, like Krøyer's, included in the Exposition Universelle, harks back to Denmark's 'Golden Age' of painting with its meticulous execution; the containment of the effete figure, however, his inward gaze and the cool space around him contribute to a contemporary mood of melancholy introspection.

Man with Crossed Arms (cat. 95) is one of a number of monumental portraits of single, unidentified figures in which Cézanne, uninterested in social status or individual character, concentrated on the almost abstract quality of the human presence. The eighteen-year-old Picasso, in the portrait of his friend the writer Josep Cardona (cat. 107), astonishes with a precocious painterly display which gives little hint of the inventiveness to come.

Rodin's monumental *Balzac* (cat. 94), a focal point of the sculptor's 1900 one-man exhibition in Paris, exemplifies the contemporary vogue for sculptures of cultural heroes. While Troubetzkoy's bust of his friend Tolstoy (cat. 96) echoes the verismo of society portraits, Bourdelle's and Klinger's sculptural portraits of Beethoven and Brahms are more generalised evocations of Romantic genius (cats 111, 112). AD

(*opposite*) Detail of cat. 99

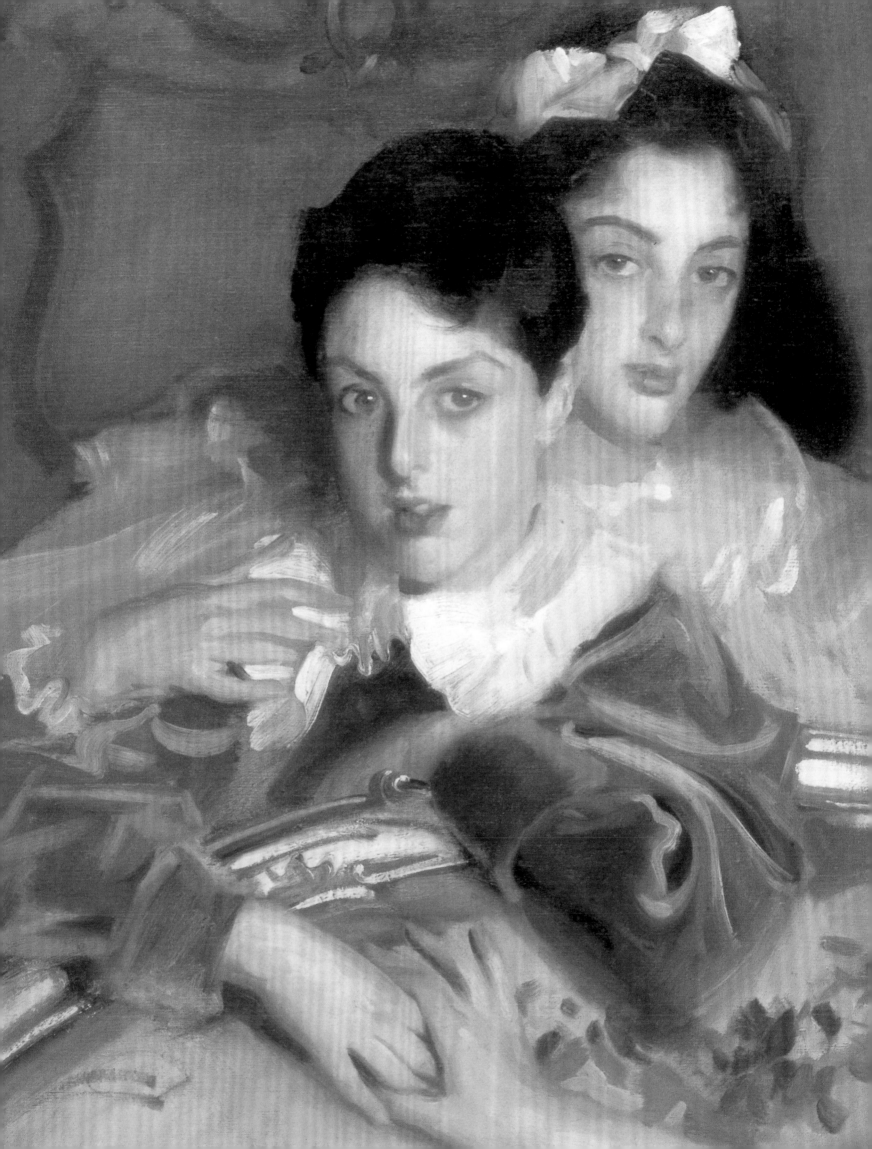

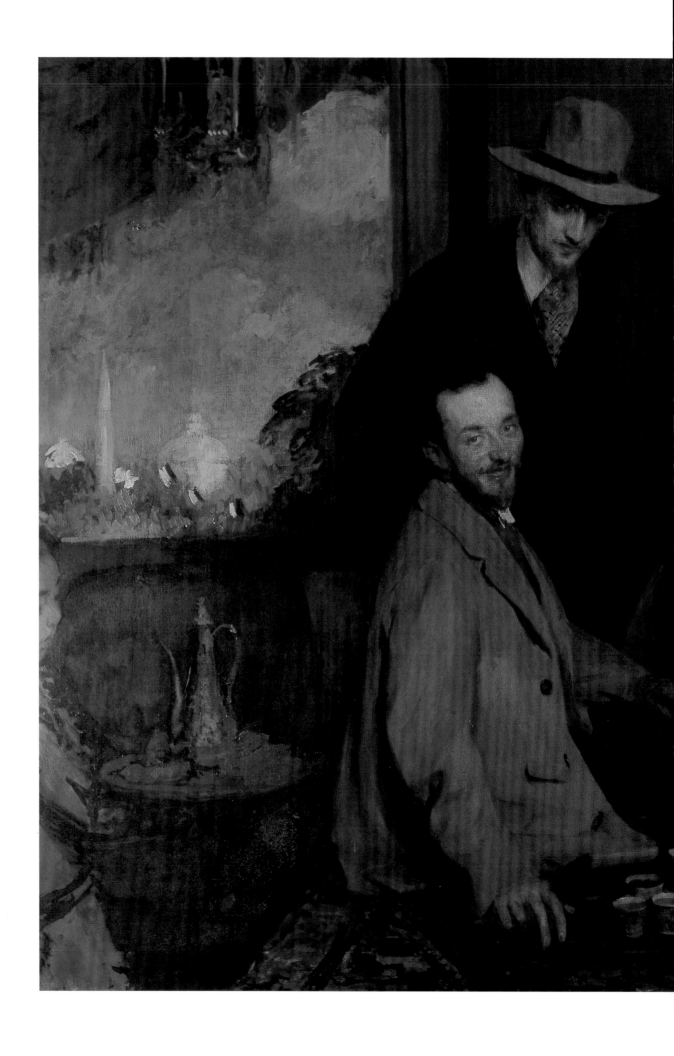

87
JACQUES-EMILE BLANCHE,
André Gide and His Friends at the
Exposition Universelle, 1901.
Oil on canvas, 156 × 220 cm.
Musée des Beaux-Arts, Rouen

88 (*opposite*)
HENRI EVENEPOEL, *The Spaniard in Paris*, 1899.
Oil on canvas, 215 × 150 cm.
Museum voor Schone Kunsten, Ghent (EU 1900)

89 (*right*)
JAMES ABBOTT MCNEILL WHISTLER,
Portrait of George W. Vanderbilt, 1897–1903.
Oil on canvas, 208.6 × 91.1 cm.
National Gallery of Art, Washington, D.C.
Gift of Edith Stuyvesant Gerry 1959.3.3 (EU 1900)

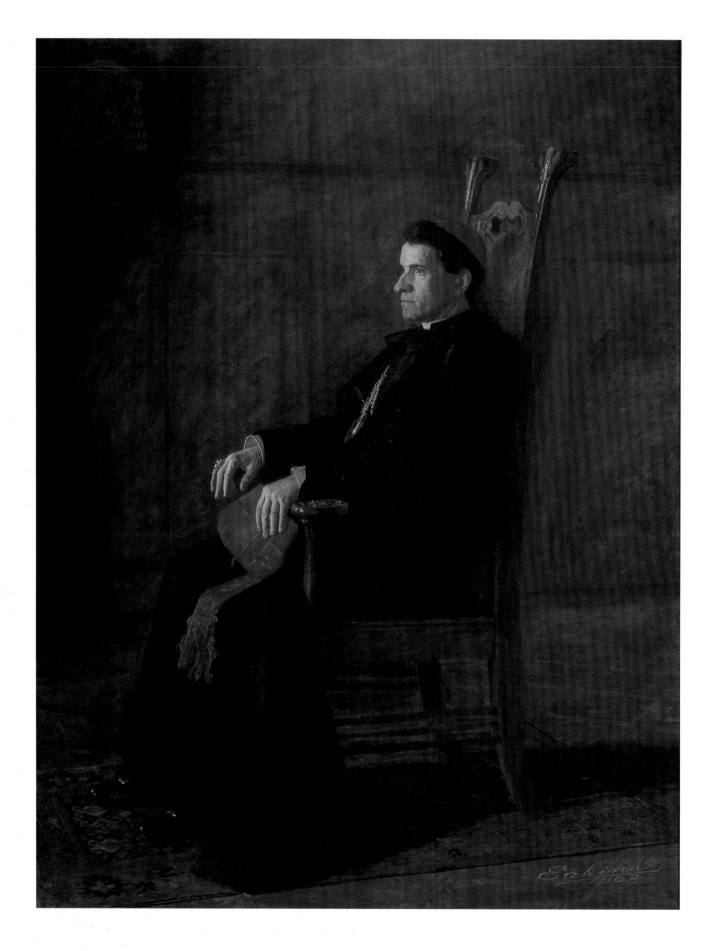

90 THOMAS EAKINS, *Portrait of Cardinal Sebastiano Martinelli*, 1902.
Oil on canvas, 199 × 152.4 cm. The Armand Hammer Collection, UCLA at the Armand Hammer Museum of Art and Cultural Center, Los Angeles

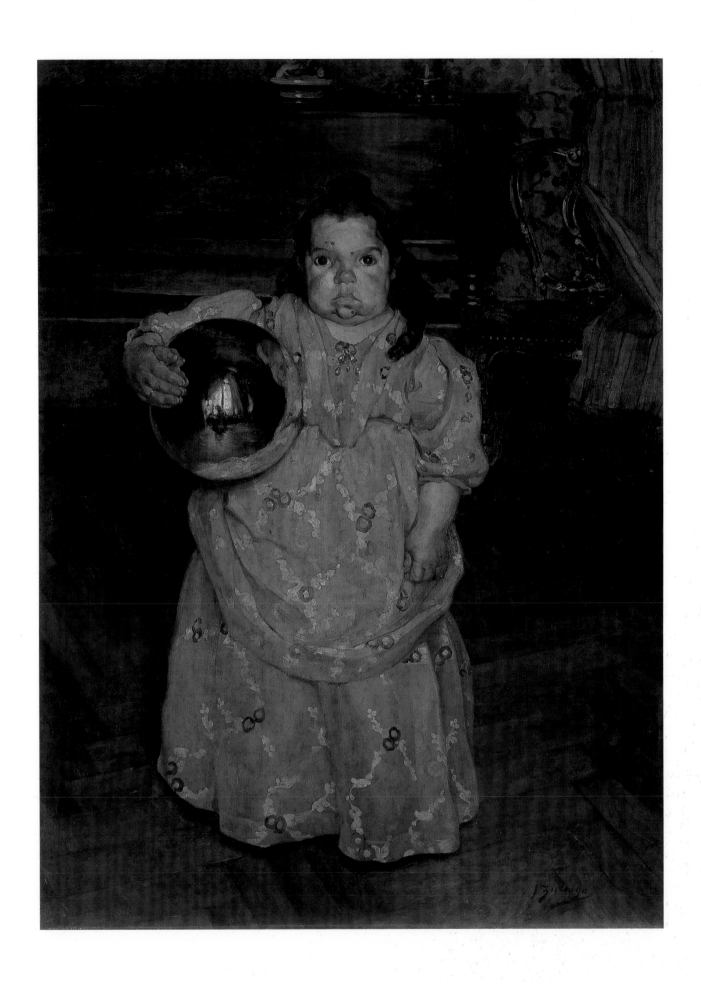

91 Ignacio Zuloaga, *Portrait of a Dwarf*, 1899. Oil on canvas, 150 × 55 cm. Musée d'Orsay, Paris

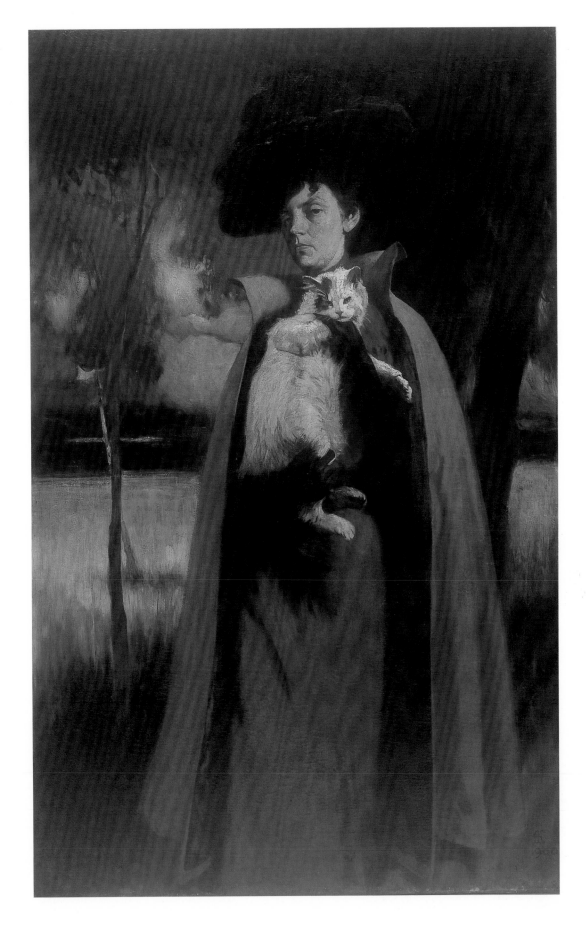

92 DMITRY KARDOVSKY, *Portrait of Marya Anastasievna Chroustchova*, 1900. Oil on canvas, 150.2 × 95 cm. Solomon R. Guggenheim Museum, New York (50.1289)

(*opposite*) Detail of cat. 91

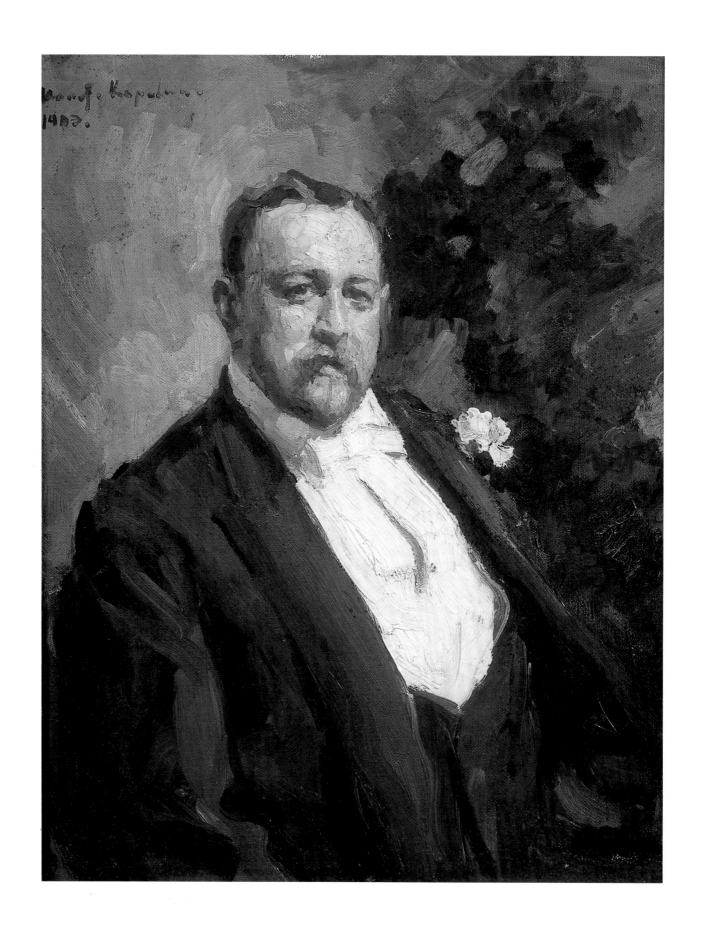

93 KONSTANTIN KOROVIN, *Portrait of Morozov*, 1902. Oil on canvas, 90.4 × 78.7 cm. State Tretyakov Gallery, Moscow

94 (*opposite*) AUGUSTE RODIN, *Balzac, c.* 1897. Bronze, 110.2 × 49 × 42.3 cm. Musée Rodin, Paris

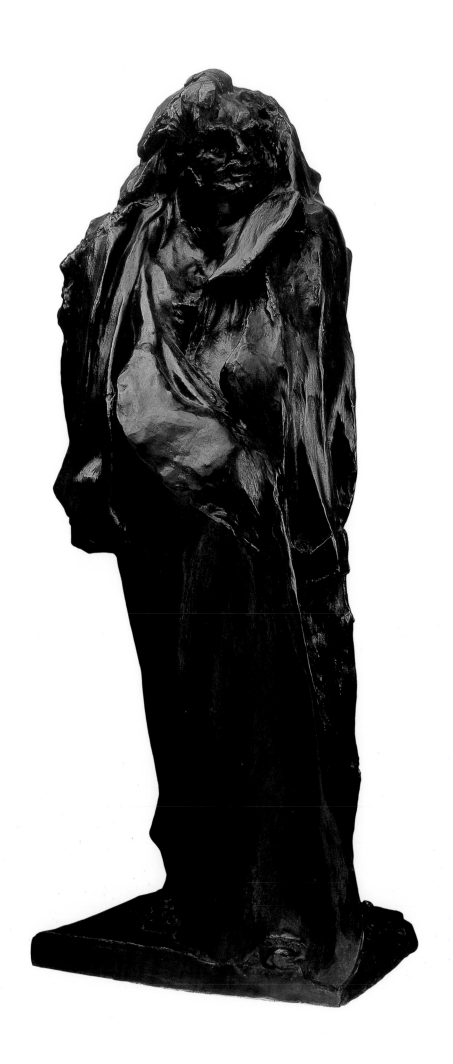

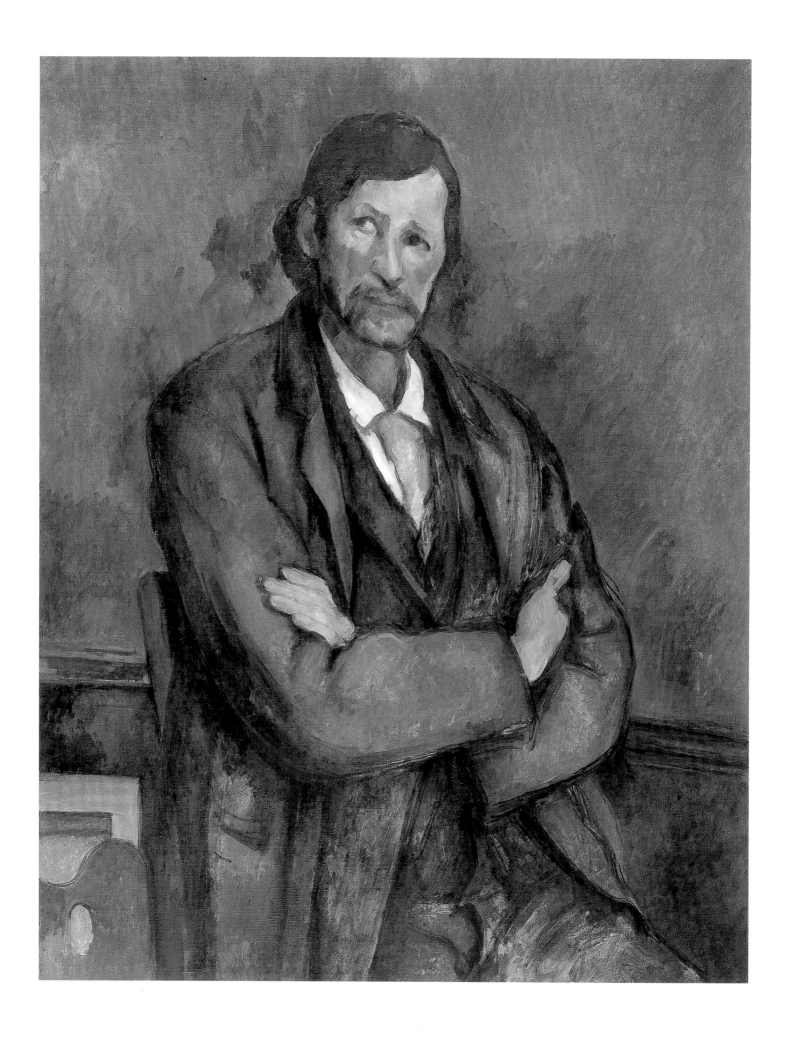

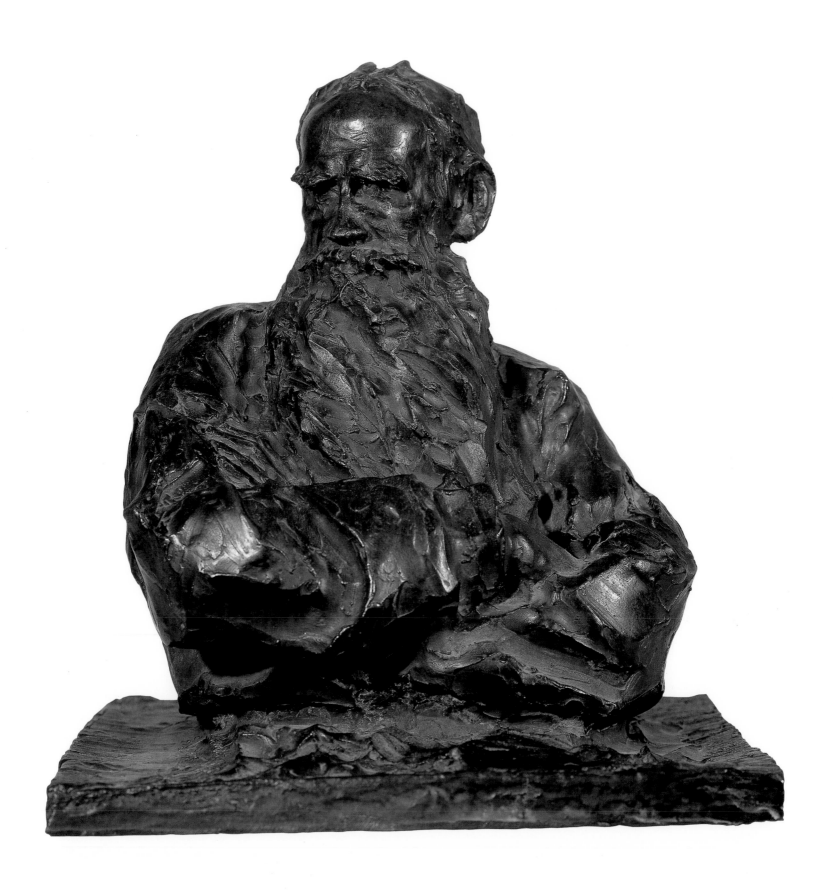

95 (*opposite*) PAUL CÉZANNE, *Man with Crossed Arms*, *c.* 1899. Oil on canvas, 92 × 72.7 cm. Solomon R. Guggenheim Museum, New York (54.1387)

96 (*above*) PRINCE PAOLO TROUBETZKOY, *Count Leo Tolstoy*, 1899. Bronze, 33 × 29 × 26 cm. Hatton Gallery, University of Newcastle-upon-Tyne (EU 1900)

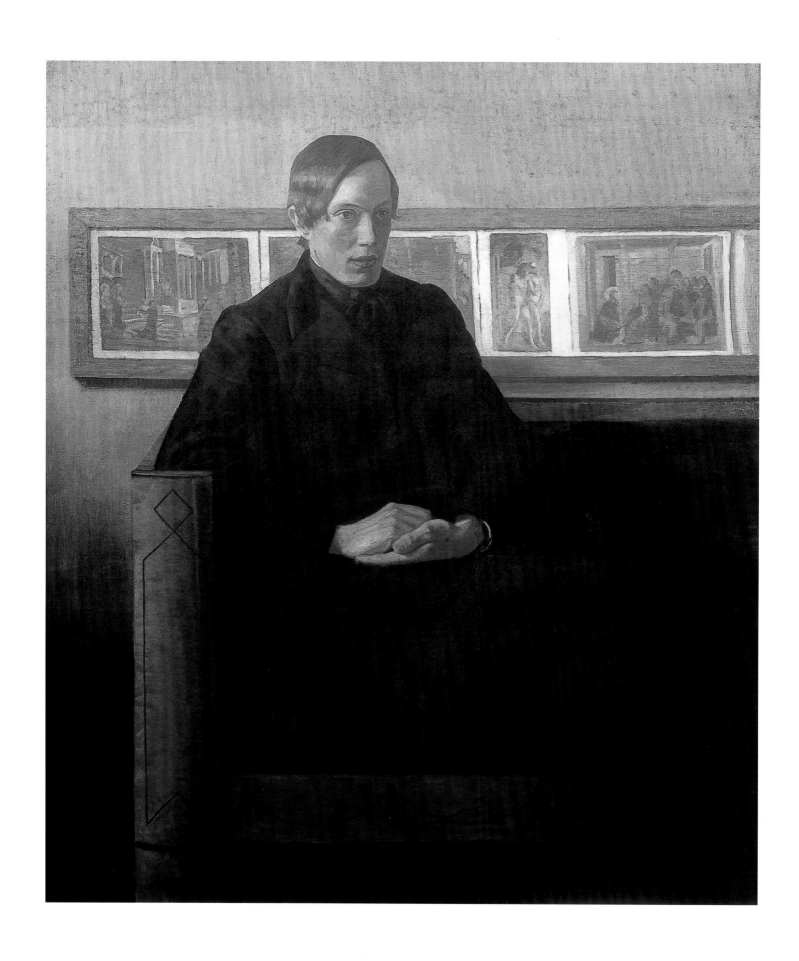

97 LUDVIG FIND, *Portrait of a Young Man. The Norwegian Painter Thorvald Erichsen*, 1897. Oil on canvas, 113 × 97.5 cm. The Hirschsprung Collection, Copenhagen (EU 1900)

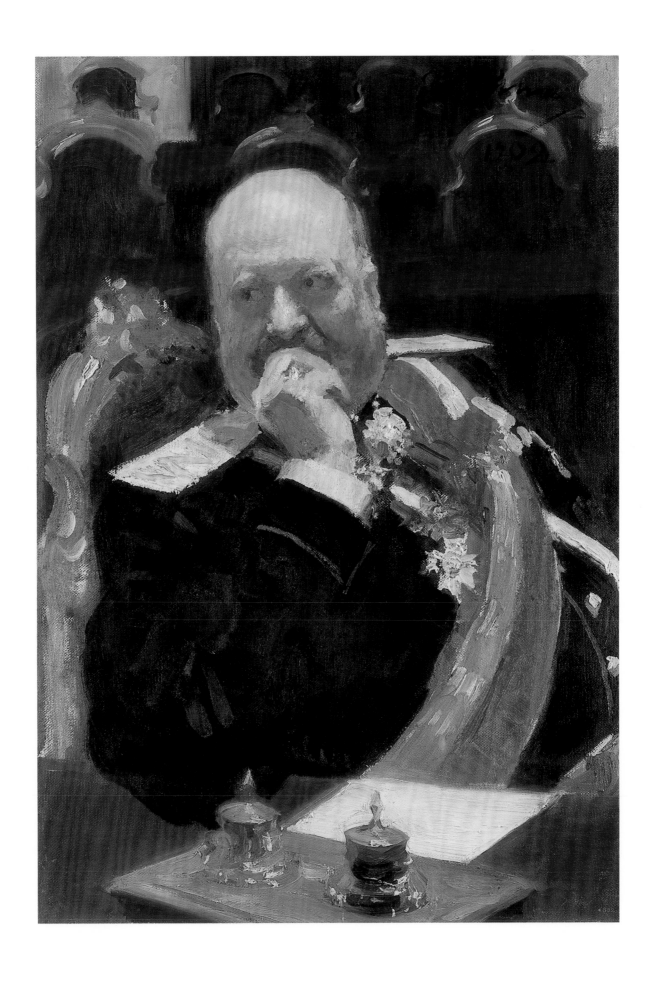

98 IL'YA REPIN, *Portrait Study of Ignatiev*, 1902. Oil on canvas, 89 × 62.5 cm. The State Russian Museum, St Petersburg

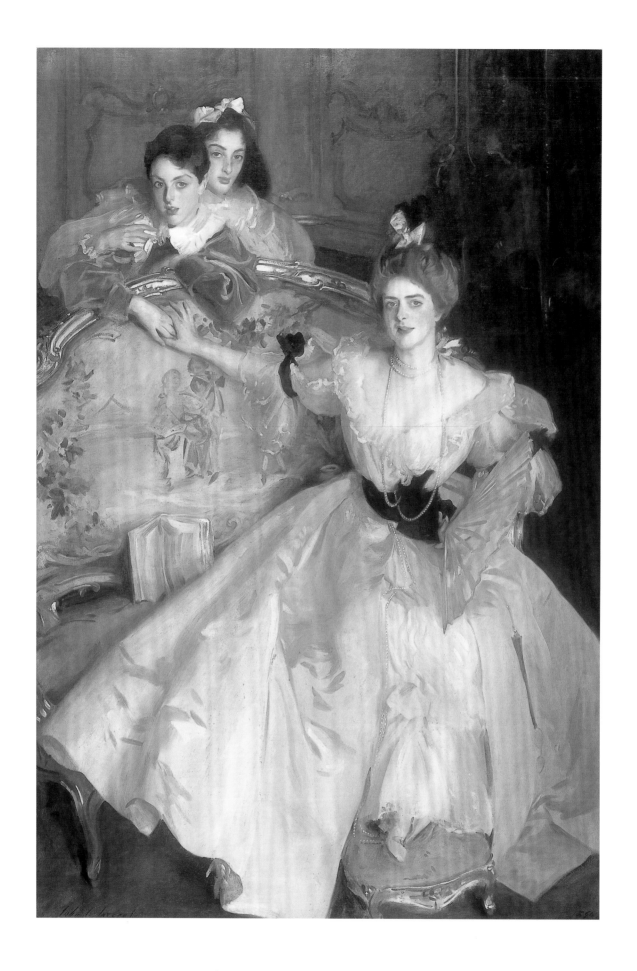

99 JOHN SINGER SARGENT, *Mrs Carl Meyer and Her Children*, 1895. Oil on canvas, 201.9 × 135.9 cm. Private Collection (EU 1900)

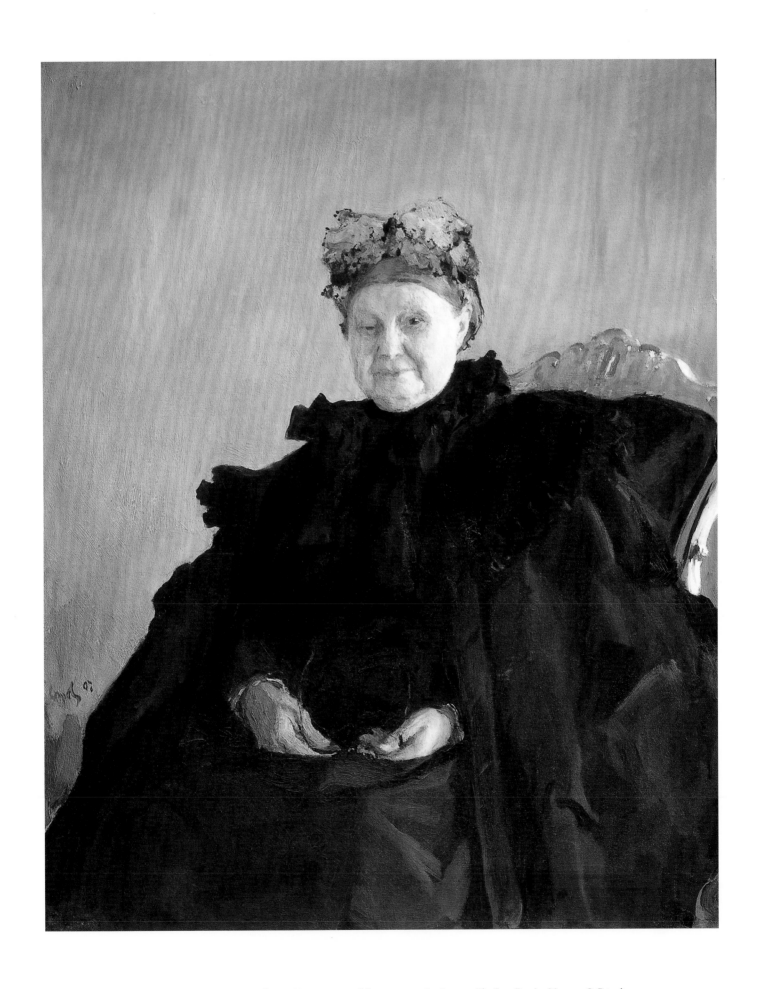

100 VALENTIN SEROV, *Portrait of Maria Morozova*, 1897. Oil on canvas, 108 × 87.5 cm. The State Russian Museum, St Petersburg

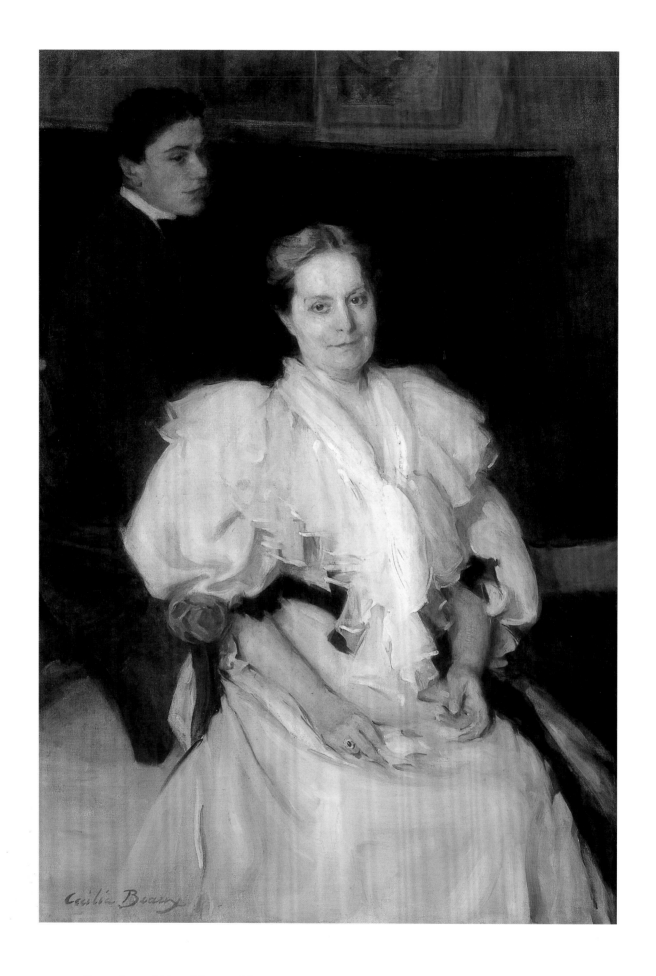

101 CECILIA BEAUX, *Mother and Son*, 1896. Oil on canvas, 145.4 × 101.6 cm. Amon Carter Museum, Fort Worth, Texas (EU 1900)

102 Sir John Lavery, *Father and Daughter*, 1900. Oil on canvas, 209 × 126 cm. Musée d'Orsay, Paris (EU 1900)

103 WALTER FREDERICK OSBORNE, *Dorothy and Irene Falkiner*, 1900. Oil on canvas, 149.9 × 114.3 cm. Private Collection, Greenwich, Connecticut (EU 1900)

104 AUGUSTE RENOIR, *The White Pierrot*, 1901–02. Oil on canvas, 81.3 × 62.2 cm. The Detroit Institute of Arts. Bequest of Robert H. Tannahill

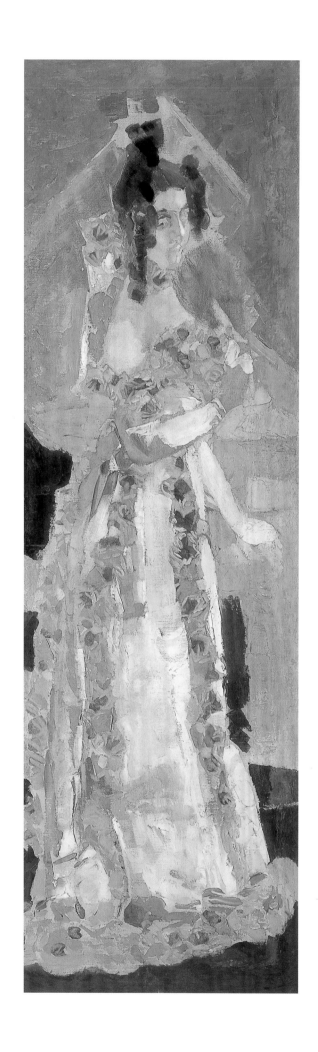

105
MIKHAIL VRUBEL,
Portrait of Nadezhda Sabela-Vrubel
at the Piano, c. 1900.
Oil on canvas, 189 × 60 cm.
State Tretyakov Gallery,
Moscow

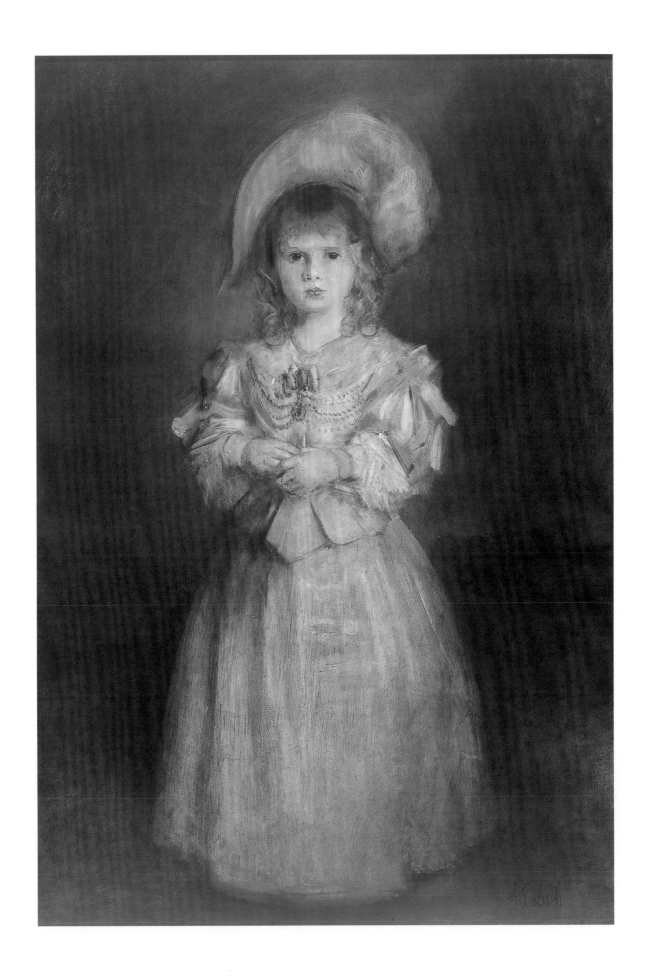

106 FRANZ VON LENBACH, *Portrait of Peggy Guggenheim*, *c.* 1903. Oil on board, 128.9 × 92.7 cm. The Solomon R. Guggenheim Foundation (98.5247)

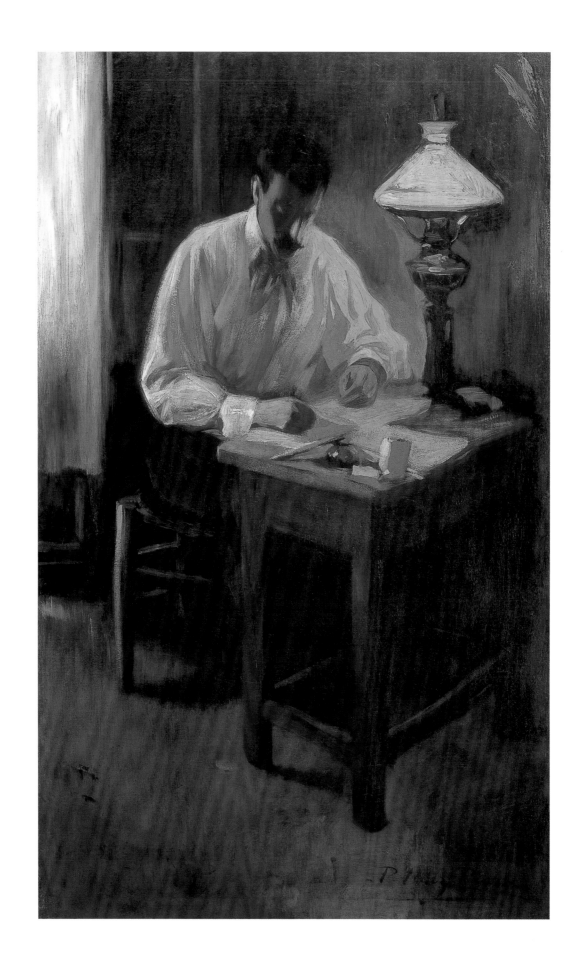

107 PABLO PICASSO, *Portrait of Josep Cardona*, 1899. Oil on canvas, 100 × 63 cm. Collection Valentin, São Paulo

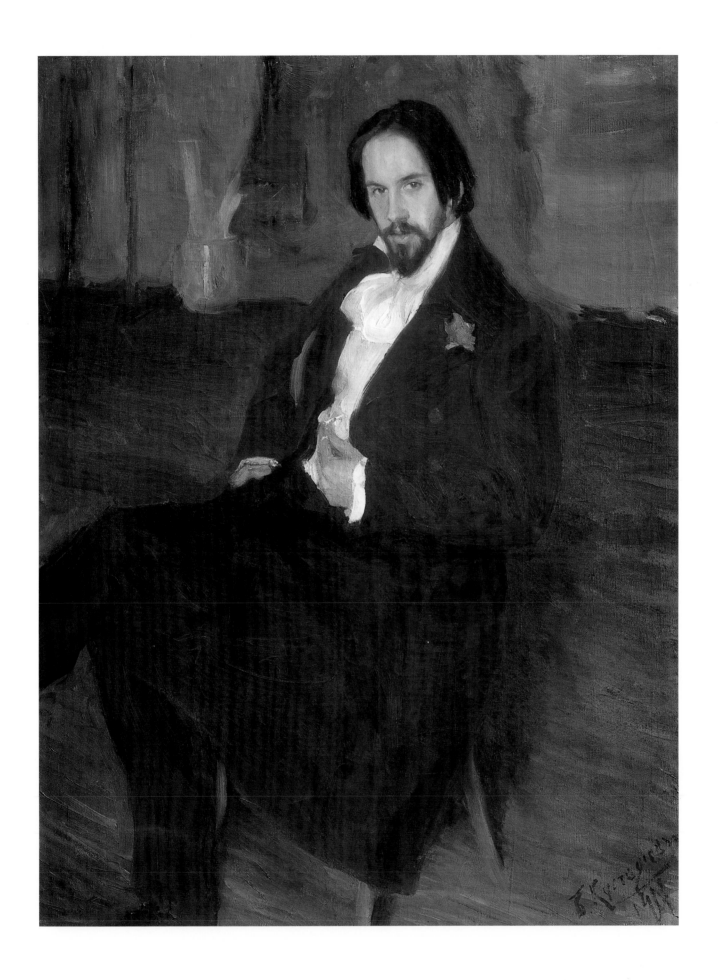

108 BORIS KUSTODIYEV, *Portrait of Bilibin*, 1901. Oil on canvas, 142 × 110 cm. The State Russian Museum, St Petersburg

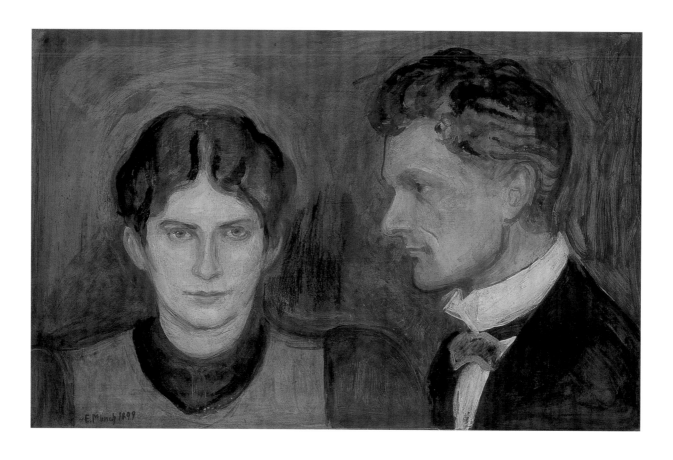

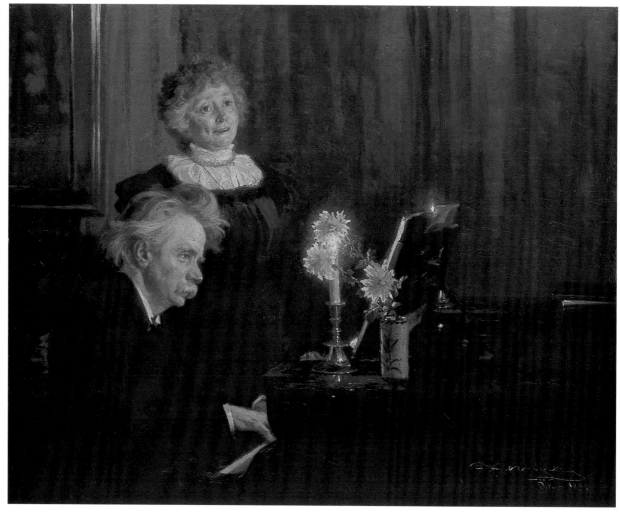

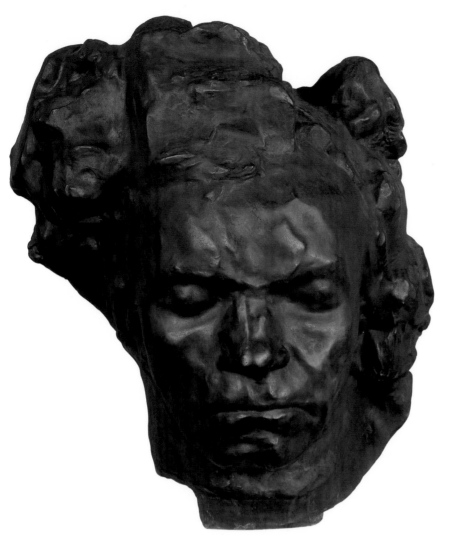

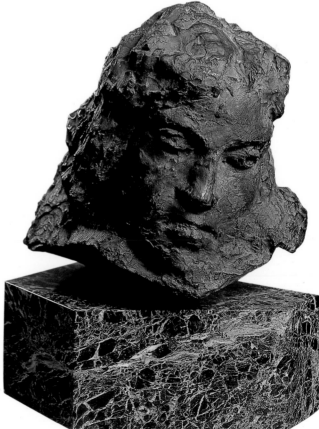

109 (opposite above)
EDVARD MUNCH,
Portrait of Aase and Harald Norregaard, 1899.
Oil on cardboard, 49.5 × 75 cm.
Nasjonalgalleriet, Oslo

110 (opposite below)
P. S. KRØYER,
Edvard and Nina Grieg at the Piano, 1898.
Oil on panel, 58.5 × 73 cm.
Nationalmuseum, Stockholm (EU 1900)

111 (above)
EMILE-ANTOINE BOURDELLE,
Beethoven Monumental Head, Study for the Metropolitan, 1902.
Bronze (Cast Godard no. 4), 64 × 65 × 50 cm.
Collection of Mrs Rhodia Dufet Bourdelle

112 (right)
MAX KLINGER,
Head of Brahms, 1901.
Bronze, 36.5 × 37 × 47 cm.
Museum der bildenden Künste, Leipzig

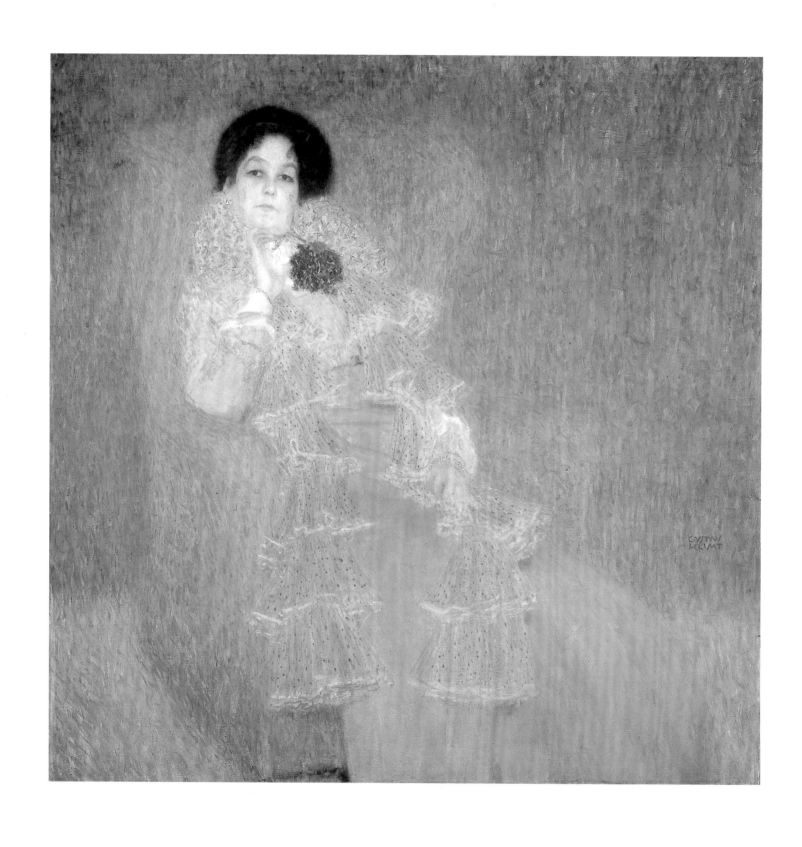

113 GUSTAV KLIMT, *Portrait of Marie Henneberg*, 1901–02.
Oil on canvas, 140 × 140 cm. Staatliche Galerie Moritzburg Halle, Landeskunstmuseum Sachsen-Anhalt

114 SIR GEORGE FRAMPTON, *The Marchioness of Granby*, 1902.
Marble, 74 × 61.5 × 30 cm. Courtesy Royal Academy of Arts, London

Social Scenes

By the end of the nineteenth century, the industrial city had become an established fact throughout most of the Western world. Its impact on the life of the individual provided artists with compelling material. In general, they shared with the great novelists of the period – Zola, Dostoevsky, Dickens and Tolstoy – a preoccupation with toil, disease and poverty, the dehumanising consequences of an alien social environment. But reactions to industrialisation were not exclusively negative. *The Coffee Factory* (cat. 116) by the Viennese artist Moll, for instance, is a luminous scene of quiet, productive industry in which the figures interact with the elegant formal pattern formed by the windows and grinding machines. Forbes's *Forging the Anchor* (cat. 115), a work chosen to represent Great Britain at the Exposition Universelle, presents a positive view of rugged, masculine labour painted in a vigorous, naturalistic style whose variety of dramatic lighting effects recalls the glowing scenes of forges and foundries by that early chronicler of the Industrial Revolution in England, Joseph Wright of Derby. Already in 1899, the evils of industrial pollution were being registered in a light-hearted but prophetic indictment by the Portuguese painter Freire (cat. 118) whose buoyant, fresh-air nymph, reminiscent of a champagne poster by Jules Chéret, floats in a crystal-clear stratosphere above a forest of chimneys belching smoke in the city below.

Workers downtrodden by unremitting labour elicited compassionate images from a number of artists including Adler (cat. 126), who, inspired by a passage from Zola's *L'Assommoir*, creates a cinematically naturalistic image of weary workers trudging to work in the chilly morning light of a Paris street. Responding to the appalling conditions in the coal-mining districts of his native Belgium, Meunier ennobled the dignity of human endurance in sculptures, such as *The Old Miner* (cat. 119), a prize-winner at the Exposition Universelle, that have the authority of Renaissance bronzes and also reveal their creator's admiration for Rodin.

Themes of social distress were particularly prevalent in Italy, where the Divisionist painters' bleak and haunting scenes of urban destitution anticipate by fifty years the stark imagery of Italian neo-realist cinema. Especially poignant is Morbelli's series of paintings of the Pio Albergo Trivulzio, an old-people's home in Milan, in which an emotive use of space and light emphasises the sadness of lives ending in destitution (cat. 125).

The innocent victims of venereal disease, another consequence of urban poverty, are the subject of works by the Spanish artist Sorolla, who was celebrated at the time for his bright palette and traditional painterly handling, and by the Norwegian Munch, whose condensed pictorial vocabulary abruptly shifted the language of painting to a more insistent and expressive register too avant-garde for inclusion in the official canon. In *Sad Inheritance* (cat. 122), which hung in the Exposition Universelle, Sorolla allies his elegant style to a subject that stands in stark contrast to the more familiar and halcyon views of seaside recreation by Krøyer and Sickert (cats 55, 54). Munch's young mother weeping over the wasted, syphilitic infant in her lap, his imminent death implied by the falling leaves on her skirt, is a heart-rending subversion of a hallowed image, the Madonna and Child of Christian iconography (cat. 123). AD

(opposite) Detail of cat. 115

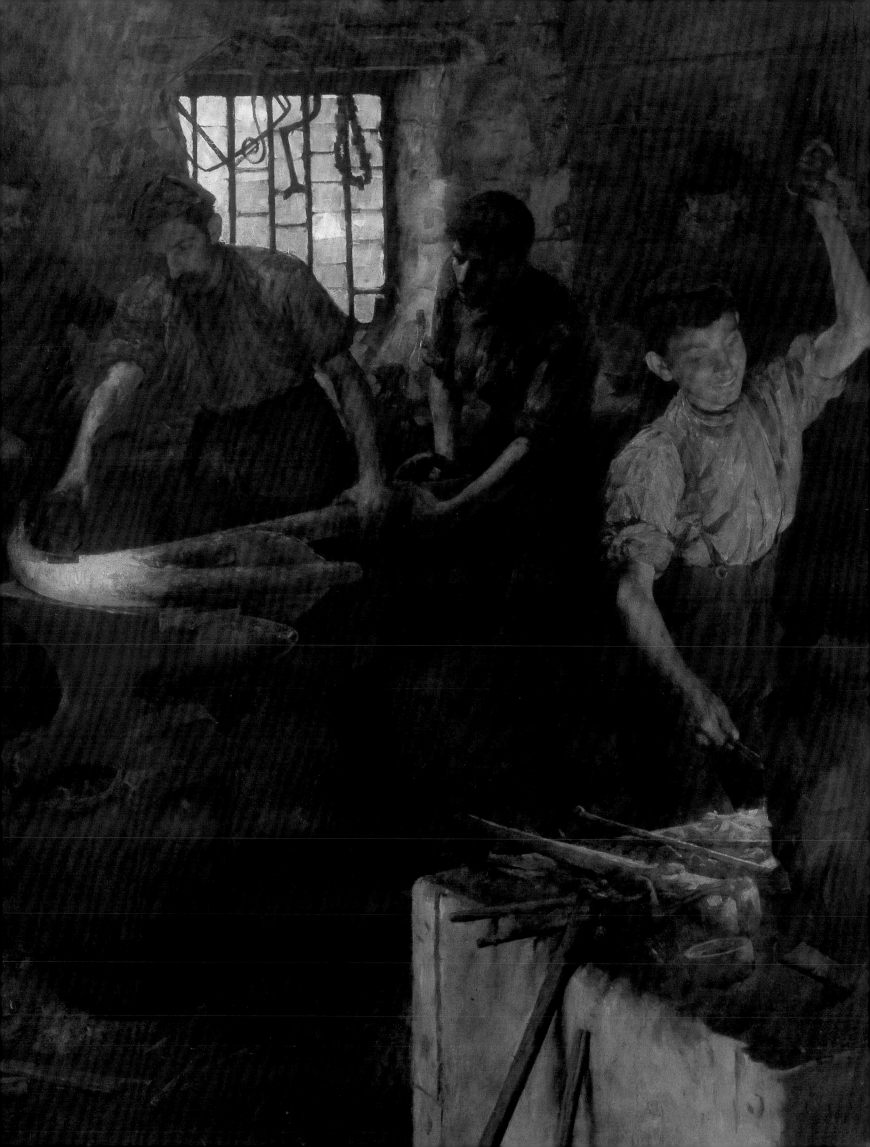

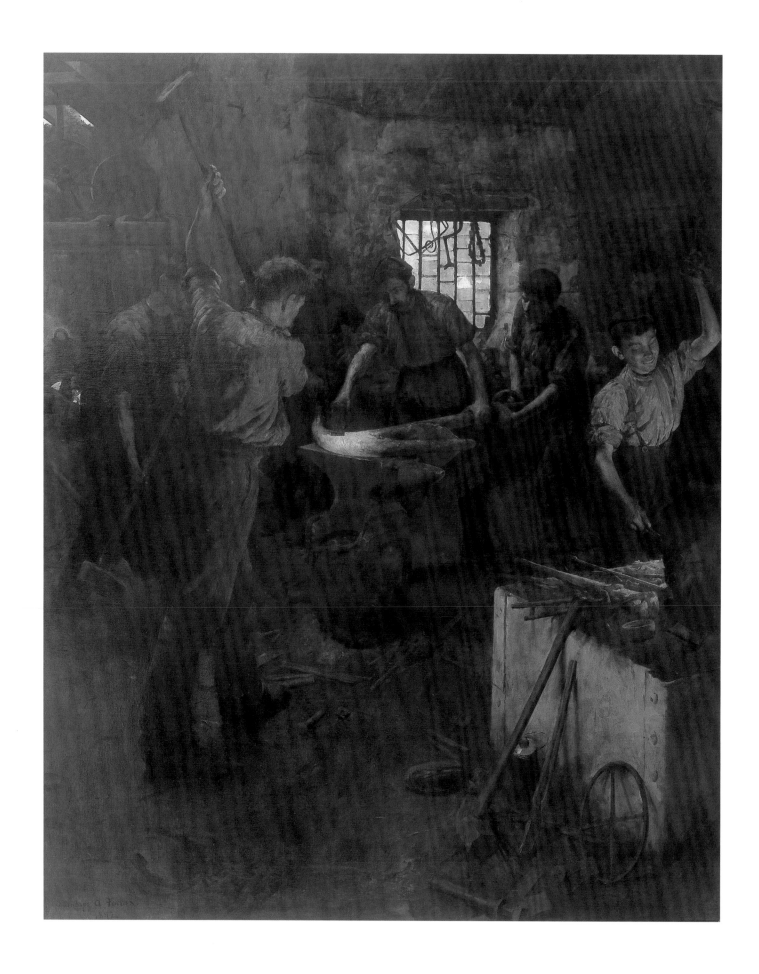

115 STANHOPE FORBES, *Forging the Anchor*, 1892. Oil on canvas, 214.6 × 172.7 cm. Ipswich Borough Council Museums and Galleries (EU 1900)

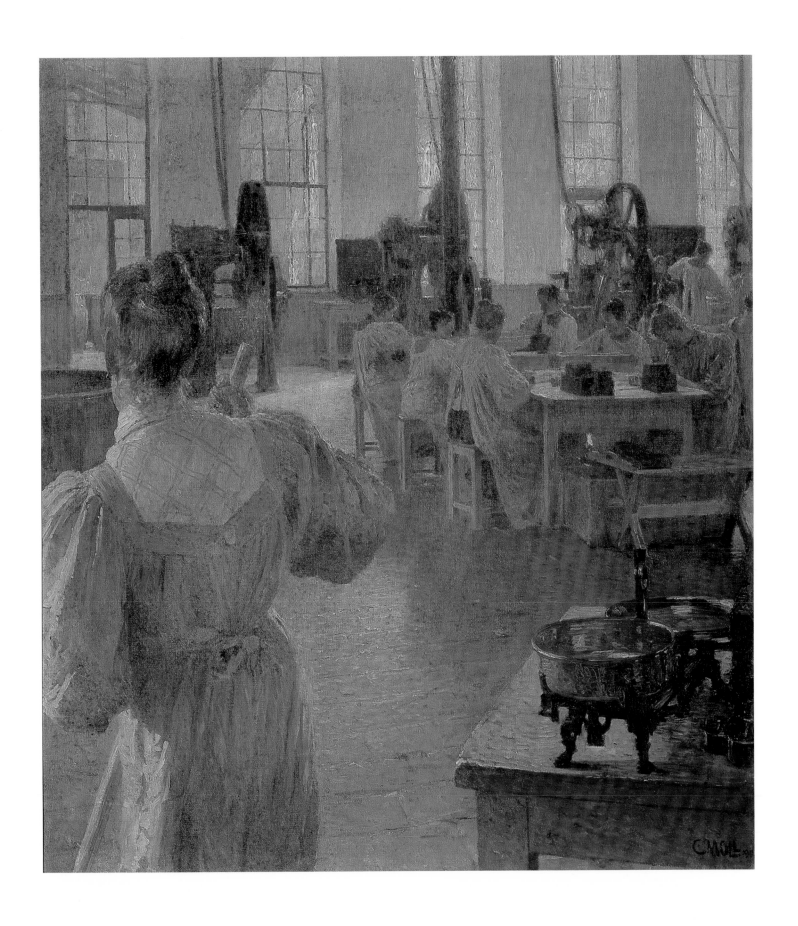

116 CARL MOLL, *The Coffee Factory*, 1900. Oil on canvas, 95.5 × 85.5 cm. Historisches Museum der Stadt, Vienna

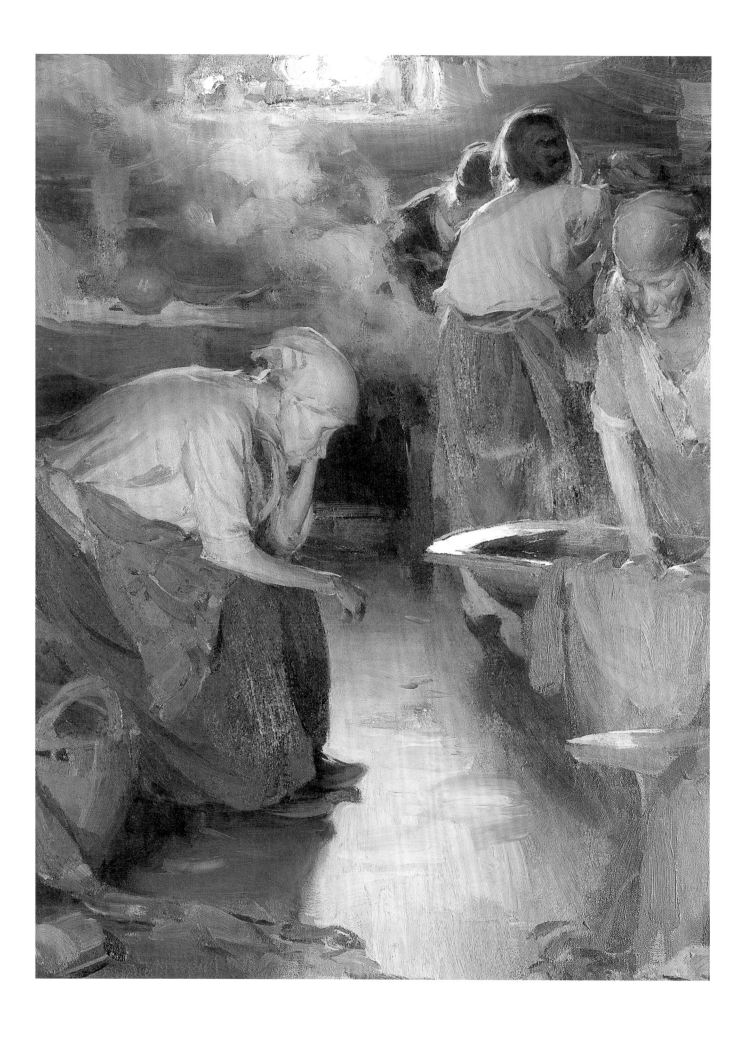

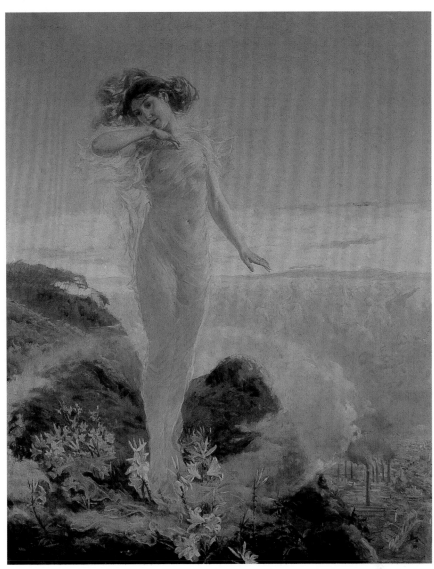

117 (*opposite*)
ABRAM ARKHIPOV,
The Laundresses, c. 1900.
Oil on canvas, 91 × 70 cm.
State Tretyakov Gallery, Moscow

118 (*above*)
LUCIANO FREIRE,
Country Perfume, 1899.
Oil on canvas, 200 × 160 cm.
Museu do Chiado, Lisbon, Inv. 29

119 (*left*)
CONSTANTIN MEUNIER,
The Old Miner, 1900.
Bronze, 61.5 × 41.5 × 28.6 cm.
Musées Royaux des Beaux-Arts de Belgique,
Brussel, inv. 10.000/676 (EU 1900)

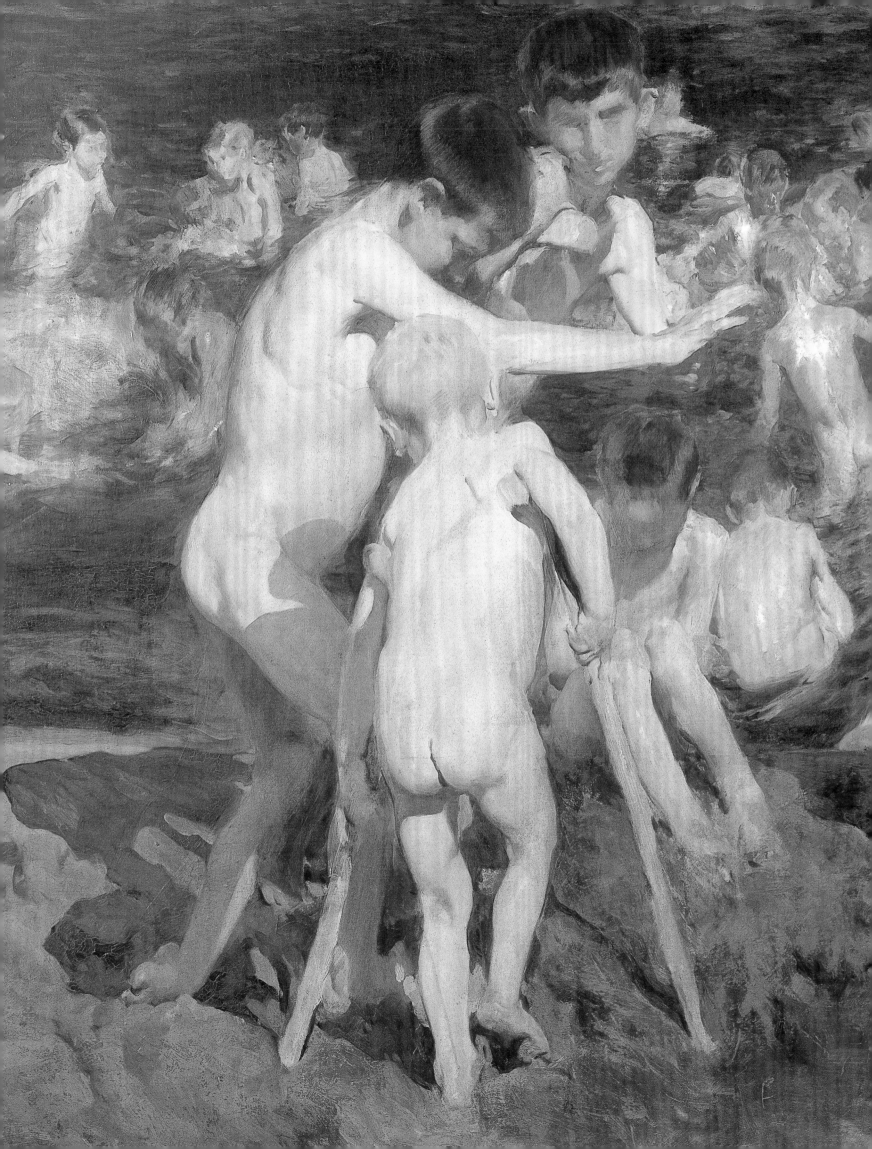

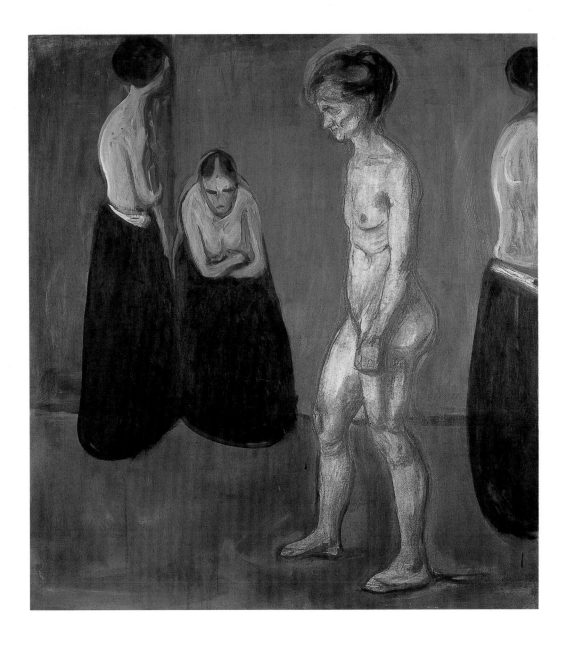

(*opposite*) Detail of cat. 122

120 (*above*)
EDVARD MUNCH,
Women in Hospital, 1897.
Oil on canvas, 110.5 × 101 cm.
Munch-Museet, Oslo

121 (*right*)
EUGÈNE ROBERT,
The Awakening of the Abandoned Child, 1894.
Marble, 50 × 130 × 85 cm.
Musée de l'Assistance Publique:
Hôpitaux de Paris (EU 1900)

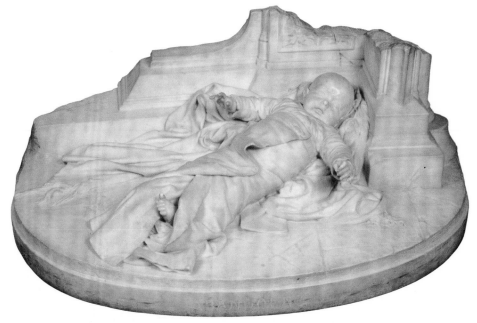

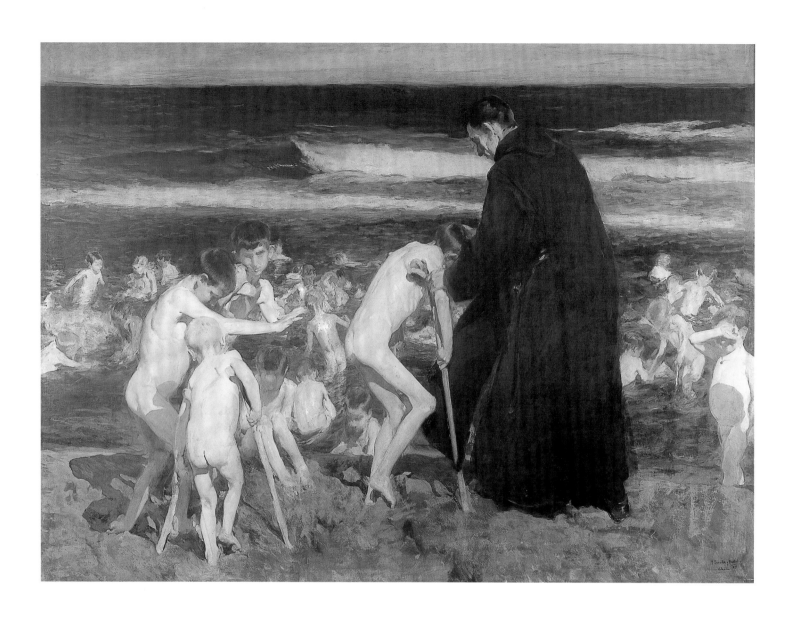

122 JOAQUÍN SOROLLA Y BASTIDA, *Sad Inheritance*, 1899.
Oil on canvas, 212 × 288 cm. Colección de la Caja de Ahorros de Valencia, Castellón y Alicante 'Bancaja' (EU 1900)

123 *(opposite)* EDVARD MUNCH, *Inheritance*, 1903–05. Oil on canvas, 119 × 100 cm. Munch-Museet, Oslo

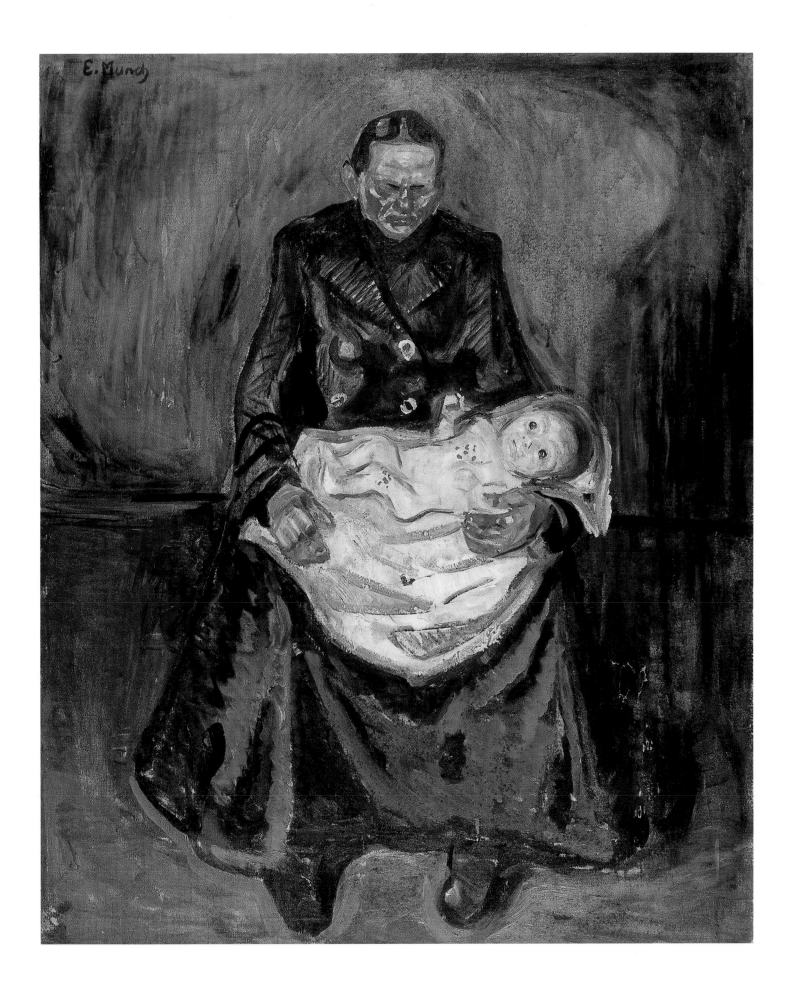

124 EMILE BERNARD, *Spanish Musicians*, 1897. Oil on canvas, 183 × 121 cm. Mme Béatrice Altarriba-Recchi

125 (right)
ANGELO MORBELLI,
When I Was a Little Girl (Entremets), 1903.
Oil on canvas, 71 × 110.5 cm.
Private Collection, Italy

126 (below)
JULES ADLER,
The Weary, 1897.
Oil on canvas, 181 × 251 cm.
Musée Calvet, Avignon (EU 1900)

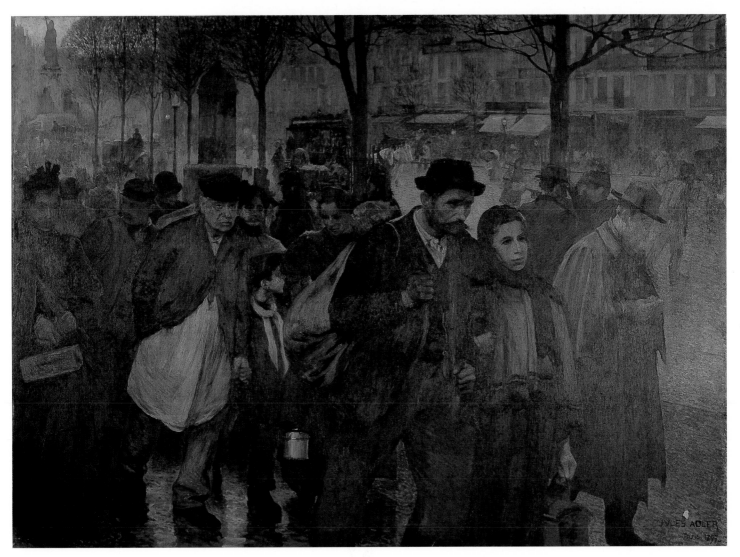

The City

The explosive growth of cities during the nineteenth century provided artists with a new realm of subjects. The Impressionists had been the first to capture in paint the experience of the modern city, specifically Haussmann's remodelling of Paris. In a reappraisal of early Impressionist views of the new boulevards, Pissarro (cat. 129) employs mere dabs and dashes of paint to render the syncopated criss-crossing rhythm of pedestrians and traffic in the street below his hotel window. The American artists Hassam and Henri brought a latter-day Impressionist technique, learnt in Paris, to their wintry New York street scenes (cats 130, 136, 134). And Rosso was the first artist to capture in sculpture the fleeting impression of a passer-by on a busy street (cat. 131).

Monet's *Charing Cross Bridge* (cat. 128), its ghostly silhouette arching across the Thames, finds a naturalist echo in the German painter Kuehl's more trenchant view of Dresden (cat. 127). Krohg, the leading figure in the Norwegian realist movement in the late nineteenth century, and Roberts, a founder of the Australian Heidelberg school, both adopted a bright, French naturalist style, more indebted to Bastien-Lepage than the Impressionists, in their street scenes of Christiana (Oslo) (cat. 140) and Melbourne (cat. 138).

In Luce's *The Sainte Chapelle, Paris* (cat. 135) a myriad of neo-Impressionist dots coalesce into a shimmering kaleidoscope of colour and light in which the famous medieval building is only a backdrop to gaslit cafés and shops. Electricity brought a new lustre to the modern city and was proudly displayed in the sparkling silhouette of the Palais de l'Electricité, a stellar attraction at the 1900 Exposition Universelle captured by the young Italian proto-Futurist, Balla (cat. 142).

Towards the end of the nineteenth century, artists turned their attention to the unglamorous industrial urban fringes. The Dutch painter Breitner depicted the construction that abounded in Amsterdam as the city was extended (cat. 133). Gambogi's muted scene of barges in dry dock at Livorno (cat. 132) brings to mind the quiet melancholy of Seurat's or Signac's depictions of the despoiled outskirts of Paris. Kanokogi, one of a colony of Japanese *Yoga* painters who adapted Western realism to Japanese subjects, introduces a solitary kimono-clad figure, her back turned to us like the lone, contemplative figures of Romantic painting, into a bleak landscape of railway tracks leading to a desolate urban wasteland (cat. 139).

In addition to urban topography, artists were stimulated by the possibilities of city entertainment. Toulouse-Lautrec chronicled the low life of Montmartre (cat. 149) as well as an operatic performance outside Bordeaux (cat. 144). The Finnish painter Enckell concentrated on the inner experience of a concert audience (cat. 145), and Degas's lifelong fascination with ballet behind the scenes resulted in introspective images of remote and seemingly random groupings of dancers (cat. 152).

The familiar cafés and bars of the Paris of the Impressionists acquire a new expressiveness in Vlaminck's and Picasso's strident visual language which looks forward to Fauvism and Expressionism (cats 153, 154). Newly arrived from Barcelona, Picasso translated one of Impressionism's iconic images, the Moulin de la Galette, into a lurid scene of nocturnal decadence (cat. 141). With one of his characteristic shifts of style, a melancholy note creeps into his Blue Period vision of the margins of city life (cat. 150). AD

(opposite) Detail of cat. 139

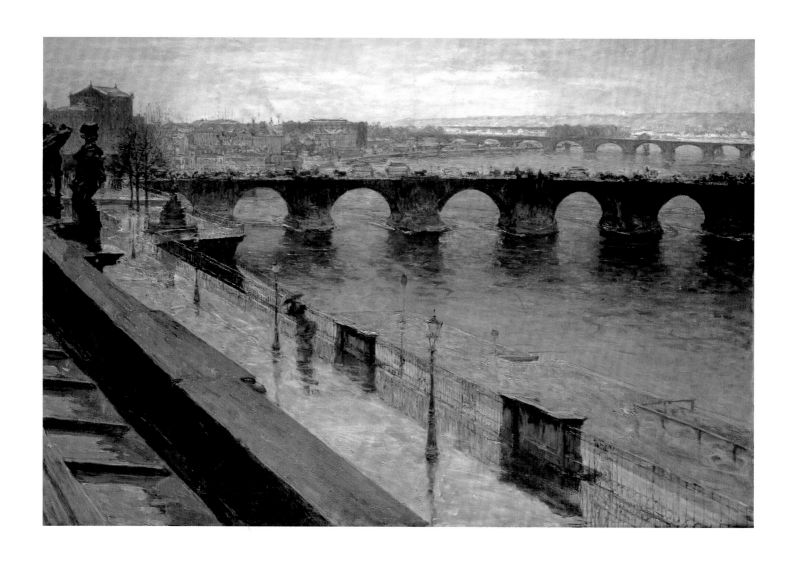

127 GOTTHARD JOHANN KUEHL, *The Augustus Bridge in Dresden, c.* 1899. Oil on canvas, 78 × 115 cm. Kunsthalle, Bremen

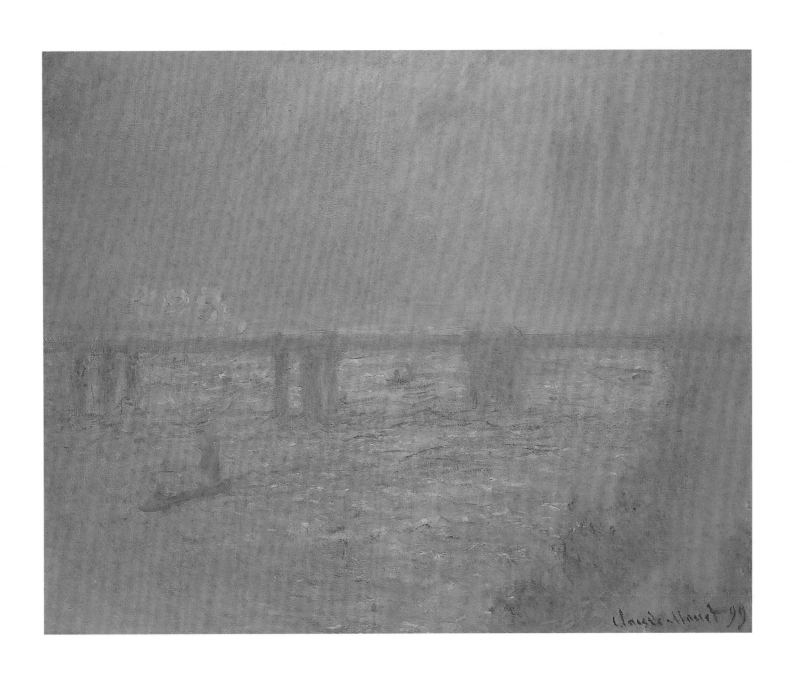

128 CLAUDE MONET, *Charing Cross Bridge*, 1899.
Oil on canvas, 65 × 81 cm. Santa Barbara Museum of Art. Bequest of Katherine Dexter McCormick in memory of her husband, Stanley McCormick

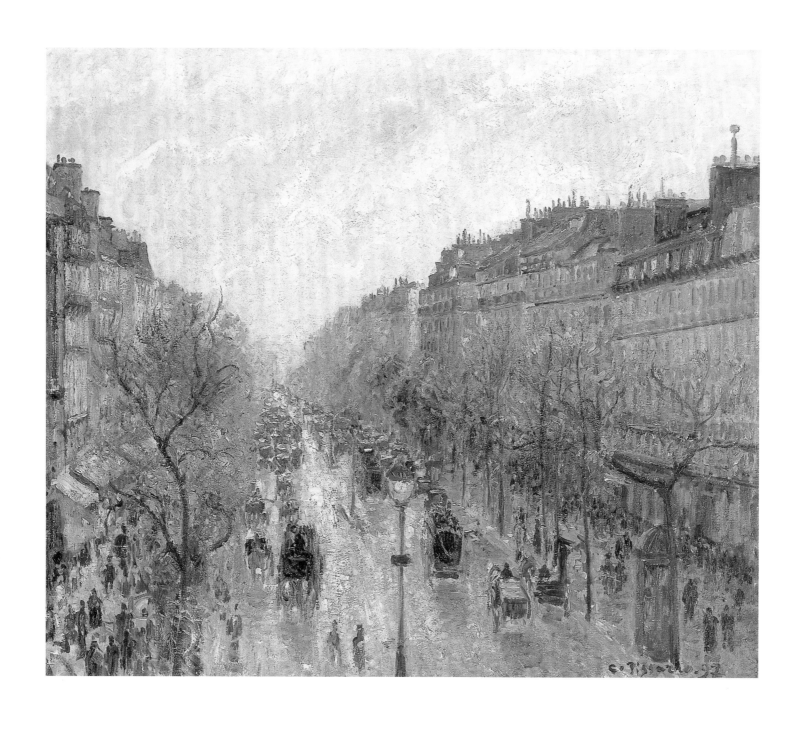

129 CAMILLE PISSARRO, *Boulevard Montmartre: Foggy Morning*, 1897. Oil on canvas, 55 × 64.7 cm. Private Collection

130 (*opposite*) CHILDE HASSAM, *Late Afternoon, New York: Winter*, 1900. Oil on canvas, 94 × 73.6 cm. Brooklyn Museum of Art. Dick S. Ramsay Fund 62.68

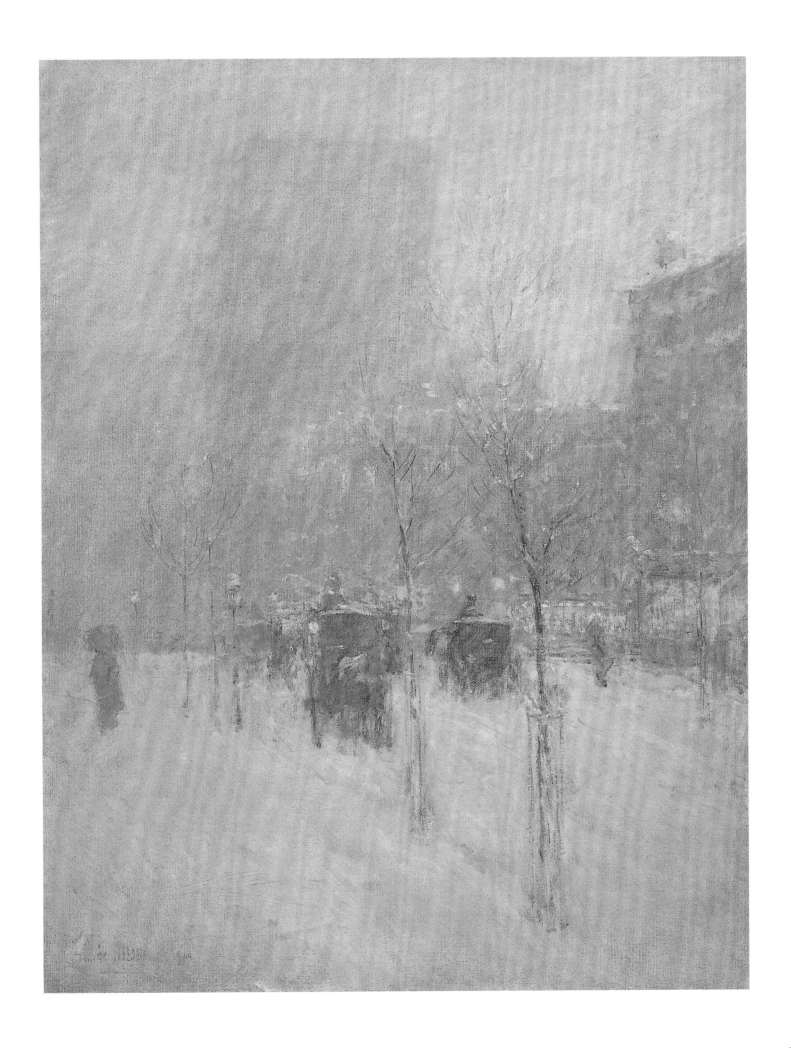

131 *(left)*
MEDARDO ROSSO,
Impression of the Boulevard. Woman with a Veil, 1893.
Wax, 60 × 59 × 25 cm.
Estorick Foundation, London

132 *(below)*
RAFFAELLO GAMBOGI,
Boats in Dry Dock at Livorno, 1897.
Oil on canvas, 78 × 137 cm.
Studio Paul Nicholls, Milan

133 *(opposite above)*
GEORGE HENDRIK BREITNER,
New Beginnings, Raadhuisstraat, 1897.
Oil on canvas, 60 × 81 cm.
Stedelijk Museum, Amsterdam

134 *(opposite below)*
ROBERT HENRI,
Street Scene with Snow (57th Street, NYC), 1902.
Oil on canvas, 66 × 81.2 cm.
Yale University Art Gallery.
Mabel Brady Garvan Collection

135 MAXIMILIEN LUCE, *The Sainte Chapelle, Paris*, 1902. Oil on canvas, 62.8 × 53 cm. Eugene A. Davidson and the late Suzette Morton Davidson

136 (*opposite above*) CHILDE HASSAM, *The Messenger Boy*, 1903. Oil on canvas, 46.4 × 81.9 cm. Museum of Art, Rhode Island School of Design. Jesse Metcalf Fund

137 (*opposite below*) ROBERT HENRI, *Cumulus Clouds, East River*, 1901–02. Oil on canvas, 63.5 × 80.6 cm.
National Museum of American Art, Smithsonian Institution. Partial and promised gift of Mrs Daniel Fraad in memory of her husband

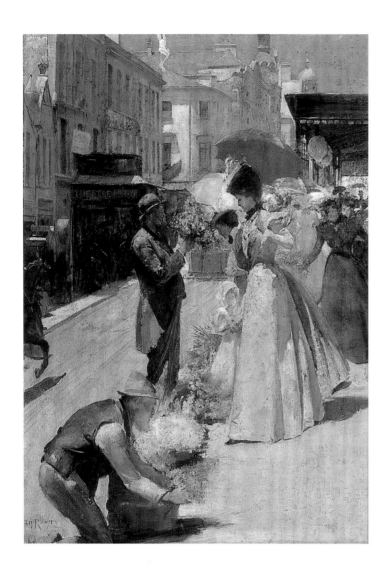

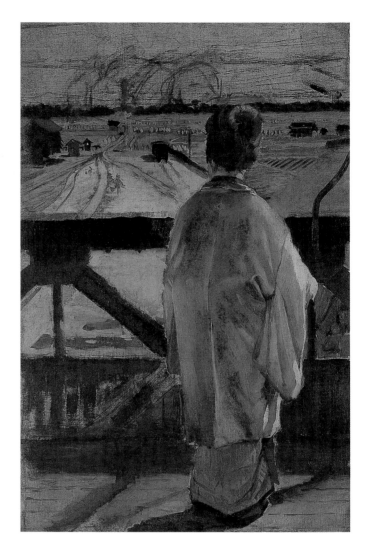

138 (*left*) TOM ROBERTS, *Christmas Flowers and Christmas Belles (The Flower Sellers)*, *c.* 1899. Oil on canvas, 52.1 × 36.2 cm. Manly Art Gallery & Museum

139 (*right*) TAKESHIRO KANOKOGI, *Tsu Station (Haruko)*, 1898. Oil on canvas, 57.1 × 39 cm. Mie Prefectural Art Museum

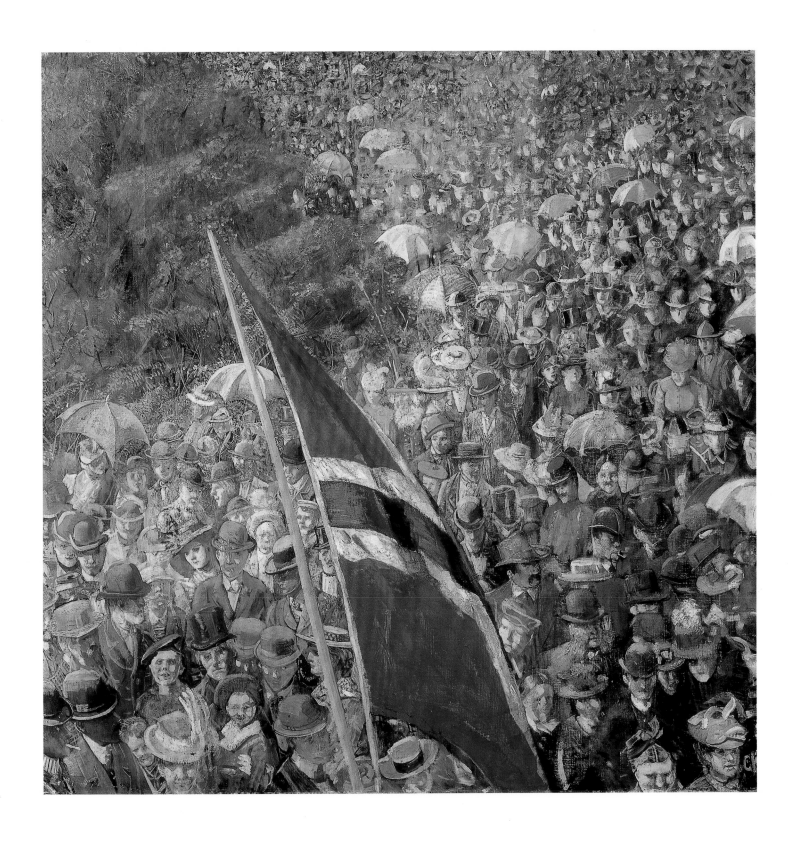

140 CHRISTIAN KROHG, *17 May 1898*, 1898. Oil on canvas, 132 × 133 cm. Private Collection

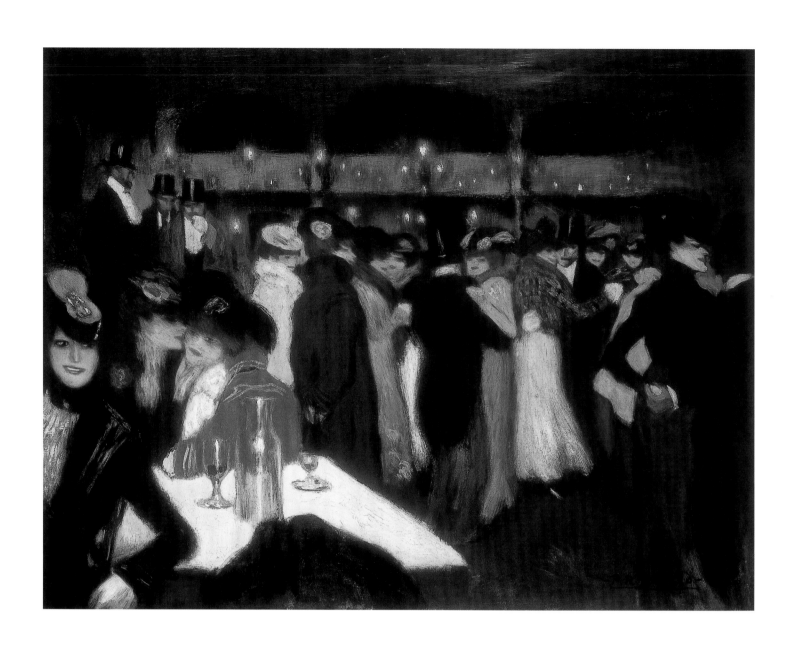

141 PABLO PICASSO, *Moulin de la Galette*, 1900.
Oil on canvas, 88.2 × 115.5 cm. Solomon R. Guggenheim Museum, New York, Thannhauser Collection. Gift of Justin K. Thannhauser (1978. 78.2514 T34)

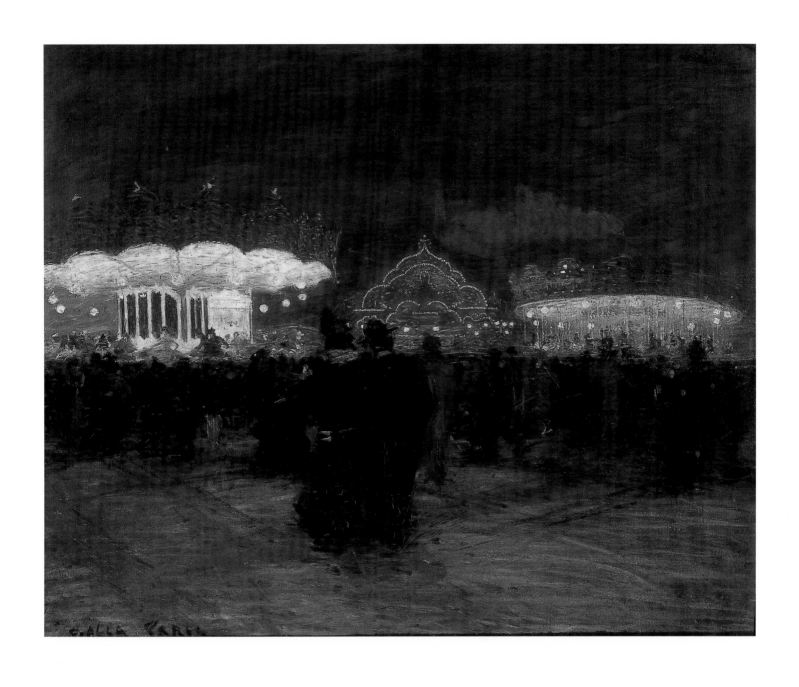

142 GIACOMO BALLA, *The World's Fair at Night (Luna Park)*, 1900. Oil on canvas, 65 × 81 cm. Civico Museo d'Arte Contemporanea, Milan

143 MIKHAIL VRUBEL, *Scene from 'Robert le Diable'*, 1896–97. Bronze, 91.5 × 137 × 124.5 cm. State Tretyakov Gallery, Moscow

144 (*opposite*) HENRI DE TOULOUSE-LAUTREC, *The Opera 'Messaline' at Bordeaux*, 1900–01.
Oil on canvas, 99.1 × 72.4 cm. The Los Angeles County Museum of Art. Mr and Mrs George Gard De Sylva Collection

145 Magnus Enckell, *The Concert*, 1898. Oil on canvas, 90 × 76 cm. The Finnish National Gallery Ateneum, Helsinki (EU 1900)

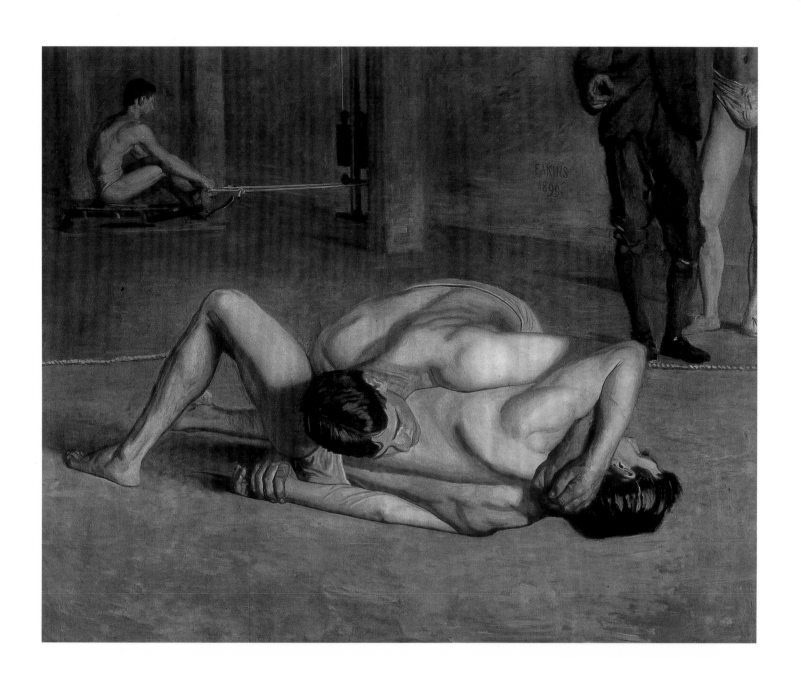

146 THOMAS EAKINS, *The Wrestlers*, 1899. Oil on canvas, 122.9 × 152.4 cm. Columbus Museum of Art, Ohio. Museum Purchase, Derby Fund

147 JOHN SLOAN, *The Rathskeller*, 1901. Oil on canvas, 90.5 × 69 cm. The Cleveland Museum of Art. Gift of the Hanna Fund 1946.164

148 Sir William Rothenstein, *A Doll's House*, 1899–1900. Oil on canvas, 88.9 × 61 cm. Tate Gallery. Presented by C. L. Rutherston 1917 (EU 1900)

149 HENRI DE TOULOUSE-LAUTREC, *In a Private Room at the 'Rat Mort'*, 1899. Oil on canvas, 55.1 × 46 cm. Courtauld Gallery, London (Samuel Courtauld Collection)

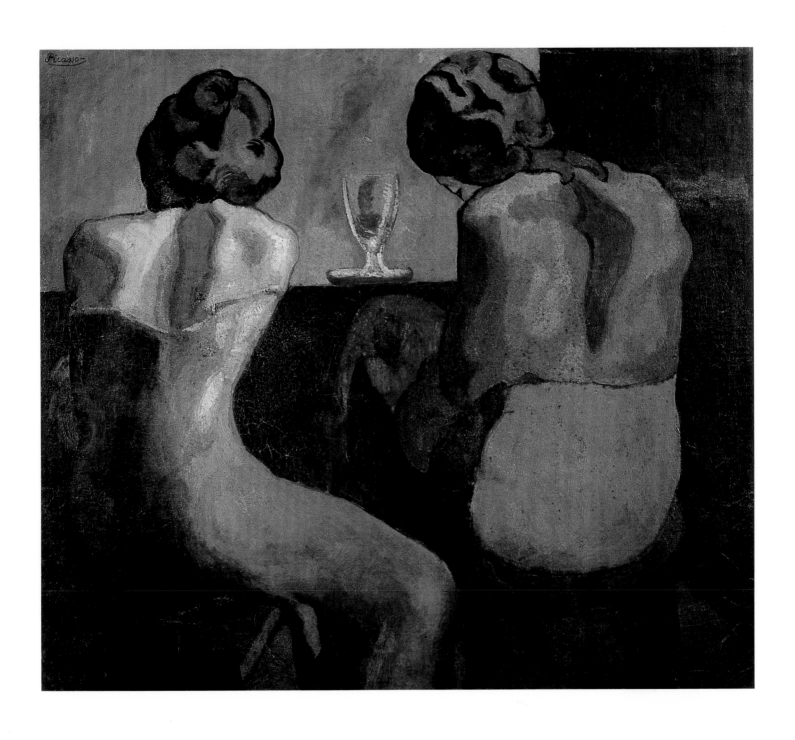

150 PABLO PICASSO, *Two Women at a Bar*, 1902. Oil on canvas, 80 × 91.5 cm. Hiroshima Museum of Art

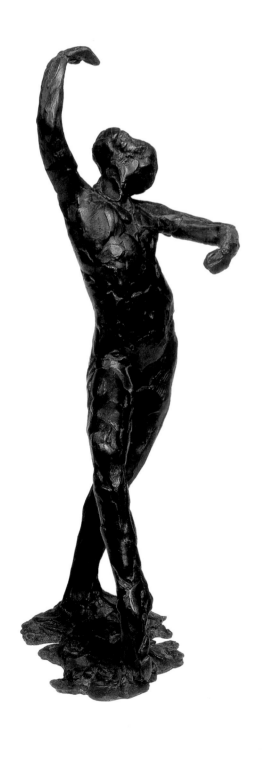

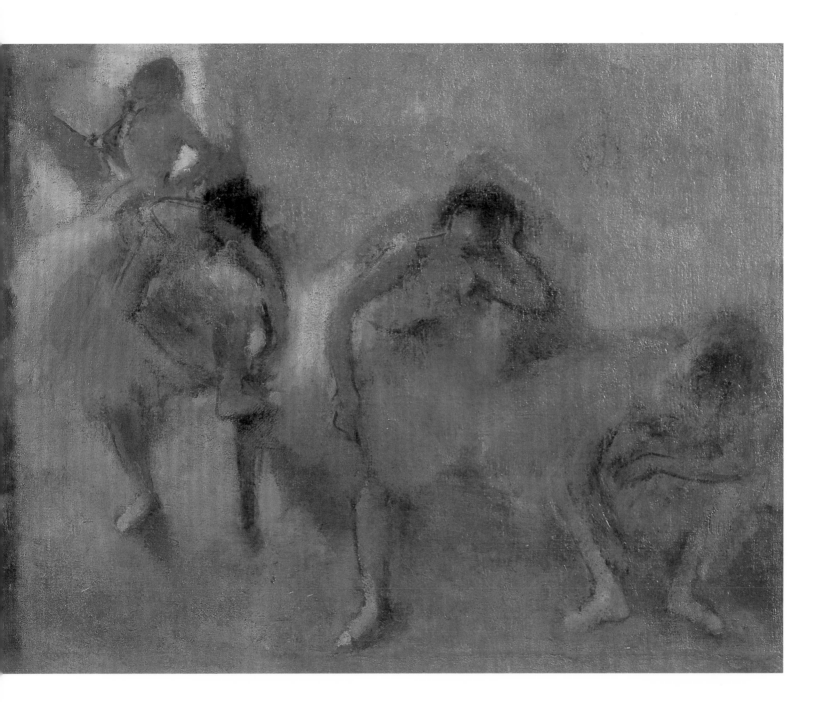

151 (*left*) EDGAR DEGAS, *Spanish Dance*, 1896–1911. Bronze, H. 40.4 × 16.5 × 17.8 cm. Solomon R. Guggenheim Museum, New York, Thannhauser Collection.
Gift of Justin K. Thannhauser, 1978

152 (*above*) EDGAR DEGAS, *At the Theatre: Dancers in the Wings*, 1898. Oil on canvas, 39 × 67 cm. Countess Gabrielle de Schallenberg

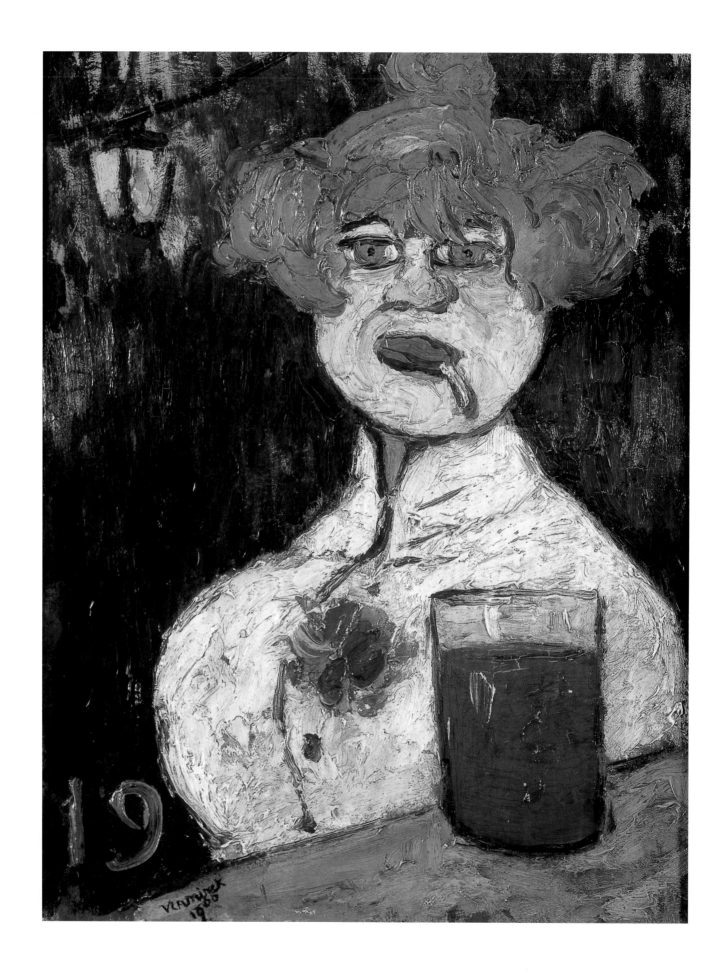

153 MAURICE DE VLAMINCK, *The Bar*, 1900. Oil on canvas, 40.3 × 31.1 cm. Musée Calvet, Avignon

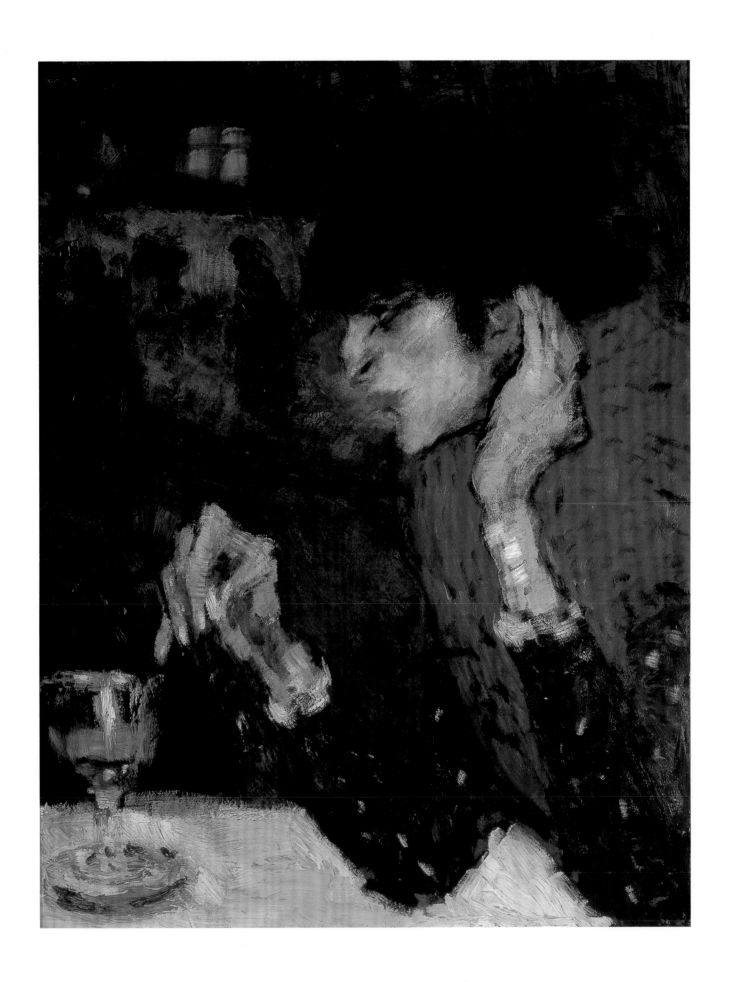

154 PABLO PICASSO, *The Absinthe Drinker*, 1901. Oil on cardboard, 65.5 × 51 cm. Private Collection

Interiors and Still-lifes

'The universe for the private citizen' is how the German social historian Walter Benjamin described the domestic interior. Much of the subject's appeal in late nineteenth-century painting sprang from the fact that it offered a haven from the parade of public life in the cities. At the same time, a period of middle-class prosperity fostered a passion for decor.

Moll's up-to-the-minute Vienna Secession interior (cat. 164) with its crisp geometric designs alludes to Dutch seventeenth-century precedents. The Danish painter Ancher's simple, country room flooded with luminous blue is an uncomplicated study of light (cat. 162), while a painting by the Norwegian Backer (cat. 163) is filled with the sense of someone who has left the room a moment before.

Meanwhile in France, the 'intimistes' Bonnard, Vuillard and Vallotton were painting interiors that reverberated with quiet, indefinable dramas. Vuillard in particular, with his densely layered patterns and textures that function as metaphors for the accretion of memory and personal association, managed to create extraordinarily palpable atmospheres (cat. 169). Even more hauntingly mysterious is Vallotton's *The Visit* (cat. 170), a rival to his remarkable wood-engravings in its quasi-cinematic observation of the psycho-drama that often lies just below the surface in the bourgeois home.

Frequently, interiors painted around the turn of the century are metaphors for an interiorised, psychological world of feeling. The hushed silence of the Danish painter Hammershøi's silvery room recalls the pristine calm of Danish Golden Age interiors, yet the empty spaces isolate the solitary figure in an island of introspection (cat. 158). Ring's portrayal of his wife lost in melancholy thoughts in the fading light of a firelit room (cat. 157) is echoed in Claudel's little sculpture of fireside reverie (cat. 155).

Three images of women seated against empty spaces pay homage, perhaps unconsciously, to Whistler's portrait of his mother, a painting that had acquired almost cult status by the end of the nineteenth century: Rothenstein's orderly composition (cat. 161) bespeaks a quiet life of pleasant occupation, Orpen's elegantly attired young woman (cat. 160) seems suspended in some faintly uneasy state of anticipation, and Rutherston's austerely composed scene (cat. 159) underlines the bleak life of the solitary seamstress. Whistler's muted palettes and japoniste *mises en scène* contribute to Maurer's *An Arrangement* (cat. 156), while a more obvious borrowing of Japanese accessories enriches the American Impressionist Chase's studio interior (cat. 166). Two other examples of this popular subject could not be more different: Matisse's studio (cat. 167) is a bare, workmanlike room, while Boldini's (cat. 168) explodes with a pyrotechnic display of brushwork charged with the Baroque energy of the Bernini bust on the mantelpiece.

As artists around 1900 felt their way towards new pictorial languages, the still-life offered fertile terrain for experiment. Cézanne's glowing bouquet (cat. 176), a tribute to the colouristic genius of Delacroix, betrays none of the pioneering analyses of space that Cézanne pursued in his other still-lifes. The legacy of these later examples of Cézanne's still-life output, combined with a contemporary veneer of Pointilliste dots, is taken up by Matisse in an opulent and complex still-life arrangement (cat. 177). For the Russian painter Jawlensky, still-life objects are a pretext for rich strokes of colour that take on their own independent identity (cat. 175). AD

(*opposite*) Detail of cat. 175

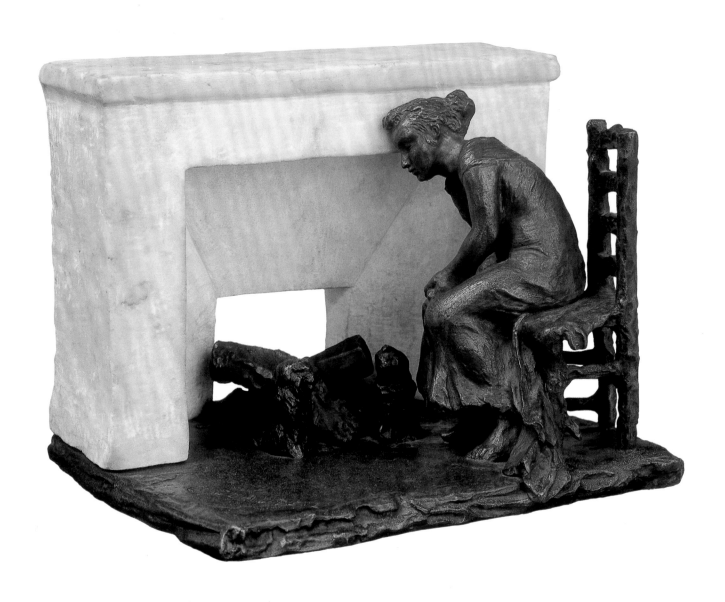

155 CAMILLE CLAUDEL, *Dreaming by the Fire*, 1899. Marble and bronze, 22.5 × 30 × 24 cm. Private Collection (EU 1900)

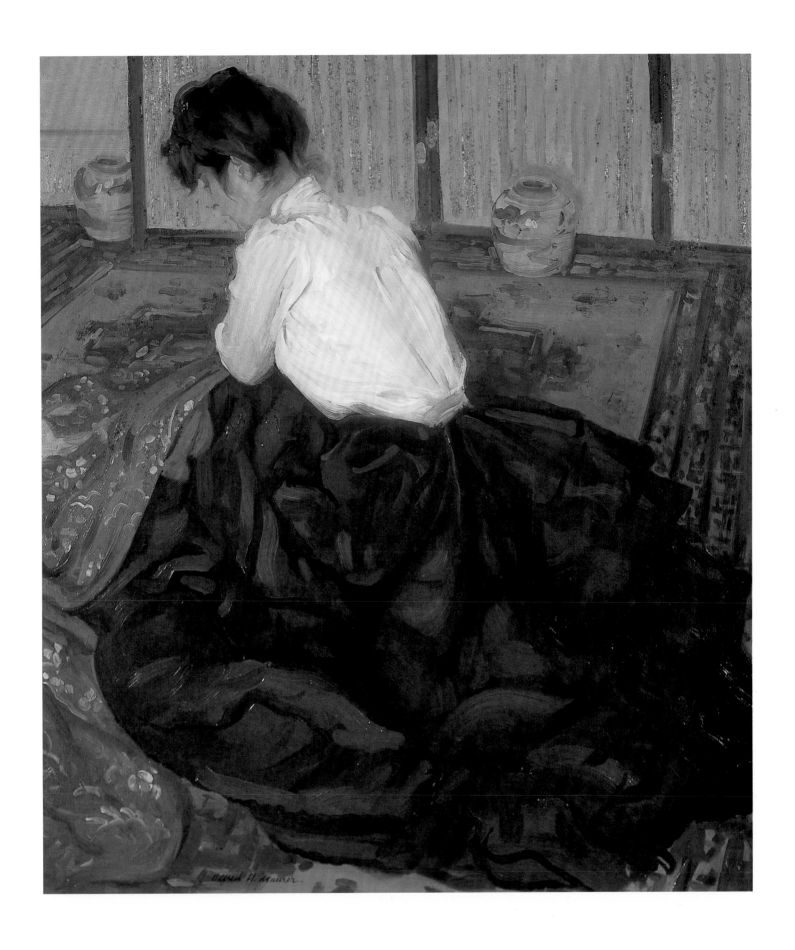

156 ALFRED H. MAURER, *An Arrangement*, 1901. Oil on cardboard, 91.4 × 81 cm. Whitney Museum of American Art, New York

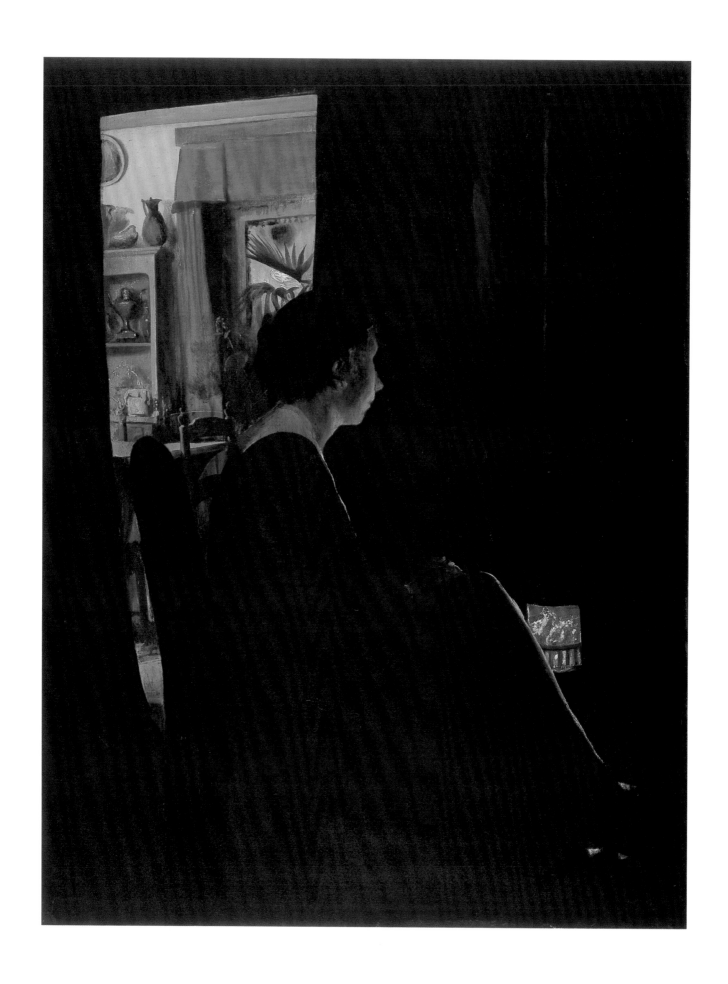

157 Laurits Andersen Ring, *Dusk, The Artist's Wife by the Stove*, 1898. Oil on canvas, 86 × 65.6 cm. Statens Museum for Kunst, Copenhagen

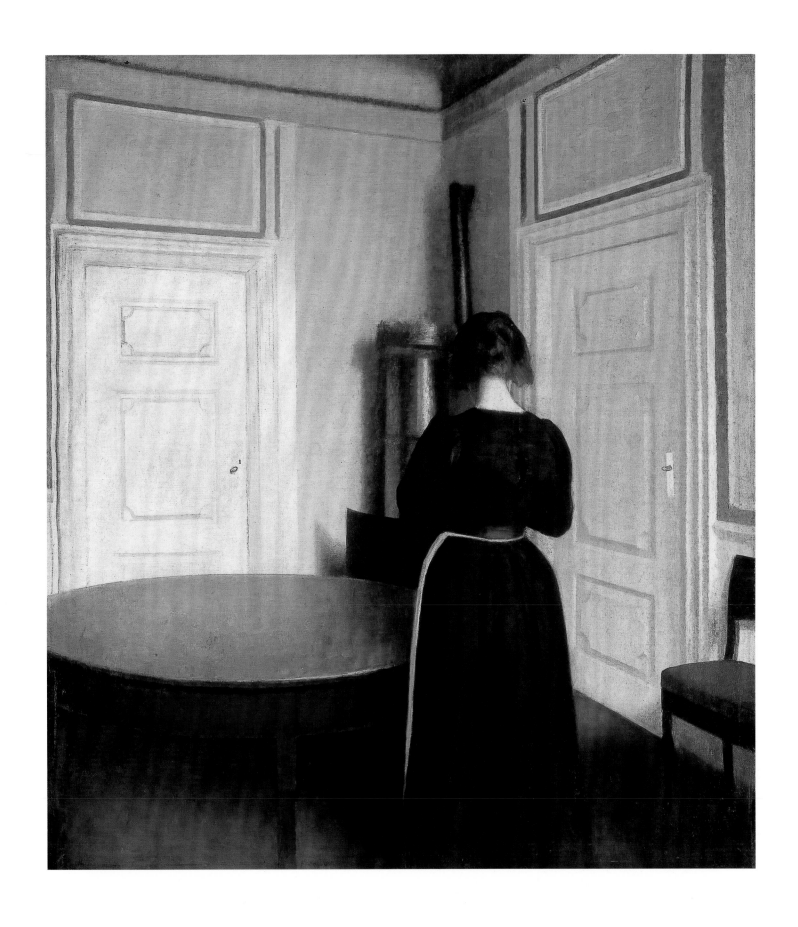

158 VILHELM HAMMERSHØI, *Interior*, 1899.
Oil on canvas, 64 × 57 cm. Tate Gallery. Presented in memory of Leonard Borwick by his friends through the National Art Collections Fund 1926

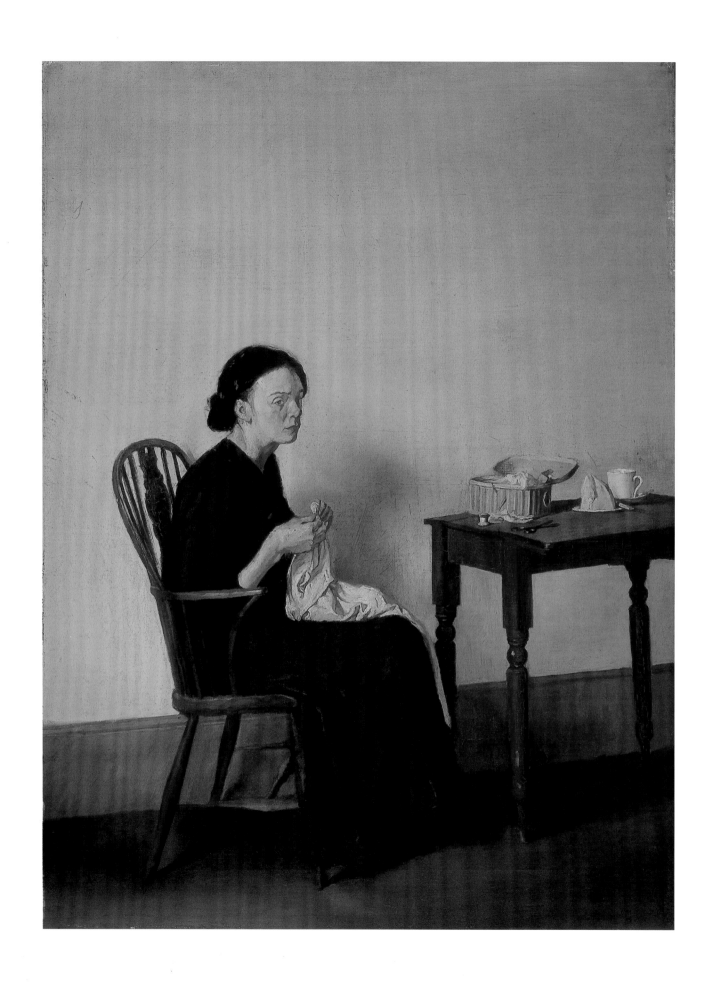

159 ALBERT RUTHERSTON, *The Song of the Shirt*, 1902. Oil on canvas, 76 × 58.5 cm. Bradford Art Galleries and Museums

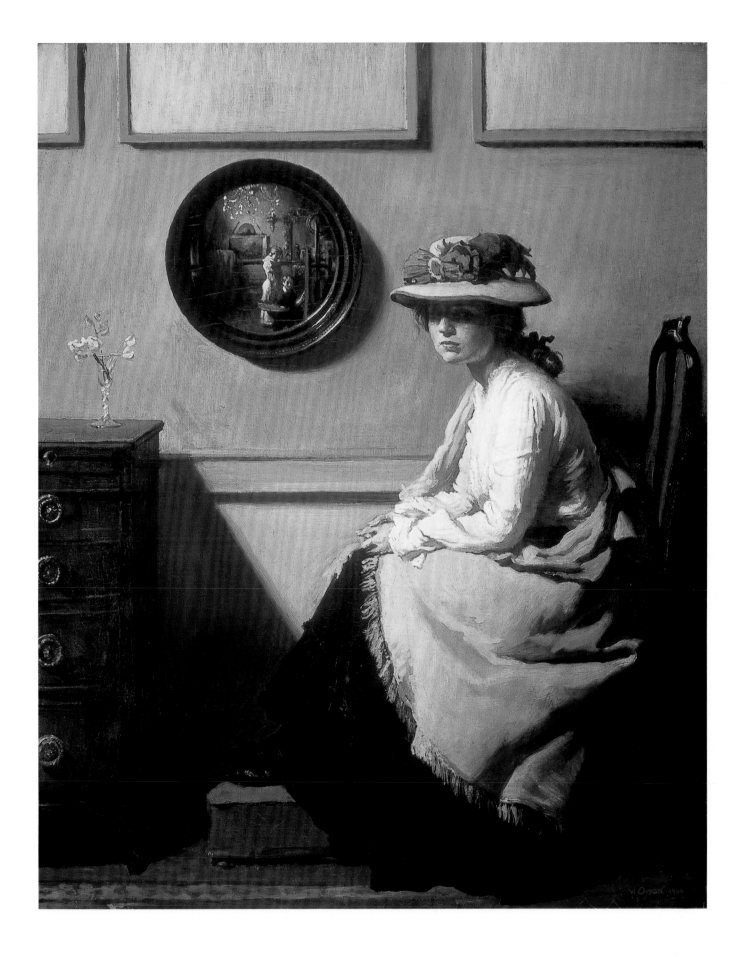

160 SIR WILLIAM ORPEN, *The Mirror*, 1900.
Oil on canvas, 50.8 × 40.6 cm. Tate Gallery. Presented by Mrs Coutts Michie through the National Art Collections Fund in memory of the George McCulloch Collection 1913

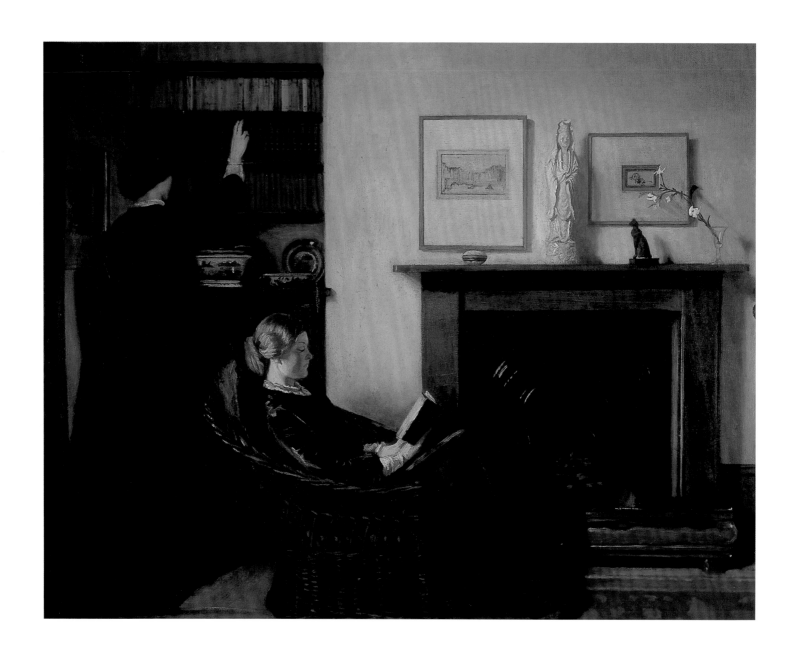

161 SIR WILLIAM ROTHENSTEIN, *The Browning Readers*, 1900. Oil on canvas, 76 × 96.5 cm. Bradford Art Galleries and Museums

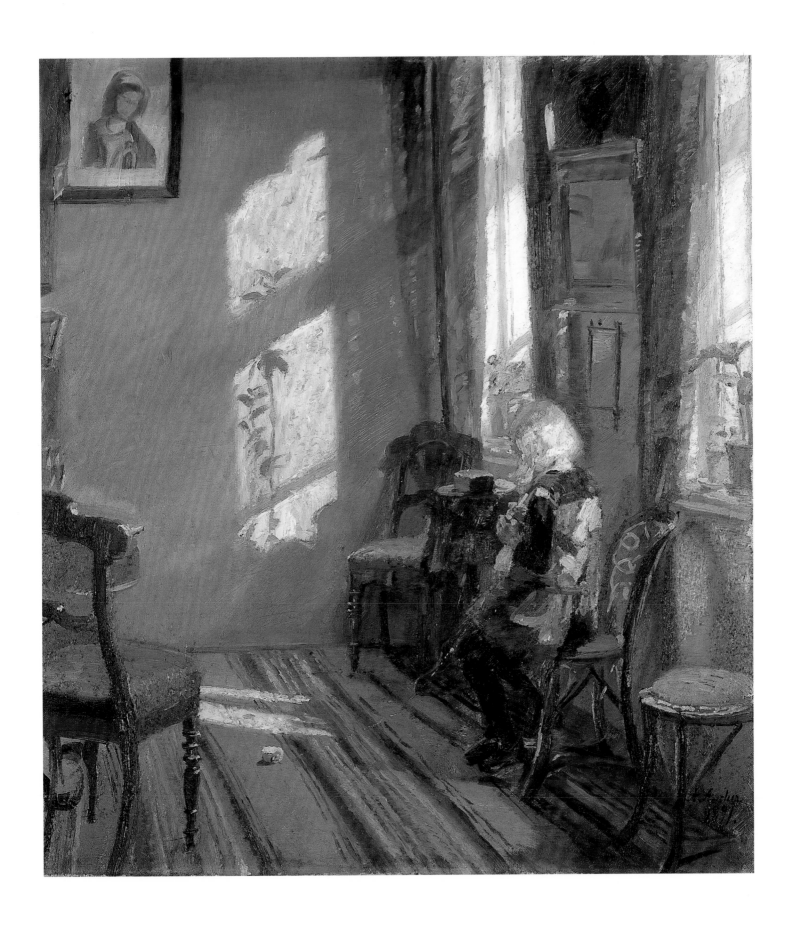

162 ANNA ANCHER, *Sunlight in the Blue Room*, 1891. Oil on canvas, 65.2 × 58.8 cm. Skagens Museum (EU 1900)

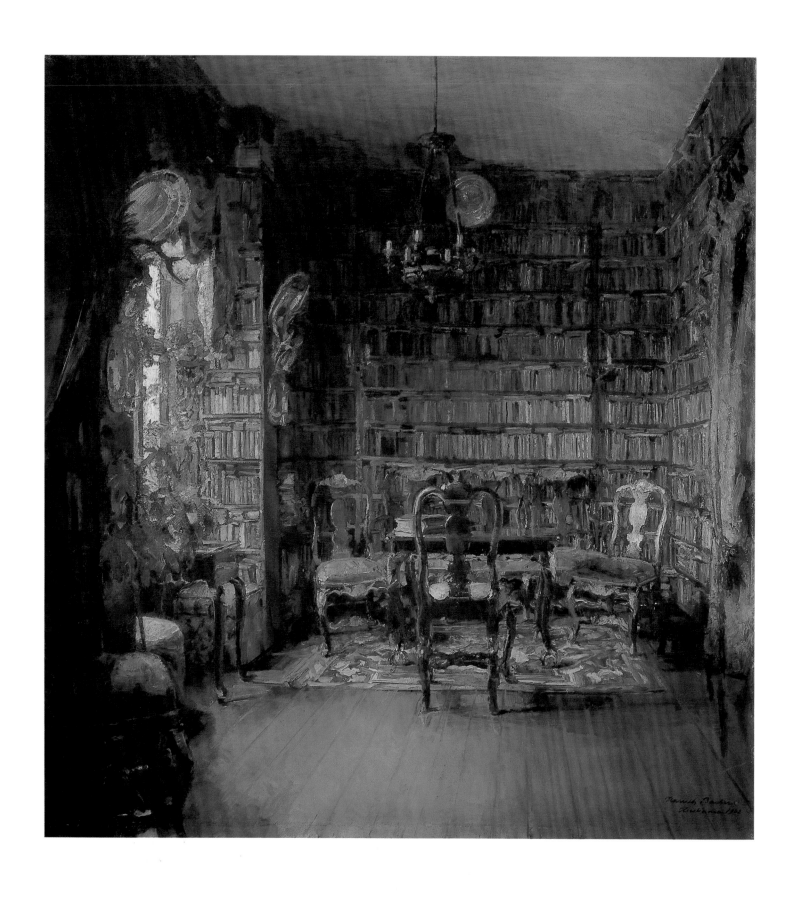

163 Harriet Backer, *The Library of Thorvald Boeck*, 1902. Oil on canvas, 94.5 × 89 cm. Nasjonalgalleriet, Oslo

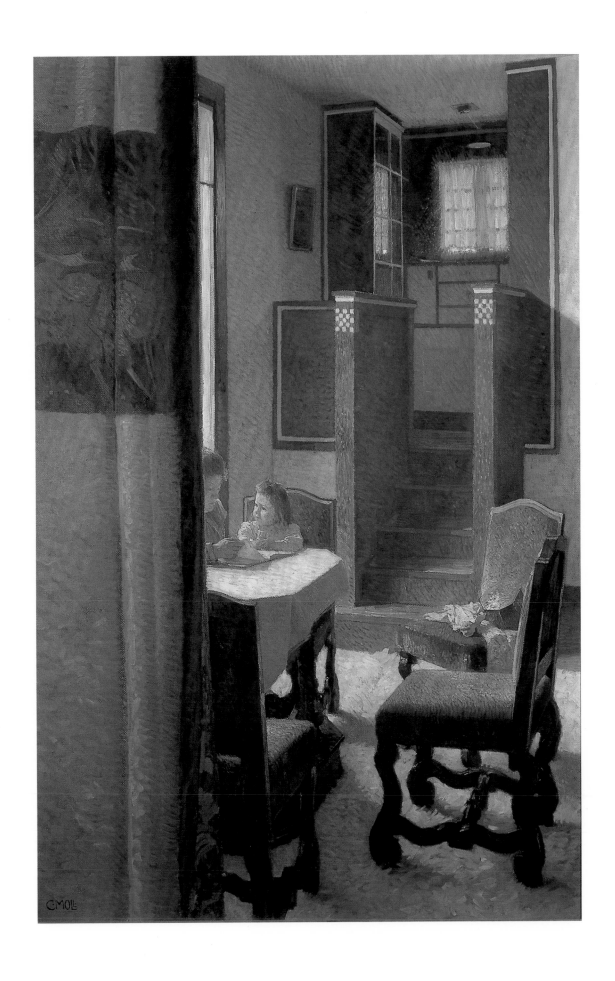

164 CARL MOLL, *Interior*, 1903. Oil on canvas, 135 × 89 cm. Historisches Museum der Stadt, Vienna

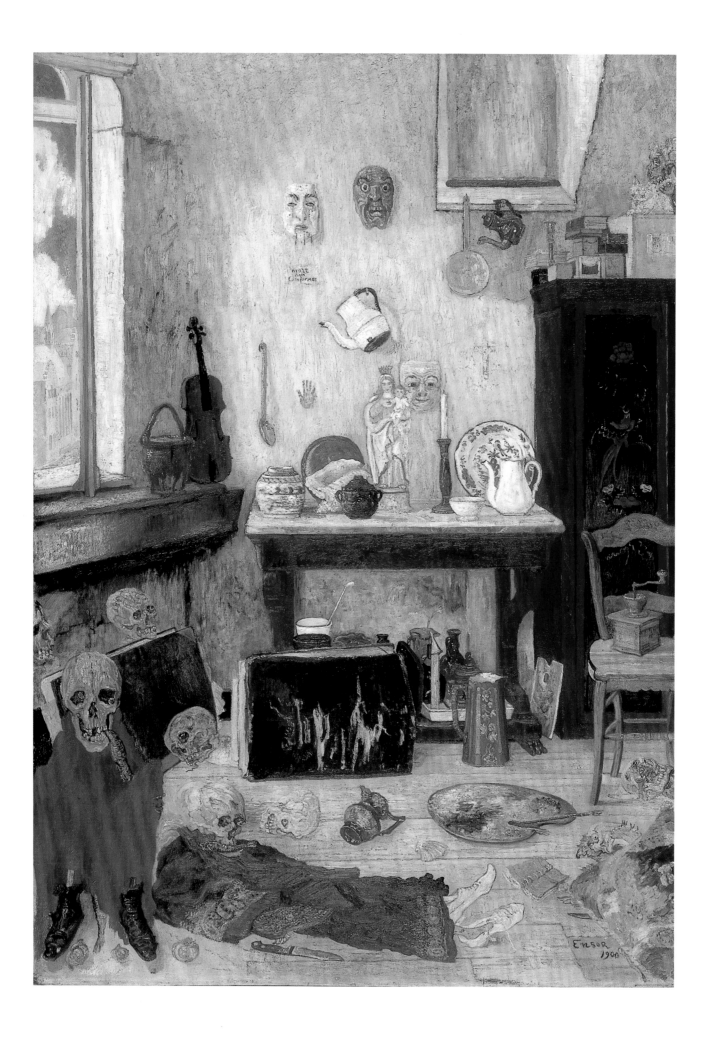

165 (*opposite*) JAMES ENSOR, *Skeleton in the Studio*, 1900. Oil on canvas, 113.9 × 80 cm. National Gallery of Canada, Ottawa

166 (*above*) WILLIAM MERRITT CHASE, *Alice in the Shinnecock Studio*, *c.* 1900.
Oil on canvas, 96.8 × 108.6 cm. The Parrish Art Museum, Southampton, N.Y. Littlejohn Collection (Acc. no. 61.5.6)

167 HENRI MATISSE, *Studio Interior*, 1902.
Oil on canvas, 54.4 × 44.5 cm. Lent by the Syndics of the Fitzwilliam Museum, Cambridge. Bequeathed by A. J. Hugh Smith through the National Art Collections Fund in 1964

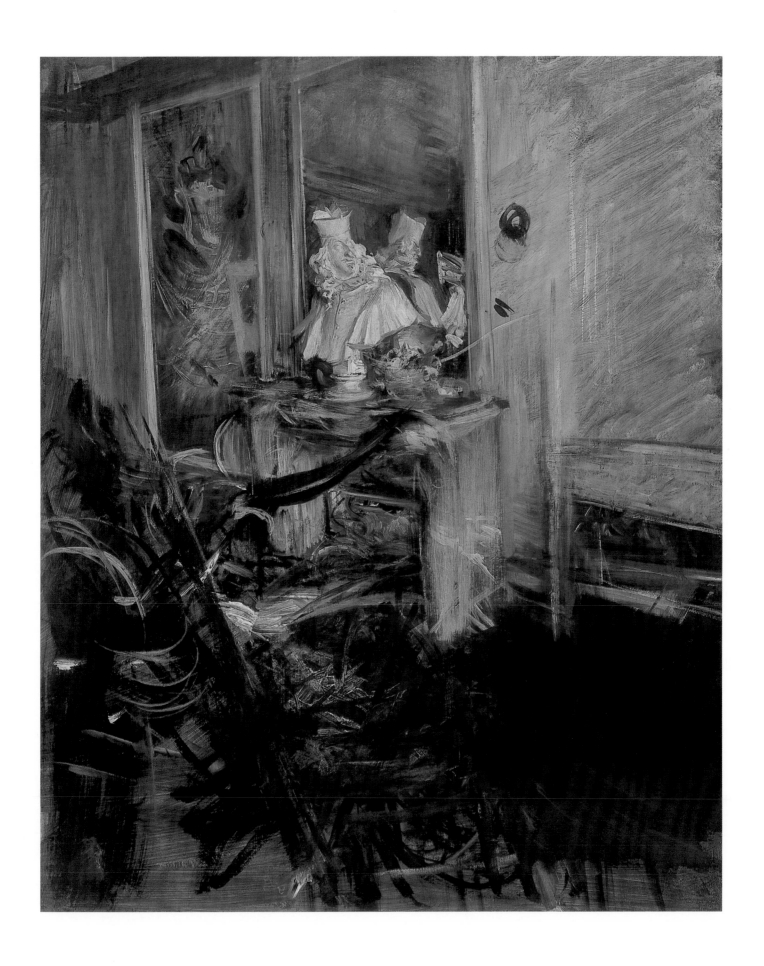

168 Giovanni Boldini, *Bernini's 'Cardinal' in the Painter's Studio*, 1899. Oil on canvas, 55.5 × 46 cm. Museo Giovanni Boldini, Ferrara

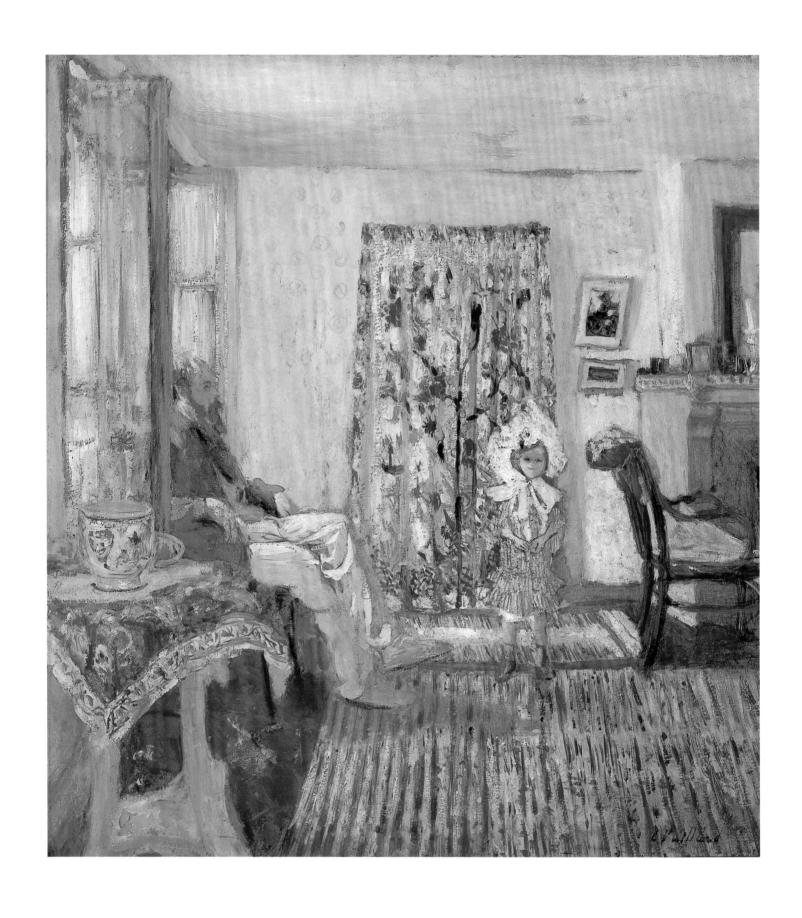

169 EDOUARD VUILLARD, *The Painter Ker-Xavier Roussel and His Daughter*, 1903.
Oil on canvas, 58.2 × 53.1 cm. Collection Albright-Knox Art Gallery, Buffalo, New York. Room of Contemporary Art Fund, 1943. RCA 43: 17

170 FÉLIX VALLOTTON, *The Visit*, *c.* 1897. Tempera on panel, 55 × 87 cm. Kunstmuseum, Winterthur

171 (left)
COLUMBANO BORDALO PINHEIRO,
A Cup of Tea, 1898.
Oil on canvas, 26.5 × 35 cm.
Museu do Chiado, Lisbon, Inv. 630 (EU 1900)

172 (below)
PIERRE BONNARD,
Lunch at Le Grand-Lemps, c. 1899.
Oil on canvas, 53.5 × 61 cm.
Szépművészeti Múzeum, Budapest

173 (opposite above)
EDOUARD VUILLARD,
Still-life with Candlestick, c. 1900.
Oil on millboard, 43.6 × 75.8 cm.
Scottish National Gallery of Modern Art,
Edinburgh. Presented by Mrs Isabel Traill 1979

174 (opposite below)
ODILON REDON,
Still-life, c. 1901.
Oil on canvas, 50 × 73 cm.
Ordrupgaard, Copenhagen

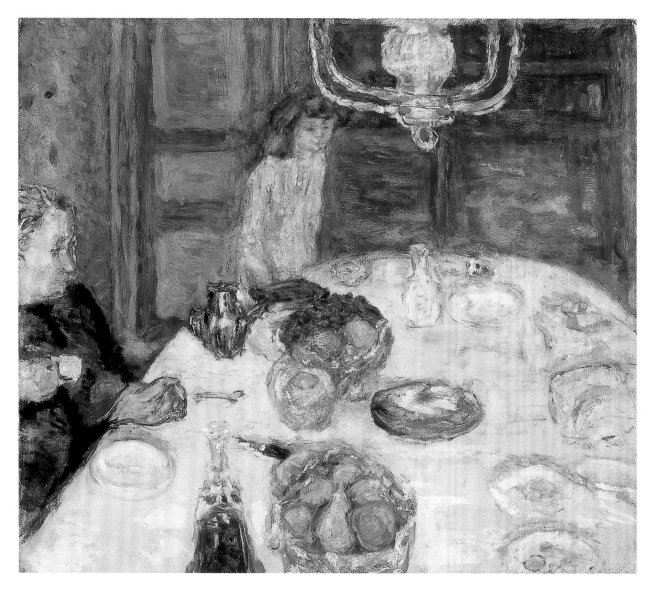

175 ALEXEI JAWLENSKY, *Still-life with Hyacinths and Oranges*, 1902. Oil on canvas, 53.5 × 44.4 cm. Private Collection

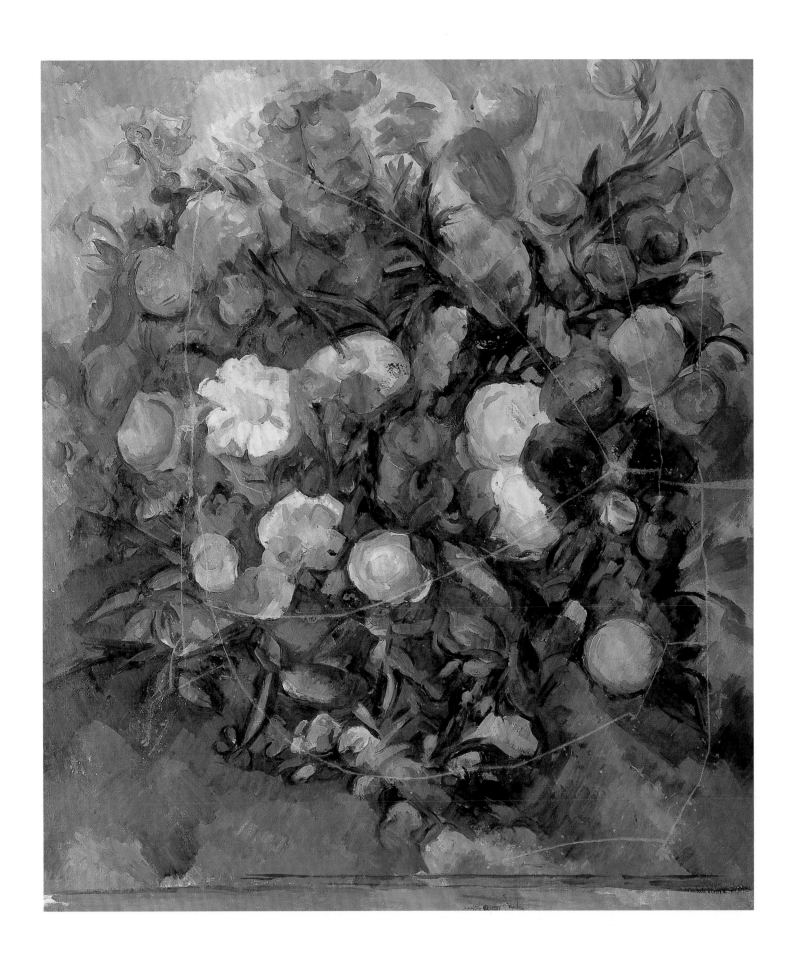

176 PAUL CÉZANNE, *Flowers (after Delacroix)*, 1902–04. Oil on canvas, 77 × 64 cm. Pushkin State Museum of Fine Arts, Moscow

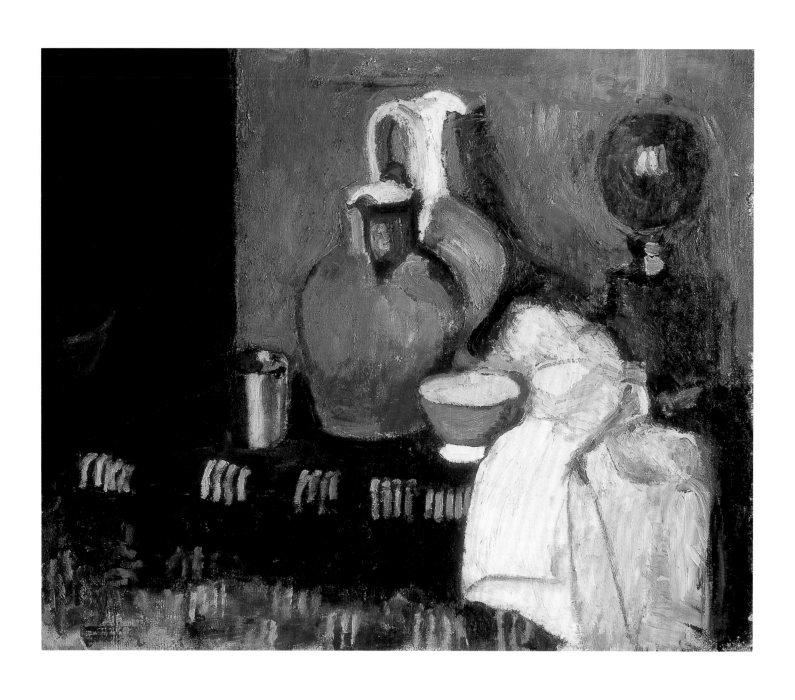

177 HENRI MATISSE, *The Blue Jug*, c. 1900. Oil on canvas, 59.5 × 73.5 cm. Pushkin State Museum of Fine Arts, Moscow

178 PAUL GAUGUIN, *Still-life*, 1899. Oil on canvas, 61 × 73 cm. Nasjonalgalleriet, Oslo

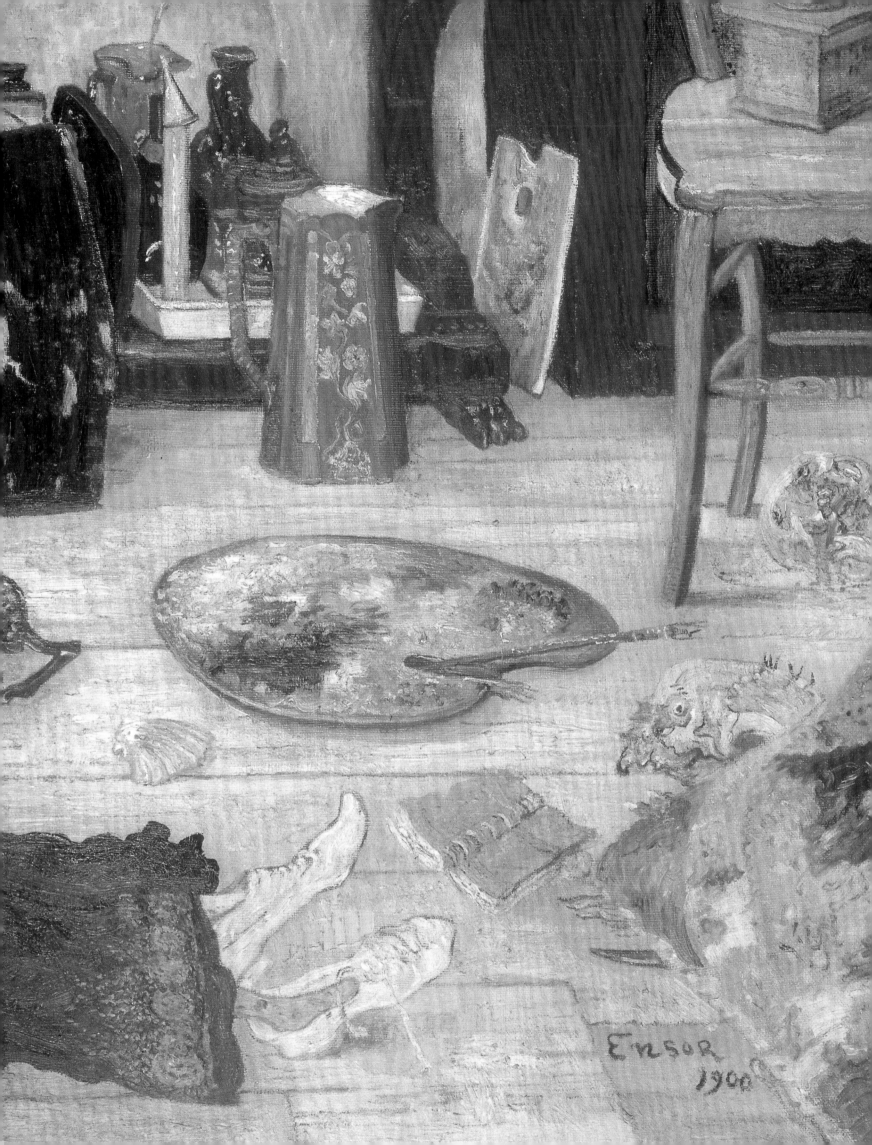

Ensor
1900

(opposite) Detail of cat. 165

179 (top)
JEAN-LÉON GÉRÔME,
Optician, 1902.
Oil on canvas, 87 × 66 cm.
Private Collection

180 (right)
JOHN F. PETO,
The Cup We All Race 4, c. 1900.
Oil on canvas and panel, 64.8 × 54.6 cm.
Fine Arts Museum of San Francisco.
Gift of Mr and Mrs John D. Rockefeller 3rd

Landscape

By the end of the nineteenth century, landscape painting enjoyed great popularity with a bourgeois audience who found respite in it from the growing assaults of nineteenth-century materialism and urban life. Although there was a general reaction against the Impressionists' truth-to-nature approach, innovative artists continued to find in banal landscape subjects a licence for formal inventiveness. Cézanne's assertively un-picturesque motif of a tangle of rocks, branches and undergrowth (cat. 214) serves as a pretext for a proto-abstract interweaving of pattern and texture that announces the pictorial revolutions of the new century, especially Cubism. Mondrian's sense of the innate geometry within a simple river view (cat. 186) or Kandinsky's free-floating patches of bright colour in an equally humble scene (cat. 215) hint at the radical innovations soon to be achieved by these pioneers of twentieth-century abstraction. Meanwhile, in the small, highly personal canvases produced by the famous Swedish writer Strindberg, paint as sheer matter attains an expressive intensity that makes him an unwitting forebear of the Abstract Expressionists (cat. 196).

Other artists heightened the abstract qualities of colour and line to intensify the emotive power of their landscapes. The Polish artist Stanislawski weaves the sinuous outlines of poplar trees, clouds and reflections into a decorative design that conveys the spiritual force he felt in nature (cat. 185), while Klimt's shimmering flame-like poplar vibrates with a mystical intensity (cat. 191). Cypress trees, clustered like dark sentinels, add a mysterious and foreboding backdrop to the mausoleum in Keller's *The Tomb of Böcklin* (cat. 190), an unmistakable homage to Böcklin's influential *Island of the Dead* (1880) and its imagery of dreams.

In the late 1880s and 1890s, the Romantics' intensely subjective experience of landscape resurfaced, often with a Symbolist inflection. Even Degas, that most trenchant observer of real-life situations could, around 1900, paint landscapes in which topographical facts are diffused with more than a hint of Symbolist mystery (cat. 208). And Monet, once the leading exponent of Impressionism's unmediated factual records, could conjure in his *Mornings on the Seine* the most dreamy evocations of light and water (cat. 181), although these are never as insubstantial as the delicately hued, vaporous veils of light that the Swiss painter Baud-Bovy could distil from an Alpine landscape (cat. 14). For the Italian Divisionist Grubicy a pantheistic immersion in nature evoked musical harmonies (cat. 187). Such synthetist connections are made explicit in Hofmann's moonlit seascape *Sunset over the Sea* (cat. 182), a homage to Beethoven whose mask-like countenance is embedded in the splendidly symbolic frame.

The transporting, quasi-religious power of landscape was a *fin-de-siècle* leitmotif that linked artists from different countries and artistic traditions. Hodler's transcendental views of Switzerland (cat. 183) share an affinity with the American Tack's orientalist visions of mountains (cat. 205) or Sohlberg's almost hallucinatory landscapes of snowy peaks soaring against diamond-hard Norwegian skies (cat. 206).

The unique light of Scandinavia, especially the magical 'blue hour' of the long summer twilights, inspired artists such as Jansson and Thorláksson to paint serenely expansive landscapes that express an emerging sense of national identity (cats 195, 203). The untamed grandeur of the New World was glorified by Moran in his epic visions of the American West (cat. 202) and by Homer in his intensely physical depictions of the dramatic Maine coast (cat. 194). AD

(*opposite*) Detail of cat. 212

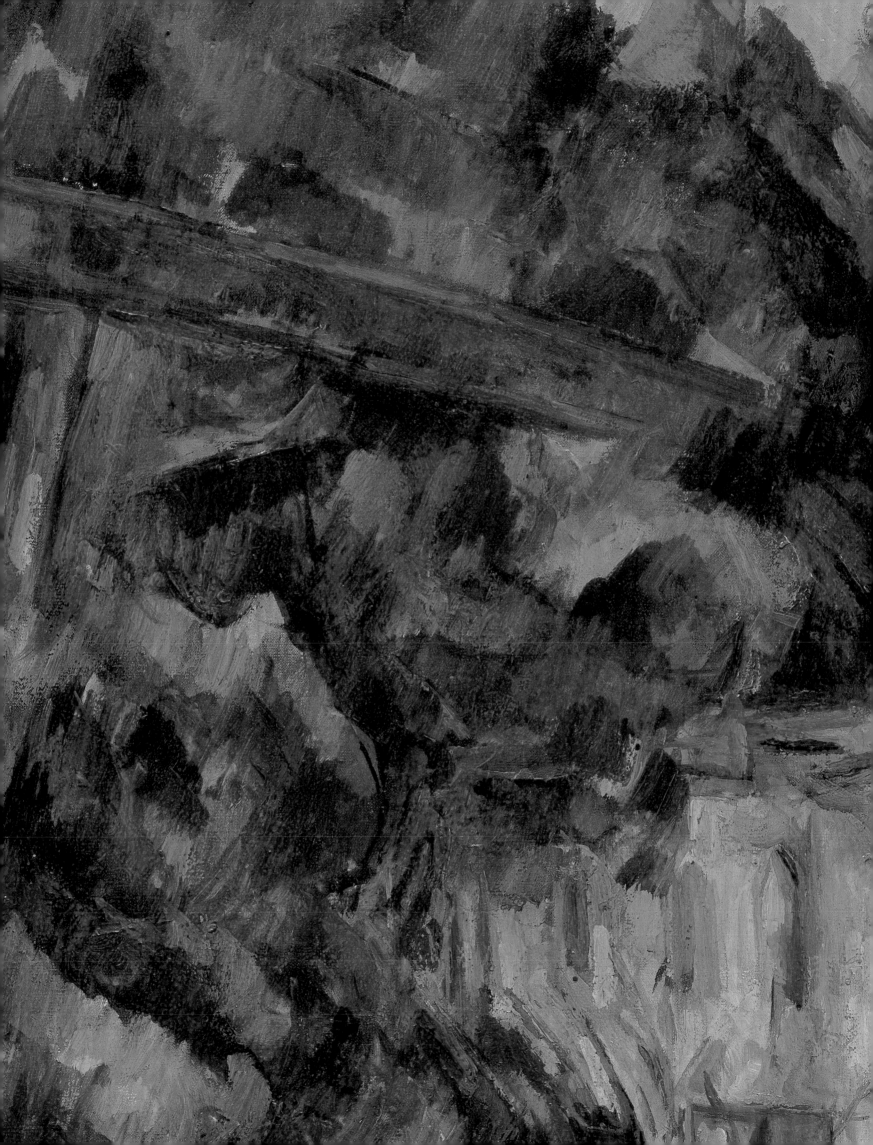

181 CLAUDE MONET, *Morning on the Seine*, 1897. Oil on canvas, 81.9 × 93.4 cm. Mead Art Museum, Amherst College, Massachusetts. Bequest of Susan Dwight Bliss

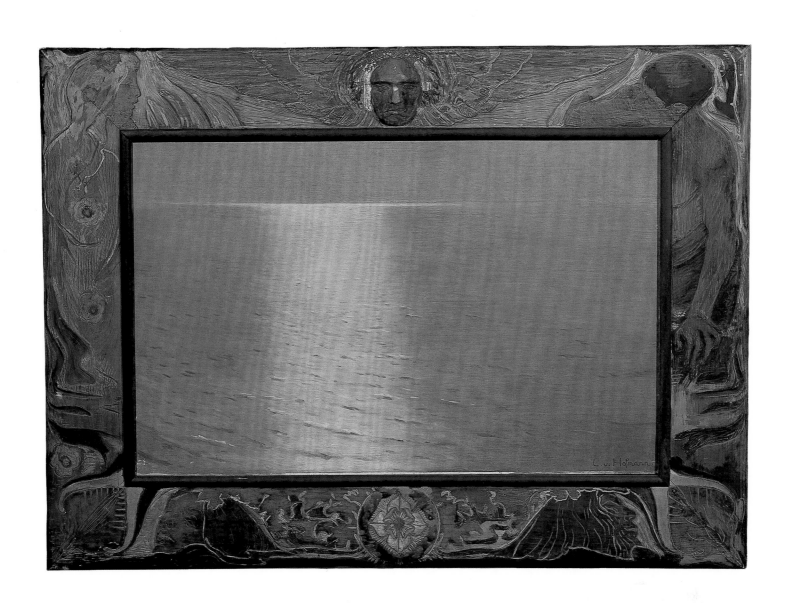

182 LUDWIG VON HOFMANN, *Sunset over the Sea, c.* 1898. Oil on canvas, 74 × 119.5 cm. Österreichische Galerie Belvedere, Vienna

183 Ferdinand Hodler, *Lake Geneva from St Prex*, 1901. Oil on canvas, 72 × 107 cm. Private Collection, Switzerland

184 ISAAK LEVITAN, *Twilight*, 1899. Oil on canvas, 50.5 × 74 cm. State Tretyakov Gallery, Moscow

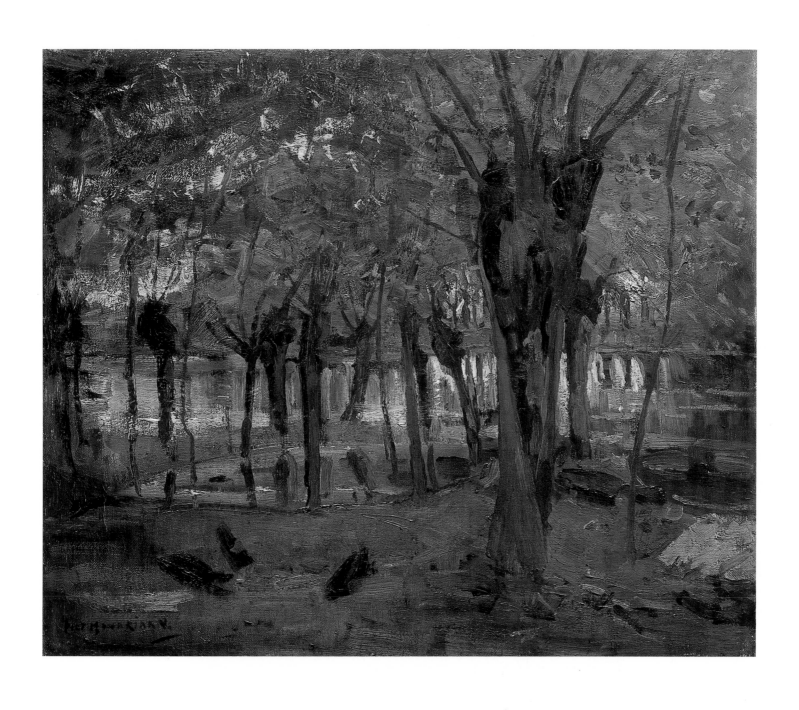

185 (*opposite*) JAN STANISLAWSKI, *Poplars on the Water*, 1900. Oil on canvas, 145.5 × 80.5 cm. The National Museum, Cracow

186 (*above*) PIET MONDRIAN, *Pollard Willows on the Gein*, 1902–04. Oil on canvas, 53.5 × 63 cm. Collection Gemeentemuseum Den Haag, The Hague

187 (*opposite above*) VITTORE GRUBICY, *Winter in the Mountains, a Pantheist Poem: Morning*, 1900. Oil on canvas, 75 × 56 cm. Civica Galleria d'Arte Moderna, Milan

188 (*opposite below*) GUSTAV KLIMT, *Pine Forest*, 1901. Oil on canvas, 91.5 × 89 cm. Private Collection (courtesy Galerie St. Etienne, New York)

189 (*above*) ALBIJN VAN DEN ABEELE, *Fir Forest in February*, 1897. Oil on canvas, 69 × 81 cm. Private Collection

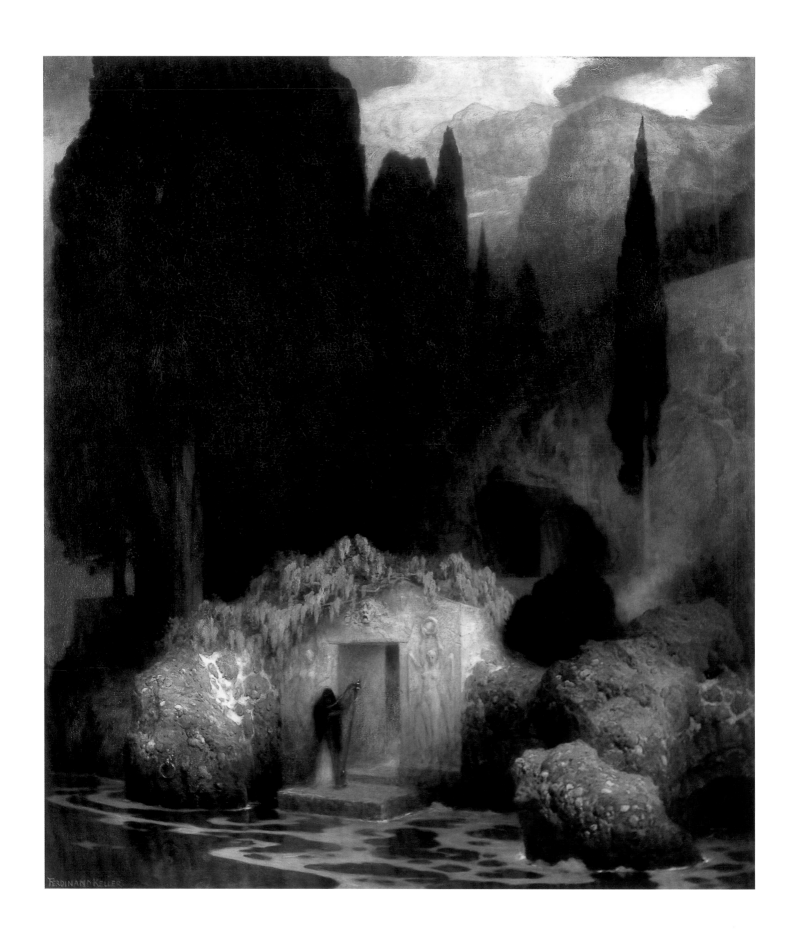

190 FERDINAND KELLER, *The Tomb of Böcklin*, 1901–02. Oil on canvas, 117 × 99 cm. Staatliche Kunsthalle, Karlsruhe

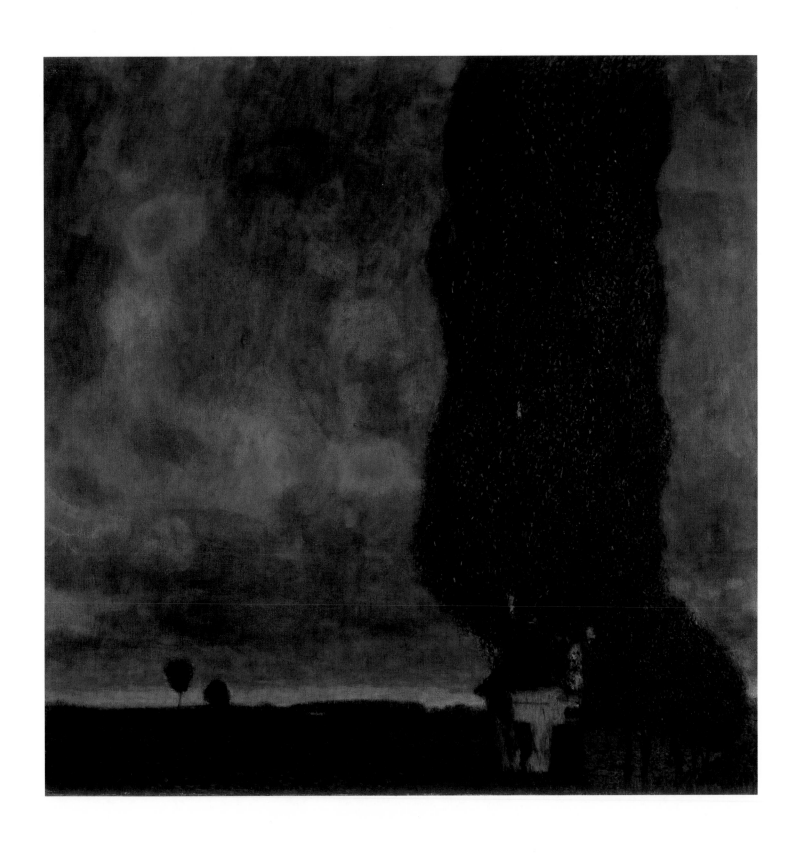

191 GUSTAV KLIMT, *The Big Poplar II*, 1902–03. Oil on canvas, 100.8 × 100.7 cm. Leopold Museum, Vienna (Private Collection)

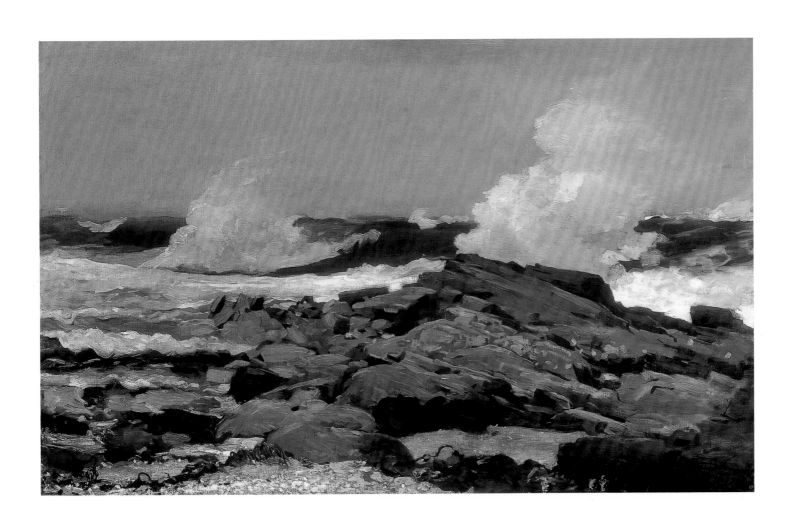

192 (*opposite above*) WILLIAM DEGOUVE DE NUNCQUES, *Grotto of Manacor, Mallorca*, 1901. Oil on canvas, 48 × 60 cm. E. & P. H. Serck

193 (*opposite below*) EMIL NOLDE, *Light Sea-Mood*, 1901. Oil on canvas, 65 × 83 cm. Nolde-Stiftung, Seebuell

194 (*above*) WINSLOW HOMER, *Eastern Point, Prout's Neck*, 1900. Oil on canvas, 77.5 × 123.2 cm. Sterling and Francine Clark Art Institute, Williamstown, Massachusetts

195 EUGÈNE JANSSON, *Midsummer Mood*, 1898. Oil on canvas, 149 × 134 cm. Private Collection

196 AUGUST STRINDBERG, *White Mark IV*, 1901. Oil on cardboard, 51 × 30 cm. City Library and County Library of Örebro Lan, Örebro

197 (*opposite above*) PRINCE EUGEN, *The Old Castle*, 1893. Oil on canvas, 101 × 97 cm. Prins Eugens Waldemarsudde, Stockholm (EU 1900)

198 (*opposite below*) PÁL SZINYEI MERSE, *Melting Snow*, 1884–95. Oil on canvas, 47 × 60.6 cm. Hungarian National Gallery, Budapest (EU 1900)

199 (*above*) EUGEN BRACHT, *Clouds over the Lüneburger Heath*, 1895. Oil on canvas, 117 × 170.5 cm. Staatliche Kunsthalle, Karlsruhe (EU 1900)

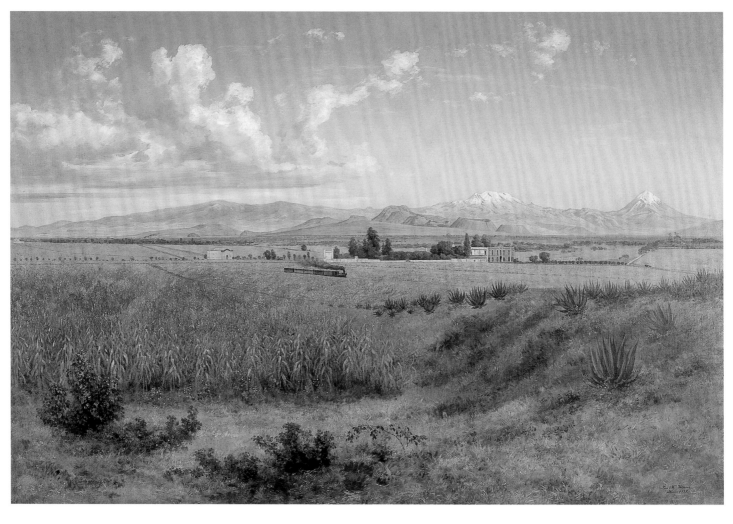

200 (*opposite above*) FRANCISCO MANUEL OLLER, *Hacienda Aurora, c.* 1898.
Oil on canvas, 32 × 55.8 cm. The Luis A. Ferré Foundation Inc. Museo de Arte de Ponce

201 (*opposite below*) JOSÉ MARÍA VELASCO, *Hacienda de Caapa and Volcanoes,* 1897. Oil on canvas, 84 × 125 cm. Colección Banco Nacional de México

202 (*above*) THOMAS MORAN, *Cliff Dwellers,* 1899. Oil on canvas, 50.8 × 76.2 cm. Berea College, Kentucky

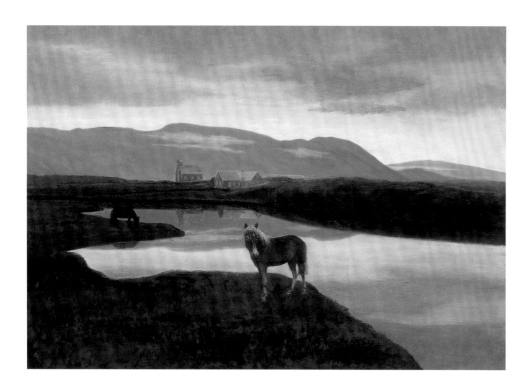

203 (left)
THORÁRINN B. THORLÁKSSON,
Thingvellir, 1900.
Oil on canvas, 57.5 × 81.5 cm.
Listasafn Islands, National Gallery of Iceland,
Reykjavik

204 (below)
EDVARD MUNCH,
Winter Night, c. 1900.
Oil on canvas, 80 × 120 cm.
Kunsthaus, Zurich

205 (left)
Augustus Vincent Tack,
Windswept (Snow Picture, Leyden), c. 1900–02.
Oil on canvas, 79 × 92 cm.
The Phillips Collection, Washington, D.C.
Acquired from the Estate of Agnes Gordon Tack, by 1959

206 (below)
Harald Oskar Sohlberg,
Winter Night in the Mountains, 1901.
Oil on board, 68 × 93 cm.
Private Collection

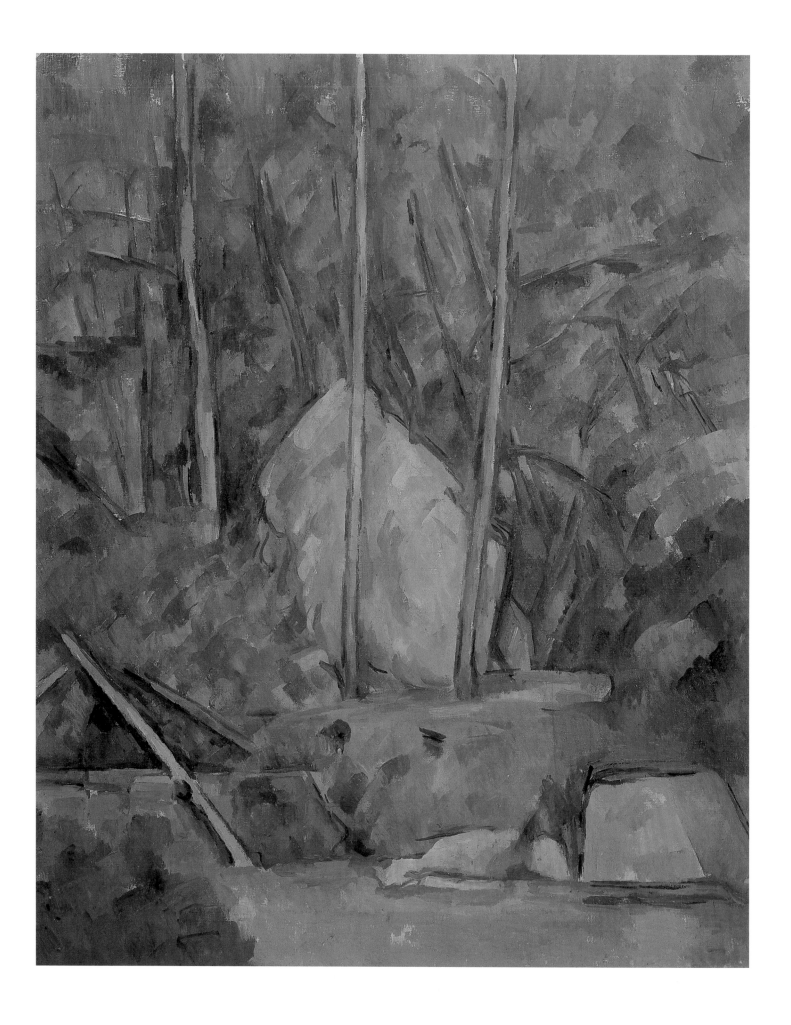

207 (*opposite*) PAUL CÉZANNE, *Well in the Park of the Château Noir*, *c.* 1900. Oil on canvas, 74.2 × 61 cm. The Henry and Rose Pearlman Foundation, Inc.

208 (*above*) EDGAR DEGAS, *View of Saint-Valéry-sur-Somme*, 1896–98.
Oil on canvas, 51 × 61 cm. The Metropolitan Museum of Art, Robert Lehman Collection, 1975 (1975.1.167)

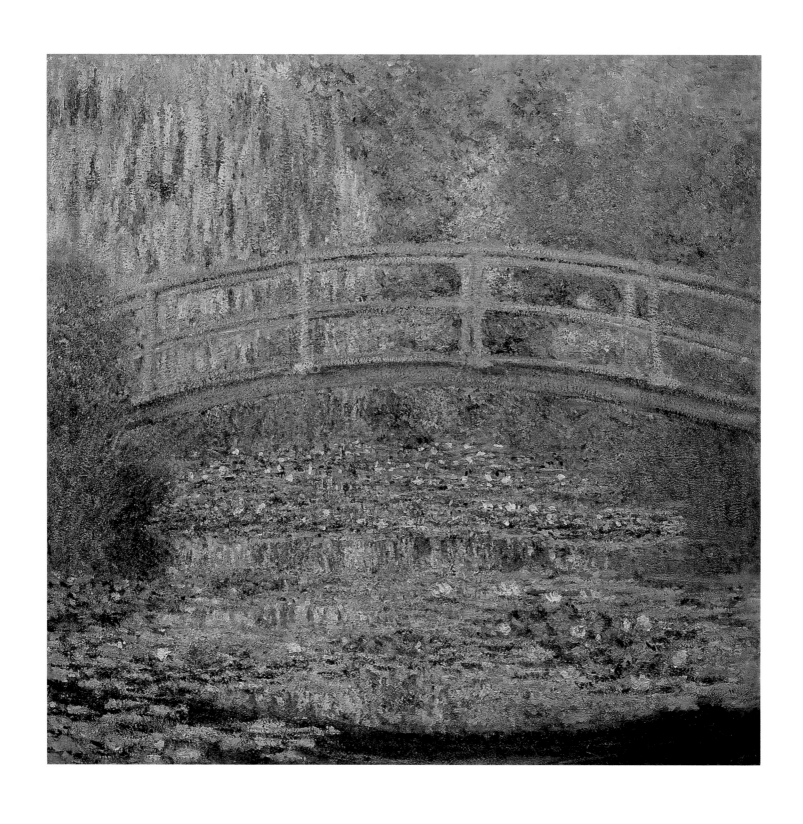

209 CLAUDE MONET, *The Water Lily Pond (Japanese Bridge)*, 1899. Oil on canvas, 89 × 92 cm. Private Collection, Japan

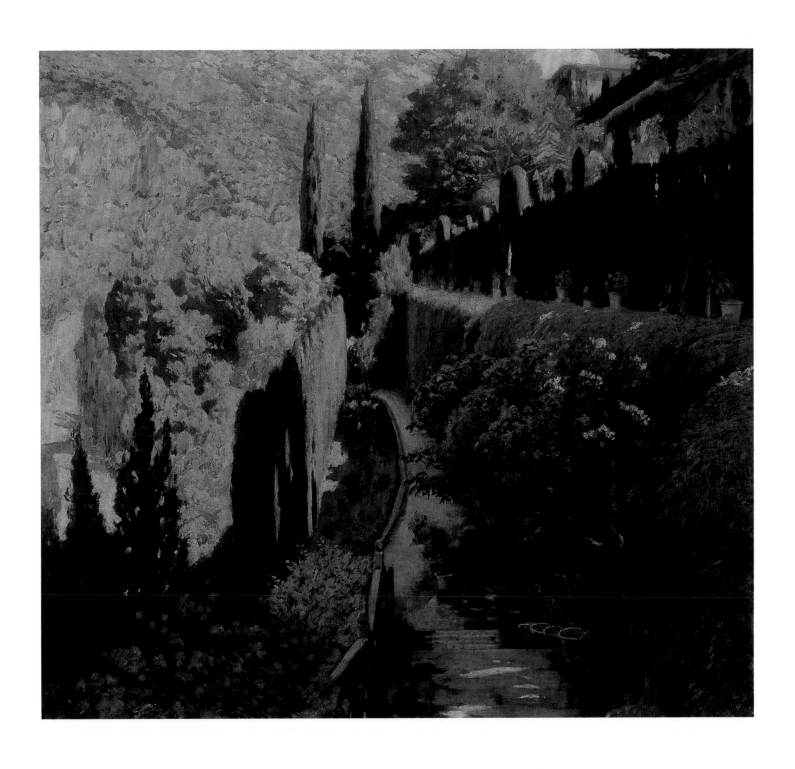

210 SANTIAGO RUSIÑOL, *The Green Wall*, 1901. Oil on canvas, 95 × 105 cm. Centro de Arte Reina Sofía, Madrid

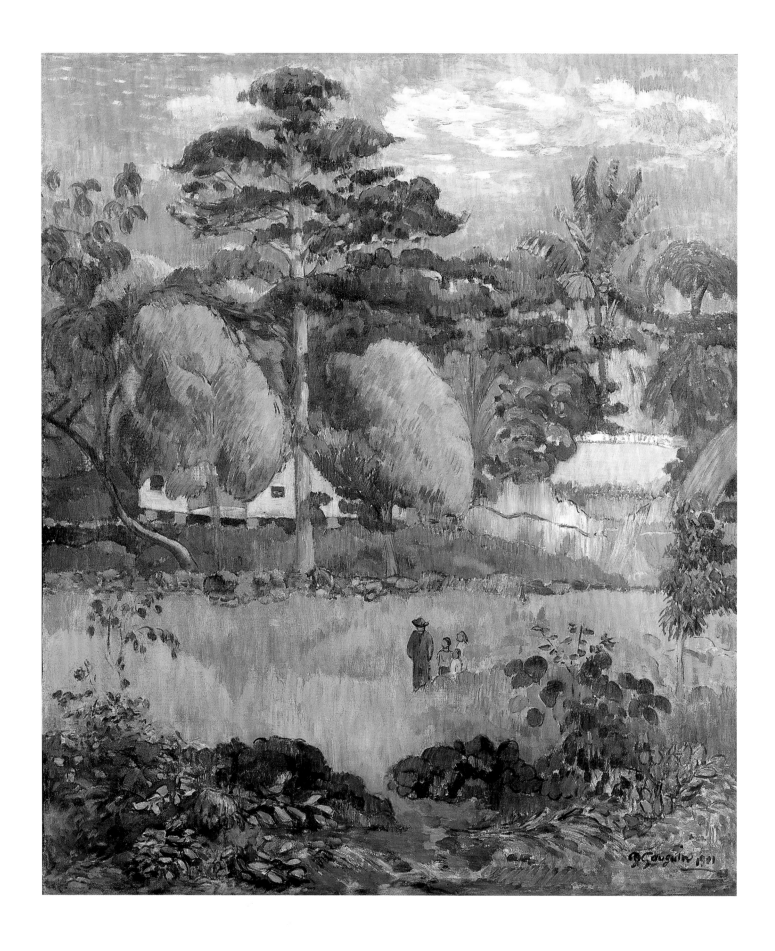

211 PAUL GAUGUIN, *The Family Walk*, 1901. Oil on canvas, 76 × 65 cm. Musée National de l'Orangerie, Paris. Collection Jean Walter and Paul Guillaume

(*opposite*) Detail of cat. 202

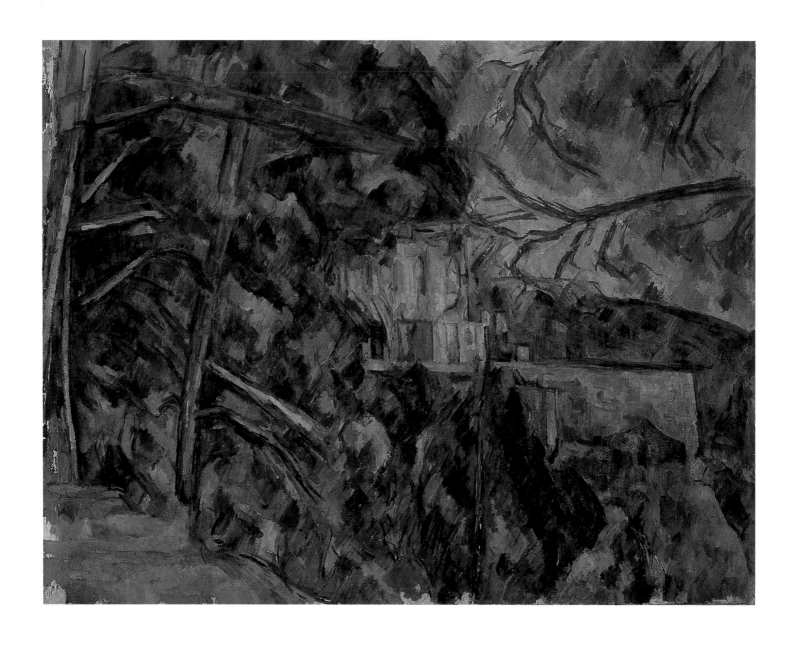

212 PAUL CÉZANNE, *The Château Noir*, c. 1900–04. Oil on canvas, 74 × 96.5 cm. National Gallery of Art, Washington, D.C. Gift of Eugene and Agnes E. Meyer 1958.10.1

213 (*opposite*) EDGAR DEGAS, *Houses at the Foot of a Cliff (Saint-Valéry-sur-Somme)*, c. 1896–98.
Oil on canvas, 92 × 72.2 cm. Columbus Museum of Art, Ohio. Gift of Howard D. and Babette L. Sirak,
the Donors to the Campaign for Enduring Excellence, and the Derby Fund

214 PAUL CÉZANNE, *Rocks and Branches at Bibémus*, 1900–04. Oil on canvas, 61 × 50.5 cm. Petit Palais: Musée des Beaux-Arts de la Ville de Paris

215 Vasily Kandinsky, *Study for a Sluice*, 1901. Oil on cardboard, 31.6 × 23.9 cm. Städtische Galerie im Lenbachhaus, Munich

Rural Scenes

In the later nineteenth century, images of peasant life formed a large and popular category in painting. Compassion for the rural poor fostered by socialist sympathies, as shown in Pellizza's *The Fourth Estate* (cat. 216), was accompanied by a nostalgia for the disappearing traditions of country life in the face of accelerating industrialisation. This found expression not only in art, but also in the writings of Hardy, Zola, Tolstoy and others, and in the music of such composers as Vaughan Williams, Delius, Brahms and Dvořák.

Millet's heroic peasants painted in the 1850s and 1860s were an enduring model for painters of rural life to the end of the century and beyond. Breton was much admired for his sentimental interpretations of Millet's themes: in *The Last Gleanings* (cat. 227) a timeless country ritual takes on a Symbolist resonance. Pissarro's more detached images of rural life (cat. 226) affirm the integration of man and the land and reflect Pissarro's anarchist beliefs. La Thangue and Clausen, who could bring a Symbolist tone of wistfulness to their English rural scenes (cats 229, 228), were among the many foreign artists who learned from the *plein-air* naturalism of Bastien-Lepage, a painter whose influence extended even to rural painters in Australia (cat. 221).

In Belgium, acute polarisation between rich and poor produced a strong socialist movement which had repercussions on art-production. Meunier's monumental bronze figures of agricultural workers recapture Millet's heroic ideal. Some of the most personal images of rural hardship were painted by Meunier's compatriot and fellow socialist Laermans, a solitary deaf-mute whose sombre art combined a contemporary naiveté with influences from his Flemish antecedents, especially Bruegel whose *The Blind Leading the Blind* (1568) clearly lies behind Laermans's *The Blind One* (cat. 234). This work, with Meunier's *The Reaper* (cat. 224) and others, represented Belgium at the Exposition Universelle.

Like most of the Italian Divisionists, Morbelli had socialist sympathies. Although he was moved by the plight of workers in the rice fields of the Po Valley during the 1890s (cat. 217), his aesthetically distancing composition extols the luminosity of this particular landscape and transmutes the harsh realities of back-breaking work into ennobling choreographed gestures reminiscent of Millet's canvas *The Gleaners* (1857). On the other hand, artists like the Polish painter Ruszczyc, who had absorbed a Northern Romantic tradition through his association with the Russian Wanderers group, saw man as but a diminutive, toiling presence amidst the vast, elemental forces of nature (cat. 230).

Images of rural life were often bound to the rising tide of nationalism throughout Europe. Nowhere was this more true than in Scandinavia. Zorn's *Midsummer Dance* (cat. 231), an archetypal Swedish scene of peasants dancing against a backdrop of vernacular buildings, reflects his deep involvement in the revival of national folk customs associated with the growing Nordic National Romantic movement. Not surprisingly, the work was chosen to represent Sweden at the Exposition Universelle. The deliberately naive character of Halonen's *Washing on the Ice* (cat. 222) belies its sophisticated origins in Italian fresco painting and the works of Puvis de Chavannes and Gauguin. Expressing an ideal of unsullied Nordic life, this was one of a number of works showing Finnish landscapes and ways of life which were commissioned for the Finnish Pavilion at the Exposition Universelle. AD

(opposite) Detail of cat. 223

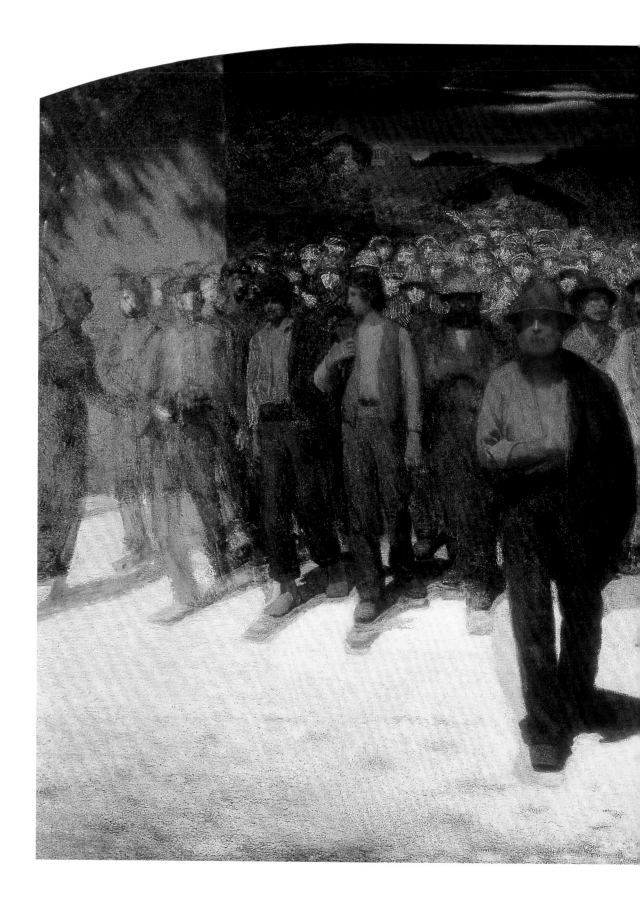

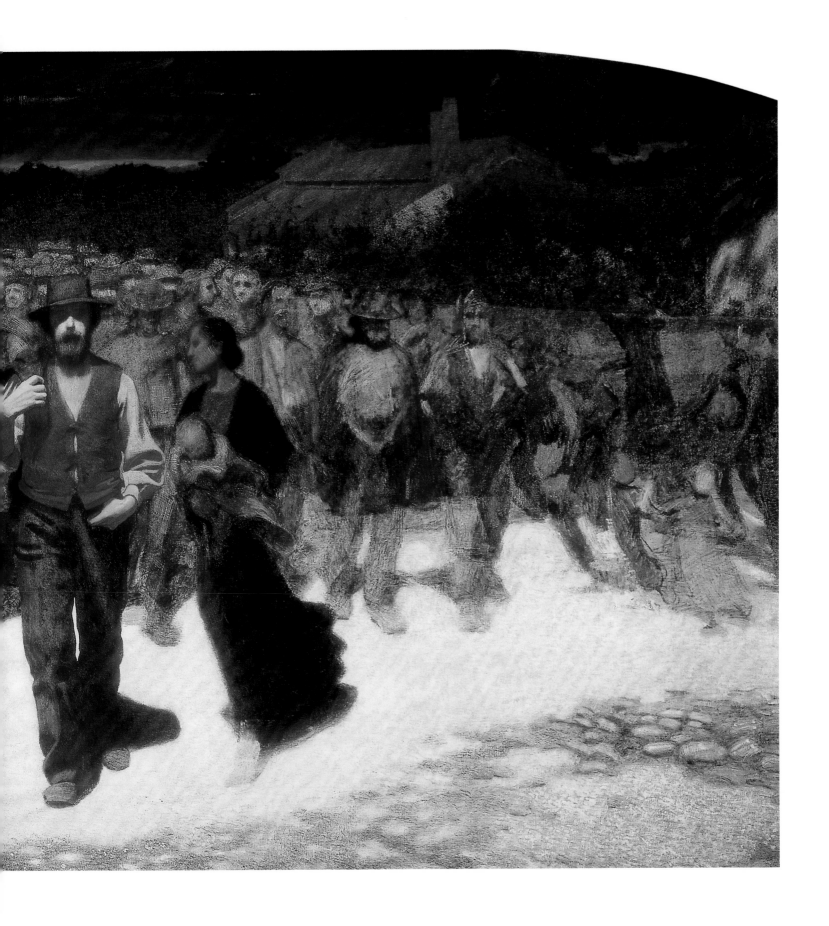

216 GIUSEPPE PELLIZZA DA VOLPEDO, *The Fourth Estate*, 1901. Oil on canvas, 283 × 550 cm. Pinacoteca di Brera, Milan

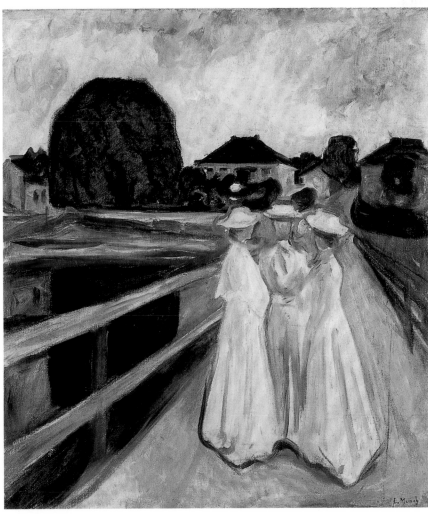

217 *(opposite)*
ANGELO MORBELLI,
In the Rice Fields, 1901.
Oil on canvas, 182.9 × 130.2 cm.
Private Collection

218 *(top)*
IGOR GRABAR,
September Snow, 1903.
Oil on canvas, 78 × 89 cm.
State Tretyakov Gallery, Moscow

219 *(right)*
EDVARD MUNCH,
Girls on the Jetty, 1903.
Oil on canvas, 92 × 80 cm.
From the Collection of Vivian and David Campbell

220 (*opposite above*) JAMES WILSON MORRICE, *The Sugar Bush, c.* 1897–98.
Oil on canvas, 53.6 × 48.3 cm. National Gallery of Canada, Ottawa. Gift of G. Blair Laing, Toronto, 1989

221 (*opposite below*) CLARA SOUTHERN, *An Old Bee Farm,* 1900.
Oil on canvas, 238 × 140 cm. National Gallery of Victoria, Melbourne. Felton Bequest, 1942

222 (*above*) PEKKA HALONEN, *Washing on the Ice,* 1900. Oil on canvas, 125 × 180 cm. The Finnish National Gallery Ateneum, Helsinki (EU 1900)

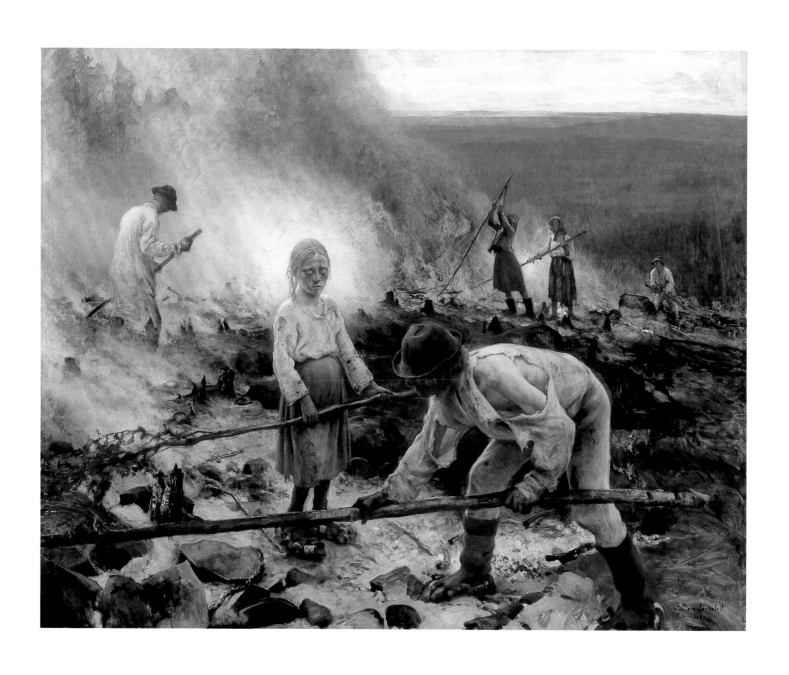

223 EERO JÄRNEFELT, *The Burn-Beating*, 1893. Oil on canvas, 131 × 164 cm. The Finnish National Gallery Ateneum, Helsinki (EU 1900)

224 (*opposite left*) CONSTANTIN MEUNIER, *The Reaper*, 1892.
Bronze, 55.6 × 24.4 × 44.5 cm. Musées Royaux des Beaux-Arts de Belgique, Brussels, Inv. 10.000/107 (EU 1900)

225 (*opposite right*) JULES DALOU, *The Peasant (Study for Monument to Labour)*, 1899, cast 1908.
Bronze, 78.5 × 27.4 × 27.1 cm. Hirshhorn Museum and Sculpture Garden, Smithsonian Institution. Gift of Joseph H. Hirshhorn, by Exchange, and Museum Purchase, 1981

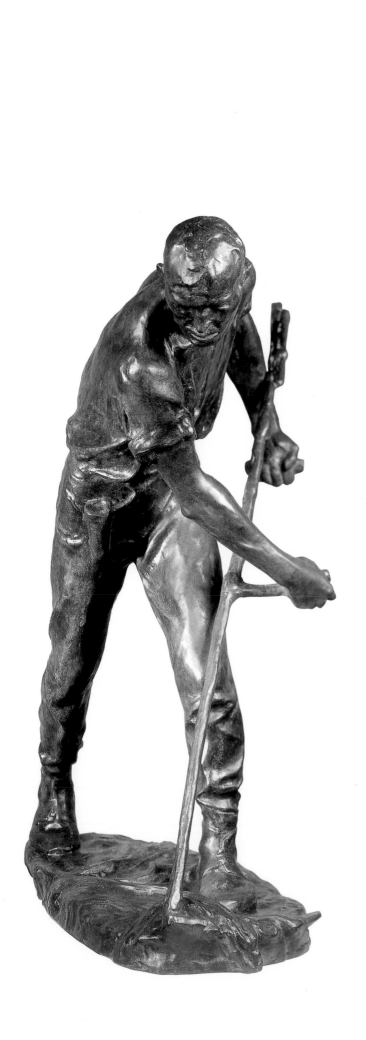
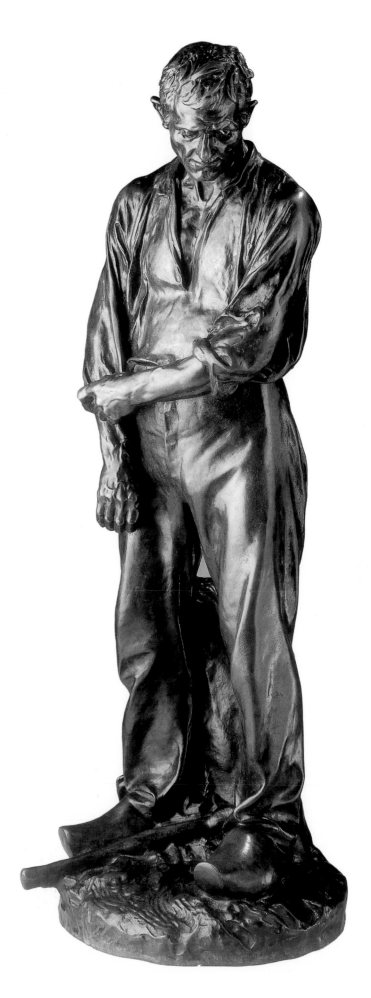

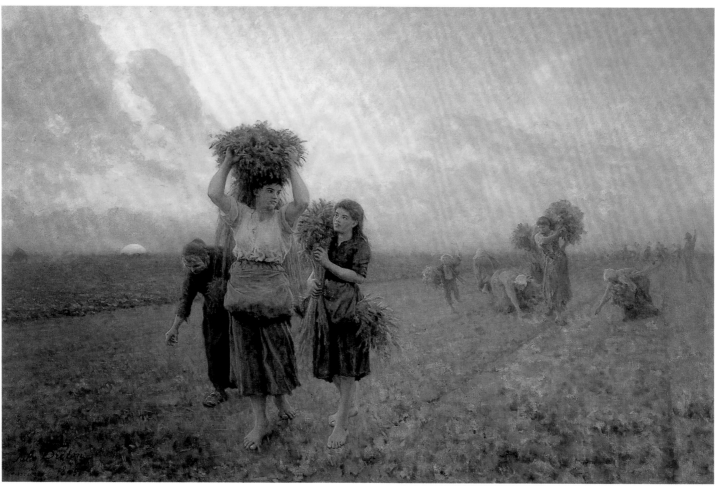

226 (*opposite above*) CAMILLE PISSARRO, *The Siesta*, 1899. Oil on canvas, 65 × 81 cm. Private Collection

227 (*opposite below*) JULES BRETON, *The Last Gleanings*, 1895. Oil on canvas, 92.7 × 139.7 cm.
The Huntington Library, Art Collections and Botanical Gardens, San Marino, California (EU 1900)

228 (*above*) SIR GEORGE CLAUSEN, *Sons of the Soil*, 1901. Oil on canvas, 69.2 × 76.8 cm. Private Collection (courtesy of Pyms Gallery)

229 (*opposite*) HENRY HERBERT LA THANGUE, *The Ploughboy*, c. 1900. Oil on canvas, 155 × 117.7 cm. City of Aberdeen Art Gallery and Museums Collection (EU 1900)

230 (*above*) FERDYNAND RUSZCZYC, *Earth*, 1898. Oil on canvas, 171 × 219 cm. Muzeum Narodowe w Warszawie (EU 1900)

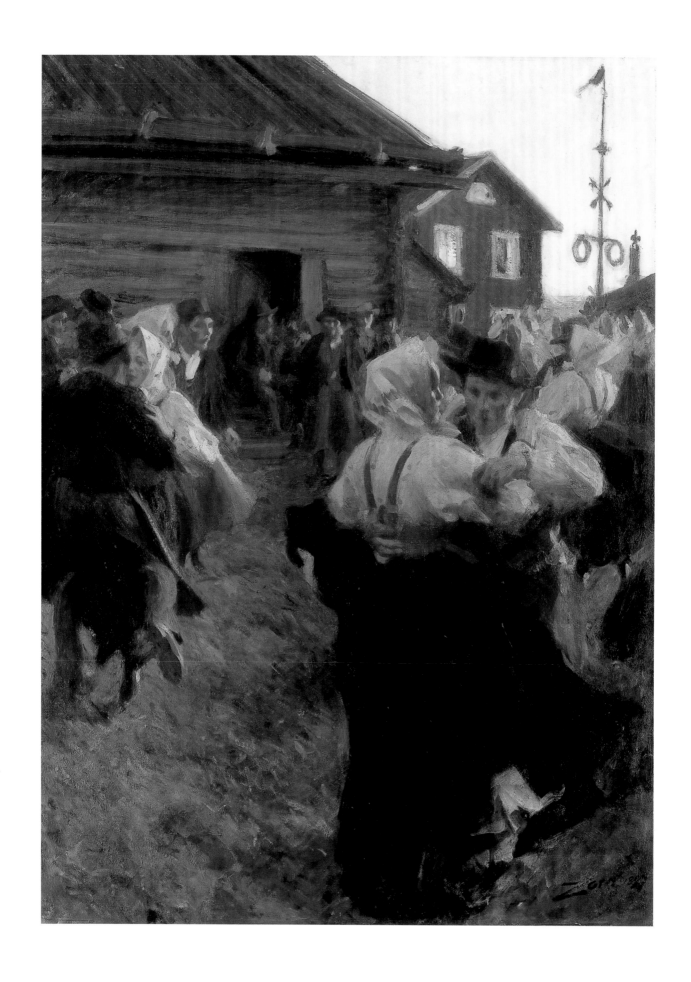

231 ANDERS ZORN, *Midsummer Dance*, 1897. Oil on canvas, 140 × 98 cm. Nationalmuseum, Stockholm (EU 1900)

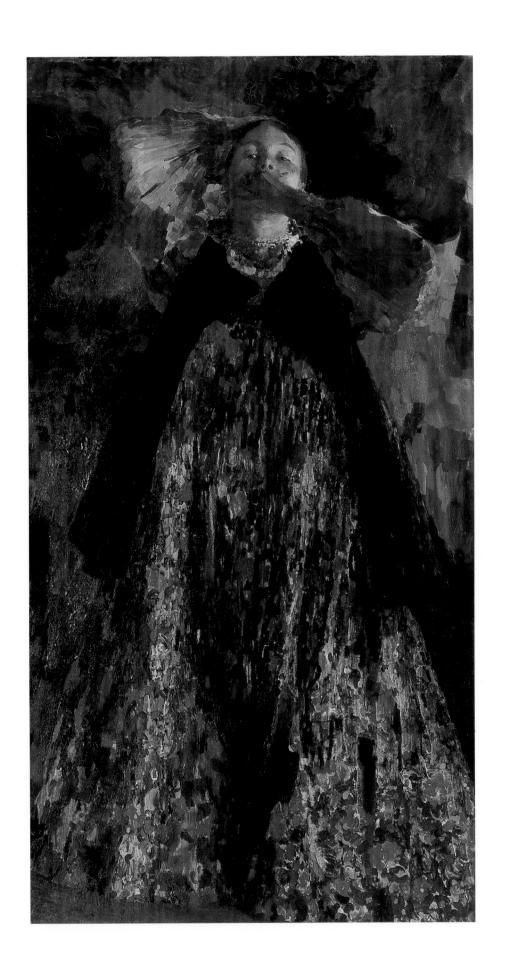

232 FILIPP MALYAVIN, *Peasant Wench*, 1903. Oil on canvas, 206.3 × 115.6 cm. State Tretyakov Gallery, Moscow

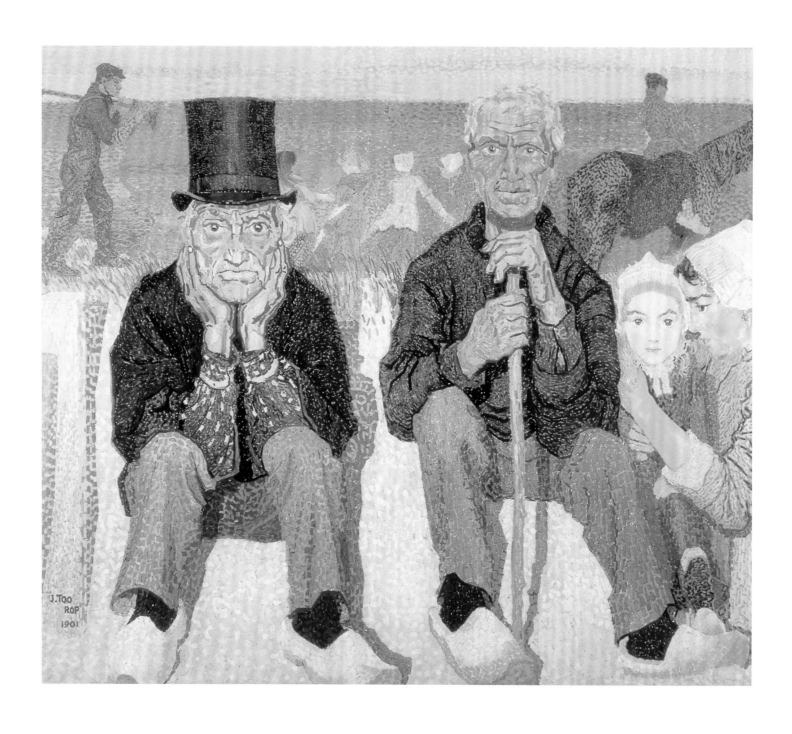

233 JAN TOOROP, *Watchers on the Threshold of the Sea, c.* 1900. Oil on canvas, 130 × 150 cm. Museum Boijmans van Beuningen, Rotterdam

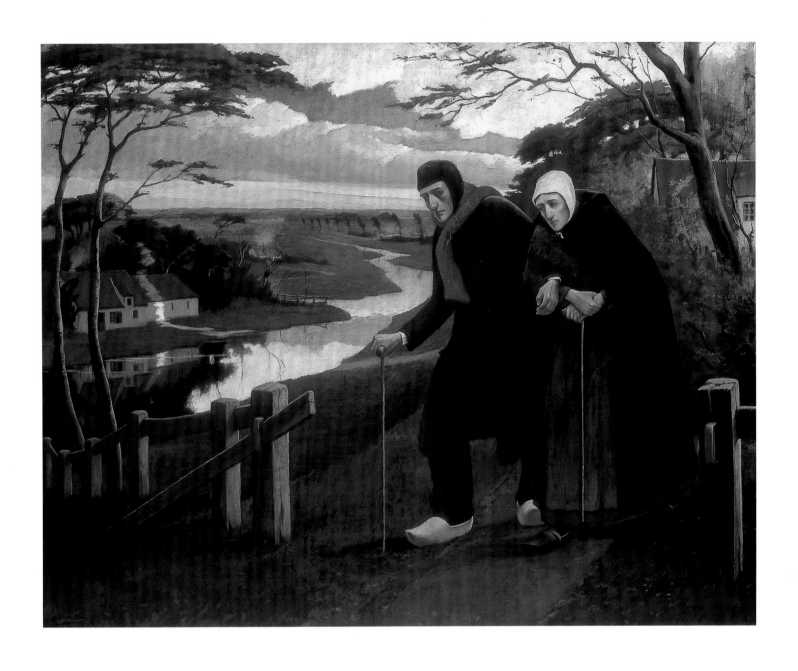

234 Eugène Laermans, *The Blind One*, 1899. Oil on canvas, 120 × 150 cm. Musée d'Orsay, Paris (EU 1900)

Religion

Although in general the nineteenth century was an age of diminishing religious faith, the end of the century saw a religious revival symptomatic of a more general spiritual yearning as a reaction against the steady rise of material culture.

With its impeccable technique and perfectly symmetrical composition, the arch-academician Bouguereau's grand religious submission to the French section of the Exposition Universelle (cat. 239), an unabashed restatement of a Raphael altarpiece, affirms the certainties of the old order. Munch's *Golgotha* (cat. 236), also painted in 1900, though not included in the Exposition Universelle, jettisons all notions of conventional composition and iconography in the interests of raw emotion; stripped of any sense of the divine, his Christ, a naked emblem of human frailty, announces the new age of anxiety.

The central themes of Christian iconography could be interpreted in ways that were either traditional or contemporary, or a mixture of both. Previati revitalises the familiar story of the Crucifixion in a daringly cropped composition (cat. 238) that rivets our gaze to the brutal detail of Christ's feet nailed to the cross, employing Divisionist colour in an emotive landscape that amplifies the lament of the grieving women. Although Carrière's Exposition picture (cat. 235) pays homage to earlier models, his distinctive dematerialising veils of mist seem to have as much to do with *fin-de-siècle* Symbolism as Christian spirituality.

The dramatic lighting and sense of narrative in *The Annunciation* (cat. 246) by the devout African-American painter Tanner carries an undoubted emotional sincerity, while Denis's fairy-tale archaising of this subject (cat. 245), emulating the chalky flatness of Puvis de Chavannes and Italian Quattrocento fresco painting, was dismissed by one critic as a 'travesty of episodes from the gospel'.

Other artists found that contemporary, and frequently humble, settings could invest the scriptures with greater relevance. One of Lhermitte's entries to the Exposition is transposed to a French peasant's simple kitchen (cat. 24). Sometimes scenes of contemporary piety were conflated with nationalism. In a work subtitled 'Finnish Legend' when it was shown in the Russian pavilion at the Exposition Universelle, Edelfelt's young Finnish Magdalene kneels before Christ in a typically Nordic landscape (cat. 244).

Contemporary scenes of worship were also popular. Religious observances in the austere Lutheran fishing communities of Denmark and Sweden (cats 23, 242) find a Catholic counterpart in the black-clad Catalan widows proffering votive candles in an opulent Spanish chapel painted by Picasso's friend, Pichot (cat. 241).

Secular images of the mother-and-child theme can be reminiscent of the Madonnas of Christian iconography, whether in the tender portrayal of a young, coarse-featured peasant girl by the German painter Modersohn-Becker (cat. 253) or in the sweeter and more conventionally naturalistic scene by Danielson-Gambogi, one of the paintings chosen to represent Finland at the Exposition Universelle (cat. 252).

Religious sculpture was no less diverse. The American Saint-Gaudens infused Renaissance models with a *fin-de-siècle* stylisation (cat. 248) while Lacombe, inspired by medieval sculpture, Art Nouveau and an avant-garde interest in the primitive shared by his mentor Gauguin, employed the unpretentious medium of wood to carve his peasant Magdalene (cat. 243). In contrast, the British sculptor Gilbert used paint and variegated patinated bronze for his courtly Virgin (cat. 247), an extravagant fusion of Art Nouveau with the jewel-like preciousness of a medieval relic. AD

(opposite) Detail of cat. 240

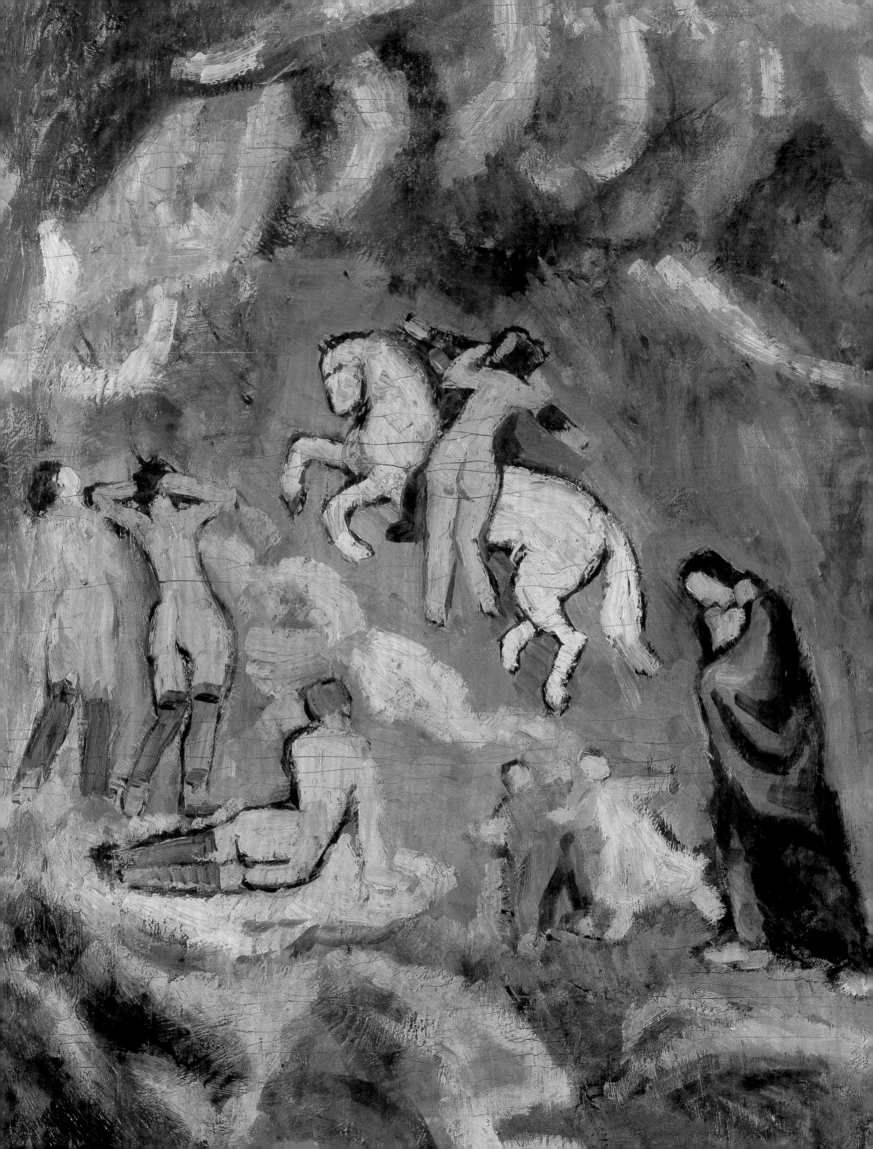

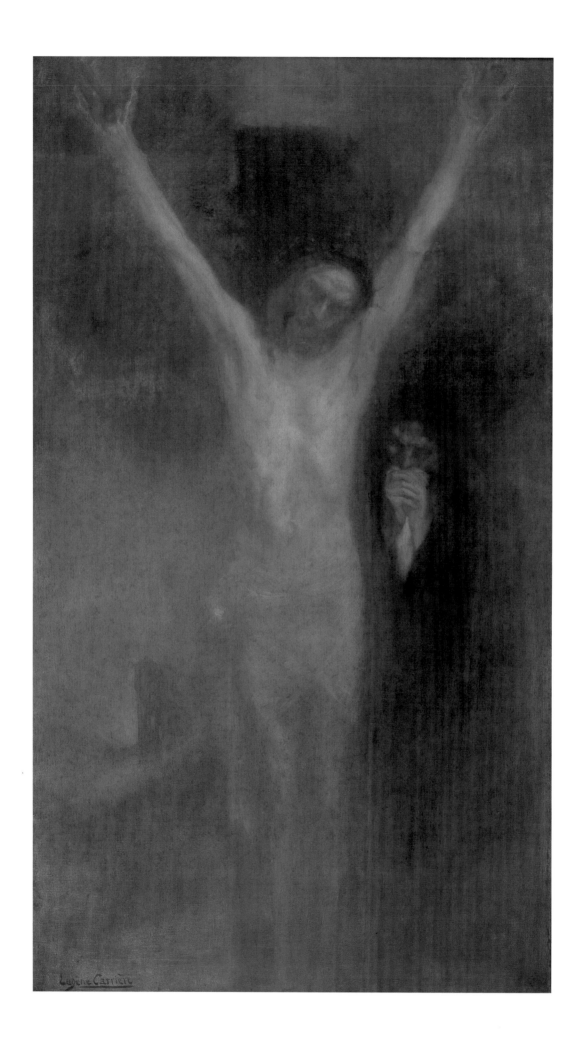

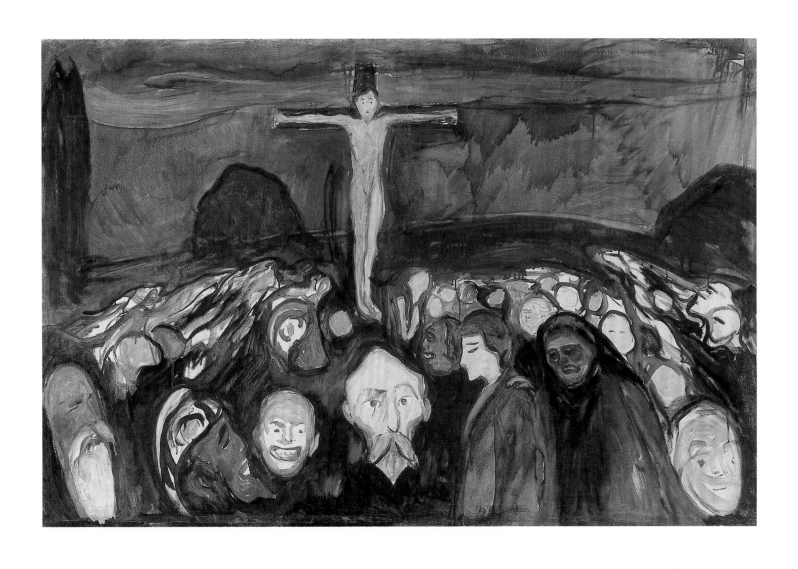

235 (*opposite*) Eugène Carrière, *Crucifixion*, 1897.
Oil on canvas, 227 × 130 cm. Musée d'Orsay, Paris. Bought through the support of a group of admirers and friends, 1903 (EU 1900)

236 (*above*) Edvard Munch, *Golgotha*, 1900. Oil on canvas, 80 × 120 cm. Munch-Museet, Oslo

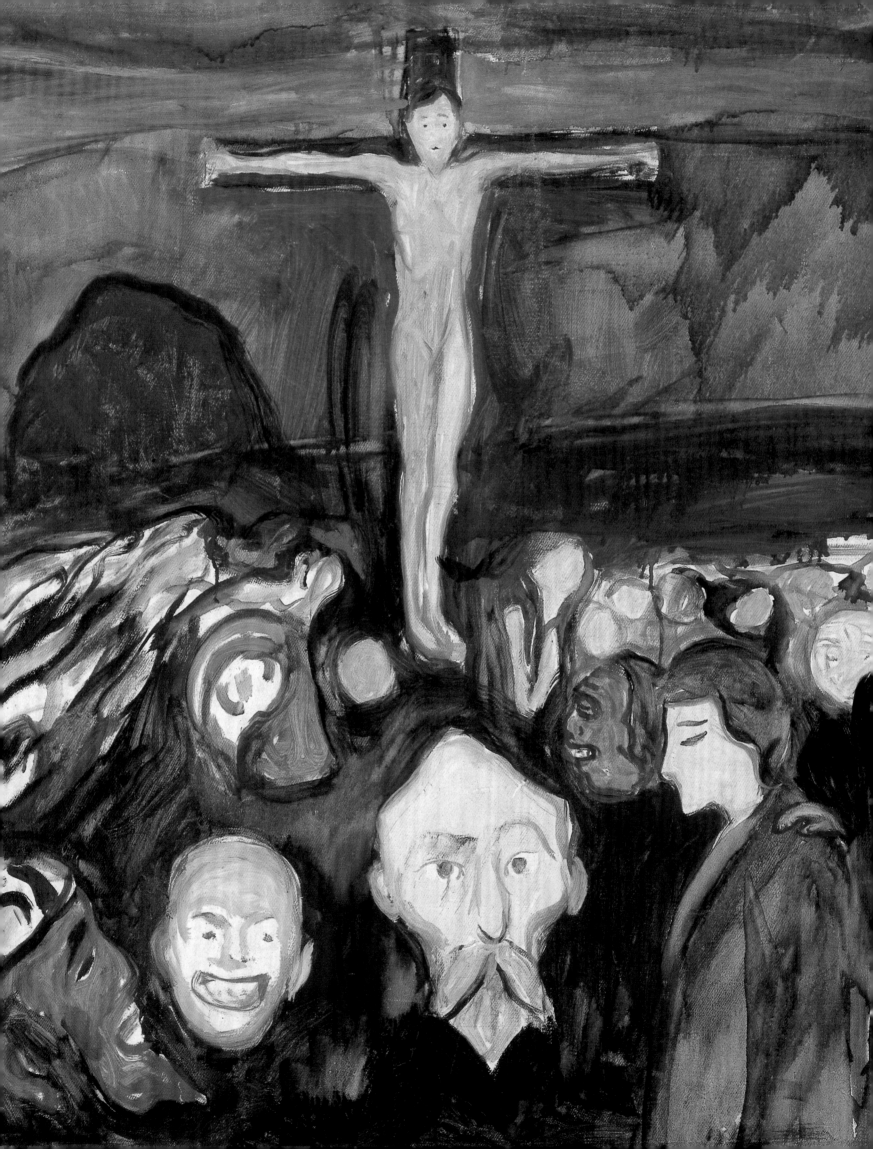

(*opposite*) Detail of cat. 236

237 (*right*)
LUDWIG HERTERICH,
Ulrich von Hutten, 1894.
Oil on canvas, 184 × 108 cm.
Gemäldegalerie Neue Meister,
Staatliche Kunstsammlungen, Dresden (EU 1900)

238 (*below*)
GAETANO PREVIATI,
The Three Marys at the Foot of the Cross, 1897.
Oil on canvas, 125 × 170 cm.
Collection Calmarini, Milan

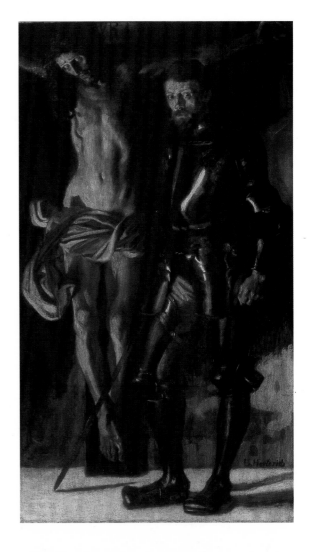

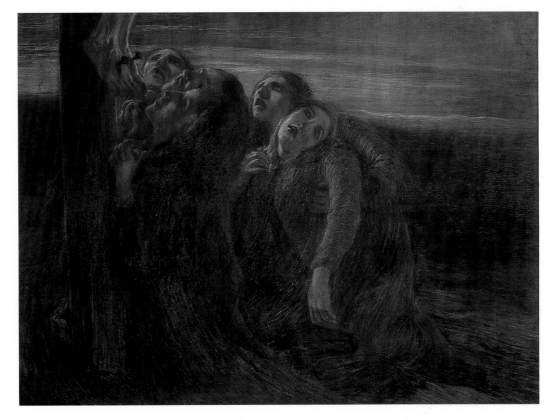

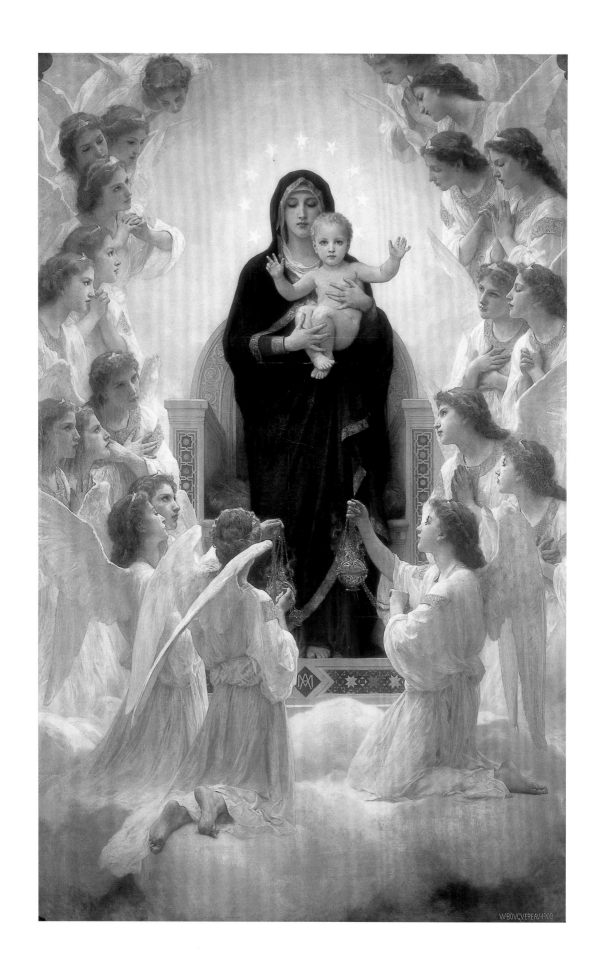

239 WILLIAM-ADOLPHE BOUGUEREAU, *Regina Angelorum,* 1900. Oil on canvas, 285 × 185 cm. Musée du Petit Palais, Musées des Beaux-Arts de la Ville de Paris (EU 1900)

240 PABLO PICASSO, *The Burial of Casagemas (Evocation)*, 1901. Oil on canvas, 150 × 90 cm. Musée d'Art Moderne de la Ville de Paris

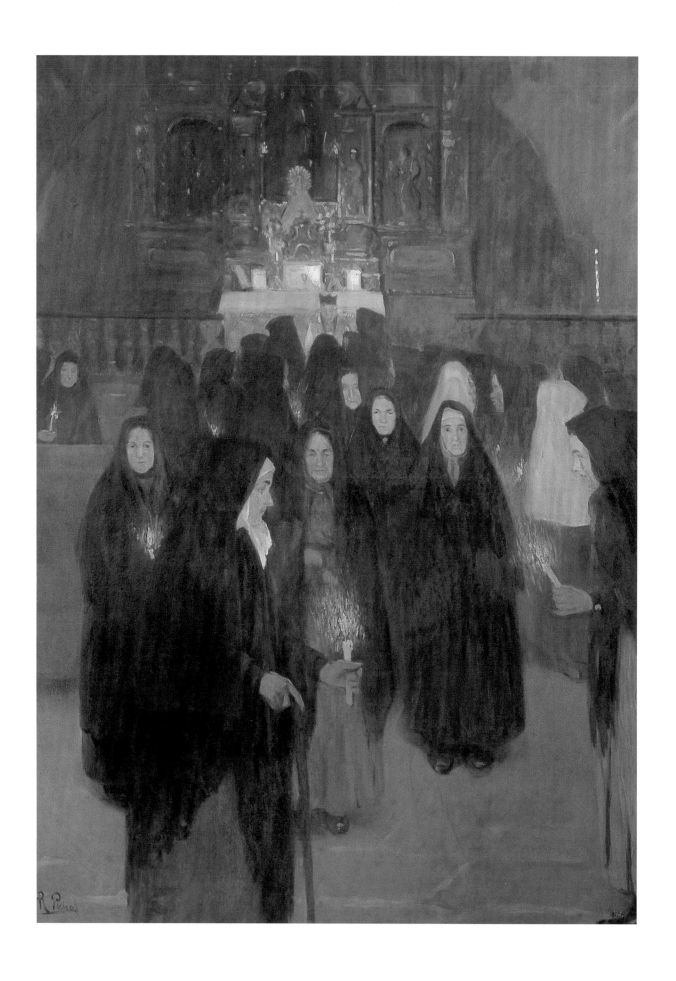

241 RAMON PICHOT GIRONÉS, *Offering, c.* 1898. Oil on canvas, 165 × 120 cm. Museu Nacional d'Art de Catalunya (Museu d'Art Modern), Barcelona

242 CARL WILHELMSON, *Fishermen's Wives Returning from Church*, 1899. Oil on canvas, 137 × 104 cm. Nationalmuseum, Stockholm (EU 1900)

243
GEORGES LACOMBE,
Magdalene, 1897.
Wood, 105 × 42 × 53 cm.
Palais des Beaux-Arts, Lille

244 (*opposite*)
ALBERT EDELFELT,
Christ and Mary Magdalene, Finnish Legend, 1890.
Oil on canvas, 221 × 154 cm.
The Finnish National Gallery Ateneum,
Helsinki (EU 1900)

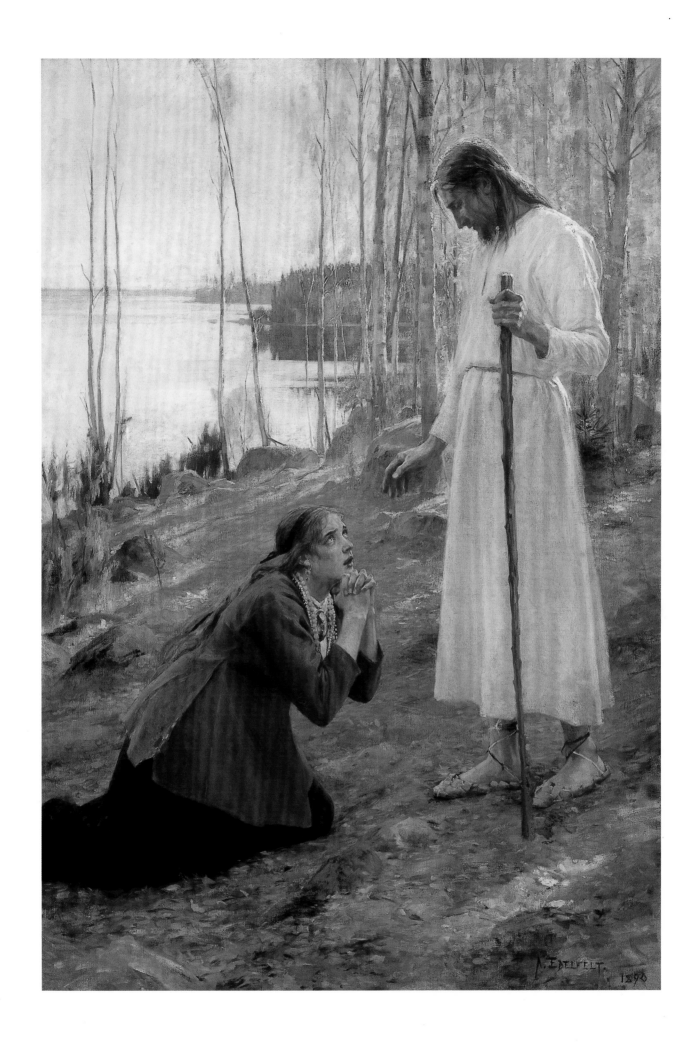

311

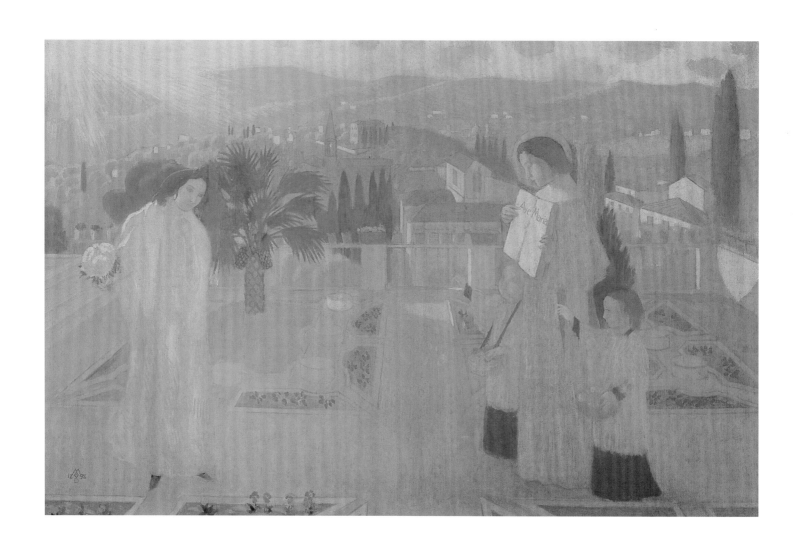

245 MAURICE DENIS, *The Annunciation at Fiesole*, 1898. Oil on canvas, 76 × 116 cm. Private Collection

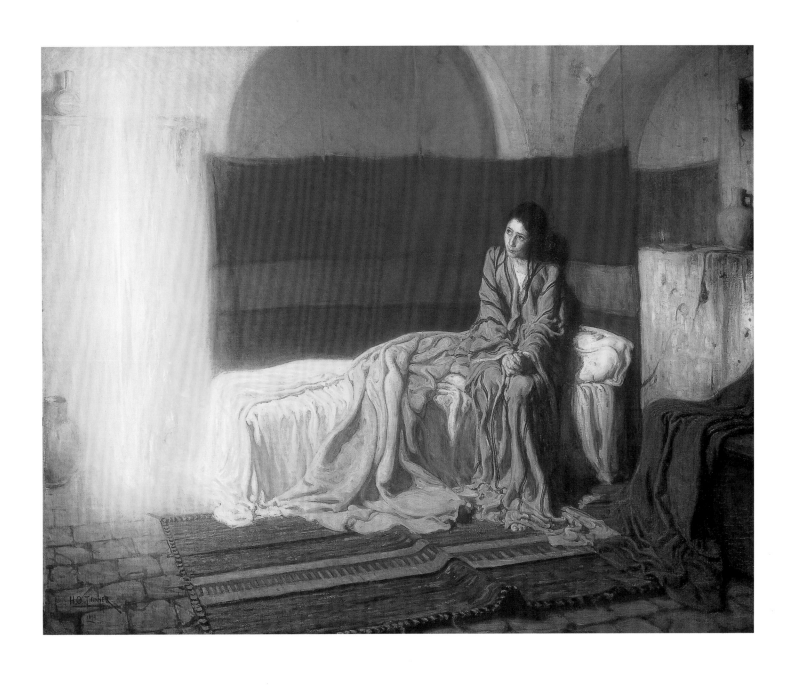

246 HENRY OSSAWA TANNER, *The Annunciation*, 1898. Oil on canvas, 144.8 × 181 cm. Philadelphia Museum of Art. W. P. Wilstach Collection

247
SIR ALFRED GILBERT,
The Virgin, 1899.
Painted bronze, 53.3 × 33 × 33 cm.
A Scottish parish church

248 *(opposite)*
AUGUSTUS SAINT-GAUDENS,
Amor Caritas, 1898.
Bronze low-relief,
101 × 44.5 × 10.2 cm.
Brooklyn Museum of Art.
Gift of Mr and Mrs Harris
Klein (68.184)

249
GEORGE MINNE,
Kneeling Boy, 1898.
Marble, 80 × 42 × 20 cm.
Museum Boijmans van Beuningen,
Rotterdam

250 (*opposite*)
GARI MELCHERS,
The Communicant, c. 1900.
Oil on canvas, 160.7 × 109.2 cm.
The Detroit Institute of Arts.
Bequest of Mr and Mrs Charles M. Swift

251 ALEKSANDR VIKTOROVICH MORAVOV, *Mother and Child*, 1902. Oil on canvas, 77 × 66.5 cm. The State Russian Museum, St Petersburg

252 ELIN DANIELSON-GAMBOGI, *Mother*, 1893. Oil on canvas, 95 × 57 cm. The Finnish National Gallery Ateneum, Helsinki (EU 1900)

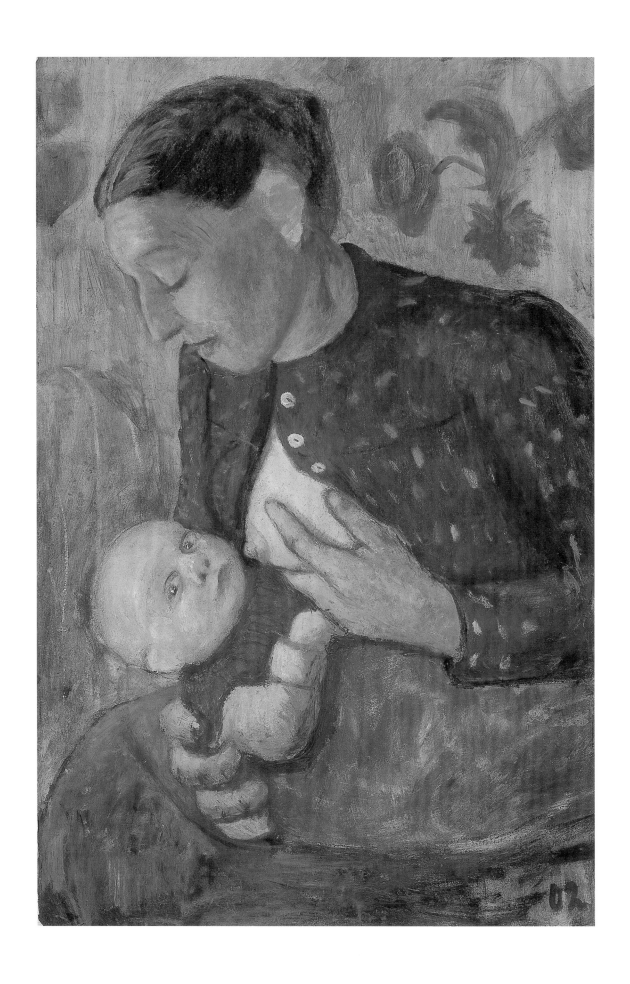

253 Paula Modersohn-Becker, *Nursing Mother*, c. 1902. Oil on paper, 72.2 × 48 cm. Galerie Michael Haas, Berlin

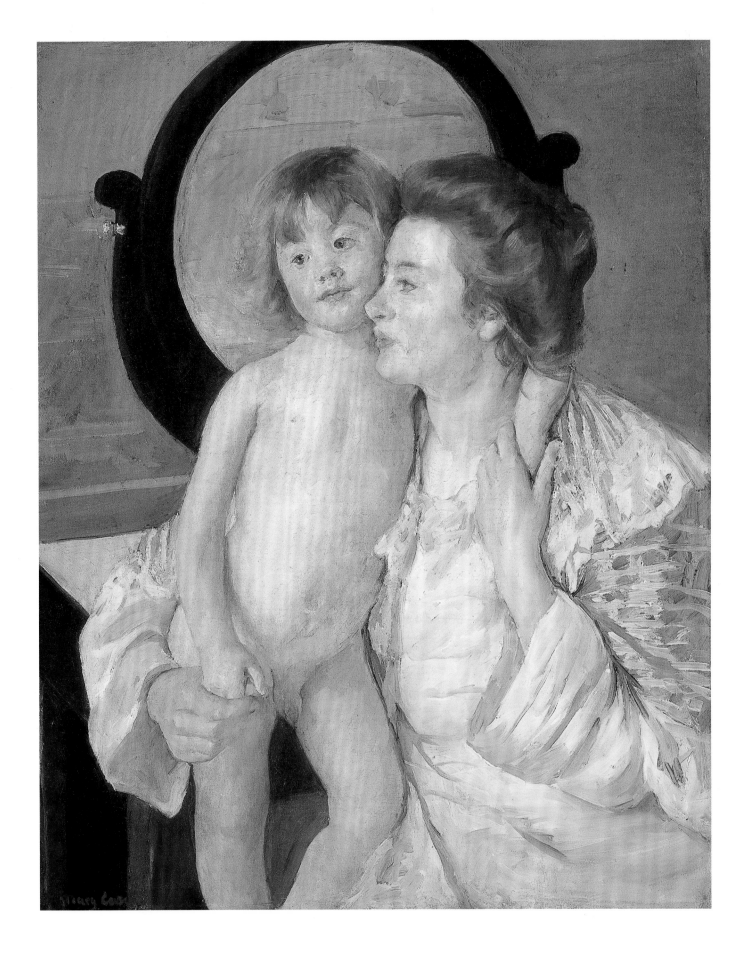

254 MARY CASSATT, *Mother and Child*, 1898.
Oil on canvas, 81.6 × 65.7 cm. Lent by the Metropolitan Museum of Art, H. O. Havemeyer Collection. Bequest of Mrs H. O. Havemeyer, 1929

Self-portraits

Many of the self-portraits painted around 1900 reflect the introspection of the age. Proust's infinitely nuanced interior journey in *A la Recherche du temps perdu* and Freud's investigations of the pysche in the new field of psychoanalysis are among the most notable manifestations of a new kind of self-awareness that emerged in the first decades of the century. Interestingly, the term 'self-portrait' dates only from the nineteenth century. In earlier periods artists' views of themselves tended to conform to ideas about man's place in a larger scheme of things, but with the Romantic period there was a drastic shift towards a new sense of self in which individual feelings predominated. It is essentially this Romantic self that persisted, though often recast in contemporary modes, throughout the nineteenth and into the twentieth centuries.

The intense gaze that is so compelling in the self-portraits of Leduc, Mondrian, Sousa and Stuck (cats 258, 277, 274, 260) often seems fixed on things beyond this world and reflects the visionary quality that, in different ways, characterises the work of each of these artists. The Swiss painter Hodler's sharply focused view of himself is filled with the same icy light that fills his pantheistic Alpine landscapes (cat. 278). Jansson, another painter of mystical 'blue' landscapes, contrasts his own enclosed persona with the landscape that stretched beyond his studio window, the Riddarfjärder bay in Stockholm that he painted at dawn and dusk for over fifteen years (cat. 261).

Gwen John's almost prim self-possession expresses the reclusive, religious side of her nature present in the many self-portraits that she painted after her liaison with Rodin (cat. 271). Modersohn-Becker's equally probing scrutiny is already evident in an unusual early work (cat. 272) whose fluid transparent handling would soon give way to the radical simplification of the many self-portraits that she subsequently painted during her short life.

Gauguin's bespectacled self-portrait (cat. 263) is unusually restrained in comparison with the flamboyance with which he usually portrayed himself. There is little restraint, however, in Corinth's extended self-investigation. In the portraits he painted each year on his birthday, he frankly exposes his various states of physical and psychological nakedness (cat. 265). Eakins, who excelled at painting portraits of the Philadelphia élite, presents an intensely private view of himself in a self-portrait (cat. 279) reminiscent of Rembrandt in its dramatic light and deep shadow.

Renoir, who was also renowned as a society portraitist, particularly of society beauties, shows his face lined with the vulnerability and pain he suffered during the onset of the rheumatic illness that would eventually cripple him (cat. 264). Sickert's view of himself (cat. 276), portrayed in a rough, unidealised technique and dull palette, is also a record of personal suffering painted during a year of self-examination following his divorce. In striking contrast, the young Dufy, soon to be celebrated for his colourful images of urbane recreation, cuts a debonair and carefree figure in the world (cat. 280). AD

(*opposite*) Detail of cat. 263

255 (above)
EUGÈNE CARRIÈRE,
Self-portrait, 1890s.
Oil on canvas, 45 × 37.3 cm.
Galleria degli Uffizi, Florence.
Collezione degli autoritratti

256 (left)
JOZEF ISRAËLS,
Self-portrait, c. 1900–10.
Oil on canvas, 58 × 47.5 cm.
Galleria degli Uffizi, Florence.
Collezione degli autoritratti

257 (*above*)
BENJAMIN CONSTANT,
Self-portrait, *c.* 1902.
Oil on canvas, 65 × 54 cm.
Galleria degli Uffizi, Florence.
Collezione degli autoritratti

258 (*right*)
OZIAS LEDUC,
Self-portrait, 1899.
Oil on paper mounted on panel, 33 × 27 cm.
National Gallery of Canada, Ottawa

259 JULIO RUELAS, *Self-portrait*, 1900. Oil on canvas, 46.5 × 35 cm.
Consejo Nacional para la Cultura y las Artes, the Instituto Nacional de Bellas Artes y Literatura, the Museo Nacional de Arte, Mexico City

260 FRANZ VON STUCK, *Self-portrait*, 1899. Oil on canvas, 30 × 23.5 cm. Museum Villa Stuck, Munich. Gift of Hans Joachim Ziersch

261 (*opposite above*) EUGÈNE JANSSON, I. *Self-portrait*, 1901. Oil on canvas, 101 × 144 cm. Thielska Galleriet, Stockholm

262 (*opposite below*) CHARLES SHANNON, *Self-portrait*, 1897. Oil on canvas, 92.7 × 96.5 cm. National Portrait Gallery, London

263 (*above*) PAUL GAUGUIN, *Self-portrait*, 1902–03. Oil on canvas, 42 × 25 cm. Öffentliche Kunstsammlung Basel, Kunstmuseum. Bequest of Dr Karl Hoffmann, 1945

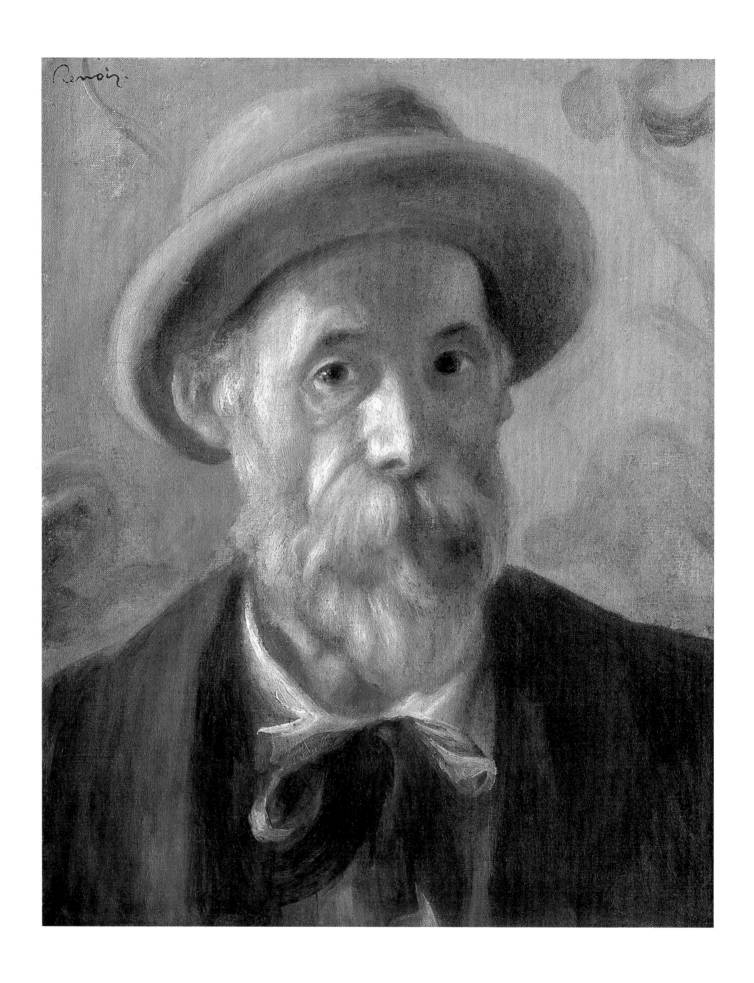

264 AUGUSTE RENOIR, *Self-portrait*, c. 1897. Oil on canvas, 41 × 33 cm. Sterling and Francine Clark Art Institute, Williamstown, Massachusetts

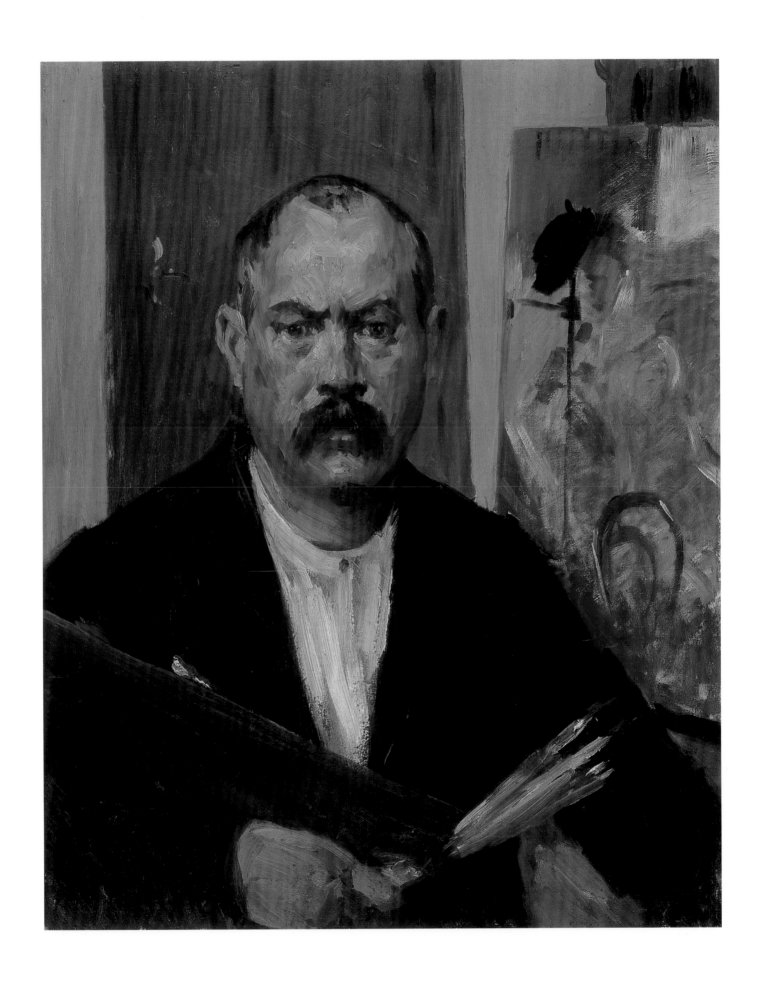

265 LOVIS CORINTH, *Self-portrait without Collar*, 1901. Oil on canvas, 73 × 60 cm. Stadtmuseum, Berlin

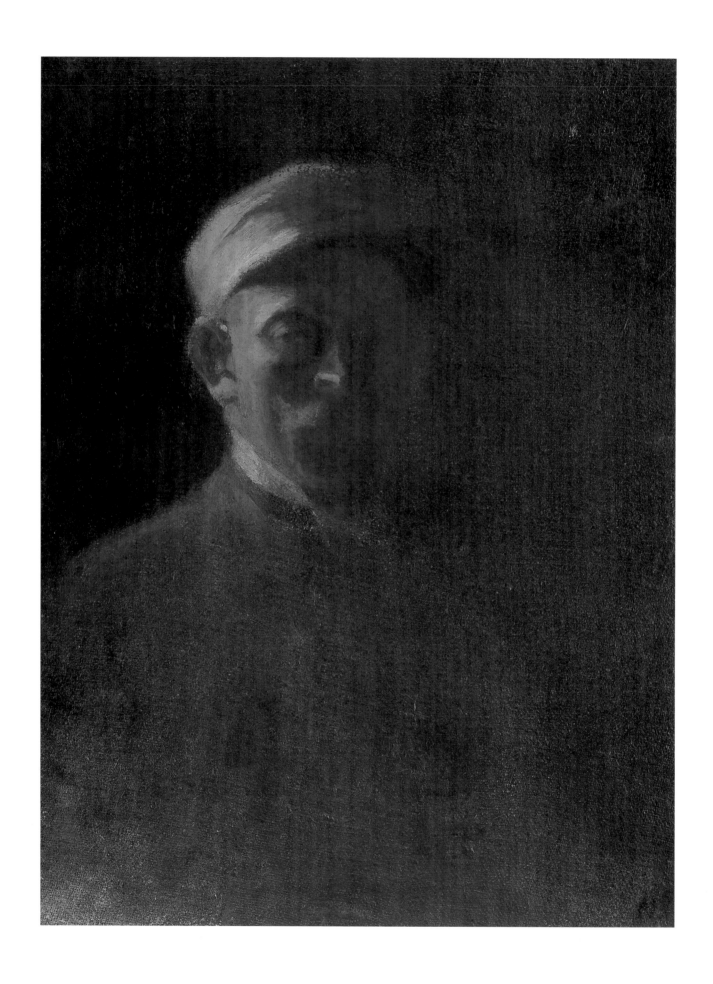

266 EMIL NOLDE, *Self-portrait*, 1899. Oil on canvas, 69 × 52 cm. Nolde-Stiftung, Seebuell

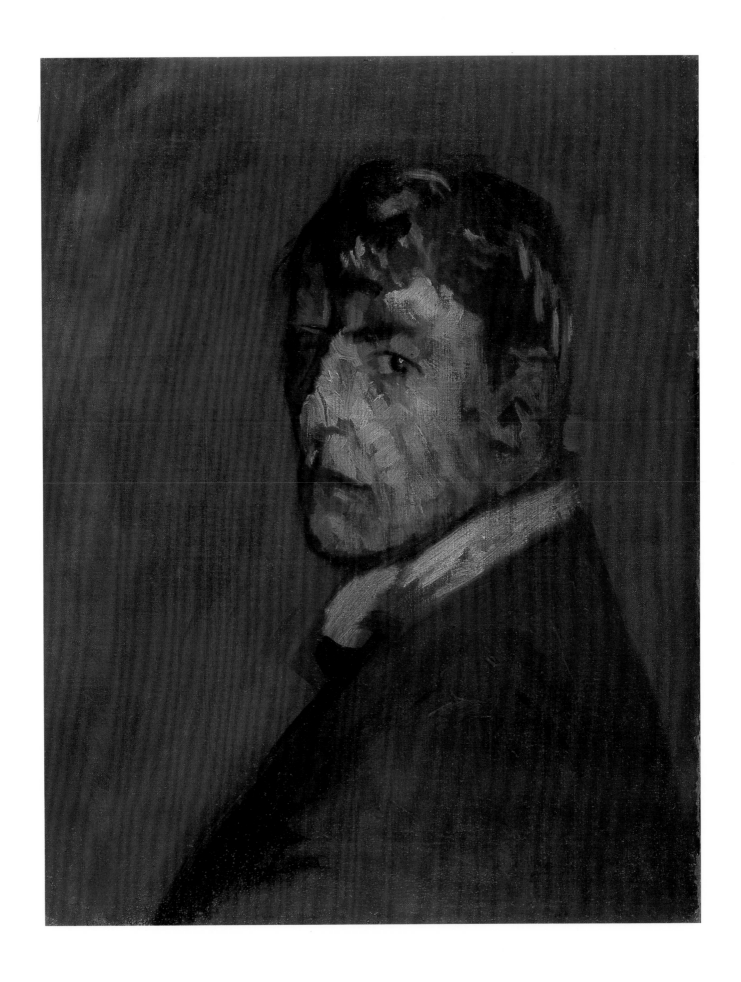

267 WALTER RICHARD SICKERT, *Self-portrait, c.* 1896. Oil on canvas, 45.7 × 35.6 cm. Leeds Museums and Galleries (City Art Gallery)

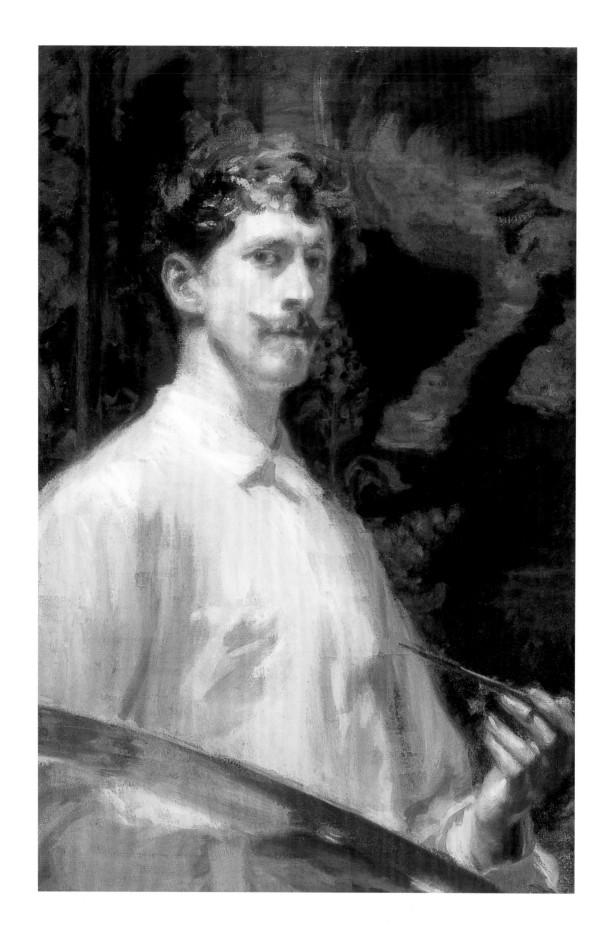

268 FREDERICK WILLIAM MACMONNIES, *Self-portrait with Palette*, 1897–1903. Oil on canvas, 81.3 × 54.3 cm. Terra Foundation for the Arts. Daniel J. Terra Collection (1992.46)

(*opposite*) Detail of cat. 270

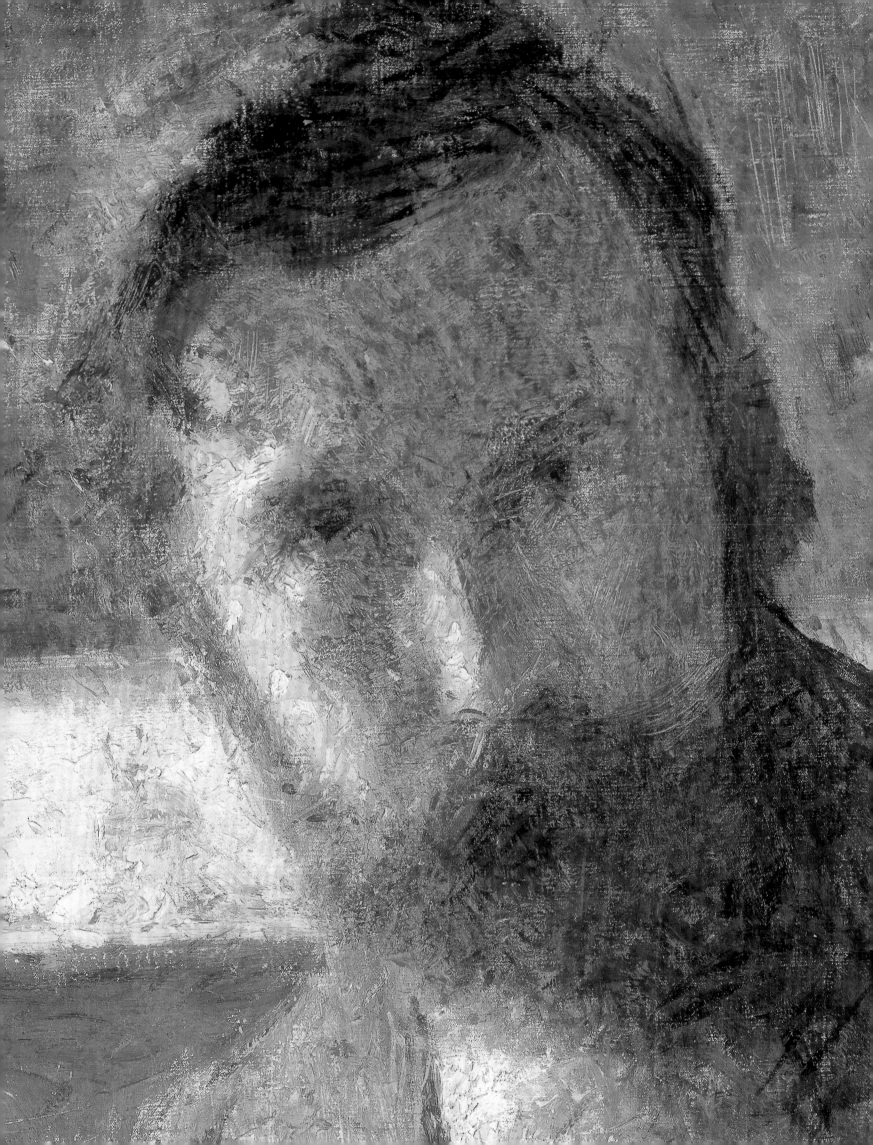

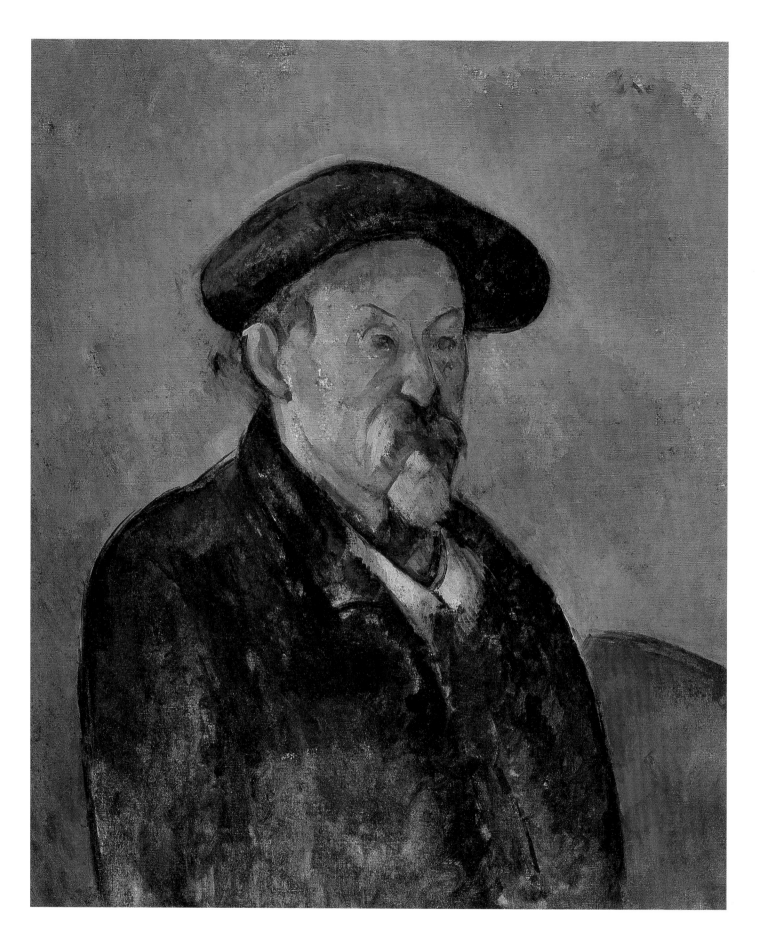

269 PAUL CÉZANNE, *Portrait of the Artist with a Beret*, 1898–1900.
Oil on canvas, 63.3 × 50.8 cm. Museum of Fine Arts, Boston. Charles H. Bayley Picture and Painting Fund and Partial Gift of Elizabeth Paine Metcalf

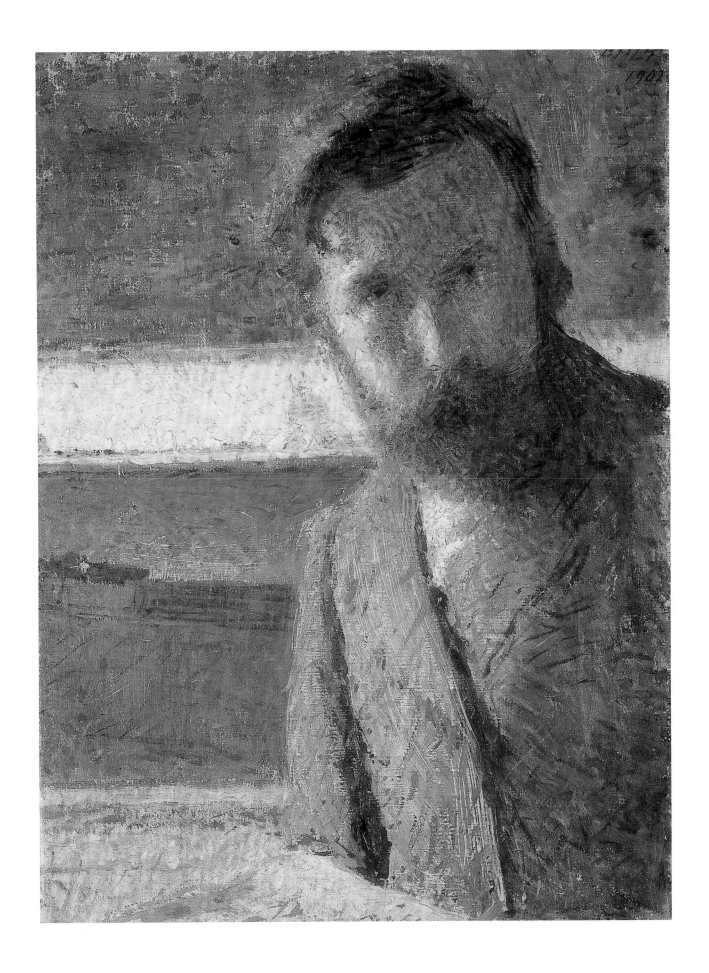

270 GIACOMO BALLA, *Self-portrait*, 1902. Oil on canvas, 59 × 43 cm. Banca d'Italia, Rome

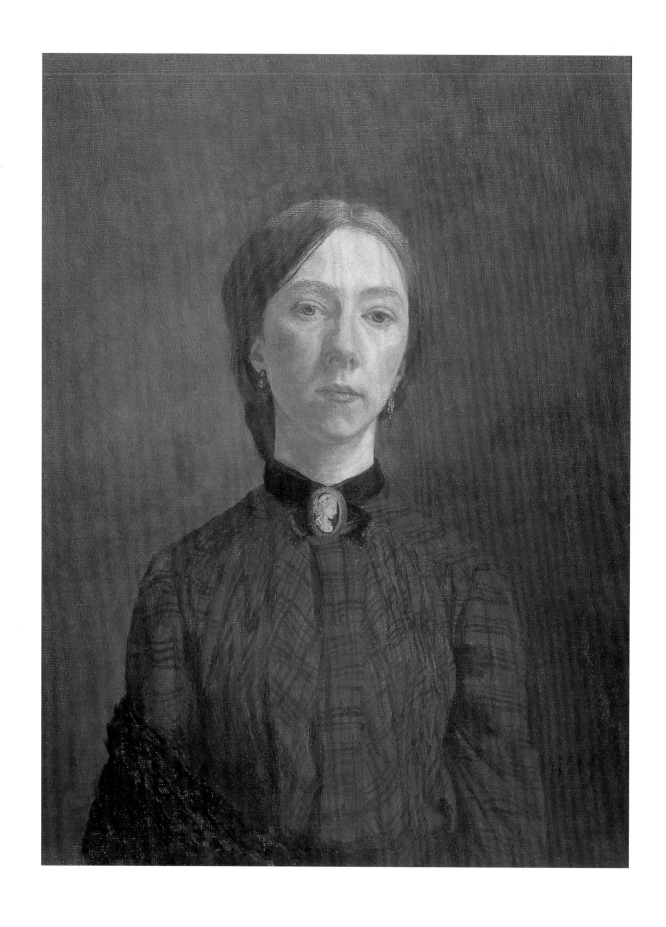

271 GWEN JOHN, *Self-portrait*, 1902. Oil on canvas, 44.8 × 34.9 cm. Tate Gallery. Purchased 1942

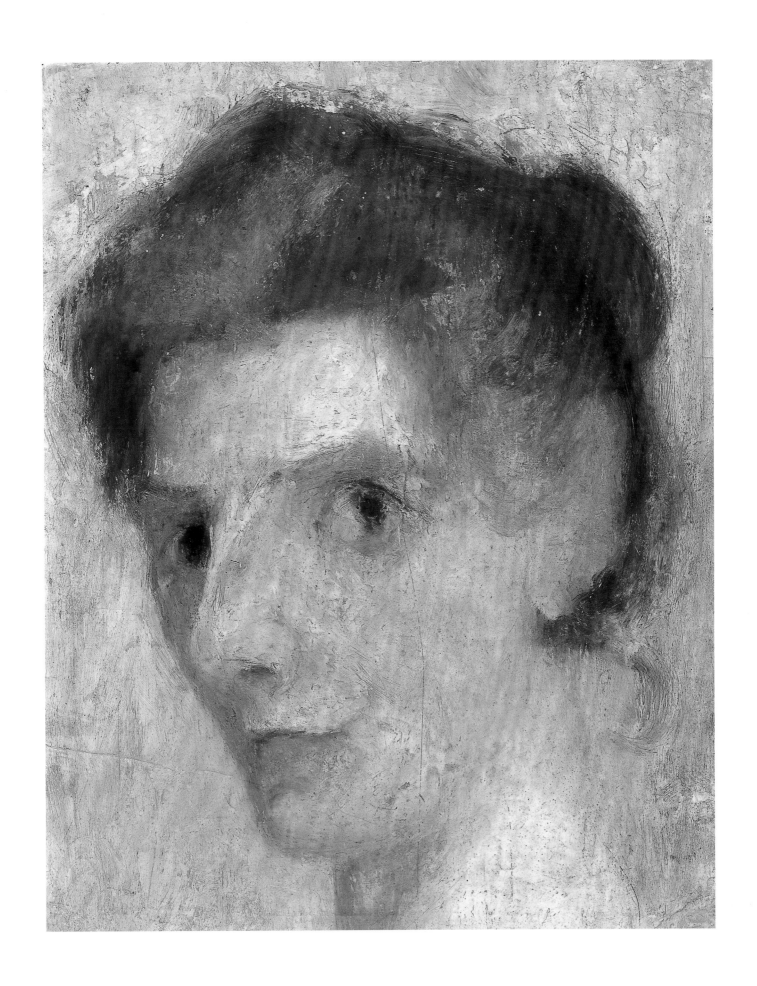

272 PAULA MODERSOHN-BECKER, *Self-portrait*, 1898. Oil on paper, 28.2 × 23 cm. Kunsthalle, Bremen

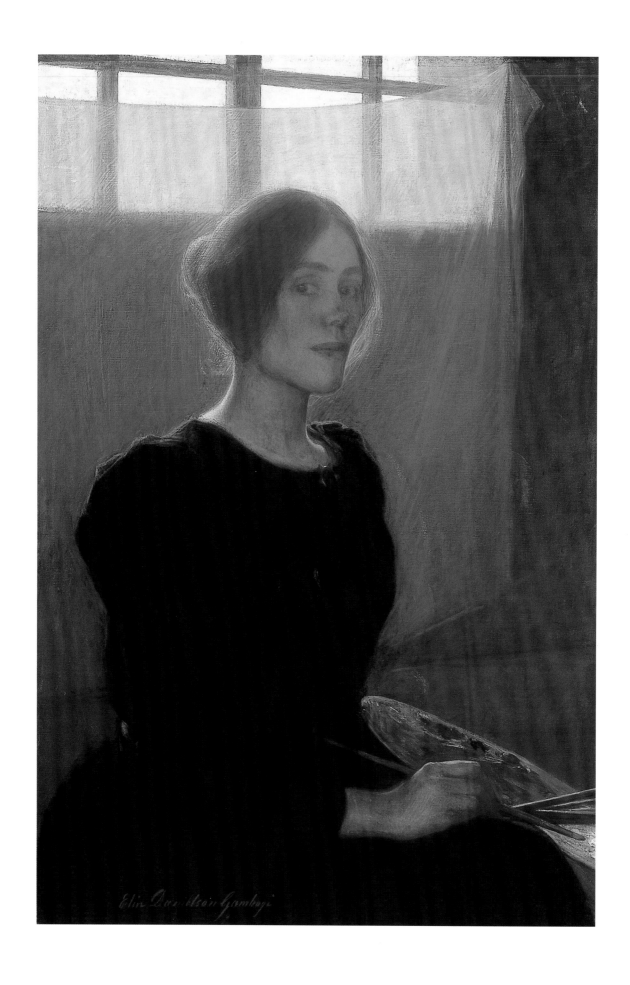

273 Elin Danielson-Gambogi, *Self-portrait*, 1900. Oil on canvas, 96 × 65.5 cm. The Finnish National Gallery Ateneum, Helsinki. Collection Antell

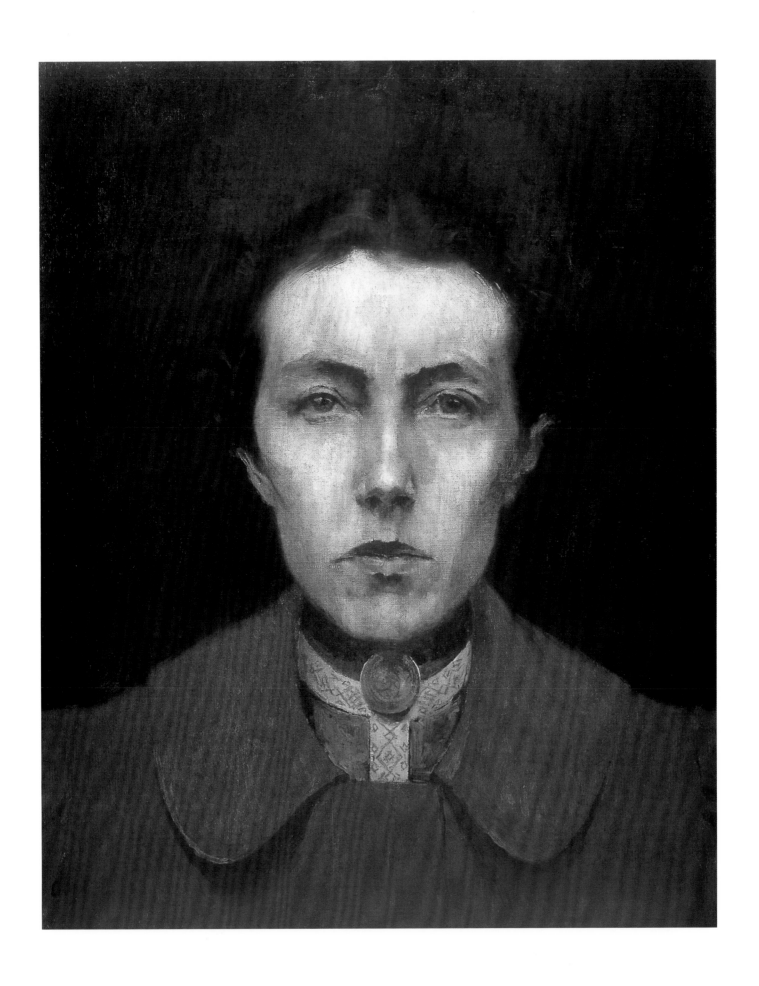

274 AURÉLIA DE SOUSA, *Self-portrait, c.* 1900. Oil on canvas, 45.6 × 36.4 cm. Museu Nacional de Soares dos Reis, Oporto

275 ALFRED H. MAURER, *Self-portrait*, 1897.
Oil on canvas, 73 × 53.3 cm. Lent by the Frederick R. Weisman Art Museum, University of Minnesota. Gift of Ione and Hudson Walker

276 PABLO PICASSO, *Self-portrait (Yo)*, 1901. Oil on cardboard mounted on wood, 51.4 × 31.1 cm. The Museum of Modern Art, New York. Mrs John Hay Whitney Bequest

277 PIET MONDRIAN, *Self-portrait*, 1900. Oil on canvas, 49 × 38 cm. The Phillips Collection, Washington, D.C.

278 FERDINAND HODLER, *Self-portrait*, 1900. Oil on canvas, 41 × 26.6 cm. Staatsgalerie, Stuttgart

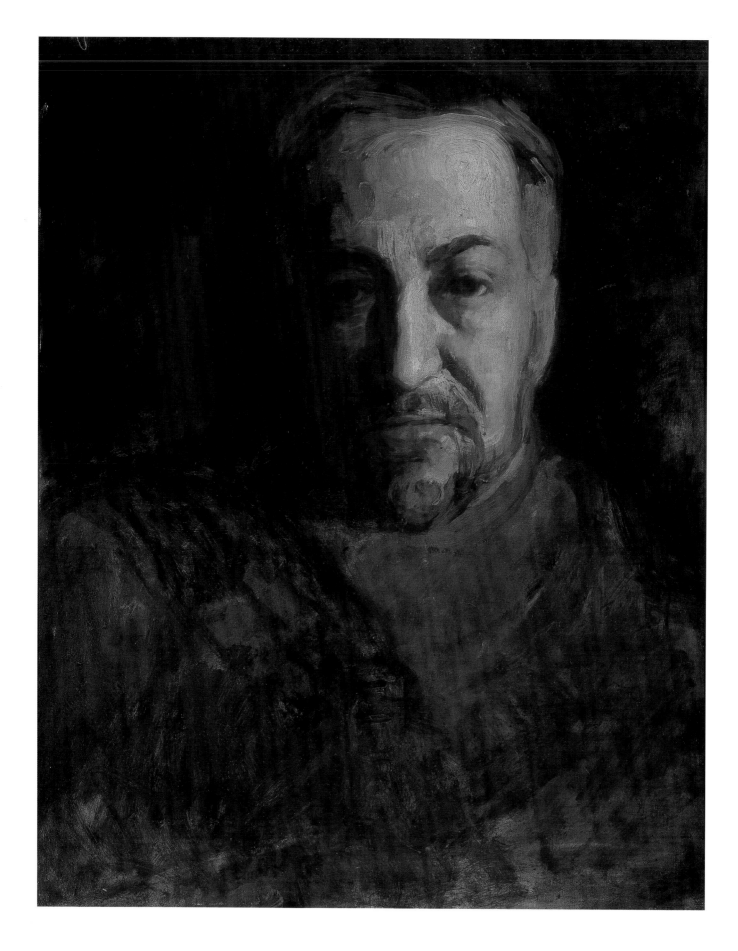

279 THOMAS EAKINS, *Self-portrait*, 1902.
Oil on canvas mounted on fibre board, 50.8 × 41 cm. Hirshhorn Museum and Sculpture Garden, Smithsonian Institution. Gift of Joseph H. Hirshhorn, 1966

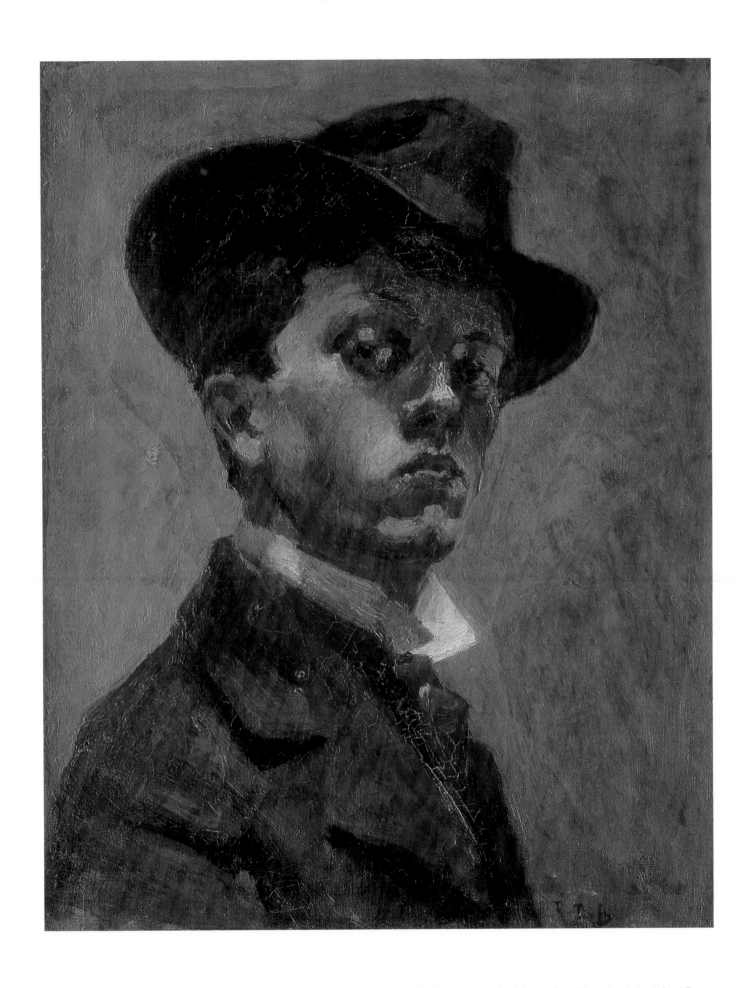

280 RAOUL DUFY, *Self-portrait*, 1899. Oil on canvas, 41 × 33.7 cm. Centre Georges Pompidou, Paris. Musée national d'art moderne/Centre de création industrielle

Triptychs

In their quest to invest modern-life subjects with the authority derived from traditional values and beliefs, many artists around 1900 turned to the Christian format of the triptych. Not surprisingly, the triptych continued to be used for religious narratives, as in Uhde's *Holy Night* (cat. 284), a work that represented Germany in the Exposition Universelle.

The triptych was also a useful format for the universal, secular themes that were so much part of *fin-de-siècle* sensibility. In Cottet's *In the Country by the Sea*, the tripartite format emphasises the quotidian round of elemental episodes in the lives of Breton fisherfolk: the men at sea, a family supper round a lamplit table and, finally, the women's lonely vigil by the seashore (cat. 285). *The Mine (Descent, Calvary, Return)*, a startlingly dramatic triptych by Meunier, a Belgian painter who specialised in images of industrial hardship, similarly ennobles the cyclical rituals of coalminers' lives, making the religious connection explicit in his title as well as his use of the altarpiece form (cat. 286).

Both the Portuguese Symbolist Carneiro and the German realist artist Kalckreuth employ the triptych for a depiction of the three stages of a woman's life (cats 282, 283). In Carneiro's account, in which fresco-like colour and dreamy mood are clearly indebted to Puvis de Chavannes, we see the heroine in the first panel as a young, naked virgin in a spring landscape, in the central panel as a fairy-tale bride of medieval legend mounted on a white horse, and finally as a black-clad widow curiously transposed to an Egyptian landscape complete with sphinx. Denis, who often relocated Christian subjects in modern-life settings, employs the altarpiece format for a secular multiple portrait of his talented friends, the Mithouard family (cat. 281). AD

(opposite) Detail of cat. 282

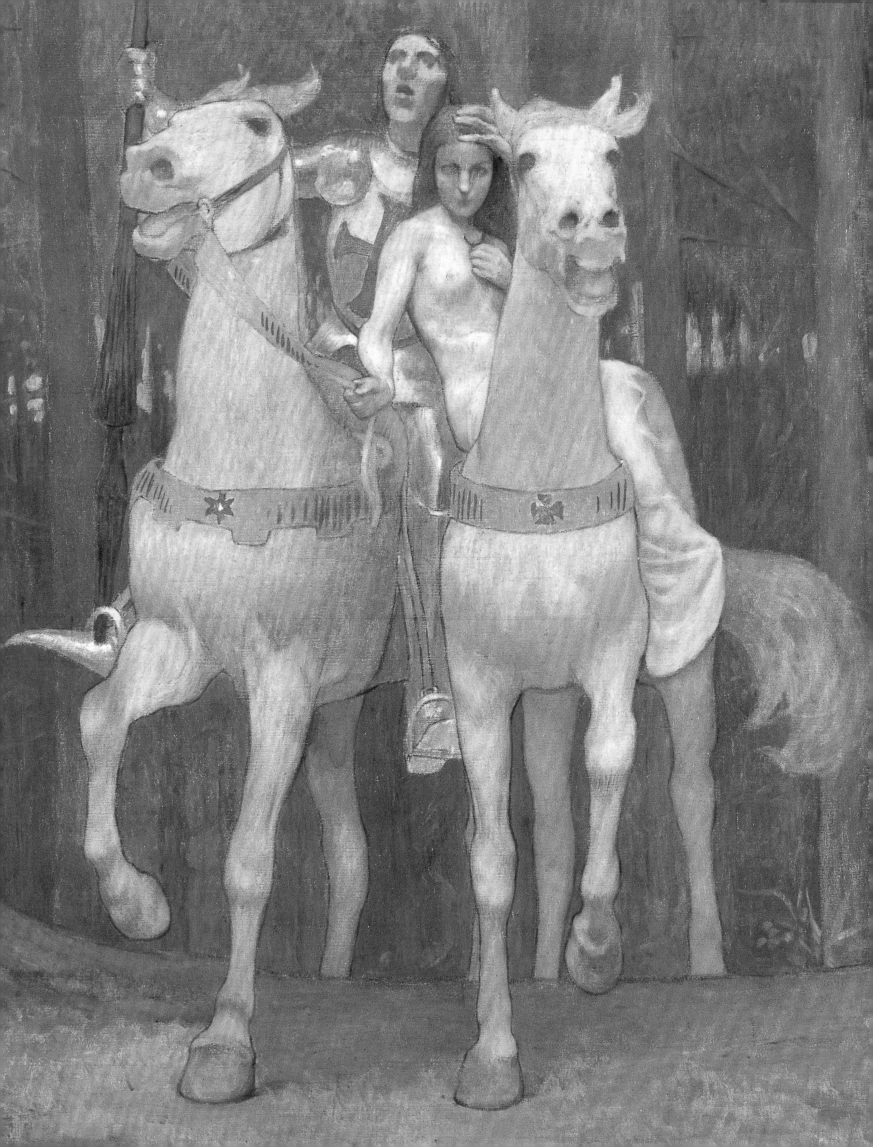

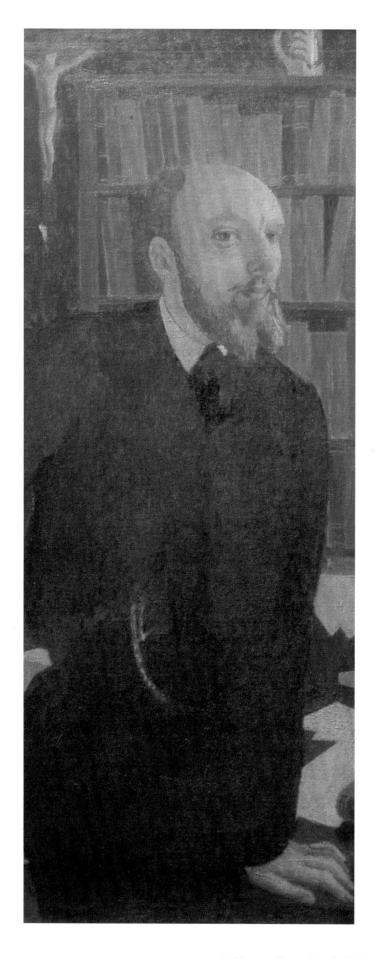
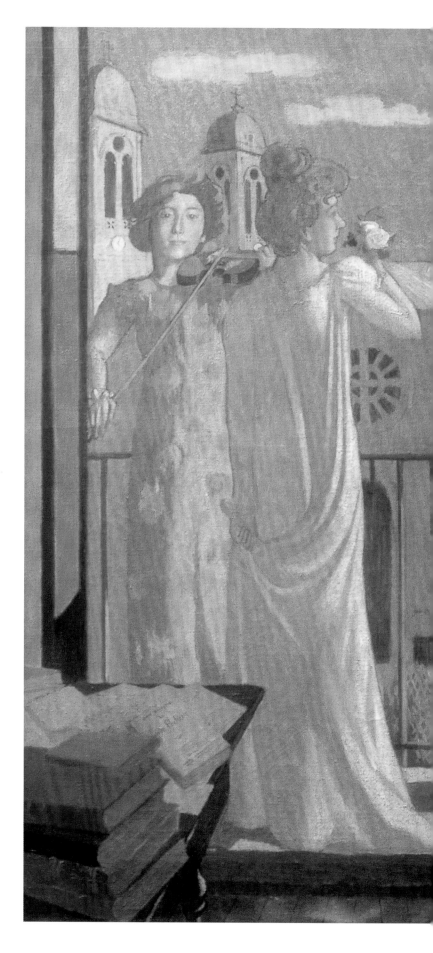

281 MAURICE DENIS, *Triptych of the Family Mithouard*, 1899. Oil on canvas, 88 × 136 cm. Private Collection

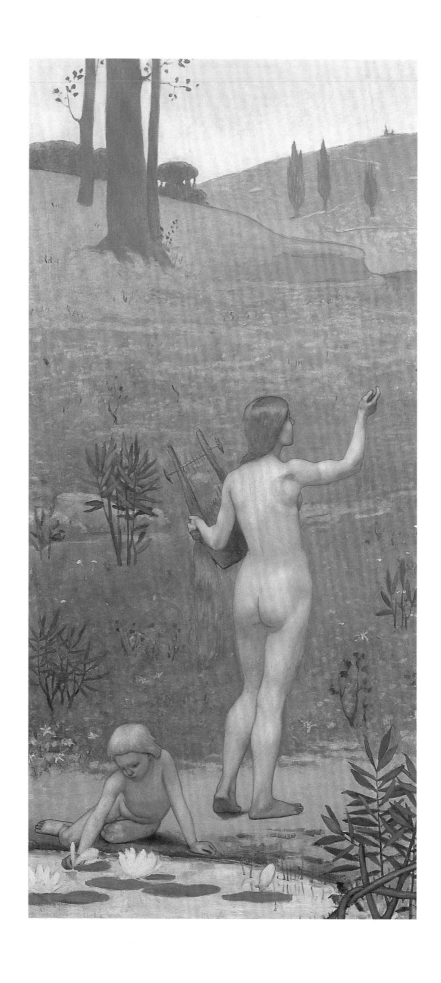

282

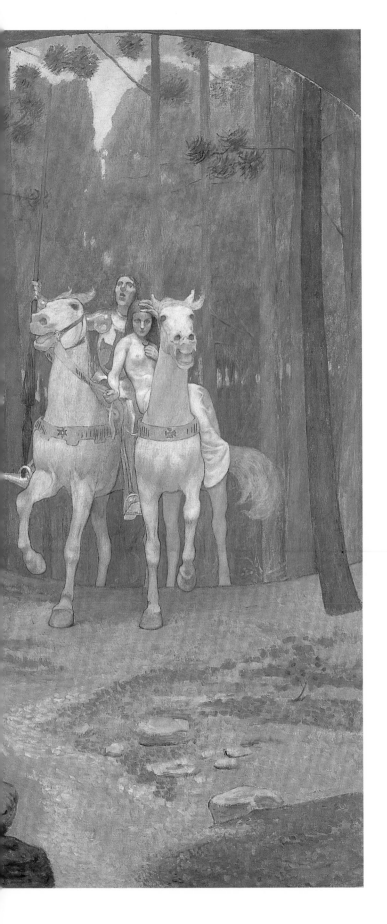

António Carneiro f. -1899-1901.

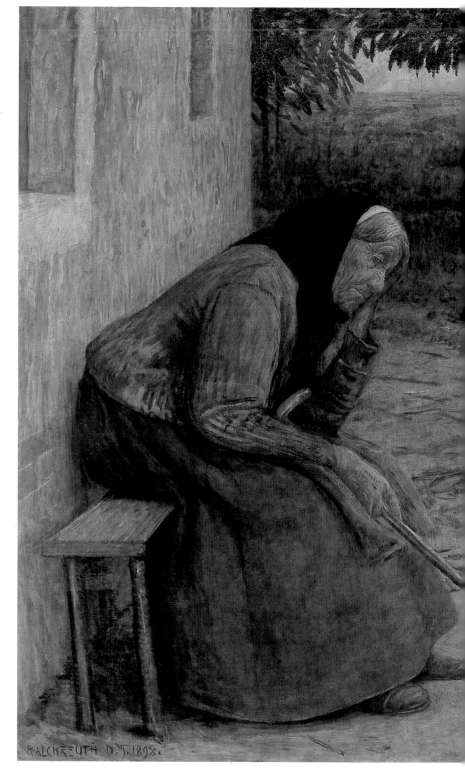

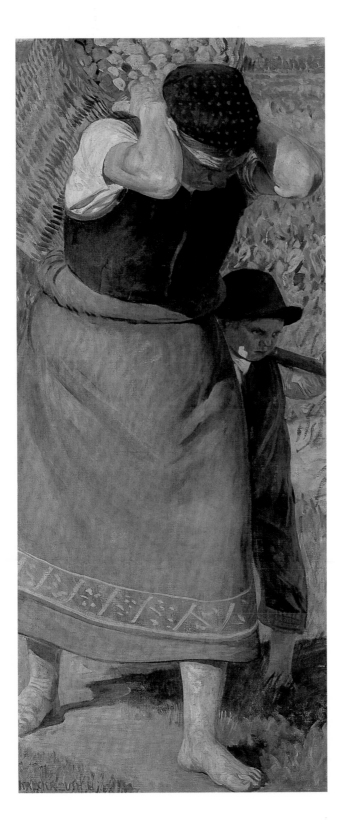

283 Count Leopold von Kalckreuth, *Three Stages of Life*, 1898. Oil on canvas, 162 × 294 cm. Bayerische Staatsgemäldesammlungen, Neue Pinakothek, Munich

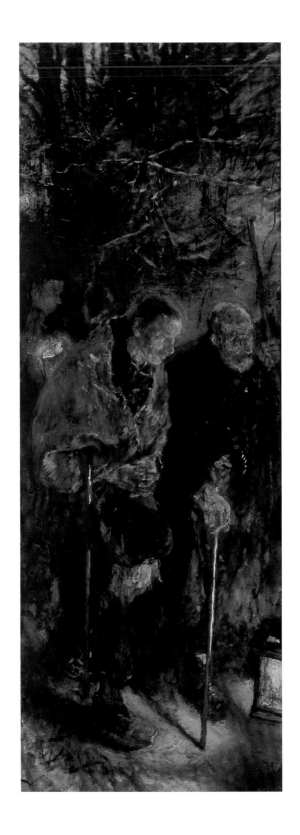

284
Fritz von Uhde,
Holy Night, 1888–89.
Oil on canvas, 134.5 × 215 cm.
Gemäldegalerie Neue Meister,
Staatliche Kunstsammlungen, Dresden (EU 1900)

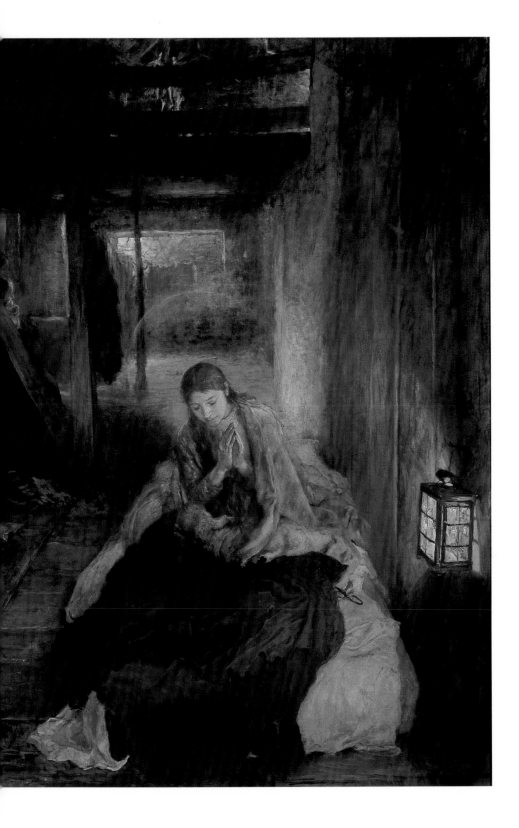
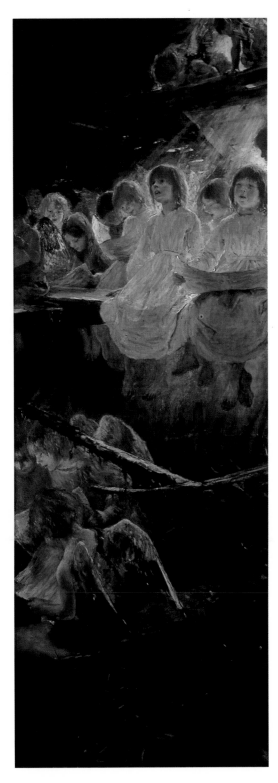

285 CHARLES COTTET, *In the Country by the Sea*, 1898. Oil on canvas, 82 × 237 cm. Museo Bottacin, Padua

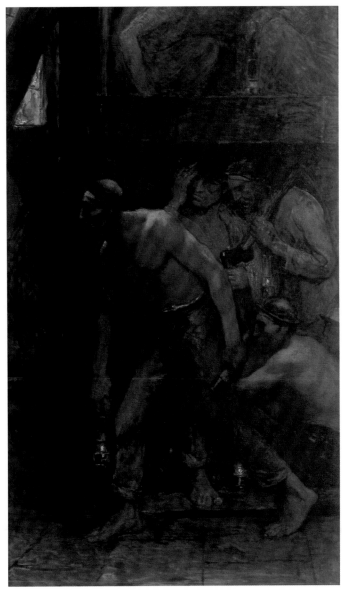

286 CONSTANTIN MEUNIER, *The Mine (Descent, Calvary, Return)*, 1900.
Oil on canvas, 140 × 170 cm. Musées Royaux des Beaux-Arts de Belgique, Brussels, Inv. 10.000/176 (1–3)

(*opposite*)
Signs displayed to warn visitors
to the 1900 Exposition Universelle
of the dangers of using the *trottoir roulant*

(*pages 364–365*)
Jan Toorop turning the wheel of a printing press in his studio, 1902

ATTENTION !

PRENEZ GARDE AUX ARBRES

NE SORTEZ NI JAMBES, NI TÊTE

BRÀVI GÈNT !

AVÍSAS-VOUS DIS AUBRE

E NOUN PASSES DEFORO NI LA CAMBO NI LA TESTO

PROVENÇAL

OUELLET !

DIHOUELLET DOH ER HOËT

TENNET AR FRAN HOU DIHOAR HA HOU PENN

BRETON

CAUTION !

BEWARE OF THE TREES

PUT OUT NEITHER HEAD NOR LEGS

ANGLAIS

КО ВНИМАНІЮ ПУБЛИКИ

Обращайто вниманіе на деревья

Не выставляйте ни головы ни ногъ

RUSSE

WARNUNG !

VORSICHT VOR DEN BÄUMEN

STRECKET WEDER KOPF NOCH BEINE HINAUS

ALLEMAGNE ET AUTRICHE

ATTENZIONE !

GUARDARSI DAGLI ALBERI

NON SPORGER FUORI NÉ LE GAMBE NÉ LA TESTA

ITALIEN

¡OJO!

Cuidado con los Árboles

NO SACAR NI PIERNAS NI CABEZA

ESPAGNOL

ATTENÇÃO !

GUARDAR-SE DAS ARVORES

NÃO ADIANTAR NEM OS PÉS NEM A CABEÇA

PORTUGAIS

WAARSCHUWING !

DENK OM DE BOOMEN

HOOFD EN BEENEN BINNEN

HOLLANDAIS

ΠΡΟΣΟΧΗ

ΠΡΟΦΥΛΑΧΘΗΤΕ ΑΠΟ ΤΑ ΔΕΝΔΡΑ

ΜΗΝ ΕΚΘΕΤΕΤΕ ΤΗΝ ΚΕΦΑΛΗΝ ΣΑΣ

ΚΑΙ ΜΗΝ ΑΠΕΚΤΕΙΝΕΤΕ

ΤΟΥΣ ΠΟΔΑΣ ΣΑΣ

GREC MODERNE

GET OICHT

OP 'T BEM ¡

STRECKT DE KAPP AN 'T BÉN NET HERAUS

LUXEMBOURGEOIS

OBSERVERA !

AKTA ER FÖR TRÄDEN

STICK EJ UT HUFVUDET ELLER BENEN

SUÉDOIS

OBSERVER

VOGTE SIG FOR TRAERNE

STRAEK HVERKEN HOVED ELLER LIDDER UD

NORWÉGIEN

OBSERVER !

PAS PAA TRÆERNE

STIK IKKE HOVED ELLER BENUD

DANOIS

Biographies

JULES ADLER
(1865–1952)

Adler was born in Luxeuil, Haute-Saône, one of five children of a cloth merchant. Recognising his artistic talents, Adler's family moved to Paris in 1882 to enrol

Jules Adler

him in the Ecole des Arts Décoratifs. He won many medals there and then attempted to enter the Ecole des Beaux-Arts, but his lack of experience of life-drawing held him back. He gained a place at the Académie Julian where he studied with William-Adolphe Bouguereau★ and Tony Robert-Fleury. His close friendships with Jean Gigoux and Pascal Adolphe Jean Dagnan-Bouveret were also to have a formative influence.

Adler eventually succeeded in entering the Ecole des Beaux-Arts where he studied with the history painter Adolphe Yvon. In 1887 he set off for the Limousin to enrich his academic knowledge with a direct study of nature. His large-scale figure compositions are some of the most evocative social commentaries on the suburban deprivation which was the other face of belle-époque Paris.

Adler's naturalism resonates with the detail and high emotion of the novels of Emile Zola. He exhibited regularly and to great acclaim in the Paris Salons of the 1890s, where he received a second class medal in 1893. Adler represented France at many World's Fairs and won a silver medal at the Exposition Universelle in 1900. He was also a founder member of the ground-breaking Salon d'Automne. CO'M

L. Barbedette, *Le Peintre Jules Adler*, Besançon, 1938

SIR LAWRENCE ALMA-TADEMA
(1836–1912)

Born in Dronrijp, Holland, Alma-Tadema entered the Academie voor Schone Kunsten in Antwerp in 1852 where Louis de Taeye, the Professor of Archaeology, much influenced his work. In 1863, while on his honeymoon, he visited Florence, Rome, Naples and Pompeii. On this and subsequent visits to Italy he built up a collection of measured drawings of ancient ruins, examined artefacts in the Naples Museum and collected photographs and information about Classical antiquities and architecture. He lived in Brussels from 1865, exhibiting there and in London, Paris and Amsterdam.

In 1870 he settled in London where he was naturalised three years later. His paintings of domestic scenes of Classical times were a novelty in England and his technical brilliance in rendering marble and rich fabrics ensured their popularity. Alma-Tadema was renowned for the archaeological correctness of the objects he featured in his paintings, and often used photographs to achieve the specificity that gave his work its 'historical' status.

He exhibited at the Royal Academy from 1869 and also at the Grosvenor Gallery where he had a one-man exhibition in 1882–83. He was elected ARA in 1876, RA in 1879 and knighted in 1899. He was awarded the Royal Gold Medal by the RIBA in 1906 for his promotion of architecture in painting. During the 1880s and 1890s he painted many outdoor scenes of ancient Rome as well s designing stage sets and costumes. He numbered all his works with Roman numerals, his last work being Opus CCCCVIII. He was buried at St Paul's Cathedral. HV

Sir Lawrence Alma-Tadema, exh. cat., Van Gogh Museum, Amsterdam; Walker Art Gallery, Liverpool, 1996–97

V. Swanson, *The Biography and Catalogue Raisonné of the Paintings of Sir Lawrence Alma-Tadema*, London, 1990

ANNA ANCHER
(1859–1935)

Anna Ancher, born in Brondum, was only twenty when she first

Anna Ancher, photographed by M. J. Knudstrup, *c.* 1905

exhibited her work, after four years' study at the Copenhagen school of Vilhelm Kyhn. Her independence was restricted by marriage in 1880 to a fellow-painter, Michael Ancher, although he encouraged her in her work. She learnt about the use of colour from the flamboyant Norwegian Realist (and colleague and teacher of Munch★) Christian Krohg.★

Sir Lawrence Alma-Tadema, photographed by J. P. Mayall for *Artists at Home*, 1884

Ancher negotiated a separate period of study in Paris in 1888–89, during which she studied with Puvis de Chavannes, the artist most favoured by Scandinavians. She also took great interest in the Impressionists' techniques; looser brushwork is sometimes apparent in her work of the 1890s.

Ancher's innovations won her respect in the Skagen artistic community, where she was happier depicting the lifestyle and broad humanity of the mainly sea-going, fishing community of her childhood, than trying to evoke the region's light and landscape. JM

Dreams of a Summer Night, exh. cat., Hayward Gallery, London, 1986

H. Grape-Albers, *Anna Ancher*, exh. cat., Skagens Museum och Anna Anchers Hus, 1994

Abram Arkhipov

ABRAM (YEFIMOVICH) ARKHIPOV
(1862–1930)

Arkhipov was born into a peasant family in Ryazan province. At the age of fifteen he enrolled at the Moscow School of Painting, Sculpture and Architecture, where he studied under Vasily Perov, Illarion Pryanishnikov, Aleksey Savrasov, Vladimir Makovsky and Vasily Polenov.

During the 1880s, Arkhipov travelled extensively throughout the Russian Empire producing numerous canvases and illustrations for books and periodicals. In 1889 he exhibited with the Wanderers (the Peredvizhniki), officially joining the group in 1891. Later, in 1903, Arkhipov joined the Union of Russian Artists and exhibited

with the World of Art (Mir Iskusstva) group. Arkhipov was a major contributor to *plein-air* landscape painting in Russia. He is best known, however, for his numerous representations of Russian peasant women. Many of these, such as *The Laundresses* (c. 1900, cat. 117), exposed the harsh working conditions for women in Russia at the turn of the century. Although trained within the realist tradition, Arkhipov's paintings frequently deploy a bold use of colour and thick impasto handling, revealing an awareness of, and an affinity with, Russian folk art and peasant culture.

Following the Bolshevik Revolution, Arkhipov's images of the harshness of peasant life took on a new and more overtly political significance. By 1919 his works were being acquired by the newly formed Museum of Painterly Culture and, in 1922, he joined the AKhRR (Association of Artists of Revolutionary Russia), a group of realist-inspired artists often regarded as highly influential in the subsequent development of Soviet Socialist Realism. He died in Moscow. MO'M

I. Barsheva, *Abram Yefimovich Arkhipov*, Leningrad, 1974

HARRIET BACKER
(1845–1932)

Harriet Backer was born in Holmestrand, Norway, into an artistic family – her sister Agathe later became a well-known pianist and composer. At a time when women seeking to be painters faced many obstacles, not least the permission to draw from the life, some Scandinavians found the atmosphere in Central Europe less restrictive; Backer spent four years studying in Munich before moving to Paris. Her first work to appear in the Salon, in 1880, was a historicist interior derived from Renaissance art in Munich, entitled *Solitude*; the figure had been added in Paris, under the aegis of Léon Bonnat, who taught her from 1878–80.

In Paris Backer shared a house with Kitty Kielland, a noted landscapist; they visited Brittany together in 1881. Backer returned to Norway regularly while studying abroad; she and Kielland spent the summers of 1884 to 1886 in Jaeren, Risor and Fleskum respectively.

Harriet Backer, photographed by J. Lathion, 1903

Backer returned to Norway in 1888, living in Sanviken outside Christiania (Oslo), and establishing and running a popular art school from 1889–1912.

In 1889 Backer was awarded a silver medal at the Exposition Universelle. Exhibiting frequently at the Christiania autumn exhibitions in the 1890s, her more settled existence allowed broader, grander and often architectural themes to emerge in her work. A major retrospective took place at the Oslo Art Association in 1914. She died in Oslo. JM

Dreams of a Summer Night, exh. cat., Hayward Gallery, London, 1986

M. I. Lange, ed., *Harriet Backer (1845–1932), Kitty L. Kielland (1843–1914)*, exh. cat., Stiftelsen Modums, Blaafarvevaert, Amot, 1983

GIACOMO BALLA
(1871–1958)

Balla was born in Turin. His father was an industrial chemist, an art-lover and an amateur photographer whose sudden death forced the young Giacomo to abandon his musical studies and to seek employment in a lithographic printing works. From 1885–90 Balla attended evening drawing classes and, briefly, the Accademia Albertina in Turin. During this time he became acquainted with Giuseppe Pellizza da Volpedo★ whose work he admired.

In 1895 Balla and his mother moved to Rome, where he painted penetrating portraits and vivid landscapes. In September 1900,

Giacomo Balla on the balcony of his studio in Via Paisiello, Rome, c. 1900

he travelled to Paris for the Exposition Universelle. Upon his return in 1901, influenced by the neo-Impressionists, he continued his experiments with Divisionist techniques, and taught, among others, Gino Severini and Umberto Boccioni. With his friend Giovanni Prini, Balla became involved in political and artistic debates. Balla's urban realism reflected his commitment to socialism, evident in his large-scale paintings of the dispossessed. He showed regularly at the Società Amatori e Cultori delle Belle Arti in Rome. Balla experimented with the fragmentation of artificial light rays, foreshadowing his allegiance to Futurism. He signed the Futurist manifesto in 1910 and persisted in his analysis of movement, light and speed. From 1916 he was the

Cecilia Beaux

Auguste Baud-Bovy

acknowledged leader of the Futurist group and subsequently remained its principal figure. The scale of his achievement encompassed not only painting and sculpture but also fashion, the applied arts, furniture and stage design. Much later, in 1937, Balla dissociated himself from Futurism, reverting to figural representation. He died in Rome. CT

Giacomo Balla 1895–1911: Verso il Futurismo, exh. cat., Palazzo Zabarella, Padua, 1998

AUGUSTE BAUD-BOVY
(1848–1899)

Baud-Bovy was born in Geneva. Between 1863–68, he was a pupil of Barthélemy Menn. The following year he was appointed Professor at Geneva's Ecole des Beaux-Arts where he taught for a decade. His earliest subjects were still-lifes and portraits, but in the 1870s he was drawn both to social-realist imagery, inspired in part by his studies with Courbet (who had settled in Geneva during his 1873–78 exile after the Paris Commune), and his principal motif, the Swiss Alps.

After travelling to Spain in 1881–82 where the art of Goya was a revelation to him, Baud-Bovy settled in Paris. He had successfully exhibited works both in the Salon des Artistes Français and the Société Nationale; his reputation was

confirmed in his 1896 one-man show at the Galerie Durand-Ruel. Briefly returning to Switzerland several times, in particular to Bundalp, Baud-Bovy settled in Aeschi in 1888 and devoted his mature work to capturing the majesty of the Alpine landscape. In *Serenity* (c. 1890, cat. 14) he conveys a sense of philosophical harmony through the landscape's atmospheric grandeur, plunging the viewer from the height of mountains into the radiant open breadth and depths of the lake. He attempted to re-create the physical experience of the Alpine landscape in his popular *Männliches Panorama* of 1892 (destroyed post-1900) in which, assisted by several artists including Eugène Burnand and François Furet, he literally surrounded the viewer with the peaks of the Jungfrau, the Eiger and the Wetterhorn. CO'M

V. Anker, *Auguste Baud-Bovy*, Berne, 1991

CECILIA BEAUX
(1855–1942)

Born in Philadelphia, Beaux began to study art at an early age, later enrolling at the Pennsylvania Academy of Fine Arts (1877–79). Her earliest paintings, primarily portraits of mothers and children, reflect the influence of the aestheticism of James Abbott McNeill Whistler.★

In 1888 Beaux went to Paris, where she studied at the Académies Julian and Colorossi. She returned to Philadelphia in 1889, and successfully supported herself as an artist. Beaux was the first full-time female professor at the Pennsylvania Academy, from 1895 to 1916. Her full-length portrait *Mother and Son* (1896, cat. 101) was highly acclaimed at the Exposition Universelle of 1900. By this time Beaux had established her studio in New York and developed a considerable clientele. Her grand-manner portraits, which subtly emphasise her subjects' high social standing and affluence through their dress and accoutrements, were much sought after by northeastern society. In her portraits of the American upper class, Beaux combined the realist idiom practised in her native Philadelphia with softer, more impressionistic brushwork and resplendent tonalities, effecting serene compositions which simultaneously present the sitters as poised and natural-looking.

After World War I Beaux was commissioned to portray several international personalities, but a crippling accident in 1924 severely hampered her artistic production, and she turned to writing her autobiography, *Background with Figures* (1930).

Beaux had many honours and awards bestowed upon her during her career and continued to receive accolades until her death at her summer residence in Gloucester, Massachusetts. VG

T. L. Tappert, *Cecilia Beaux and the Art of Portraiture*, exh. cat., National Portrait Gallery, Washington, DC, 1995

JEAN BENNER
(1836–1906)

Benner was born in Mulhouse, the son of an industrial designer and a flower painter, and the twin brother of the artist Emmanuel Benner. Jean studied with Jean-Jacques Henner★ and made his début at the Salon of 1857. He excelled in portraits and, after a visit to Capri in 1866, Italian subjects.

Benner's anti-heroine *Salome* (c. 1899, cat. 68), exhibited in the 1900 Exposition Universelle, is clearly adolescent, holding her murderous trophy with threatening serenity, emerging from a void into stark light and naturalistic detail. Salome was a favourite subject for many artists to explore sexual anxieties and fantasies brought to the surface by falling birth rates and the rising toll of syphilis deaths, the advent of the New Woman and the coded homosexuality of aestheticist circles. He was awarded the Légion d'honneur. Benner died in Nantes. CO'M

No bibliographic references known

Jean Benner, from *Album Hervé Grandsart*

Richard Bergh,
photographed by Jaeger

Emile Bernard with his wife Hannah
and son Otse in Cairo, 1895

Niels Bjerre

(SVEN) RICHARD BERGH
(1858–1919)

Bergh was born in Stockholm.
His father, Edvard Bergh, was one
of Sweden's most distinguished
and successful landscape painters.
In 1878 Bergh briefly entered the
art school of Edvard Perséus in
Stockholm, before moving to
the Konstakademi, where his father
held a professorship. After
completing his studies in 1881,
Bergh moved to Paris where he
was much influenced by the work
of Jules Bastien-Lepage and also
developed a strong interest in
Impressionism. Back in Sweden
Bergh helped to establish the
Konstnärsförbund (League of
Artists), a group formed in
opposition to the Konstakademi
and much supported by young,
pioneering artists.

Despite his reputation as a
radical, gained through his prolific
and often polemical writings,
Bergh gained much official success.
During the 1880s he was a regular
exhibitor at the Paris Salon and
in 1889 was made responsible
for commissioning works to be
included in the Swedish section
of the Exposition Universelle. He
was awarded a medal of honour
for his works in the exhibition.
From 1893 onwards Bergh worked
extensively with Karl Nordström
and Nils Kreuger at the Varberg
artists' community on the west
coast of Sweden. There he
produced Romantic and
melancholic scenes inspired
simultaneously by Nordic

mythology and folklore, and
French Symbolism. In 1915
Bergh was appointed head of the
Nationalmuseum in Stockholm
which, during the last few years
of his life, he transformed into
a new and dynamic institution.
He died in Stockholm. MO'M

R. Bergh, *Om konst och annat*,
 Stockholm, 1908, rev. 1919
Dreams of a Summer Night, exh. cat.,
 Hayward Gallery, London, 1986,
 pp. 72–75

EMILE BERNARD
(1868–1941)

Bernard was born in Lille. His
childhood fascinations with folk
and decorative art, as well as the
worlds of literature and the theatre,
indicated his later artistic interests.
He attended the Ecole des Arts
Décoratifs in Paris before entering
the studio of Fernand Cormon for
two years. There he befriended
van Gogh, Toulouse-Lautrec★
and Louis Anquetin, before being
excluded for insubordination in
1886. Working with Gauguin,★
he celebrated Breton life in his
paintings inspired by the region
of Pont-Aven.

In 1893 Bernard visited Italy
and then settled in Cairo, where he
remained until 1904. Nonetheless,
his wide range of creative
friendships, including those forged
with Cézanne,★ Redon,★ Albert
Aurier and Joris-Karl Huysmans,
ensured that he remained at the
heart of the Parisian art world.
Through his intimacy with van
Gogh, which is witnessed in their

correspondence, Bernard was
later able to help Théo van Gogh
organise the first retrospective
exhibition of his brother's work.
He also wrote many articles
devoted to his close friend.

Bernard exhibited with Gauguin
at the Café Volpini exhibition in
Paris in 1889 and at most of the
important avant-garde and
Symbolist exhibitions during the
early years of the 1890s: Le Barc
de Bouteville's Nabis shows, the
Salon des Indépendants, Les XX
in Brussels, and Sâr Péladan's
Salon de la Rose+Croix in Paris.
Bernard explored the expressive
possibilities of many media
including woodcuts, engraving and
tapestry. A prolific poet, he was
also a critic, art-theorist and
playwright. He died in Paris. CO'M

MA. Stevens, *Emile Bernard 1868–1941:
 A Pioneer of Modern Art*, Zwolle, 1990

NIELS BJERRE
(1864–1942)

Born in the remote west-coast
area of Jutland in Denmark,
Bjerre, a farmer's son, retained
his attachment to the area's dour,
rugged farming and fishing
communities all his life.

Bjerre's talents ensured him
a place at the Kongelige Danske
Kunstakademi, but he felt out of
place in Copenhagen's easy-going
artistic community, deriving more
from the scathing social criticism
of Georg Brandes's lectures, which
he heard at the university. Bjerre
joined the Independent Artists'
Study School; with one exception

(1887), all his submissions to the
annual Akademi Exhibition were
rejected.

In 1892 he was successful at the
Free Exhibition, having submitted
work on the advice of Harald
Slott-Moller. JM

Dansk Biografisk Leksikon, vol. 2, rev.
 ed., Copenhagen, 1979
Nordisk Sekelskift: The Light of the North,
 exh. cat., Nationalmuseum,
 Stockholm, 1995

JACQUES-EMILE BLANCHE
(1861–1942)

Blanche was born in Paris. The
fourth child of Dr Esprit Blanche,
who treated Maupassant, Gérard
de Nerval and Théo van Gogh in
his Passy clinic, Blanche grew up
within an extraordinarily artistic
circle. Mallarmé was his English
master and the philosopher Henri
Bergson was a classmate. Edmond
Maître took him to visit Manet and
Fantin-Latour in their studios.

Blanche and his parents created
an important art collection,
purchasing works by Monet★ and
Cézanne★ and commissioning a set
of decorative panels from Renoir★
in the 1870s. Blanche himself was
a pupil of Henri Gervex. Initially
refused, Blanche made his début
at the Salon des Artistes Français in
1882 and exhibited with many art
societies such as Les XX in Brussels
and, in Paris, the 33 group which
showed with the dealer Georges
Petit. A committed anglophile,
Blanche befriended Sickert★ and
Whistler★ and became a member
of the New English Art Club.

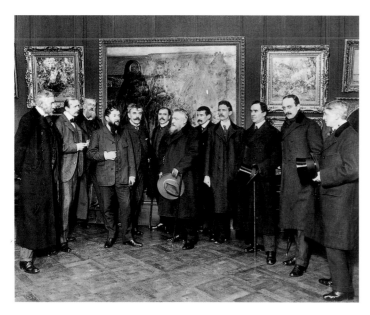

Jacques-Emile Blanche (second from left) with Rodin (centre) facing him

Giovanni Boldini, c. 1890

Blanche's characterful and colouristic portraits, his private journals, his correspondence, his articles for periodicals, such as the *Revue wagnérienne*, and his books provide a unique testament of *fin-de-siècle* art, music and literature, revealing his numerous friendships with composers, writers (such as Gide, cat. 87), and a large number of artists. Having been made Chevalier of the Légion d'honneur in 1897, Blanche was honoured with a gold medal at the 1900 Exposition Universelle for his portrait *Thaulow and His Children*. He died in Paris. CO'M

Jacques-Emile Blanche (1861–1942), exh. cat., Musée des Beaux-Arts, Rouen, 1997

GIOVANNI BOLDINI
(1842–1931)
Boldini was the eighth of thirteen children. By the age of eighteen he was already recognised in his hometown of Ferrara as an accomplished portrait painter. In 1862 with a modest inheritance he went to Florence to study at the Accademia di Belle Arti and associated with leading members of the Macchiaioli group, advocates of a new painterly freedom of form and colour. In 1867 he visited the Exposition Universelle in Paris and met Degas★ and Manet. Impressed by the portraits of Van Dyck, Reynolds and Gainsborough on visits to London in 1870–71, he established himself in Paris later that year. He began to sell eighteenth-

century costume pieces and Parisian street scenes through the dealer Goupil.

A highly personal use of paint and a fascination with movement typifies Boldini's work. On different travels he met Adolphe Menzel in Germany, admired Hals's vivid technique in the Netherlands and studied the works of Velázquez in the Prado with Degas in 1889. Friends with Paul César Helleu, Sargent★ (his landlord from 1886) and Whistler★ (whose portrait he exhibited at the Exposition Universelle [cat. 6]), he concentrated more on portraiture, his vibrant depictions often displaying striking tonal contrasts. The years around 1900 were the most successful of his career. His clientèle was a cosmopolitan cocktail of the wealthiest, and the most beautiful and *mondaine*, including such luminaries as Mme Charles Max, the Duchess of Marlborough and the Marchesa Casati. Exquisitely dressed, their allure also enhanced the reputations of flourishing couturiers.

By 1910 his slashing brushwork, sophisticated elongations and flamboyant style had become more extreme. Prolific in a variety of media, Boldini was active until the end of his life. He married the journalist Emilia Cardona at the age of eighty-seven, but died two years later in Paris. CT

E. Camasesca and A. Borgogelli, eds, *Boldini*, exh. cat., Palazzo della Permanente, Milan, 1989

PIERRE (EUGÈNE FRÉDÉRIC) BONNARD
(1867–1947)
Bonnard was born in Fontenay-aux-Roses, a suburb of Paris, the second child of a civil servant from the Dauphiné. While also studying law, Bonnard enrolled at both the Ecole des Beaux-Arts and the Académie Julian where he met the circle of artists who formed the Nabis group. Gauguin,★ Paul Sérusier and the principles of Japanese print design were key influences on his paintings of Paris and intimate interiors.

Bonnard exhibited at the Salon des Indépendants between 1891–99 and with artistic societies including Le Salon des Cent, La Libre Esthétique in Brussels and the Vienna Secession. He showed with Le Barc de Boutteville, who organised the Nabis exhibitions, and with Durand-Ruel, who held Bonnard's first one-man show in

1896. From 1894 he produced many of the most famous lithographs of the belle époque, posters for *La Revue blanche*, sheet music for Claude Terasse and, in 1900, Ambroise Vollard's edition of Verlaine's *Parallèlement*. He received commissions for decorative projects from Ivan Morosov (see cat. 93), who also employed the talents of Matisse★ to decorate his Moscow home in 1910, and from Siegfried Bing's Maison de l'Art Nouveau. He helped to create décors for the Symbolist Théâtre de l'Art in 1891 and puppets and masks for Alfred Jarry's *Ubu Roi* in 1896. In 1893, he met Maria ('Marthe') Boursin, the troubled muse of his later years. Bonnard died at Le Cannet, Alpes-Maritimes. CO'M

Bonnard, exh. cat., Tate Gallery, London, 1998
J. and H. Dauberville, *Bonnard, Catalogue raisonné de l'œuvre peint*, rev. ed., Paris, 1992

Pierre Bonnard in his garden,
photographed by Edouard Vuillard

Columbano Bordalo Pinheiro in his studio

William-Adolphe Bouguereau,
photographed by A. Gerschel

COLUMBANO BORDALO PINHEIRO

(1857–1929)

Bordalo Pinheiro was born in Cacilhas (Lisbon) and, with his brother Rafael, also a well-known artist and caricaturist, received his first painting lessons from his father Manuel Maria Bordalo Pinheiro, a noted painter of genre subjects. He continued his artistic training at the Escola de Belas-Artes in Lisbon and became a student of Miguel Ângelo Lupi and Tomás José da Anunciação.

In 1881 he went to Paris and London, and in 1883, after his return to Lisbon, he was the co-founder of the Grupo do Leão (Lion Group) whose members met at the Cervejaria Leão de Ouro bar, from which they took their name. They organised exhibitions and propagated a naturalism inspired by the *plein-air* aesthetic of the Barbizon School.

In 1900 Bordalo Pinheiro won a gold medal and the Légion d'honneur at the Exposition Universelle. In 1895 he had become an honorary member of the Escola de Belas-Artes in Lisbon, and was appointed Professor in 1901, a post he retained until 1924. In 1914 he became Director of the Museu Nacional de Arte Contemporânea in Lisbon.

Bordalo Pinheiro's only one-man exhibition in Lisbon was in 1904, although he participated in many international group exhibitions, including those in Berlin, London, St Petersburg, Rio de Janeiro and San Francisco. He was particularly noted for his portraits and interior scenes, for example *A Cup of Tea* (1898, cat. 171). He died in Lisbon.

EL

Columbano Bordalo Pinheiro, exh. cat., Leal Senado de Macau, Museu Luís de Camoes, 1986

J.-A. França, *Malohâ (o português dos portuguêses) & Columbano (o português sem portuguêses)*, Lisbon, 1987

Soleil et ombres: L'Art portugais du XIXe siècle, exh. cat., Petit Palais, Paris, 1987, pp. 49–56, 223–241

WILLIAM-ADOLPHE BOUGUEREAU

(1825–1905)

Bouguereau was born in La Rochelle. The son of an olive oil merchant, he received his first artistic training from Louis Sage, a pupil of Ingres, at the Collège de Pons, then from Jean-Paul Alaux at the Ecole Municipale in Bordeaux before barely gaining his place at the Ecole des Beaux-Arts in Paris under François-Edouard Picot. His Prix de Rome allowed him to study Giotto and the Renaissance masters during four years at the Villa Medici as a pupil of Victor Schnetz and Jean Alaux. When he returned to Paris in 1854, his Salon success led to state commissions for history paintings and decorations in St-Clothilde (1859), St-Augustin (1867) and St-Vincent-de-Paul (1881–89), and the Grand Théâtre in Bordeaux (1869).

Bouguereau was devoted to upholding academic training, teaching at the Académie Julian from 1875 and, as a professor, at the Ecole des Beaux-Arts from 1888. He exhibited regularly at the Salon and at international exhibitions, also often serving

on selection juries. His official honours were endless, including Grand Officier of the Légion d'honneur in 1903, Chevalier of the Order of Léopold in 1881 and membership of many European academies. Bouguereau applied his bravura draughtsmanship, colouring and high finish to portraits, historical and eroticised mythological scenes and religious painting. In *Regina Angelorum* (1900, cat. 239), he represents his favourite models, children and ideal Italianate beauties, in his flawless academic technique. He died in La Rochelle. CO'M

William Bouguereau, exh. cat., Petit Palais, Paris, 1984

Emile-Antoine Bourdelle

EMILE-ANTOINE BOURDELLE
(1861–1929)
Bourdelle was born in Montauban in southern France. The son of a cabinet-maker, he received his first training at the Ecole des Beaux-Arts in Toulouse. As a pupil of Alexandre Falguière at the Ecole des Beaux-Arts in Paris, a studio assistant to Auguste Rodin★ and an admirer and neighbour of Jules Dalou,★ Bourdelle developed a monumental sculptural vocabulary of great dynamism. He exhibited first at the Salon des Artistes Français from 1884 and then at the Société Nationale after its inauguration in 1891.

His youthful *œuvre* was characterised by a mixture of public commissions such as the *Montauban 1870 War Memorial* (1895–1902) and the extraordinary private explorations of the *Beethoven* series. Bourdelle's lifelong

Beethoven project inspired forty-five sculptures (cat. 111) and numerous drawings and pastels. Influenced in part by Jean-Martin Charcot's studies in psychology, Bourdelle strove to capture the great composer's inner conflicts through a vibrant sculptural surface. After 1900 when he became fascinated with the austerity of ancient Greek sculpture, Bourdelle's work was transfigured into the noble simplicity for which he is best known. He was very prolific at the turn of the century, creating decorative ensembles for the Musée Grévin (1900) and a set of low reliefs inspired by Isadora Duncan for the Théâtre des Champs-Elysées (1911–13). He also produced magisterial portrait busts of many key figures of the day. Bourdelle died at Le Vésinet, outside Paris. CO'M

G. Varenne, *Bourdelle par lui-même*, Paris, 1937

EUGEN (FELIX PROSPER) BRACHT
(1842–1921)
Bracht was born at Morges on Lake Geneva. Between 1859 and 1861 he studied at the Grossherzogliche Kunstschule in Karlsruhe, where he met the artist Hans Thoma.★ From 1861 to 1864 he worked without success as an artist in Düsseldorf and became a wool merchant in Verviers and Berlin in 1864. He resumed painting in 1875. For the next two years he was a student once again at the Karlsruhe Kunstschule. In 1881 he visited Palestine, Syria, Jordan and Sinai, and made another trip to the region ten years later. In 1882 he gained a post teaching landscape painting at the Berlin Kunstakademie, and two years later became a member of the Königliche Kunstakademie in Berlin.

It was in the 1880s that Bracht finally began to receive official commissions as well as critical acclaim. He was among the many artists who protested against the closure of the 1892 Edvard Munch★ exhibition by the council of the Association of Berlin Artists, which led to his resignation from the senate of the Berlin Akademie. In 1900 he became an honorary member of the Munich Kunstakademie and a member

Eugen Bracht, lithographic portrait, 1900

of the Königliche Akademie in Dresden. From 1901 he was Professor of Landscape Painting at the Dresden Akademie. To mark his seventieth birthday in 1912, there were retrospective exhibitions in Darmstadt and Dresden. In 1919 he was made Professor Emeritus in Dresden. He died in Darmstadt. AC

M. Osborn, *Eugen Bracht*, Bielefeld and Leipzig, 1909

GEORGE HENDRIK BREITNER
(1857–1923)
Breitner was born in Rotterdam. After studying at the academy in The Hague under Charles Rochussen, he entered the studio of Willem Maris, a major figure in the Hague School of landscape painters, and was inspired by the *plein-air* tradition of the French Barbizon School. Breitner travelled increasingly around the Dutch countryside in search of subjects, never forgetting to take his camera with him. A keen photographer throughout his career he produced hundreds of photographs, many of which he used to guide the composition of his paintings.

Breitner's interests, however, lay beyond the representation of simple landscapes. With the young Vincent van Gogh, he wandered through the back streets and poor quarters of The Hague and Rotterdam, seeking out scenes of the hardship and poverty of modern urban life. Although Breitner's subjects were in keeping with the hard-edged social realism

George Hendrik Breitner, 1911

of the period, his style was always more loosely defined and sketchy, using a thick impasto and broad, sweeping brush strokes.

In 1884 Breitner travelled to Paris where he produced scenes of the reconstruction of Montmartre. By 1886 he had moved to Amsterdam where, for the rest of his career, he painted numerous scenes recording life in the poorer parts of the city and documenting building projects in outlying districts. When he died, in Amsterdam, he left behind not only a significant body of paintings, but also a vast collection of photographic works. MO'M

George Hendrik Breitner (1857–1923), exh. cat., Stedelijk Museum, Amsterdam, 1994–95

JULES BRETON
(1827–1906)
Breton was born in Courrières, Pas-de-Calais. His father, supervisor of the estate of the Duc de Duras, instilled in him a deep love of French rural life. Breton first studied at the Collège St Bertin and in 1843 enrolled at the Academie voor Schone Kunsten in Ghent. He later married Elodie, his model and the daughter of his Belgian teacher, Félix De Vigne. When he settled in Paris in 1847 he became a pupil of Michel Martin Drolling at the Ecole des Beaux-Arts and a friend of François Bonvin and Gustave Brion.

The Second Empire régime purchased many of his idealised images of French peasant life,

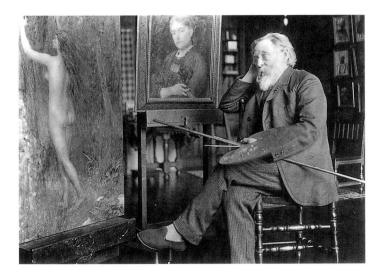

Jules Breton,
photographed by Dornac

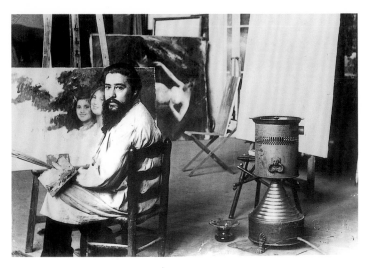

Joan Brull i Vinyoles

which won numerous Salon medals and a first class medal at the 1867 Paris Exposition Universelle. He was made a Chevalier, and then an Officier, of the Légion d'honneur, a member of the Institut and a Knight in the Order of Léopold of Belgium. Breton responded eloquently to the range of nineteenth-century artistic manners; his early works invoke both the realist empathy of Millet's peasant imagery and the idealised figures and high finish of the French academic style. His late works continue to ennoble the life of the countryside, but with a mood of *fin-de-siècle* Symbolist contemplation. Breton died in Paris. CO'M

J. Breton, *La Vie d'un artiste: Art et
 nature*, Paris, 1890

M. Vachon, *Jules Breton*, Paris, 1899

JOAN BRULL I VINYOLES
(1863–1912)
Brull was born in Barcelona. He studied at the Escuela de Bellas Artes de la Lonja in Barcelona under Simón Gómez. His master's realism influenced Brull during these early years, when his best works were of historical and genre subjects, for example *The Tonsure of King Wamba* (c. 1884).

In 1885 Brull travelled to Paris and entered the studio of the Symbolist painter Raphaël Collin.★ During this five-year period he abandoned Realism for Symbolism, to the extent that he came to be considered the Catalan Symbolist painter *par excellence*. On his return to Catalonia, Brull became involved in its cultural life, not only as a painter and teacher, but also as a polemicist and critic, participating in the gatherings

of Els Quatre Gats, founded in Barcelona in 1897, as the focus for the popularisation of Modernism in Catalan culture.

One of Brull's students was Josep Dalmau, another crucial figure for Catalan Modernism, founder of the Galerias Dalmau, who organised exhibitions of French Impressionism.

Brull won several national and international awards and medals, including a third class medal at the Exposition Universelle in 1900. He died in Barcelona. EL

J. F. Rafols, *Diccionario biográfico de
 artistas de Cataluña*, Barcelona,
 1951–54, vol. I, p. 178

SIR EDWARD (COLEY) BURNE-JONES
(1833–1898)
A painter of dreamlike scenes from Classical myths and medieval legends, and a leading figure in the Aesthetic movement, Edward Burne-Jones was born in Birmingham. He went up to Exeter College, Oxford, in 1853. He originally intended to enter the church, but after meeting his lifelong friend and collaborator, William Morris, and touring around the cathedrals of northern France with him in 1855, Burne-Jones decided to devote himself to an artistic career. In 1856 he met

Dante Gabriel Rossetti who gave him the only artistic instruction he received. The following year he helped Rossetti to decorate the Oxford Union Society with murals.

Burne-Jones visited Italy in 1859, and in 1861 was a founding partner in the decorative arts firm of Morris, Marshall, Faulkner & Co. He also contributed decorative designs for tapestries, ceramics, tiles and stained glass. His early work was mainly in watercolour but from about 1870 he worked increasingly in oils. He travelled again to Italy in 1871 and 1873 and made a special study of Botticelli, Mantegna and Michelangelo. Burne-Jones illustrated several books, a number of which were published by William Morris at the Kelmscott Press, including the famous 'Kelmscott Chaucer' (1896).

In 1877 he exhibited at the first Grosvenor Gallery exhibition; his paintings, which included *The Beguiling of Merlin* (exhibited in the 1878 Exposition Universelle) received great acclaim. From c. 1880 he concentrated on large-scale oils. He was elected ARA in 1885 but exhibited at the Royal Academy only once before resigning in 1893. He continued to exhibit regularly at the

Sir Edward Burne-Jones, with William Morris (seated),
photographed by Frederick Hollyer

António Carneiro and his family, 1901, photographed by Perez & Vera, Oporto

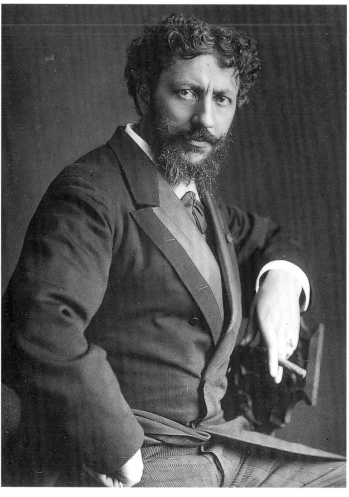

Carolus-Duran

Grosvenor Gallery and, from 1888, at the New Gallery. His work gained him considerable repute in France as well as Britain. In 1894 he was created a baronet. He died four years later in London. HV

S. Wildman and J. Christian, *Edward Burne-Jones: Victorian Artist-Dreamer*, exh. cat., Metropolitan Museum of Art, New York, 1998

ANTÓNIO TEIXEIRA CARNEIRO
(1872–1930)

Born in Amarante in northern Portugal, Carneiro studied at the Escola de Belas-Artes in Lisbon between 1890 and 1896, where he was taught by João Correia, António Soares dos Reis and João Marques de Oliveira. In 1897 he moved to Paris, where he became a student of Jean-Paul Laurens and Benjamin Constant★ at the Académie Julian. During this period he came under the influence of the Symbolism of Eugène Carrière★ and Puvis de Chavannes. The latter's influence, as well as that of Edvard Munch,★ is particularly evident in Carneiro's triptych *Life* (1899–1901, cat. 282), which has been considered the chief exemplar of Portuguese Symbolist painting.

In 1900, Carneiro won a third class medal at the Exposition Universelle, and the following year returned to Oporto where he produced portraits in oils and scraped a living selling his drawings. Towards the end of his life he executed landscapes and seascapes, often evoking mystical ideals, and also depicted interiors.

He became the artistic director of the neo-Romantic and nationalist magazine *A Águia* (1917–27), and Chairman and eventually Director of the Escola de Belas-Artes in Oporto. Carneiro also wrote art criticism and poetry, and a collection of his lyrical writings was published posthumously in 1936.

Carneiro exhibited in national and international exhibitions in Oporto, Lisbon, Saint Louis (USA), Barcelona and Rio de Janeiro. He died in Oporto. EL

J. Alves, *António Carneiro e a pintura portuguesa*, Oporto, 1972

António Carneiro 1872–1930, exh. cat., Gulbenkian Museum, Lisbon, 1973

L. Castro, *António Carneiro: o universo no olhar*, Oporto, 1996

CAROLUS-DURAN (CHARLES-EMILE-AUGUSTE DURAND)
(1837–1917)

Carolus-Duran was born in Lille, into a working-class family. He received his first lessons in drawing as a boy of eleven from the Lille sculptor Augustin-Phidias Cadet de Beaupré before being apprenticed for two years to François Souchon. Having moved to Paris in 1853, he made his Salon début in 1859. The following year he won the Wicar Prize which allowed him to travel to Rome where he lived from 1862–66. One of his Italianate genre paintings won him a medal at the 1866 Salon. He held an important one-man exhibition with the Cercle des Mirlitons in 1874–75 and was then awarded the commission to paint the ceiling of the Palais de Luxembourg.

Although Carolus-Duran painted the leading authors and painters of the day, he is most admired for his portraits of aristocratic women. While the realist manners of Courbet and Manet were a key early influence, Van Dyck and the Spanish Old Masters, whose work Carolus-Duran greatly admired on a visit to Spain in 1866–68, informed his later work. *Danaë* (1900, cat. 40) typifies his epic rhetoric, which is expressed through bravura brushwork, a dense palette and startling chiaroscuro light effects. A founder member of the Société Nationale des Beaux-Arts, he was elected its president in 1900. The honours of membership of the Institut de France and the Directorship of the Académie de France in Rome were accorded to him in 1904. Carolus-Duran died in Paris. CO'M

A. Alexandre, 'Carolus-Duran', *Revue de l'art ancien et moderne*, 1903, xiii–xiv

EUGÈNE CARRIÈRE
(1849–1906)

Carrière was born in Gournay, Seine-et Oise. One of nine children born to the family of an insurance salesman, Carrière served an apprenticeship in colour lithography at the Ecole Municipale de Dessin in Strasbourg. He then enrolled at the Ecole des Beaux-Arts in Paris under Alexandre Cabanel, determined to become a painter. Carrière was often forced to employ his talents in other media to support his family, working in the studio of the poster artist Jules Chéret in 1872–73 and at the Sèvres porcelain factory from 1880–85 where he befriended Rodin.★ A founder member of the Société Nationale des Beaux-Arts and the Salon d'Automne, Carrière also exhibited with many artistic groups such as La Libre Esthétique in Brussels and the Munich and Berlin Secessions. A key figure in the Symbolist movement, Carrière was a familiar face at the Café

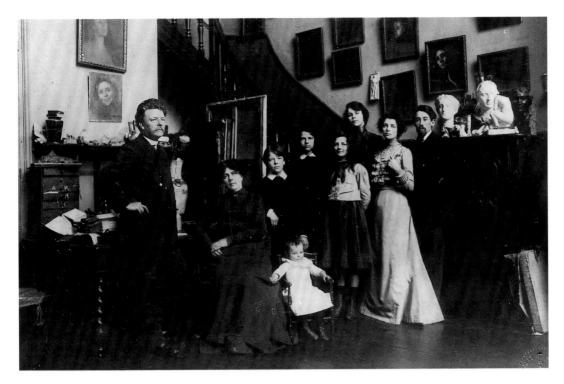

Eugène Carrière and his family,
photographed by Dornac

Voltaire, a centre for Symbolist
playwrights and poets such as
Verlaine, whose portrait Carrière
painted.

Carrière's work, immediately
recognisable by his unique brown
monochrome palette and vaporous
compositional effects, achieves a
mood of transcendence which
reflects the artist's spiritualist beliefs.
Carrière's favourite subjects,
members of his family, are an
allegorical vehicle through which
he expresses his collectivist
philosophy of a universal humanity.
Posthumous retrospectives of his
work at all his official and aesthetic
exhibiting venues reflect his
importance at the *fin de siècle*.
Carrière died of throat cancer
in Paris. CO'M

Eugène Carrière 1849–1906, exh. cat.,
Ancienne Douane, Strasbourg, 1996

MARY (STEVENSON) CASSATT
(1844–1926)

Like her fellow Impressionists,
Cassatt created images of modern
life, focusing on women and
children in her paintings, pastels,
and prints. Born in Pittsburgh,
Cassatt began attending classes
at Philadelphia's Pennsylvania
Academy of the Fine Arts in 1860.
In 1865 she went to France,
studying briefly with Jean-Léon

Gérôme★ and Thomas Couture.
In 1874 she established a permanent
residence in Paris. There she
befriended Louisine Elder (later
Havemeyer), and proved
instrumental in advising her on

Mary Cassatt at the Château du Beaufresne,
photographed by Theodate Pope, c. 1905

the formation of a formidable
Impressionist collection.

Cassatt forged ties with the
Impressionists when Edgar Degas,★
who became a close friend, invited
her to exhibit with the group in

1877. Her complex compositions,
demonstrating painterly bravura,
often portrayed upper-middle-class
women in public and private
settings. Unlike many
contemporary depictions which
presented women as objects of
urban spectacle, Cassatt's subjects
are active participants: they are
either consumers of the
entertainments which proliferated
in Paris or engrossed in activities
such as reading or sewing.

During the 1890s Cassatt
concentrated on printmaking.
These works – primarily on the
mother and child theme – exhibit
the influence of Japanese prints in
their strong lines, flattened pictorial
space, emphasis on surface pattern,
and eschewal of traditional
perspective. In 1892, Cassatt, who
later became a supporter of the
suffrage movement, created a mural
for the Woman's Building at the
1893 Chicago World's Columbian
Exposition. She continued to paint
intimate scenes of mothers and
children until her eyesight failed in
1915. She died at her home, the
Château du Beaufresne, Le Mesnil-
Théribus. VG

J. A. Barter, ed., *Mary Cassatt: Modern
Woman*, exh. cat., with contributions
by E. E. Hirshler, G. T. M.
Shackelford, K. Sharp, H. K. Stratis
and A. J. Walker, The Art Institute
of Chicago, 1998

N. M. Mathews, ed., *Cassatt:
A Retrospective*, New York, 1996

PAUL CÉZANNE
(1839–1906)

Cézanne was born in Aix-en-
Provence. A boyhood friend of
Emile Zola, he originally studied
both drawing, with Joseph Gilbert
at the Ecole Municipale de Dessin
in Aix-en-Provence, and law, to
please his father. During the 1860s
he travelled between Paris and Aix
determined to become a painter.
He enrolled at the Académie
Suisse, where he befriended
Camille Pissarro,★ and copied the
works of Titian, Veronese, Rubens
and Delacroix in the Louvre, but
failed the entrance exams for the
Ecole des Beaux-Arts. His paintings
were repeatedly refused from the
Salon, but were included in the
Salon des Refusés and the early
Impressionist exhibitions.

His early manner is characterised
by a dark palette and heavy, violent

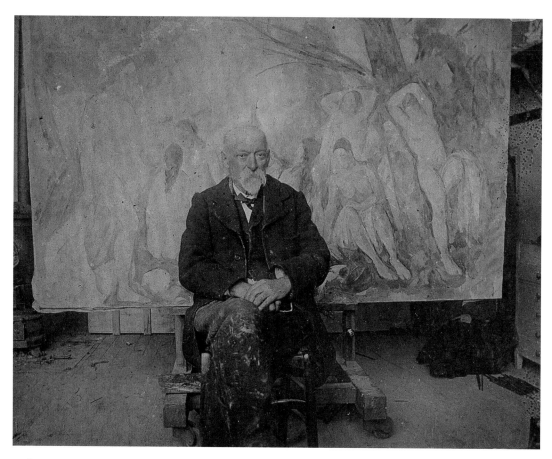

Paul Cézanne, photographed by Emile Bernard in 1904, in front of *Les Grandes Baigneuses* now at the Barnes Foundation, Merion, Pa.

brushwork whereas his later work moves from an orderly, constructive Impressionist technique to a uniquely bold architectural touch in the final years. Certain themes – epic bather scenes, searching yet restrained portraits, serene still-lifes and landscapes – dominate his *œuvre*. He coupled an Impressionist love of nature with a self-referential exploration of the psyche and the languages of visual expression rooted in Symbolism. The retrospective of Cézanne's work organised by Ambroise Vollard in 1895, his inclusion in the 1900 Exposition Universelle and a posthumous display of fifty-six works at the 1907 Salon d'Automne reflected the recognition of his importance by both the art establishment and the next generation of artists. Cézanne died in Aix-en-Provence. CO'M

J. Rewald, ed., *Cézanne, Correspondence*, New York, 1984

J. Rewald, *The Paintings of Paul Cézanne: A Catalogue Raisonné*, 2 vols, London and New York, 1996

R. Shiff, *Cézanne and the End of Impressionism*, Chicago, 1984

Paul Chabas

PAUL(-EMILE-JOSEPH) CHABAS
(1869–1937)
Chabas was born in Nantes. Like his brother Maurice, Chabas trained in the studios of William-Adolphe Bouguereau★ and Tony Robert-Fleury at the Académie Julian. Chabas made his début in 1886 at the Salon des Artistes Français, and continued to exhibit there even after the 1891 split with the Société Nationale. He served as its president between 1925–35. He received official recognition at the Salon with an honourable mention in 1892, a third class medal in 1895 and a second class medal in 1896.

He initially made his reputation with portraits, receiving an important commission for a group portrait of leading *fin-de-siècle* writers from Alphonse Lemerre in 1895. The early atmospheric landscape studies he made in Brittany and Haute-Savoie would provide the setting for the voluptuous bathers that were the main motif of his mature work. *Joyous Frolics* (1899, cat. 131) won the Prix National du Salon in 1899 and was included in the 1900 Exposition Universelle where it won a gold medal. The work is typical of Chabas's synthesis of academic figure-painting and evocations of water and vaporous aura reminiscent of Carrière,★ but infused with vibrant colour. The Prix National allowed him to travel to Greece, Norway and Algeria. He illustrated Paul Bourget's *Un Saint* (Paris, 1894) and Marcel Prévost's *Le Mariage de Julienne* (Paris, 1896). Elected to the Institut de France and the Légion d'honneur in 1902 and membership of the Académie des Beaux-Arts in 1921, Chabas died in Paris. CO'M

J. Valmy-Baysse, *Paul Chabas: Sa Vie et son œuvre*, Paris, 1910

WILLIAM MERRITT CHASE
(1849–1916)
Born in Williamsburg, Indiana, Chase moved to New York in 1869, enrolling at the National Academy of Design. In 1872 he went to Munich and studied at the Königliche Akademie. An American forerunner of *plein-air* painting, Chase produced radiant impressionistic landscapes, but his technical virtuosity also allowed him to adapt diverse stylistic tendencies, from Realism to Aestheticism, in his interiors, portraits and still-lifes.

Chase established himself in New York in 1878, a watershed

William Merritt Chase and class, Shinnecock Hills, Long Island, 1900

Camille Claudel in her Paris studio with her sculpture *Perseus and the Gorgon*, 1902

Emile Claus, *c.* 1899

year for him. He accepted a position at the Art Students League, embarking upon a successful teaching career. He also secured a studio in the Tenth Street Studio Building. Decorated with exotic furnishings, this and his subsequent studios would feature prominently as locales for his interior scenes. In the late 1880s, Chase made forays into New York and Brooklyn parks, portraying urban leisure life. His adoption of modernist spatial strategies – learned from the works of Degas★ or Sargent★ – is evident in the asymmetrical compositions of this decade.

From 1891 Chase spent summers at Shinnecock, Long Island, where he founded a school and created dazzling landscapes of that seaside region. In the late 1890s, he began painting still-lifes which are distinctive for their dark palette and sober tone. By 1900 Chase was an acclaimed artist, winning a place of honour at the Exposition Universelle. In 1901 he won gold medals at the Pennsylvania Academy of Fine Arts and the Buffalo Pan-American Exposition. A gallery was dedicated to him at the San Francisco Panama-Pacific Exposition, the year before his death in New York. VG

B. D. Gallati, *William Merritt Chase*, exh. cat., National Museum of American Art, Smithsonian Institution, Washington, DC, 1995

CAMILLE CLAUDEL
(1864–1943)
Claudel was born in Fère-en-Tardenois, Aisne. The sister of the Catholic Symbolist writer and critic Paul Claudel, Camille had a comfortable childhood in Nogent-sur-Seine where she first became interested in sculpture under the tuition of Alfred Boucher. She entered the Académie Colarossi when the family moved to Paris in 1881 and she also became a student of Auguste Rodin.★ Their turbulent intimacy, which has inspired films and books, lasted

until 1898. Public fascination with the relationship has sadly overshadowed the critical scrutiny which Claudel's work itself deserves. She was both a key creative collaborator and model for many of Rodin's projects at the turn of the century, such as the *Gates of Hell* (1880–1900). Her preferred form was the small-scale multi-figure group, often executed in unusual materials such as onyx, in which she explored the *fin-de-siècle* obsession with sensualism and the body. Her entwined figures, often posed with limbs outstretched and suspended extraordinarily in space, use boldly worked surfaces and exotic materials to convey a spectrum of Symbolist moods from exuberant passion to impending doom.

Léon Lhermitte★ encouraged Claudel to explore her gifts as a draughtswoman; her naturalistic portrait heads in charcoal and her paintings are less well known. By 1913, Claudel's emotional instability led her family to intern her in an asylum, where she remained for thirty years, forcing an abrupt end to her artistic career. She died in Villeneuve-lès-Avignon, Gard. CO'M

R.-M. Paris, *Camille*, London, 1988
A. Rivière, B. Gaudichon and D. Ghanassia, *Camille Claudel: Catalogue raisonné*, Paris, 1996

EMILE CLAUS
(1849–1924)
Claus was born in Vive-Saint-Eloi, the twelfth of thirteen children. He received his artistic training at the Academie voor Schone Kunsten in Antwerp as a pupil of Jacob Jacobs, a landscape painter. Claus made his début at the Ghent Salon and later exhibited at the Exposition Générale des Beaux-Arts in Brussels.

After having had a work accepted in the Salon des Artistes Français in 1882, Claus began to visit Paris regularly and was greatly influenced by French *plein-air* painting, in particular the work of Monet★ and late Pissarro,★ to which Henri Le Sidaner★ introduced him. This contact led Claus to abandon his youthful, highly finished narrative style in favour of atmospheric light effects. In 1883 he settled in Astene, near Ghent, where he established a meeting place for artists and writers

which he called 'Sunshine'. His friendship with the naturalist writer Camille Lemonnier, whose books he illustrated, was also an important influence.

Claus formulated a distinctively Belgian strain of Impressionism in the 1890s often described as Luminism in reference to the Vie et Lumière group of which Claus was a founder member in 1904. He often painted large-scale works and, while deriving his technique from the innovations of the Impressionists, he maintained a clearer sense of form and volume expressed in a radiant palette quite his own. He died in Astene. CO'M

J. De Smet, *Emile Claus (1849–1924)*, exh. cat., Provinciaal Museum voor Moderne Kunst, Ostend, 1997

SIR GEORGE CLAUSEN
(1852–1944)
Clausen was born in London and originally worked for a firm of decorators, studying in the evenings at the National Art Training School, South Kensington, before deciding to take up painting full-time. He travelled to the Low Countries and France and was initially influenced by the Hague School, exhibiting Dutch subjects until 1883. However at the Grosvenor Gallery exhibition of 1880 he became impressed by the work of a fellow exhibitor, Jules Bastien-Lepage. Influenced by his particular kind of realism Clausen moved into the Herefordshire countryside and began to paint farm labourers. *The Girl at the Gate* (1889) marks the height of Bastien-Lepage's influence.

A founding member of the New English Art Club in 1886, Clausen ceased to exhibit there once elected ARA in 1895. His work in pastels from the early 1890s invigorated his oils with a sense of movement and he began to use richer colours. Although he continued to produce rustic subjects on an intimate scale, Clausen also worked on mural-like paintings of monumental proportions, such as *The Boy and the Man*, exhibited in 1908, the year he was elected RA.

During World War I he was an Official War Artist, and painted such subjects as gun manufacture at Woolwich Arsenal. Aged seventy-five he undertook an important commission in the House of Commons to paint *Wycliffe's English Bible* (1926), the success of which resulted in a knighthood in the same year. After completing the mural he concentrated on small landscapes in oil and watercolour, many of which dwelt on the morning mists in the Essex countryside near his country retreat at Duton Hill. HV

K. McConkey, *Sir George Clausen RA*, exh. cat., Bradford Museums & Art Galleries; Bristol Museums and Art Galleries; Royal Academy of Arts, London; Tyne & Wear County Council Museums, 1980

Sir George Clausen

Raphaël Collin

(LOUIS JOSEPH) RAPHAËL COLLIN
(1850–1916)
Collin was born in Paris. He served on the 5th Commission which allocated funds for decorating Paris's public buildings and was also selected for the French jury for art at the Exposition Internationale held in Liège in 1905. He received many commissions to decorate public buildings, including an ensemble for the dining room of the Rector of the Sorbonne. He was one of several artists chosen to create the decorations of the foyers of the Théâtre de l'Odéon and the Opéra-Comique.

Collin replaced Jean-Jacques Henner★ who had originally been selected to execute a vertical panel for the Salle des Arcades in the Hôtel de Ville in Paris. Collin's panel, *Poetry* (1890), represented a contemplative young woman half-draped in a forest setting. In his scenes of ideal yet inviting nudes, to which he often gave allegorical titles, Collin mingled traditional academic training, which perfectly renders human anatomy, and his own version of Symbolist reverie. The aesthetic postures or adjacent attributes of these ineffectually draped nudes were usually the only specific reference to the theme their beauty was purportedly unveiled to evoke. Collin was made a member of the Institut de France in 1909 and appointed to a painting professorship at Paris's Ecole des Beaux-Arts in 1911. He died in Brionne, Eure. CO'M

La Triomphe des mairies: Grand Décors républicains à Paris, exh. cat., Petit Palais, Paris, 1986

P. Vaisse, *La Troisième République et les peintres*, Paris, 1995

(JEAN-JOSEPH-)BENJAMIN CONSTANT
(1845–1902)
Constant was born in Paris. Descended from an important political family from the Languedoc, he grew up in Toulouse and won a scholarship to study at the municipal Ecole des Beaux-Arts. After a period at the Ecole des Beaux-Arts in Paris he won a scholarship to attend Alexandre Cabanel's studio. Making his début in 1869, he exhibited at the Salon annually throughout his life, winning medals in 1875 and 1876, a third class medal at the Exposition Universelle of 1878 and a medal of honour in 1893.

After fighting in the Franco-Prussian War of 1870, Constant toured Spain where he met the Spanish artist Mariano Fortuny y Marsal. Attracted to the Islamic influence of the *Mudéjar* architecture of southern Spain, Constant and Georges Clairin travelled with the French ambassador, Charles Joseph Tissot, to Morocco.

Constant specialised in large-scale paintings of orientalist themes and literary and historical subjects. These were admired for their vibrant colour, meticulous detail in costume and setting and the portrayal of character through facial expression and gesture. In later life Constant received numerous prestigious commissions both for official portraits, in particular of the British royal family, and decorations for the Hôtel de Ville, the new Sorbonne and the new Opéra-Comique in Paris and the Capitole of Toulouse. Constant shaped a generation of artists as Professor of Painting at the Ecole des Beaux-Arts from 1883 and as Master at the Académie Julian. He was made a member of the Institut de France and elected a Commander of the Legion d'honneur. He died in Paris. CO'M

MA. Stevens, ed., *The Orientalists: Delacroix to Matisse*, exh. cat., Royal Academy of Arts, London; National Gallery of Art, Washington, DC, 1984, pp. 116–117

LOVIS CORINTH
(1858–1925)
Lovis Corinth was born at Tapiau in East Prussia (now Gvardeisk). He began his artistic training at the Königsberger Kunstakademie between 1876 and 1880, and from 1880 to 1883 was a student at the Munich Kunstakademie under Ludwig von Löfftz. He later

Benjamin Constant, by Angèle Delasalle

Lovis Corinth, c. 1920

studied in Antwerp and at the Académie Julian in Paris. He returned to Germany in 1887, living first in Berlin, then in Königsberg (1888–91), and again in Munich until 1901.

Corinth was a founder-member of the Munich Secession in 1892, but he left a year later. Unhappy in Munich, from 1900 he began to make regular trips to Berlin, where he built up contacts with Max Liebermann,★ Walter Leistikow and the Berlin Secession. He settled in Berlin in 1901. At the same time he founded an art school for women; he married one of his students, Charlotte Berend, in 1903. He also began a fruitful contract with the Berlin gallery owner Paul Cassirer. In 1911 he was elected President of the Berlin Secession but in the same year suffered a stroke that paralysed his left side and had a marked effect on his work, which he resumed in 1912. Corinth lost his presidency of the Secession in 1913, but was

Charles Cottet,
photographed by Dornac

Jules Dalou

Elin Danielson-Gambogi

CHARLES COTTET
(1863–1925)

Cottet was born in Le Puy, Haute-Loire. The son of a Savoyard justice of the peace, he was a pupil of Alfred Roll★ and Puvis de Chavannes at the Académie Julian in Paris. He exhibited at the Société Nationale and with the dealers Bing and Petit. After his first trip to Brittany in 1885, he returned annually, enthralled by the hard life of the fisherfolk of Camaret and the islands of Sein and Ouessant. His main motifs were the Breton *pardons* and processions, with their handsome regional costumes and stark coastal landscapes. Cottet was also drawn to the darker side of Brittany, often representing the grief caused by natural disasters in the beautiful but harsh coastal terrain there.

Although Cottet exhibited with the Nabis artists at Louis Le Barc de Boutteville's gallery, his closest friendships were with André Dauchez and Lucien Simon. The sombre realism of Courbet rather than either the sunlit visions of Impressionism or the bold colour

and outline of the Pont-Aven School principally inspired this 'Bande Noire'. *In the Country by the Sea* (cat. 285), which won a medal at the 1900 Exposition Universelle, grants biblical status to the hardships of Breton life. The central panel envisions the Last Supper as the parting of Breton men and women before challenging the waves. Cottet's visits to Spain in 1904 and to Iceland in 1907 inspired equally beautiful and fateful paintings. An illness in 1913 forced Cottet to stop painting. He died in Paris. CO'M

A. Cariou, *Charles Cottet*, exh. cat.,
 Musée des Beaux-Arts, Quimper, 1984

(AIMÉ-)JULES DALOU
(1838–1902)

The son of a glove-maker, Dalou was born in Paris. He was encouraged by Jean-Baptiste Carpeaux to attend the Petite Ecole from 1852–54 before entering the Ecole des Beaux-Arts between 1854–57 where he competed four times for the Prix de Rome, on each occasion unsuccessfully. His decorative works of the 1860s won him the first of many state commissions. During the 1871 Paris Commune, Dalou joined Courbet's Federation of Artists in which he was responsible for the Louvre. This participation forced him into exile in London where he established himself as Professor of Sculpture at the National Art Training School, South Kensington, until the amnesty of 1879.

Dalou's left-wing sympathies are manifest in the heroic naturalism of his sculptures of agricultural labourers and the Utopian mood of his historical and allegorical republican groups. This determination to stimulate social conscience culminated in his *Monument to Workers*, a work which was ultimately not executed. *The Triumph of the Republic* (1879–99) in the Place de la Nation, Paris, was one of many commissions from the left-wing Parisian municipal council during the Third Republic. Dalou's reliefs for the Palais Bourbon and the Mairie of the 10th *arrondissement* won him a gold medal at the 1883 Salon. His moving funerary sculptures include a memorial for Queen Victoria's grandchildren (1878) in the Royal Chapel at Windsor Castle, and the tombs of the left-wing revolutionaries Auguste Blanqui and Victor Noir (1885, 1890) in Père Lachaise Cemetery, Paris. Dalou died in Paris. CO'M

J. Hunisack, *The Sculptor Jules Dalou: Studies in His Style and Imagery*, New York, 1977

ELIN DANIELSON-GAMBOGI
(1861–1919)

Although born in Finland, Danielson-Gambogi spent most of her early career abroad, painting *en plein air* in the artists' rural communities in vogue in the 1880s. She developed a style derived from Bastien-Lepage after migrating to Brittany, as did other Finnish women artists, including Helene Schjerfbeck and the less well-known Amelie Lundahl.

In 1886 Danielson-Gambogi joined the artists' colony at Oenningsby, in the Åland islands on the east coast of Sweden, where the leading painter was Victor Westerholm, a neo-Romantic landscapist. Tentative Impressionist elements entered her work in the 1890s but naturalism remained her forte. Compared with that of Akseli Gallén-Kallela,★ her later work lost impetus as the National Romantic and Symbolist Finnish artists asserted themselves. JM

M. Valtonen, *Finnish Art over the Centuries*, Helsinki, 1992

Edgar Degas, Self-portrait with his nieces

William Degouve de Nuncques,
c. 1902–03

Jean Delville, *c.* 1907

EDGAR DEGAS
(1834–1917)

Degas was born in Paris. The eldest son of a Parisian banker, he enrolled at the Sorbonne to study law, but in 1854 entered the studio of Ingres's pupil Louis Lamothe and then enrolled at the Ecole des Beaux-Arts the following year. He travelled around Italy between 1856–59 copying Old Master paintings and frescoes. This early contact was to inform his entire career, inspiring his exquisite classical draughtsmanship and a sense of the epic, initially conceived through history subjects but also found in contemporary Paris.

A key figure in the Impressionist circle, Degas organised and participated in six of the eight group exhibitions but also sought an official reputation by exhibiting at the Salon. He demonstrated creative gifts in an extraordinary variety of media including painting, print-making, pastels, wax and bronze sculpture and photography. In times of affluence Degas was a perceptive art collector. Like Cézanne,★ Degas's financial security in the 1880s also allowed him to create and to sell works as he liked. He particularly devoted himself to pastels and sculpture. In his final years, as his sight faded, Degas developed a new, extraordinarily vibrant palette and a starkness of line, adding lyrical, imaginative landscapes (cats 208, 213) to his favourite themes of racecourses, cafés and ballerinas. He died in Paris. CO'M

Degas, exh. cat., The Metropolitan Museum, New York; Grand Palais, Paris; National Gallery, Ottawa, 1988–89

P.-A. Lemoisne, *Degas et son œuvre*, 4 vols, New York and London, 1984

WILLIAM DEGOUVE DE NUNCQUES
(1867–1935)

Degouve de Nuncques was born in Monthermé. The son of a French aristocratic family which had settled in Belgium during the Franco-Prussian War in 1870, he enrolled briefly at the Académie des Beaux-Arts in Brussels. However, the formation of his artistic temperament was most influenced by his family and friends who were at the heart of the Belgian Symbolist movement. He shared a studio with the Dutch-Javanese artist Jan Toorop★ and later with Henry de Groux. He was inspired by the new Symbolist writing, which he encountered personally through Emile Verhaeren, the brother-in-law of Degouve de Nuncques's wife Juliette Massin, a painter in her own right; he was also encouraged by Auguste Rodin.★ He exhibited both at the Paris Salon and the Exposition Générale des Beaux-Arts in Brussels and with avant-garde artistic societies in that city such as Les XX and La Libre Esthétique. Throughout his life Degouve de Nuncques travelled nomadically, visiting Italy, Germany, Austria, Switzerland and France. Initially inspired by a detailed evocation of a landscape or cityscape, he then transfigured the site, bathing it in a magical atmosphere rooted in the imaginative world of Symbolist expression. His preferred mediums of pastel or almost monochromatic paint and a love for twilight effects reminiscent of Whistler's★ *Nocturnes* heightened the fantastical yet melancholic mood of his work. From 1900–02 he settled on the Balearic Islands. Degouve de Nuncques died in Stavelot. CO'M

A. De Ridder, *William Degouve de Nuncques*, Antwerp, 1957

JEAN DELVILLE
(1867–1953)

Delville was born in Leuven, Belgium. He received his artistic training at the Académie Royale des Beaux-Arts in Brussels and as a pupil of Jean-François Portaels. Winning the Prix de Rome scholarship in 1894 allowed Delville to immerse himself in both the technical virtuosity and aesthetic idealism of the Italian Renaissance at first hand. As an artist and a writer, he was initially inspired by the Idealist art theories of Sâr Péladan, founder of the French Salon de la Rose+Croix, and later by an esoteric yet committed socialism. *The Love of Souls* (1900, cat. 76) typifies Delville's theories of aura and sensual collective spirituality which he expressed through the human figure, androgynous and serenely luminescent, executed on a monumental scale. Delville first exhibited in Brussels at L'Essor in 1885 and later founded several Symbolist exhibiting societies, including Pour l'Art from 1892 and the Salon d'Art Idéaliste from 1896. His first poems were published in *La Wallonie* in 1888; his philosophical writings remain some of the most striking manifestos of Belgian Symbolist aesthetics. Delville decorated many of Brussels's new public buildings, including the Palais de Justice and the Cinquantenaire. He taught at the Glasgow School of Art between 1900–05 and at the academies of Brussels and Mons until 1937. Deville died in Brussels. CO'M

J. Delville, *Dialogue entre nous*, Bruges, 1895

J. Delville, *La Mission de l'art*, Brussels, 1900

MAURICE DENIS
(1870–1943)

Denis was born in Granville. He was educated in Paris, at the Lycée Condorcet, then at the Ecole des Beaux-Arts and the Académie Julian. Denis was a founder

Maurice Denis in his studio at the Villa Montrouge, Rue Fourgueux, Saint-Germain-en-Laye, c. 1899

member of the Nabis group. Inspired by the spiritual themes and austerity of style created by Paul Gauguin★ and the Pont-Aven School in Brittany, this young brotherhood sought to create an art defined by Denis as 'néo-traditioniste'. Denis, alongside Symbolists and neo-Impressionists, showed his works at the exhibitions organised by the dealer Louis Le Barc de Boutteville.

Denis's art practice was always rooted in decorative harmony, but took many different forms, including decorative panels, mural ensembles, book illustration and theatre design. He designed the cover of Claude Debussy's *La Demoiselle élue* and illustrated André Gide's *Le Voyage d'Urien*. A devout Catholic from birth, Denis strove to create a new religious art. He revitalised traditional Christian narratives by portraying them through contemporary experience. Denis's first wife Marthe is transfigured to symbolise a spiritual and yet immediately modern Virgin. Technically he was inspired both by contemporaries such as Cézanne★ and Puvis de Chavannes, and by the grand lineage of decorative religious artists such as Fra' Angelico, whose work he copied and admired greatly on visits to Italy from 1896. Denis died in Paris. CO'M

M. Denis, *Théories, 1890–1910: Du Symbolisme et de Gauguin vers un nouvel ordre classique*, Paris, 1912

Maurice Denis, exh. cat., Walker Art Gallery, Liverpool, 1996

PAUL DE VIGNE
(1849–1901)
De Vigne was born in Ghent. Descended from three generations of artists, he received his initial training from his father Pierre and uncle Félix who were teachers at the Academie voor Schone Kunsten in Ghent. In 1864 he enrolled first for two years at the Antwerp Academie voor Beeldende Kunsten where he studied with his uncle, the sculptor Gérard van der Linden and the painter Louis de Taeye, and then for four years at the Academie in Leuven. Two failures in the Prix de Rome competition forced De Vigne to finance his own trip to Italy where he immersed himself in the sculpture of the early Florentine Renaissance masters.

De Vigne excelled in both political public-sculpture projects and intimate private works. He received numerous prestigious state commissions to decorate the façades of Brussels's new buildings, including the caryatids and busts for the Conservatoire de Musique and the controversial group *The Triumph of Art* for the Musée des Beaux-Arts. He also produced many free-standing monuments commemorating historical national heroes, important to the newly formed nation of Belgium, and funerary sculptures. De Vigne complemented his public idiom with a prolific exploration of the expressive possibilities of small-scale, exquisitely executed busts destined for private spaces and contemplation. After a lifetime of illness, De Vigne died in Brussels. CO'M

M. Fransolet, 'Le Sculpteur Paul De Vigne', *Mémoire de l'Académie Royale de Belgique*, xi/4, 1960

THOMAS WILMER DEWING
(1851–1938)
An exponent of American Aestheticism, Dewing is recognised for his textured paintings of languid women enveloped in misty verdant settings or sitting in interiors imbued with soft, golden light. Born in Boston, he went to Paris in 1876 and studied at the Académie Julian. By 1880 he had moved to New York where he established a studio and assumed a teaching position at the Art Students League.

Paul De Vigne, by X. Mellery

Thomas Wilmer Dewing

In 1885 Dewing spent the first of many summers in Cornish, New Hampshire, where he and a group of artists fashioned a lifestyle dedicated to the pursuit of beauty. In this period Dewing's career began to flourish. In 1888 he was elected a full member of the National Academy of Design and in 1889 earned a medal at the Exposition Universelle. In 1890 he met Charles Lang Freer, who was to become his principal patron.

Dewing produced paintings, pastels, and decorative works which reveal the influence of Edward Burne-Jones,★ James Abbott McNeill Whistler,★ Asian art, and seventeenth-century Dutch painting. His dreamlike images of idealised women are ambiguous, often betraying melancholy and claustrophobic oppressiveness. Associated with a spiritualised state of existence – possibly in reaction to Darwinism and as a response to the evolutionary theories of Herbert Spencer – these works

convey a turn-of-the-century distaste for materialism and industrialisation.

In 1901 Dewing received a gold medal at the Buffalo Pan-American Exposition. During the early 1900s, however, his work was regarded as outmoded and, in the last decade of his life, illness prevented him from painting. He died in New York. VG

S. A. Hobbs, with an essay by B. D. Gallati, *Thomas Wilmer Dewing: Beauty Reconfigured*, exh. cat., The Brooklyn Museum, Brooklyn, 1996

NIKOLAY (NIKANOROVICH) DUBOVSKOY
(1859–1918)
Dubovskoy was born in the Ukrainian town of Novocherkassk. The son of a family of Don Cossacks, Dubovskoy was raised in the vast landscape of the southern steppes. In 1877 he headed north for the imperial capital of St Petersburg, where he enrolled at the Imperial Academy of Arts, working predominantly under the successful landscape painter, Mikhail Klodt. Under Klodt's influence, Dubovskoy turned his attention to landscape painting and in 1882, after completing his studies, began his exhibiting career with the Society for the Encouragement of the Arts. Four years later he joined the Wanderers (the Peredvizhniki), becoming, within a decade, one of the group's most highly respected members.

The 1880s were an important decade for the Wanderers. Formed in 1870 in opposition to the perceived conservatism of the Imperial Academy of Arts, the group staged exhibitions across the

Nikolay Dubovskoy

length and breadth of Russia, attempting to bring art to the people. Images of social injustice are often regarded as the backbone of the Wanderers' art. Several landscape painters, including Ivan Shishkin, Isaak Levitan★ and Arkhip Kuindzhi, also played important roles in the movement. Dubovskoy's often intimate yet heroic landscapes, such as *Calm* (1890, cat. 13), amply capture the nationalist fervour of late nineteenth-century Russian landscape painting, with its emphasis on the vastness, dignity and sheer power of Mother Russia. Dubovskoy died in St Petersburg, then renamed Petrograd. MO'M

A. A. Prokhorov, *Nikolay Nikanorovich Dubovskoy*, Leningrad, 1967

Raoul Dufy

RAOUL DUFY
(1877–1953)
Dufy was born in Le Havre. One of nine children, he worked as a book-keeper for a Brazilian coffee importer from the age of fourteen. He attended the evening drawing classes of Charles Lhuillier at the Ecole des Beaux-Arts in Le Havre. He painted *en plein air* and shared a studio with Othon Friesz. He studied the proto-Impressionist seascapes of Eugène Boudin, the Romanticism of Delacroix and the classicism of Poussin in the museums of Rouen and Le Havre.

A municipal scholarship allowed Dufy to enter the studio of Léon Bonnat at the Ecole des Beaux-Arts in Paris. The posthumous retrospectives in the 1890s and 1900s of van Gogh and Cézanne★ made a great impact upon him. He experimented with Matisse's explorations in Fauvist colour and contour and Braque's early

Cubism. Both in the reduced Impressionism of his early work and in his mature styles, which place almost telegraphic hieroglyphs of sailboats or elegant promenaders in fields of pure colour, Dufy reconciled the historically polarised tools of arabesque line and exuberant colour.

With its distillation of pictorial vocabulary, the revival of the status of decoration and Symbolist philosophical enquiries, Dufy's *œuvre* highlights the roots of Modernism in *fin-de-siècle* art. He designed woodcuts, posters, ceramics, tapestries, haute-couture textile patterns, set designs for theatres and monumental mural commissions for Parisian public buildings and international expositions. Dufy died in Forcalquier. CO'M

Raoul Dufy 1877–1953, exh. cat., Hayward Gallery, London, 1982

THOMAS (COWPERTHWAITE) EAKINS
(1844–1916)
Eakins's trenchant realism, his scientific painting approach and his focus on the human figure have their roots in his early training. Born in Philadelphia, he enrolled at the Pennsylvania Academy of the Fine Arts in 1862, also attending anatomy classes and surgical demonstrations at a medical college. In 1866 he went to study with the master draughtsman, Jean-Léon Gérôme,★ at the Ecole des Beaux-Arts in Paris. On a visit to Spain in 1869 Eakins saw the works of Velázquez, whose austere, psychologically incisive pictures influenced his art.

Eakins returned to Philadelphia in 1870, where he began to paint scenes of sporting activities, often men sailing or sculling, and portraits. In 1875 he created his *Portrait of Dr Gross (The Gross Clinic)*, notorious for its unflinching depiction of a surgical procedure. Eakins became Director of the Pennsylvania Academy in 1882 but resigned in 1886 as the result of a scandal. From about 1880 he began to experiment with photography, and the images he created were sources for his paintings as well as works in their own right. Delving into other media, in the 1890s he turned to sculpture.

Thomas Eakins

Just before the turn of the century Eakins returned to athletic themes, scrutinising the virile figures in boxing and wrestling matches (cat. 146) in pictures that combine realism with a certain idealisation of the male body. Later, he produced a series of probing character studies of eminent Roman Catholic clerics (1900–06, see cat. 90). Eakins received an honourable mention at the 1900 Exposition Universelle and was elected to the National Academy of Design in 1902. He continued to paint portraits almost to his death. VG

L. Goodrich, *Thomas Eakins: His Life and Work*, Cambridge, Mass., 1982

J. Wilmerding, ed., *Thomas Eakins*, Washington, DC, 1993

ALBERT (GUSTAF ARISTIDES) EDELFELT
(1854–1905)
Edelfelt was born near Porvoo, Finland, into a cultured, cosmopolitan and aristocratic family of Swedish origin. After training with Adolf von Becker and Berndt Adolf Lindholm in Finland, where no official art school as yet existed, from 1874 he studied at the Ecole des Beaux-Arts in Paris, following a year in Antwerp. His career was officially sealed with a prize at the 1889 Exposition Universelle following the purchase by the French state of his *Portrait of Louis Pasteur* (1885): the first Finn to be so honoured. Bastien-Lepage's natural realism appealed greatly, as did the Barbizon painters' work. Edelfelt applied the lessons he learnt from them to such Parisian scenes as *The Luxembourg Gardens* (1887), as well as to Finnish landscapes showing fisherfolk and country people.

Albert Edelfelt, 1901

Edelfelt's international standing gave him a leading position among Finnish artists at the 1900 Exposition Universelle, and his diplomatic and cultivated personality was crucial to gaining Finnish recognition there. His patriotism was never in doubt, however, as is shown by his vivid illustrations to J. L. Runeberg's *Tales of Ensign Stal*, poems celebrating Swedish valour against the Russians in the war of 1808–09. Edelfelt's early, unexpected death was a great shock to the country. JM

Dreams of a Summer Night, exh. cat., Hayward Gallery, London, 1986

(KNUT) MAGNUS ENCKELL
(1870–1925)
Born in Hamina, Enckell trained first at the newly established art school in Helsinki, where he came to the notice of the influential painter Albert Edelfelt,★ who persuaded him to go to Paris. His arrival there in the 'Symbolist year' of 1891 expanded his interest in monumental mysticism: as well as Puvis de Chavannes's murals he studied Egyptian and Assyrian sculpture in the Louvre. His fascination with eschatology infused his near-monochrome works of the 1890s. Enckell also possessed more than the merely fashionable interest in the occult then current: Swedenborg particularly intrigued him. A visit to Italy in 1894–95 spurred anatomical study through Italian Renaissance examples and resulted in an academic Symbolism that mystified his contemporaries.

A strongly individualistic painter, he eschewed the enthusiasm for landscape and National Romantic subject matter prevalent in Finland

Magnus Enckell, 1905

in the 1890s, largely because of his Swedish background. Enckell produced a psychological art closer to the tense and neurotic output of Edvard Munch.★

Enckell's major commission, engineered by the supportive Edelfelt, was to paint a panel for the altarpiece of St John's church (now Cathedral) in Tampere, central Finland, with Hugo Simberg. The *Resurrection* was completed in 1907. From 1910 his work shows post-Impressionist colouristic elements. Enckell died in Stockholm of pneumonia. JM

Dreams of a Summer Night, exh. cat., Hayward Gallery, London, 1986

S. Sarajas-Korte, 'Symbolismin js syntetismin aika: Magnus Enckell symbolistinia', *Ars-Suomen Taide*, vol. 4, Helsinki, 1898

James Ensor's exhibitor's pass for the 1900 Exposition Universelle

JAMES (SIDNEY EDOUARD) ENSOR
(1860–1949)

Ensor was born in Ostend, Belgium, the son of an alcoholic Englishman and a Flemish bourgeoise who ran a souvenir shop. Ensor studied at the Ostend Academie, and then in 1877 at the Brussels Académie des Beaux-Arts. There, he met future leading artists of the *fin-de-siècle* generation, but was closest to the anarchist circle of Ernest Rousseau at Brussels University. Upon returning to Ostend in 1880, he painted many intimate yet oppressive bourgeois interiors.

In the 1880s, Ensor exhibited at the Paris and Antwerp Salons, La Chrysalide, L'Essor and the Cercle Artistique in Brussels, and helped to found Les XX, although he had a tempestuous relationship with the group. In paintings and Rembrandtesque etchings, he developed a highly personalised religious and political subject matter, typified by his monumental painting, unexhibited in his lifetime, *The Entry of Christ into Brussels in 1889* (1888–89). His own portrait, and masks and skeletons often appear in his grotesque satires.

Ensor's unusual technique, which combines a vehemently colouristic palette with expressively vigorous brushwork, grants an emotional accessibility to his otherwise enigmatic subject matter. By 1900, after many one-man shows, both the Belgian state and the next generation of artists recognised him as a pioneer. He was made a Knight of the Order of Léopold in 1903 and a Baron in 1929. CO'M

J. Ensor, *Mes Ecrits*, Liège, 1974

X. Tricot, *Catalogue raisonné des peintures d'Ensor*, Antwerp, 1992

PRINCE (NAPOLEON NICOLAUS) EUGEN
(1865–1947)

Prince Eugen, the youngest son of King Oscar II of Sweden, was born at Drottningholm. Because of his rank, he had an anomalous position in the artistic life of his country; although he sympathised with the 'moderns', he could not join a group which was openly opposed to the Akademi, as was the Artists' Association. Nevertheless, he was active behind the scenes as his

Prince Eugen

collection of contemporary Swedish art at Waldemarsudde (Stockholm) attests.

In 1887, he attended Léon Bonnat's studio in Paris, and was also taught by Puvis de Chavannes, whose monumentality is evident in Eugen's *The Light Night* (1899), a mural for the North Side Classical School in Stockholm.

Prince Eugen later visited Italy, but until early in the new century the main influences on the art of the 'Red Prince' were from northern European and, pre-eminently, Belgian Symbolism. He died in Waldemarsudde. JM

H. H. Brummer, *Prins Eugen: Minnet av ett landskapp*, exh. cat., Prins Eugens Waldemarsudde, Stockholm, 1998

M. Facos, *Nationalism and the Nordic Imagination: Swedish Art of the 1890s*, Los Angeles, 1998

I. Zachau, *Prins Eugen, Nationalromantikern*, Lund, 1989

HENRI(-JACQUES-EDOUARD) EVENEPOEL
(1872–1899)

Born in Nice into an artistically aware yet restrained bourgeois family, Evenepoel studied with Ernest Acker, Ernest Blanc-Garin and Adolphe Crespin in Brussels before enrolling at the Ecole des Beaux-Arts in Paris. Originally guided by his father towards a career as a decorative artist, he entered the studio of Gustave Moreau in 1893 after the death of his original tutor, P. V. Galland. Moreau was a supportive teacher to Evenepoel and his fellow-students and friends Rouault and Matisse.★ Evenepoel made his début at the Salon des Artistes Français in 1894 and continued to exhibit both there and with the Société Nationale. The Cercle Artistique et Littéraire hosted a one-man show of his work in Brussels in 1897. The same year he visited Algeria and

Henri Evenepoel, 1899

Ludvig Find

Stanhope Forbes,
from a photograph by Elliott & Fry published in 1897

developed a vibrant palette which prefigured Fauvist colour.

His portraits provide a unique testament of life at the *fin de siècle*. Few works capture the turn of the century better than *The Spaniard in Paris* (1899, cat. 88) and the artistic link that Montmartre provided between the decadent 1890s and the stylistic aspirations of the first decades of the twentieth century. This cosmopolitan, *demi-monde* milieu, celebrated in the backdrop of the Moulin Rouge, hosted concurrently both Evenepoel's own aesthete culture of Wagnérisme and fancy dress and the nascent challenge of Fauvism and Cubism. Evenepoel died of typhus in Paris. CO'M

H. Evenepoel, *Lettres à mon père*, 2 vols, Brussels, 1994

G. Ollinger-Zinque, *Catalogue raisonné Henri Evenepoel*, 2 vols, Brussels, 1994

LUDVIG (FREDERIK) FIND
(1869–1945)

Like many Scandinavian artists, Find trained first as a housepainter from the age of sixteen (although he enrolled at the Copenhagen Technical School at the same time). He then graduated to classes at the Kongelige Dansk Kunstakademi in Copenhagen but its old-fashioned teaching style repelled him and he went instead to the competing Independent Artists' Study School. In the late 1890s Find met with some success when he exhibited at the Free Exhibition (akin to the Paris Salon des Refusés).

Unusually for a Danish painter at this time he had many Norwegian connections, largely through the Danish Symbolist journal *Taarnet*, founded in 1893, through which he met Thorvald Erichsen and Oluf Wold-Thorne. All three, with Harald Slott-Møller, were influenced by Julius Lange, an art-historian, and Georg Brandes, a radical historian, who encouraged young painters in the north to study the Italian Renaissance. Kristian Zahrtmann, founder of an influential school, also encouraged the trek south and Find spent the years 1893–94 in Italy studying Quattrocento work. This interest is shown in the frieze of monochrome photographs of works by Masaccio, Taddeo Gaddi and Duccio in his portrait of Thorvald Erichsen (cat. 97).

Find adapted the luminous, cool, bluish light of such Danish Golden Age painters as Johan Thomas Lundbye, and was also influenced by the 'friendship' portraits of the German Romantics, which returned to favour in the 1890s with the increasing interest in the symbolic and psychological. JM
Dreams of a Summer Night, exh. cat., Hayward Gallery, London, 1986

STANHOPE (ALEXANDER) FORBES
(1857–1947)

Forbes was born in Dublin, the son of a railway manager. His family moved to London and Forbes attended Lambeth School of Art and then in 1876 entered the Royal Academy Schools. In 1880 he joined the atelier of Léon Bonnat in Paris, and was much influenced by the *plein-air* painters of the Barbizon School and the naturalist painter Jules Bastien-Lepage. He spent the summer of 1881 in Brittany with Henry Herbert La Thangue,★ a fellow student from the Royal Academy Schools, and there, using square brushes, adopted the new style of British *plein-air* realism.

He returned to London in 1883 and then moved to Falmouth. While exploring the area in 1884 he discovered the Cornish fishing village of Newlyn where a few artists were already based. He gained considerable success at the RA exhibition of 1885 with *A Fish Sale on a Cornish Beach*; this helped him to encourage other artists to form a colony in the area. These painters became known as the Newlyn School and were rigorous in their commitment to *plein-air* painting and their belief that artists should live among the scenes they sought to render.

In 1889, after his marriage to the painter Elizabeth Armstrong, Forbes decided to settle permanently in Newlyn. A decade later he and his wife opened the Newlyn School of Painting which operated until 1938 and helped to foster a second generation of artists working in and around Newlyn. Forbes was a founder member of the New English Art Club in 1886 but continued to exhibit at the Royal Academy; he was elected ARA in 1892 and RA in 1910. He died in Newlyn at the age of ninety. HV

C. Fox and F. Greenacre, *Painting in Newlyn, 1880–1930*, exh. cat., Barbican Art Gallery, London, 1985

K. McConkey, *Impressionism in Britain*, exh. cat., Barbican Art Gallery, London, 1995

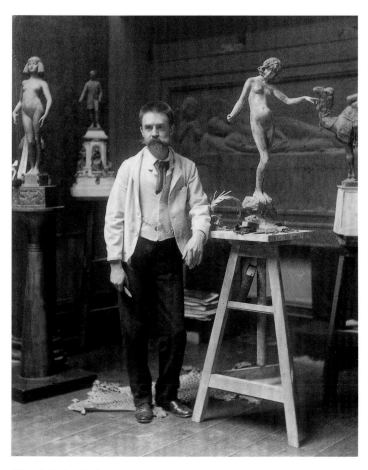

Edward Onslow Ford,
from *Members and Associates of the Royal Academy of Arts*,
photographed by Ralph Winwood Robinson, London, 1892

George Frampton,
from a photograph by L. Lowe
published in 1897

Léon Fréderic, 1900

EDWARD ONSLOW FORD
(1852–1901)

Ford was born in London, but following the early death of his father he moved to Antwerp where he attended the Academie voor Schone Kunsten as a student of painting. He then studied under Michael Wägmuller in Munich who advised him to change from painting to modelling.

Ford returned to England in about 1874 and his first exhibit at the Royal Academy in the following year, a bust of his wife, immediately attracted attention. Among Ford's public monuments are *General Gordon on a Camel* (1890) which was brought back from Khartoum and placed in the courtyard of Gordon Boys' School, Woking, and the *Shelley Memorial* (1892) at University College, Oxford. Ford was one of the leading exponents of the New Sculpture movement which prized individuality as opposed to breadth. *A Study* (1891), a turbanned head of a girl in marble (which had

appeared in bronze in 1886) was seen to evoke an elusive, spiritual ideal. His many busts uphold the New Sculpture ideals of individuality, verisimilitude and delicate modelling.

Ford also modelled a series of bronze statuettes of adolescent girls, some of which, such as *Folly* (1885–86), represented literary themes. *The Singer* (c. 1889), also of this group of works, was Egyptian in theme and set with garnets and turquoises, a characteristic of the New Sculpture which was to find its culmination in the heavily bejewelled sculptures of the younger George Frampton.★ Ford was elected ARA in 1888 and RA in 1895, and died in London. HV

S. Beattie, *The New Sculpture*, New Haven and London, 1983
F. Haskell, 'The Shelley Memorial', *Oxford Art Journal*, 1, 1978, pp. 3–6
Reverie, Myth, Sensuality: Sculpture in Britain 1880–1910, exh. cat., Stoke-on-Trent City Museum and Art Gallery and Cartwright Hall, Bradford, 1992–93

SIR GEORGE (JAMES) FRAMPTON
(1860–1928)

Frampton was born in London and began his career in an architect's office. He was later apprenticed to a firm of architectural stone-carvers. In about 1880 he studied modelling at Lambeth School of Art and entered the Royal Academy Schools the following year. He also studied with Antonin Mercié in Paris in 1887.

On returning to London in 1889 Frampton developed a highly personal style; his *Mysteriarch* (1892), executed in polychromed plaster, evoked a mood instead of portraying a particular event. Although influenced by the sculptors of the New Sculpture movement, such as Alfred Gilbert,★ Frampton developed an interest in inner psychology, and works such as *Lamia* (1900) link him to the Symbolist movement.

He was appointed teacher of sculpture at the Slade School and joint head with W. R. Lethaby of the Central Schools of Arts and Crafts from 1893. He frequently exhibited with the Arts and Crafts Society from 1893, as well as internationally in Brussels, Vienna and Munich, including the first Vienna Secession of 1898. Frampton won the grand prize for four works shown at the Exposition Universelle of 1900.

Frampton worked in many different areas including commissions for medals, architectural work, monuments, memorials and portrait busts as well

as pursuing his own interest in designing household fittings and jewellery. His principal surviving works relating to architecture are nine silver-gilt figure panels for the door of the Great Hall at Astor House, London, and a bronze group and stone spandrels for the façade of Glasgow Art Gallery (1897–1901). His best-known monuments include a statue of Queen Victoria for Calcutta (1897) and *Peter Pan* in Kensington Gardens, London (1910).

He produced a large number of portrait busts after 1900, including the *Marchioness of Granby* (1902, cat. 114), but the intensity of his earlier style gave way towards 1910 to repetitive and very smoothly modelled compositions. He died in London. HV

S. Beattie, *The New Sculpture*, New Haven and London, 1983
T. Stevens, 'George Frampton', in P. Curtis, ed., *Patronage and Practice: Sculpture on Merseyside*, exh. cat., Tate Gallery, Liverpool; National Museums & Galleries on Merseyside, 1989

LÉON (HENRI MARIE) FRÉDERIC
(1856–1940)

Fréderic was born in Brussels. The son of a jeweller, he was sent to a Jesuit boarding school in Ghent. His first artistic training was as an apprentice to Charle-Albert, a painter-decorator. Fréderic later enrolled at the Académie des Beaux-Arts in Brussels under Jean-François Portaels. Like De Vigne★ he failed to win the Prix de Rome competitions and paid for his own trip to Italy; he looked principally to the example of the Early

Netherlandish School for technical and thematic inspiration. His love of detail and line also led him to admire the British Pre-Raphaelite painters.

Fréderic enjoyed great public acclaim in his own lifetime. He exhibited in Brussels at the Triennial Salons and L'Essor in the 1880s, and the Salons of L'Art Idéaliste were the venue he selected for his later monumental Symbolist compositions. The main themes of these multipartite works were either the endurance of labourers, in the countryside and occasionally in the city, or the fecund spiritual fantasy typified by *The Stream* (*c.* 1890–99, cat. 1). His early manner has often been likened to Jules Bastien-Lepage. In his later Symbolism, adopted at the turn of the century, Fréderic maintained the technical virtuosity of his draughtsmanship and his intense, though austere, colouring to serve his more allegorical vision. He died in Schaarbeek. CO'M

F. Khnopff, 'A Belgian Painter: Léon Fréderic', *The Studio*, 40: 169, 1907
Rétrospective Léon Fréderic, exh. cat., Hotel Charlier, Saint-Josse-ten-Node, 1973

LUCIANO FREIRE
(1864–1935)
Freire was born in Lisbon. He was a student at the Escola de Belas-Artes in Lisbon from 1878 to 1886 and was taught, like Columbano Bordalo Pinheiro,★ by Miguel Ângelo Lupi and Tomás José da Anunciação, but also by José Ferreira Chaves and Antonio Carvalho da Silva Portio.

Freire travelled to Paris and England and became particularly known for his history paintings and his landscapes: his work *Country Perfume* (1899, cat. 118) shows the influence of Symbolism and Art Nouveau, both unusual styles for Portuguese artists. In 1895 he became a member of honour at the Escola de Belas-Artes in Lisbon, where he was also appointed professor between 1896 and 1933. During this later period, Freire devoted himself to the restoration of Portuguese paintings of the fifteenth century. EL

D. de Macedo, *Veloso Salgado e Luciano Freire*, Lisbon, 1954

Luciano Freire with José de Figuereido

Raffaello Gambogi (centre) with Elin Danielson-Gambogi (seated on ground)

Akseli Gallén-Kallela's exhibitor's card for the 1900 Exposition Universelle

AKSELI (VALDEMAR) GALLÉN-KALLELA
(1865–1931)
Gallén-Kallela was born and brought up in Pori on the west coast of Finland. He first studied art in Helsinki at the Finnish Fine Art Association at the age of sixteen, and then moved to Adolf von Becker's academy in the same city before travelling to Paris in 1884, where he attended both the Académie Julian and Fernand Cormon's studio.

At first a follower of Jules Bastien-Lepage's naturalism, Gallén-Kallela scorned Symbolism when he encountered it on a trip to Paris in 1891. Three years passed before, through the influence of the Strindberg★–Munch★ group at the Black Piglet tavern in Berlin,

he adopted its tenets. By 1896 he had evolved a heavily freighted Symbolist idiom, prompted largely by the death of his small daughter from diptheria. A leader of the Young Finland group, who mixed Nietzschean philosophy, fashionable occultism and a zeal for national freedom from Tsarist oppression, Gallén-Kallela was, with Albert Edelfelt,★ the major Finnish painter at the 1900 Exposition Universelle. His paintings depicting the country's national epic, the *Kalevala*, were exhibited in the Finnish pavilion. He alternated city life with backwoods simplicity and self-sufficiency; never satisfied for long, his restlessness led him to travel widely – to London in 1895, and British East Africa (Kenya) in 1909–10.

Gallén-Kallela worked in many media besides oils, including engraving, sculpture, stained glass, furniture and tapestry design. He briefly joined the German Expressionist group Die Brücke in 1907, and his later work is an eclectic mix of Expressionist colour and Jugendstil design. He died in Stockholm. JM

Akseli Gallén-Kallela, exh. cat., Ateneum Museum, Helsinki, 1996
E. Kamarainen, *Akseli Gallén-Kallela: Katsoin outoja unia* (*Artist and Visionary*), Helsinki, 1994

RAFFAELLO GAMBOGI
(1874–1943)
Born and raised in Livorno, at the age of seventeen Gambogi won a scholarship which enabled him to go to Florence. There he enrolled at the Accademia and attended the courses of Giovanni Fattori, one of the leading *plein-air* painters of landscape with figures. Gambogi was a precocious pupil whose first success came in 1896 when he was awarded the Premio Firenze for a work entitled *Leaving Mass*. After this he painted *The Exiles*, presented to the Comune di Livorno and now in the collection of that city's Museo Civico Fattori. He painted mainly landscapes and scenes of everyday life in Tuscany. *Boats in Dry Dock at Livorno* (1897, cat. 132) has been identified as the work entitled *The Dockyard*, sent by the artist to the Esposizione Nazionale in Turin of 1898. Other works by him that show some

northern influence include *Fatigue*, entered for the Premio Fumagalli of 1908 and now in the Ateneum in Helsinki, also home to his *The Madwomen*. He travelled frequently to Finland and in 1898 married the Finnish artist Elin Danielson,★ winner of medals at the Expositions Universelles of 1889 and 1900. Gambogi was appointed honorary professor at the Accademia Fiorentina. Five years after his death, three of his works were included in an exhibition on nineteenth-century painting from Livorno. CT

A. M. Comanducci, *Dizionario illustrato dei pittori, disegnatori e incisori italiani…*, vol. 3, Milan, 1972

Paul Gauguin, 1894

PAUL GAUGUIN
(1848–1903)
Gauguin was born in Paris. The son of a journalist, he travelled extensively in his youth, living in Peru and visiting many distant ports as a sailor. He worked with the Bertin brokerage firm in Paris for eleven years, an affluent time during which he married his Danish wife, Mette-Sophie Gad, and amassed an important contemporary art collection.

In the aftermath of the 1883 Depression, Gauguin devoted himself entirely to painting. In 1886 he made the first of many trips to Pont-Aven in Brittany. The following year, he and Charles Laval visited Panama and Martinique. In 1888 he attempted briefly and unsuccessfully to create a 'Studio of the South' with Vincent van Gogh in Arles. Gauguin held a one-man

exhibition in 1888 and participated in a group show at the Café Volpini during the 1889 Exposition Universelle. Inspired by the international displays, he applied for and received a Colonial Office passage to Tahiti in 1891.

Gauguin created an exotic, imaginative vision of Tahiti by mingling his passions for folk art, Asian art, and Symbolist and theosophical literature. With bold colour and naive form, he formulated a distinct vocabulary which reconciled the decorative and philosophical aims of his painting. After a two-year stay in France, when Durand-Ruel hosted his one-man show, Gauguin returned to Tahiti in 1895. He died at Atuana in the Marquesas Islands. CO'M

The Art of Paul Gauguin, exh. cat., National Gallery of Art, Washington, DC; Art Institute of Chicago; Grand Palais, Paris, 1988–89
N. Wadley, *Noa Noa: Gauguin's Tahiti*, London, 1985

JEAN-LÉON GÉRÔME
(1824–1904)
Gérôme was born in Vesoul, Haute-Saône. The son of a wealthy goldsmith, he studied under Paul Delaroche and Charles Gleyre, and at the Ecole des Beaux-Arts. Gérôme's first great success was at the Salon of 1847 where he exhibited *The Cockfight* (1847). His exquisitely high finish and minute accuracy of detail, often described as 'archaeological' by contemporary critics, won him many state commissions, from religious murals to society portraits and designing a Sèvres urn. Gérôme was made Professor at the Ecole des Beaux-Arts in 1863 and elected to the Institut de France in 1865.

During his extensive travels in the Near East he collected artefacts and made studies from which he developed his best-known orientalist works. First visiting Egypt in 1856, Gérôme made six more trips around the Near East between 1862–75. Late in life he began to sculpt, working in marble, bronze and polychromy, and made an extraordinary series of self-portraits in his studio from life models. Gérôme's eyes appear floating enigmatically in *Optician* (1902, cat. 179), an unconscious precursor to the word-play and

Jean-Léon Gérôme

juxtapositions of the Surrealists. An avid animal-painter, Gérôme is best known for his heroic big cats. He died in Paris. CO'M

G. M. Ackerman, *Jean-Léon Gérôme: A Catalogue Raisonné*, London, 1986

SIR ALFRED GILBERT
(1854–1934)
Gilbert was born in London. He enrolled at Heatherley's School of Art and then in 1874 entered the Royal Academy Schools as well as becoming Joseph Edgar Boehm's apprentice. In 1875 he went to Paris to study at the Ecole des Beaux-Arts and also travelled to Italy where his visit to Florence, in c. 1880–81, inspired his first statue in bronze, *Perseus Arming* (1882). In this work, Gilbert revived the lost-wax process of bronze-casting that rid sculpture of unsightly seams.

Gilbert was at the forefront of the progressive school of British sculpture known as the New Sculpture. He often used wax to create preliminary models for his sculptures which resulted in fantastical shapes; this effect was translated into many of his finished works, such as the throned figure of Queen Victoria (1887) in the Great Hall of Winchester Castle and the *Memorial to Queen Alexandra* (1928–32) at Marlborough Gate, London. In his *Fawcett Memorial* in Westminster Abbey, Gilbert made innovative use of oriental alloys, producing various coloured patinas as well as encrusting the monument with semi-precious stones, enamel and ivory. The *Clarence Memorial*,

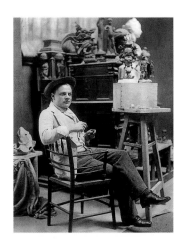

Sir Alfred Gilbert, photographed by Ralph W. Robinson, c. 1891

commissioned by the Prince and Princess of Wales, was similar in conception. Gilbert's best-known work is the *Shaftesbury Memorial* (1886–93), better known as 'Eros', at Piccadilly Circus, London.

Gilbert's chronic inability to finish commissions, mainly due to his perfectionist ideals and his tendency to take on too much at once, led to ruptures with the royal family and court cases brought by dissatisfied patrons. The crippling cost of monuments such as 'Eros' led to his bankruptcy in 1901 and a period of exile in Bruges. He returned to England in 1926 to complete the *Clarence Memorial* and was knighted in 1932. HV

R. Dorment, ed., *Alfred Gilbert*, New Haven and London, 1985
R. Dorment, ed., *Alfred Gilbert: Sculptor and Goldsmith*, exh. cat., Royal Academy of Arts, London, 1986

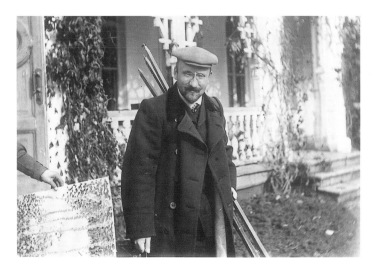

Igor Grabar

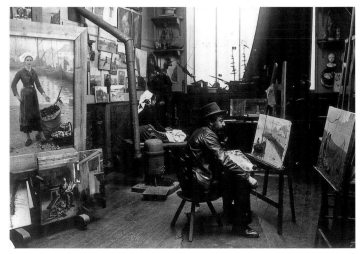

Alfred Guillou in his studio in the Place de la Croix, Paris, *c.* 1900

IGOR (EMMANUILOVICH) GRABAR
(1871–1960)

Born in Budapest, Grabar graduated in law before entering the Imperial Academy of Arts in St Petersburg in 1894. There he worked under Il'ya Repin,★ before moving to Munich to study with Anton Ažbe. Between 1896 and 1901 Grabar travelled throughout Europe absorbing many of the influences of *fin-de-siècle* art, yet he retained a particular fascination for Impressionism. In both Europe and Russia he produced landscapes, such as *September Snow* (1903, cat. 218), in which colour, texture and light effects are emphasised. In 1901 Grabar joined the World of Art (Mir Iskusstva) group, contributing works to their exhibitions over the next four years.

In addition to his career as an artist, Grabar was also an art teacher, historian and administrator. He was a professor at the Imperial Academy of Arts from 1913 and taught at the Moscow Free Art Studios after the Bolshevik Revolution. Between 1910 and 1915 he edited the thirty-volume *History of Russian Art*. After 1917 Grabar was highly valued by the new régime and became Director of the Tretyakov Gallery in Moscow. There he oversaw the restoration and cataloguing of the museum's collection of icons, many of which had been acquired as a consequence of the closure of the churches and confiscations of private property.

In his later career Grabar was renowned for his numerous depictions of Lenin. He died aged 89, with a reputation as a major figure in pre- and post-revolutionary Russian art. MO'M

V. Azarkovich, ed., *Igor Grabar*, Leningrad, 1977

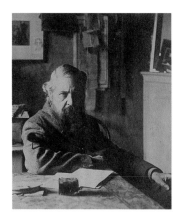

Vittore Grubicy, *c.* 1900

VITTORE GRUBICY (DE DRAGON)
(1851–1920)

The death of Vittore's father Alberto Grubicy De Dragon, a Hungarian baron, left his family in a precarious financial situation. The second of six children, Vittore was raised in an artistic Milanese milieu by his mother, an amateur painter. With his brother Alberto he embarked upon a career as a dealer, launching talents like Tranquillo Cremona, Daniele Ranzoni, Giovanni Segantini,★ Angelo Morbelli★ and Gaetano Previati.★ He travelled all over Europe, in particular to the Low Countries where he met Jozef Israëls,★ H. W. Mesdag and Anton Mauve. Mauve encouraged him to paint.

From 1885 he concentrated on his own painting, further developing Divisionist techniques with reference to texts by Eugène Chevreul and Ogden Rood. A constant presence on the contemporary art scene, he was a supporter of modernist theories. In 1886 he settled in Miazzina on Lake Maggiore and began writing for *La Riforma*. From 1889 he distanced himself from his brother's commercial activities and became increasingly withdrawn, possibly because of his ever-increasing deafness. He showed brilliantly coloured and intricately worked paintings at the 1891 Brera Triennale.

Grubicy identified music with painting, seeking parallels between sound and colour. Among the works he produced between 1894 and 1911 were the eight canvases of *Winter in the Mountains, a Pantheist Poem*, also known as the 'sinfonia invernale', of which *Morning* (cat. 187) is one. Grubicy maintained an interest in the work of fellow artists, organising in 1901 an important exhibition of Previati's religious paintings. In 1907 Giuseppe Pellizza da Volpedo★ wrote to Grubicy: 'From Cremona to Segantini, Previati, Morbelli and myself, and generally to all those who have come into contact with you, all must have felt the influence of your persuasive force.' CT

F. Bellonzi and T. Fiori, *Archivi del Divisionismo*, vol. I, Rome, 1969, pp. 83–117

S. Rebora, *Vittore Grubicy de Dragon*, Milan, 1995

ALFRED GUILLOU
(1844–1926)

Guillou was born at Concarneau. He trained in the studios of Alexandre Cabanel and William-Adolphe Bouguereau★ and achieved considerable success in the Salon, receiving a third class medal in 1877 and a second class medal in 1881. At the Expositions Universelles in 1889 and 1900, he was awarded a silver medal. He was made a Chevalier of the Légion d'honneur.

Guillou's central motif was the romance and distinctness of his native region, celebrated in works like *The Arrival of the Pardon of St Anne at Fouesnant* (1887). Brittany captured the imagination of nineteenth-century artists with its ancient Celtic folklore and menhirs, its dramatic coastal landscape, its picturesque, though fictitiously historical, regional dress and its distinctive local religious festivals. Regionalism satisfied cultural longings for a more pious, primitive, rural or localised French identity which was felt to be on the wane. The coastal waters of Brittany are treacherous and in *Farewell* (1892, cat. 18), exhibited in the 1900 Exposition Universelle, Guillou depicted the loss of life they often exact. The high emotion and naturalist detail of the work recalls the flowering of nineteenth-century novels set in Brittany, such as Blanche Willis Howard's *Guenn* (1883). CO'M

Post-Impressionism: Cross-Currents in European Painting, exh. cat., Royal Academy of Arts, London, 1979

Pekka Halonen after his studies in Paris, photographed by Daniel Nyblin in Helsinki, c. 1895

PEKKA HALONEN
(1865–1933)
Halonen was the son of a prosperous farmer. Four years' art-study in Helsinki (1887–91) were followed by a visit to Paris, returning from which he became involved in the fashion for 'Karelian studies', travelling to that area of eastern Finland and then building a Karelian-style studio home on the shores of Lake Tuusula, near Jarvenpaa, in 1892. The area became a magnet for National Romantic artists (including the composer Jean Sibelius).

A staunch friend of Akseli Gallén-Kallela,★ Halonen specialised in Finnish landscapes and rarely explored more abstruse Symbolist subjects, despite a brief period of study with Gauguin★ in 1894; his style was derived from Bastien-Lepage's naturalism. He also admired Puvis de Chavannes's monumental figures in landscape and the Barbizon painters' naturalistic depiction of peasant workers; he strove to combine the two in a Finnish context, as exemplified in *Washing on the Ice* (1900, cat. 222). Profoundly depressed by the Tsarist oppression of 1899–1904, Halonen produced powerfully emblematic landscapes, in which Finnish forests represent the Finnish nation's resistance. JM

Pekka Halonen, 1865–1933, exh. cat., Lapinlahden Taidemuseo, Lapinlahti, 1995
J. Ilvas, ed., *Pekka Halonen, sanoin ja kuva; Words and Pictures*, Helsinki, 1990

VILHELM HAMMERSHØI
(1864–1916)
For many, Hammershøi's quiet, introspective interiors are the quintessence of a certain balanced and harmonious quality in Danish art. He was certainly well aware of the 'Golden Age' artists and in particular C. W. Eckersberg and his associates. Hammershøi decided early on to intensify their perceptions of reality through a calm appraisal of light and space. At fifteen, he went to the Kongelige Akademi for de Skønne Kunster in Copenhagen and studied there for five years. In 1887 he travelled to Holland and Belgium and two years later exhibited four works at the Exposition Universelle, where he first saw Whistler's★ paintings. The latter became a major influence, and Hammershøi's subsequent (and for a Scandinavian artist, unusual) visits to London (1897–98) were largely because of his determination to see Whistler.

Hammershøi travelled widely in the 1890s: to Paris, northern Italy, Stockholm, Holland and Italy again in 1902–03. He returned to London in 1904. In 1897 Diaghilev exhibited Hammershøi's work in St Petersburg and in 1904 London's International Society showed some of his paintings. A Danish colleague remarked that Hammershøi developed 'a weakness for England in the dark autumn!' but was disappointed 'that the fog made it too dark to paint'. Critics there noted his affinity with Whistler. From 1905 Hammershøi varied his interiors (often of his Neoclassical house in Christianshavn in Copenhagen) with landscapes

Vilhelm Hammershøi, Self-portrait, 1890

of Roskilde reminiscent of Johan Thomas Lundbye and other Golden Age artists, but with a monumentality nearer Ferdinand Hodler or Caspar David Friedrich. JM

O. Billgren and P. Osipow, *Hammershøi*, Hellerup, 1995
Dreams of a Summer Night, exh. cat., Hayward Gallery, London, 1986
P. Vad, *Villem Hammershøi and Danish Art at the Turn of the Century*, New Haven and London, 1992

Childe Hassam

(FREDERICK) CHILDE HASSAM
(1859–1935)
Hassam was born in Dorchester, Massachusetts, and worked first as a wood-engraver in Boston. He attended art classes at the Lowell Institute before going to Paris in 1886 to study at the Académie Julian.

Hassam returned to New York in 1889 and began painting the city. Representing only aesthetically pleasing vistas of urban living, these works demonstrate Hassam's recently developed adherence to bright colour and cropped compositions. During his holidays in New England, Hassam also began to portray vibrant, light-filled views of the northeastern coast. A leading exponent of American Impressionism, Hassam's cityscapes and landscapes in oils and watercolours suggest the impact of Claude Monet★ in their attention to the effects of light and atmosphere.

In 1897 Hassam and nine other Impressionists resigned from the reactionary Society of American Artists to form the Ten American

Painters. In 1900 he worked in Provincetown, Massachusetts, producing canvases revealing more loosely applied brush strokes. In that same year, a city snow scene shown in the Exposition Universelle received a silver medal. In 1903 Hassam went to the artists' colony at Old Lyme, Connecticut, where he depicted traditional historic New England architecture.

Hassam began to withdraw from city life at the beginning of the century. However, in 1916 he embarked upon his *Flag* series, visually recounting the patriotic celebrations held on Fifth Avenue in c. 1917–18. Hassam's successful career lasted until his death in East Hampton, New York. VG

U. W. Hiesinger, *Childe Hassam: American Impressionist*, Munich and New York, 1994

JEAN-JACQUES HENNER
(1829–1905)
Henner was born in Bernwiller, Alsace. Apprenticed to a baker, he studied with the drawing master Charles Goutzwiller before entering the studio of Gabriel-Christophe Guérin in Strasbourg. In 1847 he won a scholarship to study at the Ecole des Beaux-Arts in Paris and entered the studios of Michel-Martin Drolling and François-Edouard Picot. He returned to Alsace for two years to nurse his dying mother. In 1858 he won the Prix de Rome which granted him four years of study, at the Villa Medici in that city.

Henner made his début at the Paris Salon of 1863 and won a third class medal. His many accolades included Salon medals in 1865 and

Jean-Jacques Henner

1866, a first class medal at the Exposition Universelle in 1878, *hors-concours* status granted at the 1889 Salon, a medal of honour at the Salon of 1898 and a grand prize at the 1900 Exposition Universelle. He was made a member of the Institut de France in 1889 and elected Grand Officier of the Légion d'honneur by 1903.

Admired for his nudes, Henner also painted religious subjects, portraits and Alsatian peasant women. A passionate translator of the Classical authors, he often drew his subjects from their narratives. Henner emulated the subdued red tonality and lush painterly technique of the northern Italian Renaissance masters, in particular Correggio, whose hazy atmospheric touch he emulated to infuse the anatomical perfection of his languorous nudes with a sense of passion and vitality. He died in Paris. CO'M
No bibliographic references known

ROBERT HENRI
(1865–1929)
Henri was a pivotal figure in the development of American art, both in his artistic ability and in his role as a teacher and a leader in creating a modern aesthetic. Born Robert Henry Cozad in Cozaddale, Ohio, a town founded by his father, Henri studied at the Pennsylvania Academy of the Fine Arts in Philadelphia, and the Académie Julian and the Ecole des Beaux-Arts in Paris. The work of Hals, Rembrandt and Manet influenced his rapid, virtuosic handling of paint, and his interest in depicting scenes and people of everyday life. After a few years in Philadelphia, Henri settled permanently in New York in 1900. The following year he won a silver medal at Buffalo's Pan-American Exposition.

Henri established a school in 1904 and encouraged his students Stuart Davis and Edward Hopper, among many others, to look to contemporary urban life for inspiration. This interest in the public milieu and the use of broad brushwork characterise the work of Henri and the informal artistic group, the 'Ashcan School', with which he was affiliated. The Ashcan School, whose principal artists also came to be known as 'the Eight', was launched by a 1908

Robert Henri

exhibition at Macbeth Galleries, New York.

Henri devoted a great deal of attention to portraiture and figure studies, and was particularly concerned with capturing the spirit of the people he met during his frequent travels to Maine, New Mexico, Ireland, Holland and Spain. Although later in his career he exhibited little, he continued to travel and remained a charismatic teacher until his death. SR
W. I. Homer, *Robert Henri and His Circle*, Ithaca, 1969
B. B. Perlman, *Robert Henri, Painter*, exh. cat., Delaware Art Museum, Wilmington, DC, 1984

LUDWIG HERTERICH
(1856–1932)
Born in Ansbach, Bavaria, the son of the sculptor and gilder Franz Herterich, Ludwig first came into contact with art in his father's studio, and it was his brother, the artist Johann Caspar Herterich, who gave him his first art lessons. From 1872 Ludwig Herterich lived in Munich, where he studied for a short time at the drawing school of the Akademie, and then entered the class of Wilhelm von Diez.

Ludwig Herterich

It was at this time that he began to undertake *plein-air* painting. In 1883 he made a trip to Italy and was particularly impressed by the frescoes of Mantegna and Raphael, whose combination of naturalistic observation and monumental form had a great influence on his work.

From 1883 onwards Herterich exhibited regularly in the Munich Glaspalast and from 1893 with the Munich Secession and at the Grosse Kunstausstellung in Berlin. From 1888 to 1896 he was an assistant tutor at the Munich Akademie, and between 1896 and 1898 he taught at the Stuttgart Kunstschule. In 1898 he became a professor at the Munich Akademie.

Herterich received many public commissions, including decorative paintings for the main restaurant in the Munich Exhibition Building, the banquet room in the town hall in Bremen, town hall rooms in Neumarkt, Wasserburg and Kaufbeuren, as well as commissions for house frescoes in Murnau. In 1908 he was ennobled and awarded the Order of Maximilian. He died in Etzenhausen. AC
U. Thieme and F. Becker, eds, *Allgemeines Lexikon der Bildenden Künstler*, vol. I, Leipzig, 1923

FERDINAND HODLER
(1853–1918)
Hodler was born in Berne. He lost his entire family to tuberculosis in childhood. He studied first with the landscapist Ferdinand Sommer before becoming a pupil of Barthélemy Menn at the Geneva Ecole des Beaux-Arts in 1873. He exhibited at the Salon de la Rose+Croix in Paris, La Libre Esthétique in Brussels, the Vienna

and Berlin Secessions (in 1904 a whole room was devoted to his work), and had a one-man show at the Cercle des Beaux-Arts, Geneva.

Hodler's theory of 'Parallelism' sought to repeat patterns of figures and landscape zones to represent the cycles of nature pictorially: *Eurythmy* (1894–95) is a good example. Hodler hoped to create a series representing the times of day; *Night* (1890) was refused from the Geneva Salon but Hodler showed it in the electoral building before it was accepted by the Salon in Paris where it was greatly admired by Puvis de Chavannes. *Day* (1900) won a gold medal at the 1900 Exposition Universelle in Paris.

Hodler attracted state patronage and was awarded a commission in 1900 to decorate the weapons room of the Zurich Landesmuseum with frescoes. He employed hard-edged line and luminous colour to create a magical alternative reality in his Alpine landscape and mythical paintings. A dominant though depressive personality, Hodler exerted a profound influence over the *fin-de-siècle* generation of Swiss painters. He died in Geneva. CO'M
J. Brüschweiler and G. Magnaguagno, eds, *Ferdinand Hodler*, exh. cat., Petit Palais, Paris; Kunsthaus, Zurich; Neue Nationalgalerie, Berlin, 1983

Ferdinand Hodler, photographed by Emile Pricam, Geneva, 1896

Ludwig von Hofmann

LUDWIG VON HOFMANN
(1861–1945)

Ludwig von Hofmann was born in Darmstadt. After studying law in Bonn from 1880 until 1883 at the request of his parents, Hofmann received his first artistic training at the Akademie in Dresden between 1883 and 1886 under his uncle Heinrich Hofmann, one of the last members of the Nazarenes. Before going to Paris in 1889, he studied with Ferdinand Keller★ at the Kunstschule in Karlsruhe and briefly in Munich. In Paris, where he visited the famous Académie Julian, he was deeply influenced by the works of Puvis de Chavannes and Maurice Denis.★

In 1890 Hofmann moved to Berlin where he was in close contact with the leading artists in opposition to the conservative academy and Emperor Wilhelm II, such as Max Liebermann★ and Walter Leistikow. Together with these, Hofmann was a founding member of the Vereinigung der XI (Association of the Eleven) in 1892, and of the Berlin Secession six years later, in 1898. Between 1894 and 1899 Hofmann spent most of his time in Italy, an influence clearly prevalent in his œuvre together with those of Puvis de Chavannes and Hans von Marées.

In 1903 Hofmann was appointed to the Kunstschule in Weimar and became involved in the foundation of the Deutscher Künstlerbund (German Artists' League) with Count Harry Kessler that same year. Hofmann's work on an important public mural commission

resulted in his appointment to the Akademie in Dresden for the professorship of monumental painting in 1916 where he stayed until his retirement in 1931. By the time of his death, Hofmann was largely forgotten. AD

O. Fischel, *Ludwig von Hofmann*, Bielefeld and Leipzig, 1903
A. Peters, *Ludwig von Hofmann (1861–1945): Zeichnungen, Pastelle, Druckgraphik*, exh. cat., Städtische Galerie Albstadt, 1995
U. Thieme and F. Becker, eds, *Allgemeines Lexikon der Bildenden Künstler*, vol. XVII, Leipzig, 1924

Winslow Homer, 1905

WINSLOW HOMER
(1836–1910)

Born in Boston, Homer was apprenticed to a lithographer before pursuing a career as an illustrator in New York in 1859. He attended classes at the National Academy of Design and studied painting briefly, but was largely self-taught. Quintessentially American, Homer's bucolic genre pictures, gaming scenes, and heroic seascapes are painted in a direct style and evoke the notion of 'truthfulness' identified with the idealised mores of his era.

Homer gained recognition for his illustrations of American Civil War soldiers in *Harper's Weekly*. Although the Civil War was the subject of his first paintings, he moved on to idyllic compositions of children in rural settings and women engaged in leisure pastimes. In 1867 he travelled to Paris, where he was influenced by the Barbizon School. Not limiting himself to oils, Homer embraced watercolour during a summer spent in Gloucester, Massachusetts, in 1873. The immediacy of this medium

allowing him to record the transience of nature.

In 1881–82, while staying on the coast of northeast England, Homer's work went through a radical change. His brushwork became bolder, his palette darker, and his subject matter harsher, depicting the fatalistic existence of fisherfolk. In 1883 he moved permanently to Prout's Neck, Maine, where he lived in isolation. He interrupted this life to fish in the Caribbean and hunt in the Adirondacks, activities which inspired some shimmering watercolours of these geographically divergent environments. Around 1890 Homer began painting rugged seascapes which embody the sheer intensity of nature (cat. 194). These works earned him a gold medal at the 1900 Exposition Universelle. By the time of his death at Prout's Neck, he was one of America's most acclaimed artists. VG

N. Cikovsky Jr. and F. Kelly, *Winslow Homer*, exh. cat., with contributions by J. Walsh and C. Brock, National Gallery of Art, New Haven, 1995

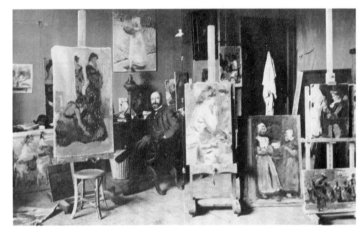

Jozef Israëls

JOZEF ISRAËLS
(1824–1911)

Israëls was born in Groningen, Holland. The son of a humble Jewish family, he synthesised a spectrum of styles reflecting his diverse artistic training. He studied at the Academie Minerva in Groningen between 1835–42 where he was a pupil of Johan Joeke Gabriel van Wicheren and Cornelis Bermudes Buijs. He attended the Koninklijke Academie in Amsterdam under Jan Willem Pieneman between 1842–44 and

1847–50 and was a private pupil of Jan Adam Kruseman. In Paris he studied with François-Edouard Picot, and, at the Ecole des Beaux-Arts, with Paul Delaroche, Horace Vernet and James Pradier.

His early subjects reflect the ambitious historical themes of the Academie and his gifts as a portraitist, but by the mid-1850s he had begun to find the distinctive Hague School realism for which he is best known. He captured the lives of Holland's fisherfolk, exploring the melancholic dramas of seafaring, such as wives and mothers awaiting sailors and the ever-present threat of drowning, as well as the attractive intimacy of humble interiors. Inspired by Ary Scheffer, Israëls's early works employ dense colours and highly finished surfaces. His attachment to the medium of watercolour in later life transformed his style into reduced tonal painting executed with more vigorous brushwork. After befriending Max Liebermann★ in 1881 Israëls also portrayed peasants and labourers. He founded The Hague Painters'

Society and exhibited there, and at the Pulchri Studio, the Dutch Drawing Society, the Paris Salon, the Berlin and Munich Secessions, the London International Exhibition of 1862 and the Venice Biennale. Elected a Commander of the Order of Netherlandish Lions in 1904, Israëls died at Scheveningen. CO'M

H. E. van Gelder, *Jozef Israëls*, Amsterdam, 1947
J. de Gruyter, 'Jozef Israëls' in *De Haagse School*, I, Rotterdam, 1968, pp. 46–59

PAUL JOSEPH JAMIN
(1853–1903)

Jamin was born in Paris, the son of a physician. He abandoned his studies at the Ecole Polytechnique to become a painter and enrolled in the studios of Gustave Boulanger and Jules Lefebvre at the Ecole des Beaux-Arts in Paris. He made his début at the Salon of 1879 and was made a member of the Salon des Artistes Français in 1883. He received many awards including an honourable mention at the 1882 Salon, a second class medal at the 1898 Salon and a bronze medal at the 1889 Exposition Universelle. Jamin was awarded a commission to assist in the decoration of the new Sorbonne and produced the panel *Lake-Dwellers: The Return of the Menfolk Announced* which was exhibited in the 1900 Exposition Universelle.

Jamin made his reputation with his dramatic evocations of early history in which cavemen or Goths survive natural catastrophes or wreak havoc on their enemies in tribal conflicts, revelling in the ensuing pillage and rape. The climate of Darwin's evolutionary theories and the colonialist encounter with other cultures which necessitated a vision of non-industrialised peoples as 'primitive' led to a broad, public fascination with human origins. Jamin, building upon the success of Fernand Cormon, explored the dilemma of Western origins through naturalist evocations of ancestral archetypes such as *Brennus and His Loot* (1893, cat. 19). He died in Paris. CO'M
No bibliographic references known

EUGÈNE (FREDRIK) JANSSON
(1862–1915)

Jansson led an outwardly uneventful life. By nature solitary and withdrawn, perhaps as a result of deafness, he nevertheless he gained the patronage of the wealthy and influential Ernest Thiel, who bought a number of the artist's characteristic 'blue-period' pictures for his Thielska Galleriet in Stockholm.

The young Jansson paid desultory visits to Edvard Perséus's art school and records show attendance at the Stockholm Akademi för de Fria Konsterna in

Eugène Jansson

1881–82, but he later claimed to be mainly self-taught. Independent-minded, he established contacts with the Akademi's sworn rival, the Artists' Union, particularly with Karl Nordström, a landscape painter as extrovert as Jansson was withdrawn.

His nocturnal and 'blue' paintings date from as early as 1883, but they flourished fully once he moved to the Södermalm quarter of Stockholm, by the harbour: the late 1890s examples have an intensity of tone unmatched by any of his eventually numerous imitators. Jansson abandoned the genre in 1905, taking up a vitalist theme of exercising male nude figures in bright landscapes, not unlike Munch.★

Aesthetic though they are, Jansson's works often have undertones of social awareness, some depicting Stockholm's suburbs with their new apartment blocks, an interest that may derive from his impoverished childhood in such tenements. JM

Dreams of a Summer Night, exh. cat., Hayward Gallery, London, 1986
Eugène Jansson, exh. cat., Liljevachs Konsthall, Stockholm, 1998
I. Zachau, *Eugène Jansson: Den bla stadens malare*, Lund, 1997

EERO (NIKOLAI) JÄRNEFELT
(1863–1937)

Unlike his fellow-painters in the Young Finland group, Pekka Halonen★ and Akseli Gallén-Kallela,★ Järnefelt came from a distinguished, influential Swedish-Finnish family with strongly socialist inclinations. His father was a government official and his mother, Elizabeth, a strong-minded

Eero Järnefelt

Tolstoyan campaigner on social issues. Järnefelt studied art in St Petersburg with an uncle, a member of the Wanderers, as well as in Paris. Throughout his life he favoured the naturalism popular in both centres during the 1880s. Järnefelt's cosmopolitan outlook resembled that of Albert Edelfelt,★ but his social conscience produced *The Burn-Beating* (1893, cat. 223), which depicts the plight of rural workers in thrall to commercial exploitation. Neither Halonen nor Gallén-Kallela produced anything so direct.

At times of national stress, in 1899 and 1910, Järnefelt produced landscapes eloquent of patriotic feeling, choosing such publicly favoured Finnish sites as the Koli Peninsula. He had first visited the region in 1892, at the high-point of Karelian enthusiasm among nationalist artists, and he returned frequently; the 1910 version presents Koli in radiant autumn

colours, implying freedom's fall in true natural symbolic style.

Järnefelt also reversed excursionary Karelianism – inviting the Karelian kantele-player, Larin Paraske, to play this ancient 'national' instrument in the Järnefelt home: Sibelius noted down the results for his *Kullervo* symphony (1892). After 1905, Järnefelt succeeded Edelfelt as the leading society portraitist. JM

Eero Jaernefelt, 1863–1937, exh. cat., with an article by R. Konttinen, Jaervenpaa, 1993

ALEXEI JAWLENSKY
(1864–1941)

Alexei Jawlensky was born in Torzhok in Russia. Following the career of his father he entered the military academy in Moscow in 1882 and was made lieutenant two years later. After a number of unsuccessful attempts, he attained his transfer to St Petersburg in 1889, so as to attend the Imperial

Alexei Jawlensky

Academy of Arts. He was taught
there by Il'ya Repin★ and met
Marianne Werefkin (another of
Repin's pupils) with whom he
lived until 1921.

In 1896 Jawlensky quit his
military service and moved to
Munich with Werefkin and two
other friends. They enrolled at the
art school of Anton Ažbe where
they soon met Vasily Kandinsky.★
Jawlensky and Werefkin travelled
to Italy, Russia and Paris in the
years around the turn of the
century, meeting Matisse,★
Hodler★ and other major figures.

In 1908 Jawlensky and Werefkin
spent the summer painting in
Murnau with Kandinsky and
Gabriele Münter, with whom,
among others, they founded the
Neue Künstlervereinigung
München the following year.

After World War I, during
which he had lived in Switzerland,
Jawlensky moved to Wiesbaden in
1921. In 1924 he founded the
association the Blue Four with
Lyonel Feininger, Kandinsky and
Klee. Three works by Jawlensky
were included in *Entartete Kunst*,
the Nazis' 'degenerate' art
exhibition in 1937; they had
forbidden him to paint in 1933.
He died in Wiesbaden. AD

T. Belgin, ed., *Alexej von Jawlensky:
 Reisen, Freunde und Wandlungen*,
 exh. cat., Museum am Ostwall, 1998
M. Jawlensky, L. Pieroni-Jawlensky
 and A. Jawlensky, *Alexej von
 Jawlensky: Catalogue Raisonné*, 4 vols.,
 London, 1991–98
A. Zweite, ed., *Alexej Jawlensky,
 1864–1941*, exh. cat., Städtische
 Galerie im Lenbachhaus, München;
 Staatliche Kunsthalle, Baden-Baden,
 1983

Gwen John (right), with Augustus, Ida and David John, 1902

GWEN(DOLEN MARY) JOHN
(1876–1939)
Gwen John was born at
Haverfordwest, Wales; her brother
Augustus was born two years later.
From 1895–98 she attended the
Slade School of Art in London,
where her brother was also a
student, and in 1898 went to Paris
to James Abbott McNeill
Whistler's★ Académie Carmen.

John returned to England in
1899 and lived in London until
1903, exhibiting during this time at
the New English Art Club. She left
for France again in 1903 and early
in 1904 settled in Paris. Two years
later she met Auguste Rodin★ and
became both his model and
mistress. She also modelled for
other women artists to support
herself. During this period her
palette changed, the warmer brown
hues being replaced by lighter,
cooler shades of mauve, blue and
grey. Her established subject
matter, however – portraits,
interiors and still-lifes – remained
constant during her working life.
John was never confident of her
own talent and worked slowly,
often reworking the same
compositions.

In 1910, she met the New York
collector John Quinn who, from
1912, sent her an annual allowance
in return for paintings. She moved
in 1911 to Meudon and in 1913
was received into the Roman
Catholic Church. Remaining in
France during World War I, she
spent her summers in Brittany
from 1915. She exhibited at the
Salon d'Automne and the Salon
des Tuileries in 1922 and 1923,
and her work was included in the
'Modern English Artists' exhibition
of 1922 at the Sculptors' Gallery
in New York. Her only one-
woman show took place at the
New Chenil Galleries, London,
in 1926. She spent her last years
as a recluse and died at Dieppe.
HV

C. Langdale, *Gwen John: A Catalogue
 Raisonné of the Paintings and a Selection
 of the Drawings*, New Haven and
 London, 1987
C. Langdale and A. D. F. Jenkins,
 Gwen John: An Interior Life, exh. cat.,
 Barbican Art Gallery, London, 1985

COUNT LEOPOLD (KARL WALTER) VON KALCKREUTH
(1855–1928)
Born in Düsseldorf, the son of
the late Romantic artist Eduard
Stanislaus, Graf von Kalckreuth,
Leopold Kalckreuth studied from
1875–78 at the Kunstschule in

Weimar which had been founded
by his father. His tutors there
included Willem Linnig,
Ferdinand Schauss and Alexander
Struys. Having completed his
military service, Kalckreuth
continued his training at the
Munich Akademie in 1879,
where he was taught painting
by Karl Theodor von Piloty and
Wilhelm von Diez, and drawing
by Gyula Benczúr.

In 1883 he made trips to the
Netherlands, Italy and France.
He began teaching at the
Kunstschule in Weimar in 1885,
but resigned from the post in 1890.
He returned to Munich and in the
following years continued to paint
at Höckricht in Silesia (now
Jedrzychowice, Poland). In 1892
Kalckreuth was a founder member
of the Munich Secession. From
1895–99 he was a tutor at the
Akademie in Karlsruhe. From
1895 he began to produce etchings,
often using similar subject matter
to that of his painting. He travelled
to Paris in 1900 and from 1900–05
was director of the Akademie in
Stuttgart. In 1903 he was
appointed as the first president
of the Deutscher Künstlerbund
in Weimar. In 1907 he settled
with his family in Eddelsen, near
Hanover, where he later died. AC

J. Kalckreuth, *Wesen und Werk meines
 Vaters: Lebensbild des Malers Graf
 Leopold von Kalckreuth*, Hamburg,
 1967

Count Leopold von Kalckreuth

VASILY (VASIL'YEVICH) KANDINSKY
(1866–1944)

Vasily Kandinsky was born in Moscow. He studied law and economics, but abandoned his academic career at the age of thirty and moved to Munich to study painting. From 1897 to 1899 he went to the private art school of Anton Ažbe where he met Alexei Jawlensky★ and Marianne Werefkin. He continued his studies under the famous Jugendstil painter Franz von Stuck★ at the Munich Akademie until 1901, when he founded the exhibition society Phalanx with its associated art school. One of his first pupils was Gabriele Münter. Between 1903 and 1907 Kandinsky and Münter travelled extensively throughout Europe and Tunisia. They stayed in Paris for one year and after a further seven months in Berlin returned to Munich in June 1908 which remained – together with Murnau – their main domicile for the next few years.

In 1909 Kandinsky was one of the main initiators of the Neue Künstlervereinigung München which he left in 1911 after a dispute over the inclusion of his practically abstract painting *Composition V*. In 1912 the first exhibition of The Blue Rider opened in Munich and Kandinsky's book *On the Spiritual in Art* as well as the *Blue Rider Almanac* were published.

At the outbreak of World War I, Kandinsky moved first to Switzerland and then returned to Russia where he stayed until 1921. In 1922 he was appointed to the Bauhaus in Weimar and Dessau, where he taught until 1933, when it was closed by the Nazis. In 1934 Kandinsky moved to Neuilly-sur-Seine near Paris, where he later died. AD

V. E. Barnett and H. Friedel, eds,
 *Das bunte Leben: Wassily Kandinsky
 im Lenbachhaus*, exh. cat., Städtische
 Galerie im Lenbachhaus, Munich,
 1996
M. M. Moeller, *Der Blaue Reiter und
 seine Künstler*, exh. cat., Brücke-
 Museum, Berlin; Kunsthalle,
 Tübingen, 1999
R.-C. Washton-Long, *Kandinsky:
 The Development of an Abstract Style*,
 Oxford, 1980

Takeshiro Kanokogi

Ferdinand Keller

TAKESHIRO KANOKOGI
(1874–1941)

A *Yoga* (Western-style) artist, Kanokogi was born in Okayama (western Honshu), Japan. He initially studied with Sangoro Matsubaru, a Western-style artist trained by a pupil of the English artist and illustrator Charles Wirgman. Kanokogi moved to Tokyo to study at the Fudosha, the Western-style art school created by Shotaro Koyama, a pupil of Antonio Fontanesi, the founder of the first Western-style art school in Tokyo.

Already established as an artist working in a naturalist style, Kanokogi travelled to Paris in 1903 to enter the studio of Jean-Paul Laurens. On his return to Japan in 1906 he established his own school of art in Kyoto and played a leading role in introducing Western-style art into the Kansei (southern Honshu) region. He was a member of the jury of the Bunten, an annual art exhibition modelled on the Paris Salon which was established under the aegis of the Japanese Ministry of Education in 1907. MAS

M. Haroda, *Meiji Western Painting*,
 vol. 6 of *Art of Japan* series, New
 York and Tokyo, 1974
N. Uyeno, ed., *Arts and Crafts of the
 Meiji Era* (English ed., R. Lane),
 Tokyo, 1958

DMITRY (NIKOLAYEVICH) KARDOVSKY
(1866–1943)

Born in Pereslavl' Zalessky in Yaroslavl' province, Kardovsky initially studied law at Moscow University, before turning his attention to the fine arts. In 1892 he enrolled at the St Petersburg Imperial Academy of Arts where his principal teachers were Pavel Chistyakov and Il'ya Repin.★ In 1896, together with Igor Grabar,★ a fellow Repin student, Kardovsky left Russia for the Munich studio of Anton Ažbe where he remained until 1900. In Europe, he encountered Impressionism, Symbolism and the emerging Art Nouveau aesthetic and experimented with these various styles. Essentially, however, he retained a strong emphasis on accurate draughtsmanship, a quality much imbued in him by Chistyakov.

Kardovsky returned to St Petersburg in 1900 where he again undertook studies at the Imperial Academy of Arts. It was at this time that he began his exhibiting career. Among his early works are a number of portraits including his *Portrait of Marya Anastasievna Chroustchova* (1900, cat. 92). Kardovsky is best known, however, for his graphic works, and particularly for his illustrations to the works of Anton Chekhov, Nikolay Gogol, Mikhail Lermontov and Leo Tolstoy.

After the Bolshevik Revolution he left St Petersburg to settle in Moscow where he produced a number of theatre designs. He held influential teaching posts both before and after the Revolution and maintained a reputation as a major graphic artist until his death. MO'M

O. Podobedeva, *Dmitry Nikolayevich
 Kardovsky*, Moscow, 1957

FERDINAND KELLER
(1842–1922)

Keller was born in Karlsruhe, but in 1857 his family moved to Brazil after his father Joseph, a building inspector, was offered work there. Keller produced a host of drawings in Brazil which enabled him to enter the Grossherzogliche Kunstschule when the family returned to Karlsruhe in 1862. He finished his training in 1866, and in 1867 moved to Rome, where two years later he acquired a studio next to the artist Anselm Feuerbach, whose work he greatly admired.

In 1873 Keller became a professor of history painting at the Karlsruhe Kunstschule. His work was noted for its bright colours reminiscent of the Austrian artist Hans Makart, whose work

(opposite) Vasily Kandinsky (right) with A. Seddeler (left) and Dmitry Kardovsky (centre) in the Ažbe-Schule, Munich, c. 1897

he probably first encountered in 1873. Keller received many commissions, such as frescoes for new museum buildings in Stuttgart and Karlsruhe and portraits of German dignitaries, including Kaiser Wilhelm II. He gave up painting in 1913, a year after a large retrospective of his work had marked his seventieth birthday. Keller died in Baden-Baden. AC

E.-M. Froitzheim, ed., *Ferdinand Keller (1842–1922): Gemälde und Zeichnungen*, exh. cat., Staatliche Kunsthalle, Karlsruhe, 1992

FERNAND KHNOPFF
(1858–1921)

Khnopff was born in Grembergen. A pupil of Xavier Mellery, he enrolled for two years at the Brussels Académie des Beaux-Arts and in 1879 studied at Jules Lefebvre's studio and the Académie Julian in Paris. He made his début at Brussels's L'Essor exhibition in 1881 and was a founder member of Les XX in 1883. He exhibited with La Libre Esthétique, but the spiritual home of his art was Sâr Péladan's Salon de la Rose+Croix in Paris where he exhibited in 1892–94 and in 1897. He was awarded silver medals in the Expositions Universelle of 1889 and 1900 and a medal in the Munich International Exhibition.

The display of works by John Everett Millais and Edward Burne-Jones★ in the 1878 Exposition Universelle began Khnopff's lifelong fascination with British Pre-Raphaelite art and poetry. From 1895 until 1914, he was the Brussels correspondent for *The Studio*. Khnopff abandoned the sober naturalism of his early work to create a suggestive, elusive world epitomised by *A Blue Wing* (1894). Even more than in his paintings, his sculptures, made primarily in the 1890s, such as *The Past* (c. 1897, see cat. 72) addressed a central issue of Symbolism: the relationship between the visible and the tangible. He designed a unique Symbolist studio and house in Brussels, now destroyed. Khnopff died in Brussels. CO'M

M. Draguet, *Khnopff, ou l'ambigu poétique*, Paris, 1995

Fernand Khnopff 1858–1921, exh. cat., Musée des Arts Décoratifs, Paris, 1979

Fernand Khnopff, 1907

GUSTAV KLIMT
(1862–1918)

Klimt was born in Baumgarten near Vienna. At a very early age he visited the school for applied arts (Kunstgewerbeschule) in Vienna, where he was mainly taught and influenced by Ferdinand Laufberger. Another important influence was Hans Makart, Austria's most famous painter at the time, who executed large-scale allegorical and historical paintings.

Between 1883 and 1892 Klimt had a joint studio with his brother Ernst and their mutual friend Franz Matsch. Large decorative, often allegorical paintings and murals were their main field of work; the spa rooms in Karlsbad, the staircases of the Burgtheater and the Kunsthistorisches Museum in Vienna are just some of the many public and semi-public spaces they decorated in a very colourful, ornamental style.

Ernst's death in 1892 and the slow detachment from his previous style resulted in a severe crisis in Klimt's œuvre. Over the following years he developed his characteristic use of sumptuous colours, especially gold, turning the surface into large patterns of intertwined

Artists at the Fourteenth Vienna Secession exhibition, 1902 (clockwise from left):
Anton Stark, Gustav Klimt (in chair), Adolf Böhm, Wilhelm List, Maximilian Kurzweil, Leopold Stolba, Rudolph Bacher, Carl Moll, Emil Orlik, Ernst Stöhr, Maximilian Lenz and Kolo Moser

forms with symbolic overtones; this made him one of Austria's most famous representatives of Jugendstil.

In 1897 Klimt co-founded the Viennese Secession and became its president until 1905 when he left the association repelled by its seeming move towards naturalism. Despite successful exhibitions Klimt received harsh criticism for many of his works and caused various scandals, often due to the difficult symbolism and discreet eroticism of his works. He died in Vienna. AD

T. Stooss, ed., *Gustav Klimt, 1862–1918*, exh. cat., Kunsthaus, Zürich, 1992

U. Thieme and F. Becker, eds, *Allgemeines Lexikon der Bildenden Künstler*, vol. XX, Leipzig, 1927

F. Whitford, *Gustav Klimt*, London, 1993

MAX KLINGER
(1857–1920)

Klinger was born in Leipzig. In 1874 he attended the Karlsruhe Kunstschule, studying under Ludwig Des Coudres and Karl Gussow. Between 1875 and 1877 he continued at the Akademie in Berlin, again under Gussow. In 1879 he was a pupil of Emile Charles Wauters in Brussels. He took a studio in Berlin in 1881 and a year later became a member of the Association of Berlin Artists. He made his first trip to Paris in 1883 and saw the work of Francisco de Goya and Gustave Doré, which had a significant influence on his prints.

Between 1883 and 1907 Klinger travelled to Italy, France, Greece, Spain and the Netherlands and in 1887 he met the artist Arnold Böcklin. From 1888–90 he lived in Rome where he became familiar with the art of Antiquity and of the Renaissance. He became a member of the Munich Akademie in 1891 and in 1892 was co-founder of the Gruppe XI artists in Berlin. In 1891 he published the treatise *Malerei und Zeichnung (Painting and Drawing)*. He settled in Leipzig in 1893 and then began a period of producing more sculptural works. In 1894 he joined the Akademie in Berlin and in 1897 was given a professorship at the Leipzig Akademie der Graphischen Künste. In the same year he became a corresponding member of the Vienna Secession. In 1903 he established a second home in

Max Klinger, 1899

Konstantin Korovin, *c.* 1890

Grossjena near Naumburg and was also appointed Vice-President of the Deutscher Künstlerbund in Weimar. He died in Grossjena. AC

Max Klinger 1857–1920, exh. cat., Städelsches Kunstinstitut, Frankfurt am Main; Kunsthalle, Hamburg, 1992

KONSTANTIN (ALEKSEYEVICH) KOROVIN
(1861–1939)

Korovin was born in Moscow. He enrolled at the Moscow School of Painting, Sculpture and Architecture while in his mid-teens, studying under Aleksey Savrasov and Vasily Polenov, and in 1882 entered the Imperial Academy of Arts in St Petersburg. Well-travelled, Korovin witnessed the work of the Impressionists in Paris in 1885–86, and soon adopted many of their techniques.

Back in Russia, Korovin was introduced to the influential art patron Savva Mamontov. Between 1885 and 1891 he produced many theatre designs for Mamontov's private opera, which also employed the services of Aleksandr Golovin and Viktor Vasnetsov. Korovin developed a life-long interest in working for the theatre. In painting, he focused on Impressionist-inspired landscape studies, both of Russian and Parisian scenes. He was also a renowned portraitist, representing such notables as the wealthy art patron Ivan Morozov (cat. 93) in 1902.

In 1900 Korovin exhibited with the World of Art (Mir Iskusstva) group, and also gained a commission to design the Russian Pavilion for the Exposition Universelle. During the first decade of the twentieth century, he occupied several key teaching posts and continued to exhibit widely. He remained highly respected after the Bolshevik Revolution, teaching at the Moscow Free Art Studios, and his work was represented at several major post-revolutionary shows. However, Korovin was far from sympathetic to the new régime. In 1923 he left Russia, spending the rest of his life in Paris. MO'M

A. P. Gusarova, *Konstantin Korovin*, Moscow, 1990

CHRISTIAN KROHG
(1852–1925)

Krohg was born in Aker, near Christiania (now Oslo). While studying law at Christiania University, he took drawing lessons at Johan Fredrik Eckersberg's private school of art and at the Royal School of Drawing. After graduating, he entered the Karlsruhe Kunstschule where he worked under Hans Gude and Karl Gussow, before moving to the Akademie in Berlin. It was here that Krohg befriended the artist Max Klinger,★ and began to produce images exposing the harsh conditions of life amongst the urban poor. In 1879 Krohg made

the first of many visits to the artists' colony at Skagen, a small village on the northern tip of Denmark, where he produced paintings of the local fishermen, who are often shown battling against the harsh conditions of the Baltic Sea. Many of these images incorporate dramatic close-up or low-angled viewpoints, adding to the drama of the scene represented.

In 1881 Krohg travelled to Paris. He witnessed the seventh Impressionist exhibition held there the following year. While the Impressionist use of colour certainly affected Krohg's work, he nonetheless remained faithful to a more narrative approach to painting. This is best seen in his series of works depicting the life of *Albertine*, a fictitious seamstress

Christian Krohg, photographed by Fred Riise, Copenhagen

whose fall from grace into prostitution is recounted in his novel of the same title. At the time of his death, Krohg was an established writer, genre and portrait painter and a major figure in Norwegian cultural circles. MO'M

Christian Krohg, exh. cat., Nasjonalgalleriet, Oslo, 1987

P. S. Krøyer, *c.* 1901

P(EDER) S(EVERIN) KRØYER
(1851–1909)

Together with Michael and Anna Ancher,★ P. S. Krøyer became one of the leading figures in the Skagen artists' colony at the extreme northern tip of Denmark. The long, low, pale sandy beaches feature in many of his 1890s paintings, as do his fellow-painters there.

At thirteen, Krøyer entered the Kongelige Akademi for de Skønne Kunster in Copenhagen, having shown talent in illustrating his father's book on crustacea three years earlier. He learnt the traditional Golden Age landscape values of the Eckersberg School, elements that were modified when he joined Léon Bonnat's studio in Paris in 1877. This was rapidly followed by a trip to Spain and copying of the then influential Velázquez works in the Prado.

Travels to Italy and France followed in rapid succession and then Krøyer visited Skagen's community of artists for the first time in 1882. He used it as a base, but continued to travel. He visited London in 1884, where Whistler's★ exhibition 'Notes, Harmonies and Arrangements' at the Dowdeswell Gallery made a big impression, and prompted the serenely atmospheric

bluish twilight that was to be Krøyer's Skagen speciality.

Krøyer taught for nearly twenty years at the Independent Artists' Study School and was respected by colleagues and pupils, but in the early years of the twentieth century his mental health deteriorated, and a sharp decline into madness marked his final stricken years. JM

P. M. Hornung, *P. S. Krøyer, 1851–1909*, Lyngby, 1987

P. S. Krøyer: Tradition, and Modernity, exh. cat., Kunstmuseum, Århus, 1992

GOTTHARD (JOHANN) KUEHL
(1850–1915)

Kuehl was born in Lübeck in northern Germany. In 1867 his studies began at the Dresden Akademie. From Dresden he moved to Munich, then a thriving artistic centre attracting artists from all over Europe; he worked there between 1870 and 1873 under the painter Wilhelm von Diez. From the late 1870s and through the 1880s Kuehl spent much time in Paris where he was drawn to the Realist works of Edouard Manet and Jules Bastien-Lepage. Kuehl was particularly fascinated, however, by landscapes and interior scenes. With this in mind he visited the Netherlands to see and study not only the work of the great seventeenth-century landscape painters such as Jacob van Ruisdael and Jan van Goyen, but also the still and tranquil interior scenes of Johannes Vermeer and Pieter de Hooch. In 1889 Kuehl returned to Dresden where he settled for the rest of his life, producing numerous Impressionist-inspired landscapes executed with bold, sweeping brush strokes. He also produced a number of images of Baroque church interiors and domestic scenes inhabited by figures in eighteenth-century costume, reminiscent of the French painter Ernest Meissonier.

In 1895 Kuehl was made a professor at the Dresden Akademie where he continued to teach until his death. One of his major achievements in the post was the staging of a number of national and international exhibitions which contributed to Dresden's development as an artistic centre. MO'M

No bibliographic references known

František Kupka in front of *The Book Lover I* (cat. 5), 1897

FRANTIŠEK KUPKA
(1871–1957)

Born in Bohemia, Kupka trained successively at Jaroměř, Prague and Vienna before settling in Paris in 1895. For the next decade he earned his living as an illustrator and printmaker, revealing a taste for grim and anarchistic subjects such as *Money*, *Religion* and *Peace* all of which appeared initially as paintings and later as lithographs in the radical magazine *L'Assiette au beurre*. Throughout this period his work showed an increasing awareness of Symbolist ideas, esoteric philosophy and, in particular, the relationship between colour and music.

After 1910 Kupka's paintings were based on repeated patterns of simple colours and shapes, suggesting an underlying, quasi-scientific order to our perception of the natural world. At the Salon d'Automne of 1912, when the Cubist aesthetic was in the ascendant, Kupka exhibited *Amorpha: Fugue in Two Colours*,

which is often described as the first appearance of abstract art in Paris. During the next decade Kupka developed this theme in works such as *Cosmic Spring*, partly inspired by the cellular and crystalline structures of biology and geology.

After World War I, in which he volunteered for active service, Kupka was appointed to a professorship at the Prague Academy although he continued to work in Paris. Despite the undoubted originality of his work, Kupka was out of step with the prevailing avant-garde in France and he became somewhat marginalised during the 1920s. He was, however, a founder member of the group Abstraction-Création in 1931. PS

František Kupka, 1871–1957, ou L'Invention d'une abstraction, exh. cat., Musée d'Art Moderne de la Ville de Paris, 1989

Boris Kustodiyev

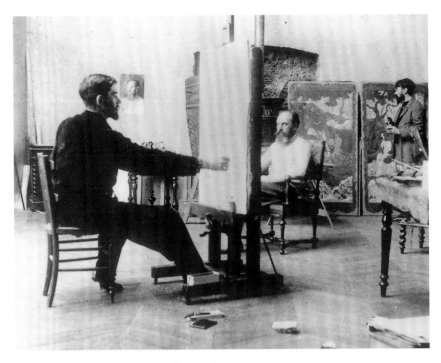

Georges Lacombe painting his portrait of Georges Ancey, 1900

BORIS (MIKHAYLOVICH) KUSTODIYEV
(1878–1927)

The son of a school-master, Kustodiyev was born in Astrakhan, southern Russia. He initially trained under the local artist Pavel Vlasov before moving to the Imperial Academy of Arts in St Petersburg in 1896. Here he entered the studio of Il'ya Repin,★ where he was highly regarded and participated collectively in the production of two of Repin's major works. Kustodiyev's early works include representations of his friends and fellow artists, such as his portrait of Bilibin (1901, cat. 108). Many of his highly finished and exquisitely detailed works deploy bright primary colours and striking contrasts of scale between foreground and background figures, features reminiscent of traditional Russian folk prints, or *lubki*. This often gives his works a celebratory, festive feel.

In 1903 Kustodiyev set off on a travelling bursary, visiting France, where he studied briefly in Paris under René Menard, and Spain. Back in Russia, he continued to produce highly colouristic portrayals of modern life, emphasising the merchant classes of modern-day St Petersburg. Kustodiyev actively participated in the 1918 decoration of St Petersburg, then renamed

Petrograd, for the first anniversary of the Bolshevik Revolution. Under the new post-revolutionary conditions he adapted his style, replacing his over-size merchants with equally monumental Bolshevik revolutionaries. By 1925 he was exhibiting with AKhRR (Association of Artists of Revolutionary Russia) and was represented at the Paris Exposition Universelle. He died in St Petersburg, by then renamed Leningrad. MO'M

V. E. Lebedeva, *Boris Kustodiev: The Artist and His Work*, Moscow, 1981

GEORGES LACOMBE
(1868–1916)

A painter and sculptor, Charles Lacombe was born in Versailles. His parents, a painter/printmaker and a cabinet-maker, nurtured his artistic inclinations. He was a pupil of three family friends, Alfred Roll,★ Henri Gervex and Georges Bertrand, before enrolling in the Académie Julian. Lacombe spent his summers in Camaret where he developed his Breton motifs and in the 1890s befriended Charles Cottet★ and the artists of the Pont-Aven School. His imaginative landscape and figure paintings reflect this association and also his assimilation of the bold colours, patterns and flattened, off-centre perspectives used in Japanese prints.

Around 1893, Lacombe began to sculpt in wood, employing naive carving techniques to create theosophical reinterpretations of Christian themes in works like *Magdalene* (1897, cat. 243). The curvaceous austerity of Lacombe's relief carvings and sculptures reflects his fascination with hieratic Egyptian art and Symbolist mystic numerals and geometry.

A man of independent means, Lacombe chose not to sell his work, but he did exhibit regularly in the Nabis shows of the dealer Louis Le Barc de Boutteville, the Salon des Indépendants and the Salon d'Automne. He commissioned mural decorations from his friends Paul Sérusier and Paul Ranson. In later life he explored both Pointillist and Impressionist techniques in his painting and pursued a more naturalist vein in his sculpture. Lacombe and his wife Marthe Wenger settled in Alençon in Normandy, where he later died. CO'M

J. Ansieau, *Georges Lacombe 1868–1916: catalogue raisonné*, Paris, 1998

EUGÈNE (JULES JOSEPH) LAERMANS
(1864–1940)

Laermans was born in Brussels. He attended the Académie des Beaux-Arts in that city between 1882–87 where he was a pupil of Constant

Montald. He then joined a free studio called La Patte de Dindon. He exhibited both in official Salon venues in Ghent and Antwerp and at artistic societies like Les XX and La Libre Esthétique in Brussels, and, in 1898 and 1899, at the Vienna Secession. His central motif was the life of the workers and peasants of his native Brabant, often depicted on a monumental scale. His loose brushwork, which in his late paintings verges upon Expressionism, and his sombre palette are reminiscent of Honoré Daumier.

As *The Blind One* (1899, cat. 234), exhibited in the 1900 Exposition Universelle, attests,

Eugène Laermans

Laermans was one of the most sensitive painters of those who suffer due to disability, age, poverty or misadventure. Having contracted meningitis, Laermans lost his hearing in 1875 and was blinded by cataracts in 1924. Many reviewers felt these experiences attuned him to the isolation which physical or social barriers inflict. Although *The Red Flag* (1893) reflects his empathy with the tragic Fourmies strikes of 1891, his identification with the oppressed was rarely expressed in such a directly socialist idiom. Hugely admired in his maturity, a retrospective of his work was held in Victor Horta's Maison du Peuple in Brussels in 1899. He was made a Baron in 1927 and died in Brussels. CO'M

Eugène Laermans, exh. cat., Galerie du Crédit Communal, Brussels, 1995

JEF(-MARIE-THOMAS) LAMBEAUX
(1852–1908)
Lambeaux was born in Antwerp. The brother of the genre painter Jules, Jef Lambeaux studied at the Antwerp Academie as a pupil of Nicaise De Keyser and Joseph Geefs. He exhibited his sculptures in bronze and marble at the Salons in Brussels, Ghent and Paris and once with Les XX in Brussels. His fountain for the Grote Markt in Antwerp blends a vivid portrait of Brabo, the town's legendary founder, with an exuberant use of formal curves and picturesque aquatic life, including mermaids and dolphins. His seven-metre relief *Human Passions* (1890–98) was admired by King Léopold II, who paid for Lambeaux's model, exhibited in the 1889 Ghent Salon, to be executed in marble. Victor Horta was invited to design a temple to house it in the Parc du Cinquantenaire, Brussels. Lambeaux won the gold medal at the Brussels International Exhibition of 1881 and the grand prize at the 1900 Belgian Exposition Coloniale. He was granted the Order of Léopold and the Order of Bavaria.

Lambeaux's work often caused controversy by evoking the baser passions as well as human virtues. Accused of immorality, he captured visceral emotion and instinctual life through dramatic but naturalistically detailed gesture and

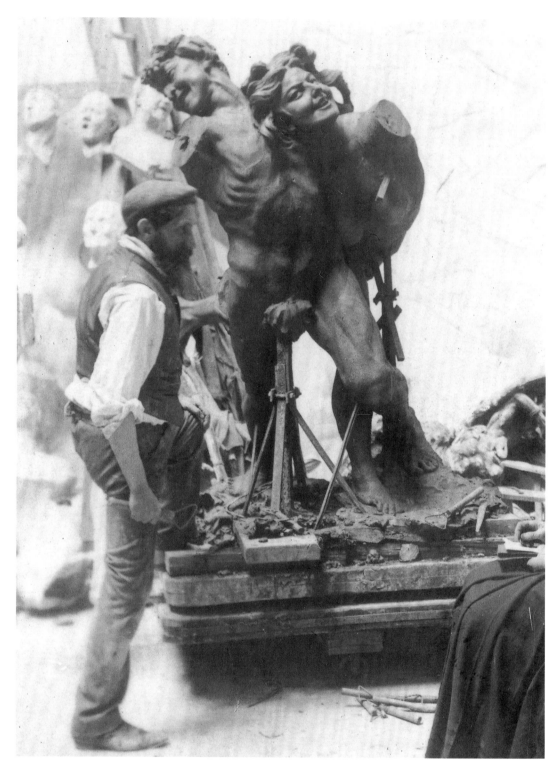

Jef Lambeaux, *c.* 1908

physiognomy, and unconventional relationships between support and figure. Lambeaux's unflinching absorption in the violence as well as the ecstasy which often underlay the *fin-de-siècle* fascination with sexuality still has the power to unsettle a century later. Lambeaux died in Brussels. CO'M

B. Fornari, *Jef Lambeaux et les passions humaines*, Brussels, 1989

HENRY HERBERT LA THANGUE
(1859–1929)
Born in Croydon, La Thangue studied briefly at Lambeth School of Art before entering the Royal Academy Schools in 1875. He completed his training in the atelier of Jean-Léon Gérôme★ in Paris, but was really absorbed by *plein-air* painting. He spent the summers

of the early 1880s with Stanhope Forbes★ in Brittany. Square brushes and a lighter palette were soon adopted on these sketching trips and the historical subject pictures which he had exhibited were abandoned.

La Thangue was a central figure in the setting up of the New English Art Club in 1886. He was elected ARA in 1898 after

Henry Herbert La Thangue,
photographed for the *Art Journal*, 1893

Sir John Lavery

exhibiting *The Man with the Scythe* in which elements of the Victorian narrative tradition were combined with a Symbolist intensity wholly French in its origins. By 1898 La Thangue had abandoned such heavily loaded narrative subjects and began a series of canvases illustrating scenes such as fruit-gathering and bracken-cutting. His interest in these subjects was to explore the artistic potential of his subjects for light and colour rather than to provide social comment.

Attracted by the strong Mediterranean light, La Thangue stayed regularly in Provence and Liguria in the 1890s and gained a new freedom in the vigour of his brushwork and in his vivid use of colour. He was elected RA in 1912. He continued to paint rural scenes in his later years, recording a way of life fast disappearing. HV

K. McConkey, *A Painter's Harvest, H. H. La Thangue RA, 1859–1929*, exh. cat., Oldham Art Gallery, 1978

K. McConkey, *Impressionism in Britain*, exh. cat., Barbican Art Gallery, London, 1995

SIR JOHN LAVERY
(1856–1941)

Lavery was born in Belfast. He trained at the Haldane Academy in Glasgow in the late 1870s before entering the Académie Julian in Paris. Like other artists of the period he was much influenced by the *plein-air* naturalist painter Jules Bastien-Lepage. He spent the summer of 1883 at the artists' colony of Grez-sur-Loing, practising *plein-air* painting.

He returned to Glasgow in 1885 and worked on *The Tennis Party*, a modern-life subject in an open-air setting which did much to establish his reputation. After exhibiting at the Grosvenor Gallery in 1890, Lavery and other artists from Glasgow, including Sir James Guthrie, were invited to show in Munich. The 'Glasgow Boys', as they became known, were highly acclaimed by critics there. Lavery made the first of many visits to Morocco in 1890.

He toured Europe in 1892. His study in Spain of the work of Velázquez much influenced his portraiture. In 1896 he moved to London and in 1898 became involved in the foundation of the International Society, an organisation which aimed to foster exhibitions of international modern art in London. By 1910, Lavery had won himself a glittering reputation, with successful exhibitions in America and Europe and over fifty works shown at the 1910 Venice Biennale. During World War I he was an Official War Artist and was rewarded with a knighthood in 1918. He was elected RA in 1921.

In the 1920s Lavery painted large formal group portraits as well as a series of dramatic and freely sketched portraits of his wife Hazel. He returned to Ireland in the late 1920s and published his memoirs in 1940, a year before his death in Kilkenny. HV

J. Lavery, *The Life of a Painter*, London, 1940

K. McConkey, *Sir John Lavery*, Edinburgh, 1993

OZIAS LEDUC
(1864–1955)

Leduc was born in Saint-Hilaire, Quebec, where he began an apprenticeship with the painter Luigi Cappello in 1886. Leduc participated in his first exhibition, Montreal's Exposition des Beaux-Arts, in 1890. During the early part of his career, in the 1890s, he painted portraits and still-lifes. In particular, he created a celebrated series of *trompe-l'oeil* pictures in which the objects evoke mystical associations that suggest a mediation between the physical and spiritual realms, a theme he would explore repeatedly. In 1892, he received his first decorative commission for the Church of Saint-Paul-l'Ermite, soon followed by a major commission for the Church of Saint-Hilaire in 1896.

A trip to Paris in 1897 exposed Leduc to Impressionism and Symbolism, both of which greatly affected his art. He developed a personalised symbolism and his interest shifted from still-lifes to landscapes and more allegorical images. These works led to the ethereal landscapes, often of Mont Saint-Hilaire, that would dominate his output between 1913 and 1921.

Leduc was praised both for his religious art and his paintings of secular subjects, his work alternately reflecting the religious and civic ideals stemming from the Catholic and nationalist milieu in which he was raised. The combination of his Catholic upbringing and his growing interest

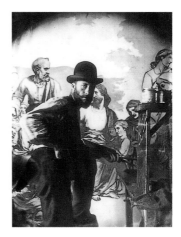

Ozias Leduc, 1899

in philosophy culminated in Leduc's production of religious works and church decorations that attempted to synthesise faith, science and the arts. Leduc completed the decoration of thirty-one churches in the course of his lifetime, including the baptistery for Montreal's Church of Notre-Dame in 1927. He remained active until his death in his native village of Saint-Hilaire. ER

Ozias Leduc: An Art of Love and Reverie, exh. cat., The Montreal Museum of Fine Arts, 1996

FREDERIC LEIGHTON, FIRST BARON LEIGHTON OF STRETTON
(1830–1896)

Leighton was born in Scarborough, the son of a doctor. His family moved to London in 1832 and, following a brief trip to Paris, settled in Rome in 1840. Leighton

Frederic, Lord Leighton,
photographed by J. P. Mayall for *Artists at Home*, 1884

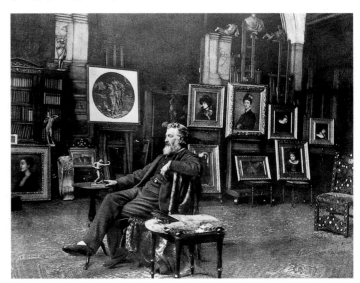

received training in various European cities and in 1854 set up a studio in Rome where he painted *Cimabue's Celebrated Madonna Is Carried in Procession through the Streets of Florence*, his first great success. The work was exhibited at the Royal Academy in 1855 and bought by Queen Victoria; this established his reputation in England.

· In 1859 Leighton moved to London where he was elected ARA in 1864 and RA in 1868. His work of the 1860s was heavily influenced by the Aesthetic Movement. Leighton is best known, however, for his cultivation in England of the 'Olympian' Neoclassical style of painting that he had absorbed in the course of his extensive continental training. Two of his most impressive works in this manner are *The Daphnephoria* (1876), a Classical procession in honour of the God Apollo, and *The Captive Andromache* (1888).

Trips to the Middle East, Egypt and Damascus between 1867–73 inspired oriental subjects such as *The Music Lesson*. Leighton's home in Holland Park in London was a shrine to orientalism and exoticism. In 1877 he had an Arab Hall built there with a fountain and Moorish tiles. Leighton was elected President of the Royal Academy of Arts in 1878, a role in which he exercised great influence in the shaping of artistic taste. He realised his preoccupation with Classical form in the sculptures executed in the 1870s and 1880s, including *Athlete Wrestling with a Python* and *The Sluggard*. He was raised to the peerage in 1896, the first artist in England ever to be so honoured. HV
Frederic, Lord Leighton, 1830–1896, exh. cat., Royal Academy of Arts, London, 1996

FRANZ VON LENBACH
(1836–1904)
Lenbach was born in Schrobenhausen the son of a master builder. In 1854 he entered the Akademie in Munich and three years later attended the classes of Karl Theodor Piloty, who was renowned for his multi-figured historical compositions and his painterly virtuosity. On winning a scholarship Lenbach accompanied his teacher on a journey to Rome.

Franz von Lenbach

At the age of 24 he was offered a professorship at the newly founded Kunstschule in Weimar, recommended for the post by Piloty. Ill-suited to teaching, he returned to Rome in 1863 under the employment of Adolf Friedrich Graf von Schack who had commissioned him to paint copies of Old Masters. His aptitude for this work prompted his patron to send him to Florence in 1865, where he also painted numerous portraits.

In 1867 Lenbach won a gold medal at the Paris Exposition Universelle. He travelled extensively and sojourned increasingly in Vienna. Contact with Wagner (whom he painted several times) aided his ascendancy as a portraitist in Vienna, though by 1876 he had given up his studio there and returned to Munich. As one of the most celebrated German portrait painters of his day, he immortalised representatives of the German Reich in the manner of an Old Master, painting nearly a hundred portraits of Bismarck alone. Lenbach frequently made use of photography in composing portraits of his family, his artist friends and society figures. His exceptional gift for capturing a gaze and defining facial expression characterises his work, as does seductive colouring and historical dress, with peripheral details often left shrouded in semi-darkness. Lenbach was ennobled in 1882. He acquired an estate in Munich on which he built an Italianate villa (see p. 52), which later became the Lenbachhaus Museum. CT
Franz von Lenbach, 1836–1904, exh. cat., Lenbachhaus, Munich, 1987

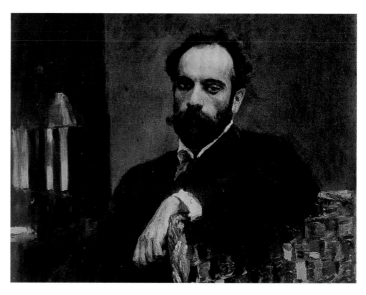

Isaak Levitan, *Self-portrait*

Henri Le Sidaner, Self-portrait, 1892

HENRI (EUGÈNE AUGUSTIN) LE SIDANER
(1862–1939)
Le Sidaner was born in Port Louis, Mauritius. The son of a naval captain, he attended the Ecole du Dessin in Dunkirk. In 1884, Le Sidaner was admitted to Alexandre Cabanel's studio at the Ecole des Beaux-Arts in Paris. Admiring Manet and the Impressionists more than his academic training, Le Sidaner joined the Etaples artists' colony on the Normandy coast to develop his own manner. A grant in 1891 allowed him to travel to Italy, to see the Italian 'primitives', and to the Netherlands. He made his début at the 1887 Salon and in the 1890s exhibited predominantly at the Société Nationale, of which he became an associate.

After a successful one-man show at the Mancini Gallery in Paris, Le Sidaner signed a contract with the dealer Georges Petit in 1899. He began to exhibit internationally, receiving a gold medal at the Munich International Exhibition in 1901 and exhibiting at the Goupil Gallery in London. In the summer of 1898 Le Sidaner was profoundly affected by his visit to Bruges. *Sunday* (1898, cat. 11) employs the hieratic poses, muted palette and spiritual yet enigmatic atmosphere and touch which characterise Le Sidaner's engagement with Symbolist aesthetics. In 1900 he visited the tiny village of Gerberoy, Oise, where four years later he was to buy the house which became the dominant motif of his late work. Le Sidaner died in Paris. CO'M
Y. Farinaux-Le Sidaner, *Le Sidaner, l'œuvre peint et gravé*, Paris, 1989

ISAAK (IL'ICH) LEVITAN
(1860–1900)
Often considered the outstanding Russian landscape painter of the 1890s, Levitan was taught by Vasily Polenov and Aleksey Savrasov. His work blends the former's *plein-air* naturalism and freshness with the latter's easy compositional power. One of the first Russian Impressionists, Levitan nevertheless maintained links with the Wanderers, among whom he had trained.

Levitan enrolled at the Moscow Art College in the mid-1880s, but found most academic teaching unsuited to his temperament. He had already sold work to the collector Pavel Tretyakov by 1879, and his early death ended an astonishingly well-rounded career.

His 1890s works, with such titles as *Above Eternal Peace*, partook of the hazy *fin-de-siècle* spiritual longings that haunted Symbolism and Art Nouveau, but naturalism is never entirely shrugged off. Even after 1895, in what turned out to be the last phase of his production, a radiant optimism and faith in nature and its renewal predominates.

Levitan showed work at Diaghilev's Exhibition of Russian and Finnish Artists (1898) and became an Academician in that year. He also exhibited with the World of Art (Mir Iskusstva) in 1899 and 1900. A posthumous exhibition was held in St Petersburg in 1901. His influence on Russian artists, especially the landscapists of the Society of Russian Artists, was to remain strong for ten years after his death. JM

D. Sarabianov, *Russian Art from Neoclassicism to Avant-Garde*, London, 1990

LÉON(-AUGUSTIN) LHERMITTE
(1844–1925)

Lhermitte was born in Mont-Saint-Père, Aisne. The son of a schoolteacher, he studied with Horace Lecoq de Boisbaudran at the Petite Ecole in 1863 where he met Jean-Charles Cazin, Jules Dalou,★ Henri Fantin-Latour, Alphonse Legros and Rodin.★ A prolific graphic designer, illustrating candy boxes as well as books such as *La Vie rustique* (1888), Lhermitte made his Salon début in 1864 with a drawing; he was a founder member of the Société Nationale, later becoming its vice-president. He was a regular contributor to the 'Black and White' exhibitions at the Dudley Gallery in London.

Lhermitte made his reputation with monumental paintings devoted to the lives of agricultural labourers. *The Harvester's Payday* (1882), purchased by the state, led to more government commissions for Lhermitte to execute decorations for the Sorbonne in 1886 and the monumental panorama *Les Halles* (1895) for the Hôtel de Ville in Paris. Lhermitte's expressive physiognomies, dextrous technique and Zolaesque narrative pathos confirmed for van Gogh and a later generation of social-realist

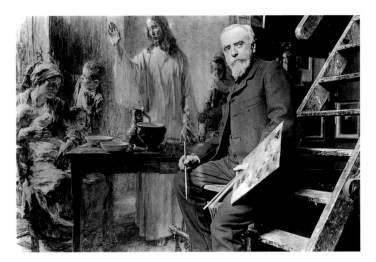

Léon Lhermitte, photographed by Dornac, 1905

painters his reputation as a naturalist painter. He was awarded a Diploma of Honour in Dresden in 1890 and the grand prize at the 1900 Exposition Universelle. Lhermitte was made a member of the Institut de France in 1905 and had risen to the rank of Commander in the Légion d'honneur by 1911. He died in Paris. CO'M

M. Le Pelley Fonteny, 'Léon-Augustin Lhermitte: Sa vie, son œuvre: Catalogue des peintures, pastels, dessins et gravures', PhD thesis, University of Paris IV, 1987

MAX LIEBERMANN
(1847–1935)

Max Liebermann was born in Berlin. In 1866, following his father's wishes, he entered the philosophy department at Berlin University, however, by 1868 he had enrolled at the Kunsthochschule in Weimar, where his tutors included Ferdinand Pauwels. In 1872 he travelled to Paris where he saw works by Courbet and Millet. The next year Liebermann moved to Paris and lived there until 1878. It was in the Louvre that he began to admire and copy the work of Frans Hals. He visited Barbizon in 1874 and 1875 and from 1875 worked regularly in the Netherlands.

In 1878 he moved to Munich, where a year later his painting *Twelve-year-old Jesus in the Temple* (1879) caused outrage. His general reception in Munich was unfavourable, and in 1884 he returned to Berlin. Towards the end of the 1880s Liebermann finally

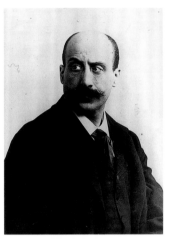

Max Liebermann, 1895

began to gain critical and commercial success. In 1896 the Berlin Nationalgalerie acquired its first works by Liebermann. In 1898 Liebermann was among the founder members of the Berlin Secession; he was President from 1899 and was made Honorary President in 1911. In 1903 he was elected President of the Deutscher Künstlerbund, an artists' association founded in protest against reactionary German art policies.

By 1912 Liebermann was receiving widespread recognition and he became a member of many prestigious groups, including the Académie Française and the Berlin Senate. From 1920 to 1932 he was President of the Prussian Akademie der Künste. He died in Berlin. AC

Max Liebermann: Der Realist und die Phantasie, exh. cat., Hamburg, Kunsthalle, 1997

SYDNEY LONG
(1871–1955)

Long was born in Goulburn, New South Wales. He trained at the Art Society of New South Wales in Sydney and served as President of the New South Wales Society of Artists from 1899–1901. He came to London in 1910 and from 1913 began to practise etching. He exhibited regularly at the Royal Academy.

In 1925 Long returned to Sydney and became a leading figure in the Australian art world. He believed that the Australian landscape could be freshly interpreted and works such as *Feeding Chickens at Richmond* (1896) show great delicacy in depicting

Sydney Long

subtle variations of colour. Although he was initially influenced by Impressionism, Roberts's art came to have more in common with that of Puvis de Chavannes. He painted and etched pastoral subjects and romantic, stylised Australian bush landscapes into which he introduced mytho-logical creatures. In *Pan* (1898, cat. 33), fauns cavort in an Australian landscape in which trees are twisted into Art Nouveau forms.

Long won the Wynne Prize for landscape in 1938 and 1940. His work as an etcher and lithographer was also highly regarded. He died in London. HV

Creating Australia: 200 Years of Art 1788–1988, exh. cat., Art Gallery of South Australia, Adelaide, 1988

J. Mendelssohn, *The Life and Work of Sydney Long*, Sydney, 1979

D. E. Paul, ed., *The Etched Work of Sydney Long*, Sydney, 1928

Maximilien Luce

MAXIMILIEN LUCE
(1858–1941)
Luce was born in Paris. The son of a working-class family from Montparnasse, Luce studied at night in a drawing school with Diogène Maillart while by day he was apprenticed to the wood-engraver Henri Théophile Hildebrand. From 1874 he engraved newspaper illustrations in the studio of Eugène Froment, occasionally attending the Académie Suisse and the studio of Carolus-Duran.★ Luce exhibited regularly at the Salon des Indépendants, becoming Vice-President in 1909, and President in 1935. Adopting a Pointillist technique after 1884, he showed with the neo-Impressionists and twice at Les XX in Brussels.

In the 1890s, Luce travelled with Camille Pissarro★ to London, with Théo Van Rysselberghe★ and Emile Verhaeren around the industrial regions of the Low Countries and visited Signac in his Utopian colony in St Tropez. Having witnessed the atrocities of the Paris Commune at first hand, Luce became a committed anarchist and provided illustrations for political periodicals like *Le Père Peinard*, *La Révolte* and *Chambard*. In 1894 he was jailed with Félix Fénéon at Mazas prison, an experience described in *Mazas*, his album of lithographs with text by Jules Vallès. He was acquitted in the infamous 'Trial of the Thirty', in which anarchist artists and writers were tried as political criminals in the aftermath of President Sadi-Carnot's assassination. The quietly heroic lives of working people and their world of markets, mines and industrial furnaces were his subject matter, portrayed in scintillating dots of exuberant colour. He died in Paris. CO'M

J. Bouin-Luce and D. Bazetoux, *Maximilien Luce: Catalogue of the Paintings*, La Celle-Saint-Cloud, 1986

FREDERICK WILLIAM MACMONNIES
(1863–1937)
One of the principal sculptors of the American Renaissance, MacMonnies created Beaux-Arts works ranging from historical monuments to mythical figures, often distinguished by rippled surfaces and lively poses. Born in Brooklyn, MacMonnies received his early training in the New York studio of Augustus Saint-Gaudens.★ In 1886 he was granted official entry to Alexandre Falguière's atelier at the Ecole des Beaux-Arts in Paris.

MacMonnies established himself in Paris, although he commuted to the United States with some frequency. There his mentor Saint-Gaudens and his friends the architects Charles McKim and Stanford White recommended him for work on public architectural projects and related sculptural programmes in the American Northeast. It was through such connections, in 1889, that MacMonnies received his first notable commission, for the statue of *Nathan Hale* for New York (1890).

In 1891 MacMonnies secured the *Columbian Fountain* commission for the 1893 Chicago World's Columbian Exposition, realising an ambitious allegorical ensemble which gained him substantial recognition. In this same fertile period, he sculpted *Bacchante with Infant Faun* (1893–94, cat. 71), a bronze reduction of which won a grand prize at the 1900 Exposition Universelle. Around the turn of the century, MacMonnies spent much time at Giverny in France where he had established a household, turning his attention to painting.

By 1915, the year of his return to New York, his style of Beaux-Arts sculpture had become outdated, as was shown by the criticism heaped upon his marble *Civic Virtue* (1920), executed for City Hall. Generally abandoning large-scale sculpture thereafter, he focused primarily on solidly modelled portrait busts until his death in New York. VG

M. Smart, *A Flight with Fame: The Life and Art of Frederick MacMonnies (1863–1937)*, with a catalogue raisonné of sculpture and a checklist of paintings by E. A. Gordon, Madison, Conn., 1996

ARISTIDE(-JOSEPH-BONAVENTURE) MAILLOL
(1861–1944)
Born at Banyuls-sur-Mer, Maillol came to Paris in 1881 hoping to become a painter. He eventually entered Alexandre Cabanel's studio at the Ecole des Beaux-Arts. However, he was greatly influenced by the Symbolist and Nabis milieu. Admiring the simplicity of Puvis de Chavannes's murals and Gauguin's★ Breton paintings, Maillol began to create decorative art objects. In 1893 he returned to his native village on the Mediterranean coast to found a tapestry studio. His designs of elegant figural friezes reflect his appreciation of Quattrocento fresco painting, Gothic tapestry and the flat picture planes of Cézanne.★

When his eyesight declined severely in 1900, Maillol took up three-dimensional media, in particular ceramics and wood-

Frederick William MacMonnies

Aristide Maillol

carving (including woodcut prints). His early sculpture transfigures Art Nouveau contours into a classical geometric austerity. The dealer Ambroise Vollard, who held Maillol's first one-man exhibition in 1902, cast the artist's small terracotta nudes in bronze. Maillol's wife was the model for *Mediterranean* (1900–02, cat. 38) which was first exhibited at the Salon d'Automne in 1905. Admired for its sober classicism by Octave Mirbeau, André Gide and Maurice Denis,★ the work's introverted pose creates both a circular movement around the perfect contours of the nude, while constantly reinforcing the purity of a cube. Marble versions of this work were purchased by two of Maillol's most committed patrons, Count Harry Kessler and the French State. Maillol died in Perpignan. co'M

H. A. Peters, *Maillol*, exh. cat., Staatliche
 Kunsthalle, Baden-Baden, 1978

FILIPP (ANDREYEVICH) MALYAVIN
(1869–1940)

Malyavin was born in Kazanka, Samara. A man of deep religious convictions, he served as a Lay Brother at Mount Athos in Greece, where he studied icon painting at the St Panteleimon Monastery. In 1892, however, he left for St Petersburg where for the next seven years he studied under Il'ya Repin★ at the Imperial Academy of Arts. Like his contemporary Abram Arkhipov,★ Malyavin focused on peasant women, as in *Peasant Wench* (1903, cat. 232), adopting bright,

Filipp Malyavin

Henri Matisse on his wedding day, 1898

Alfred H. Maurer

often lurid, colours reminiscent of traditional religious and folk art, and doubtless inspired by his own training in icon painting. In contrast to Arkhipov's social critique, however, Malyavin's images usually display the positive side of peasant life, with happy, smiling peasant women adorned in exquisite folk costumes.

Malyavin's bold use of colour and texture has often been linked with the work of the Russian avant-garde. Yet he remained essentially conservative in his attitude to the role of art in society. Following the Bolshevik Revolution, for example, Malyavin rejected the experimentalist tendencies of the avant-garde in favour of a more realist-inspired 'art for the masses'. He produced several portrait sketches of both Lenin and Trotsky and, in 1922, joined the ranks of the realist group AKhRR (Association of Artists of Revolutionary Russia). That same year, possibly in response to the new régime's attitude to religious institutions, Malyavin left Russia for France where he continued to produce paintings on the peasant theme until his death in Nice. MO'M

O. Zhivova, *Filipp Andreyevich Malyavin*,
 Moscow, 1967

HENRI (EMILE BENOÎT) MATISSE
(1869–1954)

Matisse was born at Le Cateau, Picardy. The son of a comfortable merchant family, he qualified first as a lawyer in 1889 but then decided to prepare for the entrance exam to the Ecole des Beaux-Arts in Paris by enrolling in the studio of William-Adolphe Bouguereau★ at the Académie Julian. Initially unsuccessful in the exam, he enrolled at the Ecole des Arts Décoratifs in 1892. Instead Gustave Moreau gave him a place in his studio, not only helping Matisse to gain entrance to the Ecole des Beaux-Arts in 1895 but remaining his mentor until 1898. Moreau encouraged the young Matisse to explore his own imagination and the colourist effects of the Old Masters in the Louvre. The subject matter of Matisse's early still-lifes and interiors reflects his love of the seventeenth-century Dutch Masters.

In 1896, Matisse had four paintings accepted by the Salon of the Société Nationale, of which he was made an associate member. Mme Félix Faure, wife of the President of the Republic, purchased one of these. Matisse

was commissioned to paint ornamental garlands in the Grand Palais for the 1900 Exposition Universelle. After critical disfavour at the Salon des Indépendants of 1901, he suffered a period of financial and personal insecurity before the beginning of his radiant Fauvist years in 1904. He died in Nice. co'M

J. D. Flam, ed., *Matisse on Art*, London,
 1973
J. Elderfield, *Henri Matisse:
 A Retrospective*, London and New
 York, 1992

ALFRED H(ENRY) MAURER
(1868–1932)

A versatile artist, Maurer explored the major artistic idioms of his time, including Realism, Fauvism, Cubism and abstraction. Born in New York, he worked in his family's lithography business and attended classes at the National Academy of Design. In 1897 he moved to Paris, where he briefly studied at the Académie Julian. His early work, primarily genre scenes and studies of female figures in spare interiors, reflects the aestheticism and dark tonality of James Abbott McNeill Whistler.★ These paintings were highly acclaimed. Maurer exhibited

at many venues and received a number of awards, including first prize at the Carnegie Institute's annual exhibition in Pittsburgh in 1901.

After 1904, Maurer's work underwent a dramatic shift, perhaps precipitated by his exposure to avant-garde French art through his friends Gertrude and Leo Stein. Maurer experimented with the high-keyed colours of Fauvism, the formal concerns of Cubism, and other modern art developments. While this work was not well-received by critics – Maurer was never to match the success of his early career – he continued to exhibit, sometimes at Alfred Stieglitz's '291' gallery in New York.

Maurer showed regularly with the Society of Independent Artists after he returned to the United States in 1914, and in the last ten years of his life had a close relationship with the Weyhe Gallery in New York. Still-lifes, landscapes and depictions of stylised, attenuated women dominate his later work. Although when he died, in New York, he was largely unappreciated, Maurer is now understood to have been an important early American exponent of European modernism. SR

S. Reich, *Alfred H. Maurer (1868–1932)*, exh. cat., National Collection of Fine Arts, Washington, DC, 1973

GABRIEL (CORNELIUS) MAX
(1840–1915)

Gabriel Max was born in Prague into a well-known Bohemian family of painters and sculptors whose artistic ancestors can be traced back to the sixteenth century. Both his grandfathers were sculptors, his uncle was the sculptor Emanuel Max and his father was the sculptor Josef Max. His brother, Heinrich Max was also a painter. From 1855 to 1858 Max studied at the Academy of Fine Arts in Prague and between 1858 and 1861 he attended the Akademie der Bildenden Künste in Vienna. He was a student at the Akademie in Munich between 1864 and 1867, where he studied under Karl Theodor von Piloty. He stayed in Munich and founded a private art school there in 1869. From the 1860s he illustrated a number of

Gabriel Max

literary works, including Christoph Martin Wieland's *Oberon* and Goethe's *Faust*, illustrations that clearly show the influence of the late Romantic movement on his work. He also illustrated fairy tales and writings by Friedrich von Schiller, Nikolaus Lenau and Ludwig Uhland. Max took a great interest in aspects of spirituality and studied anthropology, mysticism and occultism; these were to find expression in many of his paintings. As well as influencing painters in Germany and Austria, Max's work had a wider impact on Bohemian and Hungarian artists. He was Professor of History Painting at the Munich Akademie between 1879 and 1883, and died in Munich. AC

A. Kohut, *Gabriel Max: Portraits*, offprint from *Westermans Illustrierte Deutsche Monatshefte*, May 1883

(JULIUS) GARI(BALDI) MELCHERS
(1860–1932)

Gari Melchers was born in Detroit. He first went to Europe in 1877, enrolling at the Königliche Kunstakademie, Düsseldorf. He moved to Paris in 1881, where he attended the Académie Julian and, later, the Ecole des Beaux-Arts. In 1884 he settled in Egmond-aan-Zee, Holland.

Melchers concentrated on figure painting, creating secularised religious images which often portrayed pious women in regional dress. Works of this kind won him a grand prize medal at the 1889 Exposition Universelle. In the 1890s he continued to represent

Gari Melchers

Dutch villagers in hieratic compositions realised in a high-key palette which emphasised decorative patterning.

By then a successful artist in Europe, Melchers had a gallery devoted to his work at the 1900 Grosse Berliner Kunst-Ausstellung. He also maintained links with the United States and executed murals for the 1893 World's Columbian Exposition, Chicago, and, in 1895, for the Library of Congress, Washington, DC. In 1901 he won a first class gold medal at the Buffalo Pan-American Exposition.

In the first decades of the new century Melchers developed his own interpretation of Impressionism, painting subjects ranging from upper-class women in domestic interiors to cityscapes. In 1909 he became a professor at the Weimar Akademie. World War I forced his return to the United States in 1915, and the following year he established his residence in Falmouth, Virginia, although he spent a significant amount of time in New York, painting up until his death. VG

D. Lesko, *Gari Melchers: A Retrospective Exhibition*, exh. cat., Museum of Fine Arts, St Petersburg, Fla., 1990

CONSTANTIN MEUNIER
(1831–1905)

Meunier was born in Brussels. His older brother, the engraver Jean-Baptiste Meunier, taught him before he enrolled at the Brussels Académie des Beaux-Arts in 1845, first in the studio of the

Constantin Meunier, photographed by Hennebert, 1905

sculptor Louis Jehotte then, in 1853, with the painter François-Joseph Navez. Regular visits to the Trappist monastery at Westmalle inspired his early religious painting, while his history subjects were drawn from the eighteenth-century Peasant's War. Visiting the glassworks and rolling-mills of Wallonia in 1878, and then observing the desperation of the coal miners of the Borinage with Camille Lemonnier, Meunier found his core motif in the grandeur and degradation of modern industry.

After a government-sponsored trip to copy Flemish paintings in Spanish museums, Meunier began in 1884 to create modern sculpture, heroising the life of the labourer. Meunier was made Professor of the Academie of Leuven in 1887 and a member of the Académie Royale de Belgique in 1899. Having settled in Brussels in 1894, he purchased his house, now the Musée Meunier, in 1900. Championed by Henry van de Velde, Meunier had a one-man show at Siegfried Bing's Parisian Maison de l'Art Nouveau in 1896, while at the Expositions Universelles of 1889 and 1900 he won the grand prize for sculpture and was well received at the Munich and Dresden International Exhibitions, and the Berlin and Vienna Secessions. Meunier's *Monument to Labour* epitomises his powerful technique and beliefs. He died in Brussels. CO'M

P. Baudson, *Les Trois Vies de Constantin Meunier*, Brussels, 1979

GEORGE MINNE
(1866–1941)

Born in Ghent, Minne attended the Academie voor Schone Kunsten in that city from 1879 to 1886. Apart from a four-year sojourn in Brussels, where he briefly studied at the Académie Royale des Beaux-Arts, from 1895 Minne remained in the Ghent area.

The attenuated figures of Minne's sculptures captured the imagination of the Belgian Symbolist literary and artistic milieu. His most fervent champion was the poet and art critic Emile Verhaeren. Maurice Maeterlinck asked him to illustrate his poetry collection *Serres chaudes* (1889), while Charles Van Lerberghe and Grégoire Le Roy also admired the graceful melancholy of his art. *Kneeling Boy* (1898, cat. 249) epitomises his synthesis of sinuous Art Nouveau line and themes of isolation, hypersensitivity and ascetic androgyny. This figure was to be his central motif and was later reworked in small versions and on a public scale as in the *Fountain of Kneeling Figures* (1905) for the Folkwang Museum, Essen. Minne typically modelled his works in clay, then had them made into plaster before completing a final version in marble, bronze or wood.

He exhibited with independent exhibiting societies including Les XX in Brussels, Sâr Péladan's Salons de la Rose+Croix in Paris, the Berlin and Vienna Secessions and the Venice Biennale. From the 1890s, Minne was involved in the Laethem-Saint-Martin artists' colony which sought to re-instil a spiritual focus in its members' art and lives. He died in Laethem-Saint-Martin. CO'M

George Minne en de kunst rond 1900, exh. cat., Museum voor Schone Kunsten, Ghent, 1982

PAULA MODERSOHN-BECKER
(1876–1907)

Paula Becker was born in Dresden. In 1888 the Becker family moved to Bremen, where Paula received her first artistic training. At the insistence of her parents, she attended a teacher-training course in Bremen in 1894–95. From 1896 to 1898 she studied at the Berlin Malerinnenschule.

Paula Modersohn-Becker

George Minne with his wife

Becker first visited the artists' colony in Worpswede near Bremen in 1897, and settled there in 1898. At the colony she was taught by the painter Fritz Mackensen and met the artists Fritz Overbeck, Otto Modersohn, Heinrich Vogeler and their families. In January 1900 she made her first trip to Paris, where she enrolled at the Académie Colarossi. In Paris she visited a number of exhibitions, and was particularly impressed by the work of Cézanne.★

Carl Moll

In the summer of 1900 Becker returned to Worpswede and a year later she married the recently widowed Otto Modersohn. She made her second trip to Paris in 1903, when she was able to visit the studio of Rodin.★ She returned again in 1905 and took an interest in works by the Nabis and Gauguin.★ By 1906, in spite of her husband's objections, she was in Paris again, seeking to distance herself from the isolated Worpswede community.

She returned to Worpswede in early 1907 and died later that year, shortly after the birth of her daughter. AC

Paula Modersohn-Becker: Retrospektive, exh. cat., Städtische Galerie im Lenbachhaus, Munich, 1997

CARL MOLL
(1861–1945)

Carl Moll was born in Vienna. He enrolled at the Akademie der Bildenden Künste in Vienna in 1879, where he was taught by Professor Christian Griepenkerl. A dislike of Griepenkerl's emphasis on drawing from plaster casts, combined with a serious illness, prompted Moll to discontinue his Akademie education. In 1881 he became a private pupil of Emil Jakob Schindler, who not only influenced his style, but became one of his closest friends. In 1895, three years after Schindler's death, Moll married Schindler's widow Anna and became the stepfather of Margarethe, and Alma (later Mahler).

On trips with Schindler and his family Moll produced innumerable landscape sketches and paintings that were deeply indebted to his teacher's naturalistic style. Landscapes, next to still-lifes and interiors, remained Moll's main interest throughout the stylistic changes of his production. His early naturalistic works soon gave way to a more colourful, Impressionist style; later he slowly incorporated Expressionist tendencies.

In 1897 Moll was one of the founders of the Viennese Secession, which he left in 1905 together with Klimt★ and thirteen others after serious disputes. In 1903 he was strongly involved in the foundation of the Wiener Werkstätten, which was closely modelled on the British Arts and Crafts Movement. Moll's commitment to the organisation of exhibitions increased after he left the Secession and remained an integral part of the rest of his life. He died in Vienna. AD

H. Dichand, ed., *Carl Moll: Seine Freunde, sein Leben, sein Werk*, Salzburg, 1985

G. T. Natter and G. Frodl, eds, *Carl Moll (1861–1945): Maler und Organisator*, exh. cat., Österreichische Galerie Belvedere, Vienna, 1998

PIET(ER CORNELIUS) MONDRIAN
(1872–1944)

Mondrian was born in Amersfoort. He began his career by teaching art. Between 1892 and 1895 he studied at the Rijksacademie in Amsterdam and went to evening classes there until 1897.

Until about 1907 Mondrian executed naturalistic and impressionistic paintings; landscapes were his favourite motif. From about 1900 he began to develop his own personal style, but nevertheless remained close to the traditional forms of the Hague School. Absorbing different influences such as Pointillism, Symbolism and Cubism, he moved slowly towards abstraction. He often used one motif in a series of paintings, turning a realistic study from nature into purely geometric forms. His most famous works today are the abstract paintings, reduced to the three primary colours with white and black lines, which came to dominate his *œuvre* only after World War I.

By 1912 Mondrian had moved to Paris, but in 1914 he was caught in Holland by the outbreak of World War I. There he met people who were crucial for the further development of his career. Among them was Theo van Doesburg with whom Mondrian founded the magazine *De Stijl* in 1917. In this journal he published important articles on his aesthetic theories; the publication gave its name to the De Stijl movement, one of the most important Dutch contributions to the art of the twentieth century.

In 1919 Mondrian returned to Paris. He emigrated to London in 1938 and then to New York in 1940, where he died four years later. AD

Piet Mondrian, 1872–1944, exh. cat., Haags Gemeentemuseum, The Hague; National Gallery of Art, Washington; Museum of Modern Art, New York, 1994–95

B. Riley, *Mondrian: Nature to Abstraction. From the Gemeentemuseum, The Hague*, exh. cat., Tate Gallery, London, 1997

M. Seuphor, *Piet Mondrian: Life and Work*, New York, 1956

Piet Mondrian

Claude Monet in his second studio, *c.* 1903–04, from an article in *L'Art et les artistes*

(OSCAR-)CLAUDE MONET
(1840–1926)

Monet was born in Paris. In his youth on the Normandy coast he enjoyed a formative friendship with the *plein-air* painter Eugène Boudin. Monet attended the studio of the academician Charles Gleyre between 1862–64 and met Frédéric Bazille, Renoir★ and Sisley there. Monet had an influential exhibition career, participating in the Impressionists' group exhibitions, the Salon and, particularly in the 1890s and beyond, in numerous one-man exhibitions with the dealers Paul Durand-Ruel, Georges Petit and Boussod Valadon.

His early work celebrated Paris and its suburbs, but in the 1880s he looked to the more remote and dramatic landscapes of regional France and the Mediterranean. In the 1890s he began his famous series paintings inspired by poppy fields, poplars, haystacks, the façade of Rouen Cathedral, and the Houses of Parliament in London. Both the concept and motifs of the series reflect Monet's awareness of Japanese art.

The great fascination of his later life was the water garden he created at Giverny and the views from that property of the nearby Seine bathed in pastel mist. Monet controlled the flow of the stream, enlarged the pond twice to encourage the cultivation of exotic water lilies and willows, and built the famous Japanese bridge. He painted the changing surface effects of the water and vegetation, often in monumental canvases which prefigure the *Grandes Décorations* for the Orangerie which were his last great work. Monet died at Giverny. CO'M

D. Wildenstein, *Claude Monet: Biographie et catalogue raisonné*, 5 vols, Lausanne, 1974–91

THOMAS MORAN
(1837–1926)

Moran's expansive landscapes of the American wilderness portray the grandeur of its natural phenomena. Although influenced primarily by J. M. W. Turner's romantic, atmospheric images, Moran's sublime vistas also follow the tradition of Hudson River School artists such as Albert Bierstadt. Born in Bolton in England, Moran emigrated to

Philadelphia as a child. He learned to paint largely from his eldest brother, Edward. By 1856 Thomas was exhibiting at the Pennsylvania Academy of the Fine Arts, where he became an Academician in 1861.

Moran travelled extensively in the United States and Europe, sketching prodigiously. Most remarkably, he joined an expedition to Yellowstone in 1871. This trip signalled the turning point in his career and led him to paint his monumental *Grand Canyon of the Yellowstone* (1872) and to supply illustrations for *Scribner's* magazine. Moran, a versatile artist, created watercolours, etchings, engravings and lithographs for a multitude of publications. Soon after returning from Yellowstone, Moran moved to Newark, New Jersey. In 1881 he established himself in New York, becoming an Academician at the National Academy of Design in 1884.

In 1900 Moran made his last trip to Yellowstone. He continued to visit and paint the American Southwest. Frequently excluding all signs of human encroachment from the landscape, Moran's images reflect growing American nostalgia for a pristine Western frontier. His work had an enduring appeal and was included in Buffalo's 1901 Pan-American Exposition, the 1904 St Louis Universal Exposition, and the 1915 Panama-Pacific Exposition in San Francisco. Moran died in Santa Barbara. VG

N. K. Anderson, et al., *Thomas Moran*, exh. cat., National Gallery of Art, Washington, DC, 1997

ALEKSANDR (VIKTOROVICH) MORAVOV (1878–1951)

Born in Velikaya-Motovilovka in the Ukraine, Moravov originally studied at Nikolay Murashko's School of Drawing in Kiev before moving north in 1897 to study at the Moscow School of Painting, Sculpture and Architecture. Here he worked under Nikolay Kasatkin, Abram Arkhipov,* Valentin Serov* and Konstantin Korovin.* Moravov's exhibiting career began during his student days in 1899. After completing his studies at Moscow in about 1901–02, Moravov moved to St Petersburg where he enrolled at the Imperial

Thomas Moran

Angelo Morbelli, *c.* 1900

Academy of Arts for another year. By 1902 he had produced his *Mother and Child* (cat. 251), adopting a quasi-religious theme much in keeping with the contemporary revival of interest in icon painting. Stylistically, however, Moravov's work was closer to the realism of the Wanderers (Peredvizhniki) and in 1904 he joined the ranks of this by then illustrious group.

Although Moravov did enjoy early success, the high point of his career dates from after the Bolshevik Revolution. In 1918 he accepted a teaching post at the Tver Free Art Studios and, in 1922, exhibited at the First Russian Art Exhibition held in Berlin. The following year he joined AKhRR (Association of Artists of Revolutionary Russia) and maintained a reputation as a major contributor to Soviet Socialist Realism throughout the rest of his

Aleksandr Moravov, *c.* 1920

James Wilson Morrice

life. By the time of his death in Moscow, he had been officially recognised as an Academician of the USSR. MO'M

I. Pikulev, *A. V. Moravov*, Moscow, 1950

ANGELO MORBELLI (1853–1919)

Born into an affluent family from Alessandria in northern Italy, Morbelli moved to Milan to study and based himself there for the rest of his life. Empathy for the workers and alienated social groups inspired his subject matter; the ills of juvenile prostitution, for example, are embodied in the figure of the dying girl in *Sold* (1884). Eschewing sentimentality, his titles are at times emotive, and his figures melancholy. The year 1894 saw the beginning of a close correspondence with Giuseppe Pellizza da Volpedo* until Pellizza's premature death. In the years

leading up to 1900 the two artists had tried in vain to exhibit a group of Divisionist works.

Prior to this, and to considerable acclaim, Morbelli had shown in Milan (winning the Fumagalli Prize in 1883 for *Last Days*), in London (at the invitation of Grubicy in 1888) and many other venues. At the Exposition Universelle in 1900 he won a gold medal. From 1901 Morbelli revisited the Pio Albergo Trivulzio in Milan, a rest home for the homeless and destitute, exploring the themes of old age he had first depicted in 1883. He developed quiet images, using photography as an aid to composition and pure pigments to heighten luminosity. Morbelli's meticulous research into colour theory and notes on his working practice were recorded in his diary *La Via Crucis del Divisionismo*. He died in Milan. CT

A. Scotti, *Angelo Morbelli*, Soncino, 1991

JAMES WILSON MORRICE (1865–1924)

Morrice achieved international success through his colourful and ambient landscape paintings. Born in Montreal, he was raised in an upper-class family who appreciated the arts. Morrice exhibited his first work in the group exhibition of the Royal Canadian Academy of Arts and the Ontario Society of Artists in 1888. Praise from the critics prompted Morrice to leave law school in Canada to study at the Académie Julian in Paris in 1891.

On his numerous trips abroad, Morrice diversified his landscape scenes while continuing to develop his own style, although he was greatly influenced by his artist friends Maurice Prendergast and Robert Henri,* and by James Abbott McNeill Whistler.* By 1896, Morris was employing more subdued earth tones, much like Whistler, in an attempt to capture an atmospheric luminosity in his landscape paintings. Due to the subjective approach of his landscapes, Morrice has often been referred to as an 'Impressionist of the second generation'. Morrice also travelled to urban centres with Henri, thus introducing portraiture and cityscapes as subjects in his art. In 1898, a painting by Morrice was accepted

at the Salon of the Société Nationale des Beaux-Arts in Paris.

In the following years, Morrice continued to travel, showing his work in various exhibitions both in Europe and in North America. In 1901, he received a silver medal at the Pan-American Exposition in Buffalo. By the 1910s, however, Morrice had developed a dependence on alcohol which greatly affected his health. He died in Tunis. ER

N. Cloutier, ed., *James Wilson Morrice, 1865–1924*, exh. cat., Museum of Fine Arts, Montreal, 1985

ALPHONSE MUCHA
(1860–1939)
Born in Ivančice in Moravia and trained as a stage-designer in Vienna as a youth, Mucha studied painting in Munich before moving to Paris in 1887 to enrol at the Académie Julian.

In this period of influential illustrated journals Mucha's abilities as a graphic artist brought him plenty of employment and a rapid rise to fame – in 1894 his first poster of Sarah Bernhardt in a dramatic role pleased her so much that she arranged a long-standing contract with him. The Symbolist literary review *La Plume* dedicated an issue to Mucha's work in 1897, when public appreciation of his sinuous, slinky graphic line was at its height. He was drawn into the occult world of Sâr Péladan's Rose+Croix exhibitions of 1892–97 and was viewed as an exotic in the Parisian scene. Like many Art Nouveau artists Mucha had few qualms about the difference in status between fine and applied art, happily providing designs for calendars, jewellery, stained glass windows, colour lithographs for book illustrations and much else, including the decorations for the Bosnian pavilion at the 1900 Exposition Universelle.

After his return to his Czech homeland in 1910, Mucha produced vast murals celebrating famous episodes in Slav history. He died in Prague. JM

J. Kotalík and J. Brabcová, *Mucha 1860–1939: Peintures, illustrations, affiches, arts décoratifs*, exh. cat., Grand Palais, Paris; Ausstellhallen Matildenhöhe, Darmstadt; Jízdárna Pražského Hradu, Prague, 1980

Alphonse Mucha sitting in front of a poster of Sarah Bernhardt, *c.* 1901

EDVARD MUNCH
(1863–1944)
Born in rural Hedmark, Munch developed tuberculosis at the age of thirteen from which he made a near-miraculous recovery. In 1879, he enrolled at the Christiania (Oslo) Royal School of Drawing. More influential, however, were the Christiania Bohème, a group of Nietszchean radicals led by the novelist Hans Jaeger (who was briefly jailed for blasphemy) and Christian Krohg,★ a naturalist painter who taught Munch in 1882. In 1883 Munch exhibited for the first time in Christiania's Autumn Exhibition and in 1889 had a one-man show. That year, with a government grant, he visited Paris, enrolling in Léon Bonnat's studio. Further travel grants were obtained in 1890 and 1891.

In 1892 Munch moved to Berlin, gaining overnight notoriety when the authorities closed down his exhibition on the grounds of sacrilege. Thereafter he moved constantly between Paris, Berlin and (in summer) Norway. In 1894, while part of the Zum schwarzen

Edvard Munch seated on his trunk at 82 Lützowstrasse, Berlin, 1902

Ferkel (the Black Piglet tavern) group, Munch produced his first graphic work. He exhibited in Berlin with Akseli Gallén-Kallela★ in 1895, and the following year, in Paris, he associated with Mallarmé and exhibited at the Salon des Indépendants from 1896–98.

After a breakdown in 1908, Munch went into virtual retirement in Norway, although he continued to paint (in a substantially different style) up until his death in Oslo. JM

R. Heller, *Munch: His Life and Work*, Chicago and London, 1984

J. B. Smith, *Munch*, London, 1992

M.-H. Wood, ed., *Edvard Munch: The Frieze of Life*, exh. cat., National Gallery, London, 1992

FERDINAND HART NIBBRIG
(1866–1915)
Nibbrig was born in Amsterdam. He studied for two years at the Quellinus School before enrolling in 1883 in the studio of August Allebé at Amsterdam's Rijksacademie voor Beeldende Kunsten for six years. The early work that Nibbrig produced in Holland reflects his awareness of the sombre Impressionism of the Hague School of artists.

In 1888 Nibbrig travelled to Paris for a year where he attended the Académie Julian and the studio of Fernand Cormon. While in Paris he encountered the Pointillist technique and the radiant colour contrasts of the neo-Impressionists Georges Seurat and Paul Signac. Returning to Holland in 1889,

Ferdinand Hart Nibbrig

Nibbrig exhibited at the main Dutch exhibitions and was a member of the Arti et Amicitiae group.

Like Vincent van Gogh and Constantin Meunier,★ Nibbrig was drawn to the harsh toil of Holland's peasants and miners as subject matter. Between 1900 and 1911, he settled in Laren in the Gooi

region. He made careful sketches of local peasants who later appear as recognisable individuals in his finished works. Nibbrig began to work on a much more monumental scale, using a naturalist technique, to portray the crushing poverty and ensuing social unrest which was the daily experience of Holland's agricultural labourers at the turn of the century. He died in Laren. CO'M

Ferdinand Hart Nibbrig 1866–1915, exh. cat., Singer Museum, Laren, 1967

EJNAR (AUGUST) NIELSEN
(1872–1956)
Nielsen studied at the Royal Academy of Fine Arts in Copenhagen between 1890 and early 1893 after an apprenticeship to a house-painter. He then branched out to study at Kristian Zahrtmann's Copenhagen School in 1895–96. Visiting Paris in 1900 for the Exposition Universelle, he stayed until 1901 and the following year visited Italy. Like Laurits Andersen Ring★ in this respect, Nielsen made Paris and Italy the twin poles of his foreign travels; Pierre Puvis de Chavannes and such early Italian Renaissance artists as Andrea del Castagno became his major artistic influences. Like Ring also, Nielsen never deserted his early surroundings and experiences and tempered foreign study with subject matter drawn from the poor and dispossessed of Jutland, in particular the village of Gjern. He lived there from 1894 to 1900 and would return frequently thereafter, depicting certain models (such as the *Blind Girl*, actually the organist in the village, whose 'portrait' recurred from 1896 to 1905) almost obsessively.

The sick and crippled preoccupied Nielsen throughout his life, a legacy of the social awareness thriving in communitarian Denmark of the 1880s. His first success had been with *The Sick Girl* (1896, cat. 22), a subject common enough in Scandinavian painting of the period, but given added poignancy by Nielsen in the reduced, almost minimal setting, reminiscent of Vilhelm Hammershøi.★ The work received a bronze medal at the 1900 Exposition Universelle. Later in his career he worked on large

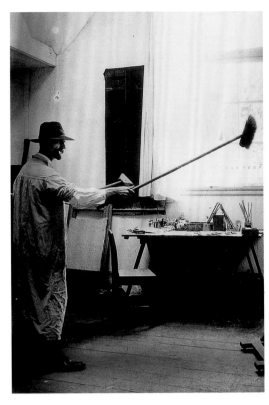

Ejnar Nielsen

decorative projects and as a portraitist. He died in Copenhagen. JM

Dreams of a Summer Night, exh. cat., Hayward Gallery, London, 1986
Ejnar Nielsen, exh. cat., with articles by A. Stabell and J. O. Hansen, Kunstforeningen, Copenhagen, 1984

EMIL NOLDE (HANSEN)
(1867–1956)
Nolde was born Emil Hansen in Nolde, Schleswig-Holstein. From 1884 to 1888 he trained as a woodcarver and then worked in furniture factories in Berlin, Karlsruhe and Munich. Between 1892 and 1897 he taught design at the arts and crafts school in Saint Gallen, Switzerland. In 1898 he attended a private art school in Munich, and subsequently studied in Dachau and Paris, where a visit to the 1900 Exposition Universelle aroused his interest in exotic cultures.

In 1902 he changed his surname to that of his birthplace. A year later he moved to the north German island of Alsen. In 1906 he was invited to join the Dresden artists' group Die Brücke, with whom he exhibited for a year and remained in close contact. Nolde joined the Berlin Secession in 1908,

Emil Nolde, 1896

only to be expelled in 1910 after the scandal caused by the pioneering primitivism of his painting *Pentecost* (1910). Until 1912 he exhibited with the breakaway Neue Sezession.

In 1913 he took part in an expedition to German New Guinea, where he saw tribal culture at first hand. In 1916 Nolde moved to Utenwarf in northern Germany and in 1927 he settled in Seebüll. Nolde became a member of the Prussian Akademie der Künste in 1931, and in 1933 joined the local Danish section of the National Socialist Party. Nolde's works nevertheless featured prominently in *Entartete Kunst*, the Nazis' 'degenerate art' exhibition of 1937, and in 1941 he was banned from painting. Until 1945 he secretly produced over 1,000 'unpainted pictures'. Nolde received widespread international recognition after World War II, including a gold medal at the 1950 Venice Biennale. He died in Seebüll. AC

Emil Nolde, exh. cat., Whitechapel Art Gallery, London, 1996
E. Nolde, *Mein Leben*, Cologne, 1976
M. Urban, *Emil Nolde: Catalogue Raisonné of the Oil Paintings*, 2 vols, London, 1987–90

FRANCISCO (MANUEL) OLLER (Y CESTERO)
(1833–1917)
Born in Bayamón, Puerto Rico, Oller did not begin his formal art training until 1851, when he travelled to Madrid to study at the Real Academia de Bellas Artes de San Fernando. He returned to Puerto Rico in 1853 and soon gained official recognition, winning silver medals at two national exhibitions.

In 1858 Oller went to live in Paris, a city which he would later visit for two more extended stays. He studied in the studios of Thomas Couture and Charles

Francisco Oller

Gleyre, and befriended Camille Pissarro★ and, later, Paul Cézanne.★ He was greatly inspired by Impressionism, the influences of which are evident in the looser brushwork and purer use of colour in his later landscapes. He was also drawn to the realist principles espoused by Gustave Courbet. Because of the modulation and blending of styles that characterise his painting, it is difficult to confine Oller's work to a single genre, although he is often referred to as a 'realist Impressionist'. A common thread in his art, however, is the embodiment of the nationalistic sentiments of Puerto Rico, which was struggling for freedom and independence during much of his lifetime.

In his attempt to forge a visual identity for his native country, Oller promoted art schools in his homeland, establishing two academies and teaching throughout his career. During the last decades of his life he painted portraits and images of Puerto Rico, capturing the spirit of the island in his impressionistic landscapes depicting lush plantations and his realist still-lifes celebrating indigenous fruits. In 1907 Oller moved to Cataño, where he died ten years later. ER

Francisco Oller: A Realist Impressionist, exh. cat., Museo de Arte de Ponce, 1983

SIR WILLIAM (NEWENHAM MONTAGUE) ORPEN
(1878–1931)
Born in Blackrock, Co. Dublin, Orpen studied at the Metropolitan School of Art, Dublin, from 1890–97 before entering the Slade School of Art in 1897 where his fellow students included Augustus and Gwen John.★ Orpen was one of the most outstanding students at the Slade, excelling at drawing and, in 1899, winning the 'Summer Composition' with *The Play Scene from 'Hamlet'*. He exhibited at the New English Art Club, and in 1900 showed one of his best-known figure paintings, *The Mirror* (cat. 160). From 1902–14 he taught part-time in Dublin at the Metropolitan School of Art and became involved in the Irish cultural renaissance led by the poet W. B. Yeats and the novelist and critic George Moore. Between 1913–16 Orpen produced large-scale allegorical works in

Sir William Orpen,
photographed by Beresford, 1903

Walter Osborne,
drawn by Nathaniel Hill

which he expressed his feelings and attitudes towards his Irish heritage.

Orpen first exhibited at the Royal Academy in 1908. He was elected ARA in 1910 and RA in 1919, a year after being knighted. In World War I he served as an Official War Artist and painted formal portraits of military officers and desolate, battle-scarred landscapes. His experience of war had a deep effect on him which was evident in his work until the 1920s. He also became one of the most fashionable and wealthy portrait painters of the day, a natural successor to Sargent.★ He had homes and studios in both London and Paris. He continued however to explore other subject matter including nudes, *plein-air* landscapes and conversation pieces. HV

B. Arnold, *Orpen, Mirror to an Age*, London, 1981
K. McConkey, *A Free Spirit, Irish Art 1860–1960*, Woodbridge, 1990

WALTER FREDERICK OSBORNE
(1859–1903)
The son of the animal painter William Osborne, Walter was born in Dublin. He attended the Royal Hibernian Academy Schools, Dublin, and in 1881 became a pupil at the Academie voor Schone

Kunsten in Antwerp. In 1883 he was sketching in Brittany and was much influenced by *plein-air* painting and the rustic naturalism of Jules Bastien-Lepage. He returned to England in 1884 and began exhibiting at the New English Art Club. Osborne's work had much in common with that of other exhibitors (who included Edward Stott and Philip Wilson Steer). Osborne often visited places such as Evesham and Walberswick to work with these and other artists. He painted scenes of rural genre and occasionally pure landscapes.

In 1892 Osborne returned to Dublin and began to broaden his subject matter to include urban scenes; he also developed a portrait practice. His brushwork became looser and his palette brighter. The influence of Whistler is evident in the increasing economy of his detail and in his portrait compositions. In 1895 he travelled to France and Spain with Walter Armstrong and in 1900 won a bronze medal for *Mrs Noel Guinness and Her Daughter* at the Exposition Universelle. By the time of his death, he had become the leading portrait painter in Dublin. HV

J. Sheehy, ed., *Walter Osborne*, exh. cat., National Gallery of Ireland, Dublin, 1983

GIUSEPPE PELLIZZA DA VOLPEDO
(1868–1907)
Pellizza was born in the northern Italian village of Volpedo near Alessandria. His lengthy academic training began in Milan, when he was urged by a family friend to enrol at the Accademia di Brera. In Rome, briefly, and then Florence, he made long-lasting friendships with Guglielmo Micheli and Plinio Nomellini, who later encouraged him to study Divisionist techniques. In 1888 he attended the Accademia Carrara, Bergamo, prompted by a desire to paint on a large scale and to perfect his drawing skills.

Refined technique, varied brushwork and balanced composition characterise Pellizza's work. The year 1892 was one of personal and professional triumph: he married Teresa (his model for *The Fourth Estate* [1898–1901, cat. 216]) and won the gold medal for *Mums* (1892) at the Italo-American exhibition in Genoa. From 1894 he corresponded with many literary figures of the day and with Giovanni Segantini,★ Vittore Grubicy,★ Leonardo Bistolfi and Angelo Morbelli,★ forging strong affiliations with the latter. In 1889 Pellizza had travelled to Paris to the Exposition Universelle and been

Giuseppe Pellizza da Volpedo, 1900

John F. Peto, *Self-portrait*

PABLO PICASSO
(1881–1973)

Picasso was born in Malaga. The son of the artist José Ruiz Blasco, Picasso received his first tuition from his father at the Escuela Provincial de Bellas Artes in Malaga. His exquisitely naturalistic childhood works predominantly portray his family and those on the margins of society. He also produced satirical illustrations for local papers such as *La Coruña*.

At fourteen Picasso was accepted into the Academy in Barcelona and later to the Academia Real de San Fernando in Madrid, but he

Last Moments (now destroyed) was accepted at the Exposition Universelle and Picasso travelled to Paris to see the exhibition in the company of his friend the painter Carles Casagemas, whose suicide in 1901 was to affect Picasso's work profoundly.

At the turn of the century, Picasso synthesised the rich palette of El Greco with the atmospheric imagery of the Symbolist generation before embarking upon the experimentation of his Blue Period, Cubism and beyond. The dealers Ambroise Vollard, Sala Parés and Berthe Weill held

particularly struck by the rural paintings of Bastien-Lepage. A decade later he returned, exhibiting *The Mirror of Life* (1895–98, cat. 2), and admiring Barbizon and Impressionist landscapes. Symbolist overtones filtered into his work; for Pellizza, realist subject matter was the starting point in a search for universal meanings. In June 1907, overwhelmed with grief at the deaths of his youngest child and of his wife and muse and unable to bear the responsibility of looking after his two daughters and his ageing parents, he hanged himself in his studio. CT

Pellizza da Volpedo, exh. cat., Galleria Civica d'Arte Moderna e Contemporanea, Turin, 1999

A. Scotti, *Pellizza da Volpedo: Catalogo generale*, Milan, 1986

JOHN F(REDERICK) PETO
(1854–1907)

Peto was born in Philadelphia and enrolled at the Pennsylvania Academy of the Fine Arts in 1877, at the time when this institution was entering the ascendancy of the realist artist Thomas Eakins.★ By then, Peto had already embraced still-life painting. Peto's still-lifes, from the *nature mortes* to the *trompe-l'oeil* rack paintings, are carefully constructed assemblages of objects relating to American daily life. These works address notions of artifice and representation, while also commenting on the materialism of the turn-of-the-century United States.

During the 1880s Peto produced 'office board' rack pictures. In these formal compositions he utilised shallow pictorial space to increase the illusion of depth. From about 1885 he painted richly coloured table-top *nature mortes* and sombre *trompe-l'oeil* scenes that employ a cupboard door format. His still-lifes featuring a violin and his 'bookshelf' images generally also post-date the mid-1880s. In 1889 Peto moved to Island Heights, New Jersey.

From about 1894 until the early 1900s, Peto also returned to rack paintings and created a number of stretcher-bar, illusionistic compositions depicting the verso of a framed canvas. Frequently autobiographical in nature, Peto's archival collections of fragments, from a worn photograph of Abraham Lincoln to scraps of newspaper to a battered cup, evoke nostalgia and – as with seventeenth-century Dutch *vanitas* paintings – allude to the ephemeral nature of life. Peto's production tapered off around 1905 and, plagued by Bright's disease, he died suddenly while visiting New York. VG

J. Drucker, 'Harnett, Haberle, and Peto: Visuality and Artifice among the Proto-Modern Americans', *The Art Bulletin*, 74, no. 1, March 1992; pp. 37–50

J. Wilmerding, *Important Information Inside: The Art of John F. Peto and the Idea of Still-Life Painting in Nineteenth-Century America*, New York and Washington, DC, 1983

Pablo Picasso, 1904

spent most of his time with fellow artist Manuel Pallarés. Having spent the summer in Horta de Ebro in 1898, he returned to Barcelona. He became a regular at Els Quatre Gats café, associated with the Catalan Modernist movement, and mounted an exhibition of 150 portrait drawings there in 1900.

exhibitions of Picasso's work in 1902. Picasso died in Mougins. CO'M

M.-L. Bernadec and C. Piot, eds, *Picasso Écrits*, Paris, 1989

J. Richardson, *A Life of Picasso*, vol. 1 (1881–1906), London, 1991

Ramón Pichot, 1913

Camille Pissarro

GAETANO PREVIATI
(1852–1920)

Hailed by Umberto Boccioni in 1916 as 'the greatest artist that Italy has had from Tiepolo until today', Previati was admired by the Futurists for the visionary quality of his painting and for his modernity. Born in Ferrara, he studied at the Accademia di Belle Arti di Brera in Milan where he received a firm grounding in drawing. Previati's links with the Scapigliati inspired him to tackle historical themes of a dramatic and fantastical nature on an imposing scale. He illustrated literary works by Edgar Allan Poe and Alessandro Manzoni; Dante, and later Gabriele D'Annunzio, also inspired his subject matter. Previati began to mix in Divisionist circles after meeting Vittore Grubicy★ in 1899 and, later, Segantini.★

In his search for a new painterly language to symbolise the 'ideal' nature of an image, whether religious, mythological or cosmic, Previati was embraced by the Symbolists but criticised by opinion-makers. During the 1890s, his critical fortune improved dramatically as a result of both his development as a Divisionist and Symbolist, and the marketing strategies adopted by his dealer. Years of financial instability came to an end in 1899 when Previati signed a contractual agreement with Alberto Grubicy's gallery. As a leading exponent of the Milan Divisionist School of painting, his writings on technique and theory were especially important. From 1905 he concentrated on formulating his theories with *La tecnica della pittura* (Turin, 1905) and its sequel *I principi scientifici del divisionismo* (Turin, 1906). He died in Lavagna. CT

F. Mazzocca, ed., *Gaetano Previati 1852–1920*, exh. cat., Palazzo Reale, Milan, 1999

RAMÓN PICHOT GIRONÉS
(1871–1925)

Pichot was born in Barcelona. He was the brother of the renowned singer María Pichot de Gay. He began his career with the 'Saffron Group', so-called because of the yellow tones that were predominant in their work. In 1895 he visited Paris and there he studied by himself and exhibited at the Salon. In 1898 he travelled through Andalusia with Santiago Rusiñol★ to paint *plein-air* landscapes and other genre subjects. The works that resulted from this long trip were shown in Madrid and in Barcelona and consolidated his reputation.

Pichot was also part of the group of painters who integrated Catalan Modernism and attended the gatherings of Els Quatre Gats. At the beginning of the century he established himself finally in Paris, where his work developed in parallel with that of his friend Pablo Picasso.★ Nevertheless, Pichot returned frequently to Madrid and Barcelona, and exhibited at such galleries as the Galería Dalmau. He died in Paris. EL

M. L. Borrás i González, *Ramón Pichot*, Barcelona, 1997

R. Santos Torroella, *Ramón Pichot*, Barcelona, 1986

(JACOB-ABRAHAM-) CAMILLE PISSARRO
(1830–1903)

Pissarro was born in St Thomas, in the Danish Virgin Islands. The son of a Jewish shop-keeping family, he was befriended by the Danish artist Fritz Melbye with whom he set up a tropical studio in Venezuela between 1852–54. He settled in Paris in 1855 and began his more formal education by studying the works in the 1855 Exposition Universelle and the Louvre, and by enrolling privately at the Ecole des Beaux-Arts and the Académie Suisse, where he first met Cézanne,★ Monet★ and Armand Guillaumin. Pissarro sent many works to the Salon and most were accepted until 1870 when he fled to London during the Franco-Prussian War. He was the only artist to show at all eight Impressionist exhibitions. His bold brushwork and large-scale panoramic compositions of the 1860s gave way in the late 1870s, when he was working closely with Cézanne, to a constructive system of even touches. Degas★ encouraged him to explore the print media at this time, and both he and Gauguin★ refocused Pissarro's attention upon figure subjects. Meeting Signac and Seurat in 1885 inspired Pissarro to adopt the Pointillist technique and begin the search for luminosity which dominates his work throughout the 1890s. Always a man of the left, he became deeply committed to the anarchist cause late in life, financing and illustrating anarchist journals. He died in Paris. CO'M

J. Bailly-Herzberg, ed., *Correspondance de Camille Pissarro 1865–1894*, vols 1–4, Paris, 1980–89; vol. 5, St Ouen-l'Aumone, 1991

Camille Pissaro 1830–1903, exh. cat., Hayward Gallery, London; Museum of Fine Arts, Boston; Grand Palais, Paris, 1980

Gaetano Previati

ODILON (BERTRAND-JEAN) REDON
(1840–1916)

Redon was born in Bordeaux. In his youth, spent on his family's estate at Peyrelebade in the Médoc, Redon studied drawing with Stanislas Gorin while the botanist Armand Clavaud introduced him to the wonders of nature and the world of literature, both of which were to fuel his imagination.

After entering the studio of
Gérôme* in Paris, Redon returned
to Bordeaux where he was
befriended by the engraver
Rodolphe Bresdin. He served in
the Franco-Prussian War and then
settled in Paris and began to
produce the mystical charcoal
drawings which he called *Noirs*.
From his first album of lithographs,
Dans le rêve (1879), until the turn of
the century, Redon's main artistic
endeavours involved the translation
of these private drawings into
twelve more widely available
albums of lithographs, often
inspired by or accompanying
Symbolist texts.

Redon exhibited at all the
leading independent art venues in
the 1880s, including the last
Impressionist exhibition, Les XX
in Brussels, the Vienna Secession
and the Salon des Indépendants. He
was also a Symbolist author. His
reputation with the next generation
of artists was assured by a one-man
show with Durand-Ruel in 1899
and a large display in the Salon
d'Automne of 1904. From the
1890s, Redon began to abandon
his monochrome drawing forms to
adopt the radiant colour of his late
paintings. He died in Paris. CO'M

O. Redon, *A soi-même: journal
 (1867–1915)*, Paris, 1922
Odilon Redon, exh. cat., Art Institute
 of Chicago; Van Gogh Museum,
 Amsterdam; Royal Academy of Arts,
 London, 1994–95

(PIERRE-)AUGUSTE RENOIR
(1841–1919)
Renoir was born in Limoges. One
of seven children born into a family
of tailors, he was first apprenticed
to a porcelain painter. Influenced
both by his studies in the Louvre
and with Charles Gleyre and
Narcisse Diaz, he attended the
Ecole des Beaux-Arts from
1862–64. Renoir exhibited
regularly at the official Salon
throughout his career and in the
first three Impressionist exhibitions.
He held a one-man show at the
gallery of the dealer Paul Durand-
Ruel in 1883. His favourite subjects
were the figure, both as portrait
and nude, the landscape and the
still-life. By the 1880s, he had
become affluent. He travelled
widely, visiting North Africa, the
Channel Islands and touring
throughout France.

Odilon Redon,
photographed by Dornac

Auguste Renoir,
photographed by Dornac

Profoundly affected by seeing
Antique sculpture and the work of
Raphael on a trip to Italy in 1881,
Renoir solidified the radiant palette
and feathery touch of his early
Impressionist days, placing a greater
emphasis on contour and line.
In later years, while suffering from
agonising arthritis, he focused
inward, creating monumental
nudes and loving portraits of his
family. Inspired by a renewed
interest in the Rococo and by
Rubens, he again reformulated
his touch, softening his line and
warming his palette. His French
reputation was confirmed in 1900
when he received the Légion
d'honneur. American collectors
avidly sought his work. He died
in Cagnes-sur-Mer. CO'M

C. Bailey, *Renoir's Portraits: Impressions
 of an Age*, National Gallery of
 Canada, Ottawa; Art Institute of
 Chicago; Kimbell Art Museum,
 Fort Worth, 1977–78
A. Distel and J. House, *Renoir*, exh. cat.,
 Hayward Gallery, London; Grand
 Palais, Paris; Museum of Fine Arts,
 Boston, 1985

IL'YA (YEFIMOVICH) REPIN
(1844–1930)

Along with Grigory Myasoyedov, Ivan Kramskoy, Vasily Perov and Nikolay Ge, Repin came to the fore as a leading representative of the 'Association of travelling art exhibitions'. They were known as the Wanderers, the Peredvizhniki, on account of their fervent desire to record realistically the conditions of life for ordinary people in the vast Tsarist domains, rather than to produce grandiloquent history painting or effete conversation pieces.

Born into an impoverished soldier's family in Chuguyev, a small town in the Ukraine, Repin endured privation in childhood, but managed to win backing to study in St Petersburg at both the Imperial Academy of Fine Arts and the unofficial Kramskoy academy. Between 1873 and 1876 Repin travelled in Europe, and in Paris was influenced by the work of Manet and the early Impressionists. His images of Volga barge-haulers and labourers in a naturalistic style are indebted to the French artists, but also draw on his childhood experiences. Repin began to work *en plein air*, and this is evident in such peasant themes as the majestic *Religious Procession in Kursk Province* (1883).

In the 1890s his work became less startling, although his portraiture always remained psychologically vivid. After the collapse of the 1905 Revolution, Repin's democratic sympathies made him uncomfortable in Russia and he established himself in Finland, associating with Akseli Gallén-Kallela★ and the Young Finland group. JM

D. V. Sarabianov, *Russian Art: From Neoclassicism to the Avant-Garde*, London, 1990

LAURITS ANDERSEN RING
(1854–1933)

Born Laurits Andersen, Ring took the name of his birthplace. Like Ejnar Nielsen,★ he was first trained as a house-painter, and his work among the villages and rural farmsteads of Zealand in southeast Denmark supplied him with experience that he drew upon throughout his subsequent landscape painting career. From

Laurits Andersen Ring, photographed by Frederic Riise, 1896

1875 to 1877 he studied at the Kongelige Akademi for de Skønne Kunster in Copenhagen, and briefly attended the Independent Artists' Study School.

Poverty afflicted him throughout the 1880s and this is reflected in much of his work. A breakthrough occurred in 1889 when he accompanied the influential art historian, Karl Madsen, to the Exposition Universelle. Ring's social-realist proclivities drew him to the work of Millet and Jean-Francois Raffaëlli on display and their influence thereafter is noticeable.

This first journey abroad heralded a restless few years in the 1890s, as though Ring was making up for lost time. Although he stayed in Italy in 1893–95, he eventually returned to Denmark, where a happy marriage (from 1896) helped him to alleviate the periodic bouts of depression that had frequently hampered his work in his youth. From 1898 to 1902 he lived in the Frederiksværk locality of north Zealand, the 'classical' country of Denmark's Golden Age painters P. C. Skovgaard, Vilhelm Kyhn and Johan Thomas Lundbye. Ring's own calm, luminous landscapes from *c.* 1900 reflect his knowledge of and admiration for those artists. He died in St Jørgensbjerg. JM

I. V. Raaschou-Nielsen and J. P. Munk, eds, *L. A. Ring, 1854–1933*, with articles by H. Finsen and E. K. Mathiesen, Ordrupgaardsamlingen, Copenhagen, 1984

Tom Roberts, before 1903

EUGÈNE ROBERT
(*c.* 1835–1912)

Robert was born in Pau. A student of Mathurin Moreau, Robert made his début at the Salon of 1874. He was a member of the Salon des Artistes Français from 1887, and received honourable mentions at the Salons of 1880, 1881, 1884 and 1885 and in the 1889 Exposition Universelle. He was awarded a third class medal at the Salon of 1888 and a silver medal in the 1900 Exposition Universelle. He was also made a Chevalier of the Légion d'honneur.

The sculptural medium, so much associated with honorary and monumental idioms or private *objets d'art*, was employed by Robert to explore the narrative and emotive potential of a public modern sculpture rooted in private sensibility. While striving for naturalistic representation he also evoked philosophical abstractions such as vulnerability and the collective shame of degradation. *The Awakening of the Abandoned Child* (1894, cat. 121) reflects a new willingness in the nineteenth century to portray the unheroic in sculpture. The colossal baby and its distress offer a public rhetoric of social critique and empathy while appealing to the inner experience of the viewer. CO'M

No bibliographic references known

TOM (WILLIAM) ROBERTS
(1856–1931)

Undoubtedly one of the most important figures in Australian art, Roberts was born in Dorchester,

England, and travelled to Australia with his widowed mother in 1869. He earned his living in Melbourne as a photographer before studying at the Melbourne National Gallery School. In 1881 he returned to London and entered the Royal Academy Schools. In the summer of 1883 he toured France and Spain, where he met two artists who had studied in Paris, Loreano Barrau and Ramon Casas. This encounter encouraged Roberts to visit Paris in about 1884 where he briefly attended the Académie Julian.

Roberts was the first Australian artist to come into contact with French Impressionism and when he returned to Melbourne in 1885 his new Impressionist style had a profound effect on his fellow artists such as Frederick McCubbin, Charles Conder and Sir Arthur Streeton. Working out-of-doors, these artists sought to capture Australian contemporary life by depicting people both in vast landscapes and the animated streets of the city.

In 1886 he was a founder member of the Australian Artists' Association and in 1888 moved into purpose-built studios at Grosvenor Chambers in Melbourne with many other artists, including Clara Southern,★ from the mid 1880s. He organised the '9 × 5' Impression Exhibition of 1889, which included sixty-two of his own works. In 1890 he completed

(opposite) Il'ya Repin in his studio, 1909

Shearing the Rams, his most famous picture. He travelled extensively in Australia in the 1890s, painting many landscapes and rural subjects.

Roberts was commissioned to paint the opening of the first Federal Parliament by HRH the Duke of Cornwall and York, and in 1901 returned to England to complete this work which contained more than 250 portraits and took two years to paint. While in Europe he exhibited at the Royal Academy of Arts in London and at the Paris Salon. He settled permanently at Kallista in Australia from 1923. HV

J. Clark and B. Whitelaw, *Golden Summers: Heidelberg and Beyond,* exh. cat., National Gallery of Victoria, Melbourne, 1986

V. Spate, *Tom Roberts*, Melbourne, 1978

H. Topliss, *Tom Roberts 1856–1931: A Catalogue Raisonné*, 2 vols, Melbourne and Oxford, 1985

(FRANÇOIS-)AUGUSTE (-RENÉ) RODIN (1840–1917)

Rodin was born in Paris. He was a pupil of Horace Lecoq de Boisbaudran between 1854–57. Failure in the entrance exam to the Ecole des Beaux-Arts led him to study with Antoine-Louis Barye. Rodin worked as an ornamental mason before becoming a studio assistant to Albert-Ernest Carrier-Belleuse on the Brussels Bourse de Commerce project of 1871. He also worked for the Sèvres porcelain factory between 1879–82.

Rodin travelled to Italy where he immersed himself in the grandeur and freedom of Michelangelo. The extraordinary anatomical accuracy of his early works led to accusations that he copied life-casts, and the torsion and abstraction of his late manner also often led to controversy. He achieved expressive effects through disproportion, fragmentation, contorted poses and figures unfreed from the block. His often highly eroticised life drawings were a key part of developing these techniques. Rodin received many prestigious commissions for monuments to creative men such as Claude Lorrain, Victor Hugo, Honoré de Balzac and Pierre Puvis de Chavannes as well as private imaginative subjects. *The Gates of Hell* (1880–1925) an ornamental doorway for the proposed Musée des Arts Décoratifs, synthesised his explorations, incorporating versions of many of his best-known independent works, such as his passionate yet unusually harmonious *The Kiss* (cat. 30). Rodin transfigured the assured forms and pious themes of Ghiberti's Gates of Paradise of the Baptistery in Florence into a multi-figured and turbulent evocation of Dante's voyage into hell as a metaphor for the human psyche at the *fin de siècle*. He died in Meudon. CO'M

R. Butler, *Rodin: The Shape of Genius*, New Haven and London, 1993

ALFRED(-PHILIPPE) ROLL (1846–1919)

Roll was born in Paris. His fellow students at the Ecole des Beaux-Arts in Paris included Henri-Joseph Harpignies, Léon Bonnat and Jean-Léon Gérôme.★ Having made his Salon début in 1870, Roll was made a Chevalier of the Légion d'honneur in 1883. He was a founder member of the Société Nationale des Beaux-Arts where he mainly exhibited. Much sought after as a society portraitist, he strove to capture every echelon of French society in his elaborate panoramic scenes of modern life. While championing the demo-cratic ideals implicit within the Third Republic, his celebratory

Auguste Rodin,
photographed by M. Bauche at the de l'Alma exhibition, Pavillon de l'Alma, Paris, 1900

Alfred Roll, 1910

records of events knowingly reveal the cracks in the new order as well as its merits. His many civic mural decorations, such as *Flowers, Women and Music* (1895) and *Movement, Work and Light* (1905) for the Introduction Room of the Hôtel de Ville in Paris, reveal the complex confrontation of ideal and real which underpinned his virtuosity of finish and vibrant colour. Roll attempted to create a viable form of modern history painting which could express profound experiences, such as passion or human endeavour, through a viscerally evocative use of contemporary detail. His paintings allow naturalist technique, Republican ideals and Symbolist spirituality to coalesce comfortably yet in a challenging way, evoking the quintessential dichotomies of art and society in belle-époque France. Roll died in Paris. co'm

C. I. R. O'Mahony, 'Municipalities and the Mural: The Decoration of Townhalls in Third Republic France', PhD thesis, Courtauld Institute of Art, London, 1998

MEDARDO ROSSO
(1858–1928)

Born in Turin, Rosso received no known official artistic training. His 1881 Milan début revealed an interest in French realism. A subsequent enrolment at the Accademia di Belle Arti di Brera in 1882 ended in expulsion. During the following years in Milan, he began casting in wax and developed an unprecedentedly fluid handling. He personalised the innovations of Impressionist

Medardo Rosso, *c.* 1900

painting and sculpture but infused his works with an emotional charge foreign to Impressionist art; of note are *The Concierge* (1883), *Flesh of Others* (1883) and *Golden Age* (1886). He also experimented with large-scale sculpture and funerary art.

Favourable French reviews convinced him to move to Paris in 1889, where he made his greatest masterpieces (including *Impression of the Boulevard. Woman with a Veil*, 1893, cat. 131), subtly modelled heads of children and women, figurines, and unusual portraits of well-known Parisian personalities, such as Henri Rouart and Yvette Guilbert. He befriended Rodin,★

although the friendship soured after some accused Rodin of having appropriated ideas in Rosso's *After the Visit* (1889) and *Bookmaker* (mid-1890s) for his own work *Honoré de Balzac* (1898).

After exhibiting at the Exposition Universelle in 1900, Rosso consolidated his following of progressive critics, artists, poets and collectors. In 1904, the critic Julius Meier-Graefe wrote, '[Rosso's] art could have only developed in Manet's age, but it is perfectly independent,' characterising the difficulty in finding a suitable artistic category for Rosso. He exhibited and sold throughout Europe, although he made only

one new sculpture, *Ecce puer* (1906), after the turn of the century.

In later years, he recast his extremely small œuvre in new variations and created haunting photographs of his objects. After 1910, Rosso, a French citizen, attempted to rebuild his reputation in Italy. He continued to travel between Italy and France until his death in Milan. SH

Medardo Rosso, exh. cat., Centro Gallego de Arte Contemporánea, Santiago de Compostela, 1996

J. Meier-Graefe, 'Medardo Rosso' in *Modern Art, Being a Contribution to a New System of Aesthetics*, London, 1908; orig. pub. *Entwicklungsgeschichte der modernen Kunst*, Stuttgart, 1904

Sir William Rothenstein, photographed by Frederick Hollyer

SIR WILLIAM ROTHENSTEIN
(1872–1945)

Born in Bradford, Rothenstein attended the Slade School of Art in London from 1888–89 and then the Académie Julian in Paris from 1889–93. During his time in Paris he met and befriended a wide range of artists, including Whistler,★ Degas,★ Camille and Lucien Pissarro,★ Puvis de Chavannes and Toulouse-Lautrec.★ In 1899, stimulated by the contemporary interest in seventeenth-century Spanish artists, Rothenstein travelled to Spain and Morocco. He painted his first landscape at Giverny in 1890 and published a book on Goya in 1900.

From 1900 Rothenstein, like Orpen,★ worked on a series of realistic interior subjects, some of which were straightforward domestic scenes, such as *The Browning Readers* (1900, cat. 161), while others, *A Doll's House* (1899–1900, cat. 148) for example, were vaguely sinister. Portraiture also became an important part of his artistic practice, and from 1893 he published a series of lithographic portrait studies. He exhibited at the New English Art Club from 1894 and also became involved in the management of the Carfax Gallery, London.

Rothenstein visited India in 1910 and an exhibition of his Indian works took place at the Chenil Gallery, London, on his return. He served as an Official War Artist during both World Wars, serving on the Western Front in the First and with the

Henri Rousseau in his studio

RAF in the Second. He also helped to develop the Official War Artists scheme in its early years. He was appointed Principal of the Royal College of Art in 1920 and remained in the post until 1935. He was knighted in 1931. From 1912 until his death he lived at Far Oakridge, Gloucestershire, and painted many landscapes there. HV

W. Rothenstein, *Men and Memories*, 2 vols, London, 1931–32
W. Rothenstein, *Since Fifty*, London, 1939
J. Thompson, ed., *Sir William Rothenstein, 1872–1945: A Centenary Exhibition*, exh. cat., Cartwright Hall, Bradford, 1972

HENRI(-JULIEN-FÉLIX) ROUSSEAU
(1844–1910)

Rousseau was born in Laval. He was self-taught, and copied works in the Louvre from 1884. His naively executed yet imaginatively conceived art was often inspired by popular illustrations. After serving in the infantry (he never left the French mainland despite the legends that he promoted), he became a toll clerk at Paris's city walls, hence his nickname 'Le Douanier', given to him by the poet and wag Alfred Jarry.

Rousseau's visits to the Jardin des Plantes and the international pavilions at the Exposition Universelle of 1889 provided him with safely contained models for his exotic flora and fauna. He had works accepted by the official Salon and showed regularly, due to Signac's encouragement, at the Salon des Indépendants, which held a posthumous retrospective of his work. He later exhibited with the Fauves at the Salon d'Automne. The influential Cubist dealer Wilhelm Uhde and Max Weber were champions of his work.

A flatness of execution and the thick simplicity of his colour give his paintings a totemic feeling, in keeping with the spiritualist

ambitions of the Symbolists, particularly Gauguin.★ Rousseau painted portraits of many of the key figures in the Modern movement including Apollinaire and Marie Laurencin. His exotic primeval jungle scenes offer enigmatic juxtapositions of languid yet static nudes with threatening beasts in a prefiguration of the explorations of folklore and the unconscious undertaken by the Surrealists, and Kandinsky★ and Picasso.★ Rousseau died in Paris. CO'M

Le Douanier Rousseau, exh. cat., Museum of Modern Art, New York; Grand Palais, Paris, 1984

Julio Ruelas, *Self-portrait*, 1902

JULIO RUELAS
(1870–1907)
During his brief lifetime Ruelas created paintings and an impressive number of illustrations which bear a strong relationship to the works of the European Symbolists. Arguably one of Mexico's early Modernists, his fantastic imagery, eroticised women, and startling visual juxtapositions have also often led him to be cast as a proto-Surrealist. Born in Zacatecas, Ruelas first studied art at the Academia de San Carlos in Mexico City. In 1892 he went to Germany and enrolled at the Kunstschule in Karlsruhe. This trip was of great importance to his development as it afforded him exposure to European artistic currents. Some have suggested that he was particularly influenced by Arnold Böcklin.

Ruelas returned to Mexico City in 1895. There he broke with the existing academic tradition and allied himself with a group of avant-garde artists and writers who together founded the radical *Revista Moderna* in 1898, its decadent subject matter undoubtedly shocking the moralistic societal conventions of *fin-de-siècle* Mexico. Over time Ruelas supplied approximately 400 illustrations for this journal, favouring a sinewy black line and forms that emphasise the pictorial plane, in transgressive images that reveal an affinity with the work of Félicien Rops. Both Ruelas's paintings and his graphic work treat, among other themes, *femmes fatales*, mythological motifs, and profane as well as satanic subjects. In 1905 Ruelas visited Paris where he learned to etch. He died there of tuberculosis at the age of thirty-six. VG

T. del Conde, *Julio Ruelas*, Mexico City, 1976

Santiago Rusiñol, 1930

SANTIAGO RUSIÑOL
(I PRATS)
(1861–1931)
The undisputed and charismatic leader of Catalan Modernism, Rusiñol was born in Barcelona. He studied at the academy of Tomás Moragas, although he was essentially self-taught. In 1889 he went to Paris with Miguel Utrillo, Ramón Casas and Enrique Clarassó, returning the following year with Casas. In Paris, they settled at the Moulin de la Galette and started to paint suburban views of the city. During this period he studied at the Academie Gervex, where he was taught by Puvis de

Ferdynand Ruszczyc, photographed by Jadwiga Golcz, Warsaw, 1902

Chavannes and Eugène Carrière.★ He also met the Spanish painter Ignacio Zuloaga.★ The works he executed during this Parisian period introduced Impressionism into Catalan art and are symptomatic of Catalonia's cultural renewal. Rusiñol thereafter maintained his cultural links with the city through frequent trips.

At the turn of the century Rusiñol established himself in Barcelona, and became co-founder and an active participant in the discussion groups at Els Quatre Gats, while continuing to show at the official Salons in Paris and also at the Salon des Indépendants. In Sitges he established the Cau Ferrat Museum, where he organised Modernist parties, popular with writers and artists. Rusiñol was known not only as painter but also as a writer and playwright, and was co-founder of the Catalan review *Pel & Ploma*, writing almost always in Catalan. From about 1900 the subject matter of his painting was almost entirely devoted to the depiction of gardens in Spain. Rusiñol died in Aranjuez. EL

I. Cou, *Rusiñol*, Sant Sadurní de Noya, 1990

Santiago Rusiñol, exh. cat., Generalitat Catalunya, Barcelona, 1981

J. Socias i Palau, *Rusiñol*, Barcelona, 1980

FERDYNAND RUSZCZYC
(1870–1936)
Ruszczyc was born near Vilna (now Vilnius, Lithuania), of a Danish mother whose background influenced the direction of his art towards the northern Romantic landscape tradition later in life. After starting his academic career in law at St Petersburg, he switched to art at the Imperial Academy of Arts there in 1892, studying with the Russian naturalist landscape artist Arkhip Kuindzhi from 1895. Associating with the Wanderers, Ruszczyc travelled widely in the 1890s – to the Crimea, and then the Baltic Coast (1894 and 1895),

visiting Rügen (where Caspar David Friedrich had painted), the southern parts of Sweden and Berlin. After graduating in 1897, Ruszczyc settled on the family estate near Vilna, but in 1898 he travelled to Germany, France, Switzerland and Italy.

Ruszczyc was deeply involved with 'Sztuka', the Association of Polish Artists, joining it in 1900 and becoming its President in 1907. He was a founder-member of the Warsaw School of Fine Arts in 1903 and taught there for four years, before succeeding Jan Stanislawski★ in the professorship of landscape painting at Kracow University in 1907.

The following year Ruszczyc returned to Vilna, teaching at Batory University from the end of World War I. He relinquished painting for book and theatre design in later years, but remained an enthusiastic teacher until ill-health forced his retirement in 1932. He died in Bohdanów. JM

J. Ruszczycowna, ed., *Ferdynand Ruszczyc: Pamietnik wystawy (Exhibition Diary)*, Warsaw, 1966

Nineteenth-Century Polish Painting, National Museum, Warsaw; National Academy of Design, New York, 1988

Albert Rutherston, Self-portrait aged 16

ALBERT RUTHERSTON
(1881–1953)
Albert Rutherston, born Albert Rothenstein, was the younger brother of the better-known Sir William Rothenstein.★ He changed his name in 1916 for political reasons. He studied at the Slade School of Art in London from

Augustus Saint-Gaudens

1898–1902 with his contemporaries and friends Spencer Gore, Harold Gilman and William Orpen.★ He began exhibiting at the New English Art Club in 1901 while he was still a student and his work of this period is characterised by sombre tones.

In the early 1900s he often spent holidays in France with Gore, and in 1907 in London took a studio with Gore, Gilman and others at 19 Fitzroy Street. They soon became known as the Fitzroy Street Group and it was from this studio that the Camden Town Group developed. From *c.* 1910 Rutherston began to experiment in murals and book illustration, as well as designing costumes and scenes for the theatre and ballet between 1912–14. His first one-man show in 1910 at the Carfax Gallery, London, included his early experiments with watercolour on silk. By 1912 he had abandoned oil painting and only resumed it in 1938.

In 1929 he was appointed Ruskin Master of Drawing at Oxford University and held the post until 1948. He founded the Pottery Group in 1936 with Duncan Grant, Vanessa Bell, Graham Sutherland, Paul Nash and Ben Nicholson. He died in Switzerland. HV

M. Rutherston, *Albert Rutherston, 1881–1953*, London, 1988

AUGUSTUS SAINT-GAUDENS
(1848–1907)
Saint-Gaudens was born in Dublin, Ireland, but raised in New York. His Beaux-Arts sculpture – from the commemorative monuments to the relief portraits – dominated the American Renaissance. Saint-Gaudens began his artistic pursuits as a cameo cutter. In 1867 he went to Paris and, in 1868, enrolled at

John Singer Sargent, photographed by J. E. Purdy of Boston, 1903

the Ecole des Beaux-Arts, learning to work in bronze, his favoured medium.

He received his first significant commission in 1876, for the *Farragut Monument* in New York (1877–80), the earliest of his collaborative memorials with the architect Stanford White. In the wake of this success, the 1880s proved fruitful for the artist, who divided his time between Europe and New York. His commissions included the *Memorial to Robert Gould Shaw* in Boston (1884–97), a life-size relief depicting the Civil War colonel and his marching African-American regiment, and the *Adams Memorial* in Washington, DC (1886–91), a funerary monument of a draped, androgynous figure, remarkable for its silent, meditative posture. Both these sculptures illustrate the masterful naturalism and fluidity of line which characterises Saint-Gaudens's *œuvre*.

In 1892 Saint-Gaudens obtained the commission for the *Sherman Monument* in New York (1892–1903), a heroic-size, equestrian statue led by a winged Victory – the latter exemplifying the monumental allegorical women he produced throughout his career. Saint-Gaudens was elected Director of Sculpture for the 1893 Chicago World's Columbian Exposition. By 1900, he was probably the most celebrated of American sculptors and had received many honours. He went on to earn a grand prize at the 1900 Exposition Universelle and two gold medals at American expositions. He maintained a studio at Cornish, New Hampshire, where he died. VG

J. H. Dryfhout, *The Work of Augustus Saint-Gaudens*, Hanover and London, NH, 1982

K. Greenthal, *Augustus Saint-Gaudens: Master Sculptor*, exh. cat., Metropolitan Museum of Art, New York, 1985

JOHN SINGER SARGENT
(1856–1925)

Sargent was described by Rodin★ as the 'Van Dyck of our times' because of his extraordinary production of lush, painterly portraits of English and American society. Born in Florence, Sargent led the peripatetic existence of an American expatriate. In 1874 he went to Paris where he studied at the Ecole des Beaux-Arts and with Carolus-Duran,★ a champion of tonal realism and the work of Velázquez.

On his travels through Europe and North Africa, Sargent identified exoticising subjects for his early paintings, such as the Spanish dancers of *El Jaleo* (1882). Already evident are his rapid style of execution, evoking movement and a sense of immediacy, and his facility in rendering light. In 1883–84, Sargent painted the daring portrait *Madame X* (Mme Gautreau), provoking a scandal at the Paris Salon which compelled him to move to London in 1886.

In London, Sargent met Isabella Stewart Gardner through Henry James; both were instrumental in launching him in their native Boston. At about this time, Sargent also began working with the brighter palette and freer brushwork associated with Impressionism. Not limiting himself to easel painting, in 1890 Sargent secured the commission for the Boston Public Library murals.

By the mid-1890s, Sargent had attained success in London and in 1897 he became a Royal Academician. Around 1900 Sargent was a flourishing portrait painter, producing full- and three-quarter-length pictures of the élite. However, in 1907, he virtually abandoned portraiture to dedicate himself to landscapes (primarily watercolours) and murals. Just before his death in London, he had completed the final panels for the Boston Library. VG

P. Hills, ed., *John Singer Sargent*, exh. cat., Whitney Museum of American Art, New York, 1986

E. Kilmurray and R. Ormond, eds, *John Singer Sargent*, exh. cat., Tate Gallery, London, 1998

Giovanni Segantini with his wife, 1887

GIOVANNI SEGANTINI
(1858–1899)

Honoured posthumously with an exhibition in the Italian pavilion at the Exposition Universelle, and immortalised in bronze at the age of thirty-eight by Prince Paolo Troubetzkoy,★ Segantini commanded high prices, spent prodigiously and incurred severe debts. Originally called Segatini, he was born in Arco, near Trento, in 1858. After a tragic childhood marked by poverty, rebellion and romantic self-mythologising, he studied at the Accademia di Belle Arti di Brera in Milan, initially attending evening classes only, switching to full-time study after 1878. Critically acclaimed at the Esposizione Nazionale di Brera in 1879, he was befriended by Vittore Grubicy,★ his dealer from 1883.

In 1880, on Grubicy's advice, Segantini left for the Brianza region with his companion Bice Bugatti. Encouraged to paint *en plein air*, Segantini broke away from academicism and advanced towards Divisionism: the second version of *Mary Crossing the Lake* (1886) was painted under Grubicy's supervision using this new technique. Segantini's landscapes are characterised by sweeping panoramas and intense lighting. In 1888 the Grubicy Gallery showed his work at the Italian Exhibition in London. From 1889 he began to paint his first Symbolist works, to the detriment of his friendship with Vittore. Cementing his allegiance to Alberto Grubicy, his international reputation extended

Valentin Serov, *c.* 1900

to Germany and Austria where he associated with the Viennese Secessionists.

From 1890, Segantini explored themes of motherhood, harmony and spirituality. In 1896 he embarked on a vast scenographic installation for the 1900 Exposition Universelle displaying the alpine splendour of the Engadine. Lack of funds prompted drastic revisions to the scheme. In its place he worked on the *Triptych of Nature*; the third panel *Death* remained incomplete when Segantini's own life was cut short by peritonitis in Schafberg, Switzerland. CT

A. P. Quinsac, *Segantini: Catalogo generale*, 2 vols, Milan, 1982

VALENTIN (ALEKSANDROVICH) SEROV
(1865–1911)

The son of the composer Aleksandr Serov, Valentin was born in St Petersburg. Before his tenth birthday, he had received lessons in Paris from Il'ya Repin.★ In 1875 he lived at Savva Mamontov's artists' colony at Abramtsevo. In 1880, still in his mid-teens, he returned to St Petersburg to study under Pavel Chistyakov at the Imperial Academy of Arts.

On one of many trips to Europe, Serov befriended Edgar Degas and was introduced to Impressionism. Throughout the 1890s he produced numerous canvases inspired by French Impressionism and the work of the Russian artists Konstantin Korovin★ and Repin. It was also during this decade that Serov established a considerable reputation as a portraitist. His sitters included his fellow artists Korovin and Isaak Levitan,★ and members of the St Petersburg élite, such as Maria Morosova, whom he painted in 1897 (cat. 100). Despite this interest in portraiture, Serov joined the Wanderers (Peredvizhniki) in 1894 and, five years later, was an active participant in the World of Art (Mir Iskusstva) group.

Officially made an Academician in 1898, Serov was an influential teacher both in St Petersburg and Moscow, and regularly exhibited works throughout Europe. Much inspired by Symbolism and the decorative qualities of Art Nouveau, Serov produced some of his most exciting work in the years immediately before his death in Moscow. MO'M

D. Sarab'yanov, *Valentin Serov*, New York, 1979

CHARLES (HAZELWOOD) SHANNON
(1863–1937)

Born in Sleaford, Lincolnshire, Shannon studied wood-engraving from 1881–85 at Lambeth School of Art, where he met his great friend and collaborator, Charles Ricketts.

Shannon exhibited oils and pastels at the Grosvenor Gallery and the New English Art Club in the 1880s and then made an agreement with Ricketts to withdraw from exhibitions to concentrate on print-making

Charles Shannon,
photographed by George C. Beresford,
1903

(lithography and wood-engraving).
He only exhibited again from the
late 1890s. He supported himself by
teaching at Croydon School of Art
and illustrating magazines and
books.

In 1889 Shannon and Ricketts
founded *The Dial*, a magazine
which ran until 1897. Shannon
also designed and illustrated
Daphnis and Chloe (1893) and *Hero
and Leander* (1894), the earliest
books published by Ricketts and
Shannon's Vale Press. *The
Fisherman and the Mermaid*
(1901–03), the first and most
powerful of Shannon's early full-
scale oil paintings, was derived
from his illustration to Oscar
Wilde's story, 'The Fisherman and
His Soul'. To their friend Wilde,
Ricketts and Shannon were known
as 'Orchid' and 'Marigold'.

The influence of the Venetian
Old Masters on Shannon's painting
style and subject matter is evident
in his work. He was elected ARA
in 1911 and RA in 1920. Seriously
injured when falling from a ladder
in 1929, he never fully recovered.
HV

J. Christian, ed., *The Last Romantics:
The Romantic Tradition in British Art*,
exh. cat., Barbican Art Gallery,
London, 1989
P. Delaney, *The Lithographs of Charles
Shannon*, London, 1978

WALTER RICHARD SICKERT
(1860–1942)

Sickert was born in Munich and his
family moved to England in 1868.
He worked as an actor with
repertory companies from 1878 for
about three years. His love of the
theatre remained with him and he
painted subjects from the music
halls throughout his life. He
attended the Slade School of Art
in London from 1881–82 and then
worked with James Abbott
McNeill Whistler★ as his assistant
and pupil.

In 1883 Sickert visited Paris and
from 1885 began making regular
visits to Dieppe. While in France
he met leading Impressionists such
as Monet,★ Gauguin,★ Bonnard,★
and, significantly for his
development as a draughtsman,
Degas.★ He joined the New
English Art Club in 1888 and, with
Philip Wilson Steer, led the group
which tried to oust the Newlyn
School painters. In 1889 the New
English Art Club organised its own
exhibition, 'The London
Impressionists', at the Goupil
Gallery. Sickert's subjects at this
time were urban scenes set in
Dieppe and the music halls of
London. From 1895 he wintered in
Venice and painted many scenes of
the city He settled in Dieppe in
1898. Around 1900 his style varied
between a painterly, 'Impressionist'
style and a more premeditated
approach often involving the
transfer of squared-up drawings
onto canvas.

He returned to London in 1905
and soon became the leader of the
group of urban realist painters who
became known as the Fitzroy Street
Group. In 1911 the more advanced
nucleus broke away to form the
Camden Town Group with Sickert
once more at its centre. These
artists were committed to painting
urban scenes, often of seedy
interiors, in a direct and
unglamorous manner.

Sickert moved to Bath in 1916
and then returned to Dieppe from
1919–22 before settling in 1926 in
England for good. Paintings from
the last period of his life were often
based on press photographs and
Victorian engravings and were very
broadly executed. An important
teacher and art critic, his writings
were published posthumously in
1947 in *A Free House!*. HV

Walter Sickert photographed with family and friends, Dieppe, 1911:
(standing, from left to right) Robert Sickert, Jacques-Emile Blanche, Walter Sickert,
Oswald Sickert, Charles Ginner; (sitting) Mrs Sickert, Christine Sickert, Percy
Wyndham Lewis, Leonard Sickert, H. Gilman, Eleanor Sickert

W. Baron and R. Shone, eds, *Walter
Sickert, Paintings*, exh. cat., Royal
Academy of Arts, London;
Rijksmuseum, Amsterdam, 1993
O. Sitwell, ed., *A Free House! Or the
Artist as Craftsman: Being the Writings
of Walter Richard Sickert*, London,
1947

JOHN SLOAN
(1871–1951)

Born in Lock Haven, Pennsylvania,
Sloan studied at the Pennsylvania
Academy of Fine Arts under
Thomas Anshutz. Sloan's early
career as an illustrator of
newspapers, books and advertising
posters is generally understood as
the background for the snapshot-
like scenes of everyday life that
characterise his work. In 1892,
Sloan met Robert Henri,★ who
became an important artistic
influence and a close friend. The
two artists also befriended William
J. Glackens, George Luks and
Everett Shinn in Philadelphia in
the 1890s. The group formed the
nucleus of the Ashcan School that
gained prominence in New York.
Sloan and his colleagues rejected
the teachings of the traditional
academies, seeking instead a more
vigorous, direct art that could
capture impressions of ordinary
life, often in the public sphere.
In contrast to the strictures of
academic art and to the light palette
of Impressionism, Sloan favoured
muted colours and broad
brushwork, revealing the influence
of Hals, Velázquez and Whistler.★

After Sloan moved to New
York in 1904, his painting was
characterised by street scenes.
These are often set in working-
class areas of the city, and portray
the inhabitants in an amused,
poetic and sympathetic manner.
Sloan's etchings and drawings,
including his work for the left-
wing journal *The Masses*, reflected
more explicitly his commitment
to social and political causes.

After 1913, Sloan developed
a brighter palette, and spent more
time on figure studies and
landscape. He taught at the Art
Students League, worked at the
artists' colonies of Gloucester,
Massachusetts, and Santa Fe,
New Mexico, and painted steadily
until his death in Hanover, New
Hampshire. SR

R. Elzea, *John Sloan: Spectator of Life*, exh.
cat., Delaware Art Museum, 1988
D. Scott, *John Sloan*, New York, 1975

John Sloan

Harald Sohlberg,
photographed by Olaf Kosberg, 1902

HARALD OSKAR
SOHLBERG
(1869–1935)
Sohlberg began his artistic career
as a decorative painter, but grew
more ambitious and gained
entrance to the Christiania (Oslo)
Arts and Crafts School aged
sixteen. Always an independent
figure and a lover of solitude, he
did not enjoy formal teaching, but
briefly took lessons with the
landscape painter Erik Werenskiold
and spent a few months in the
Copenhagen studio run by Kristian
Zahrtmann, 1891–92.

Travel grants to Paris in 1895–96
brought Sohlberg into contact with
the Symbolism then prevalent
there, and Caspar David Friedrich's
landscapes, seen in Berlin on the
way to Weimar, where he stayed
from 1896–97, exerted a major
influence. He first exhibited at the
Christiania Official Salon in 1894.

Sohlberg settled in Norway's
central highlands, first in a remote
spot near the Rondane mountain
range, frequently the subject of his
landscapes at this time, and later in
the small town of Roros. Further
trips to Paris followed early in the
new century and he eventually
settled near Christiania (by then
renamed Oslo). A number of his
images derived from skiing
excursions into the mountains:
he was an enthusiatic outdoorsman
and one of the most effective
painters of the luminous
Scandinavian summer night. JM
Dreams of a Summer Night, exh. cat.,
 Hayward Gallery, London, 1986
Ø. Storm Bjerke, *Harald Sohlberg:
 Ensomhetens maler*, Oslo, 1991

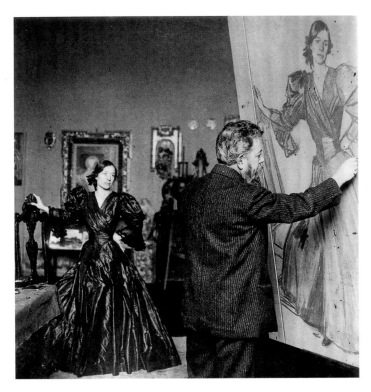

Joaquín Sorolla y Bastida

JOAQUÍN SOROLLA Y
BASTIDA
(1863–1923)
Sorolla was born in Valencia and
attended the city's Escuela de Bellas
Artes. During his early years Sorolla
was very influenced by the
luminosity of the painters of the
School of Valencia, including
Ignacio Pinazo Camarlech. In 1885,
after a visit to Madrid, where he
copied the works of Velázquez and
Ribera in the Prado, he went
briefly to Rome, and then to Paris.
Many of his studies and paintings of
Parisian streets and sites reflect the
strong impact of realist works by
such artists as Adolph Menzel and
Jules Bastien-Lepage.

Sorolla returned to Spain in
1889, and from then on he
concentrated on the depiction of
light. His paintings executed at
Biarritz during the summer of 1906
established him both as the master
of the beach scene and as a great
colourist; among his outstanding
works are those depicting the
beaches of the Levante coast.

Sorolla's international fame
resulted from his award of a first
class medal at the 1900 Exposition
Universelle. In 1911 he was
commissioned by the Hispanic
Society of America in New York
to decorate its library with scenes
recording Spanish regional costumes
and occupations. He also produced
many portraits of important Spanish
figures, some also commissioned by
the Hispanic Society. Sorolla died
in Cercedilla, Madrid. EL
E. Peel, *Joaquín Sorolla y Bastida*,
 Barcelona, 1996
*Sorolla y Zuloaga. Dos visiones para un
 cambio de siglo*, exh. cat., Fundación
 cultural Mapfre Vida, Madrid, 1998

AURÉLIA DE SOUSA
(1865–1922)
Born in Valparaiso, Chile, Aurélia
de Sousa emigrated to Oporto in
1871. She studied drawing with
Caetano da Costa Lima and
between 1893 and 1898 was the
pupil of João Marques de Oliveira
at the Escola de Belas-Artes in
Oporto. In 1900 she went to Paris
and attended the courses of Jean-
Paul Laurens and Benjamin
Constant★ at the Académie Julien.
In her subsequent travels, which
included visits to Belgium, The
Netherlands, Germany and Spain,
she absorbed the influence of such
artists as Velázquez, Van Dyck,
Whistler★ and Böcklin.

On her return to Oporto, Sousa
settled at her family house on the
River Douro, where she painted
numerous landscapes. She also
produced scenes of family life
and interiors, a rare subject in
Portuguese art. Her *Self-portrait*

Aurélia de Sousa

(c. 1900, cat. 274) is one of the
most striking self-portraits in
nineteenth-century Portuguese art.
Sousa died in Oporto. EL
J. Costa, *Aurélia de Sousa: A sua vida
 e a sua obra*, Oporto, 1937
J. A. Franca, *A arte em Portugal no
 século XIX*, vol. 2, Lisbon, 1966,
 pp. 245–246
M. L. de Jesús, *A Aurélia de Sousa*,
 Oporto, 1959

CLARA SOUTHERN
(1860–1940)
Southern was born in Kyneton,
Victoria, Australia. She began her
art training as a pupil of Madame
Mouchette, the painter and founder
of the Alliance Française in
Victoria, and later studied with
Walter Withers. Between 1883–87
she attended the Gallery School in
Victoria where she earned the
nickname 'Panther' for her lithe
beauty. In 1886 she was admitted
to the Buonarroti Society, a
sketching and musical circle.

Clara Southern, c. 1900

From the mid-1880s she shared a teaching studio in the fashionable Grosvenor Chambers in Melbourne with Jane Sutherland, where Tom Roberts★ also had a studio. It was from here that Southern regularly joined weekend painting excursions to the Eaglemont artists' camp at Heidelberg. In 1902 she was elected to the Council of the Victorian Artists' Society and served in this position until 1906. She married John Flinn in 1905 and moved to 'Blythe Bank' at Warrandyte. Here she painted many neighbouring landscapes and farm buildings with great sensitivity and lyricism. Her presence and work attracted other artists so that Warrandyte soon became an artists' colony which included painters such as Louis McCubbin, Harold Herbert and Frank Crozier. Southern continued to paint and live at Warrandyte until her death at the age of seventy-nine. HV

J. Burke, *Australian Women Artists 1840–1940*, Melbourne, 1980

Catalogue of Paintings by Clara Southern (Mrs J. Flinn), exh. cat., Athenaeum Hall, Melbourne, 1914

A. McCulloch, *Encyclopedia of Australian Art*, St Leonards, New South Wales, 1994

JAN (GRZEGORZ) STANISLAWSKI
(1860–1907)

Born in Olszana near Horodyszcze in the Ukraine, Stanislawski took up art only after studying mathematics at Warsaw University. He had taken drawing lessons while

Portrait of Jan Stanislawski by Stanislaw Wyspiański

still in Warsaw, but did not pursue painting full time until he attended Kraców's School of Fine Arts in 1883–84. In Paris in 1886–87, he attended classes in Carolus-Duran's★ studio before travelling widely in Europe between 1888 and 1895, finally returning to the Ukraine.

Stanislawski's first artistic success was at the 1890 Paris Salon, with a Ukraine landscape. In Kraców he was appointed Professor of Landscape Painting and became active in radical social and artistic circles galvanised by the activity there from 1897 of Stanislaw Przybyszewski. Stanislawski was instrumental in establishing 'Sztuka' ('Art'), the Society of Polish Artists, and under its aegis he exhibited work in Vienna, Munich and Düsseldorf, showing with the Vienna Secession as a member several times. In 1901 he joined the Polish Applied Arts Society and contributed to the Young Poland movement active in Kraców at the turn of the century.

A popular and memorable teacher, Stanislawski greatly influenced early twentieth-century Polish landscape painting, and also produced theatre designs, posters and numerous illustrations for Warsaw's progressive art journal *Chimera*. He died in Kraków. JM

Nineteenth-Century Polish Painting, National Museum, Warsaw; National Academy of Design, New York, 1988

(JOHAN) AUGUST STRINDBERG
(1849–1912)

Born in Stockholm to a shipping agent and a waitress, Strindberg took up painting and the visual arts – he also practised sculpture and photography with spasmodic zeal – only when he was unable to write.

At twenty-five he began to work as an art critic, with shrewd, bold assessments of the current Swedish scene that influenced figures like Richard Bergh★ and Prince Eugen.★ His sympathies lay with the 'expressive' trend in *fin-de-siècle* painting.

In 1872 he began to paint, producing a sequence of fairly conventional marine subjects over the next two years. The traumatic 1880s, during which he lost his Christian faith and was virtually

August Strindberg, 1894

ostracised from society following his blasphemy trial over *Married*, were not conducive to art-production. In 1890 he attempted to sculpt, and two years later began painting again. Greater spontaneity and a prototypical 'action painting' mark Strindberg's zestful paintings of this period. His art was little understood, even by those who appreciated his writings, such as Richard Bergh. During a visit to London in 1893 Strindberg was fascinated by Turner's seascapes, and his subsequent work has a similar intensity. He died in Stockholm. JM

M. Facos, *Nationalism and the Nordic Imagination; Swedish Art of the 1890s*, Los Angeles, 1998

August Strindberg, som malare och kritiker. Ett urval, exh. cat., Nationalmuseum, Stockholm, 1994

FRANZ VON STUCK
(1863–1928)

Franz von Stuck was born at Tettenweis, Lower Bavaria, and studied at the Kunstgewerbeschule in Munich between 1878 and 1881, and then at the Munich Akademie from 1881 to 1885. He initially earned a living executing graphic work for publications such as the Munich satirical magazine *Fliegende Blätter* (between 1887 and 1892), and the Viennese journals *Allegorien und Embleme* (in 1882) and *Karten und Vignetten* (in 1886). In 1889 he won a gold medal for work he exhibited at the Jahresausstellung in Munich. He also designed the publicity poster for the exhibition.

In 1892 he visited the artist Max Klinger★ in Rome, who also

Franz von Stuck, photographed by Fritz Matthies-Masuren, 1906

provided him with studio space. In the same year Stuck was one of the founder members of the Munich Secession. In 1893, at the Secession exhibition, he exhibited a painting, *Sin* (1893), which became the focus of considerable controversy. In 1895 he became a professor at the Akademie in Munich, where his pupils later included Vasily Kandinsky★ and Paul Klee. He also joined the artists' group Pan, whose journal cover he designed. From 1896 to 1901 Stuck contributed drawings to the Munich art journal *Jugend*. In 1897–98 he designed and built for himself the Villa Stuck in Munich, which incorporated his own paintings, sculpture and furniture. In 1900 Stuck had significant success at a German art exhibition in Moscow, and he won a gold medal for his furniture designs at the Exposition Universelle. In 1904 he made a trip to Greece. He was awarded the Knight's Cross of the Order of Merit of the Bavarian Crown in 1905, and died in Munich. AC

E. Becker, *Franz von Stuck, 1863–1928. Eros and Pathos*, Amsterdam, 1995

PÁL SZINYEI MERSE
(1845–1920)

Szinyei Merse was born in present-day Slovakia. He was the champion of naturalism in Hungary during the late nineteenth century, a role that condemned him to three decades of isolation before his work was recognised. After his initial training at Nagyvárad, he studied at the Munich Akademie between 1864 and 1869 where he befriended

Pál Szinyei Merse, c. 1896

Augustus Vincent Tack (second row up, third from left)

Henry Ossawa Tanner

Wilhelm Leibl and Hans Makart. Even in this company, Szinyei Merse's devotion to painting *en plein air* seems to have set him apart, but he persisted with close studies from nature. Paintings such as *Drying Clothes* (c. 1869) and *Picnic in May* (1873) have been dubbed early examples of Impressionism in Central Europe, although Szinyei Merse had no direct knowledge of French art and did not visit Paris until 1908.

Despite winning a medal at the Vienna International Exhibition of 1873, his work was either ignored or attacked by Hungarian and Austrian critics. It was not until the 1890s that Szinyei Merse's work was recognised as part of a larger European movement towards naturalism; only then did he become a prominent figure in Hungarian artistic life.

Between 1897 and 1901 he was an adviser on art and art education to the government and in 1905 was appointed Director of the Budapest School of Art. More importantly, in 1900 he was awarded a silver medal at the Exposition Universelle, the first of several awards that confirmed his position on the international stage.

In his last years he continued to encourage younger Hungarian artists to adopt a more inter-national outlook and, on his death, a society was formed to maintain and promote his ideals. PS

A. Szinyei Merse, *Szinyei Merse Pál élete és művészete*, Budapest, 1990

AUGUSTUS VINCENT TACK
(1870–1949)

Best known for his allegorical abstractions of the 1920s, Tack merged a Beaux-Arts training with the tenets of modernism. Born in Pittsburgh, he studied from 1890 to 1895 at the Art Students League, New York, working with the American Renaissance muralist H. Siddons Mowbray, and probably with the landscape painter John H. Twachtman. The religious and decorative art of John La Farge (whom Tack portrayed in 1897–1900) was also an important influence.

From 1897 Tack divided his time between New York and Deerfield, Massachusetts, where he painted tonalist landscapes. In this period, Tack began collecting Asian art, aspects of which influenced his painting; this is especially evident in his later espousal of flattened, abstracted forms. Although more interested in landscape painting, Tack persevered with portraiture; his *Portrait of George Washington Cable in his Study* received the place of honour in the 1900 Pennsylvania Academy of Fine Arts exhibition.

In 1914 Tack met the collector Duncan Phillips, who became his primary patron. In 1917 he received his first mural commission, for the Greenwich House, New York, followed by one for the church of the Paulist Fathers, New York (1921–25), and a decorative cycle for the Nebraska State Capitol, Lincoln (1924–28).

The high point of Tack's *œuvre* was a series of decorative panels for the Phillips's Music Room in Washington, DC (1928–31). Lyrical, abstracted landscapes, replete with mystical associations, these synthesised Tack's diverse influences, from Italian Renaissance painting and Symbolism to the vast landscapes of the American West and the medium of photography. Tack was active until the day of his death in his Deerfield studio. VG

L. Furth, E. V. Chew and D. Scott, *Augustus Vincent Tack: Landscape of the Spirit*, exh. cat., The Phillips Collection, Washington, DC, 1993

HENRY OSSAWA TANNER
(1859–1937)

Tanner's mature artistic production is dominated by religious pictures which reveal Symbolist elements. Born in Pittsburgh, he was raised in Philadelphia. In 1879 he enrolled at the Pennsylvania Academy of Fine Arts, studying with the realist Thomas Eakins★ and the genre painter Thomas Hovenden. At this time Tanner's work consisted mainly of seascapes and landscapes. In 1891 he moved to Paris – where he lived much of his life – and matriculated at the Académie Julian, working most with Benjamin Constant.★

In the early 1890s Tanner began to execute naturalistic genre scenes characterised by pronounced brushwork. An African-American, in several of these images he depicted blacks in a manner that challenged prevailing racist stereotypes. Then, in a radical shift inspired in part by his religiosity, he focused on biblical themes, in canvases that strove for historical accuracy, tending towards dark tones with dramatic lighting effects. In this period Tanner's exposure to the Pont-Aven School spurred him to paint in a more Symbolist idiom. Around 1910 this led him often to employ blue and violet hues that emphasised the mystical nature of his subjects.

After 1910 Tanner's pictures reflected his knowledge of the modernist currents in Europe. He broke from painting during World War I to join the American Red Cross in France. Despite his decision to remain an expatriate, Tanner had patrons in and kept ties with his homeland. He was made an Academician at the National Academy of Design, New York, in 1927. He painted little in his old age and died in Paris. VG

D. F. Mosby, *Across Continents and Cultures: The Art and Life of Henry Ossawa Tanner*, exh. cat., Nelson-Atkins Museum of Art, Kansas City, 1995

D. F. Mosby, *Henry Ossawa Tanner*, exh. cat., Philadelphia Museum of Art, Philadelphia, 1991

HANS THOMA
(1839–1924)

Hans Thoma was born in Bernau. He briefly studied lithography and watchcase painting between 1853 and 1855, and in 1859 he entered the Grossherzogliche Kunstschule in Karlsruhe, where he was a pupil of Ludwig Des Coudres and Johann Wilhelm Schirmer. In 1866 Thoma moved to Düsseldorf, where he met the artist Otto

Scholderer. In 1868 Scholderer invited Thoma to Paris; while there Thoma was able to visit the studio of Gustave Courbet and to see works by the Barbizon School. In 1870 he moved to Munich where he met the artists Wilhelm Leibl and Arnold Böcklin, both of whom had a significant impact on his work. In 1872 Thoma shared a studio in Munich with Wilhelm Trübner.★ In 1874 he travelled to Italy, where he was particularly struck by the work of Botticelli and Signorelli. In 1876 he moved to Frankfurt, where he stayed until 1899, making a second trip to Italy in 1880.

From the early 1880s onwards Thoma received many commissions, including the costume design for Wagner's *Ring* cycle at Bayreuth in 1896. In 1890 he became an honorary member of the Munich Akademie and also had his first major critical and commercial success at an exhibition of the Munich Kunstverein. In 1892 he began to exhibit with the Munich Secession. In 1899 he was appointed Director of the Grossherzogliche Gemäldegalerie in Karlsruhe and Professor of Landscape Painting at the Grossherzogliche Kunstschule. In 1909 a Hans-Thoma-Museum was opened within the Karlsruhe Kunsthalle. Thoma died in Karlsruhe. AC

E.-M. Froitzheim, ed., *Hans Thoma (1839–1924): ein Begleiter durch die Hans-Thoma Sammlung in der Staatlichen Kunsthalle Karlsruhe*, 1993

THORÁRINN B(ENEDIKT) THORLÁKSSON
(1867–1924)

Thorláksson was the son of a Lutheran minister in Iceland. At the age of eighteen he went to Reykjavik to study bookbinding. In 1885 the first exhibition in Iceland of painting took place in the city; mainly Danish contemporary work was shown (Iceland was then a Danish colony) and, as a result, Thorláksson's earlier interests crystallised and he took lessons in drawing. Travelling to Copenhagen in 1889 for bookbinding purposes, the capital's galleries inspired him to take up oil painting.

Eventually Thorláksson gave up his job in order to attend the

Hans Thoma, 1900

Thorárinn B. Thorláksson, *c.* 1900

Sir Hamo Thornycroft, photographed by J. P. Mayall for *Artists at Home* 1884

Kunstakademi in Copenhagen and then Harald Frederik Foss's private academy, for a total of nearly seven years from 1895. He much admired the luminous landscapes of the Skagen School, in particular those by P. S. Krøyer.★

In 1900 the first private art exhibition in Iceland was of works by Thorláksson, for which he produced his most famous painting, *Thingvellir* (cat. 203), depicting a site of almost mystical importance for Icelanders, then and now. His teaching work at Reykjavik Technical College and the setting up of the Listvinafelag, the Friends of Art Society, established the basis for modern art in Iceland. Thorláksson died in Reykjavik. JM

Dreams of a Summer Night, exh. cat., Hayward Gallery, London, 1986

SIR (WILLIAM) HAMO THORNYCROFT
(1850–1925)

Born in London, Hamo was the son of the sculptors Mary and Thomas Thornycroft. Hamo worked in his father's studio and entered the Royal Academy Schools in 1869.

In 1871 Thornycroft left for Italy where he was greatly influenced by the work of Michelangelo. On his return he helped his father in the execution of the *Park Lane Fountain*, devising and modelling

himself the figure of Fame blowing a trumpet. He achieved great acclaim in 1880 for his statue of *Artemis*, which was noted for its portrayal of movement and for the intricate modelling of the muslin drapery added to the highly finished nude figure. Of all the major British sculptors of the period, Thornycroft was the least concerned with decoration and the most interested in the modelling of the figure for its own sake. His statue of *Teucer* (1881) reveals closely observed musculature in the outstretched arm and torso. During the 1880s and early 1890s, issues such as the revival of bronze-casting, the place of sculpture in society and the relationship between sculpture and architecture were of much concern to Thornycroft, and the New Sculpture and Arts and Crafts movements.

In 1884, Thornycroft made an entirely new departure in British sculpture with *The Mower*, a modern-day mower dressed in peasant clothes and hat, resting with a large scythe. Among Thornycroft's public commissions was a statue of General Gordon (1887) for the Victoria Embankment and a stone frieze for the Institute of Chartered Accountants, London (*c.* 1891). He was elected ARA in 1881, RA in 1888 and was knighted in 1917. He died at Coombe, Oxfordshire. HV

E. Manning, *Marble and Bronze: The Art and Life of Hamo Thornycroft*, London and New Jersey, 1982

JAN (THEODORUS) TOOROP
(1858–1928)
See illustration on pp. 364–365.
Born in Purworedjo, Java, Toorop went to Holland when he was fourteen. He first studied drawing at the Delft Polytechnische School before enrolling at the Rijksakademie voor Beeldende Kunsten in Amsterdam between 1880–82 and then at the Ecole des Arts Décoratifs in Brussels for three years. Toorop was inspired by spiritual endurance amidst hardship, and such themes are evident in his early paintings, executed in the manner of Courbet, of the fisherfolk of the North Sea coast. His early Hague School naturalism was transfigured by his contact with Symbolist writers and artists in the

1890s, in particular Emile Verhaeren. During his association with Les XX, he began to paint social-realist themes employing a radiant Pointillist touch.

From 1900, Toorop experimented in many emergent styles juxtaposing his Pointillist portraits and landscapes with Symbolist allegories executed in an Art Nouveau linear style. The sinuous forms and enigmatic primal forces in these spiritual fantasies are redolent with his experience of both Belgian decadence and his native Indonesia. He was equally adventurous in his exploration of different media, creating posters, ceramics, book illustrations and intricate drawings. The socialism of his youth gave way to fervent Catholicism in his maturity when he joined the Catholic artistic society De Violier (The Gillyflower). Toorop's interest in esoteric geometric mysticism was an important influence on his young friend, Piet Mondrian.★ He died in The Hague. CO'M

V. Hefting, *Jan Toorop 1858–1928* (E. Bergvelt, ed.), exh. cat., Gemeentemuseum, The Hague, 1989

HENRI(-MARIE-RAYMOND) DE TOULOUSE-LAUTREC (MONFA)
(1864–1901)
Toulouse-Lautrec was born in Albi. The son of an aristocratic family, he attended the Lycée Condorcet in Paris and then enrolled in the studios of Léon Bonnat and Fernand Cormon where he met Emile Bernard,★ Louis Anquetin and Vincent van Gogh. Toulouse-Lautrec excelled both as a graphic artist and as a painter, particularly of portraits. He exhibited a great deal at the Salon des Indépendants, with Parisian and provincial artistic societies such as the Cercle Volney and Les XX in Brussels, and with dealers like Louis Le Barc de Boutteville and Ambroise Vollard. A one-man show took place at the Goupil Gallery in London in 1898. Works by Toulouse-Lautrec were included in the lithography sections of both the Centennale and the Décennale displays at the 1900 Exposition Universelle.

Providing illustrations for many leading periodicals including *Le Courrier français*, *La Plume* and *La Revue blanche*, he also immortalised

Henri de Toulouse-Lautrec (left) and Maxime Dethomas, *c.* 1897

Prince Paolo Troubetzkoy

the performers and audiences of Montmartre's cabarets in his posters. In 1899 *Les Maîtres d'affiches* and *Le Monde moderne* both devoted a whole issue to his posters; in the same year his illustrated edition of Jules Renard's *Histoires naturelles* was published. Toulouse-Lautrec travelled widely in France, returning regularly to his native Midi, and also visiting England and Spain. His synthesis of Japanese art, the portraiture tradition and caricature allowed him to create an attentive testament, both acerbically satirical and sensitive, of Parisian circuses, theatres, cabarets, brothels and artists, and of members of his family with whom he remained intimate. Toulouse-Lautrec died in Malromé, Gironde. CO'M

Toulouse-Lautrec, exh. cat., Hayward Gallery, London; Grand Palais, Paris, 1992

PRINCE PAOLO TROUBETZKOY
(1866–1938)
Troubetzkoy was born into an aristocratic Russian family at Intra, Italy, and received no systematic, academic artistic training, instead serving apprenticeships in the sculpture studios of Giuseppe Grandi and Ernesto Bazzaro in Milan. He learnt impressionistic methods of modelling in clay and was the first Russian to return home with a working knowledge of these and the history of late nineteenth-century Italian sculpture generally. His first works were small-scale portraits, such as that of Isaak Levitan★ (1899), using a palette-knife on clay or Plasticine before plaster- or bronze-casting.

In 1900 Troubetzkoy became a member of Diaghilev's World of Art (Mir Iskusstva) group, and exhibited with it until 1903. His

major work is the equestrian monument to Tsar Alexander III, completed in 1909, for Znamenskaya Square in St Petersburg. This was much mocked, but Troubetzkoy received support from the Dowager Empress. His other famous equestrian image was that of Tolstoy (1900): much was made at the time of the mutual respect between aristocratic writer and aristocratic sculptor. In 1904 a commission from the Département des Beaux-Arts's director reached Troubetzkoy for a monument to Tolstoy in Paris, apparently on one of the bridges, and the sculptor donated his famous statue free of charge. JM

J. Kennedy, *The 'Mir iskusstva' Group and Russian Art*, New York, 1977
The World of Art, exh. cat., State Russian Museum, St Petersburg; Ateneum, Helsinki, 1998

Wilhelm Trübner, *Self-portrait*, 1913

(HEINRICH) WILHELM TRÜBNER
(1851–1917)

The son of the goldsmith and jeweller Georg Trübner, Wilhelm Trübner was born in Heidelberg and trained for a short time as a goldsmith. In 1867 he enrolled at the Karlsruhe Kunstschule. He moved to the Munich Akademie in 1869, where he studied under Alexander von Wagner and Wilhelm von Diez. He also met Hans Thoma,★ with whom he shared a studio in 1872. In the early 1870s Trübner came into contact with the circle of Wilhelm Leibl, and under his influence he left the Akademie in 1871. In 1871–72 he shared a studio with two painters from Leibl's circle, Carl Schuch and Albert Lang. In 1872 he visited

Italy and met the artist Anselm Feuerbach in Rome. A year later he travelled to Holland and in 1875 he settled in Munich.

His involvement in Munich's cultural and social life in the 1870s and 1880s led to extended periods of artistic inactivity. In 1892 he joined the Munich Secession, but never became a member of its committee. In 1896 he visited Italy, Holland, Belgium, France, Switzerland and England, where he met Alma-Tadema★ and Leighton.★ In the same year he moved to Frankfurt, founding a private art school as well as becoming Director of the Städelsches Kunstinstitut. In 1900 he married one of his students, Alice Auerbach. In 1903 Trübner joined the Karlsruhe Kunstschule and was Director in 1904–05 and 1910–11. Between 1900 and 1917 Trübner also published five books on art history and theory. He died in Karlsruhe. AC

J. A. Beringer, *Trübner Des Meisters Gemälde*, Stuttgart and Berlin, 1917

HENRY SCOTT TUKE
(1858–1929)

Tuke was born in York. His early years were spent in Falmouth, until his family moved to London in 1874. He enrolled at the Slade School of Art in 1875 and made many summer trips to continental Europe. In 1880 he travelled to Florence where he was more influenced by the English genre painter Arthur Lemon than by the Old Masters. Sketching boys with Lemon on the beaches of Italy encouraged Tuke to develop a more naturalistic painting style. He continued his studies in the Paris atelier of Jean-Paul Laurens in 1881 and also met Jules Bastien-Lepage. At this time Tuke was particularly interested in depicting the nude in pure daylight rather than the artificial lighting of the studio.

Although Tuke never considered himself part of the Newlyn School, he did spend time with them between 1883–85 before returning to Falmouth. For some time he continued to paint large dramatic compositions such as *All Hands to the Pump* (1889). In the early 1890s he abandoned his square-brush technique for more fluid brushwork, and replaced his normally grey, overcast skies with

Henry Scott Tuke

bright sunshine. He also returned to the theme of the male nude in works such as *August Blue* (1894), a painting of youths bathing from a dinghy that is essentially a celebration of the effects of sunlight on flesh and water.

Tuke's life settled into a pattern where he spent his summers in Falmouth, moved to London in the autumn, often undertaking portrait commissions, and travelled in the spring. A visit to North Africa in 1927 was his last trip abroad; he died two years later in Falmouth. HV

C. Fox and F. Greenacre, *Painting in Newlyn 1880–1930*, exh. cat., Barbican Art Gallery, 1985
D. Wainwright and C. Dinn, *Henry Scott Tuke, 1858–1929: Under Canvas*, London, 1989

FRITZ (FRIEDRICH HERMANN KARL) VON UHDE
(1848–1911)

Fritz von Uhde was born into a strongly Protestant family in Wolkenburg, Saarland. In 1866 he studied briefly at the Hochschule der Bildenden Künste in Dresden, but left the following year to become an officer in the Saxon cavalry. He later took part in the Franco-German War of 1870–71. In 1877 he left the army to restart his career as an artist, and went to Vienna to study under Hans Makart, but he was rejected and sent to Munich, where he was turned down by Karl Theodor von Piloty and Wilhelm von Diez. Instead, he studied Dutch painting in Munich's Alte Pinakothek. During 1879 he was taught privately

Fritz von Uhde, Self-portrait, 1898

by the artist Mihály Munkácsy in Paris. In 1880 Uhde returned to Munich, where he met Max Liebermann,* who aroused his interest in *plein-air* painting, which Uhde practised in Zandvoort, Holland, in 1882.

As well as for his landscapes and genre scenes, Uhde became famous for depicting scenes from the Bible in contemporary rural settings. His first three religious paintings from the mid-1880s caused outrage among many conservative and Protestant observers. In the 1890s he spent his summers at a country house in Starnberg, and his work

here increasingly began to show the influence of Impressionism. In 1892 he was one of the founder members of the Munich Secession, becoming chairman in 1899. In 1900 illness forced him to withdraw from the art world. On his sixtieth birthday in 1908 he received many honours, including final recognition from the Church in the form of an honorary doctorate from the theological faculty of Leipzig University. He died in Munich. AC

B. Brand, *Fritz von Uhde. Das religiöse Werk zwischen künstlerischer Intention und Öffentlichkeit*, Mannheim, 1978

FÉLIX (-EMILE-JEAN) VALLOTTON
(1865–1925)
Vallotton was born in Lausanne. A chemist's son, he enrolled at the Académie Julian in Paris in 1882. He made his début at the Salon of 1885 and exhibited there until 1891. He showed predominantly at the Salon des Indépendants from 1900–09 and at alternative venues such as the Salon de la Rose+Croix in Paris, the Vienna Secession from 1899 and 1903, and the Berlin Secession between 1900–05; he was a founder member of the Salon d'Automne in 1903.

Vallotton's prints employed bold linearity and japoniste absences and appeared in all the artistic periodicals of the day. He revived the woodcut medium in his album *Intimités* (1898) and also illustrated editions of Verlaine, Rémy de Gourmont and Mirbeau. He participated in the Nabis group, exhibiting with Louis Le Barc de Boutteville, Ambroise Vollard and Siegfried Bing's Maison de l'Art Nouveau. Having designed programmes for the Symbolist Théâtre de l'Oeuvre and stained glass, in 1895 he began to paint intimate interiors and park scenes.

His austere yet magical reduced technique offers clear delineation of significant details while creating a static, transcendent mood. *The Visit* (1898, cat. 170) transfigures a mundane domestic setting into a patterned and charged *intimiste* space. Vallotton died in Paris. CO'M

Félix Vallotton, exh. cat., Yale University Art Gallery, New Haven; Museum of Fine Arts, Houston; Indianapolis Museum of Art; Van Gogh Museum, Amsterdam; Musée Cantonnal des Beaux-Arts, Lausanne, 1991–93

G. Guisan and D. Jakubec, *Félix Vallotton: Documents pour une biographie et pour l'histoire d'une œuvre*, 3 vols, Lausanne, 1973–75

Albijn Van den Abeele, 1910

ALBIJN VAN DEN ABEELE
(1835–1918)
Van den Abeele was born in Laethem-Saint-Martin in East Flanders. He began his career as a writer but also worked in the local administration, becoming mayor (1869–74). He published a number of short stories and four novels that blend Romanticism and Realism stylistically.

It was only in 1874–75, at the age of thirty-nine, that Van den Abeele devoted himself exclusively to painting. His main subject was the local forested landscape, with the emphasis on light and colour (cat. 189). These closely observed images are not only depictions of particular places, but also expressions of an almost spiritual relationship to nature which Van den Abeele regarded as the only source of beauty. His paintings convey a deep sense of quiet and harmony.

Van den Abeele assimilated Realist, Romantic, Impressionist and Symbolist styles in his paintings and was greatly influential for the members of the first group of Laethem-Saint-Martin artists, George Minne,* Valerius De Saedeleer, Albert Servaes and Gustave Van de Woestyne, whose religiously inspired works express a strong love of nature.

Van den Abeele had a wide circle of friends, including artists and scientists, and was closely involved in contemporary cultural life. He remained in his home town until the end of his life. AD

Le Premier Groupe de Laethem-Saint-Martin, 1899–1914, exh. cat., Musée Royaux des Beaux-Arts de Belgique, Brussels, 1988

R. Van den Abeele, *Albijn Van den Abeele: De stamvader van de Latemse kunstenaars*, Ghent, 1993

(From left to right) Ker-Xavier Roussel, Edouard Vuillard, Romain Coulus, Félix Vallotton, July 1897

Souvenir de Tanger 1884
a l'ami Paul Du Bois
Théo van Rysselberghe

Théo Van Rysselberghe, 1884

José María Velasco

THÉO(PHILE) VAN RYSSELBERGHE
(1862–1926)
Van Rysselberghe was born in Ghent. The son of a bourgeois architect, he was educated by Théodore Joseph Canneel at the Ghent Academy, and then by Jean-François Portaels and Léon Herbo at the Académie des Beaux-Arts in Brussels; he made several visits to Morocco. In the 1880s Van Rysselberghe exhibited in Brussels with L'Essor, with Les XX, of which he was a founder member, and then at La Libre Esthétique. He exhibited internationally at the Parisian Salon des Indépendants and to great acclaim at the Vienna Secession in the 1890s. He abandoned his painterly Barbizon style after a visit to the 1886 Impressionist exhibition exposed him to Seurat's Pointillist dot technique. Initially he adopted this technique directly but gradually expanded it into his own distinctive larger square brush strokes.

Van Rysselberghe excelled in portraits, landscapes and figure scenes. With Henry Van de Velde, he was also a keen advocate of the Belgian *fin-de-siècle* revival of decoration, producing posters, book illustrations, furniture, jewellery and decorative panels. From 1898 he settled in France, first in Paris immersing himself in the Symbolist milieu of Gide, Maeterlinck and his old friend Emile Verhaeren, before moving to the Midi. In 1910, he moved into a villa designed by his brother Octave. Van Rysselberghe's Utopian Mediterranean bather scenes of the 1890s and beyond, like those of his friend Signac who had introduced him to St Tropez, reflect his sympathy with the Arcadian longings associated with anarchism. Van Rysselberghe died in Saint-Clair, Manche. CO'M

Théo Van Rysselberghe: Néo-impressionniste, exh. cat., Museum voor Schone Kunsten, Ghent, 1993

JOSÉ MARÍA VELASCO
(1840–1912)
Born in Temascalcingo, Mexico, Velasco enrolled in classes at the Academia de San Carlos in Mexico City in 1855, matriculating officially in landscape painting in 1858, for which he received a scholarship two years later. In 1865 Velasco began to study natural science, and developed a lifelong interest in the flora and fauna of Mexico, even contributing illustrations to diverse publications on these subjects. Velasco is best known for his vistas of his native country in which he resisted the picturesque and strove for geographical precision. He was also committed to preserving his country's native archeological and artistic treasures and maintained an affiliation with the Museo Nacional.

In 1868 Velasco took up photography, and this same year he began teaching perspective at the Academia. Given his dedication to his homeland, it is not surprising that Velasco never painted outside Mexico. His most prominent series depicts panoramic views of the Valley of Mexico, compositions dominated by muted greens, duns and pale blues. Beginning in 1873, Velasco created variations on this topographical theme throughout his career.

Velasco was among his nation's most acclaimed artists and was shown in the Philadelphia Centennial exhibition of 1876.

Maurice de Vlaminck

The following year he was appointed Professor of Landscape at the Academia. His inclusion in the Paris Expositions Universelles of 1878 and 1889, the 1892 Histórica Americana in Madrid, and the 1893 World's Columbian Exposition in Chicago brought Velasco more artistic honours. He continued to paint, teach, and participate in museum projects until his death in Villa de Guadalupe. VG

M. E. Altamirano Piolle, *Homenaje nacional, José María Velasco (1840–1912)*, exh. cat., Museo Nacional de Arte, Mexico, 1993

MAURICE DE VLAMINCK
(1876–1958)
Vlaminck was born in Paris. The son of two musicians, his first creative expressions took the form of music and a passion for bicycle-racing. Having worked as a mechanic, a music teacher and a journalist on the anarchist paper *Le Libertaire*, Vlaminck was called up for national service in 1900. He met André Derain around this time and they decided to share a painting studio. Vlaminck was effectively self-taught but his relationship with Derain was hugely influential, as was his visit to the van Gogh retrospective held at the Bernheim-Jeune Gallery in Paris in 1901. There he encountered a dynamism of brush stroke and an explosively vibrant palette which he was to make his

own. Derain introduced him to Matisse,★ Vlaminck's first step towards the Fauvist paintings for which he is best known. *The Bar* (1900, cat. 153) already typifies his technique with its searing colour tones, heavy impasto and bold use of outline. This brutal touch is coupled with a sexually charged harshness of conception; the bartender has a disturbingly faded, yet vigorous, bestial sensuality. Her bursting bosom is made all the more threatening by her forward, even masculine posture, her crude expression underlined by the slovenly ash-laden cigarette dangling from her mouth. As well as painting his late, powerfully expressionistic landscapes and portraits, Vlaminck was a prolific writer of prose and verse and a book illustrator. He died in Rueil-la-Gadelière, Eure-et-Loir. CO'M

The 'Wild Beasts': Fauvism and Its Affinities, exh. cat., MOMA, San Francisco; MOMA, New York; Kimbell Art Museum, Fort Worth, 1976

MIKHAIL (ALEKSANDROVICH) VRUBEL
(1856–1910)

Born in Omsk, Vrubel studied both law and art – graduating from the St Petersburg Imperial Academy of Arts in 1884. He was employed in Kiev on the restoration of frescoes in the Church of St Cyril from 1884 to 1889.

In 1889 Vrubel returned to Moscow and elaborated a sophisticated neo-Romantic Symbolism centred on the idea of the Demon, which he derived from the poem by Mikhail Lermontov of the same name. He exhibited at the Nizhny Novgorod Exhibition in 1896, and joined the World of Art (Mir Iskusstva) group in 1900, having already shown work at Diaghilev's 1898 exhibition of Russian and Finnish artists. He produced many panels for the Russian Art Nouveau architect Fyodor Shekhtel in the 1890s, as well as ceramics, sculpture and his own architecture for other clients. He undertook theatre design and even the decoration of balalaikas for Princess Tenisheva.

In 1902 Vrubel was confined to a clinic for the insane, but was released briefly to show with the

Mikhail Vrubel, Self-portrait

Mir Iskusstva (1903, 1906, and posthumously in 1911). His final works were a vivid cycle of self-portraits in pencil which have been compared to Dürer and van Gogh. He died in St Petersburg. JM

D. Sarabianov, *Russian Art: From Neoclassicism to Avant-Garde*, London, 1990

EDOUARD VUILLARD
(1868–1940)

Vuillard was born in Cuiseaux, Saône-et-Loire. The son of an army officer, he entered the Lycée Condorcet in Paris where he met Aurélien Lugné-Poe, Maurice Denis★ and Ker-Xavier Roussel (see cat. 169). Vuillard and Roussel enrolled in the studio of Diogène Maillart. A successful third attempt at the entrance exam led him to study briefly with Jean-Léon Gérôme★ at the Ecole des Beaux-Arts in 1888. At the Académie Julian as Robert-Fleury's pupil in 1889, Vuillard was inspired to join the Nabis group by Denis and by Paul Sérusier's Synthetist paintings. After participating in Paul Fort's Théâtre de l'Art, Vuillard helped Lugné-Poe to found the Théâtre de l'Oeuvre in 1893, designing costumes, puppets, décors and programmes. The plays they produced, by Ibsen, Maeterlinck and Strindberg,★ inform Vuillard's small interior scenes of the 1890s. In Vuillard's half-lit, claustrophobic, bourgeois settings and portraits, subliminal family tensions are visualised through intense emotional landscapes of colour and pattern. Several dealers, among them Louis Le Barc de Boutteville, Ambroise Vollard and later Jos Hessel of Bernheim-Jeune, exhibited and commissioned his work, including the colour lithograph series *Landscapes and Interiors* (1899). Vuillard's friendship with members of the influential Natanson family, editors of the artistic journal *La Revue blanche*, led to the commissions for one of his main art forms, decorative ensembles such as the nine *Public Gardens* panels. Vuillard died in La Baule. CO'M

G. Groom, *E. Vuillard, Painter-Decorator: Patrons and Projects, 1892–1912*, London, 1993

B. Thomson, *Vuillard*, Oxford, 1988

WOJCIECH WEISS
(1875–1950)

Together with Gauguin's Polish follower at Pont-Aven, Wladyslaw Slewiński, and the Kraców painter Jacek Malczewski, Weiss was one of the Young Poland artists who came to prominence in that country at the very end of the nineteenth century, when Poland was regaining a measure of self-respect after the shocks of failed rebellion and Russian repression (in particular that of 1863).

Born in Leorda, Romania, Weiss began his studies in Kraców at the age of fifteen, travelling to Paris in 1899 and then to Florence and Rome, regular destinations in later years. He joined Sztuka ('Art'), the Polish Society of Artists, in 1898 and was greatly influenced by art critic Stanislaw Przybyszewski. Weiss came to admire Munch's★ work (and Gustav Vigeland's

Edouard Vuillard holding his Kodak camera, photographed by Pierre Bonnard, 1900

Wojciech Weiss

sculpture) and was intrigued by
Przybyszewski's energetic satanism:
Przybyszewski's works have been
described by P.-L. Mathieu as
'rendering in orgiastic rhythms
crowds in hot pursuit of carnal
pleasures'.

However, after 1905 Weiss
abandoned morbid demonic motifs
in favour of Arcadian optimism.
A professor of fine art at the
Kracóv Academy and three times
rector there, his work included
graphic art, poster design and
sculpture. After World War II he
followed the prevailing ethos of
socialist realism. JM

W. Juszczak, *Teksty o malarzach:
 Antologia polskiej krytyki artystyc nec
 1890–1918*, Wroclaw-Warsaw-
 Kracóv-Gdansk, 1976
W. Juszczak, *Mlody Weiss*, Warsaw
 1979
L. Kossowski, ed., *Pejzaze Wojciecha
 Weissa*, exh. cat., National Museum,
 Kielce, 1985
P. L. Mathieu, *The Symbolist Generation,
 1870–1910*, New York, 1990

JAMES ABBOTT MCNEILL WHISTLER
(1834–1903)

Whistler's art, ahead of its time in
its approach to colour and its high
degree of abstraction, had a
tremendous influence on the
generation of American artists that
followed. Born in Lowell,
Massachusetts, Whistler lived
abroad for much of his childhood,
and then moved to Paris in 1855
to study art. After training at the
Ecole Impériale et Spéciale de
Dessin and at the Académie
Gleyre, Whistler moved to
London in 1859 and lived there
until his death.

His work reflects less of his
academic training than his

James Abbott McNeill Whistler

appreciation of the art of
seventeenth-century Dutch and
Spanish masters, of avant-garde
realism (as in the work of his
contemporaries Courbet and
Manet), and of Japanese art.
Whistler's affinity for Asian art
is evident in his simplified,
asymmetrical compositions.
Although he often depicted
women and London scenes, he
considered colour and design
more important than narrative.
Whistler's association with the
Pre-Raphaelites was important to
his involvement in the English
aesthetic movement; he designed
and painted his own frames and
influenced furniture design and
interior decoration. By the late
1870s, the style of his oils,

watercolours, prints and pastels
featured flattened, abstracted space
and subtle effects of colour.

Witty and sharp-tongued,
Whistler cultivated a flamboyant
persona that attracted almost as
much attention as his controversial
art. Critical reception of his early
work was mixed, but by the late
1880s his contributions were more
widely recognised. Many influential
Americans commissioned portraits
from him, and he won numerous
prizes, including two grand prizes
at the 1900 Exposition Universelle.
SR

Dorment, R. and M. F. MacDonald,
 James McNeill Whistler, exh. cat.,
 Tate Gallery, London; National
 Gallery of Art, Washington, DC;
 Musée d'Orsay, Paris, 1995

Carl Wilhelmson

CARL (WILHELM) WILHELMSON
(1866–1928)

Wilhelmson was born in Bohuslän
province on the west coast of
Sweden. When he was fifteen he
was apprenticed to a lithographer
in the nearest large town,
Göteborg. He was lucky to receive
tuition from Carl Olof Larsson,
already established as one of
Sweden's leading artists, at the
Valand art school and was
persuaded to visit Paris and enrol
at the Académie Julian.
Wilhelmson gradually adopted neo-
Impressionist and Synthetist light
effects, which he applied to rural,
particularly summer evening,
scenes on his return to Sweden in
1896. He captured the crystalline
clarity and scintillation of coastal
light with a deftness few of the
'realists' had managed. Monumental
figures and attachment to the rural
life of his childhood mark his later
work.

A successful teacher, Wilhelmson
was Director of the Valand art
school between 1897–1904. He
established his own school in
Stockholm from 1910, and taught
at the Akademi in the 1920s. He
travelled widely in the 1910s and
1920s – to Spain, Cornwall and,
unusually for the time, Lapland.
Nevertheless, he remained attached
to his Bohuslän origins. He died in
Göteborg. JM

J. Gavel, *Carl Wilhelmson, 1866–1928:
 Malningar, Teckningar, Grafik
 (Paintings, Engravings, Drawings)*,
 exh. cat., Göteborgs Konstmuseum,
 1994

Ichiro Yuasa

ICHIRO YUASA
(1868–1931)

Yuasa belonged to an influential group of *Yoga* (Western-style) artists which came to the fore in Tokyo at the end of the nineteenth century and was regarded as one of the cultural manifestations of the modernisation of Japan after the Meiji Revolution of 1868. Born in Gumma, he moved to Tokyo to study with three Western-style artists: Hosui Yamamoto (a pupil of Jean-Léon Gérôme★ in Paris in 1878), and Kume Keiichiro and Seiki Kuroda (both pupils of Raphaël Collin★ in Paris from 1886). He graduated from the Western-style art section of the Tokyo School of Fine Arts in 1898, two years after he had made a triumphant début at the inaugural exhibition of Hakubaki (the White Horse Society).

Yuasa travelled in Europe between 1906–09. After his return, he exhibited at the Bunten (Monbusho Bijutsu Tenrankai), an annual art exhibition established on the model of the Paris Salon in 1907 under the aegis of the Ministry of Education. Eventual dissatisfaction with this organisation led him in 1914 to become a founding member of an alternative, unofficial exhibition body, the Nikakai. Yuasa's work reflects the hybrid style of naturalist Impressionism which dominated Japanese Western-style painting from *c.* 1890 to *c.* 1920. MAS

Nihon no Bijutsu (Japanese Art), vol. 24, Tokyo, 1964–69

T. Fujita, ed., *Nihon Bijutsu Zenshu (Collection of Japanese Fine Art)*, vol. 6, Tokyo, 1969

Anders Zorn

ANDERS (LEONARD) ZORN
(1860–1920)

Zorn was born in Mora, in rural Dalarna. He first made a name for himself as a rebel against art as conventionally taught at the Kungliga Akademi för de Fria Konsterna in Stockholm. Fleeing abroad to study, he went first to London and then to Paris from 1888 to 1896. Like Munch,★ Zorn was an inveterate traveller, perhaps in emulation of John Singer Sargent,★ visiting Spain, Italy, the Balkans and North Africa, where the American had also been.

Zorn's fluid painterly style suited the portraiture of the time well, and his commissions came from the fields of big business, diplomacy and politics during the 1890s. Later he painted American presidents. Zorn spent his summers in Sweden, and built himself a house in Mora in 1896 (a building that in 1913 became the Zorn Museum of folk art and local traditions).

Zorn never abandoned his early love of watercolour, and was renowned for his proficient etchings. He also sculpted. He died in Mora. JM

H. H. Brummer, ed., *Till ögats fröjd och nationens förgyllning – Anders Zorn*,

exh. cat., Waldemarsudde, Stockholm; Göteborgs Konstmuseum, 1994

IGNACIO ZULOAGA (Y ZABALETA)
(1870–1945)

Zuloaga was born in Eibar. At nineteen he went to Paris, where he became a student of Henri Gervex and then Eugène Carrière★ and Pierre Puvis de Chavannes. Zuloaga quickly became part of the bohemian life of Montmartre and frequented the Cafés Tortoni and Riche. He also attended the meetings organised by Charles Morice and Mallarmé, where he became familiar with French Symbolism and Impressionism. Zuloaga often exhibited at the French Salons, having a particularly successful critical reception in 1899.

Until World War I, Zuloaga divided his time between Paris, Madrid and Segovia and was close to the Generación del '98, the group of Spanish writers who, like him, sought the revival of Spanish culture. Although he continued to paint landscapes, Zuloaga was best known as a portrait painter; his subjects included such eminent figures as the philosopher José

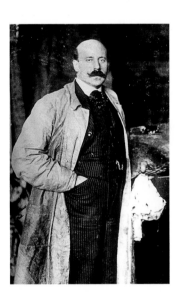

Ignacio Zuloaga

Ortega y Gasset (*c.* 1930) and the Duchess of Alba (1921).

In 1914 Zuloaga settled in Madrid and continued to paint subjects from Spanish life and figures in regional costumes; some are startling in their grotesque distortions. He died in Madrid. EL

E. Lafuente Ferrari, *La vida y el arte de Ignacio Zuloaga*, Barcelona, 1990

Sorolla y Zuloaga. Dos visiones para un cambio de siglo, exh. cat., Fundación cultural Mapfre Vida, Madrid, 1998

List of Works

RAOUL DUFY
Self-portrait, 1899. Oil on canvas, 41 × 33.7 cm. Centre Georges Pompidou, Paris. Musée national d'art moderne/Centre de création industrielle, cat. 280

THOMAS EAKINS
Portrait of Cardinal Sebastiano Martinelli, 1902. Oil on canvas, 199 × 152.4 cm. The Armand Hammer Collection, UCLA at the Armand Hammer Museum of Art and Cultural Center, Los Angeles, cat. 90
Self-portrait, 1902. Oil on canvas mounted on fibre board, 50.8 × 41 cm. Hirshhorn Museum and Sculpture Garden, Smithsonian Institution. Gift of Joseph H. Hirshhorn, 1966, cat. 279
The Wrestlers, 1899. Oil on canvas, 122.9 × 152.4 cm. Columbus Museum of Art, Ohio. Museum Purchase, Derby Fund, cat. 146

ALBERT EDELFELT
Christ and Mary Magdalene, Finnish Legend, 1890. Oil on canvas, 221 × 154 cm. The Finnish National Gallery Ateneum, Helsinki (EU 1900), cat. 244

MAGNUS ENCKELL
The Concert, 1898. Oil on canvas, 90 × 76 cm. The Finnish National Gallery Ateneum, Helsinki (EU 1900), cat. 145

JAMES ENSOR
Skeleton in the Studio, 1900. Oil on canvas, 113.9 × 80 cm. National Gallery of Canada, Ottawa, cat. 165 (NY ONLY)

PRINCE EUGEN
The Old Castle, 1893. Oil on canvas, 101 × 97 cm. Prins Eugens Waldemarsudde, Stockholm (EU 1900), cat. 197 (RA ONLY)
A Summer Night, Tyresö, 1895. Oil on canvas, 78 × 144 cm. Nationalmuseum, Stockholm (EU 1900), cat. 12 (NY ONLY)

HENRI EVENEPOEL
The Spaniard in Paris, 1899. Oil on canvas, 215 × 150 cm. Museum voor Schone Kunsten, Ghent (EU 1900), cat. 88

LUDVIG FIND
Portrait of a Young Man. The Norwegian Painter Thorvald Erichsen, 1897. Oil on canvas, 113 × 97.5 cm. The Hirschsprung Collection, Copenhagen (EU 1900), cat. 97

STANHOPE FORBES
Forging the Anchor, 1892. Oil on canvas, 214.6 × 172.7 cm. Ipswich Borough Council Museums and Galleries (EU 1900), cat. 115 (RA ONLY)

EDWARD ONSLOW FORD
Meditation, 1886. Bronze, 37 × 35 × 22 cm. City of Aberdeen Art Gallery and Museums Collection (EU 1900), cat. 16

SIR GEORGE FRAMPTON
The Marchioness of Granby, 1902. Marble, 74 × 61.5 × 30 cm. Courtesy Royal Academy of Arts, London, cat. 114 (RA ONLY)

LÉON FRÉDERIC
The Stream, 1890–99. Oil on canvas, 206 × 282 cm. Musées Royaux des Beaux-Arts de Belgique, Brussels, Inv. 6222 (EU 1900), cat. 1

LUCIANO FREIRE
Country Perfume, 1899. Oil on canvas, 200 × 160 cm. Museu do Chiado, Lisbon, Inv. 29, cat. 118

AKSELI GALLÉN-KALLELA
The Defence of Sampo, 1896. Tempera on canvas, 122 × 125 cm. The Turku Art Museum (EU 1900), cat. 28 (CAT. ONLY)

RAFFAELLO GAMBOGI
Boats in Dry Dock at Livorno, 1897. Oil on canvas, 78 × 137 cm. Studio Paul Nicholls, Milan, cat. 132

PAUL GAUGUIN
The Bathers, 1897. Oil on canvas, 60 × 92 cm. National Gallery of Art, Washington, D.C. Gift of Sam A. Lewisohn 1951.5.1, cat. 58
The Family Walk, 1901. Oil on canvas, 76 × 65 cm. Musée National de l'Orangerie, Paris. Collection Jean Walter and Paul Guillaume, cat. 211 (RA ONLY)
Self-portrait, 1902–03. Oil on canvas, 42 × 25 cm. Öffentliche Kunstsammlung Basel, Kunstmuseum. Bequest of Dr Karl Hoffmann, 1945, cat. 263 (CAT. ONLY)
Still-life, 1899. Oil on canvas, 61 × 73 cm. Nasjonalgalleriet, Oslo, cat. 178

JEAN-LÉON GÉRÔME
Optician, 1902. Oil on canvas, 87 × 66 cm. Private Collection, cat. 179

SIR ALFRED GILBERT
The Virgin, 1899. Painted bronze, 53.3 × 33 × 33 cm. A Scottish parish church, cat. 247

IGOR GRABAR
September Snow, 1903. Oil on canvas, 78 × 89 cm. State Tretyakov Gallery, Moscow, cat. 218

VITTORE GRUBICY
Winter in the Mountains, a Pantheist Poem: Morning, 1900. Oil on canvas, 75 × 56 cm. Civica Galleria d'Arte Moderna, Milan, cat. 187

ALFRED GUILLOU
Farewell, 1892. Oil on canvas, 170 × 245 cm. Musée des Beaux-Arts, Quimper (EU 1900), cat. 18

PEKKA HALONEN
Washing on the Ice, 1900. Oil on canvas, 125 × 180 cm. The Finnish National Gallery Ateneum, Helsinki (EU 1900), cat. 222

VILHELM HAMMERSHØI
Interior, 1899. Oil on canvas, 64 × 57 cm. Tate Gallery. Presented in memory of Leonard Borwick by his friends through the National Art Collections Fund 1926, cat. 158

CHILDE HASSAM
Late Afternoon, New York: Winter, 1900. Oil on canvas, 94 × 73.6 cm. Brooklyn Museum of Art. Dick S. Ramsay Fund 62.68, cat. 130 (RA ONLY)
The Messenger Boy, 1903. Oil on canvas, 46.4 × 81.9 cm. Museum of Art, Rhode Island School of Design. Jesse Metcalf Fund, cat. 136 (NY ONLY)

JEAN-JACQUES HENNER
Levite of Ephraim and His Dead Wife, 1898. Oil on canvas, 87.6 × 163.8 cm. Joey and Toby Tanenbaum, Toronto (EU 1900), cat. 21

ROBERT HENRI
Cumulus Clouds, East River, 1901–02. Oil on canvas, 63.5 × 80.6 cm. National Museum of American Art, Smithsonian Institution. Partial and promised gift of Mrs Daniel Fraad in memory of her husband, cat. 137 (NY ONLY)
Street Scene with Snow (57th Street, NYC), 1902. Oil on canvas, 66 × 81.2 cm. Yale University Art Gallery. Mabel

Brady Garvan Collection, cat. 134 (RA ONLY)

LUDWIG HERTERICH
Ulrich von Hutten, 1894. Oil on canvas, 184 × 108 cm. Gemäldegalerie Neue Meister, Staatliche Kunstsammlungen, Dresden (EU 1900), cat. 237

FERDINAND HODLER
Lake Geneva from St Prex, 1901. Oil on canvas, 72 × 107 cm. Private Collection, Switzerland, cat. 183
Self-portrait, 1900. Oil on canvas, 41 × 26.6 cm. Staatsgalerie, Stuttgart, cat. 278
Spring, 1901. Oil on canvas, 102.5 × 129.5 cm. Museum Folkwang, Essen, cat. 78

LUDWIG VON HOFMANN
Sunset over the Sea, c. 1898. Oil on canvas, 74 × 119.5 cm. Österreichische Galerie Belvedere, Vienna, cat. 182

WINSLOW HOMER
Eastern Point, Prout's Neck, 1900. Oil on canvas, 77.5 × 123.2 cm. Sterling and Francine Clark Art Institute, Williamstown, Massachusetts, cat. 194
Lookout 'All's Well', 1896. Oil on canvas, 101.6 × 76.8 cm. Museum of Fine Arts, Boston. Warren Collection (EU 1900), cat. 17

JOZEF ISRAËLS
Self-portrait, c. 1900–10. Oil on canvas, 58 × 47.5 cm. Galleria degli Uffizi, Florence. Collezione degli autoritratti, cat. 256

PAUL JOSEPH JAMIN
Brennus and His Loot, 1893. Oil on canvas, 162 × 118 cm. Musée des Beaux-Arts, La Rochelle (EU 1900), cat. 19

EUGÈNE JANSSON
Midsummer Mood, 1898. Oil on canvas, 149 × 134 cm. Private Collection, cat. 195
I. Self-portrait, 1901. Oil on canvas, 101 × 144 cm. Thielska Galleriet, Stockholm, cat. 261

EERO JÄRNEFELT
The Burn-Beating, 1893. Oil on canvas, 131 × 164 cm. The Finnish National Gallery Ateneum, Helsinki (EU 1900), cat. 223

ALEXEI JAWLENSKY
Still-life with Hyacinths and Oranges, 1902. Oil on canvas, 53.5 × 44.4 cm. Private Collection, cat. 175

GWEN JOHN
Self-portrait, 1902. Oil on canvas, 44.8 × 34.9 cm. Tate Gallery. Purchased 1942, cat. 271 (RA ONLY)

COUNT LEOPOLD VON KALCKREUTH
Three Stages of Life, 1898. Oil on canvas, 162 × 441 cm. Bayerische Staatsgemäldesammlungen, Neue Pinakothek, Munich, cat. 283

VASILY KANDINSKY
Study for a Sluice, 1901. Oil on cardboard, 31.6 × 23.9 cm. Städtische Galerie im Lenbachhaus, Munich, cat. 215

TAKESHIRO KANOKOGI
Tsu Station (Haruko), 1898. Oil on canvas, 57.1 × 39 cm. Mie Prefectural Art Museum, cat. 139

DMITRY KARDOVSKY
Portrait of Marya Anastasievna Chroustchova, 1900. Oil on canvas, 150.2 × 95 cm. Solomon R. Guggenheim Museum, New York (50.1289), cat. 92 (NY ONLY)

FERDINAND KELLER
The Tomb of Böcklin, 1901–02. Oil on canvas, 117 × 99 cm. Staatliche Kunsthalle, Karlsruhe, cat. 190

FERNAND KHNOPFF
Study for 'The Past', c. 1897. Coloured gesso, 30.5 × 10 × 5.5 cm. Patrick Derom Gallery, Brussels, cat. 72

GUSTAV KLIMT
The Big Poplar II, 1902–03. Oil on canvas, 100.8 × 100.7 cm. Leopold Museum, Vienna (Private Collection), cat. 191 (RA ONLY)
Moving Waters, 1898. Oil on canvas, 53 × 66 cm. Private Collection (courtesy Galerie St. Etienne, New York), cat. 84
Pallas Athene, 1898. Oil on canvas, 75 × 75 cm. Historisches Museum der Stadt, Vienna (EU 1900), cat. 63 (RA ONLY)
Pine Forest, 1901. Oil on canvas, 91.5 × 89 cm. Private Collection (courtesy Galerie St. Etienne, New York), cat. 188
Portrait of Marie Henneberg, 1901–02. Oil on canvas, 140 × 140 cm. Staatliche Galerie Moritzburg Halle, Landeskunstmuseum Sachsen-Anhalt, cat. 113
Silver Fishes, 1899. Oil on canvas, 82 × 52 cm. Bank Austria Kunstsammlung, Vienna, cat. 65

MAX KLINGER
Head of Brahms, 1901. Bronze, 36.5 × 37 × 47 cm. Museum der bildenden Künste, Leipzig, cat. 112

KONSTANTIN KOROVIN
Portrait of Morozov, 1902. Oil on canvas, 90.4 × 78.7 cm. State Tretyakov Gallery, Moscow, cat. 93

CHRISTIAN KROHG
17 May 1898, 1898. Oil on canvas, 132 × 133 cm. Private Collection, cat. 140

P. S. KRØYER
Boys Bathing, Summer Evening, Skagen, 1899. Oil on canvas, 100.5 × 153 cm. Statens Museum for Kunst, Copenhagen (EU 1900), cat. 55
Edvard and Nina Grieg at the Piano, 1898. Oil on panel, 58.5 × 73 cm. Nationalmuseum, Stockholm (EU 1900), cat. 110

GOTTHARD JOHANN KUEHL
The Augustus Bridge in Dresden, c. 1899. Oil on canvas, 78 × 115 cm. Kunsthalle, Bremen, cat. 127

FRANTIŠEK KUPKA
The Book Lover I, 1897. Oil on canvas, 95.5 × 152 cm. Art Collections of Prague Castle (EU 1900), cat. 5

BORIS KUSTODIYEV
Portrait of Bilibin, 1901. Oil on canvas, 142 × 110 cm. The State Russian Museum, St Petersburg, cat. 108 (RA ONLY)

GEORGES LACOMBE
Magdalene, 1897. Wood, 105 × 42 × 53 cm. Palais des Beaux-Arts, Lille, cat. 243

EUGÈNE LAERMANS
The Blind One, 1899. Oil on canvas, 120 × 150 cm. Musée d'Orsay, Paris (EU 1900), cat. 234

JEF LAMBEAUX
The Rape, c. 1900. Bronze, H. 57 cm. Musée Royal de Mariemont, Morlanwelz (EU 1900), cat. 79

HENRY HERBERT LA THANGUE
The Ploughboy, c. 1900. Oil on canvas, 155 × 117.7 cm. City of Aberdeen Art Gallery and Museums Collection (EU 1900), cat. 229

SIR JOHN LAVERY
Father and Daughter, 1900. Oil on canvas, 209 × 126 cm. Musée d'Orsay, Paris (EU 1900), cat. 102

OZIAS LEDUC
Self-portrait, 1899. Oil on paper mounted on panel, 33 × 27 cm. National Gallery of Canada, Ottawa, cat. 258

FREDERIC, LORD LEIGHTON
Clytie, c. 1895–96. Oil on canvas, 156 × 137 cm. From the collection of Mr and Mrs Schaeffer, Australia (EU 1900), cat. 27

FRANZ VON LENBACH
Portrait of Peggy Guggenheim, c. 1903. Oil on board, 128.9 × 92.7 cm. The Solomon R. Guggenheim Foundation (98.5247), cat. 106

HENRI LE SIDANER
Sunday, 1898. Oil on canvas, 112.5 × 192 cm. Musée de la Chartreuse, Douai (EU 1900), cat. 11

ISAAK LEVITAN
Twilight, 1899. Oil on canvas, 50.5 × 74 cm. State Tretyakov Gallery, Moscow, cat. 184

LÉON LHERMITTE
Supper at Emmaus, 1892. Oil on canvas, 155.5 × 223 cm. Museum of Fine Arts, Boston. Gift of J. Randolph Coolidge 92.2657 (EU 1900), cat. 24

MAX LIEBERMANN
Boys Bathing, 1898. Oil on canvas, 122 × 151 cm. Stadtmuseum, Berlin, cat. 53 (RA ONLY)

SYDNEY LONG
Pan, 1898. Oil on canvas, 108.6 × 177.8 cm. The Art Gallery of New South Wales, Sydney. Purchased 1996, cat. 33

MAXIMILIEN LUCE
The Sainte Chapelle, Paris, 1902. Oil on canvas, 62.8 × 53 cm. Eugene A. Davidson and the late Suzette Morton Davidson, cat. 135

FREDERICK WILLIAM MACMONNIES
Bacchante with Infant Faun, cast 1893–94. Bronze, H. 42 cm. Courtesy Berry-Hill Galleries, New York (EU 1900), cat. 71
Self-portrait with Palette, 1897–1903. Oil on canvas, 81.3 × 54.3 cm. Terra Foundation for the Arts. Daniel J. Terra Collection (1992.46), cat. 268

ARISTIDE MAILLOL
Eve with an Apple, 1899. Bronze (A. Bingeu et Costenoble: Epreuve d'artiste), 58 × 21 × 12 cm. Collection Musée Maillol, Paris, cat. 66
Female Bather Standing, 1899. Wood, 77 × 33 × 33 cm. Stedelijk Museum, Amsterdam, cat. 56
The Mediterranean (1st state), 1900–02. Bronze (Emile Godard: Epreuve d'artiste no. 2/4), H. 118 cm. Collection Musée Maillol, Paris, cat. 38 (RA ONLY)

FILIPP MALYAVIN
Peasant Wench, 1903. Oil on canvas, 206.3 × 115.6 cm. State Tretyakov Gallery, Moscow, cat. 232 (RA ONLY)

HENRI MATISSE
The Blue Jug, c. 1900. Oil on canvas, 59.5 × 73.5 cm. Pushkin State Museum of Fine Arts, Moscow, cat. 177
Madeleine I, 1901. Bronze (ed. 2/10), 59.7 × 19.7 × 22.9 cm. Weatherspoon Art Gallery, The University of North Carolina at Greensboro. Cone Collection, 1950, cat. 43
Male Model, 1900. Oil on canvas, 99.3 × 72.7 cm. The Museum of Modern Art, New York. Kay Sage Tanguy and Abby Aldrich Rockefeller Funds, cat. 49 (NY ONLY)

The Serf, 1900–03, cast c. 1931. Bronze, 91.5 × 37.8 × 30.7 cm. Hirshhorn Museum and Sculpture Garden, Smithsonian Institution. Gift of Joseph H. Hirshhorn, 1966, cat. 50
Studio Interior, 1902. Oil on canvas, 54.4 × 44.5 cm. Lent by the Syndics of the Fitzwilliam Museum, Cambridge. Bequeathed by A. J. Hugh Smith through the National Art Collections Fund in 1964, cat. 167

ALFRED H. MAURER
An Arrangement, 1901. Oil on cardboard, 91.4 × 81 cm. Whitney Museum of American Art, New York, cat. 156
Self-portrait, 1897. Oil on canvas, 73 × 53.3 cm. Lent by the Frederick R. Weisman Art Museum, University of Minnesota. Gift of Ione and Hudson Walker, cat. 275

GABRIEL MAX
The Jury of Apes (Monkey Critics), 1890s. Oil on canvas, 85 × 107 cm. Bayerische Staatsgemäldesammlungen, Neue Pinakothek, Munich (EU 1900), cat. 25 (NY ONLY)

GARI MELCHERS
The Communicant, c. 1900. Oil on canvas, 160.7 × 109.2 cm. The Detroit Institute of Arts. Bequest of Mr and Mrs Charles M. Swift, cat. 250

CONSTANTIN MEUNIER
The Mine (Descent, Calvary, Return), 1900. Oil on canvas, 140 × 170 cm. Musées Royaux des Beaux-Arts de Belgique, Brussels, Inv. 10.000/176 (1–3), cat. 286
The Old Miner, 1900. Bronze, 61.5 × 41.5 × 28.6 cm. Musées Royaux des Beaux-Arts de Belgique, Brussels, Inv. 10.000/676 (EU 1900), cat. 119
The Reaper, 1892. Bronze, 55.6 × 24.4 × 44.5 cm. Musées Royaux des Beaux-Arts de Belgique, Brussels, Inv. 10.000/107 (EU 1900), cat. 224

GEORGE MINNE
Kneeling Boy, 1898. Marble, 80 × 42 × 20 cm. Museum Boijmans van Beuningen, Rotterdam, cat. 249

PAULA MODERSOHN-BECKER
Nursing Mother, c. 1902. Oil on paper, 72.2 × 48 cm. Galerie Michael Haas, Berlin, cat. 253
Self-portrait, 1898. Oil on paper, 28.2 × 23 cm. Kunsthalle, Bremen, cat. 272

CARL MOLL
The Coffee Factory, 1900. Oil on canvas, 95.5 × 85.5 cm. Historisches Museum der Stadt, Vienna, cat. 116
Interior, 1903. Oil on canvas, 135 × 89 cm. Historisches Museum der Stadt, Vienna, cat. 164

PIET MONDRIAN
Pollard Willows on the Gein, 1902–04. Oil on canvas, 53.5 × 63 cm. Collection Gemeentemuseum Den Haag, The Hague, cat. 186
Self-portrait, 1900. Oil on canvas, 49 × 38 cm. The Phillips Collection, Washington, D.C., cat. 277 (NY ONLY)

CLAUDE MONET
Charing Cross Bridge, 1899. Oil on canvas, 65 × 81 cm. Santa Barbara Museum of Art. Bequest of Katherine Dexter McCormick in memory of her husband, Stanley McCormick, cat. 128
Morning on the Seine, 1897. Oil on canvas, 81.9 × 93.4 cm. Mead Art Museum, Amherst College, Massachusetts. Bequest of Susan Dwight Bliss, cat. 181

The Water Lily Pond (Japanese Bridge), 1899. Oil on canvas, 89 × 92 cm. Private Collection, Japan, cat. 209

THOMAS MORAN
Cliff Dwellers, 1899. Oil on canvas, 50.8 × 76.2 cm. Berea College, Kentucky, cat. 202

ALEKSANDR VIKTOROVICH MORAVOV
Mother and Child, 1902. Oil on canvas, 77 × 66.5 cm. The State Russian Museum, St Petersburg, cat. 251 (RA ONLY)

ANGELO MORBELLI
In the Rice Fields, 1901. Oil on canvas, 182.9 × 130.2 cm. Private Collection, cat. 217
When I Was a Little Girl (Entremets), 1903. Oil on canvas, 71 × 110.5 cm. Private Collection, Italy, cat. 125

JAMES WILSON MORRICE
The Sugar Bush, 1897–98. Oil on canvas, 53.6 × 48.3 cm. National Gallery of Canada, Ottawa. Gift of G. Blair Laing, Toronto, 1989, cat. 220

ALPHONSE MUCHA
Nature, 1900. Bronze, 69.2 × 27.9 × 30.5 cm. Virginia Museum of Fine Arts, Richmond. The Sydney and Frances Lewis Art Nouveau Fund (EU 1900), cat. 86 (NY ONLY)

EDVARD MUNCH
The Beast, 1901. Oil on canvas, 94.5 × 63.5 cm. Sprengel Museum, Hanover, cat. 61 (RA ONLY)
Girls on the Jetty, 1903. Oil on canvas, 92 × 80 cm. From the Collection of Vivian and David Campbell, cat. 219
Golgotha, 1900. Oil on canvas, 80 × 120 cm. Munch-Museet, Oslo, cat. 236 (NY ONLY)
Inheritance, 1903–05. Oil on canvas, 119 × 100 cm. Munch-Museet, Oslo, cat. 123
Man and Woman, 1898. Oil on canvas, 60.2 × 100 cm. Bergen Art Museum, Rasmus Meyers Collection, cat. 81
Portrait of Aase and Harald Norregaard, 1899. Oil on cardboard, 49.5 × 75 cm. Nasjonalgalleriet, Oslo, cat. 109
Winter Night, c. 1900. Oil on canvas, 80 × 120 cm. Kunsthaus, Zurich, cat. 204 (RA ONLY)
Women in Hospital, 1897. Oil on canvas, 110.5 × 101 cm. Munch-Museet, Oslo, cat. 120 (NY ONLY)

FERDINAND HART NIBBRIG
Abundance, 1895. Oil on canvas, 99 × 150 cm. Private Collection, The Netherlands (EU 1900), cat. 9

EJNAR NIELSEN
The Sick Girl, 1896. Oil on canvas, 112 × 164 cm. Statens Museum for Kunst, Copenhagen (EU 1900), cat. 22 (CAT. ONLY)

EMIL NOLDE
Light Sea-Mood, 1901. Oil on canvas, 65 × 83 cm. Nolde-Stiftung, Seebuell, cat. 193
Self-portrait, 1899. Oil on canvas, 69 × 52 cm. Nolde-Stiftung, Seebuell, cat. 266

FRANCISCO MANUEL OLLER
Hacienda Aurora, c. 1898. Oil on canvas, 32 × 55.8 cm. The Luis A. Ferré Foundation Inc. Museo de Arte de Ponce, cat. 200 (NY ONLY)

SIR WILLIAM ORPEN
The Mirror, 1900. Oil on canvas, 50.8 × 40.6 cm. Tate Gallery. Presented by Mrs Coutts Michie through the National Art Collections Fund

in memory of the George McCulloch Collection 1913, cat. 160

WALTER FREDERICK OSBORNE
Dorothy and Irene Falkiner, 1900. Oil on canvas, 149.9 × 114.3 cm. Private Collection, Greenwich, Connecticut (EU 1900), cat. 103

GIUSEPPE PELLIZZA DA VOLPEDO
The Fourth Estate, 1901. Oil on canvas, 283 × 550 cm. Pinacoteca di Brera, Milan, cat. 216 (RA ONLY)
The Mirror of Life, 1895–98. Oil on canvas, 132 × 288 cm. Galleria Civica d'Arte Moderna e Contemporanea, Turin (EU 1900), cat. 2

JOHN F. PETO
The Cup We All Race 4, c. 1900. Oil on canvas and panel, 64.8 × 54.6 cm. Fine Arts Museum of San Francisco. Gift of Mr and Mrs John D. Rockefeller 3rd, cat. 180 (NY ONLY)

PABLO PICASSO
The Absinthe Drinker, 1901. Oil on cardboard, 65.5 × 51 cm. Private Collection, cat. 154
The Burial of Casagemas (Evocation), 1901. Oil on canvas, 150 × 90 cm. Musée d'Art Moderne de la Ville de Paris, cat. 240 (RA ONLY)
Moulin de la Galette, 1900. Oil on canvas, 88.2 × 115.5 cm. Solomon R. Guggenheim Museum, New York, Thannhauser Collection. Gift of Justin K. Thannhauser (1978. 78.2514 T34), cat. 141
Portrait of Josep Cardona, 1899. Oil on canvas, 100 × 63 cm. Collection Valentin, São Paulo, cat. 107
Self-portrait (Yo), 1901. Oil on cardboard mounted on wood, 51.4 × 31.1 cm. The Museum of Modern Art, New York. Mrs John Hay Whitney Bequest, cat. 276 (NY ONLY)
Two Women at a Bar, 1902. Oil on canvas, 80 × 91.5 cm. Hiroshima Museum of Art, cat. 150

RAMON PICHOT GIRONÈS
Offering, c. 1898. Oil on canvas, 165 × 120 cm. Museu Nacional d'Art de Catalunya (Museu d'Art Modern), Barcelona, cat. 241

CAMILLE PISSARRO
Boulevard Montmartre: Foggy Morning, 1897. Oil on canvas, 55 × 64.7 cm. Private Collection, cat. 129
The Siesta, 1899. Oil on canvas, 65 × 81 cm. Private Collection, cat. 226

GAETANO PREVIATI
The Three Marys at the Foot of the Cross, 1897. Oil on canvas, 125 × 170 cm. Collection Calmarini, Milan, cat. 238

ODILON REDON
Still-life, c. 1901. Oil on canvas, 50 × 73 cm. Ordrupgaard, Copenhagen, cat. 174 (NY ONLY)

AUGUSTE RENOIR
Reclining Nude, 1902. Oil on canvas, 97.3 × 154 cm. Private Collection (courtesy Galerie Beyeler, Basel), cat. 39
Self-portrait, c. 1897. Oil on canvas, 41 × 33 cm. Sterling and Francine Clark Art Institute, Williamstown, Massachusetts, cat. 264
The White Pierrot, 1901–02. Oil on canvas, 81.3 × 62.2 cm. The Detroit Institute of Arts. Bequest of Robert H. Tannahill, cat. 104

IL'YA REPIN
Portrait Study of Ignatiev, 1902. Oil on canvas, 89 × 62.5 cm. The State Russian Museum, St Petersburg, cat. 98 (RA ONLY)

LAURITS ANDERSEN RING
Dusk, The Artist's Wife by the Stove, 1898. Oil on canvas, 86 × 65.6 cm. Statens Museum for Kunst, Copenhagen, cat. 157

EUGÈNE ROBERT
The Awakening of the Abandoned Child, 1894. Marble, 50 × 130 × 85 cm. Musée de l'Assistance Publique: Hôpitaux de Paris (EU 1900), cat. 121

TOM ROBERTS
Christmas Flowers and Christmas Belles (The Flower Sellers), c. 1899. Oil on canvas, 52.1 × 36.2 cm. Manly Art Gallery & Museum, cat. 138

AUGUSTE RODIN
Balzac, c. 1897. Bronze, 110.2 × 49 × 42.3 cm. Musée Rodin, Paris, cat. 94
The Earth and Moon, 1899. White marble, 120 × 68.5 × 63.5 cm. National Museums and Galleries of Wales, cat. 77 (RA ONLY)
The Kiss, 1898. Bronze, 182.9 × 112 × 112 cm. National Museums and Galleries of Wales (EU 1900), cat. 30 (RA ONLY)
Meditation I (without arms), c. 1894. Plaster, 54 × 18 × 15 cm. Musée Rodin, Paris, cat. 42
Walking Man, 1900. Bronze, 355 × 75 × 75 cm. Musée Rodin, Paris, cat. 51

ALFRED ROLL
The Sick Woman, 1897. Oil on canvas, 110 × 147 cm. Musée des Beaux-Arts, Bordeaux (EU 1900), cat. 20

MEDARDO ROSSO
Impression of the Boulevard. Woman with a Veil, 1893. Wax, 60 × 59 × 25 cm. Estorick Foundation, London, cat. 131 (RA ONLY)

SIR WILLIAM ROTHENSTEIN
The Browning Readers, 1900. Oil on canvas, 76 × 96.5 cm. Bradford Art Galleries and Museums, cat. 161
A Doll's House, 1899–1900. Oil on canvas, 88.9 × 61 cm. Tate Gallery. Presented by C. L. Rutherston 1917 (EU 1900), cat. 148

HENRI ROUSSEAU
Happy Quartet, 1901–02. Oil on canvas, 94 × 57 cm. Private Collection, cat. 83 (CAT. ONLY)

JULIO RUELAS
Self-portrait, 1900. Oil on canvas, 46.5 × 35 cm. Consejo Nacional para la Cultura y las Artes, el Instituto Nacional de Bellas Artes y Literatura, the Museo Nacional de Arte, Mexico City, cat. 259 (RA ONLY)

SANTIAGO RUSIÑOL
The Green Wall, 1901. Oil on canvas, 95 × 105 cm. Centro de Arte Reina Sofía, Madrid, cat. 210

FERDYNAND RUSZCZYC
Earth, 1898. Oil on canvas, 171 × 219 cm. Muzeum Narodowe w Warszawie (EU 1900), cat. 230

ALBERT RUTHERSTON
The Song of the Shirt, 1902. Oil on canvas, 76 × 58.5 cm. Bradford Art Galleries and Museums, cat. 159

AUGUSTUS SAINT-GAUDENS
Amor Caritas, 1898. Bronze low-relief, 101 × 44.5 × 10.2 cm. Brooklyn Museum of Art. Gift of Mr and Mrs Harris Klein (68.184), cat. 248

JOHN SINGER SARGENT
Mrs Carl Meyer and Her Children, 1895. Oil on canvas, 201.9 × 135.9 cm. Private Collection (EU 1900), cat. 99

GIOVANNI SEGANTINI
The Fruits of Love, 1889. Oil on canvas,

88.2 × 57.2 cm. Museum der bildenden Künste, Leipzig (EU 1900), cat. 8

VALENTIN SEROV
Portrait of Grand Duke Paul Alexandrovitch, 1897. Oil on canvas, 168 × 151 cm. State Tretyakov Gallery, Moscow (EU 1900), cat. 7 (RA ONLY)
Portrait of Maria Morozova, 1897. Oil on canvas, 108 × 87.5 cm. The State Russian Museum, St Petersburg, cat. 100 (RA ONLY)

CHARLES SHANNON
Self-portrait, 1897. Oil on canvas, 92.7 × 96.5 cm. National Portrait Gallery, London, cat. 262

WALTER RICHARD SICKERT
The Bathers, Dieppe, 1902. Oil on canvas, 131.5 × 104.5 cm. Board of Trustees of the National Museums & Galleries on Merseyside (Walker Art Gallery, Liverpool), cat. 54
Self-portrait, c. 1896. Oil on canvas, 45.7 × 35.6 cm. Leeds Museums and Galleries (City Art Gallery), cat. 267

JOHN SLOAN
The Rathskeller, 1901. Oil on canvas, 90.5 × 69 cm. The Cleveland Museum of Art. Gift of the Hanna Fund 1946.164, cat. 147 (NY ONLY)

HARALD OSKAR SOHLBERG
Winter Night in the Mountains, 1901. Oil on board, 68 × 93 cm. Private Collection, cat. 206

JOAQUÍN SOROLLA Y BASTIDA
Sad Inheritance, 1899. Oil on canvas, 212 × 288 cm. Colección de la Caja de Ahorros de Valencia, Castellón y Alicante 'Bancaja' (EU 1900), cat. 122
Sewing the Sail, 1896. Oil on canvas, 220.2 × 301.8 cm. Galleria Internazionale d'Arte Moderna di Ca' Pesaro, Venice (EU 1900), cat. 4 (RA ONLY)

AURÉLIA DE SOUSA
Self-portrait, c. 1900. Oil on canvas, 45.6 × 36.4 cm. Museu Nacional de Soares dos Reis, Oporto, cat. 274

CLARA SOUTHERN
An Old Bee Farm, 1900. Oil on canvas, 238 × 140 cm. National Gallery of Victoria, Melbourne. Felton Bequest, 1942, cat. 221

JAN STANISLAWSKI
Poplars on the Water, 1900. Oil on canvas, 145.5 × 80.5 cm. The National Museum, Cracow, cat. 185

AUGUST STRINDBERG
White Mark IV, 1901. Oil on cardboard, 51 × 30 cm. City Library and County Library of Örebro Lan, Örebro, cat. 196

FRANZ VON STUCK
Amazon, 1897–1903. Bronze, H. 36 cm. Museum Villa Stuck, Munich. Permanent loan from a private collection (EU 1900), cat. 70
Dancing Girl, 1897. Bronze, 63 × 33.5 × 23.5 cm. Kunsthalle, Bremen, cat. 75
Self-portrait, 1899. Oil on canvas, 30 × 23.5 cm. Museum Villa Stuck, Munich. Gift of Hans Joachim Ziersch, cat. 260
Sin, 1899. Oil on panel, 35 × 80 cm. Wallraf-Richartz Museum, Cologne, cat. 64 (RA ONLY)

PÁL SZINYEI MERSE
Melting Snow, 1884–95. Oil on canvas, 47 × 60.6 cm. Hungarian National Gallery, Budapest (EU 1900), cat. 198

AUGUSTUS VINCENT TACK
Windswept (Snow Picture, Leyden), c. 1900–02. Oil on canvas, 79 × 92 cm. The Phillips Collection, Washington, D.C. Acquired from the Estate of Agnes Gordon Tack, by 1959, cat. 205

HENRY OSSAWA TANNER
The Annunciation, 1898. Oil on canvas, 144.8 × 181 cm. Philadelphia Museum of Art. W. P. Wilstach Collection, cat. 246

HANS THOMA
Adam and Eve, 1899. Oil on canvas, 110 × 78.5 cm. The State Hermitage Museum, St Petersburg, cat. 82

THORÁRINN B. THORLÁKSSON
Thingvellir, 1900. Oil on canvas, 57.5 × 81.5 cm. Listasafn Islands, National Gallery of Iceland, Reykjavik, cat. 203

SIR HAMO THORNYCROFT
The Joy of Life, 1896. Bronze, 39 × 23 × 12 cm. Leeds Museums and Galleries (City Art Gallery) (EU 1900), cat. 74

JAN TOOROP
Watchers on the Threshold of the Sea, c. 1900. Oil on canvas, 130 × 150 cm. Museum Boijmans van Beuningen, Rotterdam, cat. 233

HENRI DE TOULOUSE-LAUTREC
Crouching Woman with Red Hair, 1897. Oil on cardboard, 47 × 60 cm. San Diego Museum of Art. Gift of the Baldwin M. Baldwin Foundation, cat. 44
The Opera 'Messaline' at Bordeaux, 1900–01. Oil on canvas, 99.1 × 72.4 cm. The Los Angeles County Museum of Art. Mr and Mrs George Gard De Sylva Collection, cat. 144
In a Private Room at the 'Rat Mort', 1899. Oil on canvas, 55.1 × 46 cm. Courtauld Gallery, London (Samuel Courtauld Collection), cat. 149 (RA ONLY)

PRINCE PAOLO TROUBETZKOY
Count Leo Tolstoy, 1899. Bronze, 33 × 29 × 26 cm. Hatton Gallery, University of Newcastle-upon-Tyne (EU 1900), cat. 96

WILHELM TRÜBNER
Salome, 1898. Oil on cardboard, 101 × 53.3 cm. Milwaukee Art Museum. Gift of the Rene von Schleinitz Foundation, cat. 67

HENRY SCOTT TUKE
Noonday Heat, 1903. Oil on canvas, 81.9 × 133.4 cm. The Tuke Collection, Royal Cornwall Polytechnic Society, Falmouth, cat. 52

FRITZ VON UHDE
Holy Night, 1888–89. Oil on canvas, 134.5 × 215 cm. Gemäldegalerie Neue Meister, Staatliche Kunstsammlungen, Dresden (EU 1900), cat. 284

FÉLIX VALLOTTON
The Spring, 1897. Oil on cardboard, 48 × 60 cm. Petit Palais, Musée d'Art Moderne, Geneva, cat. 37
The Visit, c. 1897. Tempera on panel, 55 × 87 cm. Kunstmuseum, Winterthur, cat. 170

ALBIJN VAN DEN ABEELE
Fir Forest in February, 1897. Oil on canvas, 69 × 81 cm. Private Collection, cat. 189

THÉO VAN RYSSELBERGHE
The Burnished Hour, 1897. Oil on canvas, 228 × 329 cm. Kunstsammlungen zu Weimar, cat. 32 (CAT. ONLY)

JOSÉ MARÍA VELASCO
Hacienda de Caapa and Volcanoes, 1897. Oil on canvas, 84 × 125 cm. Colección Banco Nacional de México, cat. 201 (NY ONLY)

MAURICE DE VLAMINCK
The Bar, 1900. Oil on canvas, 40.3 × 31.1 cm. Musée Calvet, Avignon, cat. 153

MIKHAIL VRUBEL
Portrait of Nadezhda Sabela-Vrubel at the Piano, c. 1900. Oil on canvas, 189 × 60 cm. State Tretyakov Gallery, Moscow, cat. 105
Scene from 'Robert le Diable', 1896–97. Bronze, 91.5 × 137 × 124.5 cm. State Tretyakov Gallery, Moscow, cat. 143

EDOUARD VUILLARD
The Painter Ker-Xavier Roussel and His Daughter, 1903. Oil on canvas, 58.2 × 53.1 cm. Collection Albright-Knox Art Gallery, Buffalo, New York. Room of Contemporary Art Fund, 1943. RCA 43: 17, cat. 169
Still-life with Candlestick, c. 1900. Oil on millboard, 43.6 × 75.8 cm. Scottish National Gallery of Modern Art, Edinburgh. Presented by Mrs Isabel Traill 1979, cat. 173

WOJCIECH WEISS
Obsession, c. 1900–01. Oil on canvas, 100 × 185 cm. Museum of Literature, Warsaw, cat. 85

JAMES ABBOTT McNEILL WHISTLER
Portrait of George W. Vanderbilt, 1897–1903. Oil on canvas, 208.6 × 91.1 cm. National Gallery of Art, Washington, D.C. Gift of Edith Stuyvesant Gerry 1959.3.3 (EU 1900), cat. 89

CARL WILHELMSON
Fishermen's Wives Returning from Church, 1899. Oil on canvas, 137 × 104 cm. Nationalmuseum, Stockholm (EU 1900), cat. 242

ICHIRO YUASA
Fishermen Returning Late in the Evening, 1898. Oil on canvas, 139.2 × 200.3 cm. Tokyo National University of Fine Arts and Music (EU 1900), cat. 15

ANDERS ZORN
Midsummer Dance, 1897. Oil on canvas, 140 × 98 cm. Nationalmuseum, Stockholm (EU 1900), cat. 231
Red Sand, 1902. Oil on canvas, 118.5 × 94 cm. Private Collection, cat. 57

IGNACIO ZULOAGA
Portrait of a Dwarf, 1899. Oil on canvas, 150 × 55 cm. Musée d'Orsay, Paris, cat. 91

Select Bibliography

Compiled by Janice Yang

Specific bibliographic references for artists follow each entry in the Biographies section (pp. 364–435)

The Age of Rossetti, Burne-Jones and Watts: Symbolism in Britain 1860–1910, exh. cat., Tate Gallery, London, 1997

The American Renaissance 1876–1917, exh. cat., The Brooklyn Museum, New York, 1979

Autour de Bourdelle: Paris et les artistes polonais 1900–1918, exh. cat., Musée Bourdelle, Paris, 1996

Baschet, L., *Catalogue officiel illustré de l'Exposition Décennale des Beaux-Arts de 1889 à 1900*, Paris, 1900

Belgian Art, 1880–1914, exh. cat., The Brooklyn Museum, New York, 1980

Bénédite, L., 'Les Arts à l'Exposition Universelle de 1900 – L'exposition décennale: La peinture étrangère', *Gazette des Beaux-Arts*, 24, 3rd series: no. 519 (1 September 1900, pp. 177–194); no. 521 (1 November 1900, pp. 483–504); no. 522 (1 December 1900, pp. 577–592)

Berri, G., and C. Hanau, *Il secolo XIX nella vita e nella cultura dei popoli: L'Esposizione Mondiale del 1900 a Parigi*, Milan, n.d.

de Boer, D., et al., eds, *Nederland rond 1900: Contouren van een cultuur: Kunst, Literatuur, Muziek, Film*, Haarlem, 1979

Bolger, D. and N. Cikovsky, Jr., eds, *American Art Around 1900: Lectures in Memory of Daniel Fraad*, National Gallery of Art, Washington, D.C., 1990

Boyd, J. P., *The Paris Exposition of 1900*, Philadelphia, Penn., 1900

Catalogue illustré: Exposition des Beaux-Arts à l'Exposition Universelle de 1900 à Paris: Hongrie, Budapest, n.d.

Christian, J., ed., *The Last Romantics: The Romantic Tradition in British Art*, exh. cat., Barbican Art Gallery, London, 1989

Comte, J., ed., *L'Art à l'exposition universelle de 1900*, Paris, 1900

Cogeval, G. (trans. D. Simon and C. Volk), *Post-impressionists*, New York, 1988

Dreams of a Summer Night: Scandinavian Painting at the Turn of the Century, exh. cat., Arts Council of Great Britain, London, 1986

Fine Arts Exhibit, United States of America: Paris Exposition of 1900, United States Commission, Department of Fine Arts, Boston, Mass., 1900

Finskt 1900, exh. cat., Nationalmuseum, Stockholm, 1971

Fischer, D. P., *Paris 1900: The 'American School' at the Universal Exposition*, exh. cat., New Brunswick, N.J., 1999

Gasser, M., *München um 1900*, Bern, 1977

Glasgow 1900, exh. cat., The Fine Art Society, London, 1979

Gordon, D. E., *Modern Art Exhibitions, 1900–1916*, Munich, 1974

Greder, L., *Loisirs d'art: Mélanges, La peinture étrangère à l'Exposition de 1900*, Paris, 1901

Gyöngyi, É., *A Golden Age: Art and Society in Hungary, 1896–1914*, exh. cat., Center for the Fine Arts, Miami, Fl., and Barbican Art Gallery, London, 1989

Hausmann, M., et al., *Worpswede: Eine Deutsche Künstlerkolonie um 1900*, Fischerhude, 1986

Hills, P., *Turn-of-the-Century America: Paintings, Graphics, Photographs, 1890–1910*, exh. cat., Whitney Museum of American Art, New York, 1977

L'Horizon inconnu: l'art en Finlande 1870–1920, exh. cat., Musées de Strasbourg and Palais des Beaux-Arts, Lille, 1999

Impressionism to Symbolism: The Belgian Avant-Garde 1880–1900, exh. cat., Royal Academy of Arts, London, 1994

Joseph, L. A., ed., *Max Jacob/Léon David: Chroniques d'art, 1898–1900*, Paris, 1987

Jullian, P., *The Triumph of Art Nouveau: Paris Exhibition 1900*, New York, 1974

Junges Polen: Polnische Kunst um 1900, exh. cat., Museum Schloss Rheydt, Mönchengladbach, 1991

Lunzer-Talos, V., *Kunst in Wien um 1900: Katalog zu einer Ausstellung des Bundesministeriums für Auswärtige Angelegenheiten*, exh. cat., Das Bundesministerium, Vienna, 1986

Makela, M. M., *The Munich Secession: Art and Artists in Turn-of-the-Century Munich*, Princeton, N.J., 1990

Mandell, R. D., *Paris 1900: The Great World's Fair*, Toronto, 1967

McCully, M., *Els Quatre Gats: Art in Barcelona around 1900*, exh. cat., The Art Museum, Princeton University, Princeton, N.J., 1978

Meiji chuki no yoga – Realistic Representation III: Painting in Japan, 1884–1907, exh. cat., The National Museum of Modern Art, Tokyo, 1988

Michel, A., 'Les Arts à l'Exposition Universelle de 1900 – L'exposition décennale: La peinture française', *Gazette des Beaux-Arts*, 24, 3rd series: no. 522 (1 December 1900, pp. 527–536)

1900: Toulouse et l'art moderne, exh. cat., Musée Paul Dupuy, Toulouse, 1990

Pantini, R., *L'arte a Parigi nel 1900*, Florence, 1900

'The Paris Exhibition', *Art Journal*, London, 1901

'The Paris Exhibition, 1900', *Art Journal*, May 1900, pp. 129–132

Post-Impressionism: Cross-Currents in European Painting, exh. cat., Royal Academy of Arts, London, and National Gallery of Art, Washington, D.C., 1979

Quiguer, C., *Femmes et machines de 1900: Lecture d'une obsession modern style*, Paris, 1979

Raeburn, M., ed., *The Twilight of the Tsars: Russian Art at the Turn of the Century*, exh. cat., South Bank Centre, London, 1991

Rheims, M., *L'Art 1900 ou le style Jules Verne*, Paris, 1965

Royal Commission, *British Official Catalogue to the Universal Exhibition, Paris*, London, 1900

Silverman, D., *Art Nouveau in Fin-de-Siècle France: Politics, Psychology, and Style*, Berkeley, 1989

Sir Isidore Spielmann, *The Royal Pavilions, Paris International Exhibition*, London, 1900

Splendeurs de l'idéal: Rops, Khnopff, Delville et leur temps, Musée Communal, Ixelles, 1997

Sterner, G., *Der Jugendstil: Lebens- und Kunstformen um 1900: Künstler, Zentren, Programme*, Düsseldorf, 1985

Symbolist Europe, Lost Paradise, exh. cat., Musée des Beaux-Arts, Montreal, 1995

Um 1900: Das alte Karlsruher Künstlerhaus, exh. cat., Bezirksverband Bildender Künstler Karlsruhe, Karlsruhe, 1987

Varnedoe, K., *Northern Light: Nordic Art at the Turn of the Century*, New Haven, Conn., 1988

Verfasser, S. B., et al., eds, *Kunst um 1900: Bildende Kunst zwischen 1890 und 1910 aus den Beständen der Magdeburger Museen*, Museen, Gedenkstätten und Sammlungen der Stadt Magdeburg, 1985

Vlcek, T., *Praha 1900: Studie k dejinam kultury a umeni Prahy v letech 1890–1914*, Prague, 1986

Walton, W., A. Saglio and V. Champiere, *Chefs d'Oeuvre of the Exposition Universelle*, Philadelphia, Penn., 1900

Weisberg, G. P., *Art Nouveau Bing: Paris Style 1900*, New York, 1986

World's Fair of 1900. General catalogue: Exposition internationale universelle de 1900, Tome 2, Paris, reprinted in T. Reff, ed., *Modern Art in Paris: 1855–1900: Two hundred catalogues of the major exhibitions reproduced in facsimile in forty-seven volumes*, vol. 6, New York, 1981

Zeitler, R., *Skandinavische Kunst um 1900*, Leipzig, 1990

Lenders to the Exhibition

Aarhus Art Museum
City of Aberdeen Art Gallery
and Museums Collection
Mme Béatrice Altarriba-Recchi
Amherst College, Massachusetts,
Mead Art Museum
Amsterdam, Fridart Stichting
Amsterdam, Stedelijk Museum
Avignon, Musée Calvet

Barcelona, Museu Nacional d'Art
de Catalunya (Museu d'Art
Modern)
Barcelona, Museu Picasso
Basel, Galerie Beyeler
Basel, Öffentliche Kunstsammlung
Basel, Kunstmuseum
Berea College
Bergen Art Museum, Rasmus Meyers
Collection
Berlin, Galerie Michael Haas
Berlin, Stadtmuseum
Bordeaux, Musée des Beaux-Arts
Boston, Museum of Fine Arts
Bradford Art Galleries and Museums
Bremen, Kunsthalle
Brooklyn, Museum of Art
Brussels, Musée d'Ixelles
Brussels, Musées Royaux des Beaux-
Arts de Belgique
Brussels, Patrick Derom Gallery
Budapest, Hungarian National
Gallery
Budapest, Szépmüvészeti Múzeum
Buffalo, Albright-Knox Art Gallery

Cambridge, Fitzwilliam Museum
Cambridge, Mass., Busch-Reisinger
Museum, Harvard University
Art Museums
Campbell, Vivian and David
Cardiff, National Museums and
Galleries of Wales
Chicago, The Terra Museum
of American Art
The Cleveland Museum of Art
Cologne, Wallraf-Richartz Museum
Columbus Museum of Art
Copenhagen, The Hirschsprung
Collection
Copenhagen, Ordrupgaard
Copenhagen, Statens Museum
for Kunst

Detroit, The Detroit Institute
of Arts
Douai, Musée de la Chartreuse
Dresden, Gemäldegalerie Neue
Meister, Staatliche
Kunstsammlungen

Edinburgh, Scottish National Gallery
of Modern Art
Essen, Museum Folkwang

Falmouth, The Tuke Collection,
Royal Cornwall Polytechnic
Society
Ferrara, Museo Giovanni Boldini
Florence, Galleria degli Uffizi
Fort Worth, Amon Carter Museum

Geneva, Petit Palais, Musée d'Art
Moderne
Ghent, Museum voor Schone
Kunsten
Ghent, E. & P. H. Serck
Greensboro, Weatherspoon Art
Gallery, The University of North
Carolina at Greensboro
Göteborg, Göteborg Museum of Art

The Hague, Haags Gemeente-
museum
Halle, Staatliche Galerie Moritzburg
Halle, Landeskunstmuseum
Sachsen-Anhalt
Hanover, Sprengel Museum
Helsinki, The Finnish National
Gallery Ateneum
Hiroshima Museum of Art

Ipswich Borough Council Museums
and Galleries

Karlsruhe, Staatliche Kunsthalle
Kracow, The National Museum

La Rochelle, Musée des Beaux-Arts
Leeds Museums and Galleries (City
Art Gallery)
Leipzig, Museum der bildenden
Künste
Lille, Palais des Beaux-Arts
Lisbon, Museu do Chiado
Liverpool, The National Museums
& Galleries on Merseyside (Walker
Art Gallery, Liverpool)
London, Private Collection
c/o Christie's
London, Courtauld Gallery
London, National Portrait Gallery
London, Private Collection, courtesy
of Pyms Gallery
London, Royal Academy of Arts
London, Tate Gallery
Los Angeles, The Armand Hammer
Museum of Art and Cultural
Center
The Los Angeles County Museum of
Art

Madrid, Centro de Arte Reina Sofia
Madrid, Museo Nacional del Prado
Manly Art Gallery & Museum
Melbourne, National Gallery of
Victoria
Mexico City, Colección Banco
Nacional de México
Mexico City, The Museo Nacional
de Arte
Mie Prefectural Art Museum
Milan, Collection Calmarini
Milan, Civica Galleria d'Arte
Moderna
Milan, Civico Museo d'Arte
Contemporanea
Milan, Pinacoteca di Brera
Milan, Studio Paul Nicholls
Milwaukee Art Museum
Minneapolis, The Frederick R.
Weisman Art Museum, University
of Minnesota

Morlanwelz, Musée Royal de
Mariemont
Moscow, Pushkin State Museum
of Fine Arts
Moscow, State Tretyakov Gallery
Munich, Bayerische
Staatsgemäldesammlungen,
Neue Pinakothek
Munich, Museum Villa Stuck
Munich, Städtische Galerie im
Lenbachhaus

Nantes, Musée des Beaux-Arts
de Nantes
Newcastle-upon-Tyne, Hatton
Gallery, University of Newcastle-
upon-Tyne
New Haven, Yale University Art
Gallery
New York, Berry-Hill Galleries
New York, Private Collection,
courtesy Galerie St. Etienne
New York, Solomon R.
Guggenheim Museum
New York, Metropolitan Museum
of Art
New York, The Museum of Modern
Art
New York, Whitney Museum of
American Art

Örebro, City Library and County
Library of Örebro Lan
Oslo, Munch-Museet
Oslo, Nasjonalgalleriet
Ottawa, National Gallery of Canada

Padua, Museo Bottacin
Paris, Centre Georges Pompidou,
Musée national d'art
moderne/Centre de création
industrielle
Paris, Musée Bourdelle
Paris, Musée d'Art Moderne de la
Ville de Paris
Paris, Musée de l'Assistance Publique:
Hôpitaux de Paris
Paris, Musée d'Orsay
Paris, Musée Maillol
Paris, Musée National de l'Orangerie
Paris, Musée Rodin
Paris, Petit Palais: Musée des Beaux-
Arts de la Ville de Paris
The Henry and Rose Pearlman
Foundation, Inc.
Philadelphia Museum of Art
Ponce, The Luis A. Ferré Foundation
Inc., Museo de Arte de Ponce
Porto, Museu Nacional de Soares dos
Reis
Prague Castle
Providence, Museum of Art, Rhode
Island School of Design

Quimper, Musée des Beaux-Arts

Reykjavik, National Gallery of
Iceland
Richmond, Virginia Museum of Fine
Arts
Rome, Banca d'Italia

Rotterdam, Museum Boijmans
van Beuningen
Rouen, Musée des Beaux-Arts

St Petersburg, The State Hermitage
Museum
St Petersburg, The State Russian
Museum
San Antonio Museum of Art
San Diego Museum of Art
San Francisco, Fine Arts Museum
of San Francisco
San Marino, The Huntington
Library, Art Collections and
Botanical Gardens
Santa Barbara Museum of Art
São Paulo, Collection Valentin
Mr and Mrs John H. Schaeffer
Countess Gabrielle de Schallenberg
Seebuell, Nolde Stiftung
Skagens Museum
Southampton, N.Y., The Parrish
Art Museum
Southampton City Art Gallery
Stockholm, Nationalmuseum
Stockholm, Prins Eugens
Waldemarsudde
Stockholm, Thielska Galleriet
Stuttgart, Staatsgalerie
Sydney, The Art Gallery of New
South Wales

Joey and Toby Tanenbaum
Mr and Mrs Peter G. Terian
Tokyo National University of Fine
Arts and Music
Turin, Galleria Civica d'Arte
Moderna e Contemporanea
The Turku Art Museum

Valencia, Colección de la Caja de
Ahorros de Valencia, Castellón
y Alicante 'Bancaja'
Venice, Museo d'Arte Moderna
Ca' Pesaro
Vienna, Bank Austria
Kunstsammlung
Vienna, Historisches Museum der
Stadt
Vienna, Leopold Museum
Vienna, Österreichische Galerie
Belvedere
V. N. Famalicão, Fundação
Cupertina de Miranda

Warsaw, Museum of Literature
Warsaw, Muzeum Narodowe
w Warszawie
Washington, Hirshhorn Museum
and Sculpture Garden,
Smithsonian Institution
Washington, National Gallery of Art
Washington, National Museum of
American Art, Smithsonian
Institution and Mrs Daniel Fraad
Washington, The Phillips Collection
Williamstown, Sterling and Francine
Clark Art Institute
Winterthur, Kunstmuseum

Zurich, Kunsthaus

Illustration Credits

BIOGRAPHY ILLUSTRATIONS

Adler: © Roger-Viollet, Paris. Alma-Tadema: London, *Artists at Home* photographed by J. P. Mayall, and reproduced in facsimile by photo-engraving on copper plates, London: Sampson Law, Marston, Searle and Rivington, 1884, © Royal Academy of Arts. Ancher: Courtesy of Skagens Museum, Denmark. Arkhipov: Moscow, Central State Archive of Literature and Art. Backer: © Nasjonalgalleriet, Oslo photo J. Lathion, Photo no. 178-NG FO17490KG. Balla: Archivio Fagiolo dell'Arco, Rome/IKONA. Baud-Bovy: © photo RMN, F. Vizzarona/M. El Garby, Paris. Beaux: Cecilia Beaux Papers, Archives of American Art, Smithsonian Institution, Washington. Benner: *Album Hervé Grandsart*, Documentation du Musée d'Orsay, Paris. Bergh: Statens Konstmuseer, The National Swedish Art Museum, Stockholm. Bernard: Private Collection. Bjerre: Det Kongelige Bibliothek, neg. no. 36476, Copenhagen/IKONA, Rome. Blanche: © Musée Rodin, Paris, photo: Stereoscopic Company, Ph 1951, London. Boldini: Archivio Doria, Bologna/IKONA. Bonnard: photo RMN, Hervé Lewandowski, © ADAGP, Paris and DACS, London 2000. Bordalo Pinheiro: Museu du Chiado, Divisão de Documentação Fotográfica, Instituto Português de Museus. Bouguereau: © Archives Larousse-Giraudon, photo A. Gerschel. Bourdelle: © Musée Bourdelle (Mairie de Paris Direction des Affaires Culturelles), Paris. Bracht: © Bildarchiv Preußischer Kulturbesitz, Berlin. Breitner: © Netherlands Institute for Art History, The Hague. Breton: © Archives Larousse-Giraudon, Paris, photo: Dornac. Brull y Vinyoles: © Institut Amatller d'Art Hispànic/J. M. Serra-16666, Barcelona. Burne-Jones: London, By courtesy of the National Portrait Gallery, Emery Walker Collection, photo: Hollyer. Carneiro: Casa oficina António Carneiro, Divisão de Documentação Fotográfica, Instituto Português de Museus, Lisbon. Carolus-Duran: © Roger-Viollet, Paris. Carrière: © Archives Larousse-Giraudon, Paris, photo: Dornac. Cassatt: Farmington, © Hill-stead Museum, CT, photo: Theodate Pope. Cézanne: Paris, © photo RMN, R. G. Ojeda, photo: Bernard Emile/ADAGP, Paris and DACS, London 2000. Chabas: Rome, IKONA. Chase: Washington D.C., Archives of American Art, Smithsonian Institution, Photography of Artists Collection 1. Claudel: © AKG, London. Claus: Musées royaux des Beaux-Arts de Belgique, Archives de l'Art contemporain en Belgique, inv. no. 29970, Brussels. Clausen: © Royal Academy of Arts, London/unknown photographer. Collin: © Roger-Viollet, Paris. Constant: Paris, photo: RMN, J. G. Berizzi, painting by Angèle Delasalle. Corinth: © AKG, London. Cottet: © Archives Larousse-Giraudon, photo: Dornac. Dalou: © Collection Viollet. Danielson-Gambogi: © Finnish National Gallery, Central Art Archives, Helsinki. Degas: Private Collection/Jean Loup Charmet, Paris. Degouve de Nuncques: Musées royaux des Beaux-Arts de Belgique, Archives de l'Art contemporain en Belgique, inv. no. 3802, Brussels. Delville: Musées royaux des Beaux-Arts de Belgique, Archives de l'Art contemporain en Belgique, inv. no. 33027, Brussels. Denis: © archives catalogue raisonné de Maurice Denis, Saint-Germain-En-Laye. De Vigne: Koninklijk Museum Voor Schone Kunsten, Anvers. Dewing: Washington D.C., Archives of American Art, Smithsonian Institution, Photographs of Artists, Collection 1. Dubovskoy: © Tretyakov Art Gallery, Moscow. Dufy: Paris, © Harlingue-Viollet. Eakins: Washington D.C., Archives of American Art, Smithsonian Institution. Photographs of Artists, Collection 1. Edelfelt: © Finnish National Gallery, Central Art Archives, Helsinki. Enckell: © Finnish National Gallery, Central Art Archives, Helsinki. Ensor: Musées royaux des Beaux-Arts de Belgique, Archives de l'Art contemporain en Belgique, inv. no. 10292, Brussels. Eugen: © Statens Konstmuseer, The Swedish National Art Museums, Stockholm. Evenepoel: Musées royaux des Beaux-Arts de Belgique, Archives de l'Art contemporain en Belgique, inv. no. 76613/458, Brussels. Find: Bodil Bierring Billeder, Copenhagen. Forbes: London, by courtesy of the National Portrait Gallery, London. Ford: © Photographic Archive, Royal Academy of Arts, London. Frampton: by courtesy of the National Portrait Gallery, London. Frédéric: Musées royaux des Beaux-Arts de Belgique, Archives de l'Art contemporain en Belgique, inv. no. 169 86, Brussels. Freire: Instituto José de Figueiredo, Divisão de Documentafão Fotográfica, Instituto Português de Museus, Lisbon. Gallén-Kallela: Wermer Gestrim/Central Art Archives, Helsinki, Gallén-Kallela Museum. Gambogi: IKONA, Rome. Gauguin: © Roger-Viollet, Paris. Gérôme: © Archives Larousse-Giraudon, Paris, photo: Dornac. Gilbert: by courtesy of the National Portrait Gallery, London. Grabar: © Tretyakov Art Gallery (Dugino Estate), Moscow. Grubicy (de Dragon): Mart Archives/IKONA, Rome. Guillou: © Galerie Gloux, Collection Municipale, Concarneau. Halonen: © Tuusula Museum, Helsinki, photo: Daniel Nytlin. Hammershøi: Statens Museum for Kunst, Copenhagen. Hassam: Peter A. Juley and Son Collection, National Museum of American Art, Smithsonian Institution, Washington D.C. Henner: © photo RMN, Paris, Hervé Lewandowski. Henri: Washington D.C., Archives of American Art, Smithsonian Institution. Photographs of Artists Collection 1. Herterich: Sächsische Landesbibliothek-Staats-und Universitäts-bibliothek/SLUB Dresden Fotothek, Dresden. Hodler: © Collection of Jura Bruschweiler, Geneva, photo: Emile Pricam. Homer, © AKG, London. Israëls: IKONA, Rome. Jansson: © Statens Konstmuseer, The Swedish National Art Museums, Stockholm. Jarnefelt: © Finnish National Gallery, Central Art Archives, Helsinki. Jawlensky: Archive Alexej von Jawlensky, Locarno, IKONA/Rome. John: Collection of Michael Holroyd, London. Kalckreuth: photo: F. Hertel, Weimar/IKONA, Rome/BPK, Berlin. Kandinsky and Kardovsky: Gabriele Münter-und Johannes Eichner-Stiftung, Munich. Kanokogi: © Tokyo National Research Institute of Cultural Properties, Tokyo. Keller: Archive of the Staatliche Kunsthalle Karlsruhe. Khnopff: Musées royaux des Beaux-Arts de Belgique, Archives de l'Art Contemporain en Belgique, inv. no. 1752, Brussels. Klimt: © AKG, London. Klinger: © AKG, London. Korovin: London, © Novosti. Krohg: © Nasjonalgalleriet, photo: Fred Riise, photo no. NG FOO5489KG, Oslo. Kroyer: © Kunstakademiets Bibliotek, Copenhagen. Kupka: © Archives Pierre Brullé, Paris. Kustodiev: © Novosti, London. Lacombe: © Amis de Georges Lacombe, Versailles. Laermans: Musées royaux des Beaux-Arts de Belgique, Archives de l'Art contemporain en Belgique, inv. no. 9183, Brussels. Lambeaux: Musées royaux des Beaux-Arts de Belgique, Archives de l'Art contemporain en Belgique, inv. no. 77488, Brussels. La Thangue: © Royal Academy of Arts, London. Lavery: by courtesy of Rupert Maas. Leduc: © Collection Bibliothèque Nationale du Québec: Fonds Ozias-Leduc, Montreal. Leighton: © Royal Academy of Arts, London. Lenbach: Städtische Galerie im Lenbachhaus, Munich. Le Sidaner: © ADAGP, Paris and DACS, London 2000. Levitan: © David King Collection, London. Lhermitte: © Archives Larousse-Giraudon, Paris. Liebermann: © Bildarchiv Preussischer Kulturbesitz, Berlin. Long: Reproduced with the kind permission of the Ophthalmic Research Institute of Australia. Luce: Musée Départemental Maurice Denis 'Le Prieuré', Saint-Germain-en-Laye. MacMonnies: Washington D.C., Peter A. Juley & Son Collection, National Museum of American Art, Smithsonian Institution. Maillol: © Harlingue-Viollet, Paris. Malyavin: Tretyakov Art Gallery, St Petersburg. Matisse: © Succession Henri Matisse/Musée Matisse, Le Cateau, Cambrésis, Nice. Maurer: Washington, Alfred Stieglitz Collection, © 1999 Board of Trustees, National Gallery of Art. Max: © Bildarchiv Preussischer Kulturbesitz, Berlin. Melchers: Washington D.C., Archives of American Art, Smithsonian Institution, Photographs of Artists Collection 2. Meunier: © Bildarchiv Preussischer Kulturbesitz, photo: Hennebert, Berlin. Minne: Musée royaux des Beaux-Arts de Belgique, Archives de l'Art Contemporain en Belgique, inv. no. 166, Brussels, photo: E. Sacré, Gand/IKONA, Rome. Modersohn-Becker: © Bildarchiv Preussischer Kulturbesitz, Berlin. Moll: photo: Bildarchiv, ÖNB Wien/IKONA, Rome. Mondrian: © Netherlands Institute for Art History, The Hague. Monet: © Archives Wildenstein Institute, Paris. Moran: Washington D.C., Peter A. Juley & Son Collection, National Museum of American Art, Smithsonian Institution. Moravov: © Central State Archive of Literature and Art, Moscow. Morbelli: Casale Monferrato, Archivio Morbelli/IKONA, Rome. Morrice: © National Archives of Canada, accession no: 1981-074 Neg. no: PA 135 252, Ottawa. Mucha: © Stapleton Collection, UK/Bridgeman Art Library, London. Munch: Oslo, photo: Edvard Munch, Collodian printing-out paper, © Munch Museum. Nibbrig: © Netherlands Institute for Art History, The Hague. Nielsen: Copenhagen, Det Kongellige Bibliothek, neg. no. 109399. Nolde: Schleswig, © Nolde-Stiftung Seebüll. Oller: Puerto Rico, Courtesy of Osiris Delgado. Orpen: London, Courtesy of The National Portrait Gallery, photo: Beresford. Osborne: Dublin, Reproduction of Walter Osborne by Nathaniel Hill, Courtesy of the National Gallery of Ireland. Pellizza da Volpedo: © Volpedo-Studio-Museo di Pellizza/Frederico Castellani, Alessandria/IKONA, Rome. Peto: IKONA, Rome. Picasso: Paris, © RMN, Archives du Musée Picasso. Pichot Gironés: Barcelona, © Institut Amatller d'Art Hispanic. Pissarro: Paris, © Archives Larousse-Giraudon. Previati: Raccolta Bertorelli, Milano/IKONA, Rome. Redon: Paris, © Archives Larousse-Giraudon, photo: Dornac. Renoir: Paris, © Archives Larousse-Giraudon, photo: Dornac. Repin: London, © AKG. Ring: Greve Museum/Sigrid Ring, photo: Frederik Riise. Roberts: Rome, IKONA. Rodin: Paris, © Rodin Museum, photo: M. Bauche. Roll: Paris, © Branger-Viollet. Rosso: © Museo Medardo Rosso, Barzio (Lecco)/IKONA, Rome. Rothenstein: London, © Courtesy of The National Portrait Gallery, London. Rousseau: Paris, © Collection Viollet. Ruelas: CNA/Biblioteca de las artes, Mexico City, coll. Morillo Sapa/IKONA, Rome. Rusiñol: Barcelona © Institut Amatller d'Art Hispanic. Ruszczyc: Warsaw, National Museum, nr. DI 59 214 111. Rutherston: Hull, Ferens Art Gallery, Hull City Museums and Art Galleries (ACC 347), by permission of Max, Selina and Jane Rutherston. Saint-Gaudens: Washington D.C., Peter A. Juley & Son Collection, National Museum of American Art, Smithsonian Institution. Sargent: London, Courtesy of The National Portrait Gallery, London. Segantini: Rome © Segantini Museum, St Moritz/IKONA. Selvatico: Rome, IKONA. Serov: London, © Novosti. Shannon: London, © Hulton-Getty, photo: George C. Beresford. Sickert: London, © Tate Gallery Archives. Sloan: Washington D.C., Archives of American Art, Smithsonian Institution, Photographs of Artists Collection 1. Sohlberg: Oslo, © Nasjonalgalleriet, photo: Olaf Kosberg, photo no: NGFOO 9489KG. Sorolla: Madrid, Museo Sorolla. Sousa: Coll. Ana Jordâo Felgueiras, Porto/Centro Portugues de Fotografia/IKONA, Rome. Southern: Rome, IKONA. Stanislawski: Warsaw, National Museum, nr Rys.Pol.210866. Strindberg: Paris, Reutlinger. Stuck: Berlin, © Bildarchiv Preussischer Kulturbesitz. Szinyei Merse: Private Collection. Tack: New York, H. Siddons Mombray Class, *c.* 1888, Collection of the Art Students League of New York, unidentified photographer. Tanner: Washington D.C., Archives of American Art, Smithsonian Institution. Photographs of Artists, Collection 1. Thoma: Berlin, © Bildarchiv Preussischer Kulturbesitz. Thorláksson: © Sigfus Eyrrurdsson/National Museum of Iceland. Thorneycroft: London, © Royal Academy of Arts. Toorop: © Spaarnstad Fotoarchief. Toulouse-Lautrec: Albi-Tarn, France, © Musée Toulouse Lautrec. Troubetzkoy: Rome, Verbania, Museo del Paesaggio/IKONA, Rome. Trübner: Karlsruhe, Staatliche Kunsthalle, photo: AKG London. Tuke: London, Private Collection/The Stapleton Collection/Bridgeman Art Library. Von Uhde: Dresden Gemäldegalerie, Neue Meister, London, AKG. Vallotton: Paris, © Archives Annette Vaillant/Jean Loup Charmet. Van den Abeele: © Netherlands Institute for Art History, The Hague. Van Rysselberghe: Brussels, Musées royaux des Beaux-Arts de Belgique, Archives de l'Art Contemporain en Belgique, inv. no. 78045, Brussels. Velasco: IKONA, Rome. Vlaminck: Paris, © Harlingue-Viollet. Vrubel: London, David King Collection. Vuillard: Paris, © photo RMN, Hervé Lewandowski/ADAGP, Paris and DACS, London 2000. Weiss: Artist's Family Collection, Cracow. Whistler: London, Bridgeman Art Library/Stapleton Collection. Wilhelmson: Stockholm, © Statens Konstmuseer, The Swedish National Art Museums. Yuasa: Tokyo National Research Institute of Cultural Properties. Zorn: Stockholm, © Statens Konstmuseer/Jaeger, The Swedish National Art Museums. Zuloaga: Paris, © Roger Viollet

Index

445